THE BOOK
BEFORE
PRINTING

THE BOOK BEFORE PRINTING

Ancient, Medieval and Oriental

David Diringer

Dover Publications, Inc.
New York

This Dover edition, first published in 1982, is an unabridged and unaltered republication of the work originally published in 1953 under the title *The Hand-Produced Book*.

Manufactured in the United States of America
Dover Publications, Inc.
31 East 2nd Street, Mineola, N.Y. 11501

Library of Congress Cataloging in Publication Data

Diringer, David, 1900-
 The book before printing.

 Reprint. Originally published: The hand-produced book. London : Hutchinson's Scientific and Technical Publications, 1953.
 Includes bibliographies and index.
 1. Books—History—400-1400. 2. Printing—History. I. Title.
Z6.D57 1982 002 81-17290
ISBN 0-486-24243-9 AACR2

CONTENTS

PREFACE

T HE results of many years' research into the history of the book are here presented. While many of the facts mentioned have been known for some time, there is much information that is believed to be new and, so far as the author is aware, these facts and the conclusions to be drawn from them have never previously been brought together. The history of the book is one of the most fragmentary chapters in the history of civilization, however great the gaps may be in other fields of research. It is, indeed, remarkable that—notwithstanding the enormous number of publications on particular aspects of the development of the book—very few comprehensive histories of the book have appeared in English during the last fifty years, a period of unexampled progress in many fields of knowledge. Some of the discoveries during this period have completely reversed the ideas concerning the history of the book current about the beginning of the century. Of late years we have learnt much regard'ng the antiquity of writing and of book production, and it is of primary importance to study the earliest records in the light of modern research. In almost every department of science the theories of yesterday are refuted by facts of today, though the ascertainment of these facts has frequently been aided by those very theories. So it is that, in the main, the works of the greatest scholars and experts have no finality; they are but stepping-stones towards the high goal of perfect knowledge.

Naturally the author's own theories must inevitably colour his presentation of facts, but so far as is known this has never been allowed to lead to any distortion for the sake of supporting a favourite thesis. In stating facts preference has been given to the actual words of the authors quoted. Since the main purpose of this volume is to provide a handy and up-to-date work of interest to the general reader, the author has not thought it necessary in all instances to supply precise references for his quotations. It has hardly been possible within the limits prescribed to do more than stimulate interest by providing sufficient information for the inquiring reader. The latter will probably wish to follow particular developments in greater detail. To meet this need, long lists of books, some dealing fully with a particular period or subject, others dealing with the field as a whole, are given after single

chapters or sections, or at the very end. Indeed, the subject is much too rich to be exhausted in one or two books, and the present volume may serve as a guide for future research.

Inevitably a certain amount of information is given on the contents or the literary aspect of some of the manuscripts mentioned—particularly in the generally less known departments—but this work is not intended as a review of the world's literature, and the contents are referred to mainly as being examples of the common phenomenon of the influence of the contents on size, shape and presentation.

Writing materials, from the hammer and chisel to the paint-brush and the pen, from stone to clay, to papyrus and parchment, have commanded a fair amount of space, and it would be unfortunate to ignore entirely the human side or some of the stories about the men whose work has culminated in the modern book as we know it. Naturally many of the books mentioned are hardly books in the modern sense, but a certain amount of latitude in the use of terms must be permitted.

The present work is another step in the plan outlined in the author's *The Alphabet, A Key to the History of Mankind*, in which it was indicated that the story of the alphabet would in due course be followed by a history of the development of writing. It is perhaps unfortunate that it has been found impossible to cover the whole story of the book in one volume, but the first of the two volumes now presented tells the story of the hand-produced book from the earliest times to the invention of printing, and the second volume will cover illumination and binding of the hand-produced book.

Of the ten chapters of the volume, chapters IV–VII tell the main story. Chapter I is something of an introduction. Chapter II deals with a subject of material importance from the point of view of the development of the book, but is not in itself a part of the history. Chapters III, VIII and IX deal with these parts of the history which are aside from the main line of development of the book as we know it. The long chapter X has been written mainly for the English reader. If the present work is translated into other languages —Italian, French, German, Spanish, Dutch, and so on—it would be the author's desire to add a chapter on the development of the book in the country concerned.

Unavoidably, a book of this kind is bound to contain a certain amount of repetition, but this has been reduced to a minimum and is usually more apparent than real; indeed, the same subject matter, if dealt with more than once, is usually presented from a different angle.

In the spelling and transliteration of Egyptian, Semitic, Indian, Chinese, Greek and other foreign words, especially place-names and proper names—as already pointed out in the Preface to *The Alphabet*—inconsistencies in a composite work such as this are unavoidable, and the general reader should understand that a quite satisfactory solution of the problem has not been found. The practice commonly adopted has in general been followed, but here and there consistency is sacrificed to the idea of presenting to the reader familiar names in their familiar forms. And since in any case inconsistency is unavoidable, certain spellings have been simplified where no confusion is likely to result. Although in some cases divergent transliterations may cause difficulties, it is reasonable to assume that general readers are indifferent to what experts know, while experts do not always agree as to the precise spelling.

As one might expect, there is a long list of people to whom the author is indebted. It seemed advisable to have all sections carefully checked by experts in the respective fields. Some of these are mentioned in the list of acknowledgements, but perhaps some should be included here, such as Professors A. J. Arberry and H. W. Bailey, Professors B. Dickins and W. F. Edgerton, Dr. I. Gershevitch, the late Prof. G. Haloun, Prof. T. Kamei, Sir Thomas Kendrick, Prof. M. C. Knowles, Messrs. J. Levcen and C. Moss, Professors R. A. B. Mynors, J. M. de Navascués and D. L. Page, Messrs. J. M. Plumley and R. M. Rattenbury, the Hon. S. Runciman, Prof. J. M. C. Toynbee, Messrs. P. van der Loon, G. M. Wickens and D. J. Wiseman, and Prof. F. Wormald. Gratitude is expressed to Mrs. Hilda Freeman and to Messrs. L. A. Freeman, and C. E. Vulliamy, who carefully read the whole book in manuscript, and made many valuable criticisms and suggestions. The suggestions made by various experts often concerned debatable questions which, in this book, the author has endeavoured to reduce to a minimum.

It is impossible for the author to express adequately his most sincere gratitude to all the librarians and others who have collaborated in the production of this volume—first and foremost to the following scholars: Abbot Anselmo Maria Albareda, Prefect of the Vatican Library; Prof. H. W. Parke and M. J. Hanna, resp. Librarian and Assistant Librarian of Trinity College, Dublin; Dr. R. J. Hayes, Director of the National Library, Dublin; Dr. R. W. Hunt and Dr. A. F. L. Beeston, Keepers, resp., of the Western and the Eastern Manuscripts of the Bodleian Library, Oxford; the staff of the University Library, Cambridge; Dr. Irma Tondi-Merolle,

Director of the Riccardian Library, Florence; Dr. P. Calisse, Secretary of the *Enciclopedia Italiana*, Rome; Prof. D. T. Rice, University of Edinburgh; Prof. J. Weingreen, Mlle F. Henry, Dr. L. Bieler, and other scholars of the two University colleges of Dublin.

The author also wishes to express appreciation to those who have given encouragement and counsel relative to bringing the work to publication, and particularly to Mr. W. H. Johnson, the manager of the Scientific and Technical Department of Hutchinson and Company. Furthermore, he desires to record his most sincere thanks to Professors A. J. Arberrey and D. Winton Thomas, Mr. R. D. Barnett, Mrs. and Mr. J. I'A. Bromwich for having read the proofs of the book, and for in other ways facilitating the publication of this work.

CAMBRIDGE, D. D.
 Easter Term, 1953.

ACKNOWLEDGEMENTS

EVERY conscientious effort has been made to give due acknowledgement and full credit for borrowed material, but if through any unwitting oversight some trespass has been committed, by quoting from secondary sources, forgiveness is sought in advance, apology is freely offered, and correction promised in any subsequent editions.

Thanks are gratefully given to the following persons, institutions and publishers for permission to quote and to reproduce illustrations contained in books written or published by them, or else to reproduce objects of art in their possession: Director F. B. Adams, Jr. and the Pierpont Morgan Library; the Librarian of the American Museum, Madrid; the American Schools of Oriental Research; Sir Leigh Ashton (Director and Secretary) and Mr. A. W. Wheen (Librarian) for Victoria and Albert Museum Crown Copyright; Dr. U. Baroncelli and the Queriniana Library, Brescia; Lt.-Col. C. F. Battiscombe and the Dean and Chapter of Durham; Dr. L. Bieler; the Bodleian Library, Oxford; Revd. D. Botto, Arciprete, Sarezzano; the British Academy; the British and Foreign Bible Society; the British Museum; Dr. Calisse and the *Enciclopedia Italiana*; Miss B. Christensen; Mr. Harold 'C. Conklin and *Pacific Discovery*, California Academy of Sciences, San Francisco; Mr. J. Conway Davies, M.A.; Dr. P. E. P. Deraniyagala and the National Museums, Colombo; Miss S. Der Nersessian; Monsieur É. Drioton and the Egyptian Department of Antiquities; Prof. G. R. Driver; Prof. W. Eberhard; Mr. H. W. Edwards, Publisher of *Antiquity*; Express Newspapers, London; Dr. L. Giles; Prof. S. R. K. Glanville; Prof. L. C. Goodrich; the late Dr. H. Guppy; Mr. G. Lankester Harding; Messrs. Harper and Brothers, New York; Canon F. Harrison; Dr. R. J. Hayes and the National Library, Dublin; Mlle. F. Henry; Prof. P. K. Hitti; Prof. S. H. Hooke; Dr. A. W. Hummel and the Library of Congress, Washington; Sir Herbert Ingram, Bt.; Sir Thomas Kendrick; the late Sir Frederick Kenyon; Dr. S. N. Kramer and the University Museum, University of Pennsylvania, Philadelphia; Mr. J. Leveen, M.A.; Sir Richard Livingstone; Mr. P. van der Loon, M.A.; Prof. E. A. Lowe; Canon P. Marinone and the Capitulary Library, Vercelli; Messrs. Gaetano Macchiaroli, Publishers, Naples; Comm. Prof. A. Maiuri, Naples; Monsieur F. Masai; Prof. F. Mateu y Llopiss and the Central Library, Barcelona; Sir Ellis Minns; Prof.

xii ACKNOWLEDGEMENTS

R. A B. Mynors; Prof. O. Neugebauer; Mr. W. Oakeshott, M.A.; Prof. D. L. Page; Prof. H. W. Parke and the Library of Trinity College, Dublin; Miss D. W. Pearson; Dr. H. L. Pinner and Messrs. A. W. Sijthoff, Leyden; Prof. D. T. Rice; Director Warner G. Rice and the Museum of Archaeology, University of Michigan; Prof. E. Robertson and The John Rylands Library; Dr. Cecil Roth; Messrs. Routledge and Kegan Paul Ltd., London; Messrs. Shinchōsha, Tokyo; Messrs. Shiryō-hensanjo and Dr. Shorijo Ota, Tokyo University; Prof. E. A. Speiser; Sen. Prof. W. B. Stanford; Prof. E. L. Sukenik; Mr. S. C. Sutton, Mr. H. L. Greenaway and the India Office Library—Commonwealth Relations Office; Messrs. Thames and Hudson, London; Mr. J. E. S. Thompson, M.A.; Prof. P. Toesca; Dr. Irma Tondi-Merolle and the Riccardian Library, Florence; Dr. John C. Trevor; the University Library, Glasgow; the Vatican Library; Prof. K. Weitzmann; Prof. W. Perceval Yetts.

THE BOOK IN EMBRYO

I T is significant that man's intellectual progress and, particularly, the recording of his achievements—history in fact—are very late developments in his story as a whole. The modern anthropologist regards the human race as having had probably a million years' existence on this earth. Of this million years, only a small fraction —the last five thousand years or so—are recorded in any contemporary form.

Indeed, the earliest known books or their equivalents are the inscribed clay tablets of Mesopotamia and the papyrus rolls of ancient Egypt, both of which, in their primitive origins, are reputed to date at least from the early third millennium B.C.

If one goes further back, however, one might by a stretch of imagination regard as very nebulous beginnings of the book the Old Stone Age cave paintings—such as we find at Altamira or Lascaux—and other prehistoric or more recent picture-writings, as well as the oral tradition, aided by gesture and song, of prehistoric or other primitive peoples. Moreover, since so little is known of the origins and the early history of the book, it may be useful to follow up some clues afforded by language, which tenaciously preserves various terms originally denoting primitive writing materials. These primitive writing materials were not necessarily used earlier than the Mesopotamian clay tablets or the Egyptian papyri.

The present chapter dealing with such prodromes of the book, is thus divided into three sections, which will treat the following subjects: (1) oral tradition; (2) primitive human records and pictographic representations of stories; and (3) primitive writing materials, especially as evidenced by some modern terms. Numerous statements from classical and other early writers are included without any expression of opinion regarding their validity, because the beliefs of such men as Theophrastus or Livy or Pliny are of interest in themselves.

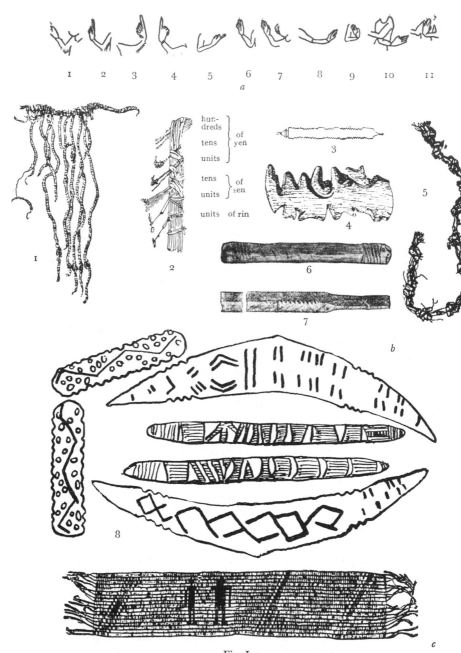

Fig. I-1

a, Chinese gestures (1–2, command; 3–5, vow, oath; 6–9, refusal; 10, refuse to marry; 11, usurpation). *b*, Knot-records and notched sticks (1, Peruvian *quipu*; 2, knot-record from Riukiu Islands; 3, notched stick from Laos, Indo-China; 4, "geographical map" from Greenland; 5, Makonde knot-record, Tanganyika Territory; 6–7, notched sticks from North America; 8, Australian notched sticks).

c, The famous *Pennwampum* of the Historical Society of Pennsylvania.

Oral Tradition

Unable to write, prehistoric man (like primitive men of today) relieved his soul by means of the spoken word aided by gesture— see Fig. I-1, *a* — and song. Whatever lore of nature and of well-being had been gained by one generation, was related by the *pater familias* or by story-tellers to the children, and lived with other traditions in their memories. Medicine men and story-tellers were selected for their personalities and exceptional gifts of memory. The first hymns, chants, jingles and tunes were invented by the story-teller to assist his memory in relating the general epics of the tribe, or by the medicine man for instruction in the mystic rituals.

Story-telling is thus one of the oldest cultural manifestations of man. From very early times, before the dawn of recorded history, man endeavoured to educate himself and his children, and told them of his and his father's adventures, of the lives and struggles of their gods and witches. His community was, of course, very much smaller than even many present-day villages. The feeling of community would be shared by all who would gather together in a convenient place of assembly, for instance, around a camp fire, where they would listen to the gifted story-teller relating the ancient traditions. The story-teller may have been a gifted singer who could recite his story in simple verse, and all would join in. Probably the story-teller or bard, growing old, would find a likely successor and pass on to him his store of stories, ballads or songs. Thus, for instance, Polynesian story-tellers trained their own memories and that of their sons so that they were able to hand down to posterity by word of mouth their people's history, especially their valuable migration traditions.

ORIGINS OF MYTHS

It is notable that in the oral traditions of primitive people there is no conception of accuracy or originality or plagiarism; lines or passages would be added or omitted, or other changes introduced. Generally, the importance of events was exaggerated; various episodes were connected with some great natural phenomenon or historical event (such as the Flood or the Trojan War), or with some mighty names (such as Gilgamesh or Samson or Ulysses or King Arthur). The natural surroundings, the phenomena of nature, the celestial bodies, the gods, the legendary heroes, the living spirits

hidden in nature, all were given the attributes of human beings.

The mythology thus shaped and preserved by the minds of these primitive tribes is an ocean filled with pearls, but it is far from sufficient for the reconstruction of prehistoric life. It is surprising, indeed, in how short a time all memory may be lost of events which are not recorded in some form of writing. Thus, it may be safely affirmed that no ancient civilized people or modern primitive tribes preserved any distinct recollection of their own origin. All experience shows that what may be transmitted by memory and word of mouth, consists mainly of heroic poems and ballads in which the historical element is so overlaid by mythology and poetry that it is not always easy to distinguish between fact and fancy.

Even with myths of relatively recent times, such as the Arthurian legends, it is difficult to know what measure of history they represent; there may, indeed, have been an historical Arthur, perhaps a chief of Christianized Romano-Britons, who led a gallant resistance to the flood of Anglo-Saxon invasion, but he is certainly not the hero of romance that Medieval Ages have made him out to be.

Real History is Based on Written Documents

To write real history, we require something very different—apart from the special qualities of the historian, with his powers of imaginative insight and keen analytical understanding; we require actual and reliable record. This, indeed, may be an ideal requirement, particularly if we include the idea of continuity in the record; but there is no doubt that we cannot entirely rely on a purely oral tradition, fostered as this would normally be by tribal feeling and pride, rather than by a concern for historical accuracy. At the very least, we require contemporary *written* documents.

As Professor R. A. Wilson points out, the world of mind advances by accumulative movement. "The library of the British Museum would illustrate adequately this cumulative movement of reason, where the various phases through which the world has passed in its previous evolution, themselves now vanished in time, are preserved in a permanent present, a pure world of mind though stored in the sensuous material of paper and ink. If we think of what a university, say, would be without a single book, and without blackboards, or notebooks, shut off from a vanished and irrecoverable past, we should have a picture of the limitations which time sets upon oral speech alone as instrument of conscious mind."

Primitive Human Records

G. H. Bushnell may be right in suggesting that presumably the first writing was done on soil by means of a human finger, followed by scratching upon trees and rocks, but, of course, there is no evidence to support any such suggestion and probably there never will be.

We do not know how "the book" began any more than we know how writing or language started. If we take "the book" to mean any kind of literary production, including story-telling, there is no people in all the world without books. If, on the other hand, we mean by "book" the handsome volumes we see in our modern libraries, we must realize that this use of the word is a relatively recent development.

Prehistoric Man probably did not think about true writing; even nowadays there are primitive tribes who can do without it. Indeed, various acoustic and optical devices (such as war-cries, signal horns, drums, gestures, and smoke-and-fire signals) suffice for their communication needs.

Primitive Devices of Communication

As man emerged from his primitive state, he must have felt a need of recording his knowledge in some permanent form, or of helping his memory in conveying important messages. Crude systems of conveying ideas or mnemonic devices are found extensively. (See *The Alphabet*, 2nd ed., 1949, pp. 21–31.) In these primitive devices of communication the symbols employed—see Fig. I-1, *b* and *c*—are mere memory aids and need the interpretation of the messenger; they may, therefore, be considered a preliminary stage of writing.

Stone-Age Paintings and Carvings

It is probable that the earliest examples extant of human attempts to scratch, draw or paint highly naturalistic or schematic pictures of animals, geometric patterns, crude pictures of objects, on cave walls or rocks or bones in the Upper Palaeolithic period and successive ages, belonging perhaps to 20,000—5,000 B.C., are also to be considered a preliminary stage of writing (see Fig. I-2). These carvings and paintings may have had religious significance, or may have served as fetishes or charms, such as hunting charms.

The marvellous cave paintings—some of them astonishingly vivid and lifelike and wonderfully distinct in detail—of Altamira,

a

b

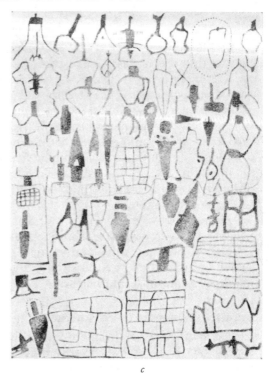

c

Fig. I–2
Prehistoric conventionalized figures, geometric signs, and so forth, painted or engraved on stone, from *a*, Spain; *b*, Portugal; *c*, Italy; *d*, Palestine; *e*, Crete; *f*, Egypt; and *g*, North Africa

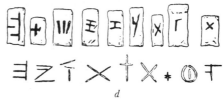

d

e

f

g

Northern Spain; of Combarelles, and Font-de-Gaume, Southern France; and of various other places in Northern Spain and Southern France, "are generally situated in the deep recesses of limestone caves, whither no daylight can penetrate. No families have ever lived in these fastnesses; they are often very difficult of access. And in executing the drawings the artist had often to adopt most uncomfortable attitudes, lying on his back or standing on a comrade's shoulders in a narrow crevice" (Prof. Gordon Childe).

These paintings show animals standing, and are merely "portraits" of those which the Palaeolithic Man hunted.

"SYMPATHETIC MAGIC"

It is not likely that any of these splendid paintings were made just for show or for the purpose of decorating these dark recesses. Sometimes they are executed one on top of the other, without any apparent order. What, then, is their meaning and purpose? Even in modern times and in "civilized" countries, the burning of images of enemy leaders is not unfamiliar; somewhere there remains the primitive feeling that what one does to the image, is done to the person it represents; it is a remnant of those ancient superstitions which still survive amongst many primitive tribes of Africa, Asia and Australasia. Medicine men and witches have been known to try to "work" magic in this way; they make an effigy of an enemy and then pierce it through the heart, or burn it, hoping that the enemy will suffer a similar fate. It would seem probable, indeed, that all these prehistoric paintings were done neither for purposes of art nor for transmitting records, but for performing magic.

Pictographic Representations of Stories

Pictography or picture-writing, which is the most primitive stage of true writing, may be subdivided into the following three classes:

(1) *Iconography*, which gives a static impression; the pictures, known as pictograms, represent the objects in a motionless state: the sketch of an animal would represent the animal, and, for example, a circle might represent the sun. Today with our action photographs and films, our comic strips and illustrations, the putting of action into pictures seems a small thing; actually it was a tremendously important development when the "artist" began to "write" picture-stories, *i.e.* when he began to make pictures tell

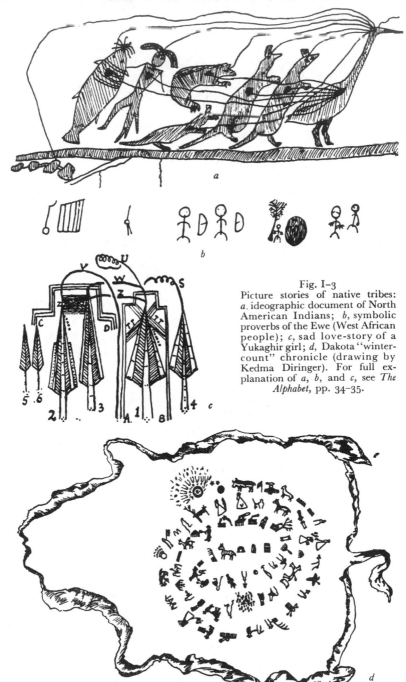

Fig. I-3
Picture stories of native tribes:
a, ideographic document of North
American Indians; *b*, symbolic
proverbs of the Ewe (West African
people); *c*, sad love-story of a
Yukaghir girl; *d*, Dakota "winter-
count" chronicle (drawing by
Kedma Diringer). For full ex-
planation of *a*, *b*, and *c*, see *The
Alphabet*, pp. 34-35.

stories—see Fig. I-3. It was, perhaps, the true beginning of the book.

(2) Thus, at any rate, arose *synthetic* or *ideographic writing*. This can best be studied in the relatively recent pictographic scripts of primitive peoples of Polynesia, West Africa, Central America, South-Western Asia, and among the Yukaghirs of N.E. Siberia (see *The Alphabet*, pp. 31–5), but the most famed among the pictorial documents are those of North American Indians, so beautifully described by Longfellow in *The Song of Hiawatha*, xiv.

A good example of these "picture-books" are the *wan'iyetu wo'wapi*, or "winter counts" of the Dakota tribes: they "count" the times by winters, which, however, they do not number, but apply to them a name taken from the main event marking the given winter, *e.g.* "plenty-stars-winter" for the winter of 1833–4: a great meteoric shower occurred in the evening of 12.11.1833 (Fig. I-3, *d*).

Fig. I-3, *d*, shows the winter count of Shunka-ishnala (Lonely Dog) of the Yanktonnai tribe of the Dakotas, living in 1876 near the Fort Peck, Montana. The "chronicle" painted on a buffalo hide consists of ideographic pictures, each of them representing one winter or year, and starts with the winter (1800–1) representing the "thirty-Dakotas-killed-by-Absarokas (or Crow Indians)", indicated by a symbol made up of thirty vertical strokes in three rows. In spiral direction from right to left, the symbols represent the "chronicle" of the years 1800–1 to 1870–1. The second symbol —"smallpox-used-them-all-up-again-winter"—represents the winter 1801–2; the last symbol, showing the "battle-between-Uncpapas-and-Absarokas-winter", is depicted at the top left hand, while the last but one represents the total eclipse of the sun (a dark sun with stars around it) of the winter 1869–70.

As to the spiral direction of writing, it is extremely interesting to compare this "chronicle" with the Phaistos disc—see p. 64 and Fig. I-4, *a*. No suggestion is made that the two documents, separated by over three and a half millennia of time and thousands of miles of space, have any relationship whatever. Curiously enough, as regards shape, the Phaistos disc can be compared with the "stone calendar" of the ancient Aztecs, these documents also being separated by thousands of years and thousands of miles; for the ancient Aztecs see p. 71 ff.

(3) *Analytic Writing*. Neither iconographic nor synthetic writing constitutes a complete system of writing, as does an analytic script, in which definite pictures, conventional and simplified, selected by custom from many experimental pictures, become fixed pictorial symbols, representing single objects or words.

Most of the important systems of writing may belong to this category: see next chapter. They are the Sumerian script, predecessor of the cuneiform writing, the Egyptian hieroglyphic script, the Cretan pictographic scripts, the Indus Valley script, the Hittite hieroglyphic, the Chinese, the Maya, and the Aztec scripts; perhaps

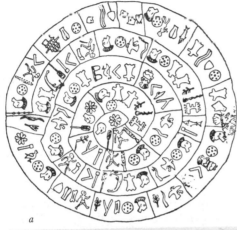

Fig. I-4,

a, One side of the *Phaistos disc*; *b*, inscribed wooden tablet from Egypt (British Museum, 1455); *c*, two Egyptian wood-labels (*obverse* and *reverse*), written in demotic— note two lines of "upside-down" Greek: right hand side, below.

also the Easter Island writing (*The Alphabet*, pp. 136–40) as well as some other medieval and modern scripts (*ibid.,* pp. 141–51) belongs to this class.

Not all these systems of writing, however, are purely pictographic and ideographic, although all of them may have been so in origin. In the later stages of development, Sumerian and cuneiform scripts, the Egyptian scripts, the Cretan and other systems are generally, but improperly, called ideographic, and are sometimes considered transitional, representing, as they do, the stage between pure ideographic writing and the pure phonetic system, and making use of the two, side by side. It is to be noted, however, that the term "transitional" is hardly appropriate to systems of writing lasting as long as three thousand years.

Nevertheless, from the point of view of the history of "the book", some of these systems can be regarded either as primitive or prehistoric, or as transitional. While in their initial stages they were not employed for book purposes as we use our writing, and were thus in a certain sense prehistoric, in their later stages they were often used for writing books, although these had a quite different form from that of the modern book.

Primitive Writing Materials, especially as evidenced by some Modern Terms

Since so little is known of the origins and the early history of "the book", it may be useful to follow up some clues which language affords us. A study of words reveals that many familiar expressions in our language, no less than in other languages, are used in senses other than those in which they were used originally.

Inference from the presence or absence of certain words is a common practice known for many years to critics and historians of literature, and is often used for what is known as "internal evidence"; but in general very little use has been made of language itself, that is to say, of the historical forms and meanings of words as interpreters of the distant cultural past.

It has only just begun to dawn on us that in modern languages the past history of humanity is spread out in an imperishable map, which preserves the inner, living history of ancient man's soul. Indeed, in many common words, words we use every day, the souls of past peoples, their thoughts and feelings, stand around us, not dead, but frozen into their attitudes like the courtiers in the garden

of the Sleeping Beauty. These words reveal in their analysis a story of the deepest interest; they represent a kind of "fossil history". But already, before these words originated, throughout much of Asia and Africa, and partly also in Europe, there were in existence different civilizations in various stages of development. Even so, such words represent early stages of cultural life, although in point of chronology they are much later than the earliest books, or their equivalents, of ancient Mesopotamia and Egypt.

What information can be deduced, for instance, from such words as "book", "write" and "library"?

THE WORD "BOOK"

What is a book? Dr. Johnson is supposed to have said that, though he could not define an elephant, he knew one very well when he saw it. Nowadays various definitions can be given to the word "book", which—in spite of their common root idea—differ very much from one another. Here, needless to say, we are concerned not with the "book" which some reader may have built up for himself in his trade or profession, or with the kind of "book" kept by the book-keeper, or with the word as used by those who "book" tickets for a theatre or a journey, or who have left their money with a "bookmaker". We are dealing with the "books" which "in all their variety offer the means whereby civilization may be carried triumphantly forward" (Winston Churchill). In this sense, the term "book" may indicate (1) a collection of paper leaves bound together; (2) a number of written or printed sheets fastened together at the back by means of some kind of cover known as binding; (3) a literary treatise, usually written or printed in one volume, but sometimes in several volumes if forming a single work; (4) a literary work; (5) main parts of a literary production (*e.g.* the *Iliad* consists of twenty-four "books").

The actual origin of the word "book" has been the subject of dispute, but it is commonly believed that it is etymologically connected with the name of the beech tree. The numerous ancient English forms of "book" (*bóc, boc, bok, bock, boke, booc, boock, booke, buk, buke, buik, buick*) show that this word is derived from Old English *bóc* (pl. *béc*), connected with Old Frisian and Old Saxon *bôk* (pl. *bôk*), Old Norse *bók* (pl. *boékr*), Old High German *buoh* (pl. *buoh*). (Middle High German, *buoch*, Modern German, *Buch*.) The Old English word for "beech tree" was *bóc*, Old Norse *bók*.

The exact connection between "book" and "beech tree", how-

ever, is not known. According to some scholars, the English monks wrote their books on white beech tablets; according to others, beech bark—for writing on bark see p. 34—was originally used for writing; still others have suggested that originally inscriptions were scratched on beech tablets.

More probable is the following theory: Old English *bóc* means "charter", and its plural means "tablets, writing tablets, written sheets"; hence, supposedly "book". The word "book" or *bóc* seems, indeed, to have been introduced into this country in Anglo-Saxon times by the ecclesiastics, who applied it to the written charters, also introduced by them; these afforded a more permanent and satisfactory evidence of a grant or conveyance of land than the symbolical or actual delivery of possession before witnesses, which was the previous system of transfer. This meaning of "book" is clearly shown in the legal term *bóc-land* (or "book-land"), property held under the express terms of a written document, and in the term *bóc-hord*, a place where charters or other written records were kept. Also Shakespeare uses "book" in this meaning: "By this our book is drawn; we'll but seal, . . ." (The First Part of *King Henry IV*, Act III, Scene i).

The Gothic language, however, has no similar form for "book", though there is *bókôs*, plural (derived probably from *bóka*, "letter"), which in the opinion of some scholars derives from the original use for writing on beech-sticks (*Buch-Stab*, in German). Curiously, also in Russian there is the word *bookva*, for "letter", but "book" is *kniga*. Finally, according to some scholars, the term "book" derives from—it would be more accurate to say "is parallel to"—the German word *Buch*, meaning "beech", and is connected with the fact that, in early days, beech wood was largely used for binding books. The beechen covers "were light, decorative, and very carefully dried and seasoned. It is remarkable how flat such old boards are, and they were no doubt very highly valued as they often have upon them the stamp of the monastery in which they were used" (C. Davenport). While, then, there is not sufficient evidence for a complete solution of the problem, there is at least a great probability that the ancient Germanic tribes used beech tablets or beech bark for writing.

The Word "To Write"

This theory finds support in the etymology of another English word, "write". It is derived from the Old English *writan*, connected with the Old Frisian *wrîta* ("to scratch, to write"), the Old Saxon

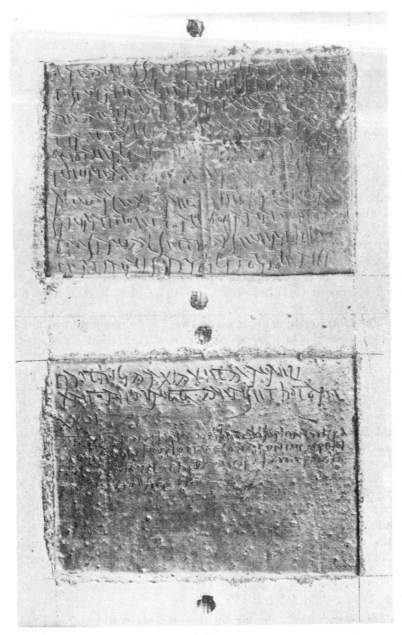

Fig. I–5

Roman wooden diptych (6 inches by 4¾ inches): waxed tablets, dated to the seventh
year of Septimius Severus (A.D. 198). The text, in Latin cursive, and a woman's
signature, written for her, in incorrect Greek, occupy the two sides of the interior
of the diptych, which are here represented (*above*, page 2 of the diptych; *below*,
page 3). Bodleian Library, at Oxford, MS. *Lat. Class.*, f. 9–10.

writan ("to cut, to write"), the Old Norse *rita* ("to scratch, to write") (Norwegian, *vrita* or *rita*, and Swedish *rita*, "to draw"), and Old High German *rîzan* ("to tear, to draw": cf. Modern German *ritzen*, "to scratch", and *reissen*, "to tear"); it is thus obvious that the ancient Teutonic conception of "writing" corresponded to the conceptions of "scratching" and "drawing" (*i.e.* on wood).

It is known, too, that the ideas of writing and drawing were identical in pre-historic Egypt and in Early Greece, as is shown by the Egyptian word *s-sh* and by the Greek *grapheîn*, both of which mean "writing" and "drawing". The word *grapheîn* gave us the main component of many words connected with "writing" or "description", such as "epigraphy", "palaeography", "ideography", "pictography", "stenography", "geography", and "choreography".

The Hebrew verb k^at^ab means "to write" as well as "to incise".

USE OF WOOD AS WRITING MATERIAL IN GREECE, EGYPT, AND ROME

Wood was the main writing material not only of the ancient Germanic tribes. Pliny says that in Greece table books of wood were in use before the time of Homer.

(*Pugillarium enim usum fuisse etiam ante Troiana tempora invenimus apud Homerum:* "We find, however, in Homer that the use of *pugillares* (wood-tablet books) existed before the Troian times. . . .": Pliny, *Nat. Hist.,* xiii, 69.)

This information however, is hardly reliable, as it is mainly based on *Iliad,* vi, 168, referring to Bellerophon ("he in the gilded tables wrote and sent"); see p. 29. According to uncertain information given us by Plutarch (A.D. *c.* 50–*c.* 120) and Diogenes Laertius (third century A.D.), Solon's laws (early sixth century B.C.) were inscribed on tables of wood. This tradition is also mentioned by Aulus Gellius (born *c.* A.D. 130): *in legibus Solonis illis antiquissimis, quae Athenis axibus ligneis incisae sunt* (ii, 12). This information, too, is not altogether reliable.

Tables of wood as writing material, however, are also mentioned by Sextus Propertius (second half of the first century B.C.), iii, 23.8; by Ovid (Publius Ovidius Naso, 43 B.C.–A.D. 17), i *Eleg.*, 2, and by many other Roman writers.

Actually, plain wooden tablets were used in Egypt (Fig. I–4, *b–c*) and in Greece—where they were called *déltos, pinax,* or *pyxion*—as early as the fifth century B.C. or earlier, for such purposes as the

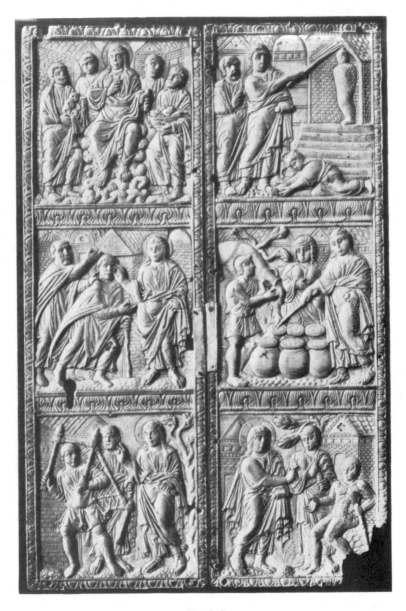

Fig. I–6

Roman ivory diptych, representing the Christian miracles; each leaf measures 12 inches by 3⅞ inches; fifth-century production from Italy. Victoria and Albert Museum, No. 51,391 (Victoria and Albert Museum Crown Copyright).

keeping of accounts, and the writing of models for schoolboys to copy (Herodotus, vii, 239). It should also be noted that in *Iliad*, vi, 169, the message carried by Bellerophon (*sémata lygrá*) plainly refers to a wooden tablet.

In Egypt, reed was also employed as writing material; for instance, a large split reed with a Coptic inscription written in ink on the inside, is reported to be in the Cairo Museum.

TABLETS: "PUGILLARES"

Wooden tablets (*tabellae* or *tabulae*) were commonly employed in ancient Rome; hence, the modern term "tablet" (from Latin *tabula*, meaning "board"). These wooden tablets were also called by the Romans *pugillares*, "notebooks", literally "handbooks"; perhaps they were so called because their small dimensions allowed of their being held in the hand or "fist", *pugnus*, *pugillus*.

The writing was at first upon the bare wood, which was cut into thin tablets, and finely planed and polished. Later, waxen tablets were used; these were made either of common wood (such as beech, fir, box, and so on) or of more expensive material such as cedar-wood—and were thinly coated with wax (in Greek *kērós* or *málthē*, *máltha*; in Latin, *cera*), usually black—see Fig. I-5, 7, 8. Sometimes, however, they were coated with a thin layer of gesso, which was polished.

The tablets were used singly, or in twos (known as *diptychon*, *diptych*, *i.e.* "double-folding [waxen tablets]": see Fig. I-5) or in threes (*triptych*, Fig. I-7, *below*); or more (*polyptych*) "leaves" (*cerae*) were hinged together—such sets of tablets being known as *codices* (see p. 35).

The writing was incised in the wax by means of a pointed implement, known as a *stilus* or *graphium* (see p. 553); it was so done particularly in the *scriptio interior* (*i.e.* in the writing on the internal sides). The *scriptio exterior* (*i.e.* the writing on the external sides) was sometimes done with ink (*atramentum*). The matter written (especially that scratched with a *stilus*) upon the waxen tablets was easily effaced, and by smoothing the wax (in the case of *gesso* tablets the writing could be washed off) new matter might be substituted for what had been written. Such tablets were, therefore, suitable for ephemeral notes, accounts, memoranda, lists of names, and so forth. They were particularly used by schoolboys.

The majority of the tablets measure 14 or 14.5 by 12 cm., but some measure 18 by 16 cm. and even 27.5 by 23.5. G. Pugliese

Fig. I-7

(*Above*) Roman inscribed wooden tablet; (*below*) Triptych from Pompei, dated
10.5.A.D.54.

Carratelli remarks, however, that the *pentaptych* and the *octoptych* (Fig. I–8, *below*) referred to further on, measure only 12.1 by 3.6 and 13.5 by 7 cm., respectively. The tablets, especially those made of box wood, were sometimes (as already mentioned) very thin and highly polished. So, for instance, the thickness of the external tablets of both the *pentaptych* and the *octoptych* is given as 0.6 cm., and of the internal tablets as 0.4 cm., the *speculum* of wax being reduced to 0.1 cm.

The outside of the codices, especially of the diptychs, was made of different materials, such as wood, ivory, or parchment—see Martial, xiv, 3–7. Originally the diptych cases were small, unornamented, and usually made of wood, but from the second century A.D. onwards they became larger and were mainly made of ivory. See Fig. I–6. Ivory diptychs, elaborately carved, were in later times used for "Byzantine" bookbindings—see the forthcoming book on *Illumination and Binding*.

The Greeks and Romans continued the use of *pugillares* long after the use of papyrus (or even parchment) became common, because they were so convenient for correcting extemporary compositions. From the *pugillares* they transcribed the final text on to papyrus rolls (or parchment), and when the work was to be published, the transcription was done by the *librarii* (see p. 34). Writing on *pugillares* is particularly recommended by Quintilian (Fabius Quintilianus, A.D. c. 35–95), *Institutio Oratoria*, X, Chapter 3.

See also, for instance, Ovid, *Metamorphoses*, ii. 522–5: (*Cf.* Fig. XI–3, *a*).

Dextra tenet ferrum, vacuam tenet altera ceram. In her right hand she holds her stilus, in her left an empty waxen tablet.

Incipit et dubitat; scribit damnatque tabellas; She begins, then hesitates; writes on and hates what she has written.

Et notat et delet; mutat culpatque probatque; Writes and erases; changes and condemns and approves.

Inque vicem sumptas ponit positasque resumit. By turns she lays her tablets down and takes them up again.

The *pugillares*, as mentioned, were generally used in schools (like slates in modern times), and sometimes for letters, the replies being written on the re-spread wax; they were particularly used for judicial and administrative purposes.

Several specimens are preserved in the British Museum (Add. MSS. 33270, 33293, 37533, and others), one of the most interesting being Add. MS. 33270, consisting of seven wooden tablets, or

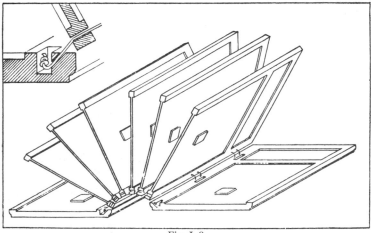

Fig. I–8

(*Above*) "Page" from a *heptaptych* (British Museum, *Add. MS.* 33270);
(*below*) *Octoptych* from Herculaneum, as reconstructed by M. Paolini.

heptaptych, belonging to the late third or early fourth century A.D. (Fig. I–8, *above*).

Amongst the numerous *codices* found at Herculaneum (see pp. 251–258), there are a few polyptychs found in the *Casa del Bicentinario,* the best preserved specimens being a *pentaptych* (*i.e.* consisting of five tablets) and an *octoptych* (consisting of eight tablets). A reconstructed design of the latter is represented in Fig. I–8, *below.*

Some specimens of ancient Roman tablets were found in the Alburnus Major (Voeroes Patak) gold mines in Dacia (Transylvania). One is of fir wood, and one of beech, each consisting of three "leaves". They are about the size of a modern octavo book. The outer parts exhibit a plain surface of wood, the inner parts are covered with a layer of wax surrounded by a raised margin of the wood; the edges of one side are pierced that they may be fastened together by means of a thread or wire. The wax is so thin that the stilus used by the writer cut through it into the wood below. The writing still remains and on one the name of the consul is given determining the date to be A.D. 169. Another document belongs to A.D. 139. The earliest extant examples of Roman tablets, dated A.D. 53 and 55, may be seen at the Naples Museum of Antiquities (they came from Pompeii).

The use of wooden tablets as writing material lasted into the modern age. In Lucbeck, there are preserved fifteenth-century waxen tablets; in outlying regions they were used for making occasional notes or accounts down to our own times.

"LIBRARY"

A few English words still remind us of the Roman use of wood as a writing material; for example, the word "library" (the building or room where books are kept, or else the collection or shelves of books), from the Old French *librairie*; "*libretto*" (book containing the text of an opera), from Italian; "libel" ("a false defamatory statement", a "formal document", but also "a little book", "a short treatise" or "writing"), from Latin *libellus*, the diminutive form of *liber*, "little book", "pamphlet"—the term *libellus* was frequently used in classical times (see Cicero, *Orationes*, i, 21; Horace, *Satires*, i, 10, 92; Suetonius, *Julius*, 56).

These and a few other words are derivations from the Latin word *liber*, "book", believed to be connected etymologically with *liber* meaning "bast", "rind", or the inside bark of a tree—the bark of trees having, according to Roman tradition, been used in early

times as a writing material. It has nothing to do, however, with the material of which paper or papyrus was made, i.e., *charta* (from Greek *khártēs*), the pith of the papyrus plant (see Chapter IV).

BARK USED AS WRITING MATERIAL

It may, instead, be assumed that in very ancient times the finest and thinnest part of the bark of such trees as the tilia, the philyra, a species of linden, the lime, the ash, the maple, and the elm, was used as writing material, just as the Sumatran (Fig. I–10, and 11, *above*), Central Asian, and Indian peoples (see pp. 354, 361, 379 and *passim*), and also the American Indians used similar substances in comparatively modern times.

A specimen of Latin writing on bark is preserved in the Cottonian collection of the British Museum. The National Library, at Madrid, is in possession of a charming book printed on bark, which the present writer examined during a recent visit to Spain.

Romance languages (French *librairie*; Italian and Spanish *libreria*; Portuguese, *livraria*) maintain the late Latin meaning of *librāria* (*sc. taberna*) as "bookseller's shop", but actually the Latin adj. *librārius*, and subst. *librārium*, mean "connected with books". The Romans had their *librarii* and *librarioli*; the former multiplied books by transcribing manuscripts, and the latter illustrated them by ornamenting the title-pages, margins, and terminations.

BIBLE-BIBLIOTHECA

The Romance and other languages employ for "library" a word such as late Latin *bibliotheca*, Italian and Spanish *biblioteca*, French *bibliothèque*, German *Bibliothek*, and Polish *bibljoteka*. These terms have derived from Greek *bibliothékē*, connected with the Greek common word for "book", *biblíon*, diminutive of *bíblos*, "the inner bark of the papyrus" (see Chapter IV).

This word gave to English and to all the other modern languages the name "Bible". The Greek plural neuter *ta biblía*, "the books", became Latin fem. sing. *biblia*, passed over to Italian, *Bibbia*, Spanish and Portuguese, *Biblia*, Provençal, *Bibla*, French, *Bible*, German, *Bibel*, Dutch, *Bijbel*, Polish, *Biblja*, etc. Curiously the word *bibliothēca* was originally used (so Jerome) for the Sacred Scriptures: in Old English we find *bibliothéce*, and in Anglo-Latin, *bibliothēca*, sometimes employed instead of the word "Bible".

In modern English we find numerous words connected with Greek *biblíon*, such as "bibliography" (history, or lists of books and

their editions), "biblioklept" (a book thief), "bibliolatry" (book worship), "bibliomania" (mania for possessing books), "bibliopegy" (art of bookbinding), "bibliophile" (book lover), "bibliophobia" (aversion to books), "bibliopoly" (book selling), "bibliotaph" (book burier), and many others. Some of these terms have preserved their meaning from ancient times. The Romans had their *bibliopegi* ("bookbinders"), who employed their skill on the embellishment of the exterior of the manuscripts, and the *bibliopola* ("booksellers"), who were engaged in the disposal of the books when finished.

Codex

Another Latin word connected with the employment of wood as writing material was *caudex* or *cōdex* (originally it meant "the trunk or stem of a tree"), signifying anything made of wood, as, for instance, a wooden tablet (see p. 29 ff.).

Later, the term was used for wooden tablets coated with a thin layer of blackened wax, commonly known as *pugillares*, or (see p. 29), for a set of two, three, or more (four, five, six, seven, or eight) tablets strung or bound together in a primitive and simple manner, of which our modern loose-leaf system may be said to be an elaborated revival. As already mentioned, the inside tablets had raised margins (*alvei*); they had also a slight projection, generally square, to prevent the wax of one tablet from rubbing against the other (which might deface or destroy the written notes): see, for instance, Fig. I–8. Finally, *codex* came to denote the set of tablets not only as writing material, but also as a book in the modern sense of the word.

When at a later period parchment and other material were substituted for wood and put together in book shape, the term *codex* was often used as synonymous with *liber*, but it was the name more particularly given to an account book, or ledger (*codex accepti et expensi*). In the time of Cicero it was also applied to a tablet on which a bill was written, and in still later times to any collection of laws or constitutions of the emperors, such as *Codex Theodosianus* or *Codex Iustinianeus*.

For literary compositions, the term *codex* was used by Christian writers, beginning with the "codices" of the sacred writings. The term was occasionally used by other writers at the end of the third century, but did not become popular till the fifth century, when the "codex" form of the "book" was firmly established (see Chapter V).

The Latin word *codex* passed into all the modern languages,

where it is used for a volume of a biblical or classical text in manuscript. English words derived from *codex* are "codify", "code", and "codicil".

WOODEN WRITING MATERIAL IN GERMANIC LANDS

The use by the ancient Germanic tribes of wooden tablets as their main writing material has already been mentioned. Another proof of this practice may be seen in the shapes of the runic letters (see *The Alphabet*, pp. 507-24), which can be considered as the "national" writing of the ancient Germanic peoples. The thorny, elongated and angular shapes of these letters, which even in inscriptions of the thirteenth and later centuries A.D. look as though they belonged to the seventh or sixth century B.C., show that this script was used chiefly for inscriptions. Indeed, there is no evidence whatever of wide literary use of runes in early times.

From our point of view it does not matter much whether the runes were originally employed simply for magical purposes or as a normal means of communication (the former theory being more acceptable), or whether they were originally used mainly for drawing and painting on clay and wood, so that the angular shapes might be due to the script from which the runes descended; the most probable theory being that they were originally carved on wood, so that the straight strokes and the angular shapes, which could be carved with ease, were preferred to curves. Sir Ellis Minns suggests the following explanation of the absence of horizontal strokes in the runic letters: "Runes must have been developed for carving on round sticks. Then every letter can be very quickly made with a knife."

Whatever their origin, the fact that the employment of these thorny letters continued for so many centuries, indicates that they were used mainly for writing on wood, or on other hard material.

FAR EAST AND INDONESIA

Wood and bamboo sticks were used as writing materials in ancient China (see p. 390, 398 ff.). About fifteen wooden tablets (known as *kohau rongo rongo*), covered with pictographic writing, still undeciphered, are the only documents extant of the "mysterious" script (unique in Polynesia) of ancient (?) Easter Island—see Fig. I-9, *b* and *c*.

SUMATRA

The Bataks, living in Sumatra, sometimes use as writing material long strips of bamboo, welded by "beating" them together, then folded together, accordion-like, between wooden covers, and bound together with a string of woven rushes. Often long strips of the thin bark of trees —such books being known as *pustakas* (see p. 379 f.)— are used.

One such book is in the Sloanian collection of the British Museum; it is on a long piece of bark folded up as in Fig. I–10, *b*. Another specimen of writing on bark, from India, is a Nabob's letter, on a piece of bark about two yards long, and richly ornamented with gold. It, too, is preserved in the British Museum. Fig. I–10 *c*, and Fig. I–11, *above*, reproduce Batak books on tree bark. The people on the Malabar coast also frequently wrote upon bark with a stilus: several specimens are preserved in the British Museum and in many other collections, public and private.

Some ancient books of the Bataks were written in brilliant ink on paper made of bark. The Lampong and Rèndjang tribes, also inhabiting Sumatra, scratch their messages and books on bamboo —see Fig. I–11, *below*—tree bark, or certain kinds of leaves. See also p. 377 ff.

THE PHILIPPINES AND ELSEWHERE

The pagan tribes of the Philippines Hanunóo (southern Mindoro) and Tagbánuwá (central Palawan) employ for purposes of writing the shiny surface of bamboo tubes and a small knife (see Fig. I–12).

Wooden writing material was also employed in many other countries to which reference has already been made. Its use in ancient Mesopotamia is mentioned by G. R. Driver (*Semitic Writing*, p. 16). A Kharoshthi book on wood from Eastern Turkestan is reproduced in Fig. 9, *a*. Amongst many primitive tribes, wood is still used as writing material.

For the *amatl* "paper" used in pre-Columbian America and even in modern Mexico, see p. 429 ff. and Fig. IX 13. In the Bodleian Library, at Oxford, there is a Mexican book on bark.

PALM LEAVES AS WRITING MATERIAL

The substances used for the reception of writing in the ancient world, as well as in modern times in some outlying regions, were numerous. Indeed, whatever was most conveniently available for the purpose was used.

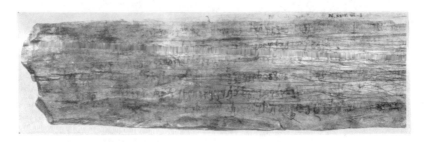

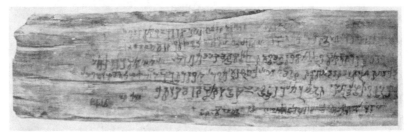

a

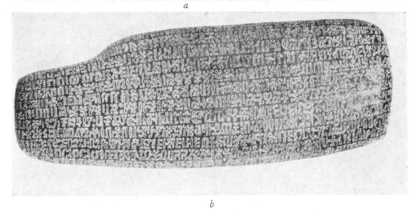

b

c

Fig. I-9

a, Kharoshthi "book" on wood, found at Niya (Ruin XXIV,vii) by Sir Aurel Stein in his second expedition to Chinese Turkestan (1906–08); *b*, and *c*, specimens of *kohau-rongo-rongo* tablets (inscribed wooden tablets from Easter Island).

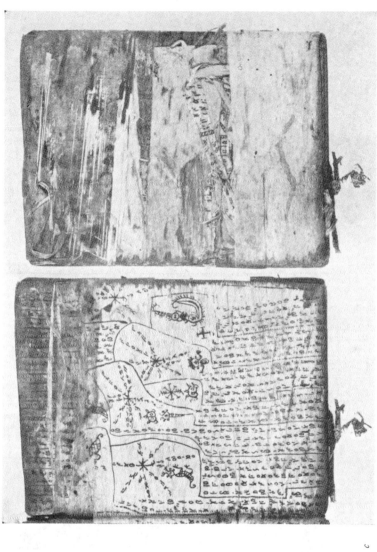

Fig. I-10

a, Forms of Oriental books; *b*, Batak divination bark-book in the form of a folded roll (*drawings by Ella Margules*); *c*, written page (left) and cover (right) of a Batak MS. written on the inner bark of *terap* tree, known as *Artocarpus kunstleri* (Cambridge University Library, *Or. 930*).

Among the various forms of perishable writing materials previously in use in Central and Southern Asia (and probably also in other parts of the world) we may place first the leaves of plants or trees; in Central and Southern Asia there were the *Talipat palm* and the *Palmyra palm*—see Chapter VIII.

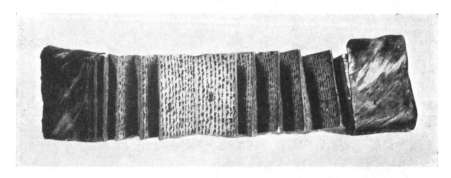

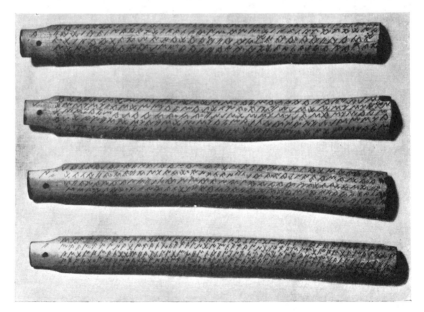

Fig. I-11

(*Above*) Another Batak divination book written on bark: represents part of the divination table for the thirty days of the month; (*below*) portion of a *Story of Creation*, written on bamboo in Malay language and Rèndjang characters employed in the South-Sumatran mountainous region in the districts of Palembang and Benkulen: the four sticks here seen are "numbered" (on the left side) with the letters *ta*, *pa*, *la*, and *sa*. (Explanation by Dr. P. Voorhoeve, University Library, Leyden).

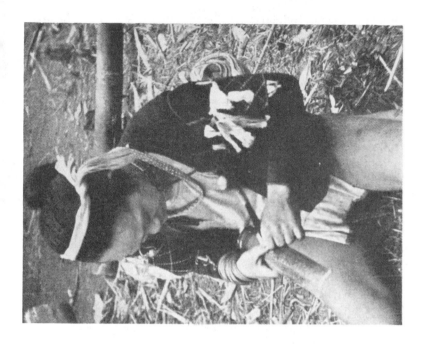

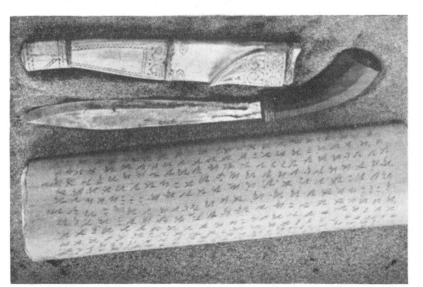

Fig. I-12

Bamboo used as writing material by the Hanunóo tribe of the Philippine islands: (*left*) Bamboo manuscript, small knife used for "writing", and sheath for the knife; (*right*) left-handed Hanunóo boy "writing" with a knife on a bamboo tube.

Pliny, speaking particularly of the Egyptians, says that men at first wrote upon the leaves of palm trees.

Pliny's passage is also important for the other writing materials he mentions. (*In palmarum foliis primo scriptitatum; deinde quarundam arborum libris; postea publica monumenta plumbeis voluminibus; mox et privata linteis confici coepta aut ceris.* "First of all, people wrote on palm leaves, then on bark of certain trees, afterwards sheets of lead were used for public documents, then also sheets of linen or waxen tablets for private documents": Pliny, xiii, 69.) This statement—which induces Sir John Myres (*Scripta Minoa*, II, Oxford, 1952, p. 2) to write that according to Pliny "the first Cretan writings were on palm-leaves"— gives a clue to the long narrow shape of the inscribed Minoan clay tablets (see p. 63).

The Palmyra and Talipat palm leaves, which are thick, but long and narrow, were the only writing material for books in ancient Odra as in other parts of the coastal provinces of Southern India; they were also used to some extent in Ceylon, Burma and Siam, and in Northern India.

The British Museum, the India Office Library (Fig. I–13, VIII–13, 15), the University Library of Cambridge (Fig. I–13, *above*), the Bodleian Library, and many other important collections, especially in India and Ceylon, contain numerous examples of books written on leaves in the Indian, Burmese, Sinhalese, and other languages. The preparation of this writing material was quite simple. Slips—from 16 to 36 inches long, and from $1\frac{1}{2}$ to 3 inches broad— were cut out from the leaves, they were sometimes boiled in water or milk, when they were smoothed, with all excrescences pared off with the knife; and they were then ready for use.

The scribes, employing an iron stilus (a sharp-pointed implement) to scratch the letters, were compelled to avoid long straight lines, because any scratch along the longitudinal fibre, which runs from the stalk to the point, would split the palm leaf, which is extremely fragile. (This gave rise to the rounded shapes of the Oriya, Burmese, and other "round" current hands—see *The Alphabet*, p. 360 and *passim*.) In order to make the signs plainer, ink—prepared from oil and charcoal—or other pigment was rubbed over the surface of the leaf, and filled up the finely incised lines to make them visible, and so permanent that they cannot be effaced. The strips of leaves were then bound, by stringing them on cords or a piece of twine, and attaching them to a board: see Fig. VIII–16.

In Siam, sacred works were written on Talipat palm leaves, their edges being gilded or painted with vermilion, and the leaves threaded on strings and folded like a fan. See also Chapter VIII.

OTHER LEAVES

It is generally suggested that in ancient times leaves of other

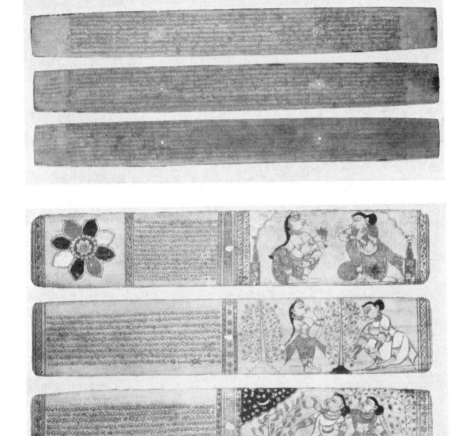

Fig. I–13

Palm-leaf books. (*Above*) *Abhidhamattha-Sangaha*, a Burmese Pali book, Cambridge University Library, *Or. 953*; (*below*) "Illuminated" Oriya manuscript—*Gītagovinda* by Yayadeva—preserved in the India Office Library—Commonwealth Relations Office.

trees were also used for writing. This is probably true, but—
except for literary evidence proof seems out of the question. The
material is, after all, perishable; specimens have never been dis-
covered, and we can exclude the possibility of any such discovery
in the future.

However, there is ample literary evidence that both in Greece
and in Magna Graecia as well as in Rome the use of leaves for
writing was quite familiar. Diodorus Siculus relates (*lib.* xi, *cap.* 35)
that the judges of Syracuse were anciently accustomed to write the
names of those whom they sent into exile upon the leaves of olive
trees. This sentence was termed *petalismos*, from *pétalon*, "a leaf".
The Sibyl's leaves are referred to by Virgil (*Aeneid*, iii, 58), and
Juvenal writes *Credite me vobis folium recitare Sibyllae.* Also the terms
"folio", "foliate", "foil", and so on, from Latin *folium*, "a leaf",
as well as the word "leaf" itself, may indicate that leaves were used
as writing material.

OTHER WRITING MATERIALS

Of the principal ancient writing materials, clay tablets, papyrus,
leather and parchment will be dealt with in the following chapters,
ink and pens will be treated in the Appendix to the present book,
while paper will be discussed in a forthcoming volume on *The
Printed Book.*

Here mention may be made of somewhat unusual writing
materials. In some countries not only the skins and intestines, but
even the shoulder blades of various animals (the shoulder blade of
a camel with a Coptic inscription in ink is in the Cairo Museum),
as well as the skins of fishes and the intestines of serpents were pressed
into the service of the scribes. See also p. 48.

The most famous instance is that of the original writing materials
used to record the *revelations* of Allah to Mohammed, which later
became the Koran (see p. 327 ff.). About a year after the Prophet's
death, his successor, Caliph Abū Bekr, at the suggestion of Omar,
ordered the collection of the scattered fragments of the Koran. Zaid
ibn-Thâbit, one of Mohammed's *ansars* ("helpers"), appointed to
carry out this task, gathered together all his material "from date
leaves and tablets of white stone, and from the breasts of men"
(Bagawi, *Mishkât al-Masabih*, i, p. 524; Engl. transl. B. viii, 3, 3.)
According to other versions, the material was collected from bits of
parchment, thin white stones, leafless palm branches and bosoms of
men. From these and other stories it is easy to understand that all

sorts of material readiest to hand—such as shoulder blades, palm-leaves, and stones—were used to write down what later became the Koran.

LINEN

Linen for writing upon was in use among the Romans in very early times. *Libri lintei* ("linen books") are mentioned by Livy not as existing in his own time, but as recorded by Licinius Macer (the democratic tribune and historian who died in 66 B.C.), who stated that linen "books" were kept in the temple of Juno Moneta. They were not "books" in the modern sense, but simply "very ancient annals and *libri magistratuum* (books of magistrates)".

The Sibylline Books were generally imagined to have been *libri lintei*, though by some, palm leaves were thought to have been their material. The old story of the Sibylline Books bought by Lucius Tarquinius Superbus (534–510 B.C.) which relates that the king twice refused to purchase the venerable volumes from the old woman who offered them to him, but afterwards provided a stone chest and two keepers to take charge of the three not very large volumes of magical *formulae*, may indicate that linen books were known to the Romans at that early date.

Livy speaks of a Samnite ritual book as *liber vetus linteus*, "an ancient linen book" (Livy, x, 38); he also mentions that when Augustus ordered the reconstruction of a ruined temple of Jupiter, he found there a book of linen. Even in a much later period, we hear of Roman linen books; the Emperor Aurelius is said to have used linen as writing material for his official diary. Also Varro (M. Terentius Varro, 116–27 B.C.) and the Roman jurist Ulpian (Domitius Ulpianus, A.D. *c.* 170–228) mention book rolls of linen, though it is doubtful whether they saw such books. However, linen seems to have been the substance on which the sacred books and the ancient records of Rome were written.

Apart from ancient Rome, it is well known that the ancient Egyptians wrote books on linen and on linen mummy wrappings (remains of a Sixth-Dynasty "book" are preserved in the Cairo Museum), that in Further India until recent times black cotton rolls were used for writing—writing being done with a white chalky material—that the Parthians sometimes wove their writings; the Arabs, too, used linen as writing material. The most remarkable ancient book written on linen is undoubtedly the Agram linen wrapping, containing the longest Etruscan document which has

come down to us—see Fig. I–14, *a*. This book, written on twelve bands or strips, which covered an Egyptian mummy belonging to the Graeco-Roman period, was found before 1880, at Alexandria, and is preserved in the museum of Zagreb or Agram (Yugoslavia). It contains about fifteen hundred words (see also p. 51).

Finally, mention may be made—though, strictly speaking, the object in question is hardly a "book"—of the famous Bayeux Tapestry, preserved at Bayeux (Normandy, France). It is a roll of linen, 20 inches wide and 231 feet long, and is a superb piece of needlework or embroidered "tapestry". It is worked in coloured woollen thread, and is supposed to be a panoramic representation of the invasion and conquest of England by the Normans. Tradition attributes it to Matilda, wife of William the Conqueror, but according to some scholars it was made for his half-brother Odo, bishop of Bayeux. It is divided into 72 compartments and contains 1,512 figures with Latin inscriptions, giving their names and the subject of composition. It was discovered in 1724. In 1803, Napoleon carried it away to Paris, and also during the last war (after the allied invasion of Normandy) the Germans took it to Paris, but in both instances it was brought back to Bayeux. It is of extreme interest, both as medieval needlework and as a record of certain details of history otherwise unknown. (Fig. I–16.)

DURABLE WRITING MATERIALS (Fig. I–14 and 15)

From very early times, men have succeeded in leaving behind them records of their activities. Apart from making articles, they painted or incised or scratched symbols or marks on durable materials. As already mentioned, the natural surfaces of rock walls, of caves or cliffs, offered the most obvious opportunities for mankind's first attempts at pictography. Later, great slabs of rock (megaliths) were incised with pictographs. Still later, smaller stone slabs were inscribed. Softer stone, like limestone and alabaster, harder stone, like marble, onyx and lapis lazuli, as well as the hardest volcanic stone (basalt, dacite, dolerite, diorite) were chosen for inscriptions.

The great majority of the inscriptions belong to three classes, commemorative or historical, dedicatory or votive, and donative. The first two comprise a vast variety of records, and these are mostly incised on stone. The donative, relating to religious endowments or secular donations, are sometimes on stone. In general, stone has always been a principal material for inscriptions, but other hard

a

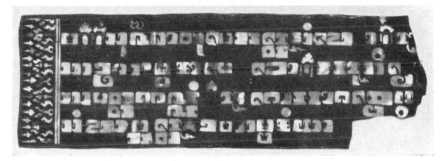

b

Fig. I-14

a, Small portion of an Etruscan book written on
strips of linen (courtesy Prof. Marcel Gorenc,
Archaeological Museum, Zagreb); *b*, book of
mother-of-pearl on wood: fragment of a "page"
from a *Manual for the Ordination of a Buddhist Priest*;
it is written in Burmese Pali (Cambridge University
Library, *Or. 789*); *c*, fragment of bone engraved
in ancient Chinese characters, from Hsiao-t'un,
near An-yang, in northern Honan, belonging to the
fourteenth century B.C.; *d*, Coptic imprecation
written on a rib. Archaeological Museum, Florence,
No. 3359.

c

d

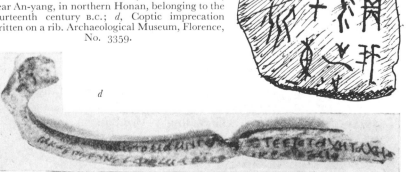

substances have also been used for the reception of writing; some-times (mostly in India) plates of copper, sometimes antimony, or copper, bronze, brass, clay, earthenware (incised or inscribed with ink), crystals, ivory, gold, silver, or mother-of-pearl on wood (see Fig. I–14, b). Even bones were used as writing material: see, for instance, Fig. I–14, c–d, and I–15 (below).

Among the Greeks, the Romans and other Italic peoples, the laws penal, civil, religious and ceremonial were often engraved on tables of bronze or of other metals. It is said that more than three thousand tables of bronze or brass kept in the Roman Capitol perished by a fire in the reign of Vespasian; these tables are supposed to have contained proclamations, laws and treaties of alliance. An important group of inscriptions, known as ostraca, consist of broken fragments of pottery or fragments of limestone, inscribed with ink.

These ancient inscriptions are very important in the history of writing (see The Alphabet, passim). Strictly speaking, with a few exceptions, they do not belong to the history of the book; indeed, they hardly come within the category of book production. It must be borne in mind, however, that men who could cut inscriptions on stone or metal or other hard material, could also write on perishable materials, such as wood, leather, or papyrus; such, indeed, as would normally be used in writing what we now call a book.

In some countries, such as Burma and Siam (see Chapter VIII), durable materials were used for books.

Pliny (Natur. Hist. xiii, 1) states that the public acts among the most remote nations were written in leaden books, and the existence of such books also seems to be suggested by Suetonius and Frontinus. Even more illuminating is Pausanias' statement (ix, 31, 4) that the Boeotians of Helicon showed him a sheet of lead, much decayed, on which was inscribed Hesiod's Works and Days.

The eminent French scholar and antiquary Bernard de Mont-fauçon (1655–1741) purchased a book at Rome in 1699, which he described as composed entirely of lead. (It is known that ancient leaden plates were frequently beaten with a hammer until they were rendered so extremely thin and pliable that they might easily be rolled up.) "It is about 4 inches long by 3 wide. Not only the pieces which form the cover, but also all the leaves, in number six, the stick inserted into the rings, which hold the leaves together, the hinges and nails, are all of lead, without exception" (L'Antiquité expliquée et représentée en figures, Paris, 1719–24, ii, 378). It contained "Egyptian gnostic figures, and writing". Montfauçon presented it

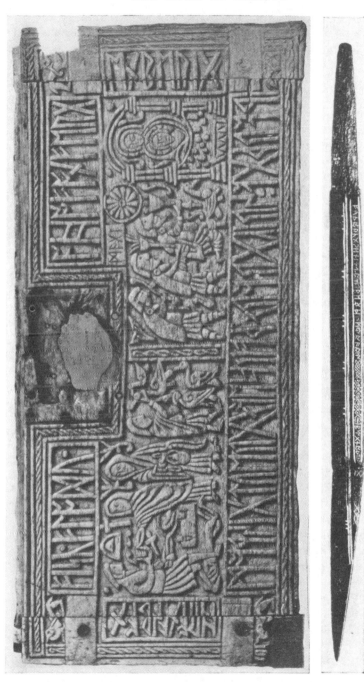

Fig. I-15

Metal and whale's bone used as writing material in England: (*above*) The *scramasax* or sword-knife, found in the Thames in 1857, and now in the British Museum; it probably belongs to about A.D. 800; (*below*) one side of the "Franks Casket", attributed to about A.D. 650 or A.D. 700; the runes have been translated: "The fish-flood (sea) lifted the whale's bones on to the mainland; the ocean became turbid where he swam aground on the shingle."

to Cardinal de Bouillon, but what has become of it is unknown.

Be this as it may, so far as we know, metals were never used for book production in the ordinary sense of the term.

CONCLUSION

We have ample evidence that at the dawn of history—which, after all, was fairly late in man's cultural development— writing was practised at various places and on various materials. Amongst peoples who had attained a certain cultural level—though this may be surprising in view of the tendency to regard "barbarism" as the

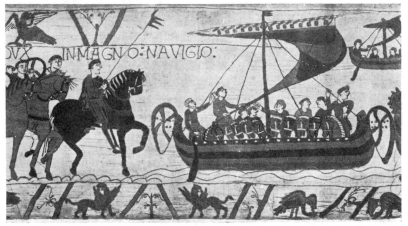

Fig. 1-16
Extract from the Bayeux Tapestry.

characteristic condition of prehistoric or protohistoric peoples— there would usually have been individuals, or rather a class, who cultivated the art of "writing". There is evidence that even at so early an age man was not without artistic promptings; and, under suitable conditions, these would find easy and natural expression in drawing, painting and carving. At the same time, with the increase in size of social and political groups and the extension of governmental authority, the need would be increasingly felt for written communication.

In time, there would gradually emerge a system—rudimentary to start with—based on pictorial or pictographic signs. At that period, perhaps even more than now, there would be an urge to record striking events, or even impressive dreams or ideas. And where

writing had developed beyond the primitive pictographic stage, we might expect an ability to reduce to writing current teachings or coherent sets of ideas. Yet, of book writing at that early stage of culture, for many lands, we have no positive evidence; but it must be remembered that the materials that would have been employed for the purpose would be perishable.

PHOENICIAN AND ETRUSCAN BOOKS

For this reason, we shall never be able to read the many books which we have reason to believe existed, for instance, amongst the Minoans, the Phoenicians and the Etruscans. As to the last mentioned—*The Alphabet*, pp. 490–501—while nearly 9,000 inscriptions (on stone, pottery, objects of bronze, lead, on walls and so on) were discovered in Etruria proper, roughly corresponding with modern Tuscany, by far the longest and the most important written document, and actually the only extant Etruscan manuscript which may be considered as a "book", is the Agram (or Zagreb) document —already referred to—written on linen wrappings of an Egyptian mummy (Fig. I–14, *a*). The text was written originally on fifteen strips or bands, and, with the exception of the first three, is almost complete; but the meaning of this text is still a matter of conjecture, all attempts at the decipherment of the Etruscan language having been unsuccessful.

The existence of Etruscan books is confirmed by Roman literary sources. See also Dionysius Halicarnasseus, i, 21. We know, indeed, that the Etruscans had religious, liturgical, "wisdom", and other books. The Romans mentioned the Etruscan *libri Tagetici*, *libri Vegonici*, *libri fatales* from Veii, *libri haruspicini, fulgurales, rituales, fatales, Acheruntici*, and others.

THE "FIRST" BOOKS

It is a happy coincidence that the earliest records of true book writing that have come down to us were discovered in the two main cradles of civilization: baked clay tablet books in Mesopotamia, and papyrus books in the Nile Valley.

When, indeed, one is faced with a cardinal historical problem, such as the "creation of the book", inquiry into the first causes is extraordinarily difficult, just as in the case of a war or revolution. For, as the late Prof. Chiera pointed out, there never was a man who could sit down and say "Now I am going to be the first man to write". Writing, that supreme achievement of

man, the one which makes possible the very existence of civilization by transmitting to later generations the acquisitions of the earlier, was the result of a slow and natural development. Even with recent events of any magnitude, it is difficult to determine their precise origin; in tracing back their causes, we reach a welter, where cause and effect condition each other and follow each other in turn. To avoid this perplexity, a starting point must be chosen, a birth certificate so to speak.

Thus, anyone wishing to study the history of "the book" must take as the starting point the earliest known "books", *i.e.* the baked clay tablets of Mesopotamia and the papyrus rolls of Egypt. Moreover, though the Mesopotamian clay tablets were books in the real sense of the word (though hardly in accord with modern conceptions), only the Egyptian papyrus book can be considered the true ancestor of the modern book.

THE EARLIEST SYSTEMS OF WRITING

HISTORY naturally relates only what we know, and, as a British scholar (Bushnell) states, "it is commonly realized that nine-tenths of the story of mankind is quite unknown; that is to say, its story has not been preserved in books and libraries". "Until a language is written, it leaves no traces of its history, except what can be inferred (and it is relatively little) from its geographical distribution and that of its related dialects; and especially from the distribution of place names, which do not migrate" (J. L. Myres), and are sometimes lasting.

WRITING INITIATES A NEW AGE

The history of "the book", even more than the history of mankind and the history of language, begins with the history of writing. Only when history began to be recorded, when the historical events, the traditions, customs, laws, religious myths and rituals, and the formerly memorized "works" of literature could be put down in writing, were they enshrined into "books" to be preserved in the libraries of temples and royal palaces.

The history of the book must obviously take into account the history of writing. The detailed account of the various systems of writing would be a long story if it could be fully told. Here it will be necessary only to suggest the main headings of the story, being for the most part a summary of the results already indicated in *The Alphabet*.

Mesopotamian Written Tablets

The earliest written documents extant are Mesopotamian tablets, inscribed with a crude pictographic writing which is certainly not cuneiform, many characters being purely pictorial and the picture symbols representing various objects, animate or in-

animate. Some of the signs, moreover, are clearly the later developments of forms which have not come down to us.

Pictorial symbols are, however, not very suitable for writing on moist and soft clay. Curves, circles and fine and long lines could not be executed satisfactorily, so that the Sumerians, the earliest known users of this writing, in the course of time replaced these symbols by combinations of short, straight, vertical, horizontal or oblique strokes, or angles, which formed what we now know as cuneiform writing.

The gradual change from the pictographic to the cuneiform—see Fig. II–1—which was not a deliberately chosen device, but came about by the employment of soft clay as a writing material, suggests that some perishable material may previously have been used, on which pictorial symbols were scratched, not impressed. Of course, this suggestion cannot be substantiated—we might unearth many more thousands of clay tablet books belonging to various periods, but it will never be possible to recover earlier "books" written on perishable material.

We must, therefore, be content to regard early clay tablet books as representing the earliest specimens of "the book". Of the many thousands of clay tablets that have been recovered no more than a few hundred can properly be termed books.

Early tablets were discovered mainly in four sites in southern Babylonia (Uruk or Warka, the biblical Erech; Jemdet Nasr; Shuruppak, the modern Fârah; and Ur of the Chaldees, the Hebrew Ur Kasdim, modern Tell el-Muqayyar). The earliest of them are generally attributed to the middle of the fourth millennium B.C.

EARLY SUMERIAN WRITING (Fig. II–1)

A limestone tablet from Kish (now in the Ashmolean Museum, Oxford), assigned roughly to the middle of the fourth millennium B.C., seems to be the earliest Mesopotamian text. According to Dr. Gadd, of the British Museum, this tablet "must be regarded for the present as representing the archetype of all Sumerian writing". It contains a number of symbols representing objects, the human head, hand, foot and *membrum virile*, a hut with a man squatting in it, a sledge, and a few signs not clearly determined. Unfortunately, this tablet cannot be read, and its meaning can hardly be guessed at.

The small clay tablets from Uruk, layer IVb, present the same stages of development; they show representations of objects still for the most part recognizable (such as parts of the human body,

Original pictograph	Pictograph in position of later cuneiform	Early cuneiform	Classic Assyrian	Meaning
				heaven god
				earth
				man
				pudenda woman
				mountain
				mountain woman slave-girl
				head
				mouth to speak
				food
				to eat
				water in
				to drink
				to go to stand
				bird
				fish
				ox
				cow
				barley grain
				sun day
				to plow to till

Fig. II-1
Development of cuneiform symbols.

fishes, heads of animals, plants, vessels, and boats), while tablets from Jemdet Nasr and Fâiali contain signs which can be considered transitional between the pictograph and the cuneiform; there also appear groups of wedges bearing little or no resemblance to the original forms.

The reasons for the invention of writing can only be guessed at; in Professor C. R. Driver's opinion they are tolerably clear. "The development of the cuneiform script was due to economic necessity, and the form that it took was conditioned by the means afforded by the Mesopotamian river-country."

Indeed, the contents of the earliest tablets, as far as they can be interpreted, seem to be economic or administrative, never religious or historical. "Writing in fact seems to have existed for over five hundred years before being put to such other uses; the only exceptions are scholastic texts, as yet mere lists of signs and words, required for the training of scribes" (G. R. Driver). According to the American scholar, E. A. Speiser, the property marks, the primitive proto-types of those which appear on the Mesopotamian cylinder seals, were the beginning of the Mesopotamian pictographic writing.

Origin of Cuneiform Writing

Not only is the exact date of the invention of this system of writing unknown; the nationality of the inventors is also uncertain. It would seem that the great invention was due to the Sumerians, a people of uncertain ethnic and linguistic affiliations, who spoke not a Semitic or Indo-European, but an agglutinative language. The Sumerians entered Mesopotamia before the middle of the fourth millennium B.C., conquered the land and established a very high culture, which they passed over to the Akkadians, who were Semites.

There are doubts, however, both whether the Sumerians did invent writing, and whether this system of writing was invented in Mesopotamia. The question of the origins—also uncertain—of the proto-Elamite script, of the Egyptian hieroglyphic writing and of the Indus Valley script, which probably have some connection with the origins of the Sumerian writing, makes the whole problem still more intricate.

Nevertheless, whether it was the Sumerians who invented the Mesopotamian pictographic writing or not, there is no doubt that it was they who developed it into the cuneiform.

Early Elamite Writing

The Elamites, a non-Semitic and non-Indo-European people, who spoke agglutinative dialects apparently related to the Caucasian group of languages, inhabited the country situated to the north of the Persian Gulf and to the east of the lower Tigris, corresponding to the modern Persian province of Khuzistan.

The early Elamites possessed an indigenous script, known as

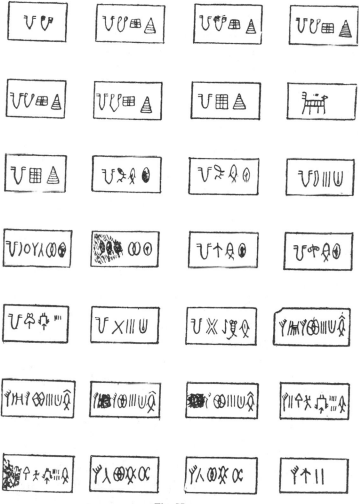

Fig. II–2
Seal inscriptions from Indus Valley.

early Elamite or proto-Elamite, which seems to have descended from pictographic symbols. According to some scholars, both the prototype of the cuneiform writing and the early Elamite script go back to a common source, but this is still an open problem.

Indus Valley Script (Fig. II-2)

Twenty-five years of excavation, exploration and study have added fifteen hundred years to the history of India. Complete cities of the third millennium b.c. have been unearthed; regular and well-planned streets, a magnificent drainage and water system, and well-equipped private houses, bear evidence to a careful system of town planning. The origins of this high civilization (known as Indus Valley Civilization or Harappa Culture) are still unknown.

The most noteworthy characteristic of this culture is the use of an indigenous script, which appears on large numbers of finely cut seals of stone or copper discovered on various sites: Fig. II-2. About eight hundred of these seals are inscribed. The writing, which still defies decipherment, may be defined as one of stilized pictographs. A connection is probable between this script and the common ancestor of the cuneiform writing and the early Elamite script, although it is impossible to determine what the connection is. It may be suggested, however, that the Indus Valley script was an indigenous invention inspired by the knowledge of the existence of writing.

Egyptian Scripts (Fig. II-3)

Still more difficult is the paramount question concerning the origin of Egyptian hieroglyphic writing. It is a moot problem which script, the Egyptian hieroglyphic or the Sumerian pictographic, is the older. Both were already in existence at the end of the fourth millennium b.c., and in the light of our present knowledge it is possible to say that in Mesopotamia and in the Nile Valley the development of writing follows a very similar but not identical course.

ORIGIN OF HIEROGLYPHIC WRITING

According to some scholars the Egyptian hieroglyphic writing was created as a whole at the beginnings of the united kingdom in Egypt (thirtieth century b.c.). The famous slate palette of the king, whose Horus-name is Nar-mer (Fig. II-3, a), and the plaque of

Fig. II–3

a–b, "Incunabula" of Egyptian hieroglyphic writing: *a,* the Nar-mer Palette; *b,* the Plaque of Aha; both probably belong to the thirtieth century B.C. *c,* Development of Egyptian signs (from G. Moeller).

Also Fig. II–3, *b* (both of whom have been identified by some students with Menes or Mena, the traditional founder of the First Dynasty, while others consider Nar-mer as the second king of this Dynasty) are regarded by some scholars as being no more than pictures, while the majority consider these documents as important

Fig. II–4

Minoan linear scripts: (*left*) main symbols of "Linear Class A"; (*above*) main symbols of "Linear Class B" (*drawings by Michael Ventris*).

evidence of the initial stage in the developments of hieroglyphic writing, *i.e.* a kind of *incunabula* of this important system. In the opinion of Sir Alan Gardiner, for instance, in the Nar-mer palette "we are able to observe the birth of hieroglyphics taking place, as it were, under our very eyes".

According to other scholars, however, in Egypt writing was

invented and developed "possibly under Sumerian influence" (G. R. Driver). And "it may be suggested that among the Egyptians the invention of the emergence of the hieroglyphic system of writing is simply the extension of already existing cultural elements to a new social situation" (S. H. Hooke).

However that may be, there is no doubt that during the initial period of the First Dynasty, Egyptian writing was already fully developed. It is now commonly agreed to place the rise of the First Dynasty in the thirtieth century B.C., which date would synchronize with the beginning of the classical Sumerian age.

CHARACTERISTICS OF EGYPTIAN WRITING

Whatever its origin, the Egyptian writing was essentially national (in complete contrast with the cuneiform); it originated in Egypt, it developed in Egypt, it was employed only for Egyptian speech (perhaps with one or two exceptions), and it died out in Egypt. The Egyptians had every reason to be proud of their writing, and from the earliest ages they had the greatest veneration for it, considering it to be the foundation of all education and well-being. In spite of its complexity, the Egyptian writing is, in a certain way, one of the most accurate and most intelligible of the great ancient systems of writing.

Its history, including the hieratic script (a cursive form, used beside the hieroglyphic for three thousand years, and of particular importance from the point of view of the history of "the book") and the demotic script (a highly cursive derivative of the hieratic), is dealt with in *The Alphabet*, pp. 58–71. See also Fig. II-3, *c*.

Cretan Scripts (Fig. II-4)

The ancient civilization of the Island of Crete—the only European country which had a culture to equal the contemporary civilizations of Egypt and Mesopotamia—presents distinctive features. It is generally known as Aegean or Minoan, and its high level is demonstrated not only by the architectural remains, fresco painting and ceramic art, but also by the considerable influence exercised on the civilization of the Greek mainland and the islands; it is noteworthy that Greek traditions regarded Crete as an ancient centre of a great civilization. This ancient culture has left many problems which may remain unsolved for all time. The ethnic and linguistic affinities of this people, their origin, history,

rulers, even their name are still open problems, as are the questions of their culture and book production.

The beginning of the Minoan civilization, corresponding to the Bronze Age epoch of Crete, seems to have coincided, roughly, with the First Dynasty of Egypt and the classical Sumerian dynasties. The Minoan culture came to an end abruptly, about 1100 B.C. owing probably to political disturbances in the eastern Mediterranean, similar to those which somewhat earlier (c. 1200 B.C.) brought about the downfall of the Hittite and the decline of the Egyptian Empires.

MINOAN SCRIPTS

The scripts of ancient Crete still remain a riddle to which a happy discovery of a bilingual inscription may, one day, provide the key. From the first phase of Early Minoan (thirtieth century B.C.) onwards, seal engraving was practised.

The engraved subjects were mainly decorative designs such as meanders, but there were also some crude picture-symbols, such as parts of the human body, animals, birds, plants and implements. "Both the engraved seal stones of Crete and many of the pictorial signs on them closely resemble those of Egypt . . . there is no doubt that the general notion of seal cutting and sign writing came from Egypt" (J. L. Myres). It is an open question whether these pictorial devices should be considered as true writing but, in Sir John Myres's opinion, they "are sufficient evidence that writing was practised".

Pictographic Class A and B

The first phase of Middle Minoan (c. twenty-second to twenty-first centuries B.C.) saw the beginning of a true system of writing, known as the "Pictographic Class A", which later developed into the "Pictographic Class B". There was already a numerical system, influenced by that of Egypt.

Linear Class A and B (Fig. II–4)

Apparently in the seventeenth century B.C. the pictographic gave place to a linear script, which is generally distinguished into "Linear Class A" and "Linear Class B". Both scripts are cursive— they may even have been book-hands—and do not appear on the seals.

Linear Class A appears engraved on stone or metal, incised on clay, or written with ink on pottery; some inscriptions have been found outside Crete. This script, containing about seventy-five

symbols, continues in the sixteenth century B.C. Linear Class B seems to be a kind of *aulic* or official script: it is found on numerous clay tablets belonging to the archives of the palaces at Knossos in Crete, and at Pylos in S.W. Peloponnesus. Until the discovery of the Pylos archives, assigned to *c.* 1200 B.C., it was thought that not even Class B continued during the last Late Minoan phase (*i.e.* from the end of the fourteenth century B.C. onwards). The number of symbols of Class B is slightly reduced, but forty-eight of them can be connected with Class A. The numeration symbols are also partly changed.

In July–August, 1952, over thirty tablets, inscribed in Linear Class B, were unearthed in the excavation of the famous ancient city of Mycenae.

ORIGIN OF MINOAN SCRIPTS

The origin of these scripts is uncertain. The theory of a derivation from the Egyptian scripts, not only of the pictorial signs of the engraved seals, but also of the pictographic scripts, and even of the linear scripts, is not acceptable.

Although some of the Cretan pictographic symbols are identical —probably externally only—with Egyptian hieroglyphs, the great majority of them seem to be of indigenous invention, since they are strictly connected with Cretan customs and religion, and indigenous agriculture.

It is thus probable that the Cretan scripts, especially the linear characters, are indigenous creations, although the inspiration may have come from outside. Some scholars have suggested Anatolian connections, but chronological reasons alone would preclude this possibility.

More recently (1949), Sir John Myres has suggested that "the Minoan pictographic and linear scripts came into existence in a region which had ceased for a while to be influenced by Egypt", *i.e.* after the collapse of the Twelfth Dynasty empire ; "another influence replaced that of Egypt: that of the Babylonian culture with its art of inscribing signs and sign-groups on tablets of clay". However, Crete "lay too far off to be affected by Babylonia; and had the peculiar fortune to be indirectly affected by the flexible pictorial script of Babylonia, not the rigid cuneiform convention of a later phase. Crete was thus able to create a composite and adaptable technique of its own, undisturbed by foreign competitors. . . ."

THE PHAISTOS DISC (Fig. I-4, *a*)

This most remarkable of all the Cretan inscriptions, which has already been referred to, was found in Crete in 1908, and is assigned to *c.* 1700 B.C. It is the first-known stamped object of its kind, being an irregularly circular terra-cotta tablet, about 6–7 inches in diameter, with highly pictorial sign groups impressed by means of separate stamps in inscribed compartments, and printed on both sides of the disc, in a spiral band, broken into concentric bands with connection marks.

Sir John Myres points out that this spiral band, an ingenious device to prevent the reader from "losing his place", recurs on a Minoan gold ring from Mavrospeio near Knossos, and on two inscriptions from Knossos painted on the inner surface of clay cups. The highly pictorial signs, which show no relationship with Cretan pictographs, number 241, and include forty-five different symbols, such as human figures and parts of the body, animals, plants and tools.

It is thought, largely because of the plumed head-dress, that the disc was not of indigenous origin, but belongs to the south-west coast of Asia Minor. According to Myres, a few of the signs suggest a Lycian origin. Some scholars connected the disc with the Philistines, others with North Africa. It must, however, be pointed out that until the present day nothing resembling it has appeared either in Anatolia or elsewhere, nor is there any trace in Crete or outside of a similar script, especially at the period in question.

Hittite Hieroglyphics (Fig. II-5)

The Hittites, a group of peoples of differing ethnical and linguistic affinities who inhabited Asia Minor and northern Syria from the third to the first millennia B.C., developed a high civilization, and during two hundred years (*c.* 1400–1200 B.C.) constituted one of the chief empires of the Near East.

The Hittite Empire having come to an end at the beginning of the twelfth century B.C., the Hittite political and cultural centre was transferred to northern Syria, where small Hittite states arose, the most important of them being Carchemish. In the eighth century B.C. all these small kingdoms were conquered by the Assyrians.

HITTITE SCRIPTS

The Hittites early adapted the Babylonian cuneiform writing

to their own language, and many Hittite written documents, including literary productions, are extant in this script (see p. 106). The Hittite cuneiform writing continued to be used until the end of the Hittite Empire. About the middle of the second millennium B.C. they developed a hieroglyphic form of script, now known as the Hittite hieroglyphic writing.

Fig. II-5

Hittite hieroglyphic cursive signs (ii, iv, vi, vii) compared with monumental symbols (i, iii, v, viii).

The majority of the inscriptions in this writing belong to the period of the Syrian Hittite states, particularly to the tenth-eighth centuries B.C.; the latest may be assigned to *c*. 600 B.C. Not many inscriptions come from the Hittite mother country, the greater number having been discovered in northern Syria (Carchemish, Hamath and Aleppo). Many inscriptions are in relief on stone monuments, others are engraved, a few on lead; there are inscribed seals (one in silver), and impressions in clay. Some are engraved in a more cursive form of writing (see Figs. II–5, columns ii, iv, vi, and vii).

With certain other facts, the existence of such a cursive hand may induce us to assume that there existed Hittite books written in Hittite hieroglyphic writing; but no such books have come down to us. It must be remembered, however, that the materials

that would have been employed for the purpose would probably be perishable (papyrus or parchment).

ORIGIN OF HITTITE HIEROGLYPHIC WRITING

Some scholars have derived the Hittite hieroglyphic writing from the Egyptian hieroglyphs, others from the Cretan pictographic script. Although the Hittite hieroglyphs are highly pictorial, as also are the Egyptian hieroglyphs (or the Cretan pictographs), there does not seem to be any direct connection between the Egyptian and the Hittite signs.

As to possible affinities with the Cretan pictographic scripts, apart from chronological difficulties, no connection can be proved so long as the Cretan scripts remain undeciphered. There is, however, the possibility that the Hittite hieroglyphic writing was an indigenous creation, perhaps inspired by the Egyptian and Cretan scripts.

Chinese Writing (Figs. II–6-7, IX–1-5)

Not only is Chinese writing the only ancient analytic (partly ideographic, partly phonetic) system of writing still used, but it is employed by a nation comprising one-fifth of the world's population, and in a country larger than the whole European continent. Notwithstanding its extensive use by peoples of high and ancient culture, and its history of almost four thousand years, the internal development of Chinese writing has been practically imperceptible.

ITS DEVELOPMENT

The main evolution of the Chinese signs was indeed technical and external—calligraphic as we may call it. The writing has never reached even the syllabic stage. The main reason for this peculiarity lies in the Chinese language, which—although it was probably once an agglutinative language—is now isolating (i.e. without grammatical terminations or other grammatical forms), monosyllabic and polytonic (i.e. capable of being pronounced on a low pitch, on a rising pitch, on a high pitch, and so on).

ORIGIN OF CHINESE WRITING

The date of the invention or creation of Chinese writing is uncertain; we may assume, however, that it was already in existence in the early second millennium B.C. The earliest Chinese

inscriptions extant, written on bone, belong to the fourteenth century B.C.

The problem of the origin of Chinese writing is also still unsolved. Direct dependence on the cuneiform writing has been suggested, but this does not seem probable. There is, however, no doubt that there exist certain internal similarities between the Chinese and the Sumerian writing as well as the Egyptian hieroglyphic script.

The theory of the American scholar, A. L. Kroeber, of "idea-diffusion" or "stimulus-diffusion" provides the most probable

Fig. II-6
The 214 "keys" of Chinese writing.

explanation of the origin of Chinese writing as well as of some other ancient scripts. On this basis it is urged that, after writing had developed in Mesopotamia, in Elam, in the Indus Valley, and perhaps in some other places still unknown to us, and when the generic idea reached China, it may well have induced some great Chinese personality to invent or create a particular script for the Chinese speech.

No.		No.		No.		No.		No.		No.		No.		No.		No.		No.	
1	一	31	匕	61	尤	91	子	121	斤	151	弗	181	乐	211	兆	241	亞	271	垂
2	丨	32	冫	62	叉	92	中	122	戶	152	冊	182	至	212	叭	242	金	272	琴
3	丶	33	刀	63	井	93	心	123	午	153	皿	183	辛	213	厽	243	來	273	旁
4	丿	34	力	64	丣	94	止	124	牛	154	且	184	衣	214	谷	244	兔	274	寅
5	乁	35	勹	65	才	95	丙	125	今	155	目	185	交	215	豆	245	帚	275	魚
6	乙	36	广	66	氏	96	不	126	木	156	自	186	亥	216	呂	246	易	276	鳥
7	乚	37	弋	67	丑	97	木	127	开	157	巨	187	糸	217	克	247	炙	277	鹿
8	乛	38	孔	68	互	98	开	128	水	158	四	188	虫	218	臣	248	函	278	朢
9	亅	39	凡	69	云	99	水	129	火	159	束	189	束	219	囚	249	嵒	279	率
10	乚	40	凡	70	无	100	无	130	犬	160	民	190	酉	220	果	250	果	280	离
11	二	41	毛	71	井	101	爪	131	凸	161	虍	191	卯	221	術	251	㐬	281	殸
12	亠	42	口	72	丹	102	爪	132	天	162	舟	192	臼	222	希	252	㐬	282	壺
13	人	43	口	73	丹	103	壬	133	天	163	自	193	角	223	發	253	象	283	象
14	入	44	回	74	亢	104	壬	134	凶	164	尤	194	自	224	非	254	爲	284	爲
15	八	45	厂	75	六	105	凶	135	禾	165	耳	195	束	225	豸	255	焉	285	焉
16	儿	46	三	76	文	106	日	136	禾	166	臣	196	彖	226	面	256	眢	286	昝
17	几	47	彡	77	方	107	日	137	矛	167	而	197	乗	227	革	257	爲	287	爲
18	九	48	巛	78	勿	108	月	138	永	168	而	198	尚	228	肩	258	樂	288	樂
19	丸	49	彳	79	马	109	勿	139	瓜	169	因	199	弟	229	盾	259	樂	289	樂
20	十	50	个	80	糸	110	玉	140	戊	170	西	200	車	230	鹵	260	鼠	290	鼠
21	七	51	小	81	气	111	主	141	矢	171	凸	201	貝	231	彔	261	蜀	291	蜀
22	冂	52	宀	82	毛	112	玄	142	冬	172	肉	202	百	232	癸	262	齊	292	齊
23	卜	53	巾	83	手	113	白	143	正	173	臼	203	身	233	泉	263	壽	293	壽
24	冖	54	山	84	半	114	凷	144	皮	174	甘	204	艮	234	者	264	齒	294	齒
25	冖	55	山	85	丰	115	瓦	145	穴	175	凶	205	辰	235	畏	265	嚳	295	嚳
26	凵	56	巿	86	斗	116	田	146	它	176	由	206	長	236	乖	266	龍	296	龍
27	匚	57	土	87	卝	117	由	147	宁	177	曲	207	東	237	飛	267	龜	297	龜
28	冂	58	工	88	牙	118	甲	148	米	178	羽	208	隹	238	馬	268	燕	298	燕
29	厶	59	干	89	牙	119	用	149	羊	179	兆	209	隹	239	鬲	269	芻	299	芻
30	匸	60	也	90	予	120	田	150	史	180	兆	210	隹	240	举	270	爵	300	爵

Fig. II-7

The 300 Chinese primary elements.

It is possible, moreover, that prior to the invention of Chinese writing, there existed in China, as suggested by local traditions, some primitive devices of communication, such as the mystic trigrams and hexagrams, or a knot device similar to the ancient Peruvian *quipus* (see Fig. I-1, *b* and *The Alphabet* p. 26) or the tally sticks (see Fig. I-1, *b*). Also the typical Chinese gestures —Fig. I-1, *a*—ornamentation and ritual symbolism played a not inconsiderable part in the creation of the Chinese characters. For the development of Chinese writing see *The Alphabet*, pp. 98–119.

The Maya and Aztec Scripts (Figs. II-8 and IX-10-17)

Although this story refers primarily to the writings of the peoples which contributed directly or indirectly over a long period to the development of our "book", mention must be made of the civilization of pre-Columbian Central America and Mexico. Its importance is to be viewed in relation to the general problem of ancient culture-building.

The other great civilizations of antiquity originated and developed, roughly speaking, simultaneously, mainly in great river valleys situated in one more or less continuous land area, within the northern sub-tropical belt. They appear successively as we travel, east or west, from the great cradle of civilization, Mesopotamia. Their culture was based on the knowledge of writing, the employment of metals, the cultivation of wheat, the domestication of certain animals, the use of the wheel, and town building. No other area presents this homogeneity in fundamentals, but at least in some respects, there seems to be one, and only one, exception—ancient Central America and Mexico.

The time is not within sight when a complete and generally agreed solution of all the problems connected with this fascinating subject can be put forward. There is, however, fairly general agreement nowadays concerning the part played by the Mayas, the Toltecs and the Aztecs in the cultural development of ancient Central America and Mexico. The Mayas are regarded as the originators of the highest pre-Columbian civilization of America; the Zapotecs, Mixtecs, and the Toltecs are considered the intermediaries between the Mayas and the Aztecs; both the Toltecs and the Aztecs, belonging to the linguistic group of the Nahuas, built the ancient civilization of Mexico.

THE MAYAS

The Mayas, even nowadays, are one of the most important peoples of native America. The Old Empire, which probably arose about the beginning of the Christian Era, and flourished for about four hundred and fifty years in southern Yucatan, was the Golden Age of Mayan art and culture; it was the period of the great city

Fig. II–8

Maya and Aztec symbols. *a–c*, Maya symbols: *a*, symbols of the months, according to the *Codex Dresden*; *b*, symbols of the days, according to monuments (upper part) and manuscripts (lower part); *c*, the highest number found in a Maya inscription (1,841,639,800 days, corresponding to over 5,100,000 years); *d*, Mexican symbols representing the twenty days

of Palenque (now in northern Chiapas), which was the seat of art, of Copan (now in western Honduras), which was the main religious and cultural centre, and of various others.

MAYAN SCIENCE AND ART

Amongst the Mayas, the mathematical and astronomical sciences seem to have been far ahead of the contemporary knowledge of any other people. The Mayas had already a sign for zero: the possibility of using the principle of position depends mainly on the employment of a separate symbol for zero, without which we could not distinguish, by reference to position, between 22, 220, 202, 2002, 2200, 2020, and so on. The Mayan calendar was even more accurate than the Julian still in use, and is capable of dealing with periods of time over five million years (Fig. II-8, c).

THE TOLTECS

The Toltecs ("Skilled Workers") were the supposed originators of Mexico's Golden Age; they were excellent architects; at their traditional capital, Tollan, they built pyramids, temples, palaces and storeyed buildings. About the middle of the first millennium A.D. they seem to have entered Mexico and about A.D. 770 they arrived at the site of their future capital.

Their culture, which reached its apogee about the end of the ninth century, was probably borrowed mainly from the Mayas, through the Zapotecs and Mixtecs, who (though very little is known about the history of these two peoples) seem to have played the part of cultural intermediaries between the Maya Empire in the east and the Toltec "empire" in the west.

THE AZTECS

The Aztecs or Azteca (the "Crane People"), if we are to believe their own tradition, immigrated from the north about A.D. 1168. According to the *Mendoza codex*, in 1325 they founded, on the salt marshes on the western edge of the Lake Tezcuco or Texcoco, the town Tenochtitlan, which became the modern Mexico City. About 1430 they founded a confederacy with two other states and started an "imperialistic" expansion, which only the Spanish conquest stopped.

Their culture was a mosaic of elements borrowed from other cultures, mainly Maya, Zapotec, Mixtec and Toltec. The Aztecs, however, developed considerable skill in the art of metal working and architecture.

MAYA WRITING (Figs. II–8, *a-c*, and IX, 10–12)

How and when the Mayas invented writing we do not know, and we shall probably never be able to say. As far as it is possible to judge from present-day knowledge, the Maya script and astronomical and mathematical sciences were already fully developed at the beginning of the Mayan Old Empire: this presupposes either a previous evolution of long duration, of which nothing is known, or some cultural importation, which is hardly thinkable.

The written material extant consists of (1) three manuscripts (see pp. 425 ff. and Fig. IX, 10–12); (2) numerous beautiful and mainly well-preserved *stelae* (huge, vertical monolithic pillars), carved all over in low relief with glyphs and figures, and also large oval stones or altars, similarly carved; (3) some polychrome clay pottery painted with glyphs and figures; as well as (4) carvings and engravings on metal and bone.

The glyphs or cartouches are highly conventionalized groups of many picture signs gathered into a single frame, and they have some external, but undoubtedly casual, resemblance to the Egyptian royal cartouches. The script is on the whole undeciphered, except for the calendar symbols and for notation signs (Fig. II–8, *a–c*).

This fact is the more unfortunate as the knowledge of the Mayan writing has apparently been lost in the last two and a half centuries only. According to Spanish sources, records in Mayan hieroglyphic writing continued to be made as late as the end of the seventeenth century, when some Spaniards seem still to have known it, but it is not certain that the script of this period was identical with that of the early period.

AZTEC WRITING (Figs. II–8, *d* and IX, 14–17)

The Aztec writing is perhaps a degenerate derivative of the Mayan script; indeed, from the aesthetic standpoint, there cannot even be a comparison between the beautiful Mayan glyphs and the crude, barbaric Aztec picture signs; there is no likeness even in the external form of the symbols of the two scripts. Nevertheless, while a simple adoption by the Mexicans of the Maya script is not probable, there can hardly be any doubt that the Mexican peoples, indirectly at least, received the idea of writing from the Mayas.

In the highly pictographic Aztec script there are numerous instances of pure ideographic writing; sometimes the script is even

more in the nature of mnemonic aids to be supplemented by oral description than of a true writing. In some respects, however, the Aztec script is more advanced; many conventional signs have phonetic value, either as word-signs or as syllables.

Abstract ideas are represented by signs borrowed from *homonyms* (*i.e.* words having the same sound, but a different meaning), even when the homonymy is not exact. A syllable could be expressed by an object whose name began with it. The transcription of personal names was facilitated by the use of the *iconomatic* system in names (*e.g.* "Blue Dog", "Eagle Star", "Plumed Serpent").

The Aztec script (which was also employed under Spanish domination) is better known than the Mayan writing. It has been partly deciphered. Many of the deities have been identified, the personal and place names can be read, some of the ceremonies are understood, the meaning of some historical events can be perceived (they were depicted with considerable ingenuity by means of pictographs accompanied by symbols showing the place and the year).

Still, we are far from complete victory; in many cases, the decipherment is a more or less acceptable guess which cannot be either proved or disproved. See also *The Alphabet,* pp. 120–35.

Phonetic or Sound-Writing

It was a long way from the primitive picture-writing to the alphabet. In the former there is no connection between the depicted symbol and the spoken name for it; the latter has become the graphic counterpart of speech. Indeed, each element (which may be of any shape) in the phonetic writing corresponds to a specific element (*i.e.* sound) in the language to be represented. Thus, a direct relationship has been established between the spoken language (*i.e.* speech) and the script, the latter being a representation of the former. Phonetic writing may be syllabic or alphabetic.

SYLLABARIES OR SYLLABIC SYSTEMS OF WRITING

These systems of writing developed more easily and appeared as a creation more often than did an alphabet. In the systematic syllabaries, the single symbols represent syllables, *i.e.* elementary sound blocks; a combination of signs representing a group of syllables would convey a spoken word. In many instances a word, if monosyllabic, would be represented by one symbol.

For a language that, for reasons of phonetic decay or otherwise, has multiplied the consonants in a single syllable (*e.g.* the English word "strength"), the syllabary becomes a cumbrous mode of writing, especially because it generally contains only open syllables (*i.e.* consonant+vowel) or vowels, when these constitute syllables. Thus, for instance, while it would be easy to represent by a syllabary

Phonetic value	Kata kana	Hira gana	Phonetic value	Kata kana	Hira gana	Phonetic value	Kata kana	Hira gana	Phonetic value	Kata kana	Hira gana
i	イ	い	wa	ワ	わ	w(i)	ヰ	ゐ	sa	サ	さ
ro	ロ	ろ	ka	カ	か	no	ノ	の	ki	キ	き
fa (ha)	ハ	は	yo	ヨ	よ	o	オ	お	yu	ユ	ゆ
ni	ニ	に	ta	タ	た	ku	ク	く	me	メ	め
fo (ho)	ホ	ほ	re	レ	れ	ya	ヤ	や	mi	ミ	み
fe (he)	ヘ	へ	so	ソ	そ	ma	マ	ま	si (shi)	シ	し
to	ト	と	tu (tsu)	ツ	つ	ke	ケ	け	w(e)	ヱ	ゑ
ti (chi)	チ	ち	ne	ネ	ね	fu	フ	ふ	fi (hi)	ヒ	ひ
ri	リ	り	na	ナ	な	ko	コ	こ	mo	モ	も
nu	ヌ	ぬ	ra	ラ	ら	e	エ	え	se	セ	せ
ru	ル	る	mu	ム	む	te	テ	て	su	ス	す
(w)o	ヲ	を	u	ウ	う	a	ア	あ	n	ン	ん

Fig. II-9
The Japanese syllabaries.

a word like "fa-mi-ly", the word "strength" would have to be written *se-te-re-ne-ge-the,* or the like, and such a representation of sounds would be far from adequate. Moreover, syllabaries require a much greater number of symbols than alphabetic writing.

It must, however, be pointed out that, for example, Japanese, which is the only important language still employing syllabic systems of writing, admits no consonant clusters and no syllables, except those closed with *n* (such *n* is indicated by a special sign).

Apart from the Japanese syl!abaries, termed *Hira gana* and *Kata kana*—Fig. II–9—which evolved in accient times from Chinese scripts, but are still employed (in addition to the ideographic characters of Chinese origin), the following syllabic systems of writing may be mentioned: (1) the Assyrian cuneiform writing,

	a	*e*	*i*	*o*	*u*
vowels					
y ÷ vowel					
f ÷ ,,					
r ÷ ,,					
l ÷ ,,					
m ÷ ,,					
n ÷ ,,					
p ÷ ,,					
t ÷ ,,					
k ÷ ,,					
s ÷ ,,					
z ÷ ,,					
l h ÷ ,,					

Fig. II–10
The Cypriote syllabary.

which was at certain times practically a syllabary; (2) the Semitic script of ancient Byblos (northern Syria); (3) the script of ancient Cyprus (Fig. II–10), probably developed from a Minoan script; and (4) some artificial modern syllabaries which existed or still exist in Western Africa and in North America—Fig. II–11 and 12. See also *The Alphabet*, pp. 158–85.

THE ALPHABET

Alphabetic writing is the last, the most highly developed, the most convenient, and the most easily adaptable system of writing. The alphabet is now employed by the large majority of civilized peoples; its use is acquired in childhood with ease. There is obviously an enormous advantage in the use of letters which represent single sounds rather than ideas or words or even syllables: it is certainly

1848	1898	phonetic value		1848	1898	phonetic value
		a				bu
		ā				bū
		è				gba
		e				gbe, gbè
		ē, ɔ̄				gbi
		i				»
		i̤				gbī, gbè
		ō, ū				gbo, gbò
						gbu
		ba				ñgba
		»				ñgbe
		ba				ñgbi
		bè				ñgbo
		be, bē				
		be, mbe				mba
		bi				mbe, mbè
		bi̤				mbē, mbi
		bò				mbi
		»				mbò
		bo				mbo
		bó				mbō, mbū
		bō				mbu

Fig. II–11

The Vai syllabary.

D	a	R	e	T	i	Ꮗ	o	Ꮕ	u
Ꮖ	ga	Ꮷ	ge	Ꭹ	gi	A	go	J	gu
Ꮻ	ha	?	he	Ꭿ	hi	Ꮸ	ho	Ꮁ	hu
W	la	Ꮈ	le	Ꮅ	li	Ꮊ	lo	M	lu
Ꭶ	ma	Ꮺ	me	H	mi	Ꮿ	mo	Ꮗ	mu
Ꮎ	na	Ꮄ	ne	Ꮒ	ni	Z	no	Ꭴ	nu
Ꮝ	gwa	Ꮃ	gwe	Ꭹ	gwi	Ꮽ	gwo	Ꮙ	gwu
Ꮄ	sa	4	se	Ꮟ	si	Ꮨ	so	Ꮁ	su
Ꮷ	da	Ꮥ	de	Ꮧ	di	Ꭺ	do	S	du
Ꮉ	dla	L	dle	Ꮳ	dli	Ꮴ	dlo	Ꮿ	dlu
Ꮯ	dza	Ꮳ	dze	Ꮵ	dzi	K	dzo	Ꮵ	dzu
Ꭼ	wa	Ꮺ	we	Ꮹ	wi	Ꮼ	wo	Ꮎ	wu
Ꭼ	ya	Ꮽ	ye	Ꮃ	yi	Ꮁ	yo	Ꮿ	yu
Ꭵ	ö	E	gö	Ꮷ	hö	Ꮑ	lö	Ꮒ	nö
Ꮛ	gwö	R	sö	Ꮷ	dö	P	dlö	Ꮄ	dzö
Ꮆ	wö	B	yö	Ꮻ	ka	Ꮧ	hna	G	nah
Ꮹ	s	W	ta	Ꮏ	te	Ꮯ	ti	Ꮈ	tla

Fig. II–12

The Cherokee syllabary.

much easier to master twenty-two or twenty-four or twenty-six signs of an alphabet than hundreds or thousands of symbols of ideographic systems of writing (nine thousand to eighty thousand in Chinese scripts).

The alphabet may also be passed from one language to another without much difficulty. Indeed, the same alphabet is used now (with unimportant changes) for most Indo-European, Finno-Ugrian, Malay-Polynesian, Negro-African languages and many others.

Thanks to the simplicity of the alphabet, writing has become far more common; it is no longer the more or less exclusive domain of the priestly or other privileged classes, as it was in Egypt or Mesopotamia. Education has become largely a matter of reading and writing, and is possible for all. It may be said that alphabetic writing, helped by the introduction of paper, and the invention and diffusion of printing, has solved the problem of universal illiteracy.

The fact that alphabetic writing has survived with relatively little change for three and a half millennia, notwithstanding the advent of printing and the typewriter, and the extensive use of shorthand-writing, is the best evidence of its suitability for the needs of the whole modern world. It is this simplicity, adaptability and suitability which have secured the triumph of the alphabet over the other systems of writing.

It is generally agreed that the alphabet was already in existence before 1500 B.C., and that it was invented by a north-western Semitic people of Syria-Palestine. It is also agreed that the many hundreds of alphabets, those which existed or are still employed in Europe, India, Arabia, Central Asia, Korea, and so on, the Latin alphabet and its descendants, the Greek and its descendants, the Runic, and all the others, are alike descendants of the early North Semitic alphabet, though the similarities between any two may be quite unrecognizable. Indeed, each important civilization modifies its script and adapts it to its language, and time makes its relation to some of its near relatives indistinguishable.

Alphabetic writing, its origin and its development in its numerous branches, constitutes a long story in itself. No other system of writing has had so extensive, so intricate and so interesting a history: see *The Alphabet*, particularly pp. 193–576.

Bibliography
See the works quoted in *The Alphabet*, 2nd ed., London and New York, 1949 (3rd reprint, New York, 1952).

CLAY TABLET BOOKS

THE history of the book is at a disadvantage in comparison with the history of writing in that the former is based mainly on perishable writing material, which could not be expected to endure to our time; the latter has, of course, at its disposal inscriptions on durable material. Thus, with few exceptions, very little can be said of "the book" of ancient antiquity which may as indicated on p. 53 have been written on wood or leaves as early as the fourth millennium B.C. before the use of clay tablets.

The Elamites, the Cretans, the Hittites, and many other peoples had their books and their libraries, but, apart from the Mesopotamian peoples, who wrote on clay tablets (and those who borrowed the custom from them), ancient nations—with the possible exception of the ancient Cretans —wrote their books on perishable writing material. Only the splendid protective covering of the Egyptian sands have, secretly, preserved for us thousands of books or fragments of books written on papyrus or (more rarely) on parchment or leather. The papyrus and parchment books, which are the direct ancestors of our modern "book", will be dealt with in the next chapters.

CLAY TABLET LITERATURE

The literature of the clay tablet books is voluminous, and much more awaits the archaeologist and philologist, as well as the historian in all his fields. All types of literature are represented. There are poetry and prose, myths and epic tales, prayers and hymns, incantations and hepatoscopy (*i.e.* the practice, very popular in Babylonia, of deriving omens from the shape, size, or condition of the liver), historical, legal, scientific, and commercial texts. Although a very large number of these books have been published and annotated, much yet remains to be done to enable students of history, religion, ethics and law, and of political, economic and social services,

who are not "Assyriologists", to use this vast material for the benefit of modern culture and learning.

Translations of numerous complete texts are available, and there are numerous modern books with fragmentary translations, but there is no complete *corpus*, and we may have to wait many years before such will be ready. In Mr. D. J. Wiseman's opinion, a *corpus* of cuneiform literature will never be practical: "A translation of approximately three-quarters of a million tablets would be impossible to handle and would in its greater part be worthless, since the majority are economic texts which must be studied in their context and the remainder would largely duplicate previous publications." (From a letter to the author.)

Even the orientalist who is not an Assyriologist is not much better off; he expects from the Assyriologists better, and up-to-date grammars and interpretation. In particular, the interpretation of Sumerian texts is still in its infancy. In the present state of our knowledge, any first translation of unilingual Sumerian texts is largely tentative.

The first collection of cuneiform tablets was excavated in 1843 by the French consular agent at Mosul, Paul Émile Botta, in the palace of Sargon II (721–705 B.C.) at Khorsabad or Dur-Sharrukin ("City of Sargon"); it arrived in France in 1846. Austen Henry Layard's excavations, begun in 1845, constitute, however, the main landmark in this field of knowledge; in 1847 he discovered the great palace of Sennacherib (704–681 B.C.) at Kuyunjík (part of the site of ancient Nineveh), and in 1849–50 he found there the first palace library. His work was continued by Hormuzd Rassam, who in 1853 discovered there the great library of Ashurbanipal (see p. 109). Some twenty thousand cuneiform tablets in the British Museum now bear the inventory letter K (for Kuyunjík) or Rm. (for Rassam). In the hundred years which have followed these first discoveries, hundreds of thousands of tablets have been unearthed and brought to the museums of Europe and America.

WRITING AND READING IN ANCIENT MESOPOTAMIA

Ancient Mesopotamia, like Egypt, was a land of scribes (Fig. III–1), but in the opinion of some modern scholars it differed from the sister civilization in one important respect. In Egypt, the scribe, or educated man, was essentially an official, and it is very doubtful indeed whether the general body of the people were able to read or write. In Babylonia, to write, and consequently to read, was a duty

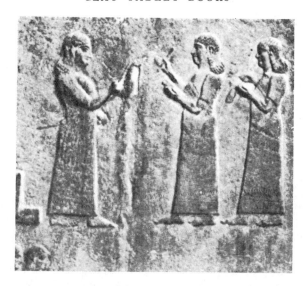

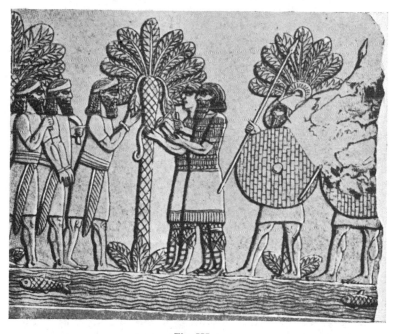

Fig. III–1

Assyrian sculptures from the royal palace at Ashur, representing scribes. (*Above*)
Scribes in the act of writing; (*below*) two scribes writing out lists of booty (see p.
174).

imposed on all, except the lowest class of people. Amongst the duties imposed upon the parent was that of having his son taught to write: there is ample proof that there were regular schools and colleges attached to most of the temples in Babylonia (see p. 99)—certainly at Borsippa, Nippur and Larsa. According to eminent Egyptologists, however, literacy was not more general in Mesopotamia than it was in Egypt.

Education was, indeed, as in the Middle Ages, under the direction of the priests; in the temples of every great city there was a "house of tablets", or books—in other words, a library (see p. 99). Not only could books be borrowed from this library, but in the part analogous to a modern public record office all documents relating to business transactions, including conveyancing of land and slave ownership, were filed. Royal decrees and correspondence, lists of taxes and official chronicles, would probably be placed in a special record office of the palace.

With education placed upon a broad basis, it is perhaps not surprising that letter-writing and record-making covering all transactions were practised to a remarkable extent. The law required that every business deal, even down to the smallest transaction, should be in writing and duly signed by the contracting parties and witnesses.

At the same time, it must not be assumed that there were no illiterates. Writing on tablets was far from easy, and we cannot marvel that, notwithstanding the general duty to learn to write and to read, not many attempted to master the art. It was so much easier to hire someone to do the writing than to waste years at school oneself. Is it too fantastic to suggest, that, with the advent of the shorthand-typist of today, our modern business leaders may in time be unable to write?

VARIOUS WRITING MATERIALS IN MESOPOTAMIA

In addition to clay, stone was extensively used by the Mesopotamian scribe (obelisks, bas-reliefs, statues of bulls and lions, boundary stones, stone gate sockets, etc.).

Stone was sometimes the main material used for perpetuating a code, or a legal agreement, or for immortalizing the work of a ruler. Sometimes the hardest volcanic rocks were employed for the purpose; sometimes softer stones, especially alabaster and marble, and even stones of comparative rarity, such as lapis lazuli, were employed. Plaster and gypsum were occasionally used. Semi-precious stones were cut for seals.

Metals, too, were used—usually bronze, copper, and antimony. The more precious metals such as silver and gold—the latter being very rare—were occasionally inscribed; so was ivory.

INSCRIBED CLAY TABLETS

The inscribed clay tablets, countless in number and infinitely various in size, shape and contents, far outweigh in importance all other kinds of cuneiform inscriptions in existence. Cuneiform writing on clay tablets was used, indeed, for many centuries, throughout the whole of ancient western Asia for correspondence, promulgating decrees, recording history, codifying laws, compiling religious literature, and for all the needs of a thriving and highly developed society. In Mesopotamia it was the main and permanent medium of communication and of the transmission of thought for nearly three thousand years.

Preparation of Writing Material

The writing material was prepared in the following way. The scribe would make a tablet or brick of clay of the proper size and thickness. It had to be moist and soft enough to take the impression of a broad-headed *stilus* (consisting of a straight stick or piece of reed, bone, hard wood or metal—see Fig. III–2,*f*), but not so soft that it clung to it and hindered the scribe as he worked. Assyrian monuments represent scribes holding the stilus in their closed fist and pressing upon the tablet (see Fig. III–1).

While the clay was still damp and soft, the scribe impressed the cuneiform strokes, line by line, with the edge or front of his stilus. Naturally, the strokes impressed were thick on the top and on the left, the direction of writing being from left to right, thus giving birth to a series of wedge-shaped characters. Large tablets, which would require some considerable time for writing, were kept soft by being wrapped in damp cloth. The tablet was normally inscribed on both sides.

To make the tablet durable, it was exposed to the sun and dried hard. Experience proved, however, that clay dried in the sun was liable to crumble, and therefore an alternative method of baking in kilns was introduced, small holes being made in the clay to allow the moisture to escape and so reduce the risk of breakage: thus, a most durable record of thoughts and actions was the result. Kiln-baked tablets, however, appear concurrently with sun-dried ones, the difference being usually one of subject-matter. Royal annals,

law codes and literary works, *e.g.* epics, were baked to give extra preservation. Most temporary matter, such as correspondence, receipts, letters, and so forth, were sun-dried in all periods.

The writing is sometimes exceedingly minute, though marvellously clear and sharp; sometimes, however, it is more stereotyped in character. According to some scholars, whilst the term "stereotyped" could be applied to styles of writing in all periods, the main variations of writing in the size of its symbols, and the degree of its cursiveness are due to the development of the cursive style, the signs being generally simplified in the later period.

Various Sizes and Shapes of Clay Tablets (Fig. III-2)

The size and shape of the tablets are sometimes indicative of the period to which they belong, sometimes of the subject-matter with which they deal. The earliest tablets so far recovered are mostly rectangular, either square or oblong, measuring 4–5 cm. in length and $2\frac{1}{2}$–3 cm. in breadth; the edges are also sharply rectangular and the sides flat, while the corners are somewhat rounded. In this period, too, oval tablets occasionally occur. A very early type is also represented by round tablets (Fig. III-2, *a*). As time goes on, the size of the tablet increases until one from Uruk measures 11.3 × 10.6 cm. Tablets from Shuruppak are broader than they are long; they contain lists and inventories of property.

The commonest type of clay tablet is the rectangular; these tablets are sometimes square, but more frequently oblong, and varying greatly in size. The tablets in the Kuyunjik (Nineveh) collection, which represents the largest, and in one sense the only, Assyrian library yet discovered, vary from $2\frac{1}{2}$ to $37\frac{1}{2}$ cm. in length when complete. The tablet on which the Middle-Assyrian Laws are inscribed (see p. 109) measures $31\frac{1}{2} \times 20.6 \times 3.2$ cm., and the text contains 828 lines of writing arranged in eight columns, four on the obverse and four on the reverse side.

"The Books"

A book often consisted of many more than one tablet, just as our books have many leaves. It was, of course, impossible to sew the clay tablets together as we bind the leaves of a book, but all the tablets of a series were numbered. The number of the tablet and the "name" of the book to which it belonged were written on each tablet. Examples of this are the seven tablets of the Epic of Creation (see p. 97 ff.). This book begins with the words, "In the

Fig. III–2

a–e, Cuneiform tablets of various shapes; f, Extract from Hammurabi's *Code of Laws* showing the stilus.

beginning that which is above was not called the sky"; on every tablet of this book this sentence is inscribed, followed by "No. 1", "No. 2", and so on. In addition, in many books the "stamp" of the library is "printed".

The books were all carefully indexed and cross-indexed, and arranged on shelves in convenient and correct order. Unfortunately, as we might expect, in times of war or other calamities, the tablets would become separated and lost. Copying texts was considered a pious duty, and many undertook it in order to obtain remission of sins.

OTHER CLAY TABLETS

The round tablets dealt mainly with the sale and purchase of land or were used for school texts (Fig. III–2, *a*). Legal contracts were inscribed on small oblong tablets, both sides being slightly concave; these tablets looked like a small narrow pillow. Many were enclosed in clay envelopes, in order that the original should not be interfered with; the terms of the contract were copied in duplicate, and the seals of the contracting parties and of the witnesses were affixed.

The later (Neo-Babylonian) legal and commercial documents are more varied in size and shape; they are generally oblong; the smaller ones contain the text inscribed over the length of the tablet, not over its breadth; larger legal documents are sometimes written on very thick tablets.

"ENVELOPES"

Clay envelopes or cases were used for letters, despatches and other inscribed tablets, to ensure their preservation. The making of this envelope was relatively simple: after the tablet had been duly written and sometimes signed, the scribe would flatten out a moist lump of clay; then he would take the written document and fold it into the flattened "sheet". All the excess clay would be removed, leaving enough to cover the document; the rough edges would be turned in, then smoothed out, and baked. The "envelope" would thus have the same shape, but be slightly larger than the original document. The covering was a good protection against wear and tear, but it had to be broken when the document was used.

Clay Tablets Having Curious Shapes
(Fig. III–2, *a-e*, 6, *a*, and 10, *right*)

Wedge-shaped or nail-shaped or cone-shaped tablets were employed as foundation-deeds in the walls of the temples (in Babylonia) or of the fortifications (in Assyria)—Fig. III–6, *a*. The Assyrian kings left complete records of their campaigns and activities, impressed on hollow cylinders or prisms, with six, seven, eight or even ten faces, each covered with as much minute writing as it could possibly hold (Fig. III–10, *right*).

Finally, there were tablets of various curious shapes, to meet special needs, such as liver-shaped tablets for divinatory information—Fig. III–2, *b* (the famous Etruscan *templum* of Piacenza has been compared with this liver-shaped tablet); a paw-shaped bracket (Fig. III–2, *e*), a clay model of an ox-hoof (Brit. Mus. No. R.620) inscribed with forecasts; a clay model of a sheep's liver, also magical in character (Brit. Mus. No. 92668).

A four-sided block of clay, $9\frac{1}{2}$ cm. square and 24 cm. high, is inscribed with lists of the names of fishes, birds, plants, stones, and garments. Maps (Fig. III–2, *d*) and plans (Fig. III–8, *a*) were drawn on circular tablets. Astrolabes or instruments for making astrological calculations, were also made of clay.

The Sumerians

It is very difficult to estimate the number of Sumerian tablets and fragments which have been discovered, some in official excavations and some in clandestine diggings, but two hundred and fifty thousand would probably be an underestimate, of which more than ninety-five per cent are economic in character (contracts, wills, receipts and letters). Then, there are about six hundred building and dedicatory inscriptions, which are important historical sources.

Their Literary Productions (Fig. III–3–5)

About three thousand, largely unbaked, tablets and fragments, mainly of the late third millennium and early second millennium B.C., contain literary compositions. Only about three hundred of them are in the British Museum and the Ashmolean Museum. Of the three thousand, about two thousand one hundred were excavated by the University of Pennsylvania on the site of Nippur (to the south-east of Babylon) in the course of four campaigns,

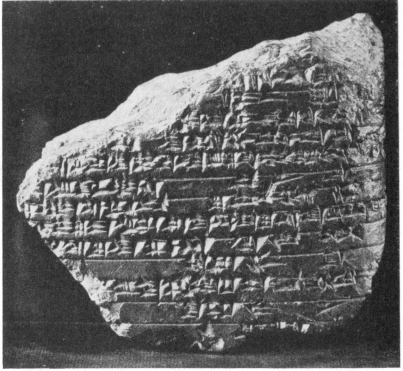

Fig. III–3

(*Above*) Sumerian literary catalogue, belonging to the early second millennium B.C. (University Museum, Philadelphia, No. 29-15-155): it may be considered as the first example in man's history of a list of "books"; (*below*) Sumerian Flood tablet from Nippur (belonging to the same collection).

Fig. III-4

(*Left*) Nippur archaic cylinder, c. 2400 B.C. (the same collection, No. 8383): the oldest known example of a "book"; (*right*) Nippur grammatical text, of the early, second millennium B.C. (the same collection, No. 4483): earliest "book" other than literary.

1889-1900. Nippur appears to have been the Sumerian spiritual centre of the third millennium.

The preserved tablets are probably only a small part of a vast, varied, and highly developed literature, consisting of myths, hymns, prayers, and epic tales, proverbs and aphorisms, lamentations and love songs. There are also some historical, economic and legal texts, as well as very important lexicological texts which contain Sumerian dictionaries and grammatical material. The Sumerians represented, indeed, the dominant cultural group of the ancient Near East for more than fifteen hundred years, namely from the last centuries of the fourth millennium B.C. until the first centuries of the second millennium.

These fragments of clay tablets—in contrast with the texts preserved in later Babylonian or Assyrian recensions, which will be discussed further on—have come down to us as they were actually written by Sumerian scribes; generally they are in several copies.

S. N. Kramer divides this literature into the following groups: (1) Nine epics, of which six relate the deeds of three Sumerian mythical heroes, Enmerkar, Lugalbanda, and Gilgamesh (who were supposed to live in the late fourth or early third millennium B.C.), the remaining three describing the destruction of the mythical monster Kur. (2) Myths of Origins, dealing with the Creation of the Universe, and its Organization, as well as with the Creation of Man; a Paradise myth; myths of Kur; the Deluge; the Marriage of Martu; an agricultural myth which Kramer entitles *Inanna Prefers the Farmer*; and the Tammuz myth. (3) The divine hymns, consisting of songs of praise and the exaltation of the deities, as well as the mainly self-laudatory royal hymns. (4) Lamentations for the destruction of cities (of Ur, Nippur, Agade) or of the country Sumer as a whole. (5) Proverbs and aphorisms; fables and didactic compositions.

Extremely interesting is a tablet, of *c.* 2000 B.C., from the Nippur collection of the Pennsylvania University Museum, deciphered by Kramer, and containing a literary catalogue, listing by title one group of Sumerian literary compositions (Fig. III-3, *above*). The list contains sixty-two titles; this list and another Sumerian catalogue of literary compositions give us the titles of nearly ninety different epics and other literary compositions known in the early second millennium B.C., but "they do not exhaust the number of Sumerian literary works of that period, which probably ran into the hundreds" (Kramer).

As to the date of the Sumerian literary documents extant, Kramer says: "We are amply justified in stating that although practically all our available Sumerian literary tablets actually date from approximately 2000 B.C., a large part of the written literature of the Sumerians was created and developed in the latter half of the third millennium B.C."

BARDS TRANSMITTED SUMERIAN EPICS TO POSTERITY

The preserved Sumerian texts are but little fragments, broken and time-worn, recalling to us to some extent the famous songs of Omar Khayyam and other late poets. There are Sumerian fragments inscribed with curious poems, relating to local events, which seem to have been part of other epic poetry. The ancient Oriental was a born singer. Wandering musicians and bards kept alive most of the hymns and sagas. To hymn the praise of heroes or the glories of the tribe, to improvise poems that would thrill and inflame the hearts of men, driving them to deeds of daring, was often the oriental form of public speaking.

How long the bards continued to go from house to house, singing their songs and praising the national and local heroes, and entertaining the people in exchange for gifts and the plaudits of their listeners, we have no means of knowing. Some of the later bards got their names "in print", otherwise they would never have been known to posterity. At the end of some of these songs the scribe has added "from the mouth of. . . ."

There is no way of knowing what changes are due to the imaginative power of the bard, and to the importance of a particular deity or of a hero in the district in which the poem was sung; the vaudeville performer of today also varies his "turn" according to his ability and to the place where it is given. This explains why the same Sumerian story may differ from one tablet to another.

BABYLONIAN MAGIC AND DEMONOLOGY A SUMERIAN DERIVATION

One of the oldest known religious texts from Babylonia is a Sumerian incantation copied from a foundation cylinder of the time of the dynasty of Agade (twenty-fourth century B.C.). This cylinder was found on the site of Nippur. Part of nineteen columns of writing remain, and not more than one whole column of writing is missing. The late Prof. Barton considered this text as possibly half a century older than the Pyramid Texts of Egypt (see next chapter). Whatever its exact date, it is certainly one of the

oldest religious expressions that have survived from any people. It contains a primitive but comparatively refined strain of religious thought. The text, like some other Sumerian documents, is written from the animistic point of view: the world was full of spirits of which people were in terror; but the chief among these spirits were gods, who, however capricious, were the givers of vegetation and life.

All objects in nature were the abodes of spiritual forms, which could only be controlled by invoking the aid of the more powerful spirits, such as the dominant spirits of heaven and earth. The text exhibits the neighbourly admixture of religion and magic. For such a creed, the natural priesthood would be magicians, who knew the spells and exorcisms that would compel the spirits to obey. These spells would be gradually embodied in the form of magical litanies, and form a regular liturgy of magic and religion.

Thus magic and demonology, which, as commonly thought, were so characteristic of Babylonian thought, seem to be of Sumerian origin. In the time of Gudea (end of the third millennium B.C.), we find references to the dread of witches and others who were turned out of the city when the king laid the foundation of his temple.

The Babylonian astrological omens are contained in a large series of texts; the most important one, called *Enûma Anu Enlil*, contained at least seventy numbered tablets, with a total of about seven thousand omens, and reached its final form *c.* 1000 B.C.

Babylonia, more than Egypt, was the home of the black arts— the main centre of magic and sorcery. It was from the "Chaldaean" soothsayers and magicians that the Jews (as well as the Persians, the Greeks, the Syrian Christians, the Mandaeans, the Arabs and others) derived the main elements of their belief in demons, witches, ghosts and wizards, which found their way into the New Testament, and, in the Middle Ages, into Europe, and are still current among some classes of our modern population.

When compared with the Egyptian Pyramid Texts, the Sumerian incantation tablet presents one striking difference. The Pyramid Texts centre around the king and are concerned with his fortunes as he enters the abode of the gods; one text even represents the Egyptian king as a cannibal, who in heaven eats gods to obtain their strength. This Sumerian document, on the other hand, in a certain way represents the Nippur City-state. If not the religious expression of a democracy, it represents, at least, the city leaders.

APPRAISAL OF SUMERIAN LITERATURE

According to Dr. Kramer, "As literary products, these Sumerian compositions rank high among the creations of civilized man. . . . Their significance for a proper appraisal of the cultural and spiritual development of the Near East can hardly be over-estimated. The Assyrians and Babylonians took them over almost *in toto*. The Hittites translated them into their own language and no doubt imitated them widely. . . . As practically *the oldest written literature of any significant amount ever uncovered*, it furnishes new, rich, and un-expected source material to the archaeologist and anthropologist, to the ethnologist and student of folklore, to the students of the history of religion and of the history of literature."

Great Part of Literature Inherited from the Sumerians

The Sumerian fragments are not sufficient for the reconstruction of the literary conditions and the literary productions of the Sumer-ians in the days of their independence. How much of the vast literature and learning of the Akkadians (see p. 96 ff.) had been created or initiated by the Sumerians and how much by the Akkadians themselves we do not know; probably much more by the former than by the latter.

Hammurabi's Code of Laws (eighteenth century B.C.)

Consider, for instance, the codes of laws. It is well known that the Babylonians, the Assyrians, the Hittites and other ancient nations had regular legal codes for maintaining the social order. Several such codes have been found. The best known is the code of Hammurabi. Modern Old Testament scholars have been astonished to see to what extent it anticipated, and in some respects even surpassed the much later Mosaic legislation. It also shows that the Romans had been anticipated in the legal field by two thousand years.

This code of laws, one of the oldest in the world, was inscribed by order of Hammurabi on a block of black diorite nearly eight feet in height and set up in Babylon, but at a later time, an Elamite con-queror took this pillar away as a trophy to his capital, Susa, where it was discovered in the de Morgan excavations during the winter of 1901–2. The laws are written in Semitic Babylonian (or Akkadian). It is obvious that they were not invented or created by Hammurabi, great though he was.

Hammurabi, indeed, tells us that he received his laws from the

god of justice, and in the upper part of the pillar he is represented in the act of receiving them from this god. He codified the already existing customs, and no doubt used codes which had already been reduced to writing. In his endeavour to unify the laws of his vast empire, he probably sanctioned some Sumerian laws and customs, and rejected or modified others. See also *The Alphabet*, Fig. 21, 1.

EARLIER CODES OF LAW

A Sumerian code of law (Fig. III–5, *a*) compiled under the reign of Lipit-Ishtar (thus antedating Hammurabi's Code by more than a century and a half), has been reconstructed by Dr. F. R. Steele, of the University of Pennsylvania, from seven clay tablets and fragments, found mainly at Nippur. Tablets containing another pre-Hammurabi code (the Laws of the kingdom of Eshnunna) have been recently excavated at Tell Abu Ḥarmal, to the east of Baghdād.

GILGAMESH EPIC

There are certain works in which the original authorship of the Sumerians may be assumed as more or less proved, notwithstanding the numerous additions, cancellations, and other changes of the later editors of these works. Such is the case of at least a part of the famous Gilgamesh Epic, which is one of the most ancient and most interesting poems in the world. Its theme is essentially a secular one. It describes the mythical wanderings and adventures of a hero, Gilgamesh, one of the earliest kings of Erech.

This Babylonian Epic consisted of twelve tablets or sections, but it is generally believed that this sub-division is late. The eleventh tablet (which is the longest, consisting of over 300 lines), contains what is now known as the Babylonian account of the Deluge: Fig. III–6, *c*.

This Epic is of great antiquity; it originated, partly at least, with the Sumerians, perhaps in the fourth millennium B.C. Indeed, fragments of a Sumerian account of the Deluge are extant, which seem to have belonged to this Epic: Fig. III–3, *below* and 5, *b*. Also the latter tablet was found at Nippur; it is inscribed on both sides, with three columns to the side. S. N. Kramer has pointed out that there are sixteen Sumerian fragments available which are part of the same poem. Besides, illustrations of various episodes of the Gilgamesh Epic are found upon inscribed seal cylinders and other objects belonging to the third millennium B.C.

a

b

Fig. III–5

a, Fragments of the Lipit-Ishtar Law Code (belonging to the same collection as Fig. III–3–4): the oldest law-code in man's history; *b*, Sumerian tablet from Nippur with the Story of the Creation and the Deluge (the same collection).

Prof. E. A. Speiser points out, however, that Tablet XII is not of a piece with the other eleven tablets of the poem, but is instead a literal translation from the Sumerian. "The epic proper, on the other hand, while utilizing certain motifs which are featured in Sumerian poems, does so largely in the course of developing a central theme that has no Sumerian prototype. In other words, the first eleven tablets . . . constitute an instance of creative borrowing which, substantially, amounts to an independent creation."

That this Epic is, partly at least, of Sumerian origin, very well illustrates how the loss of independence did not mean the end of Sumerian history; how political decay did not prevent the continuation of Sumerian culture and supremacy. It also shows, with numerous other instances, that the Semitic victors not only adopted the script of the Sumerians and their religious and literary language, but borrowed a considerable part of their literature and even transmitted it to other nations.

Indeed, apart from the Sumerian fragments, the Gilgamesh Epic is represented by three Akkadian tablets of the early second millennium B.C.; by fragmentary editions, discovered in Boghazköy (the site of the capital of the Hittite Empire), written not only in Akkadian but also in Hittite and in Hurrian; by an Assyrian tablet found at Ashur; by the numerous tablets and fragments of tablets now preserved in the British Museum, which were made in the seventh century B.C. for the Royal Assyrian Library at Nineveh (Sin-liqi-unni(n)ni is named as one of the editors); and by some small neo-Babylonian fragments.

The Akkadians (*i.e.* The Babylonians and the Assyrians)

THEIR LITERARY PRODUCTIONS

The two greatest periods of vigour in Assyro-Babylonian history, that of Hammurabi, eighteenth century B.C., in Babylonia, and that of the ninth-seventh centuries B.C. in Assyria, were marked by a corresponding activity in literature and especially in book writing and book production. Hammurabi's dynasty was the Golden Age of Babylonian literature and science; practically all the preserved Babylonian literature was written down in that period.

The Sumerian people had been completely conquered by the militarily stronger but culturally weaker Amorite invaders. With the coming of these Semites a great change would seem to have taken place in the literary activity though not in the literary

conditions of Babylonia. It is one of the ironies of history that the people who would seem to have given a death blow to the ancient Sumerians gave the signal for a great literary activity and for the collection of everything which could be preserved for later ages. The Babylonians made the study of Sumerian their basic discipline; they compiled dictionaries and interlinear translations of Sumerian works; the transition from the Sumerian to the Semitic culture in the First Dynasty of Babylon was gradual and largely by absorption.

The total number of Babylonian tablets which have reached museums has been estimated to be at least 500,000; there are many more still to be unearthed in the ruins of Mesopotamian cities.

AKKADIAN MYTHS AND EPICS

With that adaptive faculty which Semitic peoples have exhibited in many lands and all ages, the new rulers began to collect, or, at least, to edit the various myths, and form them into cycle or epic poems. Of these compilations there are many, but two are of considerable length, and fortunately well preserved. These are the Gilgamesh Epic—already referred to—and the Cosmic or Creation Epic.

THE CREATION EPIC (Fig. III-6, *b* and 8, *b*)

The Creation Epic contains the Babylonian legendary story of the creation of the world. This myth, too, may be partly of Sumerian origin, but according to the majority of scholars, in the First Dynasty of Babylon (mainly during the eighteenth century B.C.) it was given the form in which it was to be told for the next thousand years, and, interestingly enough, in the form in which it is most familiar to us. "This poem was recited with due solemnity on the fourth day of the New Year's festival, and it was the most significant expression of the religious literature of Mesopotamia" (Speiser).

The earliest fragments of this epic were found in Ashur and belong to *c.* 1000 B.C.; others, found in the Royal Library of Nineveh, belong to the seventh century B.C.; and still others to the sixth and later centuries B.C. Despite the relatively late date of these tablets, and despite their composite character, due to the handiwork of more than one editor, it is generally agreed that the poem originally consisted of about 1,000 lines, and that, at an early period, it was divided into seven tablet books. The epic, known also from its two opening words, as *Enûma elish* ("When on high") has been

c

b

Fig. III-6

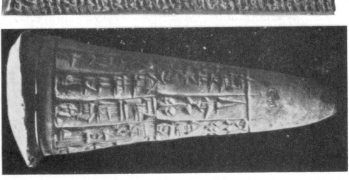

a

a, Cone inscribed with the name and titles of Ur-Bau, governor of Lagash: second half of the third millennium B.C. (British Museum, No. 91,061); *b*, the Fourth Tablet of the Assyrian account of the Creation and the Flood (British Museum, No. 93,016) *c*, fragmentary tablet containing the Babylonian account of the Deluge (British Museum, K-3375).

compared with *Genesis* i, 1 – ii, 3, but the differences are far more striking than the similarities.

On one tablet (Fig. III–8, *b*) there is an account of the creation of Man which has been compared, wrongly, with *Genesis*, ii, 7; it contains, however, a tradition similar to that of *Genesis*, that God formed Man from clay.

RELIGIOUS AND SECULAR LITERATURE

There are also the Adapa (=Adam?) Myth, the myth of Nergal and Ereshkigal, the epic poems of Atrahasis (="Exceeding Wise"), the Zu Myth, the myths of the Nether World and those describing the creation of man out of clay mixed with the flesh and blood of a slain god, the secular legends of the kings Etana and Sargon. There are, of course, rituals, such as those for the daily sacrifices of Uruk, for the New Year's festival at Babylon, and many others. There are hymns and prayers (to the Moon-god and the Sun-god, to Ishtar, to Marduk, and to other gods); there are fables, proverbs and "wisdom" literature.

TEMPLE SCHOOLS AND LIBRARIES (Fig. III–8, *c*)

Leading Semitists have suggested that there were in ancient Mesopotamia two main types of schools: (1) the writing school, known as the "tablet house", where boys and presumably also girls learned to read and write, and (2) the "house of wisdom", where higher education was imparted; the latter included linguistics, theology, magic arts and medicine, astronomy and mathematics. The main temples had their schools and libraries, which generally were filled with literary productions of the most varied character, including copies of the great epics just mentioned. Their section of learned books would include religious and magical literature, linguistic and grammatical texts (such as syllabarics —Fig. III 7, *right*—or dictionaries, explaining cuneiform signs with their Sumerian and Akkadian values, as well as bilingual grammars), numerous and very important historical texts (including chronicles —Fig. III–7, *left*—lists of dynasties and kings, tables of chronological events, descriptions of campaigns and battles, self-laudatory inscriptions of kings, and biographies), magico-medical works (medical texts, descriptions of diseases and of healing herbs and potions), technical books (such as instructions for working in metals), and books in the various fields of science.

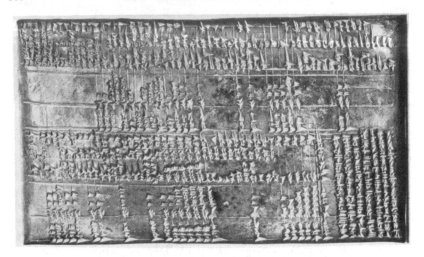

Fig. III-7

(*Left*) Babylonian Chronicle, from 744 to 668 B.C. (British Museum, No. 92,502); (*right*) Babylonian syllabary or spelling book, dated 455 B.C. (British Museum, No. 92,693).

BOOKS OF SCIENCE (Fig. III-2, *c* and *d*; and 8, *a*)

There are maps, indicating the courses of rivers and the positions of seas (one dating back well into the third millennium, and thus of Sumerian origin, which was discovered quite recently, must have been used to establish the exact boundaries of an estate) as well as plans of cities; there are also codes of law, such as those of Eshnunna and of Hammurabi, lists of plants, stones, birds, fishes and insects (see pp. 87 and 93 f.).

It is commonly but wrongly held that the majority of Babylonian documents are concerned with religion, magic or number mysticism; in fact the overwhelming majority of cuneiform texts extant concern economic items, "some even including computations of compound interest" (Neugebauer).

Mathematics

The Babylonians had already formulated the fundamental laws of mathematics; a very important feature of Babylonian numerical notation is the existence of special signs for $\frac{1}{2}$, $\frac{1}{3}$, and $\frac{5}{6}$, and these fractions undoubtedly played an important part in the arrangement of metrological units. Occasionally, a strictly decimal notation is to be found in these texts, while the sexagesimal system was the basis of Babylonian numerical computations. There are tables of quadratic equations, squares and square roots, of cubes and cube roots, of the sums of squares and cubes. According to an authoritative hypothesis, certain multiplication tables alone, as they existed *c.* 1800 B.C., would put the Babylonians ahead of all numerical computers in antiquity. However, cuneiform tablets with mathematical contents have come down mostly from the so-called "Old Babylonian" period, *c.* 1800 to 1600 B.C., and these texts show the highest level ever attained in Babylonia. Mathematical texts for the succeeding thirteen hundred years are lacking, and those from the Seleucid period are scarce, but the latter suffice to prove that Babylonian mathematical knowledge was always highly developed. "In both mathematical and astronomical texts of the Seleucid period appears a special sign for zero" (Neugebauer).

Astronomy and Astrology (Fig. III-2, *c*)

Their astronomical and astrological knowledge was also considerable, but no astronomical texts of any scientific significance belong to the early period; the tablets extant belong instead to the period of the renaissance of Babylonian learning under the Seleucid

dynasty (see pp. 103 and 112). In earlier times, however, the Babylonians did computations concerning the duration of day and night, and the movement of the moon and Venus. The preserved early Babylonian cuneiform texts show two systems of computations. The older one, according to B. L. van der Waerden, probably

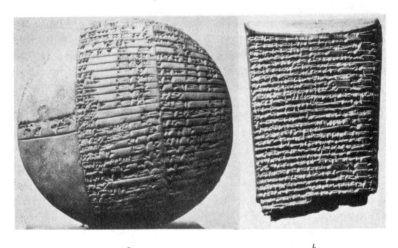

a b

c

Fig. III–8

a, List of eleven estates with measurements and statistics, from Ur, of the late third millennium B.C. (British Museum, No. 18,039); b, fragmentary tablet containing part of the Babylonian account of Creation (British Museum, No. 93,017); c, Master and disciples as represented on an Assyrian relief.

originated before 1000 B.C. It is represented by the circular astrolabe, the fourteenth tablet of the great omen series known as *Enûma Anu Enlil* (see p. 92), and two other texts. In this system, the spring equinox is on the fifteenth of the Babylonian twelfth month, the longest day is on the fifteenth of the third month, "and the proportion of the longest day to the shortest night is 2 : 1. The year is divided into twelve schematical months of thirty days each. The months are connected with the heliacal rising of certain fixed stars; there is no mention of the zodiac" (van der Waerden). The later system is assigned to *c.* 700 B.C., and is represented for example by the ivory prism discovered in Nineveh and now in the British Museum (56-9-3, 1136). In this system, the spring equinox is on the fifteenth of the first month, the longest day on the fifteenth of the fourth month, and the proportion of the longest day to the shortest night "is sometimes assumed as 2 : 1, sometimes in the same text as 3 : 2", but the latter is "not mentioned in computations. The year is again divided into twelve schematic months of thirty days each, but the months are now related to a division of the zodiac into four parts in such a way that the sun dwells three months in each of the parts. . . . In the Seleucid era these simple rules were replaced by more accurate ones" (van der Waerden).

The Babylonians developed methods for the computation of lunar and planetary movements, which by modern astronomers are classed among the great achievements of ancient science, comparable with the work of the Greeks. The oldest preserved clay tablets seem to represent three regions in the sky, each with twelve parts, giving thus thirty-six spaces. In each of these there is the name of a constellation and a number, which seems to be connected with some, still unknown, calendar scheme. Modern astronomers consider the Babylonians as the first to develop astrology systematically; this provided some stimulus to a further study of astronomy. "More and more it becomes clear, how closely interrelated Babylonian and Greek astronomy and Hellenistic astrology are" (van der Waerden).

Results from Modern Research

There is scarcely another chapter in the history of science—states Prof. Neugebauer—where an equally deep gap exists between the generally accepted description of a period, and the results which have slowly emerged from modern scientific research. For instance, magic, number mysticism, astrology, are still ordinarily considered to be the guiding forces in Babylonian science, while modern re-

search has proved that mathematical theory played the major role in Babylonian astronomy as compared with the very modest role of observations, whose legendary accuracy also appears more and more to be only a myth. Early Babylonian astronomy appears to have been crude and merely qualitative, while the later theories—of the last three centuries B.C.—proved to be of the highest level, fully comparable to the corresponding Greek systems, and of truly mathematical character.

a

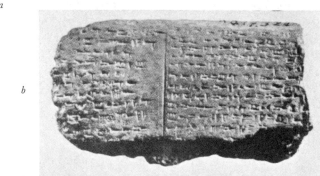

b

Fig. III–9

a, Hittite law-text in cuneiform writing; *b,* tablet from Ugarit written in cuneiform alphabetic script.

CONCLUSION

The importance of the Babylonian contribution to the development of civilization will be particularly clear if we take into due consideration the view which has been expressed that Babylonian astronomy is the most important force in the development of science since its origin, some time around 300 B.C., to the sixteenth and the seventeenth centuries (Copernicus, Tycho Brahé, Galileo, Kepler).

Diffusion of Learning in Ancient Western Asia

Apart from the work of the Sumerians and Akkadians, very little can be said about the diffusion of book writing and book making in ancient Western Asia. The quantity of clay tablets recovered shows that throughout Bronze-Age Western Asia writing was commonly employed in business and social transactions as well as in private correspondence, diplomatic relations and international trade. It is, however, not easy to determine how many people could read and write, because the majority of the tablets were written by professional scribes.

At the same time it must be emphasized that there may be writing without book writing, *i.e.* literature, in the same way as there may be literature without writing (see Chapter 1). However, there can be no doubt that under the influence of the ancient Babylonians literature, learning, and bookmaking spread out to northern Mesopotamia, Syria, and Asia Minor. This suggestion is confirmed by various discoveries.

AMORITES

In the 1935–8 excavations of the ruins of Tell el-Harîri (the site of the ancient capital city of Mari), on the Middle Euphrates, not far from the Syro-Iraq border, amongst some 20,000 clay tablets recovered, there are fragments which show that the Babylonian mythical-historical literature was known among the Amorites (a north-western Semitic people).

HURRIANS

From other tablets it is evident that the Gilgamesh Epic was translated into both Hurrian and Hittite. An Old Babylonian myth known as "Toothache Incantation" is preserved only in a Hurrian text: "it attributes toothache to a worm that had obtained the

permission of the gods to dwell among the teeth and gums" (E. A. Speiser). The Hurrians were a non-Semitic people of N -W, Mesopotamia and N.-E. Syria.

HITTITE LITERARY PRODUCTIONS (Fig. III–9, a)

Almost all Hittite "books" come from the archives of their capital Hattusa, represented by the ruins near the village Boghazköy (Anatolia). Various myths have been preserved, for example, the Telepinus Myth, the Illuyankas Myth and the Ullikummis Myth.

There are prayers, such as the daily prayers of the kings, the prayers of the kings Muwatallis, Arnuwandas, Mursilis; the prayers of Pudu-Lepas, the queen-consort of Hattusilis, the son of Mursilis; the prayer of Kantuzilis. Characteristic are the Hittite rituals against pestilence, against impotence, against domestic quarrels; rituals for purification, for erection of a new house or of the royal palace; ritual before battle and the soldiers' oath; there are omens to placate the anger of the gods. There are a few surviving historical texts and a Hittite code of law (Fig. III–9, a).

CANAANITES (see Fig. III–10, left)

The Canaanite population of Syria and Palestine of the middle second millennium B.C. knew the Babylonian myths of Adapa and Ereshkigal; this is shown by clay tablets found among the Tell el-Amarna letters. However, from the point of view of the history of "the book", the contribution of these peoples is certainly not comparable with that of the Sumerians, or the Akkadians, i.e. the Babylonians and Assyrians, or the Egyptians. From the standpoint of bookmaking, these people have made no contribution whatsoever, as they followed the clay tablet book pattern of the Mesopotamians.

THE UGARIT LIBRARY (Fig. III–9, b)

In Syria, as in Mesopotamia and Egypt, literature and learning seem to have been the prerogative of the priestly classes. In Syria, too, schools were attached to the most important temples. A school for scribes, containing two schoolrooms with rows of benches, remarkably preserved, has been unearthed at Mari; but the most important discovery, outside Mesopotamia and Egypt, in relation to the history of ancient literature and learning was made at Ugarit.

This epoch-making discovery was made by pure chance in 1929 at Ras esh-Shamrah (Fennel Head), which is about half a

mile inland from the little bay of Mînet el-Beyḍā (White Port), on the Syrian coast opposite the most easterly cape of Cyprus. It was revealed as the site of the ancient and important city of Ugarit, mentioned in Egyptian and Hittite inscriptions and in the Tell el-Amarna letters. Ugarit reached great heights of influence and prosperity; it was not only a flourishing commercial centre; it was also a thriving centre of culture.

In 1929 and the following years, C. F. A. Schaeffer, G. Chenet and Ch. Virolleaud, excavating this site, found the Late Bronze Age remains of what had evidently been an extensive school and library, where priests and scribes were trained to read and write. This building was situated between the city's two great temples, one dedicated to Baal and the other to Dagon.

Of revolutionary importance was the discovery of hundreds of clay tablets recovered in the library, dating from the fifteenth and early fourteenth centuries B.C., which proved to be of inestimable value in many fields of research such as epigraphy, philology and the history of religion. They are written in a script previously quite unknown; but, within a few months of its publication, it was deciphered; it is evidently the earliest-known alphabet written with wedge-shaped signs (see *The Alphabet*, pp. 202–4).

The tablets are, as mentioned, of clay, and vary in height from one and a half inches to ten inches. Some of them contain as many as eight columns. The great majority of the tablets are written in the local language, now known as Ugaritic, which is closely related to biblical Hebrew and Phoenician, and is considered by Professor Albright as substantially identical with the language spoken in contemporary Canaan.

There are also, however, tablets written in other languages; some contain "syllabaries" or dictionaries written in two or three languages (Ugaritic, Akkadian and Sumerian); the fourth language is Hurrian (see p. 106).

Most of the texts written in Ugaritic are poetic in form, and there are astonishingly close parallels between this poetry and the poetry of the Hebrew: for instance, Ugaritic poetry exhibits the same characteristic feature of parallelism as does Hebrew poetry. Most remarkable is a group of mythological epics and religious texts, which deal at length with religious rituals, ancient traditions and myths concerning Canaanite gods and heroes; there are also the great mythical epic of Ba'al and 'Anat, the legend of King Keret, and the Tale of Aqhat (previously known as the Epic of Daniel or Danel, Aqhat's father). We are confirmed in the view that the

religion of the Canaanites was centred to a great degree in interest in the fertility of the soil. Their study throws light on several religious beliefs and practices reflected in the Hebrew Bible; for instance, the connection between the Psalms and the Ugaritic poems is much closer than a mere similarity of language and ideas. The epic of 'Aleyan Ba'al, the legend of Keret, and other poems show that the Canaanites had their own rich mythology.

Various other books were found, among them a veterinary manual, dealing with the treatment of sick horses.

ASSYRIAN LITERARY PRODUCTIONS

The libraries of the Assyrian kings contained many tens of thousands of clay tablets. Astrology, astronomy, history, religion, lists of gods, hymns, prayers, mythology, magic, omens, medicine, mathematics, books of science, law, lexicography and grammar were all well represented in these libraries. Many of the texts are copies of older Babylonian literature made by Assyrian scribes, and stored away in the royal archives. Some of the texts are bilingual, the top line giving the Sumerian ideographic version, and the lower line the Assyrian translation, and these bilinguals together with the "syllabaries" have enabled scholars to unravel and elucidate, at least to some extent, the Sumerian language.

Among the larger rectangular clay tablets are those containing "syllabaries", *i.e.* they are a kind of dictionary. They are larger and more complete than the Babylonian "syllabaries" (Fig. III–7), and contain very fine examples of lexicography. Owing to changes in shape, and especially to the simplification which the cuneiform characters underwent in the course of ages, the Assyrian scribes found it necessary to make lists of the Sumerian symbols, adding what they believed to be the late Assyrian equivalents. Most of the Assyrian syllabaries consist of three columns—the left giving the Sumerian symbol; the middle, the corresponding Assyrian sign; the right, either the Assyrian meaning or the name for the sign, occasionally both.

Other large rectangular tablets are of a historical nature; they are inscribed with lists of the principal events under different kings, and are obviously of immense importance for the reconstruction of Mesopotamian history. One tablet deals with Tiglath-Pileser III's building operations and conquests, and mentions as one of his vassals Ahaz, King of Judah. The largest tablet of the Nineveh library measures, in its fragmentary condition, about 38 cm. in

length, and contains a list of the names and titles of various gods.

The Middle Assyrian Laws are preserved to us on tablets found in Ashur (modern Qal'at Shergat) during the German excavations from 1903 to 1914. These tablets date from the time of Tiglath-Pileser I (twelfth century B.C.), "but the laws on them may go back to the fifteenth century" (T. J. Mcck).

Systematic observations of astronomers to the kings were reported from 700 B.C. onwards.

ASHURBANIPAL

Few persons in the history of mankind have done so much for the history of "the book" as the last great king of the Assyrian Empire, Ashurbanipal (669–633 B.C.), the Sardanapulus of the Greeks. His extensive and successful military campaigns, and also his cruelty, are as famous as the high level of culture his country reached under his rule. Ashurbanipal's early interest in learning is evidenced from his inscriptions: "I, Ashurbanipal, learned the wisdom of Nabu, the entire art of writing on clay tablets. . . . I received the revelation of the wise Adapa, the hidden treasure of the art of writing. . . . I considered the heavens with the learned masters. . . . I read the beautiful clay tablets from Sumer and the obscure Akkadian writing which is hard to master. I had my joy in the reading of inscriptions on stone from the time before the flood. . . ."

Like other young sons of emperors, he had been originally prepared for the priesthood; he probably studied in the temple school of Nabu, at Nineveh, where a library had already been in existence for at least half a century. Ashurbanipal, however, established a great royal library, which was discovered exactly a hundred years ago in the British Museum excavations under the direction of Sir Henry Rawlinson (see p. 80).

Ashurbanipal sent scribes throughout Mesopotamia to copy and to translate into the Assyrian language and script all the books they could find, and thus tens of thousands of clay tablets were brought to the Royal Library. Much of what we know of Babylonian literature—historical, scientific, economic, religious, mythological—comes from the copies of Babylonian texts found in this great library. Many of these books may be seen in the British Museum. Ashurbanipal's library contained also a collection of proverbs in two languages, arranged as reading lessons for students. One of these proverbs says, "Writing is the mother of eloquence and the father of artists."

NEO-BABYLONIAN BOOKS

In 625 B.C., with the fall of the Assyrian Empire and the capture of Nineveh by the Medes, Babylon's independence was again asserted. Thus began the Neo-Babylonian Empire, which revived the ancient glory of Babylonia. Babylonian learning, which was dimmed during the previous centuries, flared up again under the New Empire. The Babylonians were generally far more cultured and produced far more books "than their warlike neighbours, the Assyrians. The children were sent to school at an early age; and it is astonishing what a large proportion of them learned to read and write. . . . Some of the clay school-books have been recovered, and they show what care and pains were taken in teaching the student to acquire his knowledge as easily and as speedily as possible. . . . The old Sumerian authors were read both in the original and in Semitic translations; and there would be commentaries to explain archaic forms and obsolete terms" (C. Clark).

Nearly all the Neo-Babylonian literary texts are copies or translations of Sumero-Akkadian books. There are, however, numerous original historical texts. There is an interesting tablet, preserved in the British Museum, which contains Neo-Babylonian laws. Of the original sixteen paragraphs, only nine are well preserved; "the script, orthography and wording, all clearly indicate a date in the Neo-Babylonian Period" (Meek).

NEBUCHADREZZAR

Numerous clay tablets have been found of the reign of Nebuchadrezzar II (commonly known as Nebuchadnezzar), king of the Neo-Babylonian Empire, from 605 to 562 B.C. He is familiar to all Bible readers because of his destruction of the kingdom of Judah. Before he ascended the throne, he defeated Pharaoh Necho in the decisive battle at Carchemish. Later, he invaded and conquered Egypt. He rebuilt Babylon, and the excavations of the German Oriental Society under the direction of Robert Koldewey (1899 onwards) have revealed a magnificent palace, a vast system of fortifications, splendid town planning, canals, and temples. With Nebuchadrezzar departed the glory of Babylon. The greater part of this king's writings deal rather with his extensive building operations than with his military successes.

Nabonidus and Belshazzar

As to Nabonidus, a king set up by the priests, some of his "books"

deal with historical, antiquarian, and political subjects, while others are religious in character. Nabonidus' son, Belshazzar, mentioned in the Book of Daniel, left clay cylinders containing prayers and "books" dealing with other matters.

END OF THE CLAY TABLET BOOKS

The gradual displacement of the cuneiform writing by the Aramaic alphabetic script, due no doubt to the simplicity of the latter in comparison with the complexity of both the cuneiform

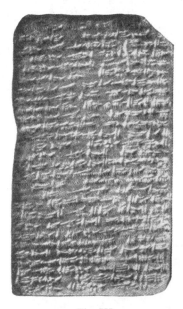

Fig. III–10

Historical sources: (*left*) letter written by Abdi-Khiba, ruler of Jerusalem, to Akhnaton (fourteenth century B.C.): one of the 360 or so letters (written by vassal princes and governors in Syria and Palestine) found at Tell el-Amarna, the site of Akhetaton, which was the new capital founded by Akhnaton; (*right*) baked clay prism of Sennacherib, king of Assyria (705–681 B.C.), inscribed with account of his invasion of Palestine and the siege of Jerusalem.

writing and the Egyptian scripts, coincides with the increasing influence of the Aramaic language and the progressive employment as writing materials of papyrus and leather or parchment.

SPREAD OF THE ARAMAIC LANGUAGE AND ALPHABET

There is ample evidence of the considerable extent to which the Aramaic language and script, as well as leather as a writing material, came into use in Assyria from the end of the eighth century B.C., owing partly, no doubt, to the Assyrian policy of transplanting masses of Aramaeans as of other conquered populations. At the end of the seventh century B.C., all Syria and a great part of Mesopotamia became Aramaized. Aramaic (and its script) became the *lingua franca* of the day, and under the Persian Achemenidae it became one of the official languages of the Empire and the principal speech of traders from Egypt and Asia Minor to India.

Nevertheless, the habit of writing in cuneiform character on clay tablets lingered on to the Christian Era, kept alive by some conservative priests, soothsayers and magicians, astrologers and astronomers. Indeed, private and business correspondence was the first to abandon it; letters in this script, numerous before the Persian conquest, ceased at the beginning of the fifth century B.C., as the spoken Babylonian language fell into disuse, being replaced by Aramaic. At the end of the same century, legal contracts and similar documents ceased to be written in cuneiform characters.

But clay tablet books written in cuneiform were still employed; indeed, during the third to the first century B.C., as already mentioned, there was a period of renaissance of ancient science and learning, in which cuneiform writing seemed to come into fashion again; this was due to the favour of the Seleucid dynasty (312–64 B.C.), with its pro-Greek and anti-Aramaic policy. The latest record extant of a cuneiform clay tablet is a specimen of the sixth year B.C. After this, the script (and its use on clay tablets) vanished and was forgotten by man, for sixteen hundred years.

BIBLIOGRAPHY

See the works quoted in *The Alphabet*, pp. 56 f.

J. B. Pritchard (ed.), *Ancient Near Eastern Texts*, etc., Princeton, N. J., 1950, and the numerous works quoted.

PAPYRUS BOOKS

THE supposedly static character of Egyptian culture has been explained by the fact that there was no other country in the ancient world where cultivated life was maintained through so many centuries in relative peace and security; "by and large, peace in Mesopotamia or Greece must have been as exceptional a state as war in Egypt" (Neugebauer).

The general reader may find useful the following sketch of Egyptian chronology. It must be remembered that no complete system of Egyptian chronology can as yet be formulated. The "high" system, which placed the beginning of the First Dynasty in the first half of the sixth millennium B.C., and also the system which placed it in the fifth millennium—systems which have been followed by well-known Egyptologists such as Petrie—can now be disregarded, and even the "low" chronology has been progressively brought down from the second half of the fourth millennium B.C. to the thirtieth or the twenty-ninth century B.C. Even nowadays, Egyptian chronology is in a state of flux, particularly for the period of the Old Kingdom.

The dates here given are mainly in terms of the nearest round number, and represent a chronology which is fairly widely accepted.

Early Dynastic Period (Dynasties I and II), the thirtieth, or twenty-ninth to the twenty-eighth centuries B.C.

Old Kingdom (Dynasties III–VI), 2700–2200 B.C.

First Intermediate Period (Dynasties VII–X), twenty-second century B.C.

Middle Kingdom (Dynasties XI and XII), 2150–1775 B.C.

Second Intermediate Period, including the so-called "Shepherd Kings" or Hyksos (1725–1575 B.C.), 1775–1575 B.C.

New Kingdom (Dynasties XVIII–XX), 1570-1090 B.C.

Dynasties XXI–XXV, 1090–663 B.C.

Saite Period (Dynasty XXVI), 663–525 B.C.

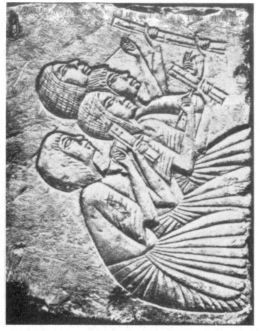

Fig. IV–1

Egyptian scribes. *a*, The Scribe of the Louvre, known in French as the *Scribe accroupi* (Louvre Museum, Salle du Scribe); this statuette—only 5.3 cm. high—found by Mariette at Saqqarah in a tomb belonging to the period of the Fifth Dynasty, is considered as one of the finest objects that art has ever produced; *b*, Scribes depicted in a tomb of the period of the Old Kingdom: they squat on the ground with the case for the papyrus rolls near them; the strip of the papyrus on which they are writing is held by their left hand, the reed-pen in their right hand, a reed-pen in reserve is behind the ear; *c*, Egyptian limestone relief of the Eighteenth Dynasty, depicting four scribes with papyrus rolls and reed-pens.

Persian Period (Dynasties XXVII–XXXI), 525–332 B.C.
(Alexander the Great.)
Ptolemaic Period (thirteen Ptolemies, followed by Cleopatra
and her son, Ptolemy XIV), 323–30. B.C.
Roman Conquest, 30 B.C.
Moslem Conquest, A.D. 640.

Egyptian Science, Learning and Literature

As Mesopotamia may be considered the cradle of writing, so
may Egypt be considered the cradle of "the book". From the earliest
ages the Egyptians had the greatest veneration for books, writing and
learning (see Fig. IV–1).

When the wise Khety (or Akhthoy), the son of Duauf, voyaged
up the Nile, with his son Pepy, to place him in the Writing School,
i.e. in the government secretarial training college, he admonished
him thus: "I shall make thee love writing more than thy (own)
mother; (thus) I shall make beauty enter before thy face."

Khety concludes his introduction thus:

"Behold, I have set thee on the way of god. The Renenut of a
scribe is on his shoulder on the day of his birth. He reaches the halls
of the magistrates, when he *has become a man*. Behold! there is no
scribe who lacks food, from the property of the House of the King—
life, prosperity, health! Meskhenet is (the source of) the scribe's
welfare, he being set before the magistrates. His father and his mother
praise god, he being set upon the way of the living.

"Behold these things I (*have set them*) before thee and thy
children's children.

"It has come to a happy ending in success. . . ."

This instruction comes from a book probably written in the
Middle Kingdom or earlier. The preserved copies of the book,
mostly belonging to the Nineteenth Dynasty (1320–1200 B.C.), are
Papyrus Sallier II, British Museum, 10182 (Fig. IV–12, *a*); *Papyrus
Anastasi VII*, British Museum, 10222 (Fig. IV–2, *above*); *Papyrus
Chester Beatty XIX*, British Museum, 10699, besides numerous
ostraca, and a writing tablet, most of these documents being frag-
mentary. The text is commonly, but wrongly, known as the *Instruction
of Duauf*. The present translation is that of Prof. J. A. Wilson, in
Ancient Near Eastern Texts, Princeton, 1950.

It has already been mentioned that the practice of writing in

Egypt goes back to the thirtieth century B.C. It is not unreasonable
to suppose that the writing of books began roughly at the same time.
"Chapter xxx B" of the "Book of the Dead" (see p. 144 ff.), accord-
ing to an Egyptian tradition was composed by Thoth (the god of

Fig. IV–2

(*Above*) *Papyrus Anastasi VII* (British Museum, 10222), half of sheet 6, *recto*; (*below*)
Rhind Mathematical Papyrus (British Museum, 10057 and 10058).

writing, of wisdom, and of priestly lore), and it was "found" by
Ḥertataf, a son of Khufu, or Cheops (Fourth Dynasty, c. 2700 B.C.);
according to another tradition, it was "found" in the reign of Semti-
Ḥesepti, a king of the First Dynasty (perhaps c. 2900 B.C.).

Furthermore, King Djoser of the Third Dynasty (c. twenty-
eighth century B.C.) is said to have been already a patron of learning
and literature, and his minister I-em-hotep (or Imhotep) was one
of the famed sages of Egypt, and was deified; some modern scholars
call him the Aesculapius of the Egyptians. Other traditional or
legendary Egyptian sages were Har-dedef or Djedef-Hor, a son of
King Khufu, Ka-iris (or Kairos), Ptah-em-Djedhuty, Nofry, Khety
(see above), Kha-kheper-Rescneb (or Kha'kheperra'sonb), Ke'
gemni (of the late Third or early Fourth Dynasty; see p. 141) and
the Vizier Ptaḥ-ḥotep (see p. 141). They were credited with the
earliest Egyptian books of wisdom.

The Egyptians valued learning mainly because of the power
achieved by the learned men; indeed, they had very little interest
in pure scholarship, however much they valued literature for aes-
thetic reasons. No fragment of a lexicon or of a systematic grammar
has yet been found in any Egyptian papyrus, though there are word-
lists and explanatory glosses. The Egyptians never succeeded in mak-
ing a final definitive text of their sacred writings. Although there must
have been official chronicles, and there are preserved lists of kings,
copies of treaties and other historical records, it is doubtful whether
the Egyptians possessed a complete written history.

CALENDAR

The twelve-division of day-time and night-time, and the calendar
are among the Egyptian main contributions to civilization. The
Egyptian calendar—consisting of twelve months of thirty days each
and five additional days at the end of each year—is "the only
intelligent calendar which ever existed in human history"
(Neugebauer).

The Egyptian priesthood thus laid the foundations of our calendar.
Some scholars even think that the earliest Egyptian calendar was
based on the heliacal rising of Sothis (=the Dog Star, Sirius), and
it shows the existence of astronomical activities as far back as the
fourth millennium B.C., but this contention has been disproved
by Neugebauer, who emphasizes the basically non-astronomical
character of the Egyptian calendar. It is known, however, that the
Egyptian priests tried to keep strictly to themselves all the astronom-

ical and similar knowledge acquired, and this may to some extent account for the lack of any Egyptian treatise on astronomy.

ASTRONOMY

That they knew the crude elements of astronomy is certain, but (in contrast with the records of Chinese and Mesopotamian astronomy in which many accounts of observations have been found) no Egyptian record of an observation has so far been discovered. Many observations for ceremonial date fixing and the orientation of monuments were no doubt made, but not recorded.

Such observations must have been made in very ancient times, as is shown by the orientation to the sun of such early monuments as the temples and the pyramids. A whole modern literature of nonsense has been built up around the measurements and other "mysteries" of these structures, and especially the Pyramid of Khufu.

The Egyptian priests alone possessed an elementary knowledge of astronomy, and they alone performed the valuable function of predictors for the Nile floods, which irrigated and fertilized the whole country. Some scholars credit them with the ability to predict eclipses, which could be of great value for impressing the masses of the population, but the only Egyptian eclipse record known concerns a solar eclipse of A.D. 601!

Most of our knowledge of early Egyptian astronomy has been derived from inscriptions and representations on the ceilings of tombs and on coffin lids of the Middle Kingdom and the New Kingdom (which apparently also represent the rising and setting of star groups), but little or nothing from books; still, astronomical books must have existed.

Two demotic documents of the Copenhagen Carlsberg collection (*Papyrus I*, and No. 9), recently published, represent older Egyptian methods. The first, probably written at the beginning of the Christian Era, is a translation of, and commentary on, a much older hieratic text whose hieroglyphic replica is still preserved in the tomb of King Seti I (about 1300 B.C.); its subject is the description of the travel of the "decans" over the body of the sky goddess. At the time of its discovery, the papyrus contained the picture of the sky goddess with all the constellations and their dates of rising and setting, but when the text reached Copenhagen the picture was gone. The other papyrus, also belonging to the Roman period, deals with the Egyptian twenty-five-year cycle, which was well known and often used in Hellenistic astronomy.

However, none of the early Egyptian "astronomical" texts contain mathematical elements; they are crude observational schemes, partly religious, partly practical in purpose. Only with the beginning of the second century b.c. do mathematical-astronomical and astrological papyri appear; and later also horoscopes and planetary texts, written in Greek or in Demotic or both; they are based on computations. Therefore, it becomes increasingly clear from recent researches "that the date of origin of the Egyptian true astrological lore must be fixed to the Ptolemaic period", and this lore "thus appears as a truly Hellenistic creation" (Neugebauer).

Mathematics

Their mathematics was never at a very high level; its two leading principles were simple addition and the extensive use of "natural fractions". They knew still less of geometry than they did of arithmetic. On the whole, it may be said that their theoretic knowledge of science was much inferior to that of the Babylonians.

The famous *Rhind Mathematical Papyrus* (Fig. IV-2, *below*) was obtained by Mr. A. H. Rhind at Thebes *c.* 1858, and in 1864 it was bought by the British Museum. This roll, about seventeen feet long, covers a large part of the arithmetical knowledge and practice of the Egyptians under the Old and Middle Kingdoms. It is a copy made under one of the Hyksos kings (eighteenth to sixteenth century b.c.) of an older work, and is a collection of specimen examples of all kinds of arithmetical and geometrical problems. It seems to have been found together with a mathematical leather roll (see next chapter), which suggests that the house they were found in, may have belonged to a mathematician or to an accountant. Another large mathematical papyrus is preserved in Moscow.

Superstitions, Magical Spells and Medical Lore

There is, on the other hand, a comparatively large literature on superstitions. The idea that it is lucky to undertake a particular affair on some days, but unlucky on others, and the belief that there were words and actions by which men could produce an effect on the powers of nature, upon every living being, upon animals, and even upon gods, appears prominently in ancient Egyptian writings, and is not limited to their funeral ceremonies and worship. Hence, the origin of the magical formulae of all kinds, of amulets worn by

the dead and by the living, of the magical remedies for sicknesses, and so forth.

An Egyptian tradition associates King Semti-Ḥesepti, of the First Dynasty, with a recipe in a book of medicine which is said to have been written or edited in his reign. The magical spells and medical prescriptions preserved in the great *Papyrus Ebers* (it measures

Fig. IV-3

Papyrus Ebers, belonging to the period of the early Eighteenth Dynasty (University of Leipsic), p. 2.

nearly sixty-seven feet), Fig. IV–3, and in the Berlin Papyrus 3038, are assigned to the period of Usaphais, a king of the First Dynasty, and those preserved in the British Museum Papyrus 10059 are assigned to Khufu's time. (It is known, however, that the Egyptians often invoked the authority of ancient times in order to popularize their own works.) The *Papyrus Ebers* is assigned to the early Eighteenth Dynasty; in 1873, it was bought in Luxor by G. Ebers, and is now (or was before the last war) preserved in the University Library, at Leipsic.

These "medical" or "surgical" papyri are far from being scientific treatises. Indeed, they are "a curious mixture of science and super-stition—and magic" (J. A. Wilson, *Journal of Near Eastern Studies,* 1952), as can be exemplified by the recipe for a fractured skull, which included an ostrich egg, to be ground up and applied to the fracture. This recipe is given in the *Edwin Smith Surgical Papyrus,* otherwise containing a serious and scientific treatise; it is written in a beautiful hieratic hand; the papyrus formerly belonged to the New York Historical Society, but in December, 1948, it was pre-sented to the New York Academy of Medicine.

EGYPTIAN LITERATURE

MYTHS AND TALES

A comparatively large number of myths and tales have come down to us from the various periods of Egyptian history.

The myth of "The Creation by Atum" is known from a hierogly-phic inscription carved inside the pyramids of Mer-ne-Re and Pepi II, or Nefer-ka-Re, of the Sixth Dynasty (twenty-third century B.C.), as well as from later texts, such as the hieratic papyrus Chester Beatty IX, *recto*, viii, 3–21, of the thirteenth century B.C. The text of another myth of Creation is inscribed on four wooden coffins from el-Bershch (Middle Egypt), and is dated to the Middle King-dom (*c.* 2000 B.C.).

A hieratic papyrus of the period of Ramses II (*c.* 1301–1234 B.C.) describes Thebes as the site of Creation. Two hieratic papyri of the Nineteenth Dynasty (1350–1200 B.C.) tell us "how the supreme god Re had many names, one of which was hidden and was thus a source of supremacy" (J. A. Wilson).

The deliverance of mankind from destruction is the theme of a myth inscribed on the walls of Theban royal tombs of the four-teenth to twelfth centuries B.C., "although the language used and

the corrupted state of the text show that it followed an older original" (J. A. Wilson) A myth describing an amusing contest of Horus and Seth is given in a Theban hieratic papyrus of the twelfth century B.C. There are various other myths which have come down to us in Egyptian manuscripts.

SHORT STORIES

Some scholars consider the Egyptians as the inventors of the short story.

In the period of the Middle Kingdom, the Egyptians seem to have been especially fond of stories of travel, in which the hero relates his own adventures. Other books are in the nature of historical romances. One of the earliest stories written on papyrus in the Hyksos period (and now in the Berlin Museum) relates the wonderful deeds of magicians in King Khufu's time, i.e. about the twenty-seventh century B.C. This *Tale of Cheops and The Magicians* is assigned by Sir Alan Gardiner to the Hyksos period.

Another romance, written about the close of the Nineteenth Dynasty (end of the thirteenth century B.C.), deals with the beginning of the Hyksos wars; and another, of the same period, with Tutmose III's occupation of the town of Joppa: *Papyrus Harris 500*, now British Museum No. 10060, *verso*, i–iii. There are a few "once upon a time" fairy-tales.

The *Story of Si-nuhe* (Fig. IV–4) seems to have been a "best seller"; it is represented by five papyri and at least seventeen ostraca (belonging to the period running from the late Twelfth Dynasty, c. 1800 B.C., to the Twenty-First Dynasty, c. 1000 B.C.). It is a classic and its literary style is considered as the best among Egyptian *belles-lettres*. Some other stories—such as the *Shipwrecked Sailor*, which is the shortest, and the *Eloquent Peasant*, as well as panegyrics, songs, hymns, royal "Teachings", and "Wisdom" literature, belong to this period.

As to the literary activities of the New Kingdom, Sir Alan Gardiner mentions the *Tale of the Two Brothers,* a hieratic papyrus of c. 1225 B.C., the *Doomed Prince*, and particularly the *Story of Wenamûn*, a hieratic papyrus of the Moscow Museum, dated to the eleventh century B.C. (see also p. 151).

The books of the Middle Kingdom were considered by ancient Egyptians to be patterns of classical grace, and in the official school-texts of the New Kingdom their heavy style and antique phraseology were imitated, although such imitations were far from light reading.

Fig. IV-4

Portion of a copy of the *Story of Si-nuhe* (Berlir Papyrus 3022, Twelfth or Thirteenth Dynasty).

DIDACTIC AND WISDOM LITERATURE. MODEL LETTERS

The earliest Wisdom literature has already been referred to. The schoolbooks which date from the Middle Kingdom are intended not only to teach wise living and good manners, but also to warn against a frivolous life. The instructions of the New Kingdom, which are couched in the form of letters from teacher to pupil, harp wearisomely upon the same idea: "It is a misfortune to be a soldier, and a misery to till the ground, for the only happiness for mankind is to turn the heart to books during the day and to read during the night!"

One of the best examples of literature of the New Kingdom is the *Anastasi Papyrus I* (now British Museum 10247); it probably comes from Memphis, and is assigned to the late Nineteenth Dynasty (end of the thirteenth century B.C.). It is a complete book, and consists of a sarcastic epistle sent by a high official to a royal scribe. Such "letters" were not intended to convey news, but merely to show off the writer's fine wit and graceful style in a literary dispute. The same letter is preserved, in addition to the *Anastasi Papyrus*, on other written documents, from the Nineteenth and Twentieth Dynasties (three fragmentary papyri and about forty ostraca, all being schoolboy exercises). This book gives us a wonderful glimpse into the taste and life of the *literati* in the New Kingdom.

For the *Book of Dead*, which was a sort of liturgical Baedeker, see pp. 144–47. Fig. IV–6 and 7.

POETRY

Charming are the Egyptian ballads and love songs. As to lyric poetry, the hymns, which have come down to us in great numbers, are mostly in the form of litanies in praise of the power of the gods, including the king-gods. Comparatively speaking, the best amongst these religious poems are the hymns to the Sun, the hymns to the Nile, a hymn to Amon-Re, and the beautiful hymns of Akhenaton. Various prayers have also come down to us. A prayer (to the Sun-god Atum Re-Har-Akhti) is found in a manuscript of model texts for schoolboys: *Papyrus Anastasi II* (British Museum No. 10243, *recto*, x, 1–xi, 2); it is probably from Memphis, and dates from the late Nineteenth Dynasty.

Various poems dealing with death have also come down to us.

There is only one example extant of epic poetry—it is even doubtful whether it is an epic—a poem on the great battle which Ramses

II fought with the Hittites at Kadesh; although this story is in poetic style, it is difficult to say whether its form is truly poetic.

There are numerous historical texts, but these are mainly inscribed on *stelae* or other monuments of hard material. No Egyptian code of law has come down to us.

Manufacture of Papyrus Books

Although the ancient Egyptians employed various materials for writing, such as wood, linen (see Chapter I), leather (see Chapter V), stone for inscriptions, and wooden tablets and ostraca for short notes, papyrus (prepared from the plant of that name) was their chief material for writing books. Indeed, it was not only employed in Egypt, but for a thousand years it was the chief writing material for the Graeco-Roman world (see pp. 151–54), and was used both for literary and for ordinary purposes, such as legal documents, receipts, petitions, notices of birth, and official and private letters.

The term "papyrus", from Greek *papyros* (*papúros*), is of Egyptian origin, and various theories have been suggested with regard to its original meaning, such as "the growth of the River (Nile)" or "the (one) belonging to the River (Nile)", or else "the (stuff) belonging to Pharaoh" as a royal monopoly, but none of these opinions is final. However, the word "papyrus" gave us the terms "paper" (in English), *papier* (in French), *Papier* (in German), *papier* (in Polish), *papka* (in Russian), and similar words in other languages. On the other hand, the Greek word *khártēs*, meaning a "leaf" of papyrus (generally, papyrus prepared for writing but not yet written upon was called *khártēs*), appears in Latin *charta*, and in English "cartaceous", "chart", "charter", "chartered", as well as in "card", in Italian *carta*, in Polish *karta*, and other words in various languages.

Another Greek word, *bíblos*, from *býblos (búblos)*, meaning the "pith of the papyrus stalk", gave the Greek word *biblíon*, which was the common word for "papyrus scroll" or "papyrus roll"; its plural was *biblía*, "papyrus rolls", and *tà biblía*, "the scrolls" or "the books" came to indicate "the Books", *par excellence, i.e.* the Sacred Scriptures. See also p. 34 f.

Our modern word "volume" derives from the Latin term *volumen* (the Latin word for "roll", or rather "a thing rolled up"), a derivative of the verb *volvere*, "to roll" (*sc.* the papyrus), *volumen* being parallel to Greek *kýlindros (kúlindros)*, "cylinder"; the Latin

term *evolvere*, "to unroll", was often used in the sense of "to read" (a book). The word "explicit" is interesting, since it is equivalent to "the end (of the roll)", probably a contraction from *explicit(us) est liber*, "the book is (unrolled) to the end". In Roman times the term *volumen*, like *liber*, was in common use for "book". Only one book was included in a "volume", so that a work generally consisted of as many volumes as books.

PAPYRUS FACTORIES

The best papyrus factories were in Alexandria, hence the "Alexandrian papyrus" was known all over the Greek and Roman worlds.

It is generally assumed that papyrus was imported into Greece, Italy and the other Mediterranean countries, already manufactured; and it is doubtful whether any native papyrus grew in any of these countries. The Greek geographer, Strabo (*c.* 63 B.C.–A.D. 25), says that papyrus was found in Lake Trasimene and other lakes of Etruria (now Tuscany), but the accuracy of this statement has been disputed.

On the other hand, it is known that manufacture of papyrus (*e.g.* the *Charta Fanniana*) was carried on in Rome—also Pliny (xiii, §77) records that papyrus was manufactured at Rome (as well as at Alexandria and elsewhere)—but it is held that it was a "re-manufacture" of imported material. Apparently, the more brittle condition of the Latin papyri, as compared with the Greek papyri, found at Herculaneum (see p. 253 ff.) is due to the effect of this "re-manufacture". However, it is known that Rome had great storehouses for papyrus, called *horrea chartaria*.

In Schubart's opinion, papyrus was put on the wholesale market, not in sheets or rolls, but in bales, which were cut by the retailer into rolls and single sheets.

MANUFACTURE OF PAPYRUS (Fig. IV–5)

Papyrus was made from the stems of the papyrus plant (Fig. IV–5, *a*), called in Latin *Papyrus antiquorum* or *Cyperus papyrus* (Linnaeus), which in ancient times grew abundantly in the marshy districts of Lower Egypt. It was so characteristic of this region that it became emblematic of the north, and was used for the armorial bearing of Lower Egypt, while the flowering rush, characteristic of the South, was employed for Upper Egypt. It also grew, but in small quantities, in northern Palestine.

a
b

c

Fig. IV-5

a. Egyptian papyrus plant; *b*, Egyptian reeds; *c*, the gathering of papyrus, as depicted in the tomb of Puyemre (Eighteenth Dynasty).

Nowadays, it grows only in the Sudan, Abyssinia, and particularly in Sicily, near Syracuse, where it was probably introduced during the Arab occupation, and where it is still utilized for making a special kind of paper. It is reared as a curiosity in many botanical gardens, some in England, where, however, it needs to be removed to cover in the autumn. Its leafless stem rises from four to fifteen feet above the water, and it has an umbrella-like top of delicate green rays. The root lies obliquely, and is about the thickness of a man's wrist; the section of the stalk is triangular, and it tapers gracefully upwards towards the extremity. In ancient times it grew in six feet of water or less. It is described by Theophrastus (Aristotle's successor as head of the Academy of Athens, 323 – c.288 B.C.)—*Hist. Plant.*, iv, 8.3 —and particularly by Pliny (see below).

This plant appears in Egyptian art from the earliest times (Fig. IV–5, *c*). We see here how the great papyrus shrubs lift up their beautiful heads high above the height of man, while their roots are bathed in water, and their feathery tufts wave on their slender stalks. With the help of other reeds and water plants they formed an impenetrable thicket—a floating forest.

This odd plant was a real friend to the ancient Egyptians. It formed a substitute for wood, which was never plentiful in Egypt. From it boats, vessels, canoes, mats, ropes and sandals were made by weaving its stalks together; blankets and clothes were produced from its bark. It was used as fuel, and, according to some scholars, even cooked for eating, and sweet drinks were made of its juice.

But above all, it supplied the main material for writing, and as such, it formed one of the chief articles of export. It seems to have been a government monopoly in Egypt; Sir Frederic Kenyon mentions a Tebtunis papyrus (No. 308) containing a receipt for 20,000 papyrus stems. In Roman times, it became an imperial monopoly. Firmus, the imperial pretender in A.D. 273, is said to have "boasted that he could keep a whole army on the proceeds of the revenue from the papyrus trade". He may, however, have possessed large papyrus factories. Papyrus was also a state monopoly under the Byzantine rule and under the Arabs, and the first sheet of each roll or bale was stamped with the state-seal stamp (in Moslem times, in Greek and Arabic), which proved that the duty was paid.

An account—although not completely clear—of the way in which the papyrus was treated in the Egyptian "paper" factories is given by the great Roman naturalist, Pliny, in *Naturalis historia*, xiii, 11 f. (A.D. 23–79). "Paper is made from the papyrus, by splitting it with a needle into very thin leaves, due care being taken that

they should be as broad as possible. That of the first quality is taken from the centre of the plant, and so in regular succession, according to the order of division. . . . All these various kinds of paper are made upon a table, moistened with Nile water; a liquid which, when in a muddy state, has the peculiar qualities of glue." The last statement is not exact:

"Although the Nile water at flood time is thick, and may even be slightly slimy from the finely divided clay it contains, yet this clay was certainly not the adhesive used" (A. Lucas); and what material was employed—whether gum, glue, or starch, to mention the three most likely substances—has not been determined. In the opinion of some scholars, the Egyptians made a kind of glue from flour, hot water, and a little vinegar.

PAPYRUS ROLLS

"This table," continues Pliny, "being first inclined, the leaves of papyrus are laid upon it lengthwise, as long indeed as the papyrus will admit of, the jagged edges being cut off at either end; after which a cross layer is placed over it. . . . When this is done, the leaves are pressed together, and then dried in the sun; after which they are united to one another, the best sheets being always taken first, and the inferior ones added afterwards. There are never more than twenty of these sheets to a roll (*scapus*)."

This last statement should not be misunderstood. Pliny is probably referring to the length of the papyrus rolls as they were customarily placed on the market; this does not mean that papyrus rolls never contained more than twenty sheets. Assuming that individual sheets had the usual width of 9 inches, a roll of twenty sheets would have been 15 feet long. If a book was of greater length, the scribe could glue on a second roll to the first; if it did not reach the length of a roll of twenty sheets, he could cut off the superfluous material. Sir Frederic Kenyon, the foremost student of this subject, pointed out that there are several Egyptian liturgical rolls of 50 feet and over, such as the *Nu Papyrus* (British Museum 10477, Fig. IV–6, *a*), 65½ feet; the *Ani Papyrus* (British Museum 10470, Fig. IV–6, *b*), "probably the finest extant Egyptian book", 76 feet; the *Nebseni Papyrus*, 77 feet, and some others; a few even exceed 100 feet; the *Greenfield Papyrus* (a fine hieratic manuscript, preserved in the British Museum, No. 10554, is 123 feet long, and one—which is not liturgical but panegyrical—is known to be of 133 feet; it is the *Great Harris Papyrus* (Fig. IV–8, *above*).

This important manuscript, also known as *Papyrus Harris I*, now in the British Museum (No. 10053), was found with several others in a tomb behind Medinat Habu, at Thebes, and at once purchased by Mr. A. C. Harris of Alexandria. When unrolled, it was found to be 133 feet long and 16¾ inches broad, containing seventy-nine "pages" of very large size, which are now divided and laid down on cardboard. The manuscript relates to the achievements and benefactions of Ramses III, and is a kind of comprehensive manifesto, written by order of Ramses IV immediately after the death of Ramses III (*c.* 1164 B.C.). The document refers to—and is our only source for that period—the chaotic state of Egypt, in the *interregnum* between the end of the Nineteenth Dynasty (*c.* 1205 B.C.) and the beginning of the reign of Ramses III's father, Set-nakht (*c.* 1197 B.C.), and gives the details of what Ramses III himself had done for the temples of his country during the thirty-one years of his reign.

Of great importance is the recently published *Wilbour Papyrus* (A. H. Gardiner, *The Wilbour Papyrus*, 3 vols., Oxford, 1948). Although not as long as the rolls just referred to—its original total length appears to have been nearly thirty-five feet—"in the bulk of the matter it contains it has surely no equal" (Gardiner). It consists of two texts, one written in 102 columns containing 4,500 lines, the other, written on the *verso* in twenty-five broad pages, contains 723 lines. As Prof. Edgerton has remarked, this papyrus contains more columns, more lines, and perhaps more words than any other Egyptian text. Its contents is "a unique record of holdings in land, comparable in some degree with our Domesday Book" (Gardiner). In 1928 or 1929 the papyrus—then consisting of three separate rolls—was brought to the Cairo Museum by a Luxor dealer. After protracted negotiations it was bought by the Brooklyn Museum out of the resources bequeathed by the family of the American Egyptologist Charles Edwin Wilbour (1833–96): hence its name *Wilbour Papyrus*.

The scholiasts speak of Thucydides and Homer being written each in one long roll. The roll of Thucydides is estimated at the incredible length of 378 columns, or nearly 100 yards. A roll 120 yards long was said to have been in existence at Constantinople. These are abnormal instances. We have also been told, with more probability, of rolls 150 feet long, which would contain the whole *Iliad* or *Odyssey*.

However, such rolls were too cumbrous for ordinary reading (hence the saying attributed to Callimachus, librarian at the

Fig. IV-6

a, The *Nu Papyrus* (British Museum, 10477); *b*, the *Ani Papyrus* (British Museum, 10470); *c*, *Book of the Dead* (British Museum, 10257).

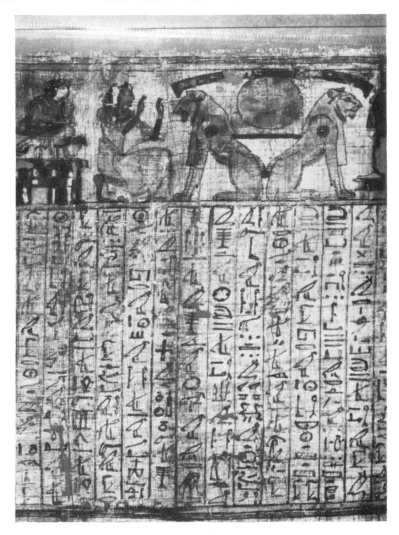

Fig. IV-7

Book of the Dead written in the so-called cursive hieroglyphs, belonging approxim-
ately to the Eighteenth Dynasty (Trinity College Library, Dublin).

Alexandrina, *méga biblíon, méga kakón,* "great [or rather 'large']
book, great evil") and Greek literary rolls seldom, if ever, exceeded
thirty-five feet—a length which is sufficient for a single book of
Thucydides or one of the longer Gospels, or else, two or three
"books" of the *Iliad* or two books of Plato's *Republic.* Such a roll,

when rolled up, would be about two and a half inches thick, and it was thus suitable to be held in one hand.

Indeed, in contrast to the huge roll of Homer, which was supposed to have existed, there is extant a papyrus roll of the twenty-fourth book of the *Iliad*, found at Elephantine, so that the complete *Iliad* could have been in twenty-four "volumes". A British Museum fragmentary roll, "the handsomest specimen of Greek book production", containing a portion of *Odyssey iii*, would have been seven feet, if it contained only this book, or twenty-one feet if it contained books i–iii.

In other preserved Greek papyri the length of the rolls varies from fourteen feet (British Museum, No. 132: Isocrates, *Perì Eirénēs*) to thirty-four feet (*Pap. Oxyrh. 224*: Euripides, *Phoenissae*) and thirty-five feet (*Pap. Grenf. 4: Iliad* xxi–xxiii). Some books, however, appear to have been *c.* fifty feet long (*Pap. Petrie 5*, third century B.C.: Plato *Phaedo*; and *Pap. Oxyrh. 225*, first century B.C.: Thucydides, ii), but Kenyon suggests that originally such a book could have occupied two rolls; indeed, Berlin Pap. No. 911 (first half of *Genesis*) confirms the probability of this suggestion. Generally speaking, the length of the rolls seems to have varied according to taste and convenience.

The width was limited by the length of the strips of pith; ten inches was the usual width of rolls employed for works of literature, but specimens exist which are as wide as fifteen inches (the *Ani Papyrus*); the *Great Harris Papyrus*, measuring seventeen inches in width, and the *Greenfield Papyrus*, of nineteen inches, are exceptionally wide.

The rolls recovered at Herculaneum (see Chapter VI) are two to three inches in diameter and about six inches in width. The width of the columns varies from two and a half inches to four inches in the Greek manuscripts, while in the main Latin manuscript it is nearly eight inches. Many rolls have about 100 columns and from 2,000 to 3,000 lines; the largest manuscript contains about 160 columns.

Papyrus Sheets

Single sheets (*kollémata*) were also on sale; they would suffice for short writings—such, for instance, as the second and third *Epistles* of St. John—letters or documents. They were made in a variety of sizes (see p. 134); papyri are extant of less than two inches to over fifteen inches in height; the fine and large sheet was in Rome called *macrocollum*; the average size was nine to eleven inches in width and six to nine inches in length.

There is evidence to show that the scribe did not usually write on separate sheets which were later glued together to form a roll (see, however, p. 138f), but he wrote on the roll already made up before he started writing on it; indeed, the writing frequently ran over the junction of two sheets.

Kenyon records the width of the sheets of a few of the finest Egyptian books, preserved in the British Museum: the *Nu Papyrus*, 15 inches; the *Ani Papyrus*, 12–13 inches; the *Hunefer Papyrus*, 10–11½ inches; in some fine papyri, however, the sheets are much narrower: 8¼ inches, for instance, in the *Greenfield Papyrus*.

It is noteworthy that the sheets of the fine Greek papyri are much smaller than the Egyptian. Even if we omit the pocket rolls containing poetry, such as the *Mimes* of Herodas or the third-century B.C. *Hibeh Papyrus* containing comedy, which are about 5 inches wide—the smallest papyrus roll known (Berlin Pap. 10571; it contains epigrams) being less than 2 inches wide—we have British Museum Pap. 128 (*Iliad*), whose sheets measure 9¾ × 5–6 inches; British Museum Pap. 134 (Hyperides, *In Philippidem*), 9¼ × 7½ inches; a Bacchylides papyrus, 9¼ × 8–9 inches (Bacchylides of Ceos, fifth century B.C.). There are, however, exceptions such as British Museum Pap. 736 (*Iliad*), which is 12½ inches wide; *Pap. Oxyrh. 843* (Plato, *Symposium*) and *844* (Isocrates, *Panegyricus*), both 12¼ inches wide, and a few others; the widest being British Museum Pap. 268 (a tax-register), 15½ × 5 inches long.

On the whole, the papyrus sheets for literary works rarely, if ever, exceeded 13 × 9 inches; and 10 × 7½ inches apparently was the common size for books of moderate pretensions.

QUALITY GRADES

The finished papyrus varied considerably in quality (just as we have many grades of paper), in some instances being coarse and in others of very fine texture. In Rome, there were about ten sorts or qualities of papyrus. The best grade (made of the heart of the stalk), in which the papyrus strips are the longest, and thus the width of the sheet is greater, was called by the Egyptians *hieratica* or "sacred", because they used it in writing their sacred books.

By the Romans the *hieratica* was sometimes called *regia* ("royal") —so, for instance, Catullus (Valerius Catullus, 87 – c.54 B.C.) mentions the *chartae regiae* as the best-grade papyri; afterwards it was termed *Augusta*, in honour of the Emperor Augustus; it was thirteen digits, about nine to ten inches wide, and was pre-

pared for writing on one side only; it was thin and semi-transparent. The second grade was sometimes called, in Rome, *Livia*, from the name of Livia, the wife of Augustus. Under the governorship of Cornelius Gallus, a fine-quality papyrus, called *Corneliana*, was manufactured. Other grades of papyrus were named after the location of its factory (*amphitheatrica, Saïtica, Taeniotica*). In Rome —as already mentioned—a grade called *Fanniana* was used, which was manufactured in the factory belonging to a certain Fannius.

In Claudius' time, the *Augusta* papyrus was improved upon, and was then called *Claudia*; this was a foot wide, thicker than the best papyrus of an earlier date, and prepared for writing on both sides.

The commoner kinds of papyrus, when used for accounts or literary purposes, were sometimes used over again for schoolboys' exercises or rough notes. Sometimes the *verso* (see below) of the papyrus was used for these purposes; at other times, the original writing was sponged out, as in a parchment palimpsest (see pp. 215 ff), and the *recto* of the papyrus was used over again. The coarse papyrus, generally used for wrapping up parcels or merchandise, was called *emporetica*, "merchants' papyrus".

These were the quality grades of the Roman market; it is probable that similar classification existed in Egypt, but we have no evidence to prove it, and the various grades cannot be identified in the papyri which have been recovered.

WRITING COLUMNS OF PAPYRUS ROLLS

The text was written in a column or a series of columns, called (in Greek) *selides* or (in Latin) *paginae* (hence, the word "page"), running, of course, from left to right; the "columns" do not correspond with the "sheets" (see p. 133 f.). The lines of writing generally ran parallel to the long sides of the roll, *i.e.* the top and bottom.

In poetry, the width of the column is adapted to the length of the lines, and when large letters are used, its width may even reach $7\frac{1}{2}$ inches (or $9\frac{3}{4}$ inches, including the margin, in a sumptuous Homer)—for instance, *Iliad*, Bodleian Library, Oxford, Gr. class A, i or British Museum Pap. 742—or be only 4 to $5\frac{1}{2}$ inches (including the margin), as for instance in Bacchylides papyri (Fig. VI–6 *above*). In the Timotheus papyrus—in Berlin—which belongs to the fourth century B.C., and is the earliest preserved Greek literary document (Fig. VI–3)—the length of the lines varies between $6\frac{1}{4}$ and 10 inches.

In Greek prose texts, the lines are much shorter. In some papyri, the lines are $1\frac{3}{4}$ (*Pap. Oxyrh. 666*) or $2\frac{1}{4}$ (British Museum Pap. 134)

Fig. IV–8

(*Above*) Portion of the *Great Harris Papyrus* or *Papyrus Harris I* (British Museum, 10053); (*below*) earliest known fragments of hieratic Papyri (Cairo Museum).

inches wide, including margins; in others, the length of the lines varies between 2¼ and 4 inches, including margins; for instance, *Pap. Oxyrh. 842* is 4 inches.

The normal width is between two and three inches. There are, however, exceptions, especially when the text is written in a non-literary hand, for instance, the *Athenaiōn Politeia*, or "Constitution of Athens", by Aristotle (Fig. VI-4), in which the lines of one column are eleven inches wide (see p. 157 f).

Moreover, the number of lines in a column and the number of letters in a line of prose vary greatly; they even vary—though not very much in the former instance—in the columns of a given papyrus, or in the lines of a given column. Most have between twenty-five and forty-five lines to a column, and eighteen to twenty-five letters to a line. However, there is hardly a manuscript with less than sixteen letters to a line. Of seventy pagan manuscripts examined by Milne, forty-seven have from twenty-five to forty-five lines to a column; twelve have less than twenty-five lines, and three (all poetry) less than twenty; eleven have more than forty-five, and only six more than fifty (of which, three are in poetry, and only three in prose). The right-hand edge is generally uneven, mainly because of the rules fixing the division of words between lines.

The margins between the columns were not large; they varied between about half an inch and one inch, in the more elegant books; so that the columns were close together. The upper and the lower margins also varied; in the more elegant books, the former was about 2–2½ inches, and the latter 2⅝–3 inches. In the common books, the margins were curtailed. Lines or words omitted in the text were sometimes written in these margins, and an arrow indicates the place where they should be inserted.

What is probably a survival of the parallel columns of writing on papyri is seen in the earliest vellum codices (see p. 195 ff), with their writing of three or four columns to a page.

According to the Latin historian Suetonius (*c.* A.D. 75–160), *De vita Caesarum, Iulius,* 56, down to the time of Caesar it was the custom to write official documents *transversa charta, i.e.* the reverse way, that is, across the whole width of the roll, so that the lines of the writing were at right angles to the long sides of the roll.

Recto and Verso

Ordinarily only one side of the papyrus was used for writing, and as a rule only one side was used in books meant for sale; this

side was the *recto*, usually the side in which the fibres ran in a horizontal direction. In some rolls, called *opistographa* or "opistographs", especially in those which were for private use or in the nature of rough copies, the *verso* was also used, *i.e.* the side of the papyrus in which the fibres ran vertically.

Egyptian papyri, however, are often written on both sides; examples in which the texts on the *verso* are earlier than the *recto* are not limited to any one period. Sometimes this is the result of washing out earlier texts on the *recto* (information by Prof. Edgerton).

On the other hand, not many Graeco-Roman preserved literary texts show such practice, though various ancient writers refer to them (Lucian, *Vit. Auct.* 9; *Ezekiel*, ii, 10; Pliny, *Ep.*, iii, 5.17; Juvenal, i, 1.5). The magical roll British Museum Pap. 121 is an outstanding example of an opistograph. Such rolls mark either the poverty of the writer or the excess of his matter. In some instances, papyrus rolls already written on their *recto* have been again used, and the new text is inscribed on the *verso*; for example, the *Athēnaiōn Politeia* (Fig. VI–4), *Pap. Oxyrrh. 841* and *842*, British Museum Papyrus 1532. Such copies were generally for private use, but sometimes they were produced for the cheap market. Since the writing on the *recto*, as mentioned, almost invariably precedes that on the *verso*—though there are a few exceptions in the third century B.C.—valuable evidence for dating may be obtained from such documents.

PREPARATION OF PAPYRUS BOOKS

In the early stage of the employment of papyrus for literary purposes in Greece and Rome, the papyrus rolls apparently consisted of sheets fastened or sewn together by strings. The damage caused by this procedure, where the material was so frail as papyrus, led to the invention (or rather introduction) of paste or glue. There is no doubt, however, that the Egyptians knew the value of glue in early times—see p. 129—but in the Graeco-Roman world the "invention" of glue, or binder's paste, was ascribed to Phillatius. It is even said that the Athenians erected a statue to his memory (see Olympiodorus). Of the use of glue for this purpose among the Romans, Cicero (iv, 4) has left a proof, and Pliny confirms it. Pollux (in Cicero, vii, 32) also mentions writers and vendors of books, and the glueing of them.

Usually, prepared rolls were used for writing upon, but sometimes the columns or pages were written first, and afterwards pasted

together into a roll by slaves called *glutinatores*. The first operation of the Greek and Roman *glutinatores* and, later, of the *bibliopegi* ("the bookbinders"), was to cut the margins (*frons*) of the papyrus above and below perfectly even, and the rolls at the beginning and end square. They then gave the edges and the exterior of the roll the most perfect polish possible by means of pumice-stone, with which substance the scribes had previously smoothed the interior. Horace, Pliny, Martial, Ovid, and Catullus (see Chapter VI) all bear testimony to this use of pumice, which to the present day is used by hand-bookbinders in some of their operations. The edges at each end of the roll were coloured just as are the edges of some modern books: for instance, Ovid (*Tristia*, i, 2.8) describes a roll with black edges.

Then, a projecting label (in Greek, *sillybos*) of papyrus or vellum, with the *titulus* (hence, our word "title") was affixed to the roll, usually at the end, but sometimes in the middle of the edge of the roll. The *titulus* corresponded not only to our title-page, but sometimes also to the "lettering-piece" and contents-table combined; sometimes it bore the total number of pages, verses or lines. Thus Josephus reckons 60,000 lines at the end of his twentieth book of *Antiquities*, and Justinian gives to the *Digests* "centum quinquaginta paene milia versum". The *titulus* sometimes also contained the price. The title was generally coloured, often of a red tinge—see also p. 159.

Roman frescoes (Fig. XI–2) show rolls with their labels hanging out. The British Museum papyrus fragment containing poetry by Bacchylides has still the label inscribed *Bakkhylidou Dithyramboi*; this fragment, probably belonging to *c.* 50 B.C., was found in Egypt in 1897.

Instead of the label with the *titulus*, sometimes the papyrus roll had a title which was written at the end of the book. The fact that the title was appended at the end, seems to imply that when a roll had been read it was left with its end outside, and a newcomer before taking the trouble to re-roll it in order to bring the beginning to the outside—would see the title of the book at the exposed end of the roll.

ROLL RODS

The roll was fastened to—although, according to T. Birt, it was only wound round—a wooden rod, so that it could be rolled from one end to the other. This rod was called *omphalós* in Greek, and

umbilicus in Latin; the term *omphalós* or *umbilicus* is said to derive from the fact that when the manuscript was rolled up, the rod would be in the centre. The same sort of *umbilicus* is used today for rolled maps kept on shelves, whereas the Hebrew ritual Bible scrolls have two rods (with ornamented ends), one attached to the beginning and the other to the end of the scroll. The Roman rod was of various shapes or colours, was ornamented at its ends, and had sometimes projecting ornamental knobs or bosses, termed *bullae* or *cornua* ("horns"); in time the two terms *umbilicus* and *cornua* became interchangeable, especially when used figuratively to indicate the end of a book. The rod was sometimes made of tightly folded papyrus. Moreover, some Roman rods seem to have been of ebony, ivory, or even gold.

In order to read a roll (the procedure was similar to, but not identical with, the reading of the modern Hebrew ritual scrolls), the rod had to be taken in the right hand. The roll was then opened with the left hand, and the reader began with the first column; as he proceeded further and further towards the right, he rolled up with his left hand the portion he had already read. Thus, when he had gone through the book, the beginning of the text was innermost, so that the roll, for the next reader, had to be re-rolled from right to left. A Pompeii fresco, preserved in the Naples Museum of Antiquities, shows a young lady holding in both hands an open roll; similarly, another Pompeii fresco, preserved in the same museum, shows a young lady reading a book; but she had forgotten to roll up the portion she had already read.

Birt, the foremost German expert on the ancient book, pointed out that whenever a person is represented in ancient sculptures or paintings as holding a roll in his right hand, we must understand that he is about to read it; whereas, if the roll be in his left hand, we may infer that he has finished the reading, and is pondering about it, or is about to address an audience on it. It is uncertain whether Birt is right; a Vatican statue represents Poseidippus (one of the main representatives of the Greek "New" Comedy) holding a roll in his right hand, but he seems to have just *finished* reading.

What we do know about the rollers, comes from ancient literary sources; as a matter of fact, no specimens of rollers appear to have yet been discovered. On the other hand, in some cases the ends of the roll are strengthened by an extra thickness of papyrus, and some papyrus rolls had quills attached to one end, to serve as rollers.

History of Book Writing on Papyrus

Papyrus was used in Egypt as far back as the third millennium B.C., if not earlier. The earliest preserved papyrus—though non-inscribed—seems to go back to the period of the First Dynasty. The earliest hieratic papyri, acquired by Naville in 1893 in Cairo, and now mainly preserved in Geneva, Cairo (Fig. IV–8), and in the British Museum, are attributed to the period of King Issy or Izezi of the Fifth Dynasty. Apparently they come from a temple near Abusir, where also a few other fragments—belonging to the same period—were found in the excavations of the German Oriental Society, and are in Berlin. Berlin Papyrus 9874 is reproduced on Fig. IV–9, a. Fragments, apparently found in the family archives of the Governor of Elephantine, and assigned to the period of the Sixth Dynasty, were acquired in 1896 in Aswân and Luxor. They are partly in Berlin (Pap. 9010, 8869, 10523), and partly in Strasbourg and in other collections. Berlin Pap. 9010 is partly reproduced on Fig. IV–9, b, and completely on Fig. 10, *left*.

Moreover, some hieratic papyri of the Middle Kingdom—such as the *Papyrus Prisse* (see below)—contain copies of much more ancient documents, dating even from the First to the Fourth Dynasties (see p. 117). Furthermore, the fact that such documents were commonly employed during the Old Kingdom (c. twenty-eighth to twenty-third centuries B.C.) is evidenced by the constant appearance on Egyptian funerary monuments of this period of the figure of the scribe with his rolls, his pens and his ink palette (Fig. IV–1). See also Fig. XI–1 a, representing ancient Egyptian writing palettes.

However, even the papyri from the Middle Kingdom are not too plentiful. An important specimen is the *Papyrus Prisse* (Fig. IV–11). It was purchased from a native of Western Thebes by the French scholar, E. Prisse d'Avennes, who was making excavations there. In 1847 it was given by him to the Royal Library in Paris, now the National Library, where it is preserved (Egypt., 183–94). The papyrus was written in hieratic characters under the Eleventh or Twelfth Dynasty, the former date being preferred by the editor of the *Papyrus Prisse* (G. Jéquier), the latter date by other experts, such as G. Moeller.

It supplies us with a copy, more or less accurate, of the text of two "wisdom" treatises supposed to have been compiled by Ke'gemni, who is said to have lived in the reign of Ḥuni, of the Fourth Dynasty (c. 2650 B.C.), and by Ptaḥ-ḥotep, the vizier of King Izezi,

c

b c d

Fig. IV-9

Hieratic papyri. *a*, One of the earliest documents, Fifth Dynasty (Berlin Papyrus 9874); *b*, portion of Berlin Papyrus 9010, attributed to the period of the Sixth Dynasty; *c*, Berlin Papyrus 3024, attributed to the period of the Middle Kingdom; *d*, Berlin Papyrus 3033 (Early New Kingdom).

Fig. IV-10

(*Above*) Berlin Papyrus 8523; attributed to the period of the Late New Kingdom; (*left*) Elephantine Papyrus belonging to the period of the Sixth Dynasty (Berlin Papyrus 9010).

of the Fifth Dynasty (c. 2450 B.C.). It is thus one of the chief collections of Egyptian moral and religious teachings, written in the early second millennium B.C., and the works contained in it, if we are to believe their own statements, were composed respectively in the first half of the third millennium, and c. 2450. Later copies of this work, belonging to the Eighteenth Dynasty, are the British Museum Papyri 10371, 10435, and 10509.

THE "BOOK OF THE DEAD" (Fig. IV-6 and 7)

The preservation of many Egyptian manuscripts—which have lain buried in hermetically sealed tombs and jars for thousands of years, and only a few generations ago have been brought to the light of day again—is mainly due to the fact that the Egyptians looked upon death as a continuation of this life, and believed that magical formulae, the *glorifications*, as they called them, when buried with the deceased individual, would secure eternal happiness for him. They served as a kind of guide book, as a Baedeker, so to say, for his safe guidance to the gates of Amenti (the Egyptian underworld), and contained instructions as to prayers, "negative confessions", and magical formulae, including denials of guilt in various enumerated crimes and shortcomings, to be uttered when confronted with the monsters and demons who guarded the sacred portals, or before a posthumous court.

The earliest recension of such texts is the so-called Pyramid-text or "Pyramid Recension"; these texts are found carved in the pyramids at Saqqârah of Unis (the last king of the Fifth Dynasty, twenty-fifth century B.C.) and Nefer-ka-Re or Pepi I, of the Sixth Dynasty (twenty-fourth century B.C.). From the use of archaic phraseology, it is not unreasonable to suppose that these texts must have been written much earlier than the Fifth Dynasty; and it is very probable that they were written on some perishable material before being carved on stone.

The massive sarcophagi prepared for kings, queens, and persons of rank or wealth were also carved with scenes and inscriptions, in relief or intaglio, chiefly containing ritual texts of magical formulae. Under the Middle Kingdom the inside of the sarcophagi and especially of the wooden coffins was closely inscribed with such texts, and the inner coffins were generally similarly inscribed all over.

In later times, when these mortuary texts increased more and more in number, they had not room enough for them on the sides

Fig. IV-11

Page 1 of *Papyrus Prise* (National Library, Paris, Nos. 183-194): this extremely important manuscript is variously attributed to the period of the Eleventh or to that of the Twelfth Dynasty.

of the coffin. Under the New Kingdom, therefore, they were written out on rolls of papyrus, which were decorated with vignettes, and bound up inside the bandages of the mummy, or placed in painted wooden figures representing divinities, or in cavities of the stands, which were buried with the dead. These texts had been collected by modern scholars under the name of the *Book of the Dead*—be it noted, incidentally, that this name is entirely modern.

The earliest papyrus copy extant of the *Book of the Dead* is assigned to the early Eighteenth Dynasty (second quarter of the sixteenth century B.C.); it contains the "Heliopolitan Recension". At the same time, or slightly later, there appear papyri inscribed with selections of texts known as the "Theban Recension".

Fine copies of these papyri vary in length from fifteen feet to ninety feet, and in width from twelve to eighteen inches. The texts are written in black ink in vertical columns of hieroglyphics, separated by black lines, but the titles, the first words of the chapters, and the "rubrics", are written in red ink. There are also designs or vignettes, traced in black outline, and partly copied from earlier coffins. On the other hand, hardly any original literary work of that period has been preserved.

The most famous papyrus of the Eighteenth Dynasty (1570–c. 1350 B.C.) is the *Papyrus of Ani*, already referred to. It is a long roll of fine papyrus about fifteen inches wide; the writing is enclosed within a double border composed of two lines of colour, the inner one of brick-red, the outer of dull yellow. The text is arranged in vertical columns, ¾ inch wide; it is adorned at intervals with brightly coloured and well-drawn pictures and vignettes, illustrating the passage of the deceased (Ani, a royal scribe and overseer of granaries at Thebes) and his wife to the abode of bliss, and with representations of many strange gods. The papyrus, obtained in 1888 by E. A. W. Budge, is preserved in the British Museum (10470); it has been reproduced in facsimile by Sir P. Le Page Renouf, 1890, and re-edited by Sir E. A. W. Budge in 1913. See Fig. IV–6, *b*.

The copies of the *Book of the Dead* of the Nineteenth Dynasty (1319–1205 B.C.) are also beautifully decorated; the vignettes are painted in very bright colours, but the texts are sacrificed to the illustrations as shown, for instance, by the splendid *Hunefer Papyrus*. See also the forthcoming book on *Illumination and Binding*.

Under the Twenty-first and Twenty-second Dynasties (c. 1150–c. 750 B.C.) the decline of Egypt set in fully; it is noticeable, too, that the artistic and calligraphic work of the *Book of the Dead* greatly deteriorated. Papyri with inaccurate texts became more and more

common. "It became customary to write in hieratic and to trace the vignettes in outline in black ink. Some papyri measure about fifty feet by one foot six inches, but in others the dimensions are considerably less" (Budge).

LATE EGYPTIAN BOOKS

After Ashurbanipal's invasion of Egypt, a brief period of revival was at hand. Psamtik I (or Psammetichus), c. 663–609 B.C., of Saïs, succeeded in establishing a new dynasty: the Twenty-sixth. With the political, religious and artistic renaissance, Egypt enjoyed a revival of literature.

The *Book of the Dead* was re-edited and partly re-arranged (possibly by an assembly of priests). More important, however, is the "Ptolemaic Recension", in which the chapters have a fixed order. The text is written, as in the earliest recension, in long, vertical columns of hieroglyphics (which have, however, a purely conventional form), separated by black lines. The vignettes are traced in outline in black and, with a few exceptions, occupy small spaces at the top of the text.

Small portions of this recension were written upon papyri a few inches square and buried with the dead. The most primitive formulae and practices, however, continued to be the basis of religious ceremonies, and there is sufficient evidence to show that the knowledge of the old recensions of the *Book of the Dead* was not quite forgotten even in the early centuries after Christ.

Egyptian (including Coptic) book illustration will be treated more fully in the volume on *Illumination and Binding*.

LANGUAGES AND SCRIPTS USED ON PAPYRI
(Figs. IV–2–4, 6–18; VI–1–6, 9, 11)

The Egyptian papyri are written in hieratic (Fig. IV–2–4, 8–11), hieroglyphic (Fig. IV–6–7), demotic and Coptic (Fig. IV–14). There are also papyri written in other languages and scripts: Aramaic (Fig. IV–15, c and 17, *above*), Greek (Figs. IV–12, 13, 15, 18 and VI–1–6, and 9), Latin (Fig. IV–13, *bottom*, 15, g, 16; VI–11), Persian (Fig. IV–15, e), Arabic (Fig. IV–15, f), Hebrew (Fig. IV–12, b, 15, d, and 17, *below*) and Syriac (Fig. IV–15, b).

Papyrus was known also in Assyria, but in Prof. G. R. Driver's opinion the word by which "papyrus" is known, seems to be first mentioned in a text of the Assyrian king Sargon (721–705 B.C.).

ARAMAIC AND HEBREW PAPYRI (Fig. IV–12, *b*, 15, *c* and *d*, and 17)

Nearly a hundred official and private documents, written on papyri, dated in the fifth century B.C., were found in 1903 on the island of Elephantine at the First Cataract in Egypt. The documents, coming from a Jewish military colony settled there, are written in

b *c*

Fig. IV–12

Hieratic, Greek, and Hebrew papyri. *a, Papyrus Sallier II* (British Museum, 10182), Col. IX; *b, Nash Papyrus* (University Library, Cambridge); *c*, one of the few documents extant written in the Doric dialect.

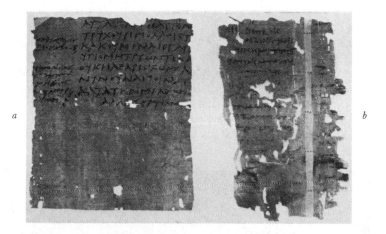

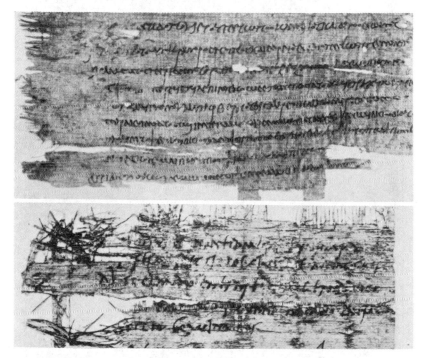

Fig. IV-13

Greek and Latin papyri: *a*, fragment of a lost Greek tragedy (written in a broad
rather sloping uncial character))with scholia written in a cursive hand, third cen-
tury A.D. (British Museum, Papyrus 695); *b*, fragment of a lost philosophical work,
third century B.C. (Bodleian Library, MS. Gr. Class., *e*, 63); *in the middle*, Greek
fragment dated to the seventh year of Nero; *bottom*, Latin papyrus, belonging to the
first century A.D.

Aramaic (the *lingua franca* of the ancient Near East of the day), and give us valuable information of a religious and economic nature concerning this colony. The earliest Aramaic papyrus found in Egypt seems to belong to 515 B.C.

There are not many Hebrew papyri extant, and they are mainly late. Some of them are in the British Museum, some in the Bodleian Library, at Oxford, and in other collections. An extremely interesting Hebrew papyrus codex has been preserved at the Cambridge University Library (Fig. IV–17, *below*). It has been dismantled to facilitate the reading of its contents.

Fig. IV–14

Papyrus Q: Oldest Coptic Gospel (*St. John*). Fourth century A.D. Bible House Library, London.

The celebrated *Nash Papyrus* (Fig. IV–12, *b*), containing the Hebrew Decalogue and *Shema'*, and assigned by some scholars to the first or the second century B.C., is also preserved in the Cambridge University Library.

Papyrus, the Main Writing Material for Books of the Graeco-Roman World

Although there is hardly any doubt that papyrus-roll books were used in Greece in very early times, the date of the introduction of papyrus into that country is uncertain. Curiously enough, on Greek soil there are only two references to papyrus before Alexander the Great; one, on an inscription in Athens of the late fifth century B.C., and the other, on an inscription in the Peloponnese, of the fourth century B.C. In addition, a beautiful fifth-century Attic relief on a tomb, now preserved at Grottaferrata, near Rome, represents a boy reading from a roll, which is obviously a papyrus roll.

On the other hand, the passage of Herodotus (v. 58) may be taken as evidence that by the middle of the fifth century B.C. papyrus was the only writing material for the books of all civilized peoples. It also shows that in earlier times some other writing material (*i.e.* leather) was used only under the pressure of necessity.

Papyrus, then, was not only in general use in the Greek lands at least from the sixth century B.C. onwards, but its use also covers at least the period of the lyric poets (see Chapter VI), and there is no reason why it should not be carried back even to the beginning of Greek literature. Furthermore, if there was writing in the days of Homer and Hesiod, it is a probable corollary that the material used was papyrus.

This last suggestion may be confirmed by the explanation of the origin of the word *biblíon*, the Greek term for "book". Indeed, the Egyptian *Story of Wenamûn*, written on papyrus *c.* 1100 B.C. (see p. 122) is strictly connected with the ancient city of Byblos, in northern Syria, though Sir Alan Gardiner is probably right in his statement that "It is often confidently asserted that the actual Greek words for 'papyrus-reed' (*býblos*) and for 'book' (*biblíon*) are derived from the name of the said Phoenician city, *Gublu* in Babylonian, and *Kupni* in Egyptian. Perhaps a more plausible view is that the Greek form of that place-name was in part due to the assonance,

Fig. IV-15

Miscellanea: *a*, Euripides, *Melanippe* (Berlin, Papyrus 5514); *b*, Syriac papyrus of the sixth century A.D. (Berlin Papyrus 8285); *c*, Aramaic papyrus (Berlin Papyrus 3206); *d*, Hebrew papyrus of the seventh or eighth century A.D. (Berlin Papyrus 8280); *e*, Persian papyrus attributed to *c.* 619–29 A.D. (Berlin Papyrus 8354); *f*, Arabic papyrus of the early eighth century A.D. (Berlin Papyrus 7901); *g*, Latin letter dated 7th October, 167 A.D. (British Museum, Papyrus 730.)

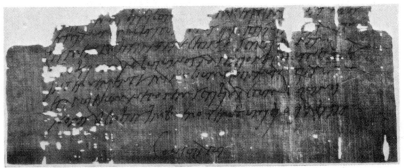

and in part to the knowledge of the role played by Byblus in the diffusion of papyrus." However, the fact must be duly considered that from the tenth century onwards, Byblos declined and was replaced as the leading city of Phoenicia by Tyre and Sidon. Therefore, from the Greek usage of the place-name Byblos to indicate "papyrus-reed" and "book", we may assume that the Greeks knew papyrus before the tenth century B.C.

At any rate, it is probable that the Greeks employed papyrus from the tenth century B.C. onwards. There can be no doubt that at least from the seventh century B.C. onwards, the papyrus roll was the regular material for book production in Greece; it continued to be so throughout the classical, Hellenistic and Graeco-Roman periods up to the fourth century A.D., *i.e.* for over a millennium, and it lingered on as writing material down to about the year A.D. 1000. From the classical period, however, no specimens are extant. With very few exceptions, the material now available comes from Egypt, which from the late fourth century B.C. onwards became more or less completely Hellenized.

For the papyri unearthed at Herculaneum, see pp. 251–58.

A number of literary and non-literary papyri poorly preserved —were found in 1937, in southern Palestine, during the excavations at 'Auja el-Hafir (the site of ancient Nesana) by the American Colt Archaeological Expedition. The find included three manuscripts of the New Testament—fragments of papyrus codices written in uncials or capital letters, of the seventh or eighth century; and two fragments of Latin papyrus manuscripts—a Latin-Greek glossary of Virgil's *Aeneid* and fragments of *Aeneid*, ii—vi, both attributed to the sixth century A.D. See L. Casson and E. L. Hettich, *Excavations at Nessana*, Princeton, 1950, Vol. II: *Literary Papyri*.

ROME

As to the employment of papyrus by the Romans, it will suffice here to quote two eminent scholars; in Chapter VI the subject will be dealt with in greater detail. "The form in which literature was preserved and circulated during the earlier period of the history of Rome did not differ from that which prevailed in the Greek world" (M. R. James). "Egypt supplied the whole Roman Empire, from Hadrian's Wall to the Euphrates and from the Danube to the First Cataract, and papyrus was used as naturally by Irenaeus in Gaul, as by Origen in Alexandria" (C. H. Roberts).

To sum up, although at no time in the ancient world was papyrus as writing material manufactured outside Egypt it was for many centuries the chief material for writing in the Greek and Roman worlds, both for literary and for all ordinary purposes, such as legal documents, receipts, notices of birth, and official and private letters.

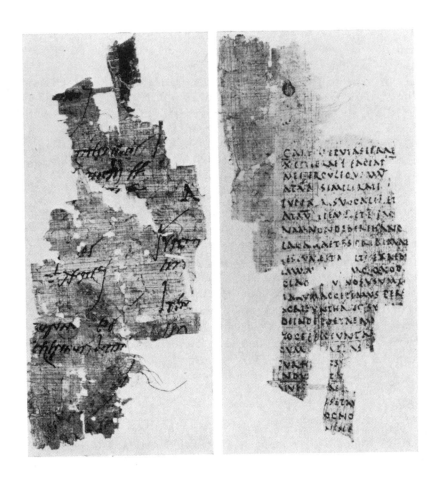

Fig. IV-16

Latin papyrus written on both sides: (*left*) obverse, Military document of A.D. 163–72; (*right*) reverse, Fragment of an unknown grammatical treatise of the early third century A.D.: Museum of Archaeology, University of Michigan (Papyrus 4649).

THE ALEXANDRINA

The establishment of the great Alexandrian Museum and Library —see p. 268 ff.—led to improvements in the manufacture of papyrus and its increased production. The deep influence exercised by the Alexandrian scholars "in establishing the texts and often the authenticity of classical works has always been recognized", and there can be no doubt that these scholars did their work with skill and thoroughness (C. H. Roberts).

The labours of the Alexandrian scholars of the third and second centuries B.C. were fruitful in separating authentic from spurious writings, in the revision of texts of, and commentaries upon, the best Greek poets and writers, in useful selection of the best texts from the enormous mass of literature which had come down to them. These Alexandrian scholars were eminent in letters as well as in science.

Zenodotus of Ephesus, the head of the Alexandrian Library in the reign of Ptolemy Philadelphus (c. 282 247 B.C.), published a Homeric and a Hesiodic recension and glossary; his successor, Callimachus of Cyrene (c. 246–235 B.C.), the Father of Bibliography, composed the famous *Pinakes,* a catalogue in 120 books of the chief writers in every branch of literature; his successor, Eratosthenes (c. 230–195 B.C.), was the author of mathematical, astronomical, geographical, poetical, philosophical, historical and critical works, and dealt also with theatres, scenery, actors, dresses, and poetical styles. Aristophanes of Byzantium (195–180 B.C.), who succeeded Eratosthenes, was a great librarian and critic; he published an edition of Aristophanes, the best representative of the Greek Old Comedy (see p. 233), and drew up a list of the great Greek poets. Aristarchus of Samothrace (flourished in the middle of the second century B.C.) was the last head of the Alexandrina who was a giant in scholarship and librarianship. He is generally considered as the greatest critic of the Alexandrian scholars, and indeed of antiquity, and as the greatest scholar of antiquity. He wrote commentaries on Homer, including the mythology, archaeology and topography of the poems. He also wrote twenty-four books on *Historical Monuments.* Aristarchus is mainly known from the *Epitome* of Didymus —the last famous scholar of Alexandria (flourished c. 30 B.C.), who himself was a grammarian and critic.

See also Chapter VI.

PAPYROLOGY

The importance of the papyrus as the chief writing material of
the ancient Graeco-Roman world and of the papyri discovered in the
last seventy-five years is so great, that it resulted in the emergence of
a whole department of humanistic science, known as *papyrology*.

In the widest sense of the word, papyrology is the science of the
use of papyrus; it should thus deal with the growth of the plant and
with its manufacture, as well as with the production of books made
of papyrus, as employed by the Egyptian and by other peoples of
antiquity. In the conventional sense, however, papyrology treats
of the writings which happen to have come down to us on papyrus,
especially in Greek, and belong particularly to the period in which
Egypt was more or less completely under Hellenic influence, and
Greek was its main cultural language. The beginning of this period
may be fixed at 322 B.C., corresponding with the conquest of Egypt
by Alexander the Great, and the end with the Arabic conquest of
Egypt in A.D. 641.

The number of the preserved Greek papyri is estimated at about
30,000. The majority of these manuscripts are of slight interest to
the world at large, being principally collections of *magical formulae*,
monetary accounts, leases, legal documents, wills, and other private
documents; but here and there works of classical literature have
been recovered (see Chapter VI), though always in a more or less
fragmentary state. Thanks to papyrology, however, we have at our
disposal a wealth of detailed information of so great a variety that
there is no region and no period in antiquity of which we know so
well the full daily life as Graeco-Roman Egypt. Modern literature,
Biblical criticism, classical philology, palaeography, political
administration, economic and legal history, and other fields of
knowledge, have benefited largely from these documents.

Papyrology is one of the best-organized fields of modern studies;
an unusual spirit of collaboration between classical scholars and
specialists in law, sciences, economics, agriculture, history of
religion, anthropology, and other branches of knowledge, has made
possible the publication of numerous texts with translations, com-
mentaries and glossaries, as well as of handbooks. On the other hand,
there are a great many papyri that have not yet been published,
especially those of the smaller collections, and there is a great
number of fragments, which have disappeared from excavations,
are stowed away in private or small public collections, and are
rapidly disintegrating into dust, as their preservation in climates

less favourable than that of Egypt requires greater care than they are given.

The word papyrology itself seems to have made its appearance in 1898. Still, the first written papyrus brought (by the commercial traveller Nicholas Schow) from Egypt to Europe in modern times, the *Papyrus Schow* or *Charta Borgiana* (preserved in Naples), reached the Italian cardinal Stefano Borgia in 1778. During the next century, only about 175 texts were published; but in 1877 thousands of documents were brought to light from the Greek rubbish heaps of Arsinoë (Medinet el-Fayyûm).

GRAECO-ROMAN PAPYRUS BOOKS

The real emergence of papyrology into a place of paramount importance dates from the last decade of the last century. This period was marked by a succession of notable events: Flinders Petrie's excavation of the Ptolemaic cemetery at Gurob (near the mouth of the Fayyûm) in the winter 1889-90; the papyri discovered were published in 1891; F. G. Kenyon's identification (on 26.2.1890) of Aristotle's treatise *Athēnaiōn Politeia*; the discovery in 1893 of a considerable group of fourth-century (A.D.) documents; the 1895-6 expedition (under B. P. Grenfell, A. S. Hunt, and D. G. Hogarth) of the Egypt Exploration Fund, for the discovery of papyri; and, especially, the most rewarding excavations (from 11.1.1897 onwards) of Grenfell and Hunt in the rubbish mounds of the ancient town of Oxyrhynchus; all these events are milestones in the early development of this branch of knowledge.

ATHENAION POLITEIA (Fig. VI-4)

The Greek manuscript containing Aristotle's *Athēnaiōn Politeia* ("Constitution of Athens"), repeatedly referred to, had been lost for many centuries, and was known to scholars only by short quotations. The discovered manuscript—published in 1891 by F. G. Kenyon—contains thirty-seven columns, written on four separate rolls (the last being in fragments) of rather coarse papyrus, the cross fibres and the joinings of the pages of which are distinctly visible. The rolls measure respectively 7 feet 2½ inches, 5 feet 5½ inches, 3 feet and 3 feet. The width of the rolls is about 11 inches, except the last which is about 10 inches wide. The papyrus is of a dull brown colour.

Four different handwritings appear in the manuscript, all probably belonging to the late first or early second century A.D. The manuscript is a sort of palimpsest (see the following chapter):

the Aristotle is written on the *verso* (that is, on the back), while the accounts of the under-manager of an Egyptian farm are written on the *recto*; these accounts are dated to the years corresponding to A.D. 78 and 79.

EARLIEST BIBLICAL PAPYRI

Most interesting are the fragments of a papyrus roll now preserved in the John Rylands Library, at Manchester (*Pap. Gr. 458*): see Fig. VI–9, *above*. They are from the book of *Deuteronomy* and are assigned to the second century B.C., thus being the earliest extant manuscripts of the *Septuagint*. Also the oldest existing fragments of the New Testament are preserved in the John Rylands Library (*Pap. Gr. 457*): see Fig. VI–9, *below*. They are from the *Gospel of St. John* (Ch. xviii), and are assigned to the first half of the second century A.D.

GREEK SCIENCE

The importance of papyrology for our knowledge of Greek science is due to the fact, emphasized by Neugebauer, that the majority of manuscripts on which our knowledge of Greek science is based, are Byzantine codices, written between five hundred and fifteen hundred years after the lifetime of their authors. Hence, the importance of every scrap of papyrus from a scientific or astrological treatise, of originals which were written during the Hellenistic period itself, not yet subject to the selective editing of later centuries.

TEXTS WRITTEN ON PAPYRUS

"Different materials encourage different sorts of pen stroke in the quick writer and set different artistic ideals before the calligrapher." Although "In the Timotheus papyrus (see Fig. VI–3) the irregular epigraphic forms have not succumbed to the soft material, and the books of the third century had not yet settled down to the typical papyrus hand, yet fourth-century cursive must certainly have grown out of any such awkwardness, for a long development lies behind such a hand as" the cursive document of 255–4, B.C. published in *Pal. Soc.*, ii, 142 (Minns).

It has been observed in *The Alphabet* (p. 64) that in Egypt, in drawing on papyrus, which was mainly used for cursive writing, the brush-pen naturally gave to the signs a bolder, more cursive form, and little by little, alongside the hieroglyphic system a cursive form was developed, in which the signs lost more and more their

original pictorial character. From the seventh century B.C. onwards a highly cursive derivative of hieratic, known as demotic (see *The Alphabet*, p. 67), gradually developed.

In Greece and Rome while the classical alphabets were always retained as the monumental scripts, more cursive forms, all of them being developments from the classical alphabets, were employed in writing on papyrus, and later on parchment. It was the pen, with its preference for curves, which eliminated the angular forms; it was papyrus, and still more parchment, which made these curves possible. Thus, both in Greece and Rome, from the classical alphabets there sprang the Greek uncial, cursive and minuscule scripts, and the Latin uncial, semi-uncial, cursive and minuscule hands.

In Greek and Latin papyrus texts, words are generally not divided and initials are not marked, though in more cursive hands there may be an unconscious division; these divisions are sometimes very misleading, a new word beginning in the middle of a ligature. In some cases, however, when there might be ambiguity, a dot or inverted comma was used as a separation mark. Accents and breathings are rarely used, being commonest in epic or lyric poetry; generally they have been added by a different hand. Punctuation is seldom used; it is never full and systematic; it is most uncertain and arbitrary; it may consist either of a single point, mostly placed on the level with the top of the letter, or of a short stroke called *parágraphos* (hence our word "paragraph"), which is placed under last line of a clause, below the first letters of this line. Sometimes there is a short blank space before the new paragraph. Ends of metrical divisions are sometimes indicated by a *coronis* or hook placed before the *parágraphos*. The *coronis* often assumed fanciful shapes, as for instance in the Timotheus papyrus, where it is in the form of a bird (Fig. VI-3). Titles of the books are sometimes placed at the end of the roll. Some collections of poems have titles of individual poems; these titles are prefixed to the poems, but they are later additions. See also p. 139.

Sir Frederic Kenyon doubts whether in Graeco-Roman times there were organized corps of scribes such as those of the Middle Ages (see p. 205 ff.), though the libraries of Alexandria, Pergamum, and so on, probably had *scriptoria* similar to those of the medieval monasteries. However, while some preserved papyri obviously were written by skilled scribes (the errors having been corrected), others are the work of more or less bad copyists, and contain numerous scribal errors. Greek scribes never attained the meticulous accuracy

Fig. IV-17

(*Above*) Aramaic papyrus from Elephantine (a Jewish military colony in Upper Egypt), attributed to the fifth century B.C.; (*below*) Hebrew papyrus codex—now dismantled—of the eighth or ninth century A.D. (University Library, Cambridge).

of the copyists of the Hebrew Scriptures. Finally, there are so many variations in the handwritings of the papyri extant that only in rare instances can close resemblances be found between two manuscripts.

PAPYRUS CODICES (Fig. IV–17, *below*, and 18; VI–1, *c*, and 11)

Until twenty years ago, it was supposed that as a "book" the papyrus roll was employed almost, if not quite, exclusively up to the time when papyrus was superseded by vellum (fourth century A.D.). It is now known that this is only partly true; it is, indeed, mainly true for pagan writings, but is less true for early Christian writings.

The roll was somewhat inconvenient, especially for books so much used for reference as those of the Bible. There was no easy way to collect information from a number of different works, or to refer to particular passages in larger rolls; to find a given section might necessitate unrolling the book to the very end. Consequently, those engaged in any kind of literary research were induced to transcribe extracts from books on the *pugillares* (see Chapter I). These were fastened together in a *codex* (see p. 35), as in a modern book. At a somewhat later period, the *pugillares* were replaced by leaves of papyrus.

How early the codex form of papyrus books was in use we cannot say, but it was certainly in use among the Christians from the early part of the second century. Indeed, some early codices are assigned to the second century A.D.; these are, *e.g.*, a fragmentary leaf of the Fourth Gospel, two leaves of an unknown Gospel, and a fragmentary codex of *Numbers* and *Deuteronomy*; another important specimen extant in codex form is a papyrus leaf from Egypt of the third century A.D. containing the *Sayings of Jesus* (see p. 245, and Fig. IV–18).

The employment of the codex may, perhaps, go back to the first century B.C. An inscription found at Priene, belonging to the beginning of the first century B.C., makes mention apparently of *codices* (*teúkhē*) both of papyrus and of parchment, in which the public acts of the city had been transcribed, and, at Rome in 52 B.C., the *codices librariorum* formed part of the pyre which an angry mob kindled under the corpse of Clodius. These *codices* were probably transcripts of official documents, like those of Priene. Furthermore, Martial (late first century A.D.) mentions a text of Virgil, which was probably a codex (Martial, xiv, 186).

However, the earliest extant papyrus codex belongs to the middle second century A.D. Together with ten other papyrus codices, attributed to the third to fifth centuries A.D., it was bought in Egypt by A. Chester Beatty in 1931. All contain Christian literature, though mainly from the Old Testament. The Berlin Museum Pap. No. 217 is also a second-century (A.D.) codex.

Of great importance is the fragmentary codex, containing portions of thirty-three leaves, of the *Minor Prophets*, now preserved in the Freer Collection, at Washington. It is known as *Cod. V*, and is assigned to the second half of the third century A.D. Another early codex is the *Berlin Genesis* (State Library, Berlin, *Gr. fol. 66*, 1, 11), containing portions of thirty-two leaves, and assigned to the early fourth century A.D.

With regard to secular literature, we may mention a papyrus codex, of the third century A.D., containing *Iliad*, ii–iv, and written on one side only of each leaf, which is preserved in the British Museum (Pap. 126, Fig. VI–1, *c*). Several books of magic, belonging to the fourth century, are preserved in the British Museum and in Paris. A fragmentary manuscript, of the fourth century, containing parts of *Aetia* and *Iambi* by Callimachus, comes from Oxyrhynchus. Interesting Christian codices of the seventh century are preserved in Heidelberg, Dublin and Paris. There are several Coptic papyrus codices extant, of which the most important, containing four plays by Menander, was discovered in 1905, and is attributed to the fifth century A.D.

An examination of all the manuscripts discovered in Oxyrhynchus up to 1926, has given the following results: There are no earlier papyrus codices than the third century A.D. From this century onwards the figures—which are supported by the discoveries from other sites—are given in the table.

A.D.	MSS. of Pagan Lit.	Papyrus		Vellum Codices	Christian works	Papyrus		Vellum Codices
		Rolls	Codices			Rolls	Codices	
Third Century	106	100	6	—	17	7	8	2
Fourth Century	14	6	3	5	36	2*	21	13
Fifth Century	25	4	17	4	21	4	7	10
Sixth Century	6	2	3	1	8	2	5	1

* A schoolboy's exercise and a text written on the back of an *Epitome* by Livy.

It is evident from this table and from what has been said previously that if the codex form of the papyrus book was not actually a Christian invention, it was most promptly employed by the Christian community, and it was the growth of this community which

brought it into prominence. Indeed, whereas the roll continued to be commonly used for works of pagan literature during the second and third centuries A.D., the majority of Christian works were already in codex form.

ARRANGEMENT OF PAPYRUS CODICES

The papyrus codices were bound like our modern book in groups of sheets or quires—a sheet of papyrus was folded in the middle, thus forming two leaves or four pages; by fastening together a number of such quires, a codex could be formed; or, a number of such sheets could be laid one on top of another and the whole folded so as to produce a multiple-quire codex. Examples are extant composed of as many as fifty-nine such sheets, or 118 leaves. This form must have been very inconvenient, and ultimately it was found that quires of about ten or twelve leaves was the more convenient form. As a result of the gradual change, from rolls to codices, the narrow columns of short lines have been widened, and while there are papyrus codices which have two columns on a page— the columns being only about two inches wide—the great majority of the preserved papyrus codices have only one column.

Unlike the vellum codices—to which stabbed binding was not suited—the papyri codices were mainly stabbed, "that is to say, the rectangular pages were kept in position by a binding cord laced through holes pierced sideways, right through the entire of the back of the book. The marks of these holes can often be seen along the inner margins of ancient papyri, and they also show in many instances of rebound copies of our early English printed books" (C. Davenport).

Another essential difference is that while a large sheet of vellum was usually folded in both directions, vertically and horizontally, and thus formed quires of two, four, eight or sixteen leaves, papyrus was not tall enough to be folded in more than one direction, and it was not flexible enough to be folded more than once. Hence, the codex was formed either of single-sheet quires, or of multiple quires consisting of sheets folded only once. Indeed, some papyrus codices formed, as said, single quires, containing as many as 118 leaves or 236 pages, though other codices consisted of quires of four, five or six sheets, respectively forming eight, ten or twelve leaves.

In making up the codex, the sheets were usually arranged with the *recto* side (*i.e.* the side having its fibres vertical) uppermost; thus in the first half of the quire the *verso* (*i.e.* the side having its fibres horizontal) would precede the *recto*, and in the second half the *recto*

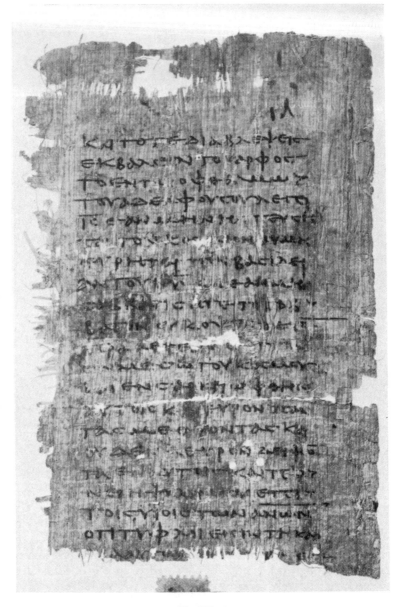

Fig. IV-18

The *Sayings of Jesus*, fragment of a papyrus codex found at Oxyrhynchus and preserved in the Bodleian Library, at Oxford ; attributed to the third century A.D.

would precede the *verso*. There are, however, codices in which *recto* faces *recto*, and *verso* faces *verso*. While all the Greek codices are arranged in one way or another, the Coptic codices, such as British Museum Or. 5000 and 5001 appear to be arranged irregularly.

The dimensions of the papyrus codices vary greatly. While some Chester Beatty manuscripts measure between 8 × 7 inches, or $9\frac{1}{2}$ × $5\frac{1}{2}$, and 11 × 7, the pages of the great Menander codex at Cairo measure $12\frac{1}{4}$ × $7\frac{1}{8}$ inches and the Cyril at Paris and Dublin measures 12 × $8\frac{1}{2}$ inches. Coptic codices are even larger; Or. 5984 of the British Museum, containing the *Sapiential Books*, measures as much as $14\frac{1}{4}$ × $10\frac{1}{2}$ inches; on the other hand, a Coptic *Gospel of St. John* measures only 10 × 5 inches. Unusually tall and narrow is a Chester Beatty codex, measuring 14 × 5 inches.

LAST STAGE OF EMPLOYMENT OF PAPYRUS

The papyrus codex does not seem to have enjoyed great popularity. The relative fragility of the papyrus, especially in climates less favourable than that of Egypt, and its tendency to crack when folded, precluded it from being widely used in codex form. Although, when made, it is of about the same consistency as paper, it does not stand the damp; and, if kept dry, becomes very brittle with age (as dead leaves do).

There were some other causes which produced the ultimate victory of the vellum codex over papyrus roll and codex. The vellum codex form was much more convenient especially for collections of laws and for Sacred Literature (see p. 203 ff.).

Furthermore, with the growth of Christianity, and the increasing need that was felt for a more durable writing material, parchment or vellum came into prominence, though for some centuries papyrus did not wholly go out of use. Throughout the third to the sixth centuries A.D. all the three forms of books were employed: papyrus roll, papyrus codex, and vellum codex (and even, though rarely, parchment roll), but by the fourth century the papyrus roll was superseded by the parchment codex as the main form of book, especially as far as it concerns Christian literature.

The following table, based on C. H. Oldfather's research, may give a rough survey—which should be treated with caution, as it is not quite up to date—of the papyri and vellum codices recovered in Egypt and dealing with secular or pagan subjects (see also the table on p. 162).

It is evident from this table that the decline of papyrus is definitely

to be dated from the fourth century, but its use lasted through the early Middle Ages. In Egypt it was eventually superseded by really excellent paper. The manufacture of papyrus would seem to have ceased about the middle of the tenth century.

A.D.	No. of MSS.	Papyrus		Vellum Codices
		Rolls	Codices	
Third Century	304	275	26	3
Fourth Century	83	39	34	10
Fifth Century	78	23	43	12
Sixth Century	29	15	10	4
Seventh Century	13	2	5	6

Though by the fourth century A.D., papyrus had ceased to be used as the main writing material for books, its use lingered on in Europe for documents of daily life until the eleventh century. In the Papal chancery, following the usage of the Byzantine imperial court, papyrus was employed until the second half of the eleventh century; its last recorded use is in 1057, under Pope Victor II.

BIBLIOGRAPHY

Mathematical Papyrus Rhind, ed. by Eisenlohr, 1877; by T. E. P. Peet, London, 1923; by Chace, Bull, Manning, and Archibald, 2 vols., Oberlin (Ohio), 1927–9.

E. Naville, *Das aegyptische Todtenbuch*, etc., 3 vols., Berlin, 1886; *The Funeral Papyrus of Iouiya*, London, 1908; *Papyr. funéraires de la XXI^e dynast.*, Paris, 1912 onwards.

J. P. Mahaffy, *The Flinders Petrie Papyri*, 3 vols., Dublin, 1891–1905; *A History of Egypt*, etc., London, 1899; —— and W. A. Goligher, *Hellenistic Greeks*, London, 1928.

W. M. Flinders Petrie, *Ten Years' Digging in Egypt*, London, 1892; *Ancient Egyptians*, London, 1925; *Egyptian Tales translated from Papyri*, 4th ed., London, 1926; *The Making of Egypt*, Oxford, 1939.

Aegyptische Urkunden aus den Museen zu Berlin, 8 vols., Berlin, 1893–1933.

British Museum, *Autotype Facsimiles of Greek Papyri*, 3 vols., London, 1893–1907.

F. G. Kenyon (and H. J. Bell), *Greek Papyri in the British Museum*, London, 1893 (and 1917); *The Palaeography of Greek Papyri*, Oxford, 1899; *Fifty Years of Papyrology*, "Actes du V^e Congr. Intern. de Papyr.", 1938. See also Bibliography to Chapters V and VI.

C. H. S. Davies, *The Egyptian Book of the Dead*, New York, 1895. National Library, Vienna, *Corpus papyrorum Raineri Archiducis*

Austriae: 1. *Griechische Texte,* etc., Vienna, 1895; *Series Arabica,* I/1, Vienna, 1924.

B. P. Grenfell and A. S. Hunt, *The Oxyrhynchus Papyri,* London, 1898 onwards; *Greek Papyri,* Oxford, 1903; *The Hibeh Papyri,* London, 1906; *Hellenica Oxyrhynchia,* etc., Oxford, 1909; ——, ——, and D. G. Hogarth, *Fayûm Towns and their Papyri,* London, 1900; ——; ——, and others, *The Tebtunis Papyri,* London, 1902–38.

F. Ll. Griffith, *The Petrie Papyri. Hieratic Papyri from Kahun and Gurob,* London, 1898; *The Demotic Magical Papyrus,* etc., London, 1904–9; *The Adler Papyri,* London, 1939.

E. A. W. Budge, *The Book of the Dead,* etc., London, 1899 (2nd ed., New York and London, 1949); *Facsimiles of Egyptian Hieratic Papyri in the British Museum,* London, 1910; 2nd ser., 1923; *The Greenfield Papyrus,* etc., London, 1912; *The Teaching of Âmen-em-âpt,* etc., London, 1924.

G. Vitelli and D. Comparetti, *Papiri fiorentini,* 3 vols., Milan, 1906–15.

L. Mitteis, *Griech. Urkunden d. Papyrussamml. zu Leipzig,* Leipsic, 1906; —— and U. Wilcken, *Grundzuege u. Chrestomathie d. Papyruskunde,* 2 vols., Leipsic and Berlin, 1912.

J. H. Breasted, *Ancient Records of Egypt,* 5 vols., Chicago, 1906–7; *The Conquest of Civilization,* New York, 1926 (new ed., 1938).

P. Jouguet, *Papyrus grecs (Univ., Lille),* Paris, 1907–8.

A. H. Gardiner, *Liter. Texte d. Mittleren Reiches,* 2 vols., Leipsic, 1908–9; *The Admonitions of an Egyptian Sage,* etc., Leipsic, 1909; *Literary Texts of the New Kingdom. Egyptian Hieratic Texts (Berlin),* Leipsic, 1911; *Egyptian Letters to the Dead,* etc., London, 1928; *Description of a Hier. Papyr. (Chester Beatty Papyri, No.* 1), Oxford, 1931; *Late Egyptian Stories,* Brussels, 1932; *The Attitude of the Ancient Egyptians to Dead,* etc., Cambridge, 1935; ed., *Hieratic Papyri in the British Museum,* 3rd ser., London, 1935; *Late Egyptian Miscellanies,* Brussels, 1937; ed., *The Wilbour Papyrus,* 3 vols., London, 1941–8; *Ramesside Admin. Documents,* London, 1948.

K. Sethe, *Die altaegyptischen Pyramidentexte,* 4 vols., Leipsic, 1908–22; *Die Totenliteratur der alten Aegypter,* Berlin, 1931.

Guide to the Egyptian Collections in the British Museum, London, 1909.

G. Moeller, *Hieratische Palaeographie,* 4 vols., Leipsic, 1909–36; *Die beiden Totenpapyrus Rhind d. Museums zu Edinburgh,* Leipsic, 1913.

C. Wessely, *Papyrorum scripturae graecae specimina isagogica,* Leipsic, 1910; *Die aelt. griechischen u. latein. Papyri Wiens,* "Stud. z. Palaeogr. u. Papyrusk.", vol. XV.

W. Schubart, *Papyri Graecae Berolinenses,* Bonn, 1911; *Einfuehrung*

in die Papyruskunde, Berlin, 1918; *Die Papyri als Zeugen antiker Kultur,* Berlin, 1938.

J. de M. Johnston, V. Martin, and A. S. Hunt, *Catal. of the Greek Papyri in the John Rylands Library,* 2 vols., Manchester, 1911–15.

G. Vitelli, *Papiri greci e latini,* 10 vols., Florence, 1911–32.

J. Maspero, *Papyrus grecs,* etc. (*Cairo*), Cairo, 1911–16.

E. Meyer, *Der Papyrusfund von Elephantine,* Leipsic, 1912.

The Ebers Papyrus: German ed., by W. Wreszinski, Leipsic, 1913; English ed., by B. Ebbell, Copenhagen, 1937.

P. M. Meyer, *Griechische Texte aus Aegypten,* Berlin, 1916.

T. E. Peet, *The Antiquity of Egyptian Civilization,* "Journ. of Egypt. Archaeol.", 1922; *The Great Tomb-robberies of the Twentieth Egyptian Dynasty,* Oxford, 1930; *A Comparative Study of the Literatures of Egypt, Palestine, Mesopotamia,* London, 1931; *The Present Position of Egyptological Studies,* Oxford, 1934.

Egypt Exploration Fund, *Guide to a Special Exhibition,* etc., London, 1922.

A. Erman, *Die Literatur der Aegypter,* Leipsic, 1923; *The Literature of the Ancient Egyptians* (transl. by A. M. Blackman), London and New York, 1927; *Die Welt am Nil,* Leipsic, 1936.

A. E. Cowley, *Aramaic Papyri of the Fifth Century B.C.,* Oxford, 1923.

A. Grohmann, *Corpus Papyrorum Raineri. Allgemeine Einfuehrung in die arabische Papyri,* Vienna, 1924; also numerous articles in "Archiv Orientální", Prague.

W. Spiegelberg, *Demotische Grammatik,* Heidelberg, 1925.

F. Preisigke, *Woerterbuch d. griech. Papyrusurkunden,* Berlin, 1925.

S. Eitrem, *Magical Papyri,* Oslo, 1925.

U. Wilcken, ed., *Urkunden d. Ptolomaeerzeit,* Berlin and Leipsic, 1927 onwards; *Ueber den Nutzen d. latein. Papyri,* "Atti d. IV Congr. intle. di papirol.", Milan, 1936.

P. Collomp, *La papyrologie,* Paris, 1927; *La critique des textes,* Paris, 1931; ed., *Papyrus grecs de la Bibl. Nat. et Univ. de Strasbourg,* Paris, 1948.

K. Preisendanz, *Die griech. Zauberpapyri.* "Arch. f. Papyrusforschung", 1927; also, Leipsic, 1928–31; *Papyri Graecae,* Leipsic, 1931; *Papyrusfunde und Papyrusforschung,* Leipsic, 1933.

A. Calderini, *Papiri milanesi,* Milan, 1928; *Manuale di papirologia antica greca e romana,* Milan, 1938; *Papiri latini,* etc., Milan, 1945.

M. Norsa, *Papiri greci,* etc., Rome, 1928–46.

The Edwin Smith Surgical Papyrus, ed. by J. H. Breasted, New York, 1930.

Moscow Mathematical Papyrus, ed. by W. Struve, "Quell. u. Stud. z. Gesch. d. Mathem.", 1930.

Michigan Papyri, Ann Arbor (Mich.), 1933.

H. I. Bell and T. C. Skeat, ed., *Fragments of an Unknown Gospel*, etc., London, 1935.

H. Grapow, *Sprachliche und schriftliche Formung aegypt. Texte*, Glueckstadt, 1936; *Zur Erforschungsgeschichte des Demotischen*, "Orient. Lit. Zeit.", 1937.

H. Ranke, *The Art of Ancient Egypt*, Vienna, 1936.

J. A. Wilson, *The Present State of Egyptian Studies*, "The Haverford Symposium", New Haven (Conn.), 1938; see also J. B. Pritchard (1950).

The Development of the Book, "Bull. of the Princeton Library", 1938.

S. R. K. Glanville, *Catal. of Demotic Papyri in the B.M.*, London, 1939; ed., *The Legacy of Egypt*, Oxford, 1942; *The Growth and Nature of Egyptology*, Cambridge, 1947.

A. Volten, *Kopenhag. Texte zum demotischen Weisheitsbuch*, Copenhagen, 1940; *Das demotische Weisheitsbuch*, ibid., 1941.

H. O. Lange and O. Neugebauer, *Papyrus Carlsberg I*, etc., Copenhagen, 1940.

O. Neugebauer, *The Origin of the Egyptian Calendar*, "Journ. of Near East. Studies", 1942.

G. Steindorff and K. Seele, *When Egypt Ruled the East*, Chicago, 1942.

W. Peremans and J. Vergote, *Papyrologisch Handboek*, Louvain, 1942.

J. Černý, in "Annales du Service des Antiquit. de l' Egypte", 1943; *Paper and Books in Ancient Egypt*, London, 1952.

M. David and B. A. van Groningen, *Papyrological Primer*, 2nd ed., Leyden, 1946.

H. and H. A. Frankfort, J. A. Wilson, and others, *The Adventure of Ancient Man*, etc., Chicago, 1946.

B. Gunn, in B. Lewis, *The Land of Enchanters*, London, 1948.

G. Lefebvre, *Romans et contes égyptiens*, etc., Paris, 1949.

P. Gilbert, *La Poésie égyptienne*, 2nd ed., Brussels, 1949.

R. A. Parker, *The Calendars of Ancient Egypt*, Chicago, 1950.

J. B. Pritchard, ed., *Ancient Near Eastern Texts Relating to the Old Testament*, Princeton, N.J., 1950.

A. Scharff and A. Moortgat, *Aegypten und Vorderasien im Altertum*, Munich, 1950.

See also BIBLIOGRAPHY to Chapters V and VI.

FROM LEATHER TO PARCHMENT

SIDE by side with papyrus, another writing material for books was extensively employed for several centuries. This was parchment, the prepared skin of animals such as cattle, sheep, goats, and occasionally deer, and preferably from the young of these animals. The finer quality (derived from the calf) was called vellum (in Latin *vitulinum*); it is finer in grain, whiter and smoother than ordinary parchment. The whitest and thinnest kind (made from the skin of an aborted calf) was called uterine vellum, and was employed chiefly for elaborate miniatures.

PARCHMENT AND ITS TRADITIONAL ORIGIN

Parchment was, of course, the most beautiful and suitable material for writing or printing upon that has ever been used, its surface being singularly even and offering little or no resistance to the pen, so that every sort of handwriting can be made upon it with equal ease. Although the exact meaning of the words "parchment" and "vellum" is as has just been explained, and although some scholars employ the former for sheepskin and the latter for calfskin, in common but incorrect usage, the two words are synonymous.

The word "parchment" (French, *parchemin*; German, *Pergament*; Italian, *pergamena*)—being a derivation of the Greek *Pergamēné* and the Latin *Pergamena* (or *charta Pergamena*), *i.e.* stuff prepared at Pergamum, which was an important city and kingdom in Asia Minor—is strictly associated with a milestone in the history of this writing material. According to Pliny the Elder (*Natur. Hist.*, xiii, 11), quoting the earlier Roman writer Varro, King Ptolemy of Egypt—he probably refers to Ptolemy V Epiphanes (*c.* 205 – *c.* 185 B.C.)—jealous of a rival book collector, feared that the library of Eumenes, King of Pergamum—probably, Eumenes II (*c.* 197 – *c.* 159 B.C.)—might come to surpass the library of Alexandria, and he therefore

laid an embargo on the export of papyrus from Egypt, in order to retard the literary progress of the rival city. Eumenes, thus debarred from obtaining papyrus rolls, was driven to the invention of parchment. This would imply that parchment was invented about the first decade of the second century B.C. But this account is not considered as historical.

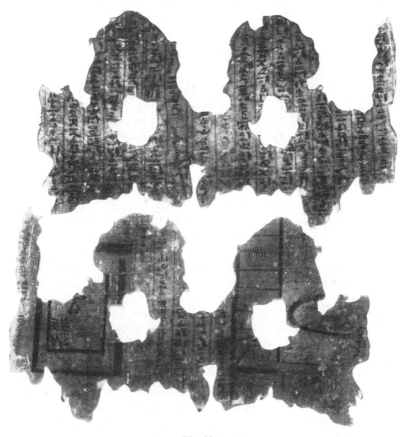

Fig. V–1

Earliest extant book written on leather. Hieratic manuscript attributed to the Sixth Dynasty (Cairo Museum).

Moreover, parchment cannot be considered a true invention. It was rather the result of a slow development, or else an improvement upon an old practice, this being the employment of hides or skins of animals as writing material. Whereas leather is simply tanned, the

fabrication of parchment is much more complicated; the skin (of the sheep, lambs, kids, goats, asses, pigs, or cattle, especially calves), washed and divested of its hair or wool, is soaked in a lime-pit, stretched tight on a frame, and scraped clear of the remaining hair on one side and the flesh on the other; it is then wetted with a moist rag, covered with pounded chalk, and rubbed with pumice stone; finally, it is allowed to dry in the frame.

Leather used as Writing Material in the Ancient Near East

It is uncertain how and when the change came about from the use of leather to that of parchment as writing material. The employment of skins of animals for writing, however, was familiar in ancient times in Egypt, Mesopotamia, Palestine, Persia, Asia Minor, and in other countries.

EGYPT

"Ancient Egypt," wrote Erman, "was exceedingly rich in skins, the result of the stockbreeding so extensively carried on in that country." ". . . while leather made into a kind of parchment and used . . . for writing material." A. Lucas writes, "From raw hide to skin treated sufficiently to render it pliable and thence to fully tanned leather are steps that the Egyptians took at an early date, and leather-working became an important industry and is depicted in a tomb painting of the Eighteenth Dynasty at Thebes." "Articles of leather were often coloured, red, yellow or green."

The first mention of Egyptian documents written on leather goes back to the Fourth Dynasty (c. 2550–2450 B.C.), but the earliest of such documents extant are: a fragmentary roll of leather of the Sixth Dynasty (c. twenty-fourth century B.C.), unrolled by Dr. H. Ibscher, and preserved in the Cairo Museum (Fig. V–1); a roll of the Twelfth Dynasty (c. 1990–1777 B.C.) now in Berlin; the mathematical text now in the British Museum (MS. 10250), Fig. V–2; and a document of the reign of Ramses II (early thirteenth century B.C.).

The mathematical roll, which is written in hieratic character, is $17\frac{3}{8}$ feet by $10\frac{1}{4}$ inches; Prof. Glanville assigns it to "much the same date" as the *Rhind Papyrus* (see Chapter IV); it thus belongs to the Hyksos period or, at latest, to the beginning of the Eighteenth Dynasty (sixteenth century B.C.). The leather is of a pale

cream colour and extremely brittle, so that its unrolling and restoration were only possible thanks to expert treatment by the British Museum authorities. The material is an animal skin, many of the hairs and their roots being easily seen. The process used originally

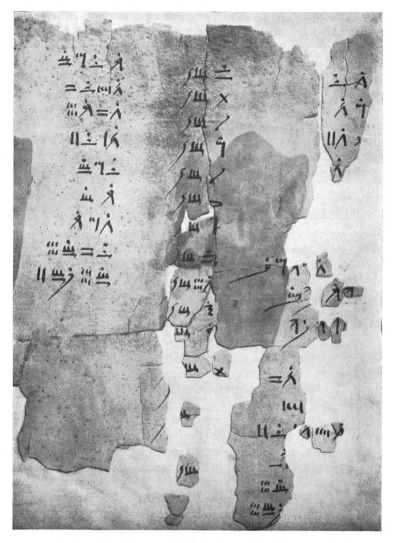

Fig. V–2

Egyptian mathematical manuscript on leather roll (British Museum 10250, Col. 1 and part of Col. 2).

to preserve the skin is unknown, but the experiments made so far—by Dr. Alexander Scott —seem to indicate that it was not by means of "tanning" as we understand it.

The victory of Thutmose III at Megiddo was recorded upon a roll of leather in the temple of Amun; and according to an Egyptian inscription of the Eighteenth Dynasty (the sixteenth to the fourteenth century B.C.) laws were written on rolls of leather.

It is, however, very probable that—before the introduction of parchment—skin, because of its expense, was used much less extensively than papyrus, and was never in general use. Indeed, it was mainly employed for important or official documents. This view seems to be confirmed by archaeological finds. While, as already explained, papyrus was the chief writing material, still cheaper materials, such as ostraca (see *The Alphabet, passim*) and small wooden tablets (see p. 27) were used by poorer people or for merely ephemeral purposes.

MESOPOTAMIA

It is very probable that skin was employed in ancient Mesopotamia, but in G. R. Driver's opinion the Babylonian expression "missive of leather" is apparently not found before the early years of the Seleucid period (311–95 B.C.).

On the other hand, the representation of a scribe in an Assyrian bas-relief of the seventh century B.C., holding a scroll, has been considered as evidence of the use of leather, but the scroll may represent either leather or papyrus. Part of the relief, preserved in the British Museum, is reproduced on Fig. III–1, *below*. It represents two scribes taking a memorandum of the spoils of war after an Assyrian victory. The bearded man, probably an Assyrian, holds an angular stilus in the right hand, and a tablet in the left. The other man, who "is marked by his shaven face as a foreigner" (Burney), holds a reed-pen in the right, and a piece of curling material in the left. There can hardly be any doubt that the former is writing in cuneiform character upon a clay tablet, and the latter is possibly writing in the Aramaic alphabet and language on a roll of leather or papyrus. A similar scene is represented on another bas-relief (also preserved in the British Museum), which seems to be a continuation of the same series. Thus, apparently the lists of booty—and possibly other official documents—were usually taken down in a double entry, in Assyrian cuneiform writing upon clay tablets, and the Aramaic alphabet on scrolls of leather or papyrus (more probably on rolls of leather).

ANCIENT HEBREWS

Many facts suggest that the ancient Hebrews employed leather as a writing material at an early time. When Jeremiah dictated his prophecies to Baruch the son of Neriah (*Jer.* xxxvi, 4), they were "taken down" on a *megillath sepher* ("roll of a book"), and later a *taʿar ha-sopher* ("scribe's knife" or "penknife") was used to cut the roll in pieces when the King wished to burn it (*ibid.*, 23). Either leather or payrus is implied in this and other references in the Bible (*Jer.*, xxxvi, 2; *Ezek.*, ii, 9; *Zech.*, v, 1; *Psalm* xi, 8). The Hebrew word *megillah* means "roll", and only papyrus or leather (including parchment) could form book rolls. The term *megillah* is generally employed to indicate the *Book of Esther*, while the *Five Megilloth* indicate the books of *Esther, Canticles, Ruth, Lamentations*, and *Ecclesiastes*. *Megillah*, however, is never used for the Scrolls of the Law or for any other Biblical book.

The exact meaning of the early Hebrew word *sepher* is uncertain; it is generally translated "book", but it often means "letter" (as in *Esth.*, ix, 25, or in the Lachish ostraca, for which see *The Alphabet*, p. 240), and sometimes it indicates a legal or a private document. In Phoenician and Aramaic inscriptions it even means "inscription". At the same time, *sepher* in the Bible may denote historical chronicles, legal codes, collections of poems, and even the Sacred Scriptures.

Therefore, the old theory of Jewish scholars that *megillath sepher* means "leather roll" is not exact, although in the *Mishnah* (traditional commentary on the Hebrew written law, completed in the early third century A.D.) *sepher* is used for leather or parchment, and in the mishnaic tractate *Makkoth* ("Stripes") we are told that the Law was written upon the hides of cattle: this statement reflects an ancient tradition.

ANCIENT HEBREW TRADITIONS

This tradition no doubt underlies the *Talmud* regulation that all copies of the *Torah* (or "Law") must be written on rolls (or scrolls) of skin; thanks to this regulation, which is still in force, there exist many thousands of such Law Scrolls in the Jewish synagogues all over the world.

Exodus, xxvi, 14 shows that the art of preparing and colouring skins was known in very early times, and the passage of *Ezekiel*, in which the roll was referred to as written *panīm ve-aḥōr* ("within and without") would suggest leather rather than papyrus. See, however,

C. F. Burney, *Book of Judges*, London, 1918, pp. 253 and 259.

According to Kenyon, the *ta'ar ha-sopher* of *Jer.*, xxxvi, 23—already referred to—was the scribe's scraping-knife, part of the normal equipment of a scribe writing on leather or parchment, and used for erasures, as shown in medieval pictures; this would point to the probability that the roll was of leather. According to other scholars, however, the "penknife" was probably used for sharpening the reeds, which served for writing on papyrus.

Further evidence of the use of leather or parchment for the Hebrew Law Scrolls is provided by the "letter" of Pseudo-Aristeas (nowadays assigned to the middle second century B.C.), which refers to a magnificent copy of the Law written on *diphthérai*, *i.e.* leather, in letters of gold, which was supposed to have been sent to King Ptolemy I (of Egypt) in 285 B.C., for the purpose of making the *Septuagint* translation of the Hebrew Bible into Greek.

However, it is most probable that costly leather was the regular material for important or official documents as well as for formal copies, while the much cheaper papyrus (see Chapter IV) and ostraca—as evidenced by finds at Samaria, Lachish, Jerusalem, and other places—were employed for more or less private and merely ephemeral matters: see *The Alphabet*, p. 238 ff.

In the Jewish colony of Elephantine (see p. 148 ff.), beside the famous papyri, there was found a fragment of leather, which contains a few broken lines of Aramaic text: it is assigned to the fifth century B.C. See also p. 190.

THE DEAD SEA SCROLLS (Fig. V–3–8)

There were probably many early Hebrew books; but in the damp soil of Palestine no leather or papyrus could be expected to endure to our time, unless preserved in conditions similar to those referred to in *Jer.*, xxxii, 14: "Thus saith the Lord of hosts, the God of Israel: Take these deeds . . . and put them in an earthen vessel; that they may continue many days."

THE FIND

In the late spring months of 1947 an epoch-making discovery was made. It is common knowledge that the earliest extant Hebrew Biblical books hitherto known belong to the ninth century A.D., and no scholar was in a position to challenge the authoritative statement

made a few years ago by Sir Frederic Kenyon: "There is, indeed, no probability that we shall ever find manuscripts of the Hebrew text going back to a period before the formation of the text which we know as Masoretic."

So common has been this belief and so astonishing the discovery, that a great deal of scepticism has been current regarding the authenticity of the new finds; a distinguished member of the Catholic "École Biblique et Archéologique Française" in Jerusalem, a great rabbinical scholar in America, and other eminent scholars considered the newly found manuscripts forgeries; while several other eminent scholars, leading authorities on Biblical studies and Semitic philology, have expressed the belief that the manuscripts are medieval.

As generally happens with great discoveries, this one was quite casual. Two Beduin goatherds of the Taamerah tribe, looking for a goat which had strayed amongst the heights of the Dead Sea, near the northern end, came upon what proved to be a natural cave high up the steep rock in a wady, some twelve kilometres south of Jericho, four north of 'Ain Feshkha, and two to the west of the shores of the sea: (Fig. V-3, a)

In the first instance only three rolls were discovered, which probably were the *Sectarian Document, Isaiah "A"*, and the *Habakkuk Commentary*. The remaining books—and perhaps also some books which are still hidden away were brought to light in the clandestine excavation by Mr. George Isaiah of the Syrian Orthodox Convent of St. Mark in Jerusalem. (Personal information by Mr. Gerald Lankester Harding.)

THE NEW BOOKS

All told (apart from those which may still be hidden away) eleven rolls of leather were discovered; among the numerous fragments of pottery there were two entire jars (which were sold for two pounds). Apparently the rolls, wrapped in linen, had been put into the jars for safety. Six of the rolls (with the two entire jars) were bought by Prof. E. L. Sukenik of the Hebrew University of Jerusalem, and the remaining five by Mar Athanasius Samuel, the Syrian Metropolitan and head of the Convent of St. Mark in Jerusalem. For the two jars, see Fig. V-4, *a*; for the manuscripts, see Fig. V-3, *b*, 4, *b-c*, 5–8.

The five rolls in possession of the Syrians are reduced to four books; two rolls being part of one single book, now called the "Sectarian Document" or "Manual of Discipline" (Fig. V-6, *right*):

Fig. V-3

(a) The 'Ain Feshkha cave. (*Above*) Interior; (*below*) entrance to the cave: smaller hole at right is the original entrance; large hole was made by clandestine excavators, in November 1948. (b) Portion of *Isaiah Scroll A* (showing *Isaiah*, xxxviii, 20–xxxix, 4).

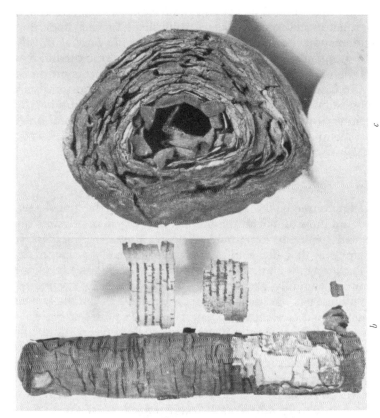

Fig. V-4

a, Jars reputed to have been found in the 'Ain Feshkha cave (Archaeological Museum, Hebrew University, Jerusalem). *b, Lamech Scroll* (still unrolled) with fragments; *c*, end view of *Lamech Scroll.*

this book describes the initiation rites and oaths of allegiance of a sect whose identity has not yet been established. Another book is a kind of commentary on the first two chapters of the *Book of Habakkuk* (Fig. V–5, *c*, and 7 *right*): a short passage is taken from the Biblical text, and then follows a comment on contemporary conditions. Another scroll, which—being the most brittle of all the scrolls in Syrian possession—has not yet been unrolled notwithstanding the most careful treatment, appears to be the Aramaic apocryphal book of *Lamech*, mentioned once in a Greek list of apocryphal books: Fig. V–4, *b-c*.

THE BOOK OF ISAIAH (Fig. V–3, *b*, and 5, *a*)

While these three books were hitherto unknown, the fourth one, the largest and most important, contains in its fifty-four columns the complete text (with the exception of a few *lacunae*) of the *Book of Isaiah*. It appears that the whole scroll was originally prepared by sewing together with thread seventeen sheets of somewhat coarse parchment (or carefully prepared leather approaching the refinement of parchment). The sheets vary a great deal in length, but all are $10\frac{1}{4}$ inches high (containing about twenty-nine lines of writing) making a scroll $23\frac{3}{4}$ feet long in its present state of preservation. The sheets were carefully lined (with a semi-sharp instrument); the lines were used as a guide for the tops of the letters, except that the *lamedh* naturally projected beyond. Notable features in the *Isaiah Scroll* (now known as *Isaiah A*) are particularly the strange orthography (which appears also in other scrolls) and some textual divergences from the Massoretic text, but on the whole the text is much closer to the Massoretic text than some scholars would have expected, though the affinities with the *Septuagint* are very marked.

THE HEBREW UNIVERSITY MANUSCRIPTS

Of the Hebrew University manuscripts, four are part of one extremely interesting book (Fig. V–5, *b*, and 7, *left*), which Prof. Sukenik calls the "Scroll of Thanksgivings" (*Megillath ha-hodayōth*): it consists of large sheets, each one folded up, and, unlike the other manuscripts, not made up into rolls; all told, there are twelve large columns, with an addition of a great number of fragments. The text consists of beautiful hymns which have a strong flavour of the *Psalms*, although in style they are quite distinct from them and from any psalm-like composition preserved in the Apocrypha. Another of Sukenik's scrolls describes (in its elegant

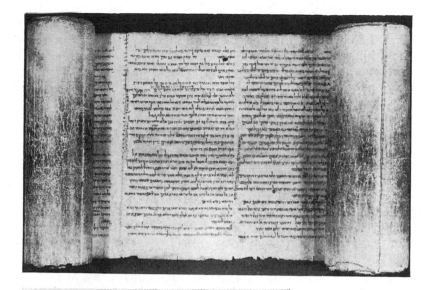

a

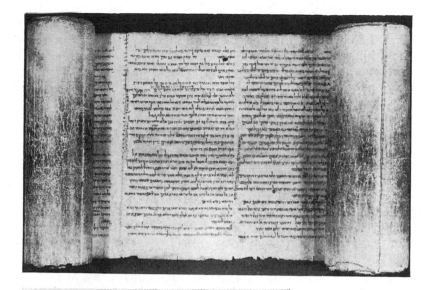

b

Fig. V-5

a, *Isaiah Scroll A* (showing Cols. 32–33); b, portion of the *Songs of Thanksgiving*; c, portion of *Habakkuk Commentary*; note the Divine Name (l. 7, third word from the right) written in the Early Hebrew script, while the scroll is written in the Square Hebrew character.

c

Hebrew handwriting, the clearest in all the scrolls) a war between "The Children of Light and the Children of Darkness"; it is uncertain whether this "war" refers to some historical event or is purely allegorical, the scroll—in nineteen columns—being a sectarian ritual.

Finally, there is a second, but fragmentary, copy of the *Book of Isaiah* (now known as "Isaiah B"), containing the chapters xli–xlvi (with small *lacunae*) and small fragments of the chapters xvi, xix, xxii–xxiii, xxviii–xxxix. With a few minor exceptions, this text follows (unlike "Isaiah A") the spelling of the Massoretic text. Owing to its brittle state, the *Isaiah Scroll B* (Fig. V–6, *above*), was unrolled in the summer months of 1949 only after careful treatment.

The Divine Name (Fig. V–5, *c*)

Not all the interesting features of the Dead Sea Scrolls can be here discussed or even mentioned; one of the most noteworthy is the variety of ways in which the Divine Name is represented. In a few places we have the Tetragrammaton (the Hebrew Divine Name, *YHWH*) as in the Massoretic text, but with *'Adōnay* ("my Lord") written above it; in other places we have *'Adōnay* with the Tetragrammaton written above it. In some places the Divine Name is omitted, but five dots are written above the succeeding words. In the "Sectarian Document", the word *'El* ("God") or *'Elī* ("My God") or dots replace the Tetragrammaton, and in column 8, l.13 there is an abbreviation (*hw'lh'*) for *hū' ha'elōhīm*, "He is God".

Still more striking is the "Habakkuk Commentary" where (in column 6, l.14; 10, l.7 and 14; and 11, l.10) the Tetragrammaton is written, in the quotations from the Biblical text, in Early Hebrew letters, although in a stylized manner, whereas in the exposition following the text the scribe always uses *'El* in Square Hebrew letters. In a few places (in the "Thanksgivings Scroll" or in other fragments) the word *'El* or *'Elī* is also written in Early Hebrew letters, in a beautiful book-hand.

Uncertain Details of Discovery

It is quite natural that in the disturbed political conditions in Palestine at the time of the discovery, and during the subsequent war between Arabs and Jews, several details of the discovery could not be adequately investigated, and they may never be fully ascertained. The more so, as an unauthorized excavation was made after the first discovery, and apparently during this illicit activity the contents

of the cave were "thoroughly turned over, and a new larger entrance opened up at a lower level to give easier access" (Harding). "Many sherds and much linen were lying about in the filling and the rubbish outside."

Fig. V-6
(*Above*) *Isaiah Scroll B* before unrolling; (*right*) *Manual of Discipline*, col. 1.

Harding-De Vaux Excavation (Fig. V-8)

Mr. Gerald Lankester Harding, Chief Curator of Antiquities of the Hashemite Kingdom of Jordan, and Father R. de Vaux of the "École Biblique" of Jerusalem, excavated the cave from the middle

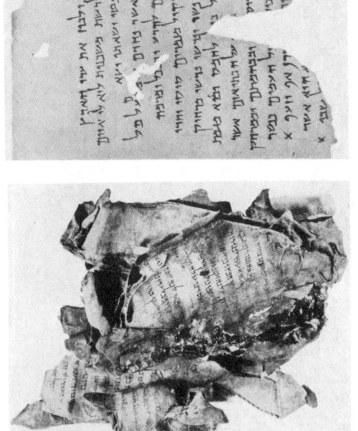

Fig. V-7

(*Left*) A sheet of the *Songs of Thanksgiving* before its restoration; (*right*) Habakkuk
Commentary.

of February to 5th March, 1949. No new scrolls were discovered, but "patient and careful work—the whole cave being cleared with the use of only penknives and fingers—resulted in the recovery of many hundreds of small fragments of scrolls, varying in size from pieces bearing only one letter to several lines of inscription" (Harding).

There was also found a larger fragment of a scroll, "terribly damaged through careless and inexpert handling", which has been carefully treated by Dr. Plenderleith of the British Museum. Apart from these leather and parchment fragments, a few papyrus fragments were recovered, written in some cases on both sides.

Many fragments of linen (later cleaned and treated by the British expert, Mrs. Grace M. Crowfoot), a few pieces of string and thread, as well as many broken fragments of pottery, were also recovered. Judging from the preserved fragments, the excavators suggest that the original deposit must have contained at least forty jars (c. 2 feet high and 10 inches in diameter), and as many bowls ("which were presumably inverted over the necks of the jars to close them"). "Five or six scrolls could easily have been stored in one jar, so about 200 scrolls may have been hidden in the cave" (Harding). However, according to later information collected by Mr. Harding, when the Beduins entered the cave all the jars were empty with the exception of one which contained the scrolls that have survived.

The excavators assigned the jars and the bowls to the late Hellenistic period, towards the end of the second century B.C., whereas the fragments of two lamps and a cooking pot of the Roman period, which were also found in the cave, are generally considered as intrusive pieces, introduced by the first intruders in the cave. For Father de Vaux's more recent theory, see below.

EARLY HEBREW BOOK-HAND (Fig. V-8)

In addition to the rolls and fragments written in the Square Hebrew script, there are a few fragments on leather written in Early Hebrew script (see The Alphabet, pp. 236-242). These are the only documents extant written in the Early Hebrew book-hand: a similar hand must have been employed by the secretaries of the kings of ancient Israel and of the prophets, as well as by ancient Israelite professional scribes. These fragments, containing passages from the book of Leviticus (xix, 31-34, xx, 20-23, xxi, 24-xxii, 3, and xxii, 4-5), may perhaps be assigned to the late fourth or early third century B.C., and thus be considered as the earliest fragments of the Bible extant, apart from the fact that they are written in the original

Lev. 19,31-34

Lev. 20,20-23

Lev. 21,24 - 22,3

Lev. 22,4-5

language and script. Beside the *Leviticus* fragments, two other tiny ragments were also found by Harding, written in Early Hebrew character; they contain only a few words or letters, but apparently were part of different manuscripts.

FRAGMENTS IN SQUARE HEBREW SCRIPT

The other fragments (discovered by Mr. Harding and so far identified), those written in Square Hebrew script, contain passages from *Genesis, Deuteronomy, Judges, Daniel* (in Aramaic), and from the *Book of Jubilees*.

THE CONTROVERSIAL DATE

Already, a quite extensive literature has been published on these scrolls, but there is no agreement as to their date, some scholars preferring the second or first century B.C.—Albright, Bea, Birnbaum, Brownlee, Burrows, De Vaux, Diringer, Dupont-Sommer, Harding, Milik, Rowley, Segal, Sukenik, Trever, and others—others a post-Christian date (a few scholars suggest even the seventh or eighth century, or even a later date)—Driver, Kahle, Lacheman, Teicher, Weiss, Zeitlin, and others.

Up-to-date bibliography may be found in H. H. Rowley, "ANAL. LOVAN. BIBLICA ET ORIENT.", Ser. II, Fasc. 30, 1952, and "BULL. OF THE JOHN RVL LIBR.", September 1952.

It is unwise at present to be dogmatic (as some scholars have been) regarding the date of these scrolls and their importance for Biblical study and philological, theological, or allied research, as well as regarding the identification of the sect of the scrolls. However, the palaeographical and archaeological evidence seems to point to a pre-Christian date (such as the second or first century B.C.); this is also suggested by certain other features, such as the coarse writing material used, the varying width of the columns of writing in the same scroll—in "Isaiah A", the narrowest column, 52, is but 3.62 inches wide, while the widest, 11, is a little more than $6\frac{1}{2}$ inches wide. At present, the controversy concerning the date continues with unabated vigour, the most recent and ingenious theory—by Dr. J. L. Teicher of the University of Cambridge—being that the scrolls belonged to the Jewish-Christian sect of Ebionites, and were hidden in the cave during Diocletian's persecution of the Christians in A.D. 303.

Prof. Dupont-Sommer and other scholars have identified the

sect of the Scrolls with the Essenes; others, with Pharisees, Sadducees, Zealots, Dositheans, Therapoutae, the Karaites, and the followers of John the Baptist.

Radioactivity-dating, the method based on carbon fourteen, has been tried on the linen found in the cave. It is a new method for dating the past which has only recently been developed. Although very great accuracy has not been obtained, the result of the carbon fourteen method shows that the scrolls should be placed between 167 B.C. and A.D. 230.

MORE RECENT DISCOVERIES

In the winter of 1951–2, both clandestine and legal excavations were carried out at Khirbet-Qumran (less than a mile from the cave in which the Dead Sea Scrolls were found) and in four grottoes of the Wâdi Maraba'at (about ten miles from Khirbet-Qumran, but only two hours' walk from the Dead Sea). These excavations will be resumed, and when more information will be available, some scholars may revise their opinion with regard to the dating of the Dead Sea Scrolls.

Father de Vaux, who previously dated the jars found in the cave of the Scrolls to the Hellenistic period, and thus considered the Scrolls as pre-Christian, has already abandoned this theory. In his report to the French Académie des Inscriptions and Belles-Lettres, de Vaux argues that the jars of the same type were found in Khirbet-Qumran, where they were in use for domestic purposes in the second half of the first century A.D. De Vaux now accepts the theory held by Prof. Dupont-Sommer that the Scrolls may have belonged to the Jewish sect of the Essenes, and may have been part of the library of Khirbet-Qumran, which possibly was an Essene monastery. The Essenes—before suffering martyrdom at the hands of the Romans—may have hidden their library in the cave of the vicinity, after the Jewish War of A.D. 66–70.

In the grottoes of Wâdi Maraba'at, apparently numerous fragments of leather were found, some written in Aramaic or Greek, others in Hebrew; there are included portions of *Genesis*, *Exodus*, and *Deuteronomy*, as well as two letters, said to have been written by the famous—though partly mythical—Jewish hero Bar Kokhba, the great leader in the Jewish War of A.D. 132–5. Even more exciting—at least from the literary point of view—is the discovery of a papyrus palimpsest, not yet deciphered, but apparently written in the Early Hebrew script, employed in the period of the Hebrew monarchy.

The discoveries of Wâdi Maraba'at are said to have no connection with the Dead Sea Scrolls.

A further report from Jerusalem (of April 12th, 1952) mentions the research carried out in forty caves in the neighbourbood of the Dead Sea. In one cave, two tightly rolled strips of copper or bronze were found. They are said to be about $94\frac{1}{2}$ inches long and 12–14 inches wide, and to be engraved with a long text in Square Hebrew characters, divided into columns.

The "most sensational archaeological event of our time" has been reported recently (April, 1953) from Amman, apparently consisting in the discovery, in caves overlooking the Dead Sea, of seventy Biblical scrolls, in Hebrew, Greek and Aramaic, believed to be about 2,000 years old.

PERSIANS AND IONIAN GREEKS

According to Diodorus Siculus (*Bibl. Hist.* II, xxxii, 4), Ctesias, the Greek historian of Persia, reported to have derived his knowledge of early Persian history from the Persian royal chronicles (*basilikaì diphthérai*, "royal leathers"), which were written on skins of sheep or goats; the date of these chronicles is, however, not specified. It is probable, moreover, that the Persian "book of records of the chronicles" (*sepher ha-zikronōth dibrē ha-yamīm*) of *Esth.*, vi, 1, and the royal record written on a "roll" mentioned in *Ezra*, vi, 2, were also written on leather. The Avesta (*i.e.* the Persian or Zoroastrian sacred literature is supposed to have been written on skins of oxen.

An important collection of fourteen official letters (or fragments of letters)—assigned to 411–408 B.C. or thereabouts—written in Aramaic by Persian officers, in ink on leather, is being published by Professor Driver: Fig. V–9, *above*.

Finally, Iranian documents from the Avromān Dagh are extant; they are written in the Pahlavi cursive script, in ink, on leather or parchment, and are assigned by Sir Ellis Minns to the first century B.C. See also p. 192 and Fig. V–9, *below*.

It is not known in what period the Greeks began to employ leather as a writing material, but—as already mentioned—Herodotus records (in *Hist.*, v, 58) that the Ionian Greeks had, from antiquity, called books *diphthérai* ("leathers"), because in earlier times, when papyrus was scarce, they employed in its place skins of sheep and goats; and in his own time, many of the barbarian peoples still did so. Consequently, by the middle of the fifth century B.C., the employment of leather as a writing material must have been widespread. It is quite possible that the Greeks, at least in very early times, employed leather as a vehicle for writing literature, but we have no direct evidence of it.

Introduction of Parchment

It has already been indicated that it is uncertain when and how parchment was introduced. Parchment, it must be emphasized, is leather manufactured more elaborately. It may, therefore, be assumed that the steady development in the process of the manufacture of leather continued for centuries. This may perhaps be the reason why, for some centuries, the Greeks had no special term for "parchment"; they continued to employ the word *diphthéra*, meaning "leather" (it was also the Ionian word for "book"); or they used the Latin term *membrána* (see, for instance, 2 *Tim.*, iv, 13, *tà biblía, málista tàs membránas*, "the books, especially the parchments"). Only A.D. *c.* 301—in the Edict of Diocletian—there appeared the Greek term *pergaménē.*

EARLIEST USE OF PARCHMENT

Until 1909 our knowledge of the earliest employment of parchment as writing material was rather unsatisfactory; no example was known which could be attributed to a pre-Christian date. A new chapter was begun with the discovery about the year 1909, in a cave in the mountain Kuh-i-Sālān, near Avromān (Persian Kurdistan), of a hermetically sealed stone jar containing millet seeds as well as three parchment documents, one being in Pahlavi, and two in Greek. Of the latter two, one—containing an endorsement in Pahlavi—is dated to the year 225 of the Seleucid era, which is equivalent to 88 B.C., and the other belongs to 22—21 B.C.: Fig. V-9, *below.* The earlier document is the British Museum *Add. MS. 38895 A.*

Furthermore, several documents on parchment were found in 1923 among the ruins of Dura Europos on the Euphrates, one of which bears the years 117 and 123 of the Seleucid era, equivalent to 196-195 and 190-189 B.C., thus showing that this material was then already in use at a place far distant from Pergamum. It follows, therefore, that in the time of Eumenes II (see p. 170f.), parchment was already in use as writing material. On the other hand, the earliest extant specimens of parchment used for literary purposes appear to be two leaves probably belonging to the late first or early second century A.D. One (Fig. V-10, *A*) is preserved in the British Museum (*Add. MS. 34473*), and the other in the Berlin Museum (No. 217), the former being a fragment of an oration by Demosthenes, the latter a fragment from Euripides.

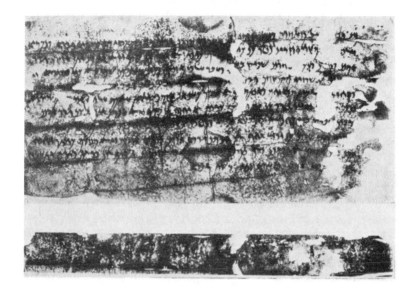

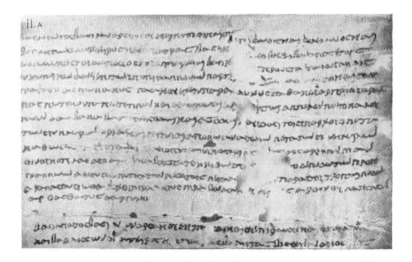

Fig. V-9

(*Above*) Aramaic letter written on leather, fifth century B.C. (Bodleian Library, Oxford); (*below*) second earliest Greek document written on parchment (British Museum, Add. MS. 38895 B). It is dated to the year 22-21 B.C. It was found with other two documents near Avromān.

Among the Romans parchment (*membrána*) was extensively used; animals' skin prepared for writing upon must have been in use among pastoral people in early times, but the purposes of *membrana* and *charta* ("papyrus") were distinct until late in the Empire: see further on.

To sum up, from the fact that in the early second century B.C. parchment was employed at an outpost such as Dura Europos, it may be assumed as certain that in more central places it was employed at least in the late third century B.C. The story concerning the invention of parchment by Eumenes II, as told on p. 170 f., may contain the truth that Pergamum was a particularly important emporium for trade in parchment and a great centre for its manufacture, probably with the aid of some new appliances by which the Pergamum product, *i.e.* the "parchment", became famous. It may also be that in the period of Eumenes II parchment came temporarily to the front as a material of book production.

For the first four or more centuries of the employment of parchment, its use was not very popular. It is referred to by Roman writers of the first century B.C. and the first century A.D. (Cicero, *Letters to Atticus*, xiii, 24; Horace, ii, 3, 2; Martial, *Epigrams*, xiv, 7), but it was then used chiefly for notebooks, "for which purpose it competed with the wax tablet" (Kenyon). The Roman Quintilian (A.D. *c*.35 – *c*.100) even preferred to write on wax tablets rather than on parchment. However, some Greek literary fragments written on parchment are extant, belonging to the first or second century A.D. (see p. 192), the third century (a fragment of Tatian's *Diatessaron*—see p. 250), and A.D. *c.* 300 (fragments of the *Iliad* and the *Odyssey*).

PARCHMENT WINS THE FIELD

With the introduction of parchment, a fine smooth writing material was produced, almost white in colour, capable of receiving writing on both sides, and of great enduring power. The chief qualities of parchment—when in later times its manufacture was greatly improved—especially of vellum, are its semi-transparent fineness and the striking beauty of its polish, particularly on the hair side. The flesh side of the parchment is somewhat darker, but it retains the ink better.

The advantages of parchment over papyrus were no doubt obvious (see also p. 165 ff.); it was a much tougher and more lasting material than the fragile papyrus; the leaves could receive writing on both sides; ink, particularly if recently applied, could be easily removed for corrections, and the surface could be readily made

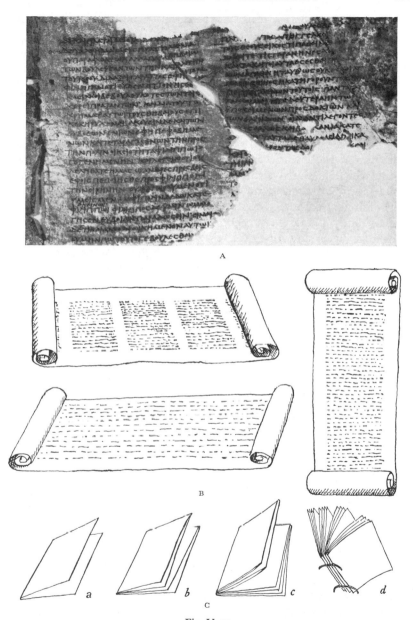

Fig. V–10

A, The earliest extant Greek literary document on parchment : *Oration* by Demosthenes; late first century A.D. (British Museum, *Add. MS. 34473*). B, Books in the form of rolls: roll written in page form; roll written longitudinally; and roll written across its width. C, Folding of parchment codices: *a*, folio; *b*, quarto (quaternion); *c*, octavo; *d*, four quaternions stitched together. Drawing by Ella Margules.

available for a second writing (a second-hand manuscript of this sort
is known as "palimpsest"—see pp. 215–223).

With all these and other advantages, the natural conservatism of
the ancient world, as well as the traditions of the book trade, especi-
ally among the non-Christians, were only gradually overcome.
However, not even parchment was without defects: for example,
with the parchment codices the edges of the leaves are apt to cockle.
Also, it was much heavier than papyrus, and more difficult to handle.
The great physician and philosopher Galen (Claudius Galenus,
born in A.D. 130), who was a very prolific writer, stated that parch-
ment, which is shiny, strains the eyes much more than papyrus,
which does not reflect light.

Parchment competed rather with wax tablets than with papyrus,
and—usually bound in the codex form—it was used for account
books, for wills, and for notes. The *membrana* mentioned in Horace
(*Sat.*, ii, 3, 2) was used for the rough copy of poems to be altered and
published later, and the same purpose was served by the parchment
in a diptych stained yellow referred to by Juvenal (vii, 24).

Parchment was the heavier and more vulgar material; and
clearly was considered inferior to papyrus. Gifts of books written in
pugillaribus membranis or *in membranis* are presents of a cheaper sort
(Martial, xiv, 183–96). Till long after the Augustine period, *charta*,
meaning "papyrus", was used for literary publications generally.
Indeed, all the references in Roman literature until the end of the
first century of the Christian era are plainly to papyrus, which is
regarded by Pliny "as the principal and essential organ of human
civilization and history".

Curiously enough, even at the end of the fourth century A.D., and
even in the Christian world and "in a country far removed from
Egypt, we find Augustine apologizing for using vellum for a letter,
in place of either papyrus or his private tablets, which he has dis-
patched elsewhere" (Kenyon).

However, as already indicated, the growth of the Christian
community brought parchment into prominence, and it was in the
first half of the fourth century A.D. that vellum or parchment
definitely superseded papyrus as the material used for the best books.
It happened that at about the same time the Emperor Constantine
the Great proclaimed Christianity as the State religion of the Roman
Empire.

The "Father" of Church history, Eusebius, known as Eusebius
Pamphili of Caesarea (*c.* 264–*c.* 349), records (*Life of Constantine*, iv, 36)
that in 332 the Emperor Constantine ordered "fifty copies of the

Sacred Scriptures . . . to be written on prepared parchment in a legible manner, and in a convenient, portable form . . .", for the churches in Byzantium (which became his new capital, Constantinople). This order was "followed (wrote Eusebius) by the immediate execution of the work itself, which we sent him in magnificent and elaborately bound volumes of a three-fold and four-fold form" (*i.e.* having three columns and four columns to the page). Furthermore, according to Jerome (d. 420), in the mid-fourth century, when the Christian library of Origen (186–*c.* 254) and of the martyr Pamphilus had fallen into decay, its damaged papyrus rolls were replaced by copies written on vellum. Finally, as early as the year A.D. 372 an edict of Valentinian mentions the employment in libraries of scribes appointed to produce codices.

EARLIEST VELLUM CODICES (Fig.V–11–13)

It is an interesting coincidence that the earliest preserved Greek Bibles written on vellum codices belong precisely to this period: these are the famous *Codex Sinaiticus* (Fig. V–11), which in 1933 was purchased by the British Museum from the Soviet Government for £100,000, and the *Codex Vaticanus* of the Vatican Library, which is considered by Sir Frederic Kenyon as the most valuable of all the manuscripts of the Greek Bible. Also the earliest preserved Latin vellum codices are attributed to the fourth century A.D., for example, the *Vercelli Gospels* (Fig. VII–1).

About 5,000 Greek vellum codices of the Bible are extant. The following are the earliest and by far the most important.

Codex Sinaiticus (Fig V–11) is known also as *Codex S* or *Codex Aleph* (the latter being the more correct term). Originally it probably had at least 730 leaves; now there are only 390 (the rest went to the Sinai "waste-paper basket"!), of which 242 contain a great part of the O.T., and 148 contain the whole N.T. with some other Christian writings. The story of its discovery in the monastery of St. Catherine at the foot of Mount Sinai, and of its acquisition by the British Museum, reads like a romance. (See F. G. Kenyon, *Our Bible and the Ancient Manuscripts*, London, 1939, pp. 128–35, where the importance of this manuscript for Biblical studies is emphasized). Forty-three leaves of this codex (all of the O.T.) are in Leipsic, three fragments at Leningrad, and all the remaining leaves are in the British Museum, beautifully bound by Mr. Douglas Cockerell (British Museum, *Add. MS. 43725*); the Leipsic fragment is known as *Cod. Gr. 1*, Leipzig, or *Codex Friderico-Augustanus*.

Fig. V–11

Codex Sinaiticus, fourth century A.D. (British Museum, *Add. MS. 43725*).

The leaves, quite well preserved, are of vellum, made from fine skins; originally they measured 15 inches by $13\frac{1}{2}$ inches. The text is written in four columns to the page (two in the poetical books), with forty-eight lines to the column; the writing is of the fourth century A.D., perhaps of the middle of that century; it is a large, clear and beautiful uncial hand, without much attempt at ornamentation. The words are written continuously without separation, but high and middle points as well as the colon are used for punctuation. There are no accents or breathings. Sacred names are abbreviated. It seems to have been written by three scribes, and it has been corrected by at least three correctors, "who seem to have worked on the manuscript at Caesarea at the end of the sixth or beginning of the seventh century" (Kenyon). The place of origin of this codex is uncertain; various places were suggested, even Rome; however, Egypt (and especially Alexandria) is probable, and Palestine (especially Caesarea) possible.

Codex Vaticanus or *Codex B* has been in the Vatican Library at least since 1481, but before the nineteenth century no scholar was allowed to study or edit it, and only sixty years ago, when a complete photographic facsimile of it was published, it became commonly available. For some years it was in Paris, where Napoleon brought it as a victory trophy, but in 1815 it was returned to the Vatican Library. Originally it contained the whole Greek Bible, but in the course of time many parts have disappeared (the *Apocalypse*, parts of *Genesis*, of the *Psalms*, and so on). It is preserved in the Vatican Library as *Codex Vat. Gr. 1209*.

Out of about 820 original leaves, there are now 759. They are of very fine vellum, and measure $10\frac{1}{2}$ inches \times 10 inches. The text is written in three columns to the page. Unlike *Codex Aleph*, this manuscript is written in small and delicate uncials, although (like the former) perfectly simple and without attempt at ornamentation. "There are no enlarged initials, no stops or accents, no divisions into chapters or sections . . . but a different system of division peculiar to this manuscript. Unfortunately, the beauty of the original writing has been spoilt by a later corrector, who, thinking perhaps that the original ink was becoming faint, traced over every letter afresh, omitting only those letters and words which he believed to be incorrect. Thus it is only in the case of such words that we see the original writing untouched and uninjured" (Kenyon). There are corrections by various hands.

Many scholars consider *Codex Vaticanus* as the best representative text of the *Septuagint*.

The place of origin of *Codex B* may be the same as that of *Codex Aleph*. As to its date, it also belongs to the fourth century A.D., but the more complete absence of ornamentation has generally caused it to be regarded as slightly the older.

Codex Alexandrinus: this—being the first of the earliest greater manuscripts to be made accessible to scholars—is called *Codex A*. Cyril Lucar, Patriarch of Constantinople and late Patriarch of Alexandria, brought it from the latter city to the former, and, in 1627, it was presented to King Charles I. George II presented it to the British Museum. Traditionally it is assigned to the first half of the fourth century A.D., but it probably belongs to the first half of the fifth century. "The leaves measure $12\frac{3}{4} \times 10\frac{1}{4}$ inches, having two columns to each page, written in large and well-formed hands of round shape, apparently by two scribes in the Old Testament and three in the New, with initial letters enlarged and projected into the margin. The text has been corrected throughout by several different hands" (Kenyon).

Codex Alexandrinus is "one of the chief treasures of the British Museum" (Kenyon): British Museum, *Royal MS. 1 D. V.–viii.*

Codex Bezae or *Codex D* (N.T.)—Fig. V–12; this is one of the chief treasures of the Cambridge University Library. (It was presented, in 1581, by Théodore de Bèze, 1519–1605, Calvin's follower at Geneva.) Its pages measure only 10×8 inches, each containing a single column of writing. It is the first example of a bilingual Bible, for it contains both Greek and Latin texts, the former written on the left-hand page, the latter on the right. The writing (in uncials of somewhat large size) is rather unusual, and the Latin and Greek characters are so similar, that both pages at first sight appear alike. As to its origin, Egypt, Rome, S. Italy, Sicily, Sardinia, S. France, and N. Africa have been suggested; in Sir Frederic Kenyon's opinion, the last one is the most probable. Also according to Kenyon, this codex is the chief representative of the Western text of the New Testament, and may belong to the fifth century. "The MS. has a provincial look and can hardly be a product of a great centre of calligraphy. The first fairly certain fact is that it was used at Lyons in the ninth century by Ado and Florus. It was from the loot of the Lyons church

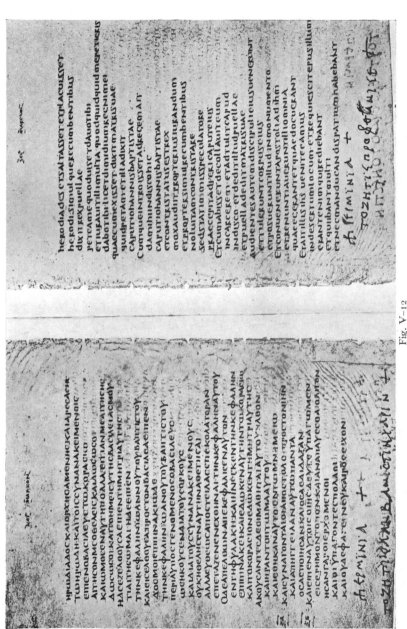

Fig. V-12

Codex Bezae (University Library, Cambridge, Nn. II, 41: fol. 304 *verso* and 305 *recto*).

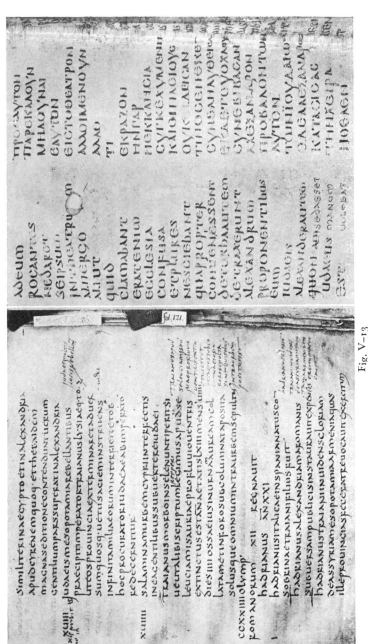

Fig. V-13

(*Left*) The earliest Christian *Chronicle*. Jerome's Latin version of the *Chronicle* of Eusebius (Bodleian Library, Oxford, MS. *Auct. T.II, 26*, fol. 121). The oldest manuscript at present known, written in uncials, in Italy, chiefly in three hands of the fifth and sixth centuries. (*right*) *Codex Laudianus*; uncials, sixth century; written probably in Sardinia. (See pp. 507 and 509).

of St. Irenaeus in 1562 that Theodore Beza . . . acquired it"
(E. A. Lowe).

Other very early Biblical codices are: *Cotton Genesis* or *Codex D*
(O.T.), Brit. Mus., *Cott. Otho B., VI*; only charred remains of this
once beautiful manuscript are extant; it was written in a fine uncial

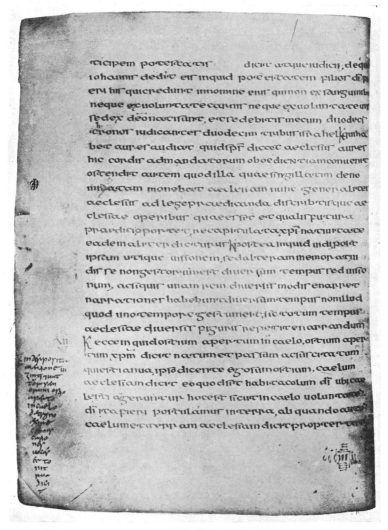

Fig. V-14

Primasius, *in Apocalypsium* (Bodleian Library, Oxford, *MS. Douce 140*); half-
uncial of the seventh or eighth century.

hand of the fifth century, and contained 250 illustrations in ancient style (see the book on *Illumination and Binding*); *Codex Ephraemi* or *Codex C*: palimpsest of the fifth century, now in the National Library, Paris (*Cod. Grec. 9*); *Codex Ambrosianus* or *Codex F* (O.T.), in the Ambrosian Library, Milan: fifth century; there are three columns to the page; unlike the other early manuscripts, it has punctuation, accents, and breathings (written by the original scribe); *Codex Sarravianus* or *Codex G*, of which 130 leaves are at Leyden, twenty-two at Paris, and one at Leningrad, fourth or, more probably, fifth century: two columns to the page; *Codex Petropolitanus* (*H*), palimpsest at Leningrad, of the sixth century; the *Vienna Genesis* or *Codex L*, of the fifth or sixth century, written with silver letters upon purple vellum, with beautiful illuminations, which will be discussed in the volume on *Illumination and Binding*.

Codex Marchalianus or Q, which comes from Egypt, and is preserved in the Vatican library (*Vat. Gr. 2125*), belongs to the sixth century A.D. It contains the Prophets and was "a principal authority for the Hexapla in the Prophetic books" (Swete). *Codices Washingtonianus I* and *Wash. II*, the former of the sixth and the latter of the sixth or seventh century, are in the Freer Collection. Finally, *Codex Tischendorfianus* or *Fragmenta Lipsensia* or *K*, preserved at the University of Leipsic (*Gr. 2, Tisch 11*) is a seventh-century palimpsest, re-used in the ninth century for an Arabic book.

EARLIEST SECULAR VELLUM CODICES

The earliest extant secular works written on vellum codices are on the whole contemporary with the earliest Bible vellum codices. It must, however, be emphasized that the dating of early vellum uncial manuscripts is a precarious task, since few fixed points are available. The task is made still harder by the apparent practice of the scribes of these codices to employ the elegant character of the second century A.D. Thus, the earliest extant Greek uncial codex, the *Iliad*, preserved in the Ambrosian Library at Milan, is written in a script which can be dated as early as the second century A.D., but the codex cannot be earlier than the third, and is probably later.

The earliest preserved Latin vellum codices containing secular works probably belong to the fourth century A.D. They are a group of Virgil codices, such as the Vatican, Palatine, and Medicean (see Chapter VI), and the palimpsest of *De Republica* by Cicero (Fig. VI–14). This date, however, is not agreed upon, and some scholars suggest the fifth century A.D. See also the book on *Illumination and Binding*.

THE FINAL TRIUMPH OF THE PARCHMENT CODEX
(Fig. V–10)

The final victory of parchment over papyrus in the sphere of book production is due to the fact that the Christian Church, influenced no doubt by Jewish practice, chose parchment to write their sacred books upon. The Christians, however, soon diverged from the Jews in respect of the form of the "book".

The earliest parchment books, as already indicated, were in roll form. Doubtless, gathered sheets of folded parchment were, though rarely, in very early times applied to various literary purposes —for instance, among the Dead Sea Scrolls, a "folded-up" book has been discovered—but the roll seems to have been the most general form for important books.

The Jews have continued until this very day to write ritual copies of the Law on parchment scrolls, whereas Christians favoured the codex, and the Bible in this form was quite common amongst them in the first half of the fourth century.

In addition to its greater convenience for continuous reading, and particularly for reference, the codex form had also the advantages that (1) its size could be increased at will; (2) collections of poems or short treatises, and especially of aphorisms, wisdom, or proverbs, could be more easily transcribed.

The Christians soon extended its use to their theological literature, and then to literature in general. The parchment or vellum codex, having thus achieved its triumph in the fourth century, remained the chief writing material for books for over a millennium, *i.e.* until the establishment of paper in general use in the fourteenth century, and until the Renaissance. This period of the dominance of the vellum book—"a book capable of the greatest magnificence and beauty that books have ever reached"—corresponds almost exactly with the dominance of Christian religion and Christian thought, "with the knowledge of classical literature maintaining a fitful and difficult existence" (Kenyon).

In the Middle Ages manuscripts were generally on vellum, but sometimes the material, though called vellum, was strictly speaking parchment. Some of the early vellum codices extant, already referred to, particularly those of the fifth and sixth centuries, are made of thin, delicate material, with a smooth and glossy surface. At a later period, as the demand increased, a great amount of inferior material came into the market. In Italy, a highly polished surface seems at most periods to have been in favour, and in the Renaissance

Fig. V–15

Sacramentary by Gelasius (Vatican Library, *Reg. Lat. 316*, fol. 46 *recto*); written at Corbie in the eighth century.

period vellum was of extreme whiteness and purity. In England, from the thirteenth to the fifteenth centuries, soft vellum was sometimes used.

SERVICE-BOOKS

One of the many Christian innovations in book production was the great service-books in the churches, such as the missal, the chorale, and the antiphonary. (Many of such works were manufactured in Rome.) So, for instance, an immense volume was laid upon the *lutrin*, or reading-desk, in the middle of the choir, and the letters of the words and musical notes, which accompanied them were of such a size, and so black, that they could be read by the canons as they sat in their stalls with as much ease as an inscription on a stone monument. These ponderous volumes, which were seldom removed from the desk, or carried only to the adjoining sacristy, were a part of the furniture, and almost of the fixtures, of the church, and were frequently of great antiquity. Often they were garnished with corners of brass, with bosses, and brass nails, to preserve the bindings from injury in being rubbed on the desk or pulpit, and were protected from dust by massive clasps. Some of the largest of these service-books, but not always the most ancient, were laid upon rollers.

"The Book" of the Middle Ages

(Fig. V–13–16; see also Chapters VII and X).

The hand-written parchment or vellum codex is "the book" *par excellence* of the Middle Ages. Such codices are generally termed "manuscripts" or MSS., from the Latin term *codices* (or *libri*) *manuscripti*, "codices (or books) written by hand". From the earliest codices extant belonging to the third or fourth century A.D., to the invention of the printing press in Europe, c. 1450, and the spread of printing in the second half of that century, giving birth to the "modern book", "the book" of the Middle Ages covers a period of well over eleven hundred years.

The Christian monasteries were the main book producers of the Middle Ages. With the din of arms around him, it was the monk who, by preserving and, especially, transcribing ancient manuscripts, both Christian and—although in much lesser degree—pagan, as well as by recording in writing his observations on contemporary events, was

handing down the torch of knowledge to future generations. In the most important abbeys and monasteries a "writing room" or *scriptorium* was assigned to the scribes, who were constantly employed in transcribing, not only service-books for the choir and the church, but also books for the library and the monastery school, and even lay books.

It must be allowed that we know very little for certain about the conditions of book production in medieval times. W. Oakeshott asks: "If a particular twelfth-century book was in a particular monastery in the twelfth century, is that satisfactory evidence that it was produced there, or were books often produced in one monastery for another?" "When did the production of books by commercial scribes, even for monastic use, become usual?" Only partial and tentative answers can be given to these questions. Oakeshott has also pointed out that if an early medieval book carries an inscription, which relates to its production, we do not always know whether the *scriptor* copied the text, designed or completed the decorations, or was responsible for all these things. "We seldom know anything of his status and seldom even his name. . . . There is nothing to suggest that in the Anglo-Saxon period"—and, for that matter, generally speaking in early medieval times—"the copying of books played anything like the part in monastic life which it was to play later." And "there is nothing positively to show that the decoration of the book, as opposed to the writing of the text, was always done in the monastery", though we often find monks described as painters, and we find artists holding some position in the Church.

The devotion shown by some religious scribes to the task of copying and illuminating is aptly indicated in the following passage.

"Let us consider then"—says a twelfth-century preacher— "how we may become scribes of the Lord. The parchment on which we write for him is a pure conscience, whereon all our good works are noted by the pen of memory, and make us acceptable to God. The knife wherewith it is scraped is the fear of God, which removes from our conscience by repentance all the roughness and unevenness of sin and vice. The pumice wherewith it is made smooth is the discipline of heavenly desires. . . . The chalk with whose fine particles it is whitened indicates the unbroken meditation of holy thoughts. . . . The ruler by which the line is drawn that we may write straight, is the will of God. . . . The tool that is drawn along the ruler to make the line, is our devotion to our holy task. . . . The pen, divided into two that it may be fit for writing, is the love of God and our neigh-

bour. . . . The ink with which we write is humility itself. . . . The diverse colours wherewith the book is illuminated, not unworthily represent the multiple grace of heavenly Wisdom. . . . The desk whereon we write is tranquillity of heart. . . . The copy by which we write is the life of our Redeemer. . . . The place where we write is contempt of worldly things." (Extract from the Sermon on *Audivi vocem de cœlo*, added in a twelfth-century hand on f.37 *recto* of MS. B. iv, 12 in Durham Cathedral, No. 59 in Mynors, *Durham Cathedral Manuscripts*; quoted from Mynors.)

THE SCRIPTORIUM

In some great monasteries the *scriptorium* was a large room, usually over the chapter-house; it was in charge of the *armarius*, whose duty it was to provide desks, parchment, pens, ink, penknives, awls (to give guiding marks for ruling lines), rulers, metal *stili* (to draw the lines), pumice-stone (to smooth the surface of the parchment), reading frames (to hold the book to be copied), and weights (to keep down the pages of the codices); but even the *armarius* was not allowed to assign work without the abbot's permission. The scriptorium was often built in the form of a series of separate little partitions or studies. In some monasteries, especially in early times, the scribes copied in the cloister.

For the support of the scriptorium estates were often granted. That at St. Edmondsbury was endowed with two mills. The tithes of a rectory were appropriated to the Cathedral Convent of St. Swithin, at Winchester, in the year 1171. Nigel, in the year 1160, gave the monks of Ely two churches, *ad libros faciendos*.

The scriptorium, besides being under the general discipline of the monastery, had special rules of its own. To guard against irreparable loss by fire and for fear of other damage to manuscripts, artificial light was entirely forbidden, so all work had to be done during daylight: the monastic scribe worked about six hours daily. To prevent interruption and distraction, access to the scriptorium was denied to all non-scribes who had no leading position in the monastery, and absolute silence was required. Scribes were not allowed even to ask for the books or other things they needed for their work. Thus, a whole system of gesture-communication was introduced: if a scribe wanted to consult a book, he extended his hands and made a movement as of turning over pages; if the book required was a psalter, he made the general sign, and then placed his hands on his head in shape of a crown (alluding to King David);

if a pagan book was needed, the general sign was followed by scratching the ear in the manner of a dog.

It may, therefore, be assumed that, as a rule, the scribe *copied* his book, and did not write from dictation. Indeed, as Madan points out, the evidence of dictation is extremely scanty. "Alcuin, who describes the copying work at York, seems to know nothing of it, and the word *dictare*, used in connection with writing, means 'to compose', not dictate." See, however, p. 214.

When no scriptorium was available, separate little rooms were assigned to book copying; they were situated in such a way that each scribe had to himself a window open to the cloister walk. Only in special cases were private rooms or cells assigned.

SECULAR SCRIBES AND ILLUMINATORS

In addition to the monks who were regular scribes and illuminators, there were special classes of secular scribes (such as *illuminatores* and *rubricatores*), who were brought to the monasteries when there were no competent men there to do the required job. There were also men who, though living—but not always—within the monastic precincts, and often adopting the outward dress of monks, were, in fact, only lay brethren, skilled in various handicrafts or trades. At Osney Abbey (Oxford), for instance, a number of workmen, such as tailors, wax-chandlers, bookbinders and book illuminators, who lived outside the water-gate, had their workshops within the abbey precincts; similar arrangements prevailed in other great monasteries.

It is also known that important university towns had scribes and illuminators who worked on a fixed tariff of charges. Particular mention should be made of the guild of binders, scribes and illuminators of the University of Paris.

It has also been suggested that there were numerous travelling groups of artists and urban bookshops, and that between these various systems of book production there was a considerable degree of overlapping. For the famous Italian *botteghe* (or "shops") see the volume on *Illumination and Binding*.

Fig. V–13–16 reproduce some interesting medieval codices. See also Chapters VII and X.

COPYING A PARCHMENT CODEX

Since parchment has two distinct sides, care was generally taken in putting together the sheets for the quire (see pp. 163 and 215) to

Fig. V–16

The *Chanson de Roland*, a French epic of the Carolingian cycle, probably of Norman origin (eleventh century A.D.), is the greatest heroic poem of the Romance period. The specimen here reproduced is from the earliest known manuscript of this celebrated poem (Bodleian Library, at Oxford, *MS. Digby 23*, fol. *43, recto*).

lay them in such a way that hair side faced hair side, and flesh side faced flesh side.

Thus, when the book was opened, the two pages before the reader had the same appearance, either flesh side or hair side. It seems that in the Greek codices, with little exception, the first page of the quire was the flesh side; while in the Latin codices, it was the hair side. A great number of books being left unbound, many scribes usually left blank the first leaf, or at least the *recto* of the first leaf; the blank page or leaf was intended to give some protection against tear and wear.

RULING

After the decision as to the style and size of the script to be employed—the largest style being naturally reserved for books to be used for public services—the margins of the pages were determined by holes pricked with a compass or awl (*punctorium*), and by lines drawn from hole to hole with a hard-pointed instrument or stilus of iron or wood (*ligniculum*) and a ruler (*regula* or *norma*); space was left for illuminations. Guide lines for the individual lines of writing were also ruled (the term for "to rule" was *sulcare*) with the stilus, which made a little furrow in the parchment (and, naturally, raised a ridge on the other side). In some early codices ruling was not drawn for every line of writing, but was occasionally spaced, so that some lines of the text lay in the spaces and some stand on the ruled lines. (It may be mentioned that in the Dead Sea Scrolls —see pp. 176–189—the letters were not written on the line, but were suspended from it, so that the effect produced was a very regular top line, except for the letter *lamed*, and a less regular lower line, made even worse by an elongated form of the final *mem*.)

Ruling with the lead point or plummet came into use in the eleventh century, and in the thirteenth century it became more or less general. In fifteenth-century manuscripts we find also lines ruled with ink. In earlier manuscripts the prickings are often within the width of the text column, and the horizontal lines were not confined within the longitudinal boundaries of the text. In later codices, however, it was the custom to prick off the spaces close to the margin, and to keep the ruled lines within the boundaries of the text, and often the prickings disappeared when the edges were cut off by the binder.

The normal practice of ruling was as follows: Unfolded bifolia were selected and laid "on top of the other, flesh facing flesh and hair

facing hair. . . . Then followed the ruling guided by the prickings previously made. Some scribes ruled each bifolium separately— this is seen in some of our oldest manuscripts—others preferred to rule by pairs; the majority, however, ruled all the bifolia at the same time. . . . Once ruled, the bifolia were folded in two to form a gathering. In Insular manuscripts ruling generally preceded folding" (Lowe). See also p. 215. There are some exceptions, however.

COLUMNS

Anciently the text might be written across the face of the page (especially in poetical works), though generally speaking—continuing the arrangements of the papyrus roll (see p. 135 ff.)—the page was arranged in columns: there were ordinarily two columns, but sometimes—especially in earlier codices or in exact copies of earlier ones—there were three or four.

Indeed, the two great volumes which head the roll of vellum manuscripts of the Greek Bible, the *Codex Vaticanus* and the *Codex Sinaiticus*, having relatively narrow columns, show that they were copied from rolls rather than from codices (see p. 197). Further experience, however, showed the advantage of a wider column. Hence, from the fifth century onwards the arrangement with two columns to the page in the large vellum codices became normal; though occasionally we find such manuscripts with single columns to the page.

SEPARATION OF WORDS

In early codices (with some exceptions, however), as in papyrus rolls (see p. 158 ff.), and down to about the ninth century, the text was written continuously without separation of words. When the minuscule writing came into use as the literary hand (see *The Alphabet*, pp. 547 ff.), separation of words from one another gradually followed, but even then the scribes used to attach short words, for instance prepositions, to the words which immediately followed them, and also to detach a final letter of a word, attaching it to the next following word. In Latin manuscripts, a perfect system of separately written words was established about the eleventh century, whereas in the Greek manuscripts the system was at no time perfectly followed.

The first lines of the main divisions of the text, such as the "books" of the Bible or of the *Iliad*, were often written in red for distinction. The initial letters of sections or chapters, as well as

rubrics, titles and colophons, were at first written in the same characters as the text, though the first letter of each page was often made larger than the rest. At a later time different style was used; for instance, in codices written in minuscule the rubrics, titles and colophons might be in capitals or rustic capitals (for this terminology see *The Alphabet*, pp. 541 ff.).

DIVISION OF WORDS BETWEEN ONE LINE AND ANOTHER

In the division of words at the end of the line, the latter generally broke off with a syllable, but there were exceptions: in Greek codices, in the case of compound words, the last consonant of the prefix or of the preposition (and, in some other instances, single consonants, especially the *sigma*) was carried to the next syllable if this began with, or was a vowel; in Latin codices, when two consonants came together, they were generally assigned to their several syllables (*par-tem, scrip-sit, misericor-dia*), but sometimes, under Greek influence, we may find *pa-rtem, scri-psit, miserico-rdia*. This division of words between one line and another is indicated in earlier manuscripts by a dot; the dividing stroke, or hyphen, appears in the eleventh century, and becomes more systematic in the twelfth century, but then it is also repeated at the beginning of the next line. In order to avoid division of a word, and perhaps also to save space, towards the end of the line the letters were often written in smaller characters.

DIVISION OF PARAGRAPHS

As in papyrus rolls, the paragraphs were at first not distinguished by blank space, but by a horizontal dividing stroke (in Greek, *parágraphos*), or else a wedge (*diplê*), which was inserted at the beginning of the new paragraph. At a later stage, the first letter of the new paragraph was made prominent, by making it project slightly into the margin, and by writing it in a larger character.

PUNCTUATION

A regular system of punctuation—consisting of the high point (corresponding to our full stop), the point on the line (corresponding to our semicolon), and the point in a middle position (corresponding to our comma)—is ascribed to Aristophanes of Byzantium (*c.* 260 B.C.): it was developed in the school of the Alexandrian grammarians (see p. 155). This system of points, or *positurae*, was accepted by the

Latin grammarians—the terms being *distinctio finalis, subdistinctio,* and *distinctio media*—but was never employed consistently. In early uncial manuscripts we find the point used as a stop; and a colon, or colon and dash, or a number of points used as a final stop of a paragraph or chapter; in the seventh century we find the high point (=comma), the semicolon (with its modern value), and a combination of points and dashes (=full stop).

In the eighth century, there appears the inverted semicolon (a sort of middle way between our semicolon and comma), the comma, and the interrogation mark. Other marks are found in both Greek and Latin manuscripts, such as the private marks of correctors or readers. There are also critical symbols, such as that known as *diplê* and the asterisk used by Aristarchus in the texts of Homer, or the asterisk and a sign called *obelus* employed by St. Jerome to distinguish certain passages in versions of the Latin Psalter.

CORRECTORS, RUBRICATORS AND ILLUMINATORS

When the quire was completed, it was checked by a *corrector*, who compared the written copy with its original; afterwards, it was sent to the rubricator, who added (in red or other colours) the titles, headlines, the initials of chapters and sections, the notes, and so on; and then—if the book was to be illustrated it was sent to the illuminator. Finally, when all quires were written, corrected, rubricated, and illuminated, the book was sent to the binder.

COPYISTS: THEIR BLUNDERS

What we have of ancient literature, including the Bible and its translations, and classical works, as already mentioned, are only such as have come down to us through manuscripts copied by hand, often several times removed from the original. It can be accepted, therefore, that, generally speaking, a text—especially if it is the translation of a copy, or a translation from such a translation—does not correspond in some respects with the original, and the danger of faulty judgments or beliefs based on inaccurate texts is now so well recognized by scholars that texts are studied in the light of this possibility.

The copyists did their best to be as accurate as possible, but the human hand and brain have not been created which could copy the whole of a long work without mistakes. Besides, in early times, the copies were made hurriedly and without opportunity for accurate

revision; the copyists were often half educated, half illiterate. Thus, mistakes were certain to creep in, and when once in existence, they were certain to remain and to increase. The scribe was not allowed to make any alteration in the text, even when the original was obviously wrong.

The sources of error in transcription are so various that any attempt to enumerate and classify them must be very incomplete. Sir Frederic Kenyon distinguished three kinds of errors.

(1) *Errors of Hand and Eye:* the copyist confuses words of similar sound (as in English *there* and *their, here* and *hear*). It is known that in later antiquity the *librarii* often employed dictation; a manuscript was read aloud and copied by several scribes simultaneously, hence the frequent errors due to confusion of sounds. More frequent, however, were errors due to the influence of the immediate context. Sometimes two successive lines of the manuscript, which was being copied, ended with the same or similar words, and the copyist's eye slipped from the first to the second, and omitted a line: such omission is called *homoioteleutón* ("similarity of endings"). The main errors of the eye are confusions of letters (such as E–F in majuscules, *s–f* in minuscules, *c–e* in the Carolingian minuscules, *c–t* in the black-letter); omissions or transpositions or additions of letters; confusions of words or abbreviations; loss of letters, syllables, words or lines through some similarity in lettering (*homoiographón*), especially where similar letters stand next to each other in the line (*haplógraphy*); *dittógraphy*, or "repetition" of letters, a group of letters, or words, or even of lines.

(2) *Errors of Mind:* the copyist's mind wanders a little from the book he is copying, just as we do nowadays when we are distracted. So, for instance, when the same event is narrated in two or more different versions, the copyist unconsciously alters the words of the one version to make them the same as those of the other; also the phonetic confusions; the transpositions of parts of words, or words, or even of one or more lines; the grammatical assimilations to the context, and similar instances.

(3) *Errors of Deliberate Alteration:* intentional alterations, *in bona fide*, of a phrase to suit the narrative of another, or the combination of two reports of some utterance into one: hence, there is a conscious tampering with the text by way of substitution, or, especially, of addition, which is known as "interpolation". Quite often an editor attempted to fill the ancient gaps; for instance, according to Strabo, Apellicon (*c.* 100 B.C.) attempted to supply what was missing in a damaged text of Aristotle.

PARCHMENT CODICES (Fig. V–10,c)

The arrangement of the leaves of ancient parchment or vellum books was essentially the same as that of modern books. Originally, the books consisted of sheets, each forming two leaves—hence the term *folio* (from Latin, meaning "sheet"); but normally the parchment book was composed of a series of quires fastened together. A "quarto" volume, called *tetrádion* in Greek, *quaternus* or *quaternio* in Latin, now *cahier* in French and "quire" in English, was formed of four sheets of vellum or parchment (about 10 inches high and 18 inches wide), folded down the middle and placed one inside the other; thus giving eight leaves or sixteen pages. They were fastened, or rather threaded together by the means of a string, thread or fibre, passing down the middle of the crease of the innermost sheet of the quire, and running from the innermost fold right through to the outermost, thus holding the leaves firmly together.

Many variations of form, both smaller and larger than *quarto* are found, and we find also quires of six, ten and twelve leaves. A quire consisting of five sheets (*i.e.* ten leaves or twenty pages) was called *quinternio* ("quinternion").

The quires fastened together to form a book were marked (so that their order might not be lost), and sent to the scribe or copyist to write on, and were eventually bound.

On the whole, "It stands to reason that not all writing centres followed the same method in the manufacture of a book. Since this was a craft, it had a technique, and different schools had different practices. Thus, for example, some centre or centres in North-East France, easily recognizable by certain script peculiarities, had a special way of ruling and arranging the leaves. . . . The same practice . . . may have a bearing on the question of the manuscript's home. Furthermore, the general observation regarding Insular manuscripts . . . is found to be valid for most of the Irish and Anglo-Saxon items, namely that Insular scribes had a tendency to rule the membranes after the bifolia were folded into a gathering, with the direct impression on the recto side of folios, now on each recto, now on alternate rectos, and occasionally, when the lines seemed too faint, even on the verso" (Lowe). See also p. 205 ff.

PALIMPSESTS (Figs. V–17–20, VI–14, and X–7, *a*)

It has already been mentioned that one of the main advantages of parchment was that writing could be washed or scraped off, so that the parchment could be used again. This practice was due to the

Fig. V-17

Greek palimpsest (Trinity College, Dublin, *MS. K.3.4.A., No. 28*); lower script,
Codex Z (*Gospel of St. Matthew*), written in Greek uncials of the sixth century A.D.

scarcity and high cost of writing material. The term *palimpsest* (from Greek *palímpsestos*, "scraped again") is already used by classical writers, such as Catullus (*Carm.*, xxii, 5), Cicero (*Ad Fam.*, xii, 18), and Plutarch (*Cum princip. Philosoph.*, ad fin.), but the passages in question refer mainly to papyrus (and once to waxen tablets), from which the ink could be washed off, but not scraped or rubbed, whereas the word must have been applied originally—as it was applied in later times—to material strong enough to bear such treatment as parchment or waxen tablets. However, it is also

Fig.–V 18

One of the most interesting palimpsests (Vatican Library, *Cod. Lat. 5750*, and Ambrosian Library, Milan, *E.147, sup.*). The primary text of the page here shown, written in Gothic uncials of the sixth century, contains a Mesogothic *Commentary* to the *Gospel of St. John*.

possible that the term became so commonly used as to have passed beyond its strict meaning.

A great destruction of vellum manuscripts of the early centuries of our era must have followed the fall of the Roman empire; political and social changes interfered with the market, and writing material would thus become scarce, and might well have been supplied from manuscripts which had become useless and were considered mere

Fig. V–19

Latin-Hebrew palimpsest (University Library, Cambridge, *Add. MS. 4320*), found in the Cairo *Genizah.*

encumbrances of the shelves. In the case of Greek manuscripts, so great was their clearance that a synodal decree of the year 691 forbade the destruction of manuscripts of the Scriptures or of the Fathers, imperfect or injured volumes excepted. Indeed, no entire work has been found in the original text of a palimpsest; we may, therefore, assume that only portions of different manuscripts were taken to make up a volume for a second text.

Palimpsests (in Latin they were also called *codices rescripti*) were

most common between the seventh and ninth centuries—indeed, the most valuable Latin texts are found in the volumes which were re-written in this period; the employment of palimpsests, however, continued even down to the sixteenth century. In the earlier centuries the works of classical writers were obliterated to make room for patristic literature or grammatical works; in the later centuries classical works were written over Biblical manuscripts.

The practice was as follows: the old writing was scraped off with a scraping knife or razor, or with pumice, and a mixture of cheese, milk, and lime was used to soften the vellum. If the first writing were thoroughly removed, none of it, of course, could ever be recovered. But, in point of fact, it was often very imperfectly effaced; the ink of the old writing had penetrated so deeply into the vellum that even severe scraping could not remove all traces of the text. Even if, to all appearances, the parchment was restored to the original condition of an unwritten surface, yet when the manuscript is soaked in certain chemicals, the blue or red outlines of the old writing appear again; even the action of the atmosphere might intensify the old ink, and make the former text legible.

Unfortunately, after chemical treatment—primarily with acid obtained from oak gall—the manuscript became so dim that it was impossible to read it. More recently, in place of tannic acid, substances such as hydrosulphide of ammonia were used; these brought out the old writing for a short time, and while the text was thus visible, photographs were taken; then the chemicals were washed out. Nowadays, photographs of the old writing can be taken without any chemical treatment, simply by employing infra-red or ultra-violet photography, or fluorescence. Many valuable manuscripts which had been lost, including codices written in capital and uncial styles of writing have thus been recovered from palimpsests.

Fig. V–20 shows part of folio 193 of the *Codex Sangallensis* known as *Codex* Δ, containing the Gospels in Greek, written in small half-uncials of western type, while the later text is written in Latin, in Insular minuscules. The photograph was taken by using the method of ultra-violet rays developed from the researches of Prof. G. R. Koegel of Vienna.

Sometimes the palimpsests are bilingual, the old writing being Greek and the new writing Latin; or the old, Syriac and the new, Arabic; or Hebrew and Latin. There are even, though rare, instances of double palimpsests, *i.e.* in which there appear three successive writings. A manuscript of the British Museum (Add. MS. 17212), which comes from the great collection of manuscripts of

Fig. V–20

Palimpsest photographed by ultra-violet light. On the left is seen part of the *Codex Sangallensis* photographed under ordinary light, and on the right the same portion under ultra-violet, the palimpsest being shown transversely. (From *Antiquity*.)

the Nitrian Desert in Egypt (see p. 301) is of that description: a Syriac translation of St. Chrysostom's *Homilies*, of the ninth or tenth century, covers a Latin grammatical treatise, written in cursive minuscule of the sixth century, which again displaced the *Annales* of the Latin historian C. Granius Licinianus (who lived in the first half of the second century A.D.) written in uncials of the fifth century. Another interesting palimpsest, from the Nitrian Desert collection, is a work of Severus of Antioch of the early ninth century, written on leaves taken from manuscripts of the *Iliad* and the *Gospel of St. Luke* of the sixth century, and of the *Elements* of Euclid of the seventh or eighth century.

The idea of using palimpsest manuscripts for the recovery of earlier works was first taken up at the end of the seventeenth century, when attention was called to the Biblical text (portions of the Old and New Testaments in Greek, of the fifth century), underlying the works of St. Ephraem of Syria, written in a hand which may be assigned to the twelfth century. The palimpsest in question is the *Codex Ephraemi* (see p. 202), now in the National Library in Paris, having been brought from the East to Italy early in the sixteenth century, and taken to Paris by Queen Catherine de'Medici

One of the most important palimpsests is a Vatican manuscript (*Vat. Lat. 5757*) containing portions of Cicero's *De Republica*, of the fourth century, written under the work of St. Augustine on the Psalms, of the seventh century (Fig. VI-14). The earlier manuscript, written "in a large and massive style . . . must have formed a large volume which . . . was presumably an *edition de luxe* on a scale which could not often have been repeated" (E. Maunde Thompson). Cardinal Angelo Mai published in 1814-15 the *Codex Ambrosianus* (Ambrosian Library, at Milan, *G.28 sup.*) of Plautus, written in rustic capitals of the fourth or fifth century under a Biblical text of the ninth century. A famous Verona palimpsest—discovered in 1816 by Niebuhr—contains the only extant fragment of the *Institutions* (being an Introduction to Roman Jurisprudence) of the eminent jurist Gaius (A.D. *c.*110 – *c.*184), and the *Fasti Consulares* of the years A.D. 487-94; the former is written in an interesting literary hand of mixed uncial and minuscule letters ascribed to the fifth century, while the latter is written in the half-uncial literary hand.

Even more curious are a manuscript of the Ambrosian Library, at Milan (*Cimelio MS. 3*), and a Vatican codex (*Palatinus, Lat. 24*), the former being a portion of Virgil (140 folios are extant), in semi-uncial of the fifth or sixth century A.D., "all rewritten, some more than once"; the upper script is Arabic of *c.* 1100 (it is a copy of a

Christian work); "the lower scripts include Hebrew, Syriac, Greek, Coptic and Latin; the Latin apparently much the oldest" (Lowe). The Vatican manuscript, a fragmentary copy of the Old Testament, written (probably at Lorsch) mainly in eighth-century uncials, a small portion being in ninth-century minuscule, consists partly of palimpsest leaves and partly of non-palimpsest leaves, which in Prof. Lowe's opinion are evidently a restoration of a portion of older palimpsest leaves. The earlier scripts of the preserved palimpsest leaves show portions of the following works or authors: Seneca (written in fifth-century uncials), Lucan (Rustic capitals, fourth or fifth century), Hyginus (uncials, fifth century), a Greek medical fragment (Greek sloping uncial, fifth century), Fronto (Rustic capitals, fourth or fifth century), an oratorical fragment (quarter uncial, fifth or sixth century), Livy (Rustic capitals, fourth century), Aulus Gellius (Rustic capitals, fourth century), Cicero, *Pro Rabirio* and *pro Roscio Comoedo* (uncials, fifth century). Another curious palimpsest is reproduced on Fig. V–18. Primary texts of this codex —apart from the *Mesogothic Commentary*—are Cicero, Fronto, Symmachus, Pliny, Juvenal, Persius, and *Tractatus Arianorum.* They are written in Latin rustic capitals, uncials and half-uncials of the fifth or sixth century. The upper text (*Acta Synodi I Chalcedonensis*) was written in Bobbio in the seventh century. (See also p. 461 and Fig. X–7, *above.*)

The Ultra-Violet Method

Mr. Leonard V. Dodds gives the following description of the ultra-violet method: Ultra-violet rays "are generated by a lamp of the familiar mercury vapour type. In this instrument a direct current of electricity is passed through the vapour of molten mercury contained in a quartz generator, and electrons in the form of ultra-violet energy are driven off similarly to X-rays. The burner is housed in a box-like structure with suitable arrangements for observation and insertion of the camera lens, and all rays emitted by the lamp other than the ultra-violet are screened from the subject examined by the provision of a special filter which is permeable to this group only. Consequently the manuscript is illuminated by a beam of invisible ultra-violet rays only. In some lamps a solution of copper-sulphate and a deep orange-dye, nitrosodimethylanaline, is used to make the filter, and this is contained between sheets of uviol blue glass, but in the Hanovia apparatus, one of the most widely used, this type of filter has been superseded entirely by a new glass, almost black in colour, which transmits the ultra-violet rays only. . . .

When an old manuscript is examined in this way, the tints and dyes left in the parchment from the earlier writings fluoresce distinctly from those of the visible text and from the parchment itself, and the palimpsest can easily be distinguished. By using a special filter the later writings may be eliminated and a photograph taken of the earlier script only, but it is of probably greater interest to see the two texts on one print. The visible writings appear as if in outline type, that is white letters with a narrow black edge, and underneath, or often transversally, may be seen the dark grey lettering of the original text. Slight imperfections due to the varying action of the cleaning process are to be expected, but it is seldom that any difficulties in deciphering occur which are due to visibility". "It is an extraordinary development of science which thus enables writing erased so long ago to be read again, and while the ability to photograph the fluorescence makes a permanent record ready for immediate reference, testing with ultra-violet rays has the great advantage over other methods using chemicals which might be employed, in that no damage is caused to the existing writings." (Quoted with permission from *Antiquity*.) See Fig. V–20.

BIBLIOGRAPHY

Palaeographical Society and New Palaeographical Society, *Facsimiles of Manuscripts*, etc. (ed. by E. A. Bond, E. M. Thompson, G. F. Warner, F. G. Kenyon, and G. P. Gilson), two series each, London, 1873–83, 1884–94, 1903–12, 1913–30. Indices, 1901, 1914, 1932.

J. T. Gilbert, *Facsimiles of National MSS. of Ireland*, Dublin, 1874–84.

W. Wattenbach and C. Zangemeister, *Exempla codicum Latinorum*, etc., Heidelberg, 1876 ; —— and A. von Velsen, *Exempla codicum Graecorum*, etc., Heidelberg, 1878.

L. Delisle, *Mélanges de paléographie et de bibliographie*, Paris, 1880; *Notice de douze livres royaux*, etc., Paris 1902; *Recherches sur la librairie de Charles V*, Paris, 1907.

E. M. Thompson and G. F. Warner, *Catal. of Ancient MSS. of the British Museum*, etc., 2 parts, (I, Greek ; II, Latin), London, 1881–4.

G. Vitelli and C. Paoli, *Collezione fiorentina di fascimili paleografici greci e latini*, 4 vols., Florence, 1884–97.

E. Chatelain, *Paléographie des Classiques latins*, 2 vols., Paris, 1884–1900; *Uncialis scriptura codicum Latinorum*, etc. Paris, 1901–2; *Les Palimpsests latins*, Paris, 1903.

W. Wattenbach, *Anleitung zur lateinisch. Palaeographie*, 4th ed., Leipsic, 1886, *Das Schriftwesen im Mittelalter*, 3rd ed., Leipsic, 1896; *Scripturae Graecae specimina in usum scholarum*, 4th ed., Berlin, 1936.

F. Battifol, *Librairies byzantines à Rome*, "MÉL. D'ARCHÉOL. ET D'HIST." 1888.

A. Palma di Cesnola, *Catalogo di MSS. ital. esistenti nel Museo Britannico di Londra*, Turin, 1890.

E. Sackur, *Die Cluniacenser*, etc., 2 vols., Halle, 1892.

S. Berger, *Histoire de la Vulgate*, etc., Paris, 1893.

British Museum, *Catal. of the Stowe MSS.*, 2 vols., London, 1895–6; *Guide to the Exhibited MSS.*, London, 1911; Part II, new ed., London, 1923; repr., 1927; *A Guide to Some Parts of the Egerton Collection of MSS.*, etc., London, 1929; *A Guide to a Select Exhibition of Cottonian MSS.*, London, 1931. See also the Catalogues of the various collections and of the Additional manuscripts.

E. Woelfflin, ed., *Benedicti Regula Monachorum*, Leipsic, 1895.

M. R. James, *Descriptive Catalogues of MSS.* (*Eton College; Fitz-william Museum; Jesus College, Trinity, King's, Peterhouse, Queens', Gonville and Caius, Clare, Corpus Christi, Christ's, Emmanuel, Pembroke,* etc., of Cambridge; *Lambeth Palace, Westminster Abbey;* the *John Rylands Library*, and so on), Cambridge, 1895 onwards; —— and A. H. Thompson, *Abbeys*, London, 1925.

R. Priebsch, *Deutsche Handschriften in England*, Erlangen, 1896.

Cte. de Montalembert, *The Monks of the West*, etc., London, 1896.

W. M. Lindsay, *An Introduction to Latin Textual Emendation*, etc., London, 1896; *Palaeographia Latina*, 6 vols. Oxford, 1922–9; —— and E. Carusi, *Monumenti paleografici veronesi*, Rome, 1929.

A. Ebner, *Quellen und Forschungen zur Geschichte des "Missale Romanum"*, Fribourg, 1896.

H. W. Johnston, *Latin Manuscripts*, Chicago, 1897.

H. Denifle, *La Désolation des églises, monastères . . . en France*, etc., 2 vols., Paris, 1897–9.

K. Wessely, *Schrifttafeln zur aelteren lateinischen Palaeographie*, Leipsic, 1898.

C. Malagola, *Sunti dalle lezioni . . . di paleografia*, etc., Bologna, 1899.

F. Carta, C. Cipolla, and L. Frati, *Monumenta Palaeographica sacra*, etc., Turin, 1899.

F. G. Kenyon, *Facsimiles of Biblical MSS.*, London, 1900; *The Story of the Bible*, London, 1936; *Text of the Greek Bible*, 2nd ed., London, 1949.

Biblioteca Vaticana, *Codices e Vaticanis selecti*, etc., Series major, Rome, 1902 onwards; Series minor, Rome, 1910 onwards; *Collezione paleografica vaticana*, Milan, 1906; *Exempla scripturarum*, etc., Rome, 1929 onwards.

Rohault de Fleury, *Gallia Dominicana*, etc., 2 vols., Paris, 1903.

J. O. Hannay, *The Spirit and Origin of Christian Monasticism*, London, 1903.

F. A. Gasquet, *English Monastic Life*, London, 1904.

W. Arndt and M. Tangl, *Schrifttafeln zur Erlern. d. latein. Palaeogr.*, I–II, 4th ed., Berlin, 1904–6; III, 2nd ed., 1907.

A. Muñoz, *I codici greci delle minori biblioteche di Roma*, Florence, 1906.

L. David, *Les grandes Abbayes de l'Occident*, Lille, 1907.

J. Chapman, *Notes on the Early History of the Vulgate Gospels*, Oxford, 1908.

M. Vogel and V. Gardthausen, *Die griech. Schreiber d. Mittelalters*, etc., Leipsic, 1909.

S. G. de Vries, *Album Palaeographicum*, etc., Leiden, 1909.

L. Traube, *Vorlesungen und Abhandlungen*, ed. by F. Boll, 3 vols., Munich, 1909–20.

A. Chroust, *Monumenta Palaeographica. Denkmaeler der Schreibkunst des Mittelalters*, new ed., Munich, 1909.

L. von Sybel, *Christliche Antike*, Marburg, 1909.

Monumenta Palaeographica Vindobonensia, Leipsic, 1910 onwards.

K. Lake, *Codex Sinaiticus*, 2 vols., Oxford, 1911 and 1922.

V. Gardthausen, *Griechische Palaeographie*, 2nd ed., Leipsic, 1911–13.

L. Havet, *Manuel de Critique verbale appliquée au textes latins*, Paris, 1911.

F. Steffens, *Proben aus griechischen Handschriften und Urkunden*, Tréves, 1912; *Lateinische Palaeographie*, 2nd ed., Berlin, 1929.

F. Ehrle and P. Liebaert, *Specimina cod. Latin. Vatican.*, Berlin, 1912; 2nd ed., 1927.

A. H. Thompson, *English Monasteries*, Cambridge, 1913 (2nd ed., 1923); *The Historic Monuments of England*, London, 1924; *Bede*, etc., Oxford, 1935. (See also M. R. James.)

Codices ex ecclesiasticis Italiae bybliothecis selecti, etc., Rome, 1913– .

J. Bédier, *Les Légendes épiques*, etc., 4 vols., 2nd ed., Paris, 1914–21.

J. Muñoz y Rivero, *Manual de Paleografía diplomatica española*, etc., 2nd ed., Madrid, 1917; *Paleografía Visigoda*, etc., new ed., Madrid, 1929.

A. C. Clark, *The Descent of Manuscripts*, Oxford, 1918.

E. Bishop, *Liturgica historica: Papers on the Liturgy and Religious Life of the Western Church,* Oxford, 1918.

P. Scheuten, *Das Moenchtum in d. altfranz. Profandichtung,* etc., Muenster i. Westf., 1919.

L. M. Smith, *The Early History of the Monastery of Cluny,* Oxford, 1920.

U. Berlière, *L'Ordre monastique,* etc., Paris and Maredsous, 1921.

G. F. Warner and J. P. Gilson, *Catal. of Western MSS. in the Old Royal and King's Collections (British Museum),* 4 vols., London, 1921.

H. Quentin, *Mémoire sur l'établissement du text de la Vulgate,* Rome, 1922.

N. Barone, *Paleografia latina,* etc., 3rd ed., Naples, 1923.

G. G. Coulton, *Five Centuries of Religion,* 3 vols., Cambridge, 1923–36.

J. Huizinga, *The Waning of the Middle Ages,* London, 1924.

O. Schissel, *Kataloge griechischer Handschriften,* Graz, 1924.

E. C. Butler, *Benedictine Monachism,* 2nd ed., London, 1924; *Western Mysticism,* 2nd ed., London, 1927; *Sancti Benedicti Regula monasteriorum,* Stanbrook, 1930.

M. Prou, *Manuel de paléogr. latine et française,* 4th ed., Paris, 1924.

S. H. O'Grady and F. Flower, *Catal. of Irish MSS.,* 2 vols., London, 1926.

D. H. S. Cranage, *The Home of the Monk,* Cambridge, 1926.

B. Bretholz, *Latein. Palaeogr.,* "Grundr. d. Geschichtswissensch.", 3rd ed., Leipsic, 1926.

C. G. Crump and E. F. Jacob, *The Legacy of the Middle Ages,* Oxford, 1926 (repr., 1948).

F. J. E. Raby, *A History of Christian-Latin Poetry,* etc., Oxford, 1927.

S. R. K. Glanville, *Leather Roll British Museum 10250,* "JOURN. OF EGYPT. ARCHAEOL.", 1927.

C. H. Haskins, *The Renaissance of the Twelfth Century,* Cambridge (Mass.), 1927.

R. Graham, *English Ecclesiastical Studies,* London, 1928.

A. A. Vasiliev, *History of the Byzantine Empire,* 2 vols., Madison (Wis., U.S.A.), 1928–29 (*Histoire de l'Empire byzantin,* 2 vols., Paris, 1932).

P. F. de'Cavalieri and J. Lietzmann, *Specimina codicum graecorum Vaticanorum,* 2nd ed., Bonn, 1929.

G. Morin, *L'Idéal monastique,* 4th ed., Paris, 1929.

T. A. Cook and W. H. Ward, *Twenty-five Great Houses of France,* London, n.d.

G. Vittani, *Nozioni elementari di paleografia*, etc., Milan, 1930.

M. Ihm, *Palaeographia Latina*, 2nd ed., Leipsic, 1931.

J. Evans, *Monastic Life at Cluny 910–1157*, Oxford, 1931; *Cluniac Art*, etc., Cambridge, 1950.

F. Doelger, *Facsimiles byzantinischer Kaiserurkunden*, Munich, 1931.

A. Milares Carlo, *Tratado de paleografía española*, 2nd ed., Madrid, 1932.

R. E. Swartwout, *The Monastic Craftsman*, Cambridge, 1932.

Z. Garcia Villada, *Paleografia española*, etc., Madrid. 1932.

A. Wilmart, *Auteurs spirituels et textes dévots du moyen âge latin*, Paris, 1932.

K. Young, *The Drama of the Medieval Church*, Oxford, 1933.

M. Heimbucher, *Die Orden und Kongregationen der kathol. Kirche*, 2 vols., 3rd ed., Paderborn, 1933–34.

E. A. Lowe, *Codices Latini Antiquiores*, Oxford, 5 vols., 1934–50.

A. Bruel, *Romans français du moyen âge*, Paris, 1934.

K. and S. Lake, *Monumenta palaeographica vetera. Dated Greek Minuscule MSS.* etc., Boston (Mass.), 1934–40.

F. II. Crossley, *The English Abbey*, etc., London, 1935 (3rd ed., 1949).

G. Battelli, *Lezioni di Paleografia*, Vatican City, 1936 (3rd ed., 1946).

G. Baskerville, *English Monks and the Suppression of the Monasteries*, London, 1937; —— and H. E. Roberts, *Notes on the Medieval Monasteries*, etc. 1949.

A. Bruckner, *Scriptoria Medii Aevi Helvetica*, Geneva, 1938.

L. Brehier and R. Aigrain, *Grégoire le Grand*, etc., Paris, 1938.

H. J. M. Milne, T. C. Skeat, and D. Cockerell, *The Codex Sinaiticus and the Codex Alexandrinus*, London, 1938.

W. H. P. Hatch, *The Principal Uncial Manuscripts of the New Testament*, Chicago, 1939.

J. Westfall Thompson, *The Medieval Library*, Chicago, 1939.

Mallon-Marichel-Perrat, *L'écriture latine*, Paris, 1939.

D. Knowles, *The Religious Houses of Medieval England*, London, 1940; *The Religious Orders in England*, Cambridge, 1948.

G. W. Beard and A. R. Billington, *English Abbeys*, Worcester, 1949.

See also BIBLIOGRAPHY to Chapters IV, VI, VII and VIII.

GREEK AND LATIN BOOK PRODUCTION

No original manuscript of any ancient Greek or Roman author (and for that matter of any ancient Hebrew, Indian or Chinese author) has yet come to light, and it generally comes as rather a shock when one first learns that the oldest manuscripts extant are sometimes separated by many centuries from the date at which the writings in question were originally composed. Perhaps a millennium separates the earliest Homeric manuscript extant—which has come down to us in fragments only—from the period in which these famous poems were composed, poems with which the matured literature of Greece and of Rome begins. And little, if anything, is known of the earlier and ruder stages of Greek literature.

Greece

The question of Greek book writing and book production in the first half of the first millennium B.C. presents various problems.

THE HOMERIC POEMS (Fig. VI-1, 2, *above*)

The traditional dates for the composition of the Homeric poems vary between the eleventh and the ninth century B.C. Some modern scholars prefer the ninth, some the eighth, and others the seventh century B.C., some suggest even a later date. Sir Frederic Kenyon is probably right in suggesting the ninth century as the latest date for Homer.

Were the Homeric poems composed in writing? The majority of scholars deny it, but Sir Frederic Kenyon's opinion cannot easily be dismissed. He admits that the feat of memorizing poems of such length is not incredible: the poems, once composed, could have been recited; but it is difficult to believe that they could have been carried

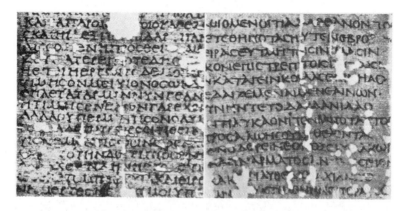

a *b*

c

Fig. VI-1

Homer manuscripts written on papyrus. *a*, Berlin Pap. 6869 (first century B.C.);
b, Fayyûm, No. VI (period of Augustus); *c*, British Museum Pap. 126 (fourth
century A.D.).

in the memory of the poet during the process of composition, and that the poet, after completing them, assembled a corps of rhapsodists around him; and recited his work over and over until they had committed it to memory.

There is an even stronger case for Hesiod's *Works and Days*. It seems incredible that such a poem should have survived unless it had been written down. "The same might perhaps be said of the poems of the Epic Cycle. . . . And if the works of Hesiod and the Cyclics were written down, it is surely straining at a gnat to refuse to allow the same to Homer." Sir Frederic Kenyon, therefore, concludes that "sober criticism must allow that the *Iliad* and *Odyssey* were composed in writing, and that written copies of them existed to assist the rhapsodists who recited them and to control their variations". On the other hand, such written copies were rare, and were only used by professional reciters; there was no reading public, and the normal method of publication was by recital.

SEVENTH AND SIXTH CENTURIES B.C. (Fig. VI–2, *below*, and 3, *above*)

In the seventh and the sixth centuries B.C. Greek literary writing was widely spread, though the recitations of the rhapsodies continued. It was the great period of martial elegy (Callinus of Ephesus, 660 B.C.; Tyrtaeus, *c.* 640 B.C.), erotic elegy (Solon, sixth century B.C., and Phocylides of Miletus) and commemorative elegy (Archilochus, seventh century; Sappho, *c.* 610–565 B.C.), of iambic poetry, such as satire (Archilochus; Semonides of Amorgos, *c.* 640 B.C.; Hipponax of Ephesus, *c.* 540 B.C.), of melic or lyric poetry (Terpander of Lesbos, *c.* 710–670 B.C.; Sappho and the slightly older contemporary Alcaeus—Fig. VI–3, Anacreon of Teos, *c.* 550–500 B.C.), of choral lyric (Thaletas of Crete, *c.* 670–640 B.C.; Alcman, *c.* 640–600 B.C.— Fig. VI–2 (see p. 245); Stesichorus of Himera, Sicily, *c.* 640–555 B.C.; Ibycus, *c.* 550 B.C.; Simonides of Ceos, born in 556 B.C.; Greek lyric reaches its zenith with Pindar (*c.* 518–*c.* 445 B.C.).

While there is no doubt that written copies of the poems circulated in fairly high numbers, it is uncertain whether their authors gathered them together into collections such as those which existed in Hellenistic times (Sappho's odes, for instance, were arranged in nine volumes; the odes of Alcaeus in six volumes). The existence of an organized book trade at the time is also improbable.

FIFTH CENTURY B.C. (Fig. IV–15, *a*, VI–7 and 8)

With Aeschylus (born in 525 B.C.), Sophocles (born *c.* 496),

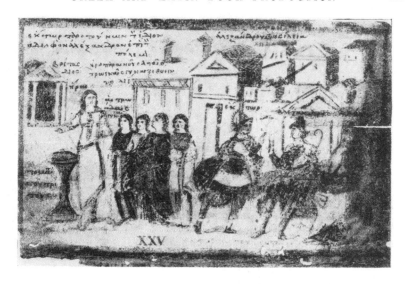

Fig. VI-2

(*Above*) The *Ambrosian Iliad* (Ambrosian Library, Milan, *Codex F.205, inf.*), variously attributed to the third to fifth centuries A.D.; (*below*) Alcman (Louvre Museum, Paris, *Pap. E. 3320*).

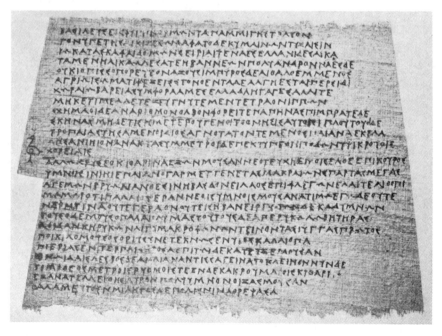

Fig. VI–3

(*Above*) Alcaeus, earliest Aeolian lyric poet; late seventh and early sixth centuries B.C. (Bodleian Library, MS. *Gr. Class. b.18* (*P.*)). Parts of four poems written on papyrus in the second century A.D.; (*below*) Timotheus, *Persae* (col. 5, v. 187–247). The earliest preserved Greek literary papyrus (fourth century B.C.). It was unearthed in 1902 at Abûsîr, and is (or was until the last war) preserved in Berlin.

Euripides (born in 480), and Aristophanes (born *c.* 448), Herodotus (born *c.* 484), Thucydides (born *c.* 470–460), and Xenophon (born *c.* 431), Greek literature reaches its zenith; book production and book trade are already organized.

Indeed, although no original ancient Greek manuscripts have been handed down to our days, we know from several sources that from the fifth century B.C. onwards the Greeks made much use of producing, selling and reading books. In the time of Eupolis (flourished 429–411 B.C.), who was a famous Athenian poet of the "Old" Comedy, there was a book market (*tà biblía*) in Athens; and Aristophanes implies that books were easily procured in his time. Xenophon relates that a rich youth, Euthydemus, surnamed the Handsome, had collected many books of the most celebrated poets and sophists, and imagined that by that means he was outstripping his contemporaries in accomplishments (*Apomnēmoneúmata* or *Memorabilia*, iv, 11). Xenophon also relates that the Greeks who accompanied him on an expedition against the Thracians found at Salmydessus, on the western shore of the Black Sea, boxes, written books, and many other things, such as seamen carry in their wooden store chests (*Anabasis*, vii, 5.14). Plutarch tells us (*Alexander*, 8) that Alexander the Great ordered the purchase in Athens of books written by Aeschylus, Sophocles, Euripides, and of other works, including histories and poetry.

HELLENISTIC AND GRAECO-ROMAN PERIODS

According to Aristotle (384–322 B.C.)—as quoted by a great literary critic of antiquity, Dionysius of Halicarnassus in *Isocrates*,18 (*c.* 25 B.C.)—the speeches of famous orators were sold in Athens by the hundred. Even more interesting is verse 1114 of Aristophanes' *Frogs* (produced in 405 B.C.), which tells us that each man of the audience holds in his hand a copy of the play.

For the Hellenistic, Graeco-Roman, and Byzantine periods, preceding the Moslem conquest, we can draw our information from the numerous literary manuscripts, written on papyri, which were discovered in Egypt (see Chapter IV). Frederic Kenyon has reached the following general conclusions. During the last three centuries B.C. Greek book production was spreading over the wide regions of the Hellenistic world; there was a large output of literature, and there was also a general habit of reading the great works of previous ages. After the Roman conquest, the Graeco-Roman population, which was mainly Greek-reading, greatly increased; and the first three

centuries of the Roman Empire mark in Egypt the climax of Greek culture, including book production and the practice of reading. With the spread and the adoption of Christianity as the State religion of the Roman Empire, while Christian book production increased, pagan or secular book production declined, "until the Arab conquest in the seventh century extinguished Christian and pagan literature at once".

Rome

It is a somewhat curious fact that Roman literature and, consequently, book production had a very late and poor beginning. Livius Andronicus, the "Father" of Latin literature, was a Greek taken prisoner at the capture of Tarentum (272 B.C.) and afterwards emancipated. He gave literary instruction in Rome, for which purpose he translated the *Odyssey* into Latin verse. He created the Latin drama, having produced in 240 B.C.—*i.e.* in the first year of peace after the First Punic War—the first Latin plays, a tragedy and a comedy, based upon Greek originals. Even the first Roman historian, the old annalist Fabius Pictor, the *scriptorum antiquissimus* of Livy, wrote in Greek. The introduction of Greek into Rome, of Greek books and Greek literature automatically caused the introduction of the Greek main writing material for books, *i.e.* the papyrus roll, which henceforth became the standard form of the Latin book.

EARLY PERIOD

There can be hardly any doubt, however, that books were produced in Rome in still earlier times. Cn. Terentius, a scribe under the consulship of P. Cornelius Cethegus and M. Baebius Pamphilus (181 B.C.), was said to have found the coffin of the mythical Numa Pompilius (the second traditional king of Rome and reputed founder of the Roman religion) together with a stone box, containing books written on papyrus anointed with cedar oil (for their better preservation); this story, told by the annalist Cassius Hemina (early second century B.C.) is recorded by Pliny, *Nat. Hist.*, xiii, 13.

The existence of earlier Roman books may also be argued from various references by Livy (such as i, 20, 31 f., 42, and iv, 7, 13). For instance, according to traditions, quoted by Livy, i, 31–32, Numa's regulations were inscribed in an *album*, or "book", on the order of Ancus Martius, and Numa's *commentarii* or "memoirs" contained instructions concerning certain sacrifices, which at a

later period were found by Tullus Hostilius. Fabius Pictor quoted the *annales maximi*, which were recorded by the Pontifex Maximus, and preserved in the temple of Juno Moneta. Aelius Tubero and Licinius Macer, who wrote in the second century B.C., cited the *libri lintei* (see Chapter I), or books written on linen, for two accounts of the consuls of 434 B.C.; Livy mentions both accounts.

THIRD AND SECOND CENTURIES B.C. (Fig. VI-19)

However, in the second half of the third and in the second century B.C. a great national literature has been created in Rome, as the following list of authors and works will testify: Gnaeus Naevius, a tragic poet of the late third century, who also wrote the *Annals*, a poetic historical narrative in Saturnian hymn; Q. Ennius (239–169 B.C.), the "Father" of Roman poetry, whose great epic *Annales* (of which only some 600 verses are preserved) occupied his last twenty years; T. Maccius Plautus (*c.* 254–184 B.C.), whose plays were so popular, that out of twenty-one reckoned genuine, twenty have come down to us; the prose writings of Appius Claudius (280 B.C.) and, especially, of M. Porcius Cato (234–149 B.C.), who compiled the earliest Roman encyclopaedia, whose work *De agricultura* is the earliest extant monument of Latin literature (though the preserved text has suffered from later revisions), and another work, *Rhetoricorum ad C. Herennium libri quattuor*, which is the earliest Latin prose work preserved in its original text; in the Middle Ages it was one of the most popular manuals; his historical work *Origines*, written *c.* 160 B.C. has been lost.

Caecilius Statius, an Insubrian Gaul playwriter, was brought to Rome in 222 B.C.; Terence or P. Terentius Afer (185–159 B.C.), who was of Numidian or Phoenician birth, was brought to Rome as a slave: he wrote six comedies, which were very popular; M. Pacuvius and L. Accius are with Ennius the three great names in the history of Roman tragedy; Gaius Lucilius (180–102 B.C.), the creator of Roman satire, is considered by some modern scholars as the most original mind of early literary Rome. Omitting casual fragments and quotations, very little has come down to us of all this literary production. Only the works of Plautus (Fig. VI-19, *below*) and Terence (Fig. VI-19 *above*) are more or less well preserved.

We can take it for granted that the dramas, the tragedies, and other plays, the lyric poems and epics, the historical works, produced in considerable quantities, must have been accessible to those who desired them; in other words, they imply the existence of a

reading public and the circulation of books in manuscript. Greek influence continued to be paramount; Latin literature was based on Greek models; education was based upon teaching of Greek and of Greek literature, and numerous Greek slaves were brought to Rome, where they taught these subjects.

However, there must have already existed a more or less organized book production and book trade, though with regard to this period we have no evidence whatever concerning the methods of publication, the appearance of manuscripts, or their circulation. In later times the circumstances were quite different. The earliest description of Latin books appears in Catullus (Gaius Valerius Catullus, 87 – c.54 b.c.), i, 1–6, xxii, 3–8, l,1–5, lxviii, 33, etc. See also Tibullus, iii, 1, 9–14, iv, 7, 7–8; Propertius, iii, 23, 1–8, 19–24; Martial, ii, 6, 1–12, 77, 5–6, iii, 2, iv, 10, 86, 89, v, 6, vi, 61, vii, 17, viii, 62 and 72, x, 1, 2, 59 and 93, xi, 1 and 107, xiv, 38.

Golden Age and Decline (Fig. VI–11–16, 18)

In the first century b.c. with Cicero, Caesar, Livy, Lucretius, Catullus, Virgil, Horace, Propertius, Tibullus, Ovid, and others, Latin prose and poetry reached their excellence. With the death of Augustus (a.d. 14) began the decline of Roman literature, notwithstanding the prominence of many writers, philosophers and poets, such as Seneca, Lucan, Persius, Quintilian, Valerius, Silius, and especially Martial, Statius, Juvenal, Tacitus, and both Plinys; and in later times, Suetonius, Fronto, and Aulus Gellius.

Book Production and Book Trade

In that period, like the Greeks, the Romans made much use of producing, selling and reading books. Atticus (see p. 244) had amongst his slaves highly educated men and numerous copyists. He published the works of Cicero and other authors, and sold them not only in Rome but also in Athens and in other Greek cities, and probably in other places connected with Rome. (See, for instance, Cornelius Nepos, *Atticus,* xiii, 3, xviii, etc.; Cicero, *Ep. ad Atticum,* xii, 40, 1; xiii, 44, 3, etc.). According to the second-century a.d. writer Lucian, the works published by Atticus and by Callinus were in demand "in the whole world". Tryphon was a famous publisher of the latter half of the first century a.d.; he published "best-sellers" such as the works of Martial (M. Valerius Martialis; a.d. c. 40–104) and the *Institutio Oratoria* by Quintilian (Fabius Quintilianus, a.d. c. 35–95): see Martial, iv, 72, 2, xiii, 3; and Quintilian's "Prefatory

Letter" to the *Institutio*. Atrectus was Martial's publisher; the new books were advertised by him on large advertising bills. The brothers Sosii were Horace's publishers: see Horace, *Ars Poetica*, 345.

The appearance of the Roman books of that period has already been described in Chapters IV and V, and various references from Latin poets have been mentioned.

Varro's works (see p. 243) are said to have been sold in "the furthest corners of the world". Horace's *Ars Poetica* "will cross the seas" (*Ars Poet.*, 345); his poems were read in Gaul, Spain, Africa, on the Bosphorus, and in other parts of the Roman Empire. Propertius (Sextus Propertius, elegiac poet of the latter half of the first century B.C.) says (ii, 7, 17) that his name is known in the northern cold countries. Ovid's works went "from East to West throughout the world" (*Tristia*, iv, 9, 21), and Martial's works were read even in Vienna (Gaul).

Rome was the main centre of the ancient book trade in Latin books—we are told, for instance, of the famous bookshops in the Argiletum; but even provincial cities like Brindisi, Lyons, Rheims, and many others, had great bookshops, where new and second-hand books were sold. The poems of Martial (i, 3, 66, 117, iv, 72, xiii, 3) give us some information about the trade in Latin books.

BOOK READING

Concerning reading, we get some information from Martial (iv, 8, vi, 60 and 64, x, 19, xi, 3, xiv, 183-95), Propertius (iii, 3 and 9), and other Latin literary sources. It must be pointed out, however, that the fashionable public recitations, of which we are informed by Tacitus (*Dialogues*, ch. 9), Juvenal (*Satire*, vii, 40-47), Petronius, and others, did no good service to reading.

REPRODUCTION OF BOOKS—ANCIENT AND MODERN

What happened to the text of these ancient books during the long periods of oral transmission, or later, when hand copying was the rule? Nowadays, when an author writes a book, he sends his typescript to the printer, from whom he receives proof sheets; he corrects these until he is satisfied that his text is printed accurately. Then, hundreds or thousands of copies are printed from the same types—each one of them, therefore, being exactly like all the rest—and are sent for sale all over the world. The means of accurate reproduction, it must be remembered, are only of comparatively recent date. It is disquieting to reflect on the extent to which, before

that date, a text was liable to be corrupted or mutilated in the
course of a long period of time.

The ancients were already complaining about the mistakes of the
copyists. Cicero (*Ad Quintum*, iii, 5) grumbles, "I no longer know
where to turn for Latin books, the copies on the market are so
inaccurate". He calls these copies "books full of lies".

PRESERVATION OF IMPORTANT WORKS

In ancient times, as in our own, certain works were considered of
high importance. The fragments of Homer which have come down
to us (see Fig. VI-1, 2) are the most numerous of any old Greek
manuscripts, but they are mainly of the *Iliad* and not of the *Odyssey*.
By 1945, the number of *Iliad* fragments found in Egypt was 364,
whereas those from the *Odyssey* numbered only 119. "Homer," says
Plato, "was described by his admirers as the educator of Hellas".
"And there was a great deal of literal truth in the claim" (R. C. Jebb).
Homer occupied a place in Greek education comparable with that
of the Bible in English schools. The extreme care with which copies
of such works were written was a guarantee against serious corruption
in those that have come down to us, even though in many instances a
fairly long chain of copies intervened between the original manu-
script and the copy which has reached us.

We may assume that libraries all over the Greek World and the
Roman Empire contained copies of books of major importance so
that in one way or another at least one of the numerous copies has
come down to us, even if it is only a copy from a copy of a copy.
Of the works of lesser poets or writers, however, remarkably little has
survived. Hundreds of poets and writers are known either by their
names only or by the titles of their works.

Athenaeus, of Naucratis in Egypt, of the late second and early
third century A.D. wrote a work, *Deipnosophistae* ("Connoisseurs in
Dining", or rather "Learned Men at Dinner"), in fifteen books;
containing a conversation lasting several days among twenty-nine
erudite diners, on literature, art, science, grammar, social and public
life, and pleasures of the table. Over five hundred authors, who
would otherwise be unknown, are mentioned in this interesting work.
Amongst the lost works is quoted *Linos*, a book written by Alexis, one
of the main representatives of the Greek "Middle" Comedy (*c.* 400–
336 B.C.). Linos asks the young Hercules to chose a book. "Look
at the titles and see if they interest you; here are Orpheus, Hesiod,
Khoerilus, Homer, Epicharmus. Here are plays and all else you

could wish for. Your choice shall show your interests and your taste." Hercules chooses . . . a cookery book.

It has already been mentioned that all civilized nations of the ancient world, and especially the highly cultured Greek and Latin peoples, had rich libraries, containing numerous books on a large variety of subjects, which were used for scientific as well as for educative purposes. Yet, no ancient Greek manuscripts have been found either in Greece or Italy, except for the charred papyrus rolls found in a private library of Herculaneum; see pp. 251–58.

Apart from the papyrus literary manuscripts, mainly recovered in Egypt (see Chapter IV) almost all preserved copies of Greek works belong to the Byzantine period, and—with few exceptions, such as the *Iliad* of the Ambrosian Library, Milan—Fig. VI–2, or Dio Cassius, a fifth or sixth-century manuscript in the Vatican Library—are rather late. Their preservation is mainly due to the fact that after the fall of Constantinople, in 1453, they were brought to Italy. In Sir John Sandys's opinion, the best manuscripts of Homer are preserved in Venice; of Hesiod and Herodotus, in Florence; of Pindar, in Rome, Florence, Milan and Paris; of Aeschylus, Sophocles and Apollonius Rhodius, in Florence; of Euripides, in Venice, Florence and Rome; of Aristophanes, in Venice and Ravenna; of Thucydides, in Florence, Rome, Munich and London; of Demosthenes and Plato, in Paris; and of Aristotle, in Venice, Rome and Paris. Homer has been preserved in 110 codices, Sophocles in nearly 100, Aeschylus in nearly fifty, Plato in eleven.

The Latin manuscripts are on the whole—Virgil is the main exception (for other exceptions, see for instance Fig. VI–14–16)— medieval copies and their preservation is mainly due to Christian monasteries. "In the peaceful seclusion of the monasteries a small part of the literature of the ancients has survived the wreck of the classical world" (Pinner).

Destruction of Ancient Manuscripts

"For every sheet of parchment or papyrus which has been preserved to the present day, it is safe to say that thousands of such sheets have been destroyed for ever. The ravages of time, the excesses of military conquest, the bigotry of religious zealots, the fury of fire and flood, and the carelessness of the ignorant and unthinking have all taken their toll, and what is left is but a fragment of the records once written in ages past" (D. C. McMurtrie).

Many peoples and events have conspired to deprive us of the greater part of the literary treasures of antiquity.

Whether it be the Persians, who delivered a fatal blow to Phoenician and Egyptian literatures, when in the sixth to fourth centuries B.C. they destroyed the Phoenician temples and schools, and the Egyptian temple-colleges;

whether it be political persecution, not unknown even in ancient times, as exemplified by the public burning in 411 B.C., at Athens, of the books of the Sophist and grammarian Protagoras; or by the public burnings of books in Rome, even by enlightened emperors, such as Augustus, who according to Suetonius (*De vita Caesarum*: *Augustus*, 31), confiscated and burned 2,000 books; also Tiberius, Domitian, and others ordered public burnings of books;

whether it be the Barbarians of the North, who invaded Italy in the fourth and fifth centuries A.D., and destroyed the famous Roman libraries;

whether it be the zeal of the Christians, who at different periods made great havoc of non-Christian or "heretic" works;

whether it be the Mongols who ravaged the books of the Moslems, or the Arabs who ravaged the books of the Christians;

whether it be—to limit ourselves now to England—the destruction by the Anglo-Saxon invaders, the civil commotions caused by the barons, the bloody contests between the houses of York and Lancaster, the general plunder and devastation of monasteries and religious houses in the reign of Henry the Eighth, or the occasional ravages of civil war in the time of Charles the First;

whether it be the ravages of time and climate, of damp or the bookworm, or of fire such as those which burned the famous Palatine Library, in Rome, about A.D. 200 and in A.D. 363, or destroyed so much in the Cotton Library of the British Museum, 23rd October, 1731;

—we must accept Mrs. G. Burford Rawlings's statement that we "will wonder, not that we have so few ancient writings in our present possession, but that we have any".

To enumerate only those Greek and Roman works of a literary and scientific nature, which are known to have been destroyed or lost, would form a catalogue of considerable bulk, but it may be interesting to quote at least some amongst the most deplorable losses which mankind has sustained. Many of the works extant are so mutilated that the fragments which remain serve only to increase our regret for what has been lost or destroyed.

LOSS OF GREEK WORKS

HISTORY

Our knowledge of the earliest Greek historians (sixth and first half of the fifth century B.C.) is scanty, but even the works of the later historians have reached us only in a fragmentary state. The *History* of Polybius of Megalopolis (end of the third century B.C. to 183 B.C.) originally contained forty books: the first five only with some extracts (made by various Byzantine compilers) and some fragments of the later books are available to us. The *Historical Library* (a sort of general history of the world) of Diodorus Siculus (*c.* 40 B.C.) consisted likewise of forty books: but only fifteen are extant (the first five, and books xi–xx) with some extracts (collected out of Photius and others).

Dionysius of Halicarnassus wrote twenty books of *Roman Antiquities* (a sort of early history of Rome extending to the First Punic war, 264 B.C.); but only eleven now remain (i–x, complete, and xi imperfect) and some excerpts. Appian or Appianus of Alexandria (A.D. *c.* 140) is said to have written a *Roman History* from the earliest times to the accession of Vespasian (A.D. *c.* 70), in twenty-four books: only books vi–viii, xi, xiii–xvii, and xxiii, and some excerpts and fragments from a few others have come down to us. Dion Cassius (third century A.D.) wrote a *Roman History* in eighty books, from the earliest times to A.D. 229: only twenty-five (xxxvi–lx) remain, with some fragments and excerpts, and an *epitome*, by Xiphilinus, of the last twenty.

POETRY AND DRAMA

Very little has come down to us of Greek lyric poetry and drama apart from occasional quotations and the papyrus discoveries. Aeschylus wrote over seventy plays: only seven remain; and the same number of plays have survived of the 113 which were written by Sophocles. Euripides wrote ninety-two plays, and Aristophanes at least forty-three: only eighteen have survived of the former, and eleven of the latter. Quite a good number of Pindar's odes have been preserved, and a small fraction of Bacchylides' poems. All the other Greek lyrics (see, for instance, p. 230) and dramas have been lost.

ANTHOLOGIES

John of Stobi, in Macedonia, known as Stobaeus, who lived in the latter part of the fifth century A.D. and the early sixth, wrote two

compilations—naturally drawing from the best works and the best authors—*Eklógai physikaí dialektikai kaí ēthikai* (a collection of extracts from prose treatises in philosophical branches) and *Anthológion* (a great anthology of prose and poetry, arranged under topics). Out of about 1,430 quotations of the first thirty sections of the *Anthology*, 1,115 are from works that are lost.

Photius (A.D. *c.* 820–91) also wrote two important compilations, the *Myriobiblon* or *Bibliotheca*, and *Lexicon*. The former contains an account of 280 volumes, including extracts from Hecataeus, Ctesias, Theopompus, Diodorus, and Arrian; it also contains a summary of two of the earliest specimens of Greek prose romance. The *Lexicon* is preserved in only one manuscript, the *Codex Galeanus*, now in the library of Trinity College, Cambridge. Photius mentions 470 names of authors quoted by Stobaeus: the works of only forty of these authors have been preserved in any substantial form.

Very illuminating is Sir Frederic Kenyon's statement that out of 366 quotations (mainly from the comic dramatists) in Athenaeus, *Deipnosophistae* (see p. 238), only twenty-three are from works that we now have.

SCIENTIFIC WORKS AND MISCELLANEA

As to scientific works, early Greek astronomy from its beginnings about 200 B.C. to Ptolemy (A.D. *c.* 150) is almost completely destroyed, except for papyrus fragments of a few elementary works used for teaching purposes. Even Ptolemy's work is only in part available, in Byzantine copies. Besides, as O. Neugebauer has pointed out, the computations in the late copies of the Hellenistic mathematical astronomical books are often hopelessly distorted: many centuries of tradition through hand-written copies have badly affected numbers which were of little interest, if not unintelligible, to the copyists. Of Hipparchus (*c.* 120 B.C.), the greatest astronomer before the Christian era—the scientist who, amongst other things, invented trigonometry, the precession of the equinoxes, and the method of determining the position of places by reference to latitude and longitude—nothing has come down to us except his commentary on the *Phaínoměna* by Aratus, a poet of about 270 B.C.

Greek mathematics "now consists of the fragments of writings of about ten or twenty persons scattered over a period of six hundred years" (Neugebauer).

We know from Athenaeus of Naucratis that the Greeks had a great number of books on cookery, horsebreeding, angling, and similar subjects, but nothing of these has come down to us.

LOSS OF LATIN WORKS

HISTORY

Many of the works of the most ancient Latin historians have either perished, or come down to us mutilated and imperfect. Sallust (C. Sallustius Crispus, 86–35 B.C.), the earliest scientific historian in Latin literature, the *rerum Romanarum florentissimus auctor*, as he was described by Tacitus, wrote a *Roman History* in five books, which was his maturest work, but only four Speeches and two Letters, with some fragments, are preserved. Livy's *Roman History* consisted of 142 books, ending with the death of Drusus (9 B.C.); of this excellent work 107 books have perished; only numbers i–x, and xxi–xlv remain. A great part of the elegant compendium of the *Roman History*, by C. Velleius Paterculus (*c.* 19 B.C.–A.D. 31) has perished. A history of Alexander the Great in ten books was written by the rhetorical historian Q. Curtius Rufus (first century A.D.), but the first two books are missing, and there are several large omissions in the copies which are preserved.

Tacitus (Cornelius Tacitus, A.D. *c.*55 – *c.*117) wrote his *History* in some twelve or fourteen books, and his *Annals* in some sixteen to eighteen books; there remain only books i–iv, and part of v of the former, and books i–iv, vi, xii–xv, and parts of v, xi, and xvi of the latter. The first universal history in Latin was written by Pompeius Trogus, from Gaul (first century B.C.?), in forty-four books; only a synopsis and an abridgement have survived—a mere shadow of Trogus. Ammianus Marcellinus (A.D. *c.*332 – *c.*400) wrote a continuation of Tacitus' *History*, in thirty-one books, but the first thirteen are wanting.

SCIENTIFIC WORKS AND MISCELLANEA

To these losses may be added a great number of works in different branches of science, law, and literature. Varro (M. Terentius Varro, 116–27 B.C.), who was styled the most learned of all the Romans, and who excelled in grammar, history, philosophy, agricultural science, and other fields of learning, wrote nearly 100 books (the number, indeed, has been put at about 500!). Of the twenty-five books of his *De Lingua Latina*, the earliest extant scientific Latin grammar, only the first six have survived. Nearly nothing has remained of his forty-one books of *Antiquitates*, of the nine books of his *Disciplinae* (the earliest encyclopaedia of the liberal arts), of his *Imagines* (brief biographies of 700 Greek and Roman celebrities), of his writings on literary criticism, or on libraries.

Atticus, already mentioned, the great friend of Cicero, who was one of the most honourable, hospitable and friendly men of his times, is said to have written many works in Latin and Greek, but nothing has survived. The inestimable loss of his work, containing biographies of great Romans, which, like Varro, he ornamented with their portraits, is much to be lamented, the more so as we know so little of the illustrations of Roman books.

MANUSCRIPTS RECOVERED IN EGYPT

From the days when classical learning began to revive in Europe, scholars have never ceased to hope for the discovery of the lost books of Greek and Roman history, philosophy and literature. At one time the buried cities of Greece and Italy were eagerly searched for precious manuscripts, at another the monasteries of the Near East were diligently explored, all with more or less negative results; but at last the sands of Egypt have yielded to the excavator's spade.

Until within the lifetime of persons still living, our information with regard to the physical form and the habitual use of books in ancient Greece and Rome was singularly scanty. But thanks to the marvellous protective covering of the Egyptian sands, we are fortunate in having some remains of Greek papyrus books, ranging from the fourth century B.C. to the seventh century A.D., found mainly in Egyptian refuse heaps, or in tombs or temples. Under other climatic conditions, papyrus could not have lasted to the present times. We often complain that modern books are short-lived; the ancients similarly complained about their books: for instance, Juvenal in his First Satire.

Mrs. G. Burford Rawlings illustrates the strange adventures of some of these books—the cartonnage cases, in which Egyptian mummies of the later period were enclosed, were made of papyrus rolls, used as waste paper. But what appeared to be destruction, was really the condition of safety; indeed, fragments (assigned to the third century B.C.) of Plato's *Phaedo* and of the lost *Antiope* by Euripides were recovered in some such way. Numerous precious literary works have thus been brought to light. The majority were recovered in rubbish baskets, in the refuse heaps (*kôm*) outside the towns and villages of Graeco-Roman Egypt, and especially those of Oxyrhynchus; those found in tombs were buried either near the dead or as mummy wrappers.

The earliest Greek literary work extant (see p. 135), that is Timotheus, *Persae*, written on a papyrus, a manuscript attributed to

the second half of the fourth century B.C. (Fig. VI-3, *b*), was also found in Egypt; it is now in Berlin (at least, it was there before the last war). Other important Greek literary texts, written on papyrus and preserved by Egyptian sands, are Aristotle's *Constitution of Athens* —Fig. VI-4 (see p. 157); Herodas, *Mimes* (Fig. VI-5); Bacchylides, *Odes* (Fig. VI-6); a new *Ode* of Sappho, and Greek fragments from the Old and New Testaments (such as *St. John*, xviii, 31–33, *recto*, and 37–38, *verso*): Fig. VI-9. The New Testament fragment is assigned to the first half of the second century A.D., thus being undoubtedly the earliest fragment extant of the N.T.: it is in the John Rylands Library, Manchester (*P. Ryl. Gk.* 457). At the same place in Egypt where it came to light, possibly Behnesa, the site of the ancient city of Oxyrhynchus, were also found the *Sayings of Jesus*—Fig. IV-18 (attributed to the second or, more probably, third century), a fragment of *St. Matthew's Gospel* (third century), and other important documents. See also Chapter IV.

Finally, though the classical Greek works on astronomy—such as the *Mĕgále Sýntaxis tês astronomías* (afterwards called *Almagest* by the Arabs) written by Ptolemy (Claudius Ptolemaeus, first half of the second century A.D.), the exposition of that famous astronomical theory which remained unchallenged for fourteen hundred years —have come down to us only in manuscripts of the Byzantine period, we have now important Greek papyri which are fragments of astronomical works, containing hundreds of extensive numerical tables, partly belonging to the Ptolemaic period (323–30 B.C.). In some of these papyri we find a special sign for $\frac{1}{2}$, and, what is more important, a special sign for zero. Neugebauer suggests that the Greek sign for zero is not, as it is usually explained, the first letter of the Greek word *oudén*=("nothing"), but an arbitrarily invented symbol intended to indicate an empty space.

IMPORTANCE OF THE RECOVERED LITERARY MANUSCRIPTS

Fragments of many classical authors have thus been recovered. Works hitherto completely lost have been found, and these are amongst the greatest treasures of papyrus literature.

They include a mutilated fragment (Fig. VI-2, *below*) of Alcman (*c.* 640–600 B.C.), the first recorded poet of the Greek choral lyric, and fragmentary speeches by Hyperides (born *c.* 389 B.C.), a pupil of Isocrates; these fragments are partly at Paris, and partly at the British Museum (Fig. VI-6); seven nearly complete "mimes" and fragments of others of Herodas (*c.* 300–250. B.C)—Fig. VI-5—

and other valuable works. One of the most important and interesting is undoubtedly Aristotle's *Athēnaiōn Politeia* (Fig. VI-4), which has been described on p. 157. An historical work, dealing with the events of 396-5, has been discovered at Oxyrhynchus; it has been variously assigned to Cratippus, a continuator of Thucydides, or to Theopompus, a pupil of Isocrates, who wrote *Hellenica* (in twelve books),

Fig. VI-4
Aristotle, *Constitution of Athens* (British Museum, Pap. 131).

Fig. VI-5

Herodas, *Mimes* (British Museum, Pap. 135-3).

and *Philippica* (in fifty-eight books), or else to Ephorus, another pupil of Isocrates, who wrote an important history of Greece from the "Return of the Heracleidae" to 340 B.C.

The literary manuscripts which have been discovered are not only of paramount importance for the recovery of works wholly lost or known to us only by quotations or references, but also for our knowledge of the literary tastes and educational practice of Graeco-Roman Egypt, as well as of book production at the time. Since the discoveries were made mainly near provincial towns or villages, our information does not apply in the same measure to great cultural centres, such as Alexandria.

The American C. H. Oldfather, in 1922, and the Italian Laura Giabbani, in 1945, have compiled lists of the literary manuscripts, including fragments, recovered in Egypt. Biblical and Christian books are omitted. Of the 1,167 works listed by Oldfather, and the 1,124 (including 83 already listed by Oldfather) of Giabbani, 537 are Homeric manuscripts (including commentaries), 397 are from works preserved otherwise, 1,357 are from works completely lost or known only by quotations, or unidentified. Demosthenes is represented by seventy-six manuscripts, Euripides by sixty-five, Plato and Hesiod by thirty-six each, Isocrates by thirty-two, Menander by twenty-six, Sophocles by twenty-five, Thucydides by twenty-one, Herodotus by nineteen, Aristophanes and Xenophon by seventeen each, and Pindar by eleven.

The distribution in time of these literary manuscripts is approximately as given in the table (G stands for Giabbani's list; O for Oldfather's list):

Century B.C.	O	G	Century A.D.	O	G
fourth	1	—	first	117	69
third	67	57	second	341	311
second	42	36	third	304	214
first	49	37	fourth	83	82
			fifth	78	61
			sixth	29	47
Cf. also tables on pp. 162 and 166.			seventh	13	11

THE DIATESSARON AND A HITHERTO UNKNOWN TRAGEDY

The importance of the literary papyri found in relatively recent

Fig. VI–6

(*Above*) Portion of a poem by Bacchylides (British Museum, Pap. 733), variously attributed to the first century B.C., or A.D.; (*below*) portion of the great papyrus containing the three speeches by Hyperides against Demosthenes and for Lycophron and Euxenippus (British Museum, Pap. 108 and 115; first century A.D.).

times has already been emphasized. Here two other examples may be noticed. The first is Tatian's *Diatessaron* or "The Harmony of the Four Gospels", which is known to have been in existence A.D. *c.* 160. Although composed by a Syrian (who had been converted at Rome by Justin Martyr), it has been preserved only in the Arabic and Latin translations; whether the original was in Greek or in Syriac has for long been a matter of disagreement amongst scholars. The discovery at Dura Europos (see p. 192) in 1933 of a third-century fragment of the *Diatessaron* containing part of the Greek text will probably facilitate a solution of the problem.

The second is a fragmentary papyrus roll found at Oxyrhynchus; this contains part of a tragedy written in three columns, the middle one comprising sixteen successive lines, being in a relatively good state of preservation. The fragment has been described by E. Lobel as surprising as any recovered from the soil of Egypt. The cursive script with a free use of ligatures induced that scholar to date this fragment to the late second or early third century A.D. Each side bears evidences of having been used for accounts.

The literary text formed the subject of his inaugural lecture by D. L. Page, Regius Professor of Greek in Cambridge University, delivered at Cambridge on 18th January, 1951. The title of the lecture—*A New Chapter in the History of Greek Tragedy*—may suffice to draw the reader's attention to the importance of this fragment. The text is, indeed, unusual; it is part of a hitherto unknown Greek tragedy based on a theme neither mythical nor of local interest, but dealing with the usurpation by Gyges of the throne of Lydia in the seventh century B.C., *i.e.* a historical event far off geographically and chronologically. The story is familiar from various literary sources (Herodotus, *History*, i, 7 seqq.; Plato, *Republic*, ii, 359; Nicolas Damascenus, fr. 47 J., and others), but we have no record that it formed the subject-matter of a drama.

Both, Lobel and Page, agree that the play may be of very early date—probably of the first quarter of the fifth century B.C. Page considers the poetry as being of high quality, closer in style to Aeschylus than to any other writer of tragedy known to us. Lobel has suggested that the author might be the older contemporary of Aeschylus, Phrynichus. However, "In force and lucidity of language, in power of narrative, and in portrayal of character", the author of our drama "was among the masters, and in particular among the old masters" (Page). The silence of antiquity regarding this important play is the more remarkable as this pre-Sophoclean tragedy was still known in the late second or the early third century A.D.

MANUSCRIPTS RECOVERED AT HERCULANEUM

Outside Egypt, Herculaneum occupies a unique position in the history of excavated ancient cities. Situated on the western slope of Mt. Vesuvius, it was destroyed by the terrible eruption of this volcano in A.D. 79. The city was then entirely buried under the stream of liquid mud and ashes mixed with water from the torrential rains or from the rivulets, advancing with relentless slowness, and penetrating everywhere.

It was not hot lava, as is commonly thought; glass was not melted, marble was not calcined, and even wood and the rolls of papyrus were not burned up. However, damp, absence of air, and the lapse of nearly seventeen centuries are enough to account for the carbonization, discolouring, or decay of wood or papyrus. This mass of mud solidified and became a kind of matrix, which—covering and preserving the forms it enveloped—acted as a prop to the buildings, which would otherwise have collapsed from age, earthquakes, or pressure overhead. In the course of time, this volcanic mass of mud and ashes consolidated into a compact mass of rock, in places exceedingly hard, popularly known as "volcanic tuff", or, in Italian, *tufo, tufa, peperino,* or *trass.*

Thus, the eruption of A.D. 79 arrested the life of a little Roman provincial town as it existed, in its full vigour and completeness. In many subsequent eruptions of Vesuvius, especially those of A.D. 471, 513, 1306-8, 1631 and 1698, cinders and lava covered the site to a depth of 70 to 100 feet. The city lay undisturbed for sixteen hundred and fifty years. A small town, Resina, and, in part, the town of Portici have grown up above it.

In 1709, the Austrian general Prince d'Elbouf purchased a site for a seaside villa at Granatello, near Portici. In 1713, in sinking a well, his workmen came upon the back of the stage of the Roman theatre. In complete ignorance of the nature of the building, d'Elbouf made a network of tunnels; slabs of precious marbles and many beautiful statues were found, which were dispatched to Vienna, or sold to private dealers. Regular excavations were promoted in the years 1738-65 by Charles (Bourbon), King of Spain and Naples, and were conducted by the Spanish chief military engineer Roco Joaquín de Alcubierre, assisted by the Swiss engineer Charles Weber.

In June, 1750, a magnificent country villa was discovered—now known as the Villa of the Papyri; it is considered to be the most luxurious Roman villa that has been preserved. The villa was splendidly decorated by frescoes and mosaics, and precious marbles

and statues were there found, which are now preserved in the Naples Museum of Antiquities. There, too, in the years 1752-4, numerous papyrus rolls were recovered. In, or near, the *tablinum*, or open hall, some twenty-one volumes were found in 1752; they were contained in two wooden cases; in 1753, eleven rolls were found in

Fig. VI-7

a, Aristophanes (Vatican Library, *Pal. Gr. 67*); *b*, Aeschylus (Laurentian Library, Florence, *Cod. 31.8*). *c*, Demosthenes (Laurentian Library, *Plut. lix. 9*; early eleventh century A.D.).

a room just south to the *tablinum*, and 250 in a room to its north.

The main find, however, occurred in 1754, when 337 Greek volumes were found, arranged in bookcases, which were inlaid with different kinds of wood, disposed in rows, and provided with cornices. The main bookcases were situated round the sides of a room, which was probably a private library; a sort of rectangular bookcase stood in the centre of the room. Some of the bookcases crumbled to dust on the first touch, or on exposure. Many papyrus rolls were found lying about; others, however, were still on the shelves. The great majority of the books were Greek, but in the same room twenty-four Latin fragmentary manuscripts were found, of which eighteen were in a *capsa* of bark.

Many of the rolls were destroyed or thrown away by the workmen, who, from the colour of some of them took them to be sticks of charcoal; others were destroyed when extracted from the volcanic tuff, in which they were embedded. After one roll fell upon the ground and broke in the middle, and many letters were seen, it was realized that the rolls were ancient manuscripts. Then, naturally, the attention of the learned world was directed towards these unique documents and their preservation.

It is uncertain how many rolls and fragments were originally found. The complete list of those now preserved, including every tiny fragment, amounts to 1,814, of which 1,756 were discovered up to 1855. Of the total number, over 340 are almost entire, about 970 are partly decayed (full of holes, or cut, crushed, or crumpled) and partly decipherable, and over 500 are merely charred fragments. Only 585 rolls or fragments have hitherto been completely unrolled, and 209 unrolled in part. Of the unrolled manuscripts, about 200 have been deciphered and published, and about 150 deciphered only; of the remainder, only 90 appear to be decipherable.

In the eighteenth century, the unrolling and deciphering of papyrus rolls was an unenviable task. The Italian monk Piaggi invented a simple machine for unrolling by means of silk threads attached to the edge of the papyrus. The method was not very successful and was very slow, but—as all the other attempts failed— it was carried on, in the *Officina* of the Papyri at Portici, from 1754 to 1876.

Attempts at unrolling were made by Sir H. Davy in England and at Naples, in 1818, and by F. C. Sickler at Oxford, in 1817–19. George IV, then Prince of Wales, took much interest in the matter, and at his private expense the Rev. John Hayter was sent to Portici. Hayter supervised the *Officina dei Papyri* from 1802 to 1806, and

Fig. VI–8

(*Above*) *Dialogues* by Plato written for Arethas of Patras in A.D. 896 (Bodleian Library, Oxford, *Clarke MS. 39*); (*below*) Thucydides, tenth-century copy (Laurentian Library, Florence, *Plut. lix. 2*).

Fig. VI–9

Earliest preserved Greek manuscripts of the Bible. (*Above*) Fragments of *Deuteronomy*,
second century B.C. (*Rylands Papyrus No. 458*); (*below*) St. *John's Gospel*, Ch. xviii,
first half of the second century A.D. (*Rylands Papyrus No. 457*).

unrolled and partly deciphered some two hundred papyri. The bulk
of the preserved manuscripts is in the National Museum of Naples;
in 1806, the Neapolitan Government presented six rolls to Napoleon
Bonaparte; in 1810, eighteen unopened rolls were given to George IV,
four of which he presented to the Bodleian Library; the others are
now mainly in the British Museum.

The library apparently contained about 800 volumes, but the
actual number of works was probably less than 200, because some of
them consist of many volumes, and of several works there are two or
three copies: there are fragments of as many as three copies of the
thirty-seven volumes of the work *On Nature* by Epicurus.

On the whole, the literary value of the Greek manuscripts is
relatively small. Apparently the owner of the library was a
philosopher who specialized in Epicurean philosophy, and was not
a man of "all-round" culture. The bulk of the works were written
by an unimportant Epicurean philosopher of Cicero's time, Philo-
demus; the remaining Greek works are written by six different
authors, including Epicurus, and his able disciple Metrodorus of
Lampsacus; there is a single fragment by the known Stoic Chry-
sippus of Soli in Cilicia. The most complete manuscripts are those
On Music (some 1,710 lines) and *On Rhetoric* (112 columns), both by
Philodemus. There are titles to sixty-nine works written by the latter,
and no Greek manuscript of this library belongs to a later period
than Philodemus. In consequence, Mrs. Barker concludes that this
philosopher was the owner of the library. According to other
scholars—such as the Italians D. Comparetti and G. De Petra—the
villa belonged to Lucius Calpurnius Piso, the father-in-law of
Julius Caesar; hence, the villa is also known as the *Villa Ercolanese
dei Pisoni*.

The Latin manuscripts belong to a later period than the Greek
rolls, and are of a quite different nature. Apparently they deal with
history, poetry and rhetoric. Unfortunately they are so damaged by
the damp that they are almost undecipherable, except for the main
roll (of which eight columns have been preserved), which is a frag-
mentary Latin poem in hexameters, on the Battle of Actium,
31 B.C. This *Carmen de bello Actiaco*, or *Carmen de Augusti bello
aegyptico*, is the earliest extant Latin manuscript. The total number
of the preserved columns in the Latin rolls is forty, while the Greek
manuscripts contain as many as 2,326 preserved columns. The
title-labels, which were attached, have all been destroyed. In recent
times, Latin polyptychs (see p. 29) were found at Herculaneum.

BIBLIOGRAPHY (on the Herculaneum papyri)

Reale Accademia Ercolanese, *Herculanensium Voluminum que supersunt.* Collectio Prior, 9 vols., Naples, 1793–1850; Collectio Altera, 11 vols., Naples, 1862–76.

F. Ventriglia, *Cenni storici sulla scoperta, svolgimento ed interpretazione dei papiri ercolanesi,* Naples, 1877.

W. Scott, *Fragmenta Herculanensia,* Oxford, 1885.

Herculaneum Fragments, 9 vols., Oxford Philological Society, 1889; Facsimiles, Clarendon Press, Oxford, 1891.

Fig. VI-10

Gospels written in 1429 by a monk Gabriel; the text is in Cyrillic character, but it is accompanied by a Greek translation in cursive script (Bodleian Library, *MS. Can. Gr. 122*).

W. Groenert, *Memoria Graeca Herculanensis*, Leipsic, 1903.

E. R. Barker, *Buried Herculaneum*, London, 1908.

C. Waldstein and L. Shoobridge, *Herculaneum Past Present & Future*, London, 1908.

G. P. Zottoli, *Bibliografia ercolanese*, "BOLLET. D. R. ISTITUTO DI ARCHEOLOGIA E STORIA DELL'ARTE", II, 1928.

Earliest Roman Manuscripts

The early Roman manuscript remains are even more scarce than the Greek ones. The earliest documents extant are assigned to the first century A.D. (or perhaps to the late first century B.C.): they are written in cursive or semi-cursive styles of writing, and are either on papyrus or on wax tablets. The following are noteworthy: the aforementioned papyrus of the *Carmen de bello Actiaco*, written in semi-cursive capitals, between 31 B.C. and A.D. 79; the *Papyrus Claudius*, found in Egypt, which contains an *Oratio in senatu habita* of A.D. 41–54; it is written in cursive majuscules; and a wax tablet from Pompei, of A.D. 53, written in cursive capitals. Interesting documents of the next century are a wax tablet from Alburnus Major (see Chapter I), written in A.D. 139 in cursive capitals, and containing an *emptio puellae*, and a papyrus of A.D. 163, written in semi-cursive majuscules, containing an *emptio pueri*, now preserved in the British Museum.

END OF AN AGE

The significance of the fourth century A.D. in the history of writing, of the book, of culture in general, and of other aspects of civilization, has been repeatedly emphasized in the present work. The table on p. 248 clearly shows that in that century there was not only a sudden decline in production and reading of papyrus books, but also of secular and pagan books in general. It is also known from literary and other sources that, with very few exceptions, the original productiveness of that period was not great.

However, in the fourth century A.D. "literary culture was the mark of the higher classes of Roman society" (Kenyon), and the books of pagan literature were then extensively read, and presumably also copied, in the dwindling society of the Roman aristocracy. "That society, however, was not a large one. . . . We have no reason

to suppose that books were extensively produced or read outside the narrow society of cultured Romans, except so far as a new literature was growing up around the Christian Church."

The Church as a whole was hostile to pagan and secular literature, though some of her leading writers were deeply steeped in such literature, and were among the foremost masters of Greek or Latin style and eloquence of the third to the fifth centuries.

It will suffice to mention Tertullian (c. 150–230), Cyprian (c. 200–65), Africanus (third century), Eusebius (bishop of Caesarea in Palestine, 314–40), Lactantius (early fourth century), Hieronymus or St. Jerome, the most scholarly of the Latin fathers (c. 340–420), St. Ambrose (c. 340–97), and St. Augustine (354–430). The estrangement of Christianity from secular literature was progressive, and the latter "ceased to perpetuate itself and to put out fresh growth".

Thus, the life of Greek and Latin literature and book production was rapidly waning, till it ceased completely. "It was . . . a dying society, and when it disappeared beneath the barbarian invasions, there was no reading public in the old sense left. A new reading public had to be created, by a long and laborious process, through the medium of the Church and the monasteries . . ." (Kenyon).

THE FOURTH CENTURY A.D.

The fourth century A.D. may thus be considered a turning-point in the history of the Latin book. The earliest Roman codices extant—like the earliest preserved Greek vellum codices, already referred to—are attributed to the fourth century A.D. (see Figs. VI–12, 14, 15, VII–1).

Virgil was, in a certain way, to the Romans what Homer was to the Greeks. Both Homer and Virgil formed the basis of school education. Other popular Roman authors were Horace, Cicero, Livy, Ovid, Propertius, Sallust, Tibullus, Catullus, and Martial.

Curiously enough, however, while Virgil has been preserved in about 100 medieval codices, there are as many as 250 codices of Horace; on the other hand, of the *Annals* by Tacitus, there is only one complete codex. The earliest copies of Virgil are about 400 years older than those of Horace, about 500 years older than those of Caesar, and nearly 800 years older than those of Cornelius Nepos.

We need not, therefore, be surprised to find that amongst the earliest Latin codices extant, and a great part of the codices

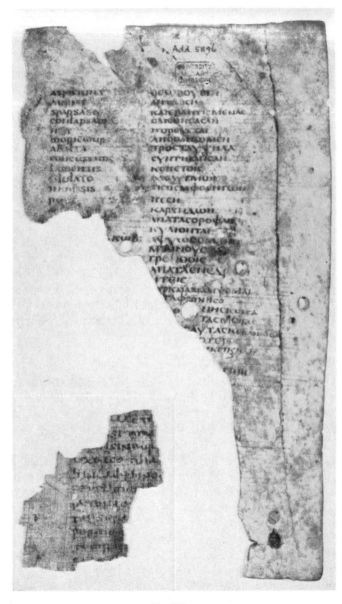

Fig. VI-11

(*Above*) Virgil, *Aeneid*; fragment from a papyrus codex, written in half-uncial of the
fifth century A.D. (University Library, Cambridge, *Add. MS. 4031*); (*insert*) *Latin-
Greek lexicon for Aeneid* (University Library, Cambridge, *Add. MS. 5869*). Incomplete
folio from a parchment codex written in uncials of the sixth century A.D. Both
from Oxyrhynchus.

attributed to the next centuries, there are Virgilian codices: Fig. VI-
11–13. Some of them are written either in the elegant book capitals
(*Codex Vergil. Augusteus, Vat. Lat.* 3256, the *Virgilian Cod.* 1394 of
St. Gall, and the British Museum papyrus manuscript from Oxyr-
hynchus), or in rustic capitals (*Codex Vergil. Vaticanus, Vat. Lat.*
3225; *Codex Medic., Cod. Laur.* 39.1 (Florence); *Codex Vergil. Romanus,
Vat. Lat.* 3867; *Codex Pulatinus, Vat. Pal. Lat.* 1631).

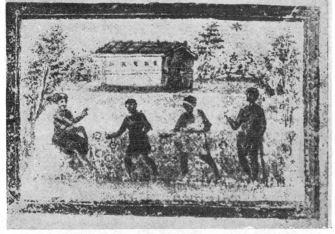

Fig. VI-12
Virgil. (*Above*) *Vatican Virgil* (Vatican Library, *Cod. Lat. 3225*); (*below*) *St. Gall
Virgil* (St. Gall, *Cod. No. 1394*), in an elegant capital book hand of the fourth
century A.D.

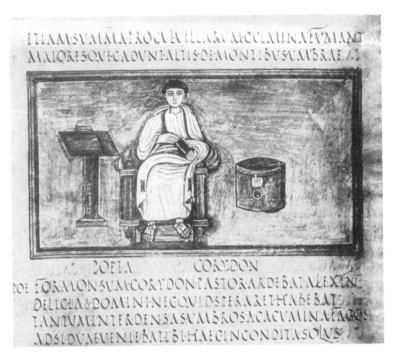

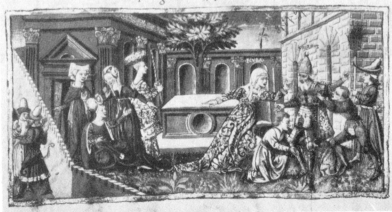

Fig. VI-:3

Virgil. (*Above*) *Roman Virgil* (Vatican Library, *Cod. Lat. 3867*, fol. 3 *verso*). (*below*)
Virgil, *Opera*, copy of the fifteenth century (Riccardian Library, Florence, MS.
492, fol. 85 *verso*).

The Latin Uncial and Semi-Uncial Book Hands

The exact origin of the Latin uncial script—see *The Alphabet*, pp. 542 f.—is uncertain; it seems to have appeared already in Roman documents of the third century A.D. In the fourth century it appeared as a perfect book hand beside the square and rustic capital scripts, and from the fifth century onwards, for over five hundred years it was the main book hand of the Christian world, especially for codices *de luxe*.

Fig. VI-14

Cicero, *De Republica*, palimpsest (Vatican Library, *Cod. Lat. 5757*). Primary script: uncials of the fourth or fifth century A.D.; written in Italy. Re-written in the seventh century, in Bobbio, to copy Augustine, *In Psalmos*.

The Greek uncial character which was the script of the earliest Greek Bible codices exercised a great influence in the rapid diffusion of the Roman uncial writing. On the other hand, not all scholars accept the theory that the Roman uncial character was *the* Christian book hand and derived directly and exclusively from the Greek uncial script of the Sacred Scriptures.

Numerous Roman codices written in this beautiful book hand are extant, and there are also manuscripts written in the book hand known as semi-uncial or half-uncial. One of the earliest forms of the latter script may be seen in the papyrus fragment of the third century A.D., containing an independent epitome of Livy's history of 150–137 B.C. It was found in 1903 in Oxyrhynchus, is now in

Fig. VI–15

Livius Lateranensis (Livy, xxxiv), portion of a fragment consisting of seven pieces of parchment, forming a leaf and a half (Vatican Library, *Cod. Lat. 10696*). Assigned to the fourth or fifth century A.D. From the seventh or eighth century onwards, it was used in the Lateran Church in Rome to preserve relics which came from the Holy Land. In 1906 it was found in a cypress box made by Pope Leo III (795–816).

the British Museum, and has been published in Vol. IV of the *Oxyrhynchus Papyri*. The semi-uncial hand is the book hand of many codices of the fifth to ninth centuries.

SPREAD OF THE LATIN LANGUAGE AND SCRIPT

In the history of the Roman or Latin book, it is important not to overlook the fact that, in ancient times, the Roman or Latin language and script had been carried by Roman legionaries and imperial officials to all parts of the vast empire, and particularly

to the regions which were not Hellenized. In a few countries (Italy, Gaul, Spain, and Roumania), Latin replaced the languages of the natives, and it became the ancestor of the modern Romance languages: Italian, French, Spanish, Portuguese, Roumanian, and a few minor languages.

At a later stage, churchmen and missionaries carried Latin still farther afield, and for many more centuries Papal Rome was the light of the western world; the centre whence religion, culture and learning were disseminated to all parts of western, central and northern Europe. The emissaries of the Pope, either legates or missionaries, travelled all over Europe and carried with them the learning of their age, and their language was Latin.

The abbeys were in the nature of large seminaries or colleges, where learning was carried on, and the monastic system spread Christianity and learning to an even wider extent. It was in the monasteries that the lamp of learning was kept alight. Education was in certain periods almost entirely monastic (obviously, only for the Christian population), or at least conducted by teachers trained in monastic institutions. There were also important centres of learning in the cathedral schools.

Some of the great monastic Orders (such as the Benedictine Order, and its daughter, the Cistercian) encouraged the study of literature, even other than theological, and although important centres of writing were not numerous, and only a small proportion of monks were allowed to take up writing, copying or illustrating, still more than half the literary work of Europe was done within the walls of the religious houses. Each important monastery had its *scriptorium* or writing-room or separate writing-cells (see p. 206 ff.). Because of this activity, the Church supplies the link between the ancient and the modern "book". Indeed, thanks to the Christian Church, for centuries after the fall of the Roman Empire—though Latin existed among the common people only in the form of broken and breaking dialects—the Latin of the grammarians continued to be the language of thought and of education throughout the western half of Europe, and remained for the educated a truly living language.

In consequence, Latin, the language of the Roman Church, became and remained for many centuries, the *lingua franca* of the European higher intellectual world: ". . . and wherever the Latin language went, thither, after the conversion of the Empire to Christianity, went the Latin Bible" and other books. "Throughout the period which we know as the Middle Ages, which may roughly be defined as from A.D. 500–1500, almost all books were written in

Latin" (Kenyon). Latin is still used extensively for learned works—especially theological treatises—in the Roman Catholic Church, and in certain other fields, such as medical prescriptions and technical terminology, although in consequence of the varied development of the last three or four centuries, it has entirely lost its dominant position.

Fig. VI-16

Juvenal (vii, 173–98). Fragment from Antinopolis (*verso*). Fifth century A.D. (?).

THE GREEK LANGUAGE AND CULTURE

The importance of the Greek language and culture in the history of civilization need not be emphasized. It will suffice to quote one sentence by R. W. Livingstone: "Epic, lyric, dramatic, elegiac, didactic poetry, history, biography, rhetoric and oratory, the epigram, the essay, the sermon, the novel, letter writing, and literary criticism are all Greek by origin, and in nearly every case their name betrays their source." We may add philosophy, natural sciences, medicine, and many other fields in which the ancient Greeks were outstanding. Even after the Roman conquest of Greece (towards the end of the second century B.C.), Greek culture remained supreme, and no young Roman would have considered himself well educated without an acquaintance with Greek literature.

The leading historian of ancient exact sciences has pointed out that the centre of ancient science lies in the Hellenistic period, *i.e.* in the period following Alexander's conquest of the ancient sites of oriental civilizations. "In this melting pot of 'Hellenism'—writes Neugebauer—a form of science was developed which later spread over an area reaching from India to western Europe and which was dominant until the creation of modern science in the time of Newton. On the other hand the Hellenistic civilization had its roots in the oriental civilizations which flourished about equally long before Hellenism as its direct influence was felt afterwards."

"And Greek, not Latin, was still the language in which most of the greatest literature of the Imperial period was written. . . . Even statistically the Empire was more Greek than anything else. . . . The Greek core of the Roman Empire played the part of western Europe in the modern world. . . . The pulse of the Empire was driven by a Greek heart, and it beat comparatively feebly in the non-Greek extremities" (A. Toynbee).

Greek was not only the language of learning and culture, but also the common language of intercourse between people of different nationalities in the East. In contrast with the Roman culture, of which Rome was nearly always the main centre, Athens cannot be considered the main and exclusive centre of Hellenistic culture, though Publius Aelius Aristeides (A.D. *c.* 117–80), who "represents the rhetoric of display at the zenith of its glory" (R. C. Jebb), writes (in the late second century A.D.!) that the libraries of Athens were the finest in the world. Actually, there were various important centres of Greek culture on the Greek continent, in Magna Graecia, in Asia Minor (Corinth, Delphi, Patras, Rhodes, Lesbos, Delos, Syracuse, Soli, Smyrna, Mylasa, and many other places).

ALEXANDRIA

After the submission of Egypt to Alexander the Great, who in 331 B.C. founded Alexandria, this city became the headquarters alike of the commerce and the literature of the East. For over a millennium it was the capital of the country.

Fig. VI-17

Priscian—Manuscript written in England, presumably at Canterbury, "in a very fine hand" of the eighth century (Corpus Christi College, Cambridge, MS. 144).

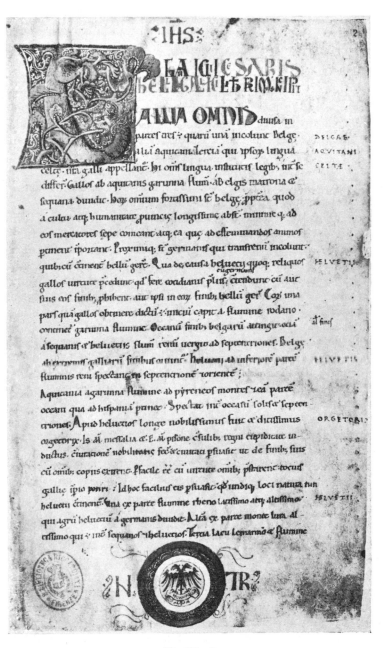

Fig. VI–18

Caesar, *Commentaria*, eleventh-century manuscript (Riccardian Library, Florence, MS. 541, fol. 2 *recto*).

There is no certainty about the founding of its famous establish-ment, known as the Alexandrian Museum and Library or, briefly, the Alexandrina. While the majority of scholars attribute it to Ptolemy II Philadelphus (283–247 B.C.), and a few to his predecessor, Ptolemy I Sotēr (323 B.C. onwards), there is an almost unanimous tradition that Demetrius Phalereus (c. 354–283-2) played an im-portant part in its beginnings, and thus may be regarded as the real founder. For the first 150 years of the existence of the Alexandrina, a chronological table of its director-librarians can be reconstructed, and two names are known for the first century A.D. and the early second, but there is a blank for the succeeding centuries. The Alexandrina continued to exist for nearly a thousand years, i.e., until after 641, when the city fell to the Arabs.

As the greatest centre of Hellenism, Alexandria was for many centuries the fountain of culture and intellect. The Alexandrina drew many students from all parts of the Greek world to Alexandria, which thus became the main centre of Greek learning and culture. It is stated that "almost every scientific man of any note in the intervening centuries either was a professor or had been a student in Alexandria" (J. Gow). Examples are Euclid, Eratosthenes, Archi-medes, and Theocritus. Many books were written and published; they dealt both with scientific subjects (medicine, natural science, engineering, astronomy) as well as with humanistic branches (such as poetry, grammar, lexicography). As one of the results of this literary and scientific activity, the Alexandrian Library was probably the largest which ever existed before the invention of printing, and the city of Alexandria became a main centre of the Greek book production and book trade. See also p. 155. For book illumination see *Illumination and Binding*.

According to E. A. Parsons (*The Alexandrian Library*, Amsterdam and London, 1952), starting with the acquisition of about 200,000 volumes by Demetrius, the Alexandrina possessed no fewer than 700,000 in the first century B.C., and with later acquisitions, including the "present" of 200,000 rolls of the Pergamum Library given by Anthony to Cleopatra, the vast collection possibly comprised nearly one million volumes. The famous daughter collection or outer library, which, starting as a carefully selected library of 42,800 volumes, may have numbered up to 300,000—if it included the Pergamum loot—was housed in the Halls of Books situated within the temple area of the Serapeum. It is known that in addition to being the great warehouse for the literature of Greece, from Homer to Demosthenes and Aristotle, the Alexandrina

Fig. VI–19

(*Above*) A twelfth-century codex of Terence, from south-west France (Vatican Library, *Vat. Lat. 3305*); (*below*) Plautus (British Museum, *Royal MS. 15, C.xi*, fol. 56).

possessed copies of the vast literature produced during the Hellen-
istic period, probably also including translations of foreign works,
such as the Hebrew Scriptures.

Finally, it is known that the Alexandrina had a paramount
importance in the editing of classical Greek texts and the fixing of
the canons of Greek literature. The *Canon Alexandrinus* may have
comprised works of about 180 poets, fifty philosophers, fifty his-
torians, and thirty-five orators.

There were, of course, other centres of less importance than
Alexandria but nevertheless of much significance in the early
development of the book. We know from literary and other sources
that considerable libraries existed in cities like Rome, Athens,
Ephesus, Antioch, Damascus, Jerusalem, and other important
capital cities.

BIBLIOGRAPHY

T. Birt, *Das antike Buchwesen*, Berlin, 1882; *Die Buchrolle in der
Kunst*, Leipsic, 1907.

F. G. Kenyon, *Classical Texts from Papyri in the British Museum*,
etc., London, 1891; *Aristotle on the Constitution of Athens*, London,
1891–2; *Ancient Books and Modern Discoveries*, Chicago, 1927; *Books
and Readers in Ancient Greece and Rome*, 2nd ed., Oxford, 1951. See
also Bibliography to Chapters IV and V.

Catalogus codicum astrologorum Graecorum, 12 vols., Brussels,
1898–1940.

U. von Wilamowitz-Moellendorff, *Timotheus' Persae*, Berlin,
1903; *Die griechische Litteratur des Altertums*, Leipsic and Berlin, 1912.

Berliner Klassikertexte, Berlin, 1904 onwards.

H. R. Hall, *Coptic and Greek Texts of the Christian Period*, London,
1905.

E. M. Thompson, *Handbook of Greek and Latin Palaeography*, 3rd ed.,
London, 1906; *Introduction to Greek and Latin Palaeography*, Oxford,
1912.

E. Mayser, *Grammatik d. griech. Papyri aus d. Ptolomaeerzeit*, Berlin
and Leipsic, 1906–34.

E. Diehl, ed., *Supplementum lyricum*, Bonn, 1908 (new ed., 1917).

C. Robert, ed., *Menander's Six Plays*, Halle, 1908.

E. J. Godspeed, *Chicago Literary Papyri*, Chicago, 1908.

A. S. Hunt, *Fragmenta Tragica Papyracea* (*Tragicorum Graecorum
Fragmenta nuper reperta*), Oxford, 1912.

F. Baumgarten, F. Poland, and R. Wagner, *Die hellenistisch-roemische Kultur*, Leipsic, 1913.

W. Leaf, *Homer and History*, London, 1915.

L. Whibley, ed., *A Companion to Greek Studies* (R. C. Jebb, *Literature*; H. Jackson, *Philosophy*; J. Gow, *Science*; A. S. Wilkins, *Education*; M. R. James, *Books and Writing*; E. H. Minns, *Palaeography*; R. C. Jebb, *Textual Criticism*; J. Sandys, *History of Scholarship*), 3rd ed., Cambridge, 1916.

W. Schubart, *Das Buch bei den Griechen und Roemern*, 2nd ed., Berlin and Leipsic, 1921; *Griechische Palaeographie*, in Mueller, *Handb. d. Altertumswiss.*, Munich, 1925; *Das antike Buch*, "Die Antike", 1938.

K. Schottenloher, *Das alte Buch*, 2nd ed., Berlin, 1921.

E. Breccia, *Alexandrea ad Aegyptum*, Bergamo, 1922.

C. H. Oldfather, *The Greek Literary Texts from Graeco-Roman Egypt*, Madison (U.S.A.), 1923.

T. W. Allen, *Homer, the Origins and the Transmission*, Oxford, 1924.

J. E. Sandys, ed., *A Companion to Latin Studies* (W. Murison, *Education*; M. R. James, *Books and Writing*; A. W. Verrall, W. C, Summers, and J. Sandys, *Literature*; R. D. Hicks, *Philosophy*; J. F. Payne, *Natural History and Science*; E. M. Thompson, *Palaeography*; J. P. Postgate, *Textual Criticism*; J. Sandys, *History of Latin Scholarship*), 3rd ed., Cambridge, 1925.

H. J. H. Milne, *Catal. of Literary Greek Papyri in the British Museum*, London, 1927.

P. Collomp, *La Critique des textes*, Paris, 1931.

National Library, Vienna, *Griechische literarische Papyri*, Vienna 1932 onwards.

S. Runciman, *Byzantine Civilization*, London, 1933.

M. Rostovtzeff, *A Social and Economic History of the Hellenistic World*, 3 vols., Oxford, 1941.

M. Norsa, *La scrittura letteraria greca*, etc., Florence, 1941.

O. Neugebauer, *On some Astronomical Papyri*, etc., "TRANSACT OF THE AMER. PHILOS. SOC.", 1942; *The Exact Sciences in Antiquity*, Copenhagen, 1951.

D. L. Page, *Greek Literary Papyri*, London, 1942.

F. Reggers, *Catalogue van de Grieksche Letterkundige Papyrustexten (1922-8)*, Louvain, 1942.

R. M. Cook, *Ionia and Greece, 800–600 B.C.*, "JOURNAL OF HELLENIC STUDIES", 1946.

L. Giabbani, *Testi letterari greci di provenienza egiziana (1920-45)*, Florence, 1947.

H. L. Pinner, *The World of Books in Classical Antiquity*, Leyden, 1940.

H. I. Bell, *Egypt from Alexander the Great to the Arab Conquest*, Oxford, 1948.

C. Wendel, *Die griechisch-roemische Buchbeschreibung*, etc., 1949.

J. J. Clère, *Un Text astronomique de Tanis*, "KÊMI", 1949.

See also Bibliography to Chapters IV and V, and the General Bibliography.

POST SCRIPTUM

It has not been possible to make use in this volume of the excellent work—quoted in the BIBLIOGRAPHY to this chapter—by Carl Wendel, *Die griechisch-roemische Buchbeschreibung verglichen mit der des vorderen Orients*, "HALLISCHE MONOGRAPHIEN", No. 3, Halle (Saale), 1949.

Although the book deals mainly with problems connected with the history of libraries, Wendel treats extensively of various general problems discussed in the present volume—namely, the clay-tablet book, the papyrus-roll book, and the libraries and the books of ancient Greece and Rome. He emphasizes the importance of Mesopotamian book-production in the history of the book, particularly its indirect influence on Greek book-production. He suggests that the Asiatic peoples, and particularly the Lydians, as well as the Phoenicians, may have been the mediators between Mesopotamia, Syro-Hittites and Hurrians, on the one hand, and the Greek world on the other. Furthermore, he suggests that the leather roll was the main writing material for books of the Ionian Greeks, the Aramaeans, and perhaps also the Phoenicians.

The subjects are discussed in great detail and with profound learning, but the evidence adduced—though vast and elaborate—is not conclusive.

THE BOOK FOLLOWS RELIGION

The Book in Western Christianity

IT has already been mentioned that nearly all the writing of medieval Europe was done in religious houses. Monasteries, in particular, assumed the otherwise neglected task of making copies of sacred and—though rarely—secular books.

St. Benedict himself (480–513)—who founded fourteen monasteries, including the famous monastery at Monte Cassino (founded in 528), which became the main centre of the Order—composed the *Regula Monachorum*, or "Rule for Monks", which laid down not only that the steady reading of books by the brethren should form part of the daily round, but also that some of the elder monks should see that this rule was duly observed. However, W. Oakeshott rightly argues that St. Benedict reckoned on the likelihood that many of the monastery's inmates would be illiterate, and that Benedict's injunction on the importance of reading books is connected especially with Lent, "and the implication clearly is that they might find thereby a suitable penance for the good of their souls".

CULTURAL ACTIVITIES OF THE MONASTERIES

In the second half of the sixth century, especially after the foundation of the monastery at St. Maur-sur-Loire, in Gaul, various Benedictine monasteries were engaged in the study of religious literature as well as of Roman and Greek classics. The monks were to learn Latin and Greek "as well as they learned their own tongue", and were thus to obtain the key to the literature and science that were then known. Their influence on western European art, literature and education was very great. The Benedictine monk was the pioneer of medieval civilization and Christianity in England, Germany, Poland, Bohemia, Sweden and Denmark.

St. Augustine introduced the Order into England, and the most important English cathedral priories and abbeys were the foundations of the Order. Some European universities, directly or indirectly, developed from Benedictine schools, and so have some colleges of Oxford and Cambridge. The abbey of St. Gall, in Switzerland, not far from the Lake of Constance, is also a Benedictine foundation: for a period it was a focus of Irish missionary effort. The famous St. Gall Chapter Library still possesses a number of manuscripts written by Irish monks, who brought with them their own peculiar style of writing. This style was taken up and imitated by the native monks, but in the ninth century St. Gall established its own centre for copying manuscripts, and towards the end of the century it developed a distinct style of writing, which in time was generally adopted in the districts bordering on the Rhine.

Other forms of monasticism arose—the most notable and distinguished, dating from an early period, being the Order of St. Augustine (or Austin canons); but their learned work was not on the level of the Benedictine Order, with its daughters, the Cistercian Order and the Maurist Congregation in France. However, numerous monasteries, which engaged in small-scale manufacturing and agriculture, also became centres of literary and artistic activity (see Chapters V and X). If monks boiled down the salt of the brine pits, they also copied and illuminated manuscripts in their *scriptorium*; if they ran rhines through the marshy moorland, and tilled the soil with vigour and success, they also painted pictures with some rude merit of their own. Although it is true that "the important centres of writing and illumination were not numerous, such as, in England, Canterbury, Winchester, St. Albans, Durham and Glastonbury," yet "at certain times and places the scribe was held in quite conspicuous honour. In Ireland, for instance, in the seventh and eighth centuries, the penalty for shedding his blood was as great as that for killing a bishop or abbot; and in Scotland, 'scriba' was regarded as an honourable addition to a bishop's name" (F. Madan).

All the main monasteries seem to have produced books, or at least to have caused the production of books.

Space does not allow to deal here with the book production of the single countries, but a few words may be said regarding France.

The main *scriptoria* in pre-Carolingian France were at Lyons, the most important centre of Roman civilization; Luxeuil, an early Irish foundation; Corbie, an offshoot of Luxeuil; St. Martin at Tours, which was a large and wealthy abbey even before it was associated

Fig. VII-1

Codex Vercellensis or *Eusebianus* (Capitulary Archives, Vercelli, North Italy); assigned to St. Eusebius, bishop of Vercelli, who died in 371 A.D. It is apparently the earliest preserved *Vetus Latina* codex.

Fig. VII-2

Codex Palatinus: 228 folios are preserved in Castel del Buonconsiglio, Trent, North Italy; one is in the British Museum, *Add. MS. 40107*; and one—here shown—in Trinity College, Dublin, *N.iv.18*. The manuscript is written in two columns of 20 lines, in silver on well prepared and deeply dyed parchment, the opening lines of *St. John* and *St. Luke* being in gold. Attributed to the fifth century A.D., and apparently the earliest preserved purple *Gospel* of the *Vetus Latina*.

Fig. VII-3

Codex Sarzanensis (Chiesa Parrocchiale, Sarezzano, near Tortona, Province of Alexandria, North Italy). The manuscript was found in 1585 under the main altar in a twelfth-century wooden box. It is a very fine and early *codex aureus* of the *Vetus Latina*, though in very bad condition of preservation. It consists of 72 folios, containing *St. John* and part of *St. Luke*, written in gold in uncials of the early sixth century on very fine and deeply dyed parchment. The golden ink has irreparably damaged the fine vellum.

Fig. VII-4

Codex Brixianus (Queriniana Library, Brescia, North Italy). 418 folios of 20 lines. Uncials of the first half of the sixth century. Written in silver on purple stained vellum, the opening lines of the chapters being in gold. Contains Eusebius Caesariensis, *Canones evangeliorum* and the *Four Gospels* in the order of the *Vetus Latina*. From the monastery of St. Salvatore and St. Giulia, at Brescia.

Fig. VII-5

Codex Amiatinus (early eighth century) : see p. 504 f.

with Alcuin; and St. Denis, near Paris, even before it became "the *foyer* of a rekindled art which was to shine on France and Europe" (Mâle) (see Fig. V–15; VII–7, *b*; 8, 1–2).

THE LATIN BIBLE MANUSCRIPTS

The main characteristics of the books produced during the Middle Ages are their illumination and binding. While, however,

Fig. VII–6

Codex Claromontanus, written in uncials of the seventh century, contains the Vulgate version (Vatican Library, *Cod. Lat. 7223*, fol. 230 *recto*).

these form a necessary part of the history of the book, they are so distinct in their nature as to deserve a fairly full treatment, and accordingly a special volume is being devoted to the subject.

Here it will suffice to mention one class—though undoubtedly the principal one—of medieval book production, the Latin Bible manuscripts, of which about 8,000 are preserved. It is well known that of Latin versions the two most important are the so-called *Vetus Latina*, or Old Latin version, and the *Vulgate*. The former, based upon the Greek text, and attributed to the second century A.D., seems to be contained in relatively few manuscripts extant, partly belonging to the fifth or sixth century. An excellent list of Old Latin Bible manuscripts is to be found in B. Fischer, *Vetus Latina*, etc., Freiburg, 1949 onwards. See also Figs. VII–1–4.

The Vulgate is the Latin version of the Bible prepared by St. Jerome in the last two decades of the fourth century (A.D.) and the following five years. In the course of time, St. Jerome's translation became corrupted and various recensions became necessary, of which the following may be mentioned: those of Cassiodorus (sixth century), Alcuin (late eighth century)—see p. 480 ff., the revision prepared for England and North France by Lanfranc, Archbishop of Canterbury (late ninth century), the revision of Stephen Harding (early twelfth century), and the *Correctorium Parisiense* (early thirteenth century). Although the Vulgate was declared authentic by the Council of Trent (1545–63), the earliest standard editions were those published by Pope Sixtus V (1585–90) and Pope Clement VIII (1592–1605). In 1907, Pope Pius X appointed a commission of Benedictine abbots to prepare a new official version for the Catholic Church, but its work is still far from complete, nor "is it likely to achieve finality as a textual recension" (B. J. Roberts).

The following are the principal manuscripts containing the Vulgate version: codices *Turonensis* or *G* (sixth or seventh century), *Claromontanus*—Fig. VII–6—*Ottobonianus* or *O*—Fig. VII–7, *a*— *Amiatinus* or *A* (early eighth century; see p. 473 f. and Fig. VII–5), *Cavensis* (ninth century), *Theodulfianus* (ninth century), *Vallicellianus* (ninth century). They all contain portions of the old Testament; the *Amiatinus*, *Cavensis* and *Vallicellianus* also portions of the New Testament, and three other manuscripts—*Fuldensis*, *Sangermanensis*, and *Lindisfarnensis* (see p. 470 ff.)—contain only portions of the New Testament. Other important groups of Latin Bible manuscripts are a Spanish "family" of the eighth century and an Italian "family" of the twelfth. Of all these manuscripts, the *Amiatinus*

—Fig. VII–5—seems to be the leading manuscript of the Vulgate (see p. 504). Concerning the "Irish" text see Chapter X.

The total number of New Testament codices, which have come down to us is 4,086, of which 169 are in uncials (two belonging to A.D. *c.* 400, and fourteen to *c.* 500; all the others, to between A.D. 600 and 1000), 2,352 are written in minuscules (and date to A.D. 900–1500), 1,565 are fragmentary. There are about fifty fragments of papyri. The number of copies of translations of the New Testament, including fragments, is said to be about 30,000.

Fig. VII–7 (a)

Codex Ottobonianus, written in North Italy in the seventh or eighth century A.D., contains the *Pentateuch* in Vulgate version with some portions in *Vetus Latina* (Vatican Library, *Ott. Lat. 66,* fol. 52 *recto*).

BOOKS WRITTEN IN "NATIONAL" SCRIPTS

As soon as the various European countries had shaken off the political authority of the Roman empire, and the educated communities had been scattered and dissolved, a marked change took place in the development of the Latin cursive or running script. Several "national" hands, or rather "national" styles of the Latin cursive minuscule, assumed distinctive features, and there thus developed on the European continent and in the British Isles, the five principal national hands, known as South Italian or Beneventan, Merovingian (in France), Visigothic (in Spain), Germanic pre-Carolingian, and Insular (in Ireland and England): Figs. VII–7, *b*, 8 and 9.

Fig. VII–7 (*b*)

The oldest complete copy of the *Hexameron* by Ambrose; written at Corbie in eighth century minuscules (Corpus Christi College, Cambridge, MS. 193).

Each of them gave rise to several varieties.

At the end of the eighth century, the Caroline or Carolingian minuscule was formed in the Frankish empire, probably under the influence of the Anglo-Irish hand. The Carolingian script became the literary hand of the Frankish empire, and during the next two centuries it became the main book hand of western Europe. The

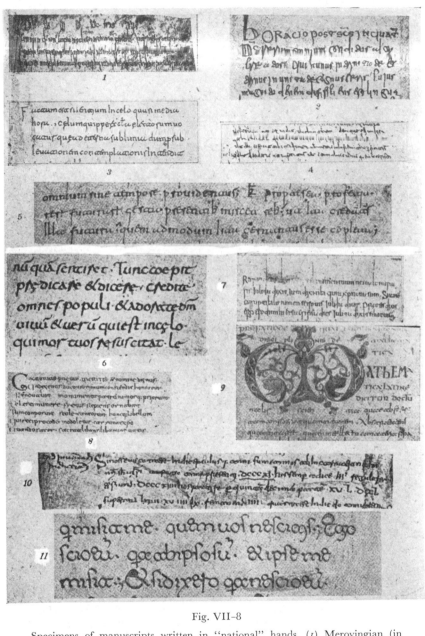

Fig. VII–8

Specimens of manuscripts written in "national" hands. (*1*) Merovingian (in France), seventh century A.D.; (*2*) Merovingian, eighth century; (*3*) Visigothic minuscule (in Spain), 945; (*4*) Visigothic cursive script, before 779; (*5*) Visigothic, eleventh century; (*6*) Roman minuscule, ninth century (*Vitae Sanctorum: Farfa codex*); (*7*) North Italian pre-Caroline minuscule (*Codex 490*, Capitulary Library, Lucca); (*8*) Idem, late eighth century; (*9*) Idem, eighth–ninth century (upper part, uncial script); (*10*) Beneventan script, from Cassino, eighth century; (*11*) Idem, eleventh century.

blending of the majuscules and the minuscules into combined service is due mainly to this script. It was employed until the twelfth century, and had some varieties, such as the English, Frankish, Italian, and German. From the late twelfth century onwards, in north-western Europe, including England, the letters gradually assumed angular shapes. The new hand, termed "black letter" or Gothic, or German, was employed in England until the sixteenth century, and is still used in Germany as a kind of "national" hand.

During the fifteenth century, a beautiful Italian cursive minuscule, the round, neat humanistic or renaissance hand, based on the earlier round minuscule—this being considered at the time as the script of the classical Roman period, the new script was called *antiqua*—was introduced in Florence, and employed for literary productions. This style developed mainly into two varieties: (1) the Venetian minuscule, nowadays known as *italics*, traditionally an imitation of the handwriting of Petrarch, and probably the most clearly legible form of characters which has yet been invented; and (2) the "Roman" type of letters, perfected in North Italy, chiefly at Venice, where it was used in the printing presses in the late fifteenth and early sixteenth centuries, and spread thence to Holland, England (about 1518), Germany, France, Spain, and other countries. The monumental Latin alphabet was taken over for the majuscules. This majuscule and both forms of the minuscule, the "Roman" and the *italics*, spread all over the world. In England they were adopted, from Italy, in the sixteenth century.

For further details see *The Alphabet*, pp. 545–52.

The "national" scripts of the modern European peoples are, strictly speaking, though with a few exceptions, adaptations of the Latin alphabet to Germanic, Romance, Slavonic and Finno-Ugrian languages; for the alphabets of the Graeco-orthodox Slavonic peoples, see p. 290 ff.; the modern Greek alphabet is a development of the ancient Greek cursive writing with some influences of the Latin alphabet.

Not only has the Latin alphabet, in all its varieties, been adapted to, and adopted by the great majority of the European languages and peoples; also the Graeco-Roman and Latin Christian book making has been inherited by modern Europe. Until the invention of printing —and even for some time afterwards—the form of "the book" did not undergo great change, except in two main fields: illumination and binding. These will be dealt with—as repeatedly mentioned— in the forthcoming book on *Illumination and Binding*.

Fig. VII-9

(*Above*) Origines, *Homiliae in Lucam*, eighth or ninth-century minuscule (Corpus Christi College, Cambridge, MS. 334). (*below*) *Varia Medica*, including Hippocrates and Galenus (University Library, Glasgow, *Hunterian MS. T.4.13*, fol. *99 recto*; it is written in "a curious and awkward mixed minuscule (Visigothic, Beneventan, Caroline. . . .") (Lowe)).

Fig. VII-10

St. Cyril of Alexandria (d. 444), *Thesaurus adversus haereticos*, transl. by Alphonsus Jorge of Trebizonda. The illuminated border shows in the upper part the Catalan royal arms, and in the lower part those of Naples. The codex, written in Italy, belonged to Alfonso V the Magnanimous (1416–58), king of Aragon, Sicily and Naples (Central Library, Barcelona, MS. 561, fol. 1).

The Eastern Church (Figs. VII-11-16)

The historical importance of the Eastern Church in early Christianity is too well known to be discussed here in great detail; it is signalized in the fact that of the Patriarchates four were in the east (Jerusalem, Alexandria, Antioch, and Constantinople) and only one (Rome) in the west.

The main weakness of eastern Christendom lay in its being riddled with sects, "heresies", and schisms. The two great "heresies" of the fifth century, Nestorianism (condemned by the Council of Ephesus, in 431), and its extreme opposite, Monophysitism (condemned by the Council of Chalcedon, in 451), caused the splitting up of the Eastern Church into various independent Churches; this made for the rapid and easy victory of Islam in Palestine, Syria and Egypt, and ultimately caused the decline of Christianity in the east. Indeed, the predominant feeling of the Syrian and Egyptian Christians (who were either Nestorians or Monophysites) at the time of the Arab invasion appears to have been a sense of relief that they were now able to practise their religion unhindered by the persecution of the Imperial Orthodox Church.

On the other hand, this separation of the various Churches produced divergences between the liturgies and traditions of the various religious schools. As a result, various native literatures were produced (Syria: Nestorian, Jacobite, and Melkite; Coptic and Ethiopic; Armenian, Georgian, and others); the Nestorians even carried their teachings, their language, their script and their books far into the Kurdistan highlands, into South India, into Turkestan, amongst the Turki and Mongol tribes of Central Asia, and into China.

Thanks to the diffusion of Christianity, and to the consequent necessity of translating the Bible into the native tongues, various languages (*e.g.* Armenian, Georgian, Alban and others, in the east; Gothic in the west) were reduced to writing, and native literatures, especially in the religious fields, were produced. Some early manuscripts in these languages are, indeed, extant, for example, the Gothic *Codex Argenteus* (Fig. VII-11, *a*), preserved at Uppsala (Sweden), and consisting of 187 pages written in silver and gold on purple-red parchment.

CONSTANTINOPLE AS CAPITAL OF EASTERN CHRISTIANITY

After the Moslem invasion of Palestine, Syria, and Egypt, the

Fig. VII-11

a, Page from the *Codex Argenteus*; *b–f,* Specimens from Russian manuscripts: *b,* manuscript, A.D. 1073; *c,* manuscript, A.D. 1284; *d,* prayer-book, A.D. 1400; *e,* manuscript of the fifteenth century A.D.; *f,* manuscript dated 1561.

Patriarch of Constantinople assumed the title of Oecumenical Patriarch ("Universal Father Ruler") and Constantinople became the most important centre of Eastern Christianity. With the gradual separation of West from East, and particularly after the definite severance, in 1054, of the Western Church from the Eastern— the former retaining Latin as its official| language, the latter Greek—the peoples who took their religion from Byzantium came within the influence of Greek culture, their languages being reduced to scripts which descended directly from the Greek alphabet.

The Book in Eastern Christianity

The division between the peoples who took their religion from Rome and those who took their religion from Byzantium, is particularly evident among the Slavonic peoples: it coincides with the line of demarcation between the peoples having Latin as their early cultural language and still retaining it for their liturgy, besides using the Roman characters, and the peoples influenced by the Greek-Byzantine culture and employing the Cyrillic alphabet, derived from the Greek. See also *The Alphabet, passim.* Fig. VII– 11, *b–f,* reproduce specimens of early Russian manuscripts.

As in the west, so in the east, the monks, and other religious people kept the lamp of ancient science and culture burning during the Middle Ages. In the east, indeed, monasticism arose earlier than in the west and continually gained new ground: men of religious propensity gradually sought solitude, or communion with kindred spirits, so that they might develop in peace the higher life. The conventual life was in part a revolt against contemporary society, with its wars and lusts and manifold corruptions, and it was ever a bulwark of the Church.

Thanks to these conditions, in the east, as in the west, numerous Christian scriptoria came into being; in the west the Latin characters were employed; in the east the Greek and the Syriac (in all its varieties, Estrangelā, Nestorian, Jacobite, Melkite, and so on), as well as the Coptic, the Arabic, or else, still farther east, the Armenian, the Georgian, and other scripts. It is not surprising, therefore, that numerous manuscripts have been brought to light from monasteries and other religious houses of Greece, Egypt, Sinai, Palestine, Syria, Asia Minor, Armenia, and other eastern countries.

"Several travellers who have managed to overcome the suspicion of the monks and their unwillingness to open their literary hoards to strangers, or to part with any of the volumes, have found immense numbers of books hidden under dust and rubbish in vaults and cellars or stowed away in chests, where they were probably thrust at some time when danger threatened them. Books written in these monasteries themselves in earlier days, or brought hither from other monasteries further East have thus lain forgotten or neglected for centuries, or, if they were noticed at all, it was only that they might be put to some ignoble use. Thus some were found acting as covers to two large jars which had formerly held preserves. . . . Some large volumes were found in use as footstools to protect the bare feet of the monks from the cold stone floor of their chapel" (G. Burford Rawlings).

Relatively few monasteries are still in existence, and these are in decadent condition. Mention may be made of the Greek orthodox convent of St. Catherine, situated about 5,000 feet above sea level at the foot of Mt. Sinai. Here the famous *Codex Sinaiticus* (p. 195 ff.) was discovered. St. Catherine's Monastery is said to have been founded in the days of Constantine the Great and the Empress Helena (first half of the fourth century A.D.). In Justinian's times (sixth century) thousands of anchorites inhabited that region, and there were various monasteries. Nowadays, there is only the monastery of St. Catherine, and only about ten monks live there, though its monastic order has still old branches at et-Tôr and at the Feirân Oasis, and some of their monks live in Cairo. The Monastery of St. Catherine occupies an area of nearly 300 by 250 feet, which is enclosed by a wall 40–50 feet high. There is the "Big Church", a mosque, about twenty chapels, and various other buildings. The precious library still contains about 3,300 manuscripts, in about a dozen languages, including some 2,300 Greek codices, about 550 Arabic, 257 Syriac, ninety Georgian, forty-one Slavonic, and six Ethiopic manuscripts. In 1950, an American expedition, headed by K. Clark, was sent by the American Foundation for the Study of Man (with the co-operation of the Library of Congress, at Washington) to microfilm the more important manuscripts of the Sinaitic monastery. The Expedition appears to have succeeded in its main task. Moreover, many new manuscripts have been "discovered", various manuscripts reported lost have been re-discovered, and a few important palimpsests have been found.

Fig. VII–12

Earliest extant dated Syriac manuscript (British Museum, *Add. MS. 12150*).
Written in *estrangelā* at Edessa towards the close of A.D. 411, preserved in the
ancient convent of St. Mary Deipara in the Nitrian desert in Egypt. The full page
has three columns, but the innermost column has been omitted to include in the
illustration the marginal annotation written in the Deipara Convent in A.D. 1087.

The Syriac Book (Figs. VII-12-14)

The terms "Syria" and "Aram", and the corresponding terms "Syrians" and "Aramaeans" are synonymous. Indeed, the Hebrew Biblical word *Aram* is rendered in the Septuagint by Syria. Conventionally, however, the term "Syriac" denotes the ancient Semitic or Aramaic language and literature of the "Syrian Christians"; the latter term denotes not "Christian inhabitants of Syria", but roughly those Christians who spoke "Syriac", a daughter-language of ancient Aramaic, or who were within the Syriac Church, which was under the influence of Syriac thought and Hellenistic culture.

Antioch of Syria, one of the most important centres of early Christianity, the city where "the disciples were called Christians first" (*Acts*, xi, 26), was the chief town of Syria, but linguistically it was a Greek city, and it was an important centre of Greek culture.

Edessa (now Urfa), the capital of the small kingdom Osrhoëne, situated in north-western Mesopotamia, to the east of the Euphrates, was the first centre and principal focus of the Christian Church in the Syriac-speaking world. Christianity was preached here already in the second century, and thence it spread to Persia.

The Edessan dialect became the liturgical language of the Syriac Church, the literary language of the Christian Aramaeans of Syria, and likewise of neighbouring countries, even of Persia; it was indeed the *lingua franca* in Mesopotamia, Syria and Persia. After Greek, it was the most important language in the Eastern Roman Empire. Nisibis (situated about 120 miles almost due east from Edessa) was another important centre of the Syriac Christians; about A.D. 300 it was recognized as an episcopal See. Both in Edessa and Nisibis there were schools of theology, the influence of which extended far into the Christian world.

SYRIAC LITERATURE

A contract of sale, dated A.D. 243, comes from Dura Europos, and is the earliest available Edessan Syriac document written on parchment in Estrangelā (*i.e.* the early Syriac script). The earliest dated Syriac manuscript (British Museum, *Add. MS. 12150*) is probably the earliest dated codex available in any language. It is dated in the year 723 of the Seleucid Era—A.D. 411: Fig. VII-12. The next oldest manuscripts are: a palimpsest manuscript, British Museum, *Add. MS.*

14512, fol. 67–124, dated in 771 Seleuc. Era—A.D. 459–60, and *Add. 14425*, fol 1–116, containing a copy of *Genesis* and *Exodus*, dated in A.D. 464. (As a matter of fact, *Add. 14425*, as at present bound up, consists of two originally distinct manuscripts, and the date refers to the first half of the codex; the second part, containing *Numbers* and *Deuteronomy*, belongs to a later period.)

The extensive Syriac literature is a Christian literature in a very special sense, nearly all the manuscripts extant dealing solely with Christian subjects. The Syriac literature flourished mainly in the fourth to seventh centuries. The internal religious conflicts are reflected in the writings of the sixth and seventh centuries.

Indeed, with the great schism in the seventh century between the Nestorians, or East Syrians, and the Monophysite Jacobites, or West Syrians, a separation took place, which implied a severance of tradition in the literature which emanated from the two sects. The Melkites, or "Royalists", continued to carry on in union with Constantinople, whereas the Maronites, who were originally Monophysists or Monothelites, about 1102 became united to the Roman Catholic Church. Syriac religious literature, however, never regained its former glory, though it continued to be produced for many centuries. In the thirteenth century, Bar-Hebraeus, also known as Abufaraj or Abulpharagius, a celebrated oriental writer of Jewish parentage, who became primate of the Jacobite Church, tried to revive both the Syriac language and its literature.

SPREAD OF THE NESTORIAN AND THE JACOBITE CHURCHES
(Figs. VII–13 and 14)

After the Arab conquest, far from declining in vigour under Moslem rule, the Nestorians and the Jacobites began a remarkable period of missionary expansion throughout Central Asia. Indeed, the Syriac Church spread widely in the east. For some time in the Middle Ages there were 150 Jacobite archbishoprics and bishoprics.

The Nestorian Church especially—or the Church of the East, which is the term preferred by its followers—was widely scattered through the countries of central and eastern Asia. After the secession of the Nestorian Church from the Imperial Orthodox Church of Byzantium, the Nestorian faith became the official religion of the then flourishing Persian Church, and the city of Seleucia became the seat of their Patriarch, or *Catholicos*. Their hostility towards Constantinople and its Imperial Church gained the Nestorians the popularity of the Sasanian rulers of Persia, who were "sworn"

enemies of the Roman or Byzantine Empire; naturally, the Nestorian Church leaders did not fail on occasion to emphasize their loyalty to the Persian King of Kings and their enmity towards the Roman Emperor.

It is only by casual literary evidence that we learn of the existence of richly illustrated Persian books of the Sasanian period (A.D. 226–636)—see the forthcoming book on *Illumination and Binding*. There can be no doubt that, thanks to the Nestorians, Persian book production, including book illumination, spread far beyond the territories of the Sasanids. Moreover, some modern scholars consider the Nestorians as a connecting link in book production between the Copts and Central Asia.

Under the Arabic dynasties, the Nestorian Church—as well as the Jacobite Church—retained the allegiance of large sections of the local population, and, as Sir Thomas Arnold pointed out, "their patriarchs were wealthy and powerful and at times exercised considerable influence at court. Some estimate may be formed of the wealth enjoyed by these Christian communities from the record of the magnificent churches they from time to time erected. . . . There must have been an ecclesiastical art corresponding to the wealth and extension of these two Oriental Churches, but very little evidence of it appears to have survived in the form of pictorial art. . . ."

In the seventh and eighth centuries, Nestorian missionaries preached Christianity in China, and in the eighth century a Nestorian bishop of Tibet was appointed. After the Mongol conquests had brought under one sceptre a territory stretching from Syria to the shores of the China Sea, and after the re-opening of the trade routes into Further Asia, a new outlet was offered for the Nestorian missionary effort. The Nestorians eagerly seized this opportunity. Marco Polo tells us that in his times the trade routes from Baghdad to Peking were lined with Nestorian chapels. In 1265, there were twenty-five Asiatic provinces, with seventy bishoprics, in Persia, Mesopotamia, Khorasan, Turkestan, India, and China.

At one time it even looked as though the Mongol emperor, Qubilay Khān (1216–94), might adopt Christianity. His brother Hūlāgū Khān, who in 1258 captured Baghdād and put an end to the splendid 'Abbāsid Caliphate, and was the first to assume the title of Il-Khān, had a Christian wife; he accorded special favours to the Nestorian patriarch and to his Church.

Half a century later, the seventh Khān chose Islam as the state

religion. There was then a growing bitterness between the Nestorian Church and the Moslem leaders, who could not forget the overbearing attitude of the former towards Islam in the period of the Mongol conquest, when the new rulers were still heathen. It is quite

Fig. VII-13

Nestorian book.

possible that this bitterness produced the last straw in Moslem intolerance towards Eastern Christianity.

Gradually all the activities of the Nestorians ceased and nothing remained to tell the glorious tale except the numerous sepulchral and other inscriptions and some illuminated Church service books in various parts of central and eastern Asia. There are now some 60,000 members of this once glorious Church.

The paramount influence, directly or indirectly exerted by Nestorian culture and book production upon Central Asia and the Far East, has left indelible traces in the Mongolian and Manchurian alphabets: see *The Alphabet*, Fig. 148.

Fig. VII-13 shows a Nestorian book completed in the year A.D. 892; it contains about 800 pages measuring 28.5 by 22.5 cm. Its author was a monk who had devoted his life to Christian research and meditation. He had travelled to China to disseminate Christian religion. In returning to his native country after many years of absence, he desired a life of seclusion; so he went up to the Hikari Mountains and dug out a cave in which to dwell, meditate and write his book. He was fed on milk supplied by the passing shepherds and on vegetables which he produced by his own labour. Having completed the manuscript, he considered his life as finished, prayed for death, and prepared himself for this great event by digging his grave in a corner of the cave that had been his abode for forty years. Years after his death, shepherds seeking shelter from a storm, found the manuscript wrapped in many layers of skin bound securely with thongs; they gave it to a priest who had happened to be a member of the monk's family.

The book was found to contain meditations, prayers, sermons, chronology dating from the earliest Disciples, and other Christian matter. The manuscript became a sacred book, and even was used as a pillow to place under the head of the sick "producing miraculous cures". It continued to serve the great purpose until the Mongol invasion in the fourteenth century, when—for precaution—it was buried in a cemetery. After the danger passed, the remainder and the descendants of those who had fled to the mountains returned to the village, found the place of the hidden treasure—which had been marked by a stone bearing the name of the writer—and unearthed the book in perfect condition. The manuscript, again used as a sacred book, has since been kept by the descendants of the monk's family. Thus runs the story.

(The present writer owes these notes and the photographs to

Fig. VII–14

Harqleian or Harqlensian version of the New Testament. In a neat regular Jacobite
cursive hand; it contains 216 leaves of vellum, measuring 9½ by 6½ inches, and is
dated *A.Gr.* 1481 corresponding to A.D. 1170 (University Library, Cambridge,
Add. MS. 1700).

his colleague, the Rev. A. E. Goodman, University Lecturer in Cambridge.)

THE PESHITTĀ

The most important Syriac literary monument is the *Peshittā* (it is called more often, but less correctly, *Peshittō*), meaning "simple", perhaps in contrast to the "learned" translation; or "common", possibly a term corresponding to the Latin "Vulgate". It is a standardized but faithful Syriac version of the Old and New Testament. The date of its origin is uncertain. Some scholars put it back to the third or even the second century. Until about twenty years ago it was generally held that the whole Peshittā was composed A.D. *c.* 200 and that it was used by the great theologian Aphrahat or Aphraates, who flourished from 336–45, and by St. Aphrēm (Ephraem), the greatest of the early Syrian fathers, who lived in the second half of the fourth century.

According to the late Prof. Burkitt, however, this belief is unfounded, and there is no evidence that—as far as it concerns the New Testament—this version existed before the fifth century. The earliest copy extant of the Old Testament (of *Genesis* and *Exodus*) dates from the year 464 (see p. 296); it has thus "the distinction of being the oldest copy of the Bible in any language of which the exact date is known" (Kenyon). Recently, it has been suggested that the Peshittā version of the New Testament was the work of Rabbūlā, bishop of Edessa from 411 to 435, of whom it is known that he translated the New Testament from Greek into Syriac, and ordered a copy to be placed in every church in his diocese.

Of the total number of 243 early Syriac manuscripts extant, nearly half, including most ancient ones, were discovered in the monastery of St. Mary Deipara (in the Nitrian Desert of Egypt), probably having been brought there from Nisibis; in 1842 they were secured for the British Museum. Two of them belong to the fifth century, the oldest being *Add. MS. 14459*, "and at least a dozen more are not later than the sixth century, three of them bearing precise dates in the years 530–9, 534, and 548" (Kenyon).

OTHER SYRIAC VERSIONS OF THE BIBLE

The Peshittā is not the only Syriac version of the Bible. An important manuscript of the Syriac collection of the Nitrian Desert —now known as the *Curetonian* manuscript (from the name of

Dr. Cureton of the British Museum who edited it)—contains an earlier Syriac version of the Bible; this manuscript, of eighty leaves, contains the Gospels and is from the fifth century. The Old Syriac version is represented also in a Syriac palimpsest manuscript discovered in 1892 by Mrs. Lewis and Mrs. Gibson in the Convent of St. Catherine on Mt. Sinai. Although the text of the Sinaitic manuscript differs somewhat from the text of the *Curetonian* manuscript, in Prof. Burkitt's opinion, they both represent the same Old Syriac version which dates to A.D. *c.* 200.

Three other Syriac versions of the Bible may be mentioned: the first, the Philoxenian Version, a revision of the Peshiṭṭā, made in 508 by Polycarp, and ordered by Philoxenus, Bishop of Mabbug, in Eastern Syria; it is represented by a manuscript in the John Rylands Library in Manchester, published in 1897. More important, however, is the later revision, known as the Ḥarqleian or Ḥarqlensian Version, from the name of Thomas of Ḥarqel who made it in 616; he, too, was Bishop of Mabbug. About fifty manuscripts extant contain this version; many of them are in England; apparently the best (Fig. VII-14), written in 1170, being in the Cambridge University Library, while two of the tenth century are in the British Museum; two manuscripts, of the seventh and eighth centuries, are in Rome, and one, dated A.D. 757, in Florence. The third, or Palestine-Syriac version of the Bible, probably made in Antioch in the sixth century, is known from fragments in the Vatican Library, in the British Museum, in the Bodleian Library, at Oxford, in the Leningrad Public Library, and in the Convent of St. Catherine on Mt. Sinai.

Amongst the volumes at this Convent was found, some twenty years ago, by Prof. Rendel Harris, an interesting Syriac book, containing a very early Christian work, hitherto supposed to be lost, the *Apology* of Aristides.

Syriac Translators of Greek Literature

It is commonly believed that the *Renaissance*, the rediscovery of the treasures of classical antiquity, took place in the fifteenth century A.D., in what is known as the period of Renaissance. This conception is misleading. The "renaissance" began in the "Dark Ages" with the translation of Greek works into Syriac and Arabic, mainly made by Syriac scholars. The original works were known to but a few, and since then many of them have been lost. The part played by

the Syrians in the east may be compared to that the Arabs and the Jews played in western Europe.

"More than any other one people the Syriac-speaking Christians contributed to that general awakening and intellectual renaissance centred in 'Abbāsid Baghdād which became and remained the chief glory of classical Islam. . . . The Arabian Moslem brought with him no art, science or philosophy and hardly any literature; . . . In a few decades after the foundation of Baghdād (762) the Arabic-reading public found at its disposal the major philosophical works of Aristotle and the Neo-Platonic commentators, the chief medical writings of Hippocrates and Galen, the main mathematical compositions of Euclid and the geographical masterpiece of Ptolemy. In all this the Syrians were the mediators" (Hitti).

The great scholar, the "sheikh of the translators", Ḥunayn ibn-Isḥāq (Johannitius; he lived from 809 to 873), a Nestorian Christian from al-Ḥīrah, has been called by a modern French historian of medicine "the greatest figure of the ninth century". Ḥunayn is supposed to have written many books in Syriac and in Arabic, and to have translated, apart from the Old Testament from the Septuagint (his version has not survived), the works of Galen, Hippocrates, Dioscorides, Plato (*Republic*), Aristotle (*Categories*, *Physics*, and *Magna Moralia*), and others. His search for Greek manuscripts led him all over the Near East and to Alexandria. He must have seen and compared hundreds of them and accumulated a large collection of his own.

From his report we learn how these translators worked, comparing defective manuscripts, restoring, explaining, excerpting. In some thirty years more than 130 books ascribed to Galen or his school were translated; of the listed 179 Syriac and 123 Arabic translations, Ḥunayn himself had done ninety-six and forty-six, respectively, besides the numerous revisions of translations done by others; eighty-one versions were done for Arab clients, seventy-three for people who knew Syriac. As a rule, the books were translated from Greek into either Arabic or Syriac.

The Armenian and Caucasian "Book"

(See also the forthcoming volume on *Illumination and Binding*, in which specimens of illuminated Armenian and Georgian books are reproduced.)

The section belongs geographically to the next chapter, but

as the earliest extant Armenian and Georgian books are strictly connected with Syriac Christianity, they may justifiably be dealt with here.

ARMENIA

This country, lying to the north of Eastern Syria (or northern Mesopotamia), between the Roman and Parthian empires, possessed no literary language, nor even a script, before Christianity reached it and the Armenian Church became independent in 369. Between A.D. 390 and 400, St. Mesrop or Masht'oz ("the saint"), in collaboration with St. Sahak and a Greek from Samosata, called Rufanos, created the Armenian alphabet, which is admirably suited to the Armenian speech: see *The Alphabet*, pp. 320–2.

The fifth century was the Golden Age of Armenian literature. A famous school of translators (*thargmanitchk'* or *surb thargmanitchk'*, "translators" or "holy translators"), founded by St. Sahak, produced a translation of both the Old and the New Testaments, partly from Greek and partly from Syriac. This version shows a marked affinity in the Gospels with the Old Syriac (see p. 301 f.). About the year 433 these translations were revised with the help of Greek manuscripts brought from Constantinople. The result was the present Armenian version, which has an interesting although very mixed kind of text. Some masterpieces of Greece and Rome were also translated into Armenian.

The earliest extant manuscript of the Armenian Gospels is dated 887: it was published in Moscow in 1899; there are probably two other manuscripts of the ninth century, and six of the tenth (the facsimile of an important manuscript of 989 was published by E. Mader). The majority of the Armenian codices, including copies of the whole Bible, belong, however, to the twelfth and later centuries. The illumination of these codices will be discussed in the book on *Illumination and Binding*.

The Armenian script and the versions of the Bible were the chief means of crystallizing Armenian speech, which was the main factor in upholding the existence and unity of the Armenian Church and nation.

GEORGIA

The ancient Colchis or Iberia, a part of the southern Caucasus, has been inhabited from about the seventh century B.C. by Georgians:

the indigenous term is K'art'li or K'art'velni. This ancient people employs nowadays both in printing and in handwriting the *Mkedruli* (from *mkedari*, "knight, warrior") or "the warriors', military, lay" script, of forty letters. Formerly, however, they also employed the *Khutsuri* (from *khutsi*, "priest") or "priestly, ecclesiastical" writing, an angular character of thirty-eight letters, in two forms (capitals, *Aso-mt'avruli*, and minuscules, *Nuskha*).

The origins of the Georgian scripts and written literature are uncertain; they seem, however, to be connected with the spread of Christianity into Georgia. Indeed, the Georgian Khutsuri script may be regarded as a Christian creation. Traditionally it is considered as St. Mesrop's invention, parallel to that of the Armenian writing. The earliest Georgian inscriptions extant go back to the fifth century A.D., while the oldest preserved manuscripts belong to the eighth century A.D. The Golden Age of Georgian literature was the twelfth and early thirteenth centuries under kings David II and George III, and Queen Tamara, and lasted for almost a century until the defeat of George IV by the Mongols in 1223.

Modern scholars, such as F. C. Conybeare in England and R. P. Blake in America, have shown that the Georgian version of the Bible, probably accomplished in the fifth century A.D., was made from an Armenian manuscript, and Blake concludes "that the Greek text on which it is ultimately based was of the Caesarean type. It is therefore a useful witness for the reconstitution of the Caesarean text."

THE ANCIENT ALBANS

The ancient Albans or Alvans also lived in the Caucasus—their territory, roughly corresponding with the present-day Soviet Republic of Azerbaijan, was the classical kingdom of Albania, the native name for it being Aghvanir or Shirvan. They were quite important in ancient times, especially during the wars between Rome and Mithridates of Pontus (first half of the first century B.C.).

According to Armenian tradition, the Alban alphabet was also created by St. Mesrop. No original Alban documents are extant, but I. Abuladze has recently identified the Albanian alphabet in an Armenian manuscript of the fifteenth century A.D.: this manuscript, which is now at Etchmiadzin (MS. No. 7117), contains a collection of the Greek, Syriac, Latin, Georgian, Albanian and

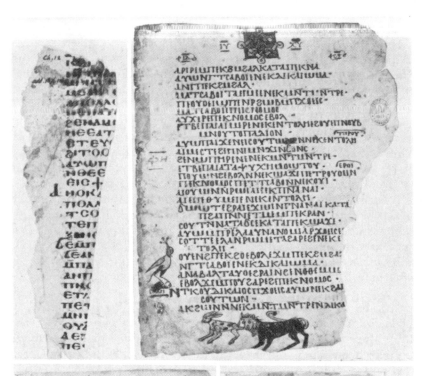

Fig. VII-15

Coptic alphabets, and Indian and Arabic cyphers, with Armenian transcriptions.

The Caucasian Albans, similarly to the Armenians and Georgians, are known to have developed a rich Christian literature between the fifth and eleventh centuries A.D.; but at the end of that period they disappeared as an ethnic entity.

The Coptic Book (Figs. IV–14, and VII–15 and 16)

We pass now from the eastern lands of early Christianity to its southern territories; these, however, were part and parcel of Eastern Christianity.

COPTIC

Coptic (from the Arabic *qopt*, *qubt*, *qibt*, a corruption from Greek *Aigýptios—gýptios*) is the last stage in the development of the Egyptian language. Curiously enough, Coptic was mainly a Christian language, at least in the manuscripts extant. It was the language which was used by the natives of Egypt at the time when early Christianity spread into that country; but it formed essentially the non-cultivated speech of its population, for the Egyptian aristocracy was then thoroughly Hellenized.

Even Coptic has a large admixture of Greek elements, especially in all that belongs to Christian doctrine, life and worship. This borrowing of Greek Christian terminology is due mainly to the fact that, as already mentioned, Greek was the main language of early Christianity. A new alphabet, based mainly on Greek, was devised for Coptic (see *The Alphabet*, pp. 467–71). This script became the mainspring of the spread of Christianity amongst the Egyptians.

SPREAD OF CHRISTIANITY

It is known that Christianity came to Egypt at a very early date; Alexandria, then the headquarters of Hellenic culture,

Fig. VII—15 (*opposite*)

Specimens of Coptic books. *Above* (*left*), Portion of the New Testament on vellum in Sahidic, fifth or sixth century A.D. (University Library, Cambridge, *Add. MS. 1876. 12*); (*right*) specimen from Herbert Thompson collection of Coptic manuscripts. *Psalm 118*, v. 124–51 (ibidem, *Or. 1699*). *Below* (*left*), Bohairic liturgical hymns (with Arabic headings), on paper, fourteenth or fifteenth century A.D. (ibidem, *Add. MS. 1886. 24*); (*right*) Arabic text, written in Coptic Bohairic hand, paper, fourteenth century. Apparently the text was read aloud and taken down in Coptic script (ibidem. *Add. MS. 1886.3*).

had commercial and cultural intercourse with Palestine, Syria and Asia Minor; large numbers of Jews, who spoke Greek from Hellenistic times onwards, lived there for centuries, and their highly developed religious thought and philosophy had already produced the earliest version in Greek of the Hebrew Bible: the Septuagint. It is of interest, too, that an Alexandrian Jew, Apollos, was a disciple of St. Paul.

The early Egyptian Christians, however, came mainly from the lower classes, and only after the fourth century did Christianity become more firmly established. In time "civilization" passed into the hands of the Christian Egyptians; and the great Coptic monasteries founded in the Akhmîmic territory (such as the White Monastery and the Red Monastery) became centres of religious and literary activity. Nevertheless, pagan culture did not disappear until towards the end of the fifth century. Generally, Coptic was the speech of the Christian rural districts, and for this reason it was able more easily to survive the Arab conquest.

THE COPTS

Nowadays, the term Copts is employed to indicate the indigenous population of Egypt, who after the Arabic conquest (in A.D. 641) maintained their Christian monophysite faith, the Coptic religion, and who, until the thirteenth century A.D., continued to use Coptic as their spoken and written language, and later as the liturgical language of their Church. While Arabic became the speech of every-day life, Coptic lingered on until the seventeenth century; indeed, in some Christian villages of Upper Egypt, it is used to this very day.

COPTIC LITERATURE

Some early Coptic inscriptions can be attributed to the second or third centuries A.D.; but the earliest manuscripts which can be definitely dated belong to the fourth century A.D. Apparently there were five main Coptic dialects: the actual number is still uncertain, although the papyri recently discovered in Egypt have added considerably to our knowledge of them. Already in the tenth century, Coptic writers (such as Severus of Eshmunain, author of a history on the Patriarchs of Alexandria) employed Arabic for literary purposes, but Coptic lingered on as a literary language at least until the fourteenth century.

Coptic literature is almost exclusively ecclesiastical—Figs. IV–14, VII–15, 16. It consists for the most part of translations from Greek, and includes versions of the Bible (Old and New Testaments) *Apocrypha* of the Old Testament (such as the *Testament of Abraham, Isaac and Jacob;* three *Apocalypses,* of late Jewish origin) and of the New Testament (*Life of the Virgin, Falling Asleep of Mary,* the *Death of St. Joseph, Acta Pilati,* the *Gospel of the Twelve,* the *Gospel of St. Bartholomew, Protoevangelium Jacobi,* and especially the apocryphal legends of the Apostles, including *Preachings* of St. James, St. Andrew, St. Philip), the *Martyrdoms* and the *Lives* of Saints. Here it will suffice to mention *Papyrus 8502* of Berlin (seven leaves of papyrus, containing part of the *Acta Petri*) and *Copt. Papyrus I* of Heidelberg (containing a portion of the *Acta Pauli*), which contain these apocrypha in their original form, including the *Acta Pauli et Theclae.*

BIBLICAL VERSIONS IN COPTIC DIALECTS

Versions of the New Testament have been identified in manuscripts written in all the main Coptic dialects—thus, including the Fayyûmic, that current in the district of Fayyûm, west of the Nile and south of the Delta; the Akhmîmic, perhaps the earliest Coptic dialect, spoken in Akhmîm, the ancient Panopolis: indeed, the most ancient Coptic manuscripts are in this dialect; and the Middle Egyptian, spoken mainly in the region of Memphis. Apart from a few Middle Egyptian fragments, versions of the Old Testament are extant only in the two more important Coptic dialects, which comprise also the chief New Testament versions.

These dialects are (1) the Sa'idic or Sahidic (from *es-Sa'id*, "the High", the Arabic name of Upper Egypt) or Thebaic (from the name of the ancient Egyptian capital Thebes, now Luxor and Karnak), which was current in Upper (*i.e.,* southern) Egypt, of which the chief city was Thebes; and (2) the Bohairic—it has been explained as the dialect of Bohaireh or the Region of the Lake (Mariût?) or as a derivation from Bohaïrah, the Arabic name of Lower, or northern Egypt. This dialect is also known as Memphitic (from Memphis, which was the ancient capital of Lower Egypt); but the latter term is not exact, because (a) the dialect was spoken in the coastal district of Alexandria, and (b) another dialect was spoken in Memphis (see above). As a liturgical language, Bohairic was probably used in the north, as early as the Sahidic dialect in the south, but the preserved Sahidic manuscripts are older than the Bohairic, and the most ancient relics of Coptic liturgy are in Sahidic. Bohairic, however, was

the most developed and most literary of all the Coptic dialects; as Alexandria was the seat of the Coptic Patriarch, Bohairic became the liturgical language of the Jacobite patriarchs when they gave up Greek; by degrees it replaced the other dialects, and ultimately (about the fourteenth century) it drove them out.

Although the earliest Coptic manuscripts extant belong to the fourth century (Fig. IV–14), there is no doubt that the translation of the Biblical books into the native Egyptian dialects was accomplished much earlier. According to Sir Frederic Kenyon, "by or soon after the end of the second century it is probable that the first Coptic versions had been made". Concerning the Old Testament books, "The Sahidic version was probably made before the end of the second century, the Bohairic somewhat later". Of the New Testament, the "Sahidic version is probably somewhat earlier than the Bohairic, but there need not be much interval between them". The date of the Bohairic New Testament version "is probably in the first half of the third century".

AKHMÎMIC PAPYRI

Two important papyrus codices in the Akhmîmic dialect may be mentioned, a fourth-century manuscript preserved in Berlin and a seventh- or eighth-century manuscript of Strasbourg, both containing (the former being almost complete) the *First Epistle* of Clement to the Corinthians under its primitive title *Epistle to the Romans*.

SAHIDIC MANUSCRIPTS

The Sahidic Biblical version is mainly known from fragments, but some of these go back to the fourth century: the British Museum acquired in 1911 a copy of the books of *Deuteronomy*, *Jonah*, and *Acts*, which is the oldest substantial manuscript written in Coptic. It is a papyrus codex, and a note at the end (written in a common non-literary hand, and, therefore, easily datable) belongs to the middle of the fourth century; the manuscript may thus be assigned to the first half of that century. Its editor—E. A. Wallis Budge—considers it as the oldest known copy of any translation of any considerable portion of the Greek Bible. The codex (now, British Museum, *Or. MS. 7594*) contains 109 leaves, but when complete it must have contained about 133 leaves.

To a slightly later period belongs the earliest preserved copy of

St. John's Gospel, discovered in 1923 by J. L. Starkey in the course of one of Sir W. M. Flinders Petrie's expeditions, and now in the collection of the British and Foreign Bible Society; it is assigned to the second half of the fourth century. The manuscript is now known as *Papyrus Q* (Fig. IV–14). It contains forty-three papyrus leaves, most of them in good condition. In the opinion of its editor—Sir Herbert Thompson—the book must have been "made by taking twenty-five square sheets of papyrus about ten inches each way and laying them one above the other, each with its horizontal fibres upwards, and then folding the whole mass in half, so as to form a volume of a single gathering or quire". See also p. 163. The book originally consisted of fifty leaves or 100 pages, all being numbered in Coptic letters. Some of the stitching which originally held the book together still remains. The largest leaf now measures 25 × 12.5 cm. The text is written on both sides in a single column. The number of lines on a page is mainly thirty-four or thirty-five. The number of letters to a line varies between sixteen and twenty-three. The manuscript is written throughout—including the corrections—by "the hand of a very practised writer, a professional copyist of literary work" (Thompson). According to Sir Frederic Kenyon and Sir W. M. Flinders Petrie there is a strong resemblance between the handwriting of this manuscript and the *Codex Vaticanus* (see p. 197 f.), allowance being made that one is on papyrus and the other on a very fine vellum.

Five single-quire Coptic books previously known also belong to the fourth or fifth century A.D.: the so-called *Pistis Sophia* or *Askew Codex* (preserved at the British Museum) and the *Bruce Codex* (Bodleian Library, at Oxford) belong to the fourth century A.D.

The British Museum has also some seventh-century Sahidic copies of Old Testament books (a complete *Psalter*; sixty-two leaves of *Proverbs, Ecclesiastes, Songs of Solomon, Wisdom*, and *Ecclesiasticus*; and a palimpsest of *Joshua, Judges, Ruth, Judith* and *Esther*). There are important codices of the Sahidic version in various other collections, the most important being the manuscripts in the Pierpont Morgan Library, New York (*M 566–8*), containing 1 and 2 *Kingdoms* (*i.e.* I–II *Samuel*), *Leviticus, Numbers, Deuteronomy*, and *Isaiah*.

Numerous homilies and sermons are extant, including those of St. John Chrysostom, St. Cyril of Alexandria, St. Gregory of Nazianzus, Theophilus of Alexandria, St. Ephraem the Syrian, St. Basil, St. Athanasius, and Proclus of Cyzicus.

Bohairic Manuscripts

Over a hundred Bohairic Biblical manuscripts are extant, but they are mainly of late date. A single leaf of the *Epistle to the Ephesians*, now in the British Museum belongs, however, to the fifth century. Otherwise, the oldest and best is a manuscript of the *Gospels* at Oxford, dated 1173–4; there is also a manuscript at Paris dated 1178–80, and one in the British Museum, dated 1192; other manuscripts belong to the thirteenth and later centuries.

About forty complete homilies or sermons of St. John Chrysostom, and several of St. Cyril of Alexandria, St. Gregory of Nazianzus, Theophilus of Alexandria, and St. Ephraem the Syrian are extant.

The Hamouli Library

The largest and oldest collection of complete Sahidic manuscripts of one provenance was casually discovered in 1910 on the site of an ancient monastery at Hamouli, in southern Fayyûm. Apparently sixty books were found, many of them still in their original bindings. Hyvernat suggested that the find represents the library of the convent "Archangel Michael", which "Very likely in a time of exceptional danger, the monks, fearing for their lives as well as for their most valued possessions, buried . . . within the precincts of the monastery. . . ." On the whole, the Hamouli collection gives a good idea of an ancient Coptic monastic library. ". . . it was, broadly speaking, a liturgical library, or rather a library of the Lectern. With the exception of the biblical manuscripts, which may have been intended for private reading in the individual monastic cells or the common library, they were all to be read in church, either as part of the service proper or for the edification of the public. These books of edification, containing *Lives of the Saints*, *Acts* of Martyrs, *Homilies* and *Discourses* attributed to the Fathers of the Church, etc., constituted the Synaxary, corresponding to the Martyrology of the Western churches."

The Hamouli collection now consists of fifty-six codices, some containing as many as 170 folios. Almost every branch of religious literature is represented. There are ten manuscripts of the Old Testament (including the *Pentateuch*, *Samuel* and *Isaiah*) and the New Testament (the *Gospels* and *Epistles*), some apocryphal works (*Paralipomena of Jeremiah* and the *History of the Death of Isaac*), liturgical books (such as collections of hymns), patristic works, such as homilies and encomiums ascribed to the Fathers of the fourth and fifth centuries (Cyril of Jerusalem, Athanasius, Chrysostom, Epi-

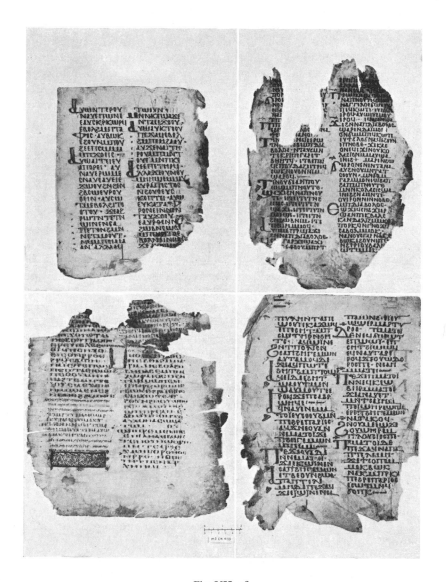

Fig. VII–16

Specimens from Herbert Thompson collection of Coptic manuscripts (University
Library, at Cambridge, *MS. Or. 1699*). *Above* (*left*), Apocryphal book on *Resurrec-
tion*; (*right*), *Homilies* by Shenūte. *Below*, *Martyrology* and *Homilies*.

phanius, Basil, Gregory of Nazianzus, Proclus, Sevrian, Ephraem) or to leaders of the Monophysite Church (Dioscorus, Theodosius, Severus of Antioch), or else to native writers, some unknown hitherto even by name; there are the *Acta* of martyrs (Colluthus, Epime, Phoebammon, Ptolemy, Cyprian, Victor Claudius, Mercurius, Philotheus), Athanasius's *Life of Antony, Histories of Apollo* (a fugitive from Justinian's persecution), *of Lucius and Longinus* (Lycians, fifth century A.D.), *of Hilaria* (the daughter of Emperor Zeno), *of Samuel* (a martyr of Heraclius' period); many of the works were hitherto unknown.

All the manuscripts are in the Sahidic dialect, excepting one which is in Fayyûmic. The size of leaves in each manuscript often varies, especially from quire to quire, as does also the number of lines from page to page, and sometimes even from column to column in the same page. All the manuscripts are written in the enlarged minuscule character. A few volumes contain the title both at the beginning (*incipit*) and at the end (*explicit*), but the original *incipit*-titles have been replaced by the later copyists by lengthy titles, including summaries. Twenty-one of the manuscripts are precisely dated—the earliest in A.D. 823, the latest in 914; the absence of date in the other manuscripts is partly due to the fact that the fly-leaf at the end of the book has disappeared, and in a few cases it "may point to a somewhat earlier period, when the dating of manuscripts had not become the rule" (Hyvernat). However, the whole find has been assigned *en bloc* to the ninth century A.D.

All the manuscripts are more or less decorated, and more than twenty contain frontispieces. These will be dealt with in the book on *Illumination and Binding*. The covers are made of papyrus pulp pressed into pasteboard, protected on the inner side by a sheet of papyrus or parchment and on the outer side by brown or dark-red leather stamped with geometrical designs. (For further detail see *Illumination and Binding*.) Most remarkable are the covers of a binding assigned to the sixth century A.D. On the inner margin of the lower cover is embroidered the name of the convent, "Parchangelos Micha". The manuscript of this binding is assigned to the eighth or ninth century; it contains the *Four Gospels*, written on 113 leaves (measuring 39 × 30 cm.), in two columns of about thirty-seven lines.

In 1911, all the manuscripts still obtainable were bought by John Pierpont Morgan (later he presented them to the British Museum). Repair, rebinding, and photography (as many as 3,277 folios were photographed) were at once set about, in the *atelier* of the Vatican Library, under the direction of the American Professor H.

Hyvernat. The repair was particularly necessary and urgent. In ancient times (before the manuscripts were put in their hiding-place) the papyrus boards of the covers disintegrated almost completely under the attacks of bookworms, and in modern times (in the short period elapsing between the discovery and the acquisition of the manuscripts by Pierpont Morgan) more than thirty books have been more or less damaged by rot due to the exposure to dampness. Moreover, great injury resulted to some manuscripts from the fact that their "illuminators" did not yet know how to mix their colours properly, and their pigments were not suited to "illumination" of manuscripts. The paint passed from the decorated page not only to the one facing it, but also, in some copies, to the underlying leaf.

The White Monastery Collection

The famous White Monastery, near Sohâg, in Upper Egypt, is a huge complex of religious and secular buildings situated on the edge of the Libyan desert opposite Akhmîm. It was described by Curzon as not unlike the bastion of some old-fashioned fortification. In the course of the last century and a half, many Coptic manuscripts, written in the Sahidic dialect and discovered in the White Monastery, have found their way into the great European and American collections.

That monastery was *par excellence* the *scriptorium* of the Egyptian Church during the purest and most prolific period of Coptic literary activity, from the time when Sinuthius or Shenûte, the long-lived monk of Atrēpe, near Akhmîm (he died in 451), the one great native writer, became archimandrite, and down through the Arab invasion, until gradually Upper Egypt lost its Christian character, the Sahidic dialect died out, and the territory and the monastery passed into Moslem control. The community of monks was dispersed, the buildings fell into disrepair, and the monastic books, well hidden for centuries from thieves and enemies, began at length to arrive piecemeal in the shops of the dealers, or were unearthed by lucky travellers, or were bought by collectors from the few poor monks that remained.

Figs. VII–15–16 show specimens from Sir Herbert Thompson's collection, purchased by him from Hyvernat, which come ultimately from the White Monastery. This collection (containing some eighty folios, now preserved in the University Library, at Cambridge, *Or. 1699*), is made up for the most part of two, three, or four consecutive leaves from various old books and is a fair example of the work done

by the Coptic monastic scribes. It comprises letters, homilies, and instructions of Sinuthius himself, *Lives of Saints, Martyrdoms*, expositions of the Scriptures, liturgical fragments, pages from the Old Testament and the New, including a very remarkable bilingual of part of the *Pastoral epistles*. Many of the leaves have been identified as belonging to the same books as leaves in the Vatican Library, in the National Library, at Paris, and the University Library, at Louvain. Most interesting are fragments of *Rules for monks, Lectures* on Easter, part of the *Apostolic Constitutions*, the *Lives of John* (of Lycopolis) and of Pachomius, the *Martyrdoms* of Apa Pteleme, Cyprianus, Justina, and Theoktistus, and the works of St. George.

A great part of the White Monastery collection is in the Pierpont Morgan Library.

Other Collections

The *Edfu Collection* consists of twenty-three manuscripts, of which one is in the Pierpont Morgan Library, at New York (*M 633*), and all the others in the British Museum. The earliest dated manuscript of this collection is later by forty-six years than the latest dated Hamouli codex.

The other collections consist mostly of fragments. One is supposed to have come from Hou, about thirty miles to the south of Denderah (Upper Egypt). It was bought by Lord Amherst of Hackney in 1905–6. It consists of twenty-nine fragmentary codices, which probably were part of a monastic library. This collection is now in the Pierpont Morgan Library, at New York.

RECENT MISCELLANEOUS FINDS

The present writer has received the following valuable information from Mr. Cyril Moss of the British Museum. During the last war Gnostic texts in Coptic were found belonging to a quite early period. An account of the discovery and a summary of the contents are given in *"VIGILIAE CHRISTIANAE"*, vol. 2 and 3. One of the treatises was edited by the late Toga Mina, of the Coptic Museum, at Cairo. Perhaps even more important is the recent find of the Coptic Manichaean texts. Some of these have been published (*e.g.* the second half of the *Psalms* or *Hymns* recited by the Manichaeans at the festival of the Bema) by the late Charles Allberry. Part of the *Homilies* was published by Polotsky, and part of the *Kephalaia* by C. Schmidt. According to de Ghellinck (*Patristique et Moyen Age*, vol. 2, Brussels-Paris, 1947),

this important find, made at Medînet Madi, to the south-west of Fayyûm, consisted in a wooden box containing a certain number of "paper-books" (*cahiers*) of papyrus; it was probably the library of a follower of Manichaeism. The manuscripts apparently belong to the latter half of the fourth century A.D. or to *c.* 400. One part of the "library" was sold to the State Library, at Berlin, the other to Mr. Chester Beatty. Finally, an article by the late W. E. Crum on an *Egyptian Text in Greek Characters*, published in "THE JOURNAL OF EGYPTIAN ARCHAEOLOGY", vol. xxviii (1942, pp. 20–31) deals with a Coptic text dated A.D. 150, which thus could be considered as the "incunabula" of the Coptic language and script.

Nubian Manuscripts

Nubia, anciently known as Ethiopia, was an ancient kingdom (with no precise limit) situated to the south of Egypt. In earlier times, it was under Egyptian political domination and cultural influence. It became independent about the ninth to eighth century B.C., but continued to employ the Egyptian language and script. The Napatan kingdom, as it was then known, flourished mainly from the White Nile to the Aswân cataract, until about 300 B.C., when the sovereignty passed from the city of Napata to Meroë.

Under the rule of the Meroitic kings, Nubian culture became more independent and started to employ its own language; at the end of the third or during the second century B.C., the indigenous script, known as Meroitic, would seem to have been created (see *The Alphabet*, pp. 189–91).

The rise of the Ethiopic kingdom of Axum (see p. 318) brought final disaster to Meroë, which was destroyed about A.D. 350. There was still, however, a more or less independent Nubian kingdom. In the following two or three centuries Christianity spread to that country, and finally a form of Christianity based on the foundations laid by Julianus and Longinus became the official religion of Nubia and remained so until the thirteenth century, when the Christian barrier fell before the Moslems. Dongola, the Nubian capital, had been destroyed some considerable time previously.

Following the Moslem Conquest, many Arabs settled in the country and won over a proportion of Nubians to the Moslem faith, but little is known of those centuries. However, about A.D. 1200 the Armenian Abū Ṣāliḥ, who visited Nubia, found there seven bishoprics, including that of Dongola.

There are not many literary remains of the Nubians today. Some fragments now preserved in the British Museum and in Berlin—belong to the ninth, the tenth and the eleventh centuries A.D. All of them deal with Christian subjects. They are written in the native script, based on the Coptic alphabet, to which three signs were added from the Meroitic cursive script for Nubian sounds which could not be expressed by Coptic characters. One of the Nubian manuscripts (British Museum, *Or. 6805*) has been published by E. A. Wallis Budge (*Texts Relating to Saint Mena of Egypt and Canons of Nicaea in a Nubian Dialect*, London, 1909). This manuscript is assigned to the ninth or tenth century A.D.

Ethiopia (Abyssinia)

SABAEAN—ITS FIRST LITERARY LANGUAGE

It is generally accepted that the South Arabian colonies, established in the second half of the first millennium B.C. in the territory now known as Abyssinia or Ethiopia, introduced in those regions the South Arabic or South Semitic speech and script; indeed, as Dr. E. Ullendorff points out, "a fairly large number of South Arabian inscriptions have been discovered on many sites" in the territory of the ancient Axumite Empire, corresponding with northern Abyssinia and southern Eritrea.

The South Arabic Sabaean soon became the literary language and script of Ethiopia, but Ethiopic was its spoken language and, according to Ullendorff, "the unvocalized Ethiopic script must have been used in the first and second centuries A.D." In the first half of the fourth century A.D., Ethiopic speech and vocalized script were adopted for literary purposes by the kings of Axum, although Sabaean speech and script continued to be employed for ornamental and archaizing purposes until the seventh or eighth century.

ETHIOPIC LITERATURE

From the fourth century onwards, after the conversion of the Axumite Empire to Christianity (according to tradition, by Syrian missionaries), there came into being a literature which was essentially Christian, more especially because of the intensification of Christian propaganda by many Syrian monks, who introduced Greek and Syriac influences.

At this time the literary and ecclesiastical language of Ethiopia was Ge'ez (*lesana ge'ez*). This language has long been dead as a form

of speech, but it has been preserved to this day as the language of the Ethiopian Church and of ancient Ethiopic literature. This Ge'ez literature consists largely of translations of ecclesiastical works from Greek and—after Arabic superseded Greek and Coptic in Egypt— particularly from the Christian Arabic literature which then flourished in Egypt.

ETHIOPIC MANUSCRIPTS

There are numerous Ethiopic manuscripts extant; some 400 of them are preserved in the British Museum, which acquired them at the time of the Abyssinian war in 1867. They are mainly of very late date, some being as late as the seventeenth century, and only a few going back to the fifteenth (British Museum *Or. 719* was written before A.D. 1434; *Or. 650* and *Add. 11678* were written between 1434 and 1468, and *Or. 706* between 1478 and 1494). The earliest preserved Ethiopic manuscripts are in the National Library, at Paris, and in the Vatican Library, and belong to the thirteenth and the fourteenth centuries. The Paris manuscripts as catalogued by Zotenberg (*Catal. des MSS. éthiop. de la Bibl. Nation.*, Paris, 1877) are: Nos. 3 (an *Octateuch*), 5 (I–IV, *Kingdoms* and *Chronicles*), 32 (*Gospels*), and 131 (*Lives of Saints and Martyrs*) belonging to the thirteenth century; and Nos. 10 (*Psalms*), 40 (*fragments of St. Luke*) 45 (*Pauline Epistles*), 52 (*Acts of the Apostles and Evangelists*), and 79 (*Ritual* on taking the monastic habit), which are of the fourteenth century. The Vatican manuscript *Borg. Aeth. 3* (*Kingdoms*) belongs to the thirteenth or fourteenth century; and *Vat. Aethiop. 21* (*Prayers*) to the fourteenth.

Nevertheless, the Ethiopic Version of the Old Testament is very interesting. According to some scholars, it was made in the fourth century A.D. from the Septuagint, and is associated with the name of the presbyter Lucian of Samosata, a leading scholar at Antioch (who suffered martyrdom during the persecution of Maximinus, A.D. 311); according to other scholars, this version is based on an Arabic revision of the fourteenth century, founded on the Arabic translation of the Jewish Gaon Saadya (first half of the tenth century).

However, the Ethiopic version includes two books (*Jubilees* and *Enoch*) which have no place in our Old Testament, or our *Apocrypha*. The original Greek of the book of *Jubilees* remained unknown until 1886, when a little vellum codex (containing the first thirty-six chapters) was discovered at Akhmîm, in Egypt; still more recently

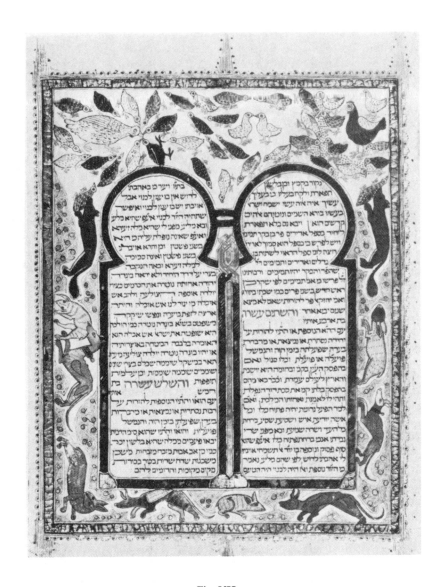

Fig. VII-17

The superb Hebrew codex known as the *Kennicott Bible*
(Bodleian Library, Oxford, *Ken. 1*).

the last eleven chapters have been recovered from one of the Chester Beatty papyri. In early March, 1949, a few Hebrew fragments of the *Jubilees* were discovered among the *Dead Sea Scrolls* (see p. 187).

Hebrew Books (Figs. IV–12, 15, *d*, 17, *b*; V–3–8; VII–17)

The Bible, "The Book" *par excellence*, is the immortal witness of the genius of the ancient Hebrews: and while the Bible was the creation of the Jews, the Jews were a creation of the Bible. With the final Roman conquest of the Holy Land, the factious disputations of Pharisee and Sadducee, the fanaticism of the Zealots, the eccentricities of the Essenes, the worldliness of the priests, the formalities of the Scribes, the cruelty, the profligacy, the domineering and hard-hearted ambition of the Roman world, the effete rhetoric of Hellenism—all these things, at least in the forms in which they were then known, gradually died away in the Jewish world (although as indirect influences they survived for ages) doomed externally by the Romans and internally by the Rabbis.

Post-exilic Judaism

Judaism became a close religious community and until the nineteenth century, the greater part of Jewish literature and Jewish thought centred round and was derived from the Bible. Thus, the annihilation of Judaea did not annihilate Judaism. To avert extinction, the great rabbis planned that the Bible, *The Book*, should become the dominating factor in Judaism.

"The Book; yes, their Book. They had no state to hold them together, no country, no soil, no king, no form of life in common. If, in spite of this, they were one, more one than all other peoples of the world, it was the Book that sweated them into unity. Brown, white, black, yellow Jews, large and small, splendid and in rags, godless and pious, they might crouch and dream all their lives in a quiet room, or fare splendidly in a radiant, golden whirlwind over the earth, but sunk deep in all of them was the lesson of the Book. . . . They had dragged the Book with them through two thousand years. . . . They had given it to all peoples, and all peoples had embraced it" (L. Feuchtwanger).

Before our discussion of the Hebrew literature of medieval Jewry, we may mention the religious literature produced by three Jewish

sects: (1) the Samaritans—the remainder of an ancient sect of Samaria, numbering today only a few hundred people; of great importance is the recension of the Hebrew Pentateuch in use among the Samaritans; (2) the Falashas, now living mainly in the district of Gondar (Ethiopia), have produced a small but interesting religious literature, all written in Ge'ez; finally, (3) the Karaites, who as an organized sect arose in the seventh or eighth century A.D., notwithstanding their small number, have produced a considerable religious literature in Hebrew, Arabic, and other languages.

THE TALMUD

The two great centres of Jewish scholarship were Palestine and Babylonia, the former having its headquarters successively at Jamnia (or Jabneh) and Tiberias, the latter at Sura and Babylon.

The *Talmud* is broadly speaking a record of the discussions at these Jewish academies, each of which preserved to some extent distinct traditions of text, explanation, interpretation and application of the Bible. The *Talmud* taken as a whole presents the appearance of a disorderly mass of the most heterogeneous material, relating to religion, ethics, history, legend, folklore, astronomy, mathematics, linguistics, law, physical life, medicine, hygiene, botany, and almost everything else. Actually it is a collection of Jewish books on the traditions, laws, rules and institutions by which, in addition to the Hebrew Bible, the conduct of Jewry is regulated. The *Talmud* has moulded the Jewish nation; stimulating their spiritual and religious life, and promoting their intellectual and literary activity, it helped to preserve the existence of Judaism. Only one complete manuscript of the *Talmud* has come down to us: it is preserved in the State Library, at Munich (*Cod. No. 95*).

The *Talmud* ("Study", abbreviation of *Talmud Torah*, "Study of the *Torah*) consists of the *Mishnah*, "Oral Teaching" (sixty-three "tractates" or books) and its *Gemara*, or "Completion."

PIYYUṬIM

Another branch of Hebrew literature—indirectly connected with the Bible—are the "liturgical poems" or the *piyyūṭim* (pl. of *piyyūṭ*, which is derived from a Greek word, out of which the word "poet" has also descended). Many of these beautiful lyrical poems find a place in the Jewish prayer-books, whilst others have not survived.

While early medieval Judaism was mainly creative, late medieval Judaism was mainly preservative. To be sure, it too possessed creative minds, philosophers, codifiers, teachers, commentators, polemical writers, grammarians, poets, philologists, but their common starting-point was, generally speaking, the *Talmud*.

Cultural Bridge Between Moslems and Christians

On the other hand, the Jews played a vital part in the trans-mission of ancient knowledge to Christian Europe in the early centuries of the present millennium. In this period, the Graeco-Roman learning and culture were lost to Christian Europe, but they were cultivated in Moslem lands. These were, however, cut off from the Christian world by differences of language, religion and tradition. "The Jews were . . . peculiarly qualified to serve as a bridge between these mutually exclusive and mutually intolerant worlds. . . . It was hence to the Jews (in most instances) that Christian students had recourse for some inkling of the intellectual achievements of the Arabs, and even the ideas of the sages of ancient Greece. There have survived many hundreds of translations carried out by Jews in the medieval period, illustrating . . . their fruitful participation in every branch of intellectual activity of the age" (C. Roth).

Destruction of Hebrew Books

It is common knowledge that the Hebrew literary production over the past three thousand years has been very vast—traditionally the Jews are called '*am ha-sepher*, "People of the Book"; but only a small portion of this literature has survived. It is not difficult to indicate the main reasons for this fact. Already in the time of the persecution by Antiochus Epiphanes or "Illustrious" (175–164 B.C.) there is a pointer: "And they rent in pieces the books of the law which they found, and set them on fire. And whosoever was found with any book of the Covenant, and if any consented to the law, the king's sentence delivered him to death" (1 *Macc.*, i, 56–7).

The darkness which closed in upon the Jews after the loss of their independence lasted for over seventeen hundred years. Through all these long centuries the clouds of prejudice and of persecution hung low and lowering over all the countries in which Jews dwelt, and it was only here and there, and for a comparatively short interval, that there was any break in the gloom.

Through all those centuries, the Jews were "outcast under the

lash of the Church and under the ban of the State". "Church and State changed faiths and names, old dynasties and old beliefs gave place to new, boundaries were shifted, and civilization took fresh forms," but the various inquisitions and all kinds of censorships, the burning of books, the frequent attempts to eradicate Hebrew literature altogether, never stopped in all those centuries. In Paris, in June, 1242, twenty-four cartloads of Hebrew manuscripts were publicly burnt, and similar destruction occurred at various times in various places.

PRESERVATION OF HEBREW LITERATURE

And still, as the author of *Maccabees* adds (after a reference to "the public archives and the records that concern Nehemiah, and how he, founding a library, gathered together the books about the kings and prophets, and the books of David, and letters of kings about sacred gifts"): "And in like manner Judas also gathered together for us all those writings that had been scattered by reason of the war that befell, and they are still with us" (2 *Macc.*, ii, 13–14). And so despite the numerous attempts at the annihilation of Hebrew literature, in all these centuries, there was hardly a period in which Hebrew books were not written and published.

As already mentioned, only a portion of the great wealth of Hebrew literature—including the invaluable Books of the Bible—has survived. The *Dead Sea Scrolls* have been discussed on pp. 176–189. The previously known Biblical and other Hebrew manuscripts belong to a much later date than the *Dead Sea Scrolls*, with the exception of some fragments written on papyrus, the earliest being the *Nash Papyrus* (Fig. IV–12, *b*).

HEBREW BIBLICAL MANUSCRIPTS (Figs. VII–17)

Hebrew Biblical manuscripts are generally classified into two main groups, codices and Synagogue-scrolls. The preserved Hebrew Biblical codices fall into four main families: the Eastern, the Hispano-Portuguese, the Italian, and the Franco-German. This distinction is based—apart from illumination, for which see the book on *Illumination and Binding*—upon external and internal criteria.

The main external criteria are: (*a*) the script—the great majority of the Hebrew Biblical codices are written in the Square Hebrew character (*The Alphabet*, pp. 261–7), though some in Rabbinic hand, and a few in cursive hand; the local Hebrew scripts were strongly

influenced by the non-Jewish script and art of their region; as a result, there appear the elegant forms of the Italian Hebrew scripts, and also—owing to the Hispano-Arabic influence—the Spanish Hebrew codices are written in elegantly formed letters; the Franco-German manuscripts are written in a comparatively rude and inelegant character; Hebrew Eastern scripts have a particular style of their own. Particularly, the identification of the Franco-German and the Eastern hands is relatively easy.

(*b*) The writing material: with the exception of the Eastern codices, frequently written on Oriental paper, hardly any Hebrew Biblical codices are written on paper. From the fifteenth century onwards, the Italian Hebrew codices were written on superfine vellum, and also the Hebrew Spanish and Portuguese codices are written on fine and flexible vellum, whereas it is seldom the case of the Franco-German manuscripts.

(*c*) The format: the Franco-German codices are for the most part of large size, the Spanish-Portuguese manuscripts are mainly of medium size, and the Italian codices of small size.

Internal criteria: (*a*) Eastern codices are often written on pages containing only one column; with the exception of some earlier codices, this is seldom the case of manuscripts belonging to the three other main families; numerous Franco-German codices have three columns to the page, whereas the majority of the Hispano-Portuguese and the Italian codices have two columns to the page. (*b*) Unlike the manuscripts of the other families, the Franco-German codices display a certain amount of divergence from the Massoretic, or traditional, text, and follow the order of the books of the Hebrew Scriptures as given in the *Talmud*.

It is known that the Hebrew Scriptures are separated into three divisions: *tōrah* ("Law", *Pentateuch*), *nebî'im* (Prophets) and *ketubîm* ("writings" or *hagiographa*). In the Prophets and the Writings the order of the books varies in manuscripts. The Massoretic order is *Joshua, Judges, Samuel, Kings, Isaiah, Jeremiah, Ezekiel* (according to the *Talmud*: *Jeremiah, Ezekiel, Isaiah*), the *Twelve*; *Psalms, Proverbs, Job, Song of Songs, Ruth, Lamentations, Ecclesiastes, Esther, Daniel, Ezra, Nehemiah,* and the *Chronicles* (according to the *Talmud*: *Ruth, Psalms, Job, Proverbs, Ecclesiastes, Song of Songs, Lamentations, Daniel, Esther, Ezra, the Chronicles*).

(*c*) Finally, numerous Hebrew codices also contain *haphtarōth* (prophetic lectionary) and *targumîm*, or (Aramaic) "translations";

the *haphtarōth* vary in the various families, and also the disposition of the *targumîm* diverges. There are, besides, a few minor criteria, which help to classify the Hebrew Biblical codices; for instance the number of the *Psalms* is generally 150 in the Hispano-Portuguese and the Italian codices, and commonly 149 in the Franco-German manuscripts, where the first two *Psalms* are taken as one.

Numerous fragments of Hebrew "Babylonian" Biblical manuscripts were discovered in the famous Cairo *Genizah* (lumber room in which defective manuscripts were laid aside), and these partly belong to the eighth century A.D. Probably the oldest book of any part of the Hebrew Bible existing in vellum codex form, is a British Museum manuscript (*Or. 4445*); it is written in three columns to the page (hence, it was probably copied from a roll); it is undated, but is generally considered to have been written not later than the ninth century, or—at the latest—in the early tenth century.

The earliest Hebrew manuscript containing a precise statement of its date, a statement that evidently can be trusted, is the Leningrad *Prophet-Codex*, written in 916–17. It is a vellum codex containing the Latter Prophets, and is written in double columns.

Some other Hebrew codices, for example, the *Codex of the Prophets* preserved in the Synagogue in Cairo, the Aleppo *Ben-Asher Codex*, the Oxford *Codex Laudianus*, the *De' Rossi Codex No. 634*, the Cambridge University Library manuscript bearing the date of 856, whether dated or undated, are attributed to the ninth or tenth centuries; but there is much doubt as to some of the datings. The majority of the Hebrew codices are of the twelfth to sixteenth centuries, the numbers increasing with the later dates.

The Synagogue-scrolls are rolls of parchment containing the *Torah* or *Pentateuch* and are reserved for use in the public reading of the Jewish worship. Indeed, the *Qeriath ha-Torah*, or "Reading of the Torah", is the central feature of the synagogue service; every synagogue must contain at least one copy of such a scroll. The scrolls are placed in the holy shrine (in the direction of Jerusalem), before which burns a perpetual light. The preparation of the Scroll of the Law is a task requiring much care, erudition, and labour.

The dates of such scrolls are very difficult to be determined, as the science of dating of the Hebrew writing of these documents has not yet been put on a firm basis. An added difficulty is that the Square character shows little change with the progress of the centuries. See also pp. 148 ff., 175–189.

Arabic Books (Figs. IV-15, f; VII-18 and 19)

By the pen and what they write (*Koran*, Sūra lxviii, 1).

The maxim "The Book follows Religion" can be exemplified by reference to the Arabic "book", the history of which is, indeed, relatively short. Arabic tribes are known to have roamed through the vast Syro-Arabian desert for thousands of years, and numerous North and South Arabian inscriptions are extant, dating from the eighth century B.C. onwards (see *The Alphabet*, pp. 223–34). Nothing is known, however, of written Arabic literature prior to Mohammed and to the compilation of the Koran, the sacred book of Islam.

This holy book was the mainspring of the Arab conquests of the seventh and eighth centuries A.D., which caused the vast expansion of the religion of Mohammed. Thanks to the diffusion of the Koran, Arabic became one of the chief languages of the world. Indeed, it is the literary language, and, in some form or other, also the spoken language in use throughout the vast territories lying between India and the Atlantic Ocean. It was formerly spoken, as well as written, in parts of Spain, in the Balearic Islands and in Sicily; Maltese seems to be a descendent of Arabic, perhaps with some traces of earlier neo-Punic influences.

SPREAD OF ARABIC SCRIPT

Even more than Arabic speech, the Arabic script was widely adopted, thanks to the diffusion of the Moslem holy book. Becoming in turn the script of the Persian and, especially, of the Ottoman Empire, its use spread in time to the Balkan peninsula, to what is now the south-eastern portion of European Russia, to India, to central and south-eastern Asia, and to a great part of Africa. Thus, the Arabic alphabet had to be adapted not only to Semitic languages (such as Hebrew), but also to languages belonging to other linguistic groups, such as Slavic (in Bosnia), Spanish (the Arabic script employed for Spanish is called *aljamiah*), Persian, Pashtu, Balochi, Balti, Urdu and other Indian languages—all these forms of speech belonging to the Indo-European linguistic family—and, in addition, to Turco-Tatar and Caucasian languages, to various Malay-Polynesian languages, and various African languages (such as Berber, Swahili, and Sudanese)—Fig. VIII-2, *c*, 3 and 12.

Apart from Arabic inscriptions and coins, the earliest written

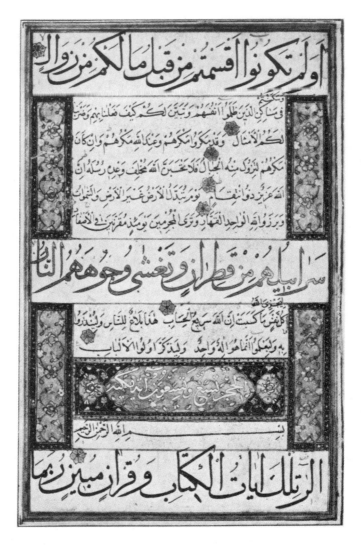

Fig. VII-:8

A very elegant copy of the Koran, measuring 13¼ by 8½ inches, of 13 lines
to a page. The copyist names himself Husain Fakhkhâr. There are pages entirely
gilt, or written on a dyed ground or ornamented with gold, blue, etc. The text is
written in *Naskhi*, but the first and last lines as well as the middle line—dividing the
page into two equal squares—are written in large *Thūlth* (India Office Library,
No. 32 A; Loth's *Catalogue*, No. 16).

documents extant are a number of papyri discovered in Egypt, some of which (now preserved in Vienna) belong to the first half of the seventh century A.D., but the greater part (now mainly in Cairo) are assigned to the second half of the same century and to the eighth century: Fig. IV–15, *f*.

KORANIC MANUSCRIPTS (Figs. VII–18 and 19, *c*)

The earliest preserved Koranic manuscripts are written on broad parchment sheets and, with one or two exceptions, in the heavy lapidary Kufic style (see *The Alphabet*, pp. 272–3). These manuscripts are seldom complete and rarely dated, and are very difficult to date. The earliest dated copy is the complete Koran, now in Cairo, dated A.H. 168 (=A.D. 784–5).

A.H. = *Anno Hegirae*, or "In the year of the Hegira", *i.e.* the Flight of Mohammed from Mecca on 13th September, A.D. 622; the Moslem era dates from this event.

Most of the dated early copies belong, however, to the third century A.H.: mention may be made of the Paris manuscript dated A.H. 229 (=A.D. 883–4) and A.H. 277 (=A.D. 890–1), as well as the manuscript, dated A.H. 256–64 (=A.D. 870–7). Part of the last manuscript is preserved in the University Library of Cambridge *Add. 1116* (see Fig. VII–19, *c*). It is the oldest dated Koranic manuscript in England: it formed part of the *waqf* (*i.e.*, charitable foundation) of Amadjur, Governor of Damascus (A.D. 870–7), and was purchased in 1878 from Prof. Palmer and the representatives of C. F. Tyrwhite Drake.

A Koranic palimpsest in the Cambridge University Library (*Or. 1287*) is of special interest: the lower script is mostly Syriac of the fifth or sixth century A.D., the upper script is a copy of the Koran in ancient Kufic. It is undated, but according to a leading authority it may be assigned to the eighth or, perhaps even to the seventh century A.D. This codex, bequeathed by Mrs. Agnes Smith Lewis, consists of ninety-four leaves. The University Library of Cambridge (*Add. 1138* and *Qq. 285*) possesses also a Kufic fragment on parchment of the tenth century and an interesting Arabic book (*Kitābu 'l-muʿammarīn*, "The Book of the Long-lived"), written in A.D. 1036–7. See Fig. VII–19, *b*.

CHRISTIAN ARABIC BOOKS (Fig. VII–19, *d*, *e*)

Not only was the spread of the Arabic language and script closely connected with the spread of Islam; orthodox Moslems—

Fig. VII-19

Arabic books. *a*, Compilation of historical notes and anthology of prose and poetry by an author who died in 1166. In a fine, bold *Naskhi* of *c*. 1200, and almost completely vowelled (Rylands *Arabic MS. 694*); *b*, the *Book of the Long-lived*, A.D. 1036–7 (University Library, Cambridge, *Qq. 285*); *c*, earliest dated Kufic manuscript in England (ibidem, *Add. MS. 1116*): it bears the dedication of Amadjur, Governor of Damascus (A.D. 870–7); part of the manuscript is in Cairo (No 40160); *d*, the oldest dated Christian Arabic manuscript: *Treatise on Christian Theology*, attributed to Theodorus Abū Kurrah, bishop of Harran (British Museum, *Or. MS. 4950*; A.D. 876); *e*, *Gospels* A.D. 1281 (Convent of St. Catherine on Mt. Sinai, *Arab. MS. 104*).

at least in the early period—were opposed to the non-Moslems using Arabic; Omar, in the charter given to the Christians expressly stipulated that they shall not read Arabic or use the Arabic language; pious grammarians would sooner starve than teach an Unbeliever the Koran, or even the grammar in which verses of the holy book were to be found. But in the course of time, this rule had to be relaxed, and Christians as well as members of other tolerated faiths were often qualified for clerical work. Nevertheless, Arabic never became the religious language of any non-Moslem faith. Syriac and Coptic remained liturgical languages long after the majority of the people had ceased to understand them. Syrians, Jews, and Samaritans, even when writing Arabic, often preferred to employ their national alphabets, especially when they wrote for purposes connected with the religious communities to which they belonged.

However, a considerable number of books written by Christians and Jews are extant, which are written in Arabic; there are also Hebrew books written in Arabic script. Here we are concerned with the Christian Arabic books. At least in the early period, these were mainly intended for the public market, not specifically Christian. Such were medical and philosophical treatises, or books dealing with science. "But even translations of the Old and New Testaments were often intended for all classes of readers" (D. S. Margoliouth). As a result, the script of the Christians (as well as of the Jews) was, as a rule, assimilated to that of the Moslems, and it is rather difficult —especially for a non-palaeographer—to distinguish Christian from other Arabic writing, though some specialists hold that the qualification "Christian type" may be assigned to some handwritings; and that some types show a tendency to introduce Syriac forms into Arabic letters, or at least give the latter a suggestion of Syriac script. Moreover, the later "Christian type" is more stiff and artificial than the Moslem type.

ARABIC THE MAIN VEHICLE OF CIVILIZATION

In the last centuries of the first millennium A.D., and in the first centuries of the second millennium, Arabic became the vehicle for research work in science, especially in medicine, optics, astronomy, astrology, alchemy (the ancestor of chemistry), geography, botany, mathematics, as well as in philosophy, history, ethics and literature, especially wisdom-literature, the theory of music, jurisprudence, Islamic theology, Arabic grammar, poetry and lexicography. " . . . it was chiefly from Moslem Spain that Arab culture advanced

to interpenetrate the Christian culture of the early Middle Ages to produce the civilization which we inherited." "Between the middle of the eighth and the beginning of the thirteenth centuries . . . the Arabic-speaking peoples were the main bearers of the torch of culture and civilization throughout the world, the medium through which ancient science and philosophy were recovered, supplemented and transmitted to make possible the renaissance of Western Europe. . . . Several of the principal towns possessed what might be called universities, chief among which were those of Cordova, Seville, Malaga and Granada. . . . Side by side with the universities, libraries flourished. The royal library of Cordova became the largest and best" (Hitti).

The Cordovan library was supposed to contain some 400,000 (or even 600,000) volumes, their titles filling a catalogue of forty-four volumes. Cordova was then, undoubtedly, the greatest centre of science and art of medieval Europe. There were other great centres of learning in Arab lands. The library of the Fāṭimids in Cairo is supposed to have contained 100,000 volumes.

PRODUCTION OF ARABIC BOOKS

As will have been gathered, the Islamic production of books was very great. There were numerous scholars, and some of them were extremely prolific; for instance, Ibn al-Khāṭib wrote more than sixty books (dealing with philosophy, medicine, history, geography, as well as poetry)—only about twenty have been preserved. To 'Ali ibn-Hazm (994–1064) as many as four hundred works are attributed. Local manufacture of paper facilitated Arabic literary production.

After the Christian conquest of Spain, in Christian Europe not many Arabic books were allowed to come down to us. "Granada was the scene of a bonfire of Arabic manuscripts" (Hitti). Still, as late as the second half of the sixteenth century, Philip II succeeded in collecting some two thousand volumes for the famous library of the Escurial Monastery (Province of Madrid). In the following century a few thousand were added to the collection, which has become one of the richest in Arabic manuscripts.

Sicily was another meeting-point of Islamic and European cultures. From the late eleventh century onwards, the Norman courts of Palermo and Naples became the centres of a syncretic culture based on the ancient Graeco-Roman civilization, imbued with Syrian-Arab influences, and dominated politically by

Christian Teutonic Normans and culturally by the neighbouring Italians. The rich collections of Arabic books at Palermo and Naples bear witness to the Islamic book production of Sicily and southern Italy in the pre-Norman and early Norman period.

THE 'ABBĀSIDS, THE FĀṬIMIDS, THE SĀMĀNIDS

The Arab-Persian literary production of some other countries, although inferior to that of Spain, and of minor influence on western civilization than that of Sicily, was nevertheless outstanding.

The splendid 'Abbāsid dynasty (c. 750-1258), the founders and builders of Baghdād—the city of fairy tales, but once also renowned for its learning, culture and art, for its flourishing trade and the oriental splendour of its imperial palace—is notable for the establishment of numerous colleges and libraries, for the encouragement of literature and the arts, for the translations from the Sanskrit and Greek languages into Arabic of works on astronomy, mathematics, metaphysics, medicine and philosophy. "It was under the 'Abbāsids that Islamic civilization experienced its golden age" (Hitti). Under the Caliph Harūn al-Rashīd (763-809), the contemporary and friend of Charlemagne, Baghdād became a brilliant centre of the learning, culture and art of the Moslem world.

"The height of Greek influence was reached under al-Ma'mūn," or 'Abdullah III, a son of Harūn al-Rashīd. "In 830 he established in Baghdād his famous 'house of wisdom', a combination of library, academy and translation bureau which in many respects proved the most important educational institution since the foundation of the Alexandrian Museum in the first half of the third century B.C." (Hitti).

The Fāṭimid dynasty established itself in Tunis in 909, but later the centre of its power was transferred to Egypt, where in 968 the city el-Kahira ("the victorious")—a name which was gradually corrupted into Cairo—was founded, and reached great heights of splendour. The library, which the Fāṭimids founded in Cairo (see p. 332) became the most important in the Moslem world. But the Fāṭimid power did not last long; it was overthrown in 1171 by the great Salah-ed-din Yusuf (known as Saladin), who fought against the Crusaders.

Even minor Moslem dynasties greatly contributed to the spread of knowledge. Prof. Arberry—dealing with Avicenna's *Autobiography*

describing the private library of the Sāmānids (a minor Persian dynasty, which ruled in Bukhara A.D. c. 872-999)—says that "this description takes the breath away". Avicenna writes: "I entered a mansion with many chambers, each chamber having chests of books piled one upon another. In one apartment were books on language and poetry, in another law, and so on; each apartment was set aside for books on a single science. I glanced through the catalogue of the works of the ancient Greeks, and asked for those which I required; and I saw books which I had never seen before and have not seen since. I read these books, taking notes of their contents; I came to realize the place each man occupied in his particular science. . . ."

DESTRUCTION OF ARABIC BOOKS

It is not difficult to realize why relatively few early Arabic books have come down to us. The reasons are the same as those already mentioned in connection with Latin or Hebrew books, destruction by fanatics or enemies.

Prof. Grohmann gives the following description of the sack, in 1068, of the Fāṭimid Library in Cairo. The precious leather bindings were torn from the manuscripts to make shoes for negro slaves; the leaves of the manuscripts were burned, and the remains blown by the wind into heaps, which could still be seen near the ruins in Maqrīzī's time and were known as the "mounds of the books".

The Crusaders "left in their wake havoc and ruin and throughout the Near East they bequeathed a legacy of ill-will between Moslems and Christians. . . ." (Hitti). They burned or plundered numerous libraries, including that of Tripolis, said to contain 3,000,000 volumes.

Further to the east, in the thirteenth century, Genghis or Chinggiz Khan, having united Mongolia, in a few years extended his dominion from Korea to southern Russia and to Persia, everywhere spreading havoc and destruction. "Before them the cultural centres of eastern Islam were practically wiped out of existence, leaving bare deserts or shapeless ruins where formerly had stood stately palaces and libraries" (Hitti). Herāt, Bukhārā, Samarqand, Balkh, Khwarizm, and other glorious cities and towns were devastated.

From 1253 onwards, with Hūlāgū, Chinggiz Khan's grandson, the second wave of Mongol hordes came on, and in 1258 the crowning horror of the sack of the splendid capital, Baghdād, marked the

end of the 'Abbāsid Caliphate. To give an idea of the immense plunder of the libraries, it will suffice to mention that the scholar Nāṣir ad-Dīn Ṭūsī, who accompanied the Mongol armies, succeeded in saving more than 400,000 volumes. How many thousands of volumes have been destroyed will never be known, as it is uncertain how many books were destroyed previously at Herāt, which is said to have contained 395 colleges with libraries, or at Bukhārā, where the Mongols are said to have stabled their horses in the great mosque, and to have torn up priceless manuscripts of the Koran, to serve as litter for their horses.

Apart from plunder and destruction by enemies, other disasters, particularly fire, were responsible for the loss of Arabic books: the rich library of the Mosque of the Prophet in al-Medīna was destroyed in 1237 by a sacristan who happened to drop a lighted candle in it, and the valuable library of the Grand Master of the Assassins in Alamūt also perished in flames in 1257.

DECADENCE OF ARABIC

However, quoting again Prof. Hitti, we may say that "Medieval times, with their Dark Ages, held no black-out for the Arab lands; but modern times did. Throughout the four centuries of Ottoman domination, beginning in 1517, the whole Arab East was in a state of eclipse."

BIBLIOGRAPHY

In addition to *The Alphabet, passim,* and the literature quoted there, see also:

P. K. Hitti, *The Arabs,* London, 1948; *History of the Arabs,* 4th ed., London, 1949; *History of Syria,* London, 1951.

OUTLYING REGIONS (1):

ANCIENT MIDDLE EAST, CENTRAL AND SOUTHERN ASIA

It must be emphasized that in the present connection the regions are outlying only in the sense that the particular mode of development associated with each is, generally speaking, away from the main stream of book development from the modern standpoint; this started in Egypt, and reached the modern world through the Graeco-Roman and Christian civilizations. In a certain respect China is an important exception, in that it gave us the invention of paper, although printing, which it also invented, was later invented, perhaps quite independently, in Europe.

ANCIENT MIDDLE EAST AND CENTRAL ASIA

A few "outlying regions" of the ancient Middle East have already been noticed; they have at least an indirect connection with our modern book in as much as their book production was mainly due, at least originally, to the same influence as that noted in the case of early medieval Europe, *i.e.* to the spread of Christianity. In this chapter, the book production of some other ancient peoples will be briefly examined.

Iranians (Figs. VIII–1–3)

Old Persian, which has already been mentioned, was the ancient language of Persia proper, which roughly corresponds to the modern province of Fars, in the south-west of present-day Persia. It was the official language of the Achaemenid dynasty, under whose rule—from the middle of the sixth century B.C., until the victories of Alexander the Great—the Persians came to occupy the foremost place in the then known world.

Fig. VIII-1
a, Manichaean; b, Eastern Pahlavi and c, Yezidi (Kitab al-Jalweh or The Book of the Revelation).

Persia proper is, however, only a small part of a vast geographical, ethnic and linguistic unit, called Iran. The Iranian group of languages (which constitutes an important branch of the Indo-European linguistic family) is, or was, spoken throughout the vast territory lying between Kurdistan in the west and the Indus Valley in the east, between the Aral Sea in the north and the Gulf of Oman in the south; thus comprising the present countries of Kurdistan, Persia, Baluchistan, Afghanistan, Tadjikistan, Uzbekistan, and Turkmenistan, as well as parts of South Russia, and of Chinese Turkestan. Even far beyond this area, Iranian tribes are known to have led a nomadic existence.

This group of languages is commonly divided into two groups, a western and an eastern. This distinction applies also to the oldest preserved forms of Iranian: Old Persian belongs to the western group, while the language of the earliest part of the Avesta may be considered to belong to the eastern group.

THE AVESTA (Fig. VIII–2)

Somewhere in the sixth century B.C. there arose Spitama Zarathushtra or Zoroaster, who preached a new gospel, Mazdayas-nianism, *i.e.* the worship of the God Ahura Mazdāh ("Lord Thought-ful"). He left seventeen poems, which are grouped in five Gāthās. These form part of a vast collection of sacred literature known as Avesta: the meaning of this word is uncertain; according to the German scholar F. C. Andreas, it derives from *upasta*, meaning "foundation", "foundation-text".

More recent and much more probable is the explanation suggested by Prof. W. B. Henning: the name Avesta should be connected with Apastāk/Abastāg, and means "The Injunction (of Zoroaster)".

The Avesta literature is a complex collection of books containing the liturgies, the law, solemn invocations, prayers, and other writings, and is still used among Parsees in India (numbering about 90,000) and in Persia (about 10,000) as a kind of Bible and prayer-book.

The Avesta, in the form in which it has come down to us, is written in a script, known as Pazand or Avesta, which seems to be an artificial creation based on the cursive Pahlavik and Parsik scripts (see *The Alphabet*, pp. 306–9). Paleographical considerations suggest that the invention of this alphabet and the recording of the Avesta took place some time between the fourth and the sixth

Fig. VIII-2

Iranian manuscripts. *a*, *Khordah Avesta*, A.D. 1723 (India Office Library, Z & P.21); *b*, Pazand: Shikand Gumani Vijar,
A.D. 1737 (ibidem, Z & P.23); *c*, Pashtu: Qissah-i-Bahramgor, A.D. 1750 (ibidem, *Pash. B.28*).

Fig. VIII-3

Persian manuscript (Bodleian Library, Oxford, *MS. Ouseley Adds. 176*, fol. *337*).

centuries A.D., at a time when the Sasanian rulers of Persia (A.D. 226-651) found it convenient to revive and promote a national religion. This is confirmed by the late Zoroastrian tradition, which tells us that after Alexander's invasion of Iran, the Avesta had been repeatedly scattered and collected again, and that the final collection was made in Sasanian times.

The Avestan manuscripts extant are relatively late. They

fall into two classes: (1) the Indian, written in rather straight and pointed characters, the oldest manuscripts of which date from the thirteenth and early fourteenth centuries A.D.; and (2) the Persian manuscripts, written in a very vigorous cursive and oblique hand, which do not go further back than the seventeenth century, but surpass their Indian contemporaries in correctness and execution.

For the employment of leather in ancient Persia, see p. 189 f. For Persian-Arabic book illumination see the section on Moslem illumination in the book on *Illumination and Binding*. See also Fig. VIII-3.

Manichaean and Mandaean Books

Manes or Manichaeus (born about A.D. 215 in Babylonia, of Persian parentage, and crucified about 273) founded in 247 the religion known as Manichaean, which for a millennium—from the third to the thirteenth century A.D.—was one of the most widely disseminated throughout the world. At the end of the third and during the fourth century it spread through western Asia, southern Europe, and northern Africa, through Spain and Gaul, but by the seventh century it was practically extinct, or absorbed, in these regions. On the other hand, during the fourth century it was carried into Eastern Turkestan, and in the early seventh century into China, where it flourished during that and the following century.

After the fall of the Uighur Empire, in 840, Manichaeism continued to hold its own in the successor states until about the thirteenth century. In some parts of China it lingered on, but before the middle of the present millennium it had been exterminated everywhere through the repressive measures of Moslems and Chinese alike.

MANICHAEAN MANUSCRIPTS (Fig. VIII-1, *a*)

Manes and his followers employed a clear, legible and very beautiful script known as the Manichaean alphabet (see *The Alphabet*, pp. 291-4). It was believed by the adversaries of Manichaeism to have been a secret, devilish script invented by Manes himself. A few interesting Manichaean inscriptions of magic texts on earthernware bowls are extant, but much more important are the Manichaean manuscripts, of which many fragments have been found in ancient convents in Eastern Turkestan. They are beautifully written on excellent paper in various coloured inks and are

ornamented with surprisingly beautiful miniatures. These manuscripts are written in different languages, more especially in a number of Iranian and Turki dialects.

It was always known that the Manichaeans, following the example set by their founder, held the arts of painting and of book illumination in high honour; they had also recognized the advantage to be derived from representational art for the purpose of religious propaganda. In the ancient Western and Eastern literatures there are many references to the magnificent manuscripts of the Manichaeans, with their fine leather bindings. It will suffice to mention St. Augustine's challenge (*Contra Faustum*, xiii, 18): *incendite omnes illas membranas elegantesque tecturas decoris pellibus exquisitas.* But whatever illuminated manuscripts existed, they perished in the ruthless destruction of them at the hands of the Moslem fanatics. We are told, for instance, that in A.H. 311 (=A.D. 923), at the public gate of the palace in Baghdād, Mānī's portrait was burned with fourteen sacks of "heretical" works, out of which fell gold and silver.

No wonder, therefore, that no authentic example of Manichaean book illumination was known to have survived up to modern times, until—in 1904—the German Professor A. von Le Coq discovered a few fragments of Manichaean paintings in a ruined city near Turfān (see p. 344 ff.), some frescoes on the walls of the ruins of a Manichaean temple, and fragments of illuminated Manichaean manuscripts. A Manichaean miniature of the eighth or ninth century A.D. represents a priest holding in his hands a book splendidly bound in red and gold; its boards seem to be decorated on the margins with green and white ivory or bone, and may be considered as made of wood. Some fragments of excellent Manichaean bookbindings have also been discovered, and—as already mentioned— Prof. Grohmann has suggested that the art of bookmaking reached the Manichaeans from Egypt.

However, Le Coq was so impressed by his finds and by other evidence that he considered the Manichaean the basis of almost all Islamic miniature painting. According to other eminent scholars, such as Grohmann, the Manichaean school of painting must almost certainly have had a strong—if not exactly a decisive—influence on early Moslem miniature art.

Moreover, it is not at all improbable that the art of the Manichaeans, long after the disappearance of their religion from Persia, continued to linger on in the ancient Persian territories, and that its

traditional methods were kept alive by the Moslem descendants of
the old Manichaean artists who had practised it. It has already been
pointed out that the sect of al-Ḥallāj (annihilated in the year 921-2),
who were strongly influenced by Manichaeism, were famous for their
finely produced books.

The reputation of Mānī as a painter long outlived all remem-
brance of him in Persia as the founder of a religion, and his name
came to be proverbially used to describe any skilful artist. Indeed,
over five hundred years after Manichaeism was uprooted in Persia,
"the highest praise that could be bestowed by a Persian upon the
illustrious Bihzād was to describe him as painting with the brush of
Mānī" (Arnold). A reproduction of Mānī's picture book, which is
known in Persian literature by the name of Arzhang, was still to be
seen in the treasury of the capital city of Ghazna by the author of a
work on the various systems of religion who wrote in the year 1092.
Sir Thomas Arnold, who mentions this fact, has suggested that the
illustrator of al-Bīrunī's *al-Āthār āl Bāqiya*, compiled A.D. *c.* 1000,
may have used the same reproduction or a copy of it. If this sugges-
tion be right, then in the codex dated 1307-8 and preserved in the
University Library of Edinburgh—this manuscript being a copy of
the work of al-Bīrunī—we may have examples of the survival of the
Manichaean type of book illumination.

MANDAEAN MANUSCRIPTS

The gnostic pagan Jewish-Christian sect of the Mandaeans is
known also under other terms, such as Nazaraeans or Naṣurai,
Galileans or Christians of St. John: the indigenous term is Mendai,
the Moslems call them Ṣabi'un, Ṣabba or Ṣubba. Their religious
writings seem to have been composed between the fifth and the
seventh centuries A.D. They are written in a relatively late eastern, or
Babylonian, Aramaic dialect, but later became slightly influenced by
the neighbouring Arabic and Persian languages. It is the most
corrupt of all Aramaic dialects. The Mandaean script differs also
very much from the other members of the Aramaic branch of
alphabets.

Nowadays the Mandaeans are almost extinct; they inhabit only
a few villages in the marshes near the junction of the Tigris and the
Euphrates; according to the 1932 census they numbered 4,805.

Very few inscriptions have survived. There are some lead
amulets, the earliest belonging probably to the early part of the

sixth century A.D., and some magic texts inside earthenware bowls, of the seventh and eighth centuries A.D.

There are, however, numerous, although late, Mandaean manuscripts in the British Museum, in Oxford, Paris, Berlin, and in the Vatican. They belong mainly to the period extending from the seventeenth to the nineteenth centuries A.D., the oldest in Europe being of the sixteenth century A.D.

Sogdian (Fig. VIII-4, *left*)

The Sogdians were an ancient population speaking an eastern dialect of middle Iranian, who inhabited Eastern Turkestan. Sogdiana (Old Persian *Sug(u)da*, Avestic *Sughda*, Greek *Sogdianē*, Latin *Sogdiana*) was a province of the Achaemenid Empire, corresponding roughly to Samarkand and Bukhārā, now the Soviet Republic Uzbekistan. In Hellenistic times it was united with Bactria.

"Sogdian" was little more than a name until the beginning of the twentieth century. The epoch-making discoveries of British-Indian, German, Russian, Japanese, French, and other expeditions, have yielded extremely important results (see *The Alphabet*, pp. 310-13).

It is now known that the Sogdian speech and script were widely used in Central Asia for many centuries, and particularly in the second half of the first millennium A.D. Sogdian was actually for a long time the *lingua franca* of Central Asia. The limits of its diffusion were indicated, in the north, by the trilingual inscription (Turki-Sogdian-Chinese) of the ninth century A.D. found in the vicinity of Qara Balgasun (the then capital of the vast Uighur Empire), on the River Orkhon, and, in the south, by a stone inscription consisting of six lines, discovered at Ladakh, on the Tibetan frontier. It is also worth while mentioning that the Uighurs adapted the Sogdian alphabet to their own language. As the result of the Mongolian and Moslem conquests, Sogdian slowly died out, although "a poor descendant" of it is still to be found in the valley of Yaghna°b.

EASTERN TURKESTAN

This Chinese province, known also as Sinkiang, is now almost wholly a sandy waste, but in the first seven or eight centuries of the Christian era it was a land "of smiling cities with rich sanctuaries and monasteries stocked with magnificent libraries". Nowadays it

is inhabited by a sparse population mainly of Turkish tongue and Moslem religion, but at that time it was a melting-pot of peoples using quite different forms of speech (Iranian, "Tokharian", Indian, Chinese, Tibetan, Turki, and others), producing books written in different languages and scripts, and professing different religions (Buddhist, Manichacan, Nestorian, and others).

Fig. VIII-4

Sogdian (*left*) and Kök Turki (*right*) books.

Very few complete Sogdian books are extant, but numerous fragmentary manuscripts were found in Eastern Turkestan, at Ch'ien-fo-tung, the "Caves of the Thousand Buddhas", in Tunhuang. The earliest fragments extant, a collection of paper documents, previously attributed to a period not later than the middle second century A.D., are now assigned to A.D. 313 or 314. It is interesting to note that the paper of these documents is made

entirely from rags of fabrics woven from Chinese hemp (*Bochineria ninea*).

The great majority of the Sogdian texts belong, however, to the eighth, and perhaps the ninth century A.D. The manuscripts are preserved for the most part in London (British Museum and India Office Library), Paris (National Library), Leningrad (Academy of Science), and Berlin (Academy of Science). Amongst these manuscripts are most extensive texts, which come from Tun-huang, some belonging to the seventh century, and others, such as Buddhist sūtras, to the tenth century. It may be noted that Sogdian books are written in three scripts, each of them peculiar to a distinct religion, *viz.* Buddhism, Manichaeism, and Christianity.

The important Sogdian books which were deposited in the National Library, at Paris, were believed lost for a number of years, but were rediscovered by M. Filiozat in 1936, and were admirably published in 1940. The majority of these manuscripts contain Buddhist texts, mostly translated from Chinese originals. Of the non-Buddhist texts, Henning considers the following books as worth mentioning: P 13, a fragment of the *Tale of Rustam*; P 19, a small medical fragment, containing three prescriptions, one each for an emetic, a purgative, and an aphrodisiac; P 25, a learner's first attempt at writing Sogdian, full of mistakes; P 3, a Shamanist rain-maker's handbook, which is a Central Asian rather than Indian production, and contains a number of Iranian terms not found in Buddhist texts. "Of great value is colophon of P 8, with its long list of personal names. . . . The name of the painter of P 26 is not *twγryk*, 'Tokharian', but *twγryl*=Toγrïl, a common Turkish name" (Henning). The very long text P 2 (containing nearly 1,250 lines) is the dullest of all.

Agnean, Kuchean and Khotanese

Until 1890, when the first manuscripts written in these languages were found, and until 1893, when these manuscripts were published by Dr. A. F. R. Hoernle, nothing was known of the existence of these forms of speech. Later, many more documents were discovered. Their decipherment was facilitated by a prior knowledge of the relative scripts (variants of the Indian Brahmī Gupta characters), and by the discovery of some bilingual manuscripts (one of the two languages being Sanskrit).

"TOKHARIAN" AND ITS DIALECTS

The contents of these documents revealed that in the latter part of the first millennium A.D., the population living between the River Tarim and the Mountains T'ien-shan, including the territories of Turfān, Qarashahr and Kucha, spoke a language—of which at least two dialects can be distinguished—belonging to the *centum* group of the Indo-European family of languages.

This language, however, now commonly, though probably wrongly, known as "Tokharian", presents several features not parallelled in the other Indo-European languages, and its relationship with the other groups has not yet been sufficiently cleared up. Partly on Prof. H. W. Bailey's suggestion, the two dialects, previously distinguished as "Tokharian Dialect A" or "I A", and "Tokharian Dialect B" or "I B", are now often termed Agnean (from the ancient kingdom Argi or Agni, later known as Qarashahr), and Kuchean, the latter being the language of the ancient kingdom of Kucha or Kuci.

THE KHOTANESE LANGUAGE

The other documents are written in a form of speech now generally considered as the Khotanese language, which was spoken in the ancient kingdom of Khotan, called in Sanskrit Gaustana, and in Tibetan Khu-then; the indigenous term for the kingdom was Hvatana- (later Hvamna-), the adject. nom. sing. being Hvatanai (later Hvamnai). This language was formerly called North Aryan (by E. Leumann), East Iranian (by French scholars), Saka (by Lueders), Khotani or Khotani Saka (by S. Konow), but at present H. W. Bailey's term "Khotanese" is preferred, though he himself is now prepared to accept the opinion that Khotanese belongs to the Saka group of the Iranian languages.

There are some indications to show that Khotanese was reduced to writing in the second century A.D., although the manuscripts extant are considerably later (ninth or tenth centuries), the earliest ones belonging probably to the eighth or at most the seventh century A.D.

AGNEAN AND KUCHEAN MANUSCRIPTS

(Fig. VIII–6, *a*)

The numerous Agnean and Kuchean manuscripts extant—recently discovered—are now in collections in London, Oxford,

Paris, Calcutta, Leningrad, Berlin, Peking, and (before the last war) in Dairen. They were found in the eastern part of the Tarim basin (Eastern Turkestan), and belong to the second half of the first millennium A.D. The texts are largely religious, but in Kuchean business documents and medical manuscripts are also extant.

Khotanese Manuscripts (Fig. VIII–6, *b*)

The many Khotanese fragmentary manuscripts have been discovered in Eastern Turkestan and at Ch'ien or Ts'ien-fo-tung (the "Caves of the Thousand Buddhas") in Tun-huang. They are now in London (British Museum and India Office Library), Paris (National Library) and Berlin (Academy of Science). The contents of these manuscripts are of great variety: apart from official and business documents, there are translations of Indian tales, Buddhist religious poems, medical texts, and other kinds of literature. Some of the manuscripts extant contain a kind of cursive Gupta *ABC* (the alphabet, a syllabary, and numerals); one manuscript contains 1,108 lines of writing. Three of the more extensive and better preserved Khotanese manuscripts—belonging to the Stein Collection in the India Office Library—have been reproduced in facsimile by the leading authority in this field of study, Prof. H. W. Bailey (*Codices Khotanenses*, Copenhagen, 1938).

Early Turki Manuscripts

Apart from numerous "runic" inscriptions discovered near the River Orkhon, to the south of Lake Baikal, and in other parts of southern Central Siberia, north-western Mongolia, and north-eastern Turkestan, mainly belonging to the seventh or eighth century A.D., some later fragments of manuscripts, written in the same script, but in a more cursive form, were found in Eastern Turkestan. This script is variously termed Orkhon-script, Siberian, or Early Turki, also Kök Turki or pre-Islamic Turki. (Fig. VIII–4, *right*).

The language of these inscriptions and manuscripts is early Turki, this being the oldest known form of the Turkish tongue; it differs very widely from Ottoman Turkish. Although the earliest inscriptions extant belong to the seventh century, the script must already have been in use in the sixth century, and in the same period some literature may have been written.

Uighur Manuscripts (Fig. VIII-5, *above*)

The Uighurs, originally Toquz Oghuz (the "Nine Oghuz") were a strong people of Turki speech and Shamanist religion. They founded a vast and powerful empire in Mongolia, which had its capital at modern Qara Balgasun, on the River Orkhon. Later,

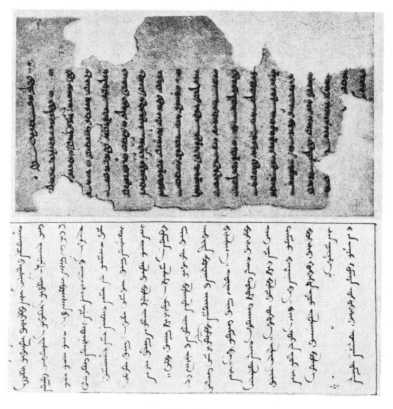

Fig. VIII-5

Uighur (*above*) and Mongolian (*below*) books. The Mongolian manuscript is *Altasamba, c.* 1860 (India Office Library, *R.305*).

however, their kings embraced Manichaeism, while a part of the population became Nestorians or Buddhists. Subsequently, they became Moslems.

The destruction of the Uighur Mongolian Empire, about the middle of the ninth century, did not mean the end of the Uighur

influence. From the cultural angle, the later Uighur kingdom of Eastern Turkestan was more important than the former Uighur-Mongolian Empire. The Uighurs ruled Kashgaria in the tenth-twelfth centuries: they subdued the whole of the country, but intermixed so completely with the local population, which was of "Tokharian" and Iranian origin, that they may conveniently be called Turkized Indo-Europeans. However, the region became the "country of the Turks", *i.e.* "Turkestan". After the conquest by Chinggiz Khan, the Uighurs retained a semi-autonomy for some time.

The cultural influence of the Uighurs on the neighbouring countries is best illustrated by the fact that in the thirteenth century their alphabet was employed as the official script of the Mongolian Empire. Numerous fragments of the Uighur manuscripts were discovered in Eastern Turkestan at Turfan and in other places. Their contents are mainly religious: Buddhist, Manichaean, and Christian (Nestorian): see Fig. VIII–5.

With regard to script, the Uighur literary manuscripts have been classified into three main groups. (1) A few fragmentary manuscripts, belonging to the earliest period, are written in a script showing forms of letters which frequently appear in Sogdian manuscripts. The Uighur manuscripts of this group are in pōthī form (see p. 362); the leaves (generally of paper, rarely of palm leaf or birch bark) measure about 30 × 10 cm.; the lines run longitudinally. (2) The script of a few other Uighur manuscripts is more recent than that of group (1)—though it is closely connected with it—and appears more seldom in Sogdian manuscripts. The books are in pōthī form, but the format is much larger, sometimes measuring as much as 54 × 23 cm.; the lines run not longitudinally but across the leaves. (3) Numerous Uighur manuscripts belong to this group. The script shows characteristics which do not occur in Sogdian manuscripts. The book form is again the small form of pōthī (about 29 × 12 cm.), and the direction of lines longitudinal.

Apart from these main book hands there existed an extremely cursive current hand as shown by Uighur documents; these "were exclusively written with a brush on thinner, softer and coarser paper than the religious texts. The script of the earlier ones is closely connected with the Sogdian cursive; that of the more recent" (Le Coq) shows Arabic influence. It was the Uighur current hand which was adopted as the official script of the Mongolian Empire (see Fig. VIII–5, *below*; see also *The Alphabet*, pp. 316 ff.)

With regard to contents and language, three main groups may be distinguished: Buddhist, Manichaean, and Christian texts; the language employed in the Manichaean manuscripts is apparently connected with Kök Turki (see p. 348) and may represent a western Turki dialect.

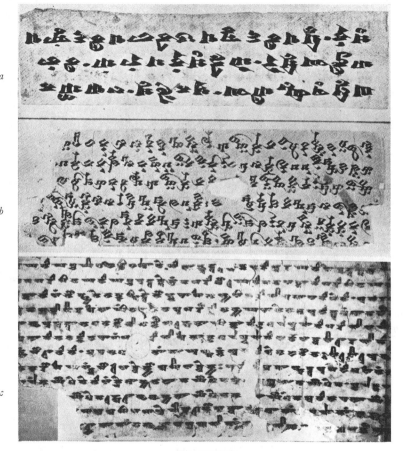

Fig. VIII-6
a, Kuchean, b, Khotanese, and c, Sanskrit Brāhmī (India Office Library).

The lines run vertically or horizontally. Of particular interest is the punctuation in Buddhist and Manichaean manuscripts. The earlier Buddhist texts contain little thick hooks, a sort of comma, written either singly or double, which take the place of our comma, semicolon and full stop. In later times, the commas were replaced

by little oblique strokes written singly or double. The end of a paragraph was sometimes marked by a group of three, four or more hooks; if there were four, two were placed on the height of the line, one above them and one below, thus ·;·. The Manichaean punctuation consisted of little ovals, often in *minium* or vermilion, around one or two dots in black Indian ink. These ovals were either single or double; sometimes they were also placed at the beginning of the line. Le Coq points out that such a punctuation is quite sufficient to denote a Manichaean text.

Uighur books show all the main forms of ancient and modern books: (1) There was the roll-form; the roll was fastened to a rod, which was ornamented at its ends or had projecting ornamental knobs made of bone, metal, or ivory. For parallels in Mediterranean countries and in the Far East, see pp. 129, 405. (2) There was the concertina-method book similar to that in China (see p. 404 f). It was generally written on one side, but sometimes, though rarely, it was written on both sides. (3) There was the pōthī-form book, already referred to. The covering tablets and all the leaves had—generally on the left-hand side—one or two string holes for the passage of the tying string. These holes were sometimes decorated with little circles painted in black or red Indian ink. (4) Finally, there was the Western codex-form, which was preferred by Manichaeans and Christians. The format varied between the folio and quarto, and the duodecimo. Although various writing materials—already referred to—were employed, the great majority of the preserved Uighur manuscripts are of paper; palm-leaf and birch-bark manuscripts have come down to us only in fragments.

BIBLIOGRAPHY

See *The Alphabet*, pp. 292–4, 309, 312–13, 315–16, 349, 351–2.

Kharoshthi Manuscripts (Fig. I–9, *a*)

Before examining the vast Indian branch, we may deal, at least briefly, with the Kharoshthi "book". Kharoshthi is the only Indian script not dependent on, or connected with, the *Brahmī*, the prototype of all the other Indian scripts (see *The Alphabet*, pp. 301–4, 328 ff.).

The term Kharoshthi, or *Kharoṣṣtrī*, now commonly used,

appears in a Chinese Buddhistic work as early as A.D. 668. It is applied to the script known from many Indo-Greek, Indo-Parthian, and Indo-Scythian coins belonging to the period between 175 B.C. and the first century A.D. It is, or was, also called Bactrian, Indo-Bactrian, Aryan, Aryo-Indian, Bactro-Palī, North-western Indian, Aramaeo-Indian, and so forth. Its importance was realized after the discovery, in 1836, of a Kharoshthi inscription incised on a rock in the vicinity of Shahbazgarhi, on the Indo-Afghan borders, giving a translation of Aśoka's edicts, belonging probably to 251 B.C.

KHAROSHTHI SCRIPT

The Kharoshthi script is undoubtedly a descendant of the Aramaic alphabet. It has been suggested that it originated in the fifth century B.C. in north-western India, at that time under Persian rule, which was the best medium for the spread of the Aramaic speech and script. The Persian administration probably introduced this script, adapting it to their own needs and those of the native population. Its use was limited to north-western India and to Indianized Iranian countries of Central Asia, i.e. to the territory occupied by the Indo-Scythian empire of the Kushana (first century B.C. or A.D. to A.D. 225).

Kharoshthi is not a monumental script, but a popular cursive and commercial, or literary and calligraphic book hand.

KHAROSHTHI DOCUMENTS

Many Kharoshthi documents are extant. They are written mainly in Middle Indian dialects, but some documents from Niya and Kucha are written in Sanskrit.

Interesting Kharoshthi documents written in Indian ink on wood, skin and paper were found in Niya and Lou-lan (Eastern Turkestan). The great collection of wooden documents found at Niya formed part of archives of the third century A.D. It shows that wood was not only the writing material most commonly used in Central Asia before the invention of paper (A.D. c. 105), but even afterwards it remained the official writing material in Central Asia at least down to about the end of the third century A.D.

"It was not until Sir Aurel Stein's discovery at Niya in 1901 that the character of the early wooden stationery was known. It takes many forms, from a mere rough twig to the ingenious double tablet of either 'wedge shape' or rectangular, designed to be closed and sealed with as much security against unauthorized inspection

as the most carefully sealed 'cover' of today. The twigs, stick-like tablets, single rectangular and *takhti* shaped tablets are generally memos., accounts, casual unimportant communications and similar matter. The double documents are more or less confidential letters, agreements and official despatches. . . . The two tablets fit together accurately. . . . The seal, made of a specially prepared clay, is packed into the cavity, embedding the crossing strings and is impressed with the sender's seal. . . . The written communication is on the two inner surfaces of the tablets which when 'closed' are face to face and are therefore secure from scrutiny until the string is cut and the tablets parted" (F. H. Andrews).

PRESERVED MANUSCRIPTS (Fig. I–9, *a*)

The most important Kharoshthi manuscript is the fragmentary manuscript known as the *Dutreuil de Rhins Manuscript*; it was discovered in the ruins of Gosinga Vihāra (Khotan), and it contains a version in north-western Prakrit of the Buddhist work *Dhammapada*. It is written on birch bark. Its date is uncertain, but according to some scholars it belongs to the first or second century A.D., thus being the earliest Kharoshthi manuscript extant. Only very few fragments of Kharoshthi paper manuscripts have been recovered (mainly at Lou-lan). See also p. 361.

The most recent Kharoshthi documents written on perishable material were discovered in the Kucha region; their date is uncertain, but they were found with non-Kharoshthi documents belonging to the seventh century A.D. (The most recent Kharoshthi inscriptions seem to belong to the fourth or fifth century A.D.)

Fig. I–9, *a*, reproduces a Kharoshthi "book" written on wooden tablets.

BIBLIOGRAPHY

See *The Alphabet*, p. 304.

India, Tibet and Further India (Figs. VIII–6, *c*–16)

The problems connected with the history of the Indian "book" are so vast and so complicated that it is impossible to deal with it in detail in this book. The origin and development of the numerous Indian, Tibetan and Further Indian scripts have been dealt with in *The Alphabet*, pp. 328–441.

INDIA: LANGUAGES AND SCRIPTS

Even if, for the sake of simplification, we accept the following statement of a leading British student of Indian philology, F. W. Thomas, it is only the beginning of the complication. "Linguistically India is not, upon a superficial comparison, more complex than the area with which it is usually compared, namely Europe exclusive of Russia. If we set over against the Sanskrit and Indo-Aryan the Classical and Romance languages, against the Munda and Dravidian the Celtic and Teutonic, against the Iranian the Baltic and Slav, against the Tibeto-Burman the Finno-Ugrian and Turkish, we have not much left on either side, say the Albanian and Basque in Europe, the Austriac, Burushaski, and Thai in India."

The main complication of India's linguistic problem lies not so much in the fact that each of the main languages has numerous dialects, as in the fact that not only may various scripts be used for a particular language, but that the employment of these scripts presents various combinations and alternatives: the Devanāgarī character is used not only for Sanskrit, but is also the main literary vehicle of various Indian languages and dialects, amongst them those of the Western Hindi group, of the Eastern Hindi varieties, of Marāthī and Nepālī; at the same time, Sanskrit, for which the Devanāgarī is generally employed, is also written or printed in all the chief alphabets. Hindustani can be written or printed in both the Persian and Devanāgarī characters.

Much of the Kashmir literature is written in Sanskrit and in the Devanāgarī character, but the Moslem Kashmir literature is written mainly in the Arabic Persian character, and the Hindu Kashmir literature is sometimes written in the ancient Kashmir script, termed Śāradā. The Moslems generally prefer the Arabic Persian alphabet (also for Punjābī, Sindhī, Lahnda, and other languages), but the Bengālī Moslems write generally in the Bengālī character. The Gurumukhī is the character of the Sikh sacred scriptures which are written in various Punjābī and Sindhī dialects and even in Hindī or Marathī. Tamil is generally written in the Tamil character, but some Moslems write it in the Arabic Persian character; and the old Grantha alphabet of the Tamil country as well as the Tulu-Malayāḷam script were formerly used for Sanskrit only.

INDIA'S EARLIEST LITERATURE

This is not the place to discuss the early or later history of the Indians or their early and later literatures. It may be mentioned,

Fig. VIII-7
Sanskrit manuscripts, written in Devānāgarī, Śāradā, and Nepālī scripts: *a*,
Devānāgarī (*Alamkaraparisekara*), *c.* 1800 (India Office Library, *E.2042*); *b*, treatise
on ritual in Śāradā script, A.D. 1781 (ibidem, *E.3326 a*); *c*, *Pañca Mahāraksa sūtrāni*,
in Nepālī script, A.D. 1677 (ibidem, *K.7754*).

however, that the immigration of Aryan tribes into India, is now generally ascribed to the second half of the second millennium B.C., and the ancient Vedic literature—the sacred scriptures of the ancient Indo-Aryans, and undoubtedly the earliest religious literary monument of Indo-European speech—is assigned to the same period, continuing, in its later parts, into the first millennium B.C. It is a great literature which grew in the course of many centuries, but for many generations it was handed down orally.

The earliest part of the Vedas, or *Rig-Veda*, is a kind of hymnbook, written in archaic language; the much later "Triple Veda" consists of (1) the *Atharva-Veda*, containing charms, exorcisms and spells against wild animals, snakes, pests and other diseases, as well as against poisons; marriage and funeral hymns, and simple philosophical reflections; (2) the *Sāma-Veda*, a book of tunes for verses taken mainly from the Rig-Veda; and (3) the *Yajur-Veda*, a ritual manual.

Four other collections of books make up the religious literature of the ancient Indians. The special ritual literature of the later period, the *Brāhmanas* (perhaps derived from *brahmā*, meaning the prayerenergy, and *mana*, the hidden power which pervades the universe), containing discussions among priests and serving for the training of pupils; the *Āranyakas*, "forests texts" or books "proper for study in the forests", which are an appendix to the Brāhmanas, and deal with ascetic practices, elaborate rituals, and deeper professional discussions intended for Brāhmans alone; the *Upanishads*, secret doctrines, or sessions of intimate discussion, which are a sort of miscellaneous philosophical literature, dealing with such matters as cosmogony, the essence of the material and the spiritual, or the development of man and of other living species; and the *Vedāngas*, or Vedic supplements, supplementary books of the Brāhmanas in their exposition of the older texts, dealing with miscellaneous subjects such as lexicography, phonetics, etymology, grammar, astronomy and astrology.

India's Great Epics

This outline of the ancient Hindu literature will be concluded with a reference to the two famous epic poems, the *Mahābhārata*, containing 100,000 couplets, and the *Rāmāyana*, of 24,000 couplets. Actually, the first traces of epic poetry are to be found in the Vedas, but it was only later that a whole heroic literature grew up, sung by the sutas or bards at various festivals. Many of these epics and ballads have been collected in the *Mahābhārata* (the longest epic poem in

the world), which seems to be the western Indian epic, and the *Rāmāyana*, probably the eastern Indian epic.

Of a much later date (perhaps of the sixth to the eighth century A.D.) are the *Purānas* (from Sanskrit *purāna*, "old"), or "Old Narratives", containing sacred Hindu poetical works in Sanskrit. Then there are also ancient heroic songs, fairy tales, and myths, together with a vast amount of gnomic poetry which is perfectly executed.

Ancient Indian scientific work was not divorced from literature proper, and verse has been the medium not only for biography and history, but also for treatises on medicine, architecture, astronomy and astrology, philosophy, and even law.

PRESERVED WRITTEN DOCUMENTS

Many thousands of Indian inscriptions, carved on stone, or engraved on plates of copper, or on iron, gold, silver, brass, bronze, clay, earthenware, bricks, crystals, ivory, and other hard material, have come down to us. They are written in Sanskrit, Pāli, Sinhalese, Tamil, Bengālī, Orīya, Nepālī, Telugu, Malayāḷam, and other languages. Numerous ancient coins are also extant.

On the other hand, relatively few documents written on perishable materials, such as palm leaves or birch bark, have been preserved. The earliest extant manuscripts on palm leaves seem to belong to the fourth century A.D.—the most important being some fragments from Kashgar, in the Godfrey Collection—or to the sixth century A.D., including the famous Horiuzji manuscripts. These latter manuscripts are written in the cursive hand of the Siddhamatrka character (known also as "nail-headed" or "acute-angled" alphabet), which is the ancestor of Devānāgarī, the script mainly used for Sanskrit.

PALM-LEAF MANUSCRIPTS (Figs. I–13; VIII–13, 15, 16)

"It cannot be doubted," wrote Buehler, "that the two large-leaved palms, the *tāḍatāla* (*Borassus flabelliformis*) and the *tāḍitāli* (*Corypha umbraculifera, C. taliera*), which probably were originally indigenous in South-India, but have now spread into the Punjāb, are the leaves which were principally employed" in India as writing material. Hoernle has proved that this statement is not exact. In his opinion, up to a certain point of time, the (true) Talipat palm, *Corypha umbraculifera*, also *Corypha taliera*, was the only palm, the

leaves of which were used throughout India, whereas the use of the leaves of the Palmyra palm or Tarigach, *Borassus flabellifer* (and not *flabelliformis*, as usually called), began at a comparatively late period, and was, and is still, limited to the south and east of India. The Palmyra palm was brought in from Africa, where it grows wild and is called *Deleb*, whereas the original home of the Talipat palm is uncertain, though according to some scholars it is indigenous to South India and grows wild in Ceylon and on the Malabar coast, up to about the 13th Lat.

The following is the description of the two kinds of leaves as given by Hoernle: Both the Corypha and the Borassus palms have plicate leaves folding like a fan, consisting of a number of segments. Through the middle of each segment, from end to end, runs a hard rib. The flabs on both sides of the rib are tough and flexible; and these yield the material which is prepared for writing purposes. They taper off from their widest point towards both ends; accordingly suitable strips are cut out from the middle, of such various lengths as the size of the natural half-segment will admit. These strips are prepared for writing, by boiling in water or milk; and finally, when wanted for writing a book, the required number of strips are cut down to a uniform size. Uniformity, however, was always more carefully attended to in point of length than in point of breadth.

The manuscript leaves of the two palms can be easily distinguished from one another. Those of the Talipat are thinner and broader, and possess clearly marked cross-veins, in the form of rills, while the Palmyra palm leaves rather present a pitted or pock-marked appearance. An analysis by Hoernle of 134 manuscripts has shown that the width of the Palmyra palm leaf never exceeds $1\frac{3}{4}$, and very rarely exceeds $1\frac{1}{2}$ inches. The majority are somewhat less than $1\frac{1}{2}$ inches wide, but a width of less than 1 inch is very rare. On the other hand, the usual width of the Talipat leaf varies between $1\frac{3}{4}$ and 3 inches, though leaves wider than $2\frac{1}{2}$ inches are not common. Manuscripts under $1\frac{3}{4}$ inches wide are rare, and less than $1\frac{1}{2}$ inches are very exceptional. Thus, the width "is an almost absolute test; any leaf, measuring $1\frac{3}{4}$ and upwards is certain to be *Corypha umbr.*, while any leaf measuring $1\frac{1}{4}$ or below, is almost certain to be *Borassus fl.*" (Hoernle). Moreover, a Talipat palm segment is much longer than a Palmyra palm segment, and it tapers off far more gently than the latter, from its widest point to its ends; besides, the half-segment (that is a segment divided longitudinally along the central rib) of a Talipat palm leaf at its widest

point, may measure 3 inches, whereas in a Palymra leaf, it may measure 2 inches, and usually measures less. Therefore it is possible to cut much longer and wider strips from a Talipat leaf than from a Palmyra leaf. As a rule, a prepared leaf measuring a length of more than 16 inches with a width of $1\frac{1}{2}$ inches is more likely to be a Talipat palm manuscript.

Finally, as Dr. Hoernle has remarked, of the Palmyra palm almost everything can be used: its fruits and buds are edible, its juice is made into liquor, its leaves can be used for domestic and literary purposes, its trunks are shaped into boats. Of the Talipat palm, on the other hand, neither the fruit is edible nor the juice drinkable.

Of the 134 manuscripts examined by Hoernle, eighty-seven can be dated with certainty (eighty-four of them bearing an actual date) and forty-seven can be dated on palaeographic grounds; the three earliest manuscripts belong to A.D. 450, 520, and 550, the latest to 1815. Only two manuscripts dating before A.D. 1675 are written on Palmyra palm leaves; they belong to 1587 and 1594, the former being only partially (at the end) written on Palmyra leaves. On the whole, "we may take the year A.D. 1675 as the epoch that marks the change from the use of Corypha to that of Borassus. . . . Borassus leaves were not used at all for book writing in Northern India before the end of the sixteenth century, nor used generally before about A.D. 1675."

Furthermore, according to Dr. Hoernle, the use of Palmyra leaves for book writing was limited to North-Eastern India, *i.e.* to Bengāl, Bihār, and Orissa. At the time when the use of such leaves came in in North-East India (in the seventeenth century A.D.), the use of paper had in Central and Western India long superseded that of palm leaves, the latter having being discontinued by the middle of the fifteenth century on the west coast, and in the interior provinces some centuries earlier. In Bengāl, the oldest preserved palm-leaf manuscript belongs to A.D. 1360, but the Palmyra palm leaves do not appear before the end of the sixteenth century. In Bihār, down to the middle of the eighteenth century, only Talipat palm leaves were employed as writing material for books. In both Bengāl and Bihār paper superseded the palm leaves in the early nineteenth century. In Orissa, on the other hand, not a single manuscript is known to exist which is written on Talipat palm leaves, all preserved palm-leaf manuscripts being written on Palmyra leaves; it must be borne in mind, however, that the earliest preserved Oriya manuscripts belong to the second half of the seventeenth century, though manuscripts

written in Oriya characters probably already existed in the fifteenth century.

In South India, the Talipat palm leaves were used in very early times, and also the Palmyra leaves were employed earlier than in other Indian regions. "The earliest recorded Borassus manuscript may be referred to about A.D. 1550, and since that time Borassus is generally, though not exclusively, made use of, in Southern India, for book writing, Corypha also being used occasionally." In Ceylon, on the other hand, Talipat leaves were the predominant writing material for books until relatively recent times.

The majority of the preserved Indian manuscripts belong to the ninth and the following centuries. Numerous palm-leaf manuscripts, dating from the tenth, eleventh and following centuries, which were recovered in Gujarāt, Rajputana and North Deccan, are written in the Devānāgarī script. According to Burnell, the oldest manuscript found in South India is dated A.D. 1428.

BIRCH BARK WRITING MATERIAL FOR BOOKS

The earliest extant Indian manuscript written on birch bark is the Kharoshthi manuscript referred to on p. 354. It is variously assigned to the first or second century A.D. Some fragments of it are preserved in Paris, others in Leningrad. It is written on strips of bark which measure about eight inches in width, but vary in length, one being over four feet long. This fact has induced Hoernle to suggest that anciently the strips of bark were used in their full size, perhaps in the form of rolls similar to the Greek papyrus rolls. As the Kharoshthi manuscript was written in a "period of a still strong Greek influence . . . its apparently roll-like form may be due to that influence" (Hoernle). Its writing is in horizontal lines running parallel to the narrow side of the strip.

The well-known *Bower Manuscripts* are the earliest extant documents written in Brāhmi script on birch bark. They were acquired by Lieutenant Bower in 1889 in the course of his journey through Kucha (Eastern Turkestan). These manuscripts are written in Sanskrit in a cursive round hand of the eastern Gupta variety of the early Indian character. The *Bower Manuscripts* consist of several distinct works, such as medical treatises, proverbial sayings and the like. They were edited in the years 1893–1912 by Hoernle.

They have been assigned to A.D. *c*. 450, and are in the typical Indian pōthī form, oblong like the Talipat palm leaf, with a string hole; there are two distinct sizes, $11\frac{1}{4}$ inches by $2\frac{1}{2}$ inch, and 9 inches

by 2 inches, but both imitate the Talipat leaf. (The Indian pōthī book consists of separate leaves, not bound in "a book", but tied together in a bundle, therefore generally the leaves have string holes for the passage of the tying string.)

The third earliest birch-bark manuscript is the *Bakhshālī MS.*, assigned to the tenth or eleventh century A.D. It measures about seven by four inches. Thus, while the original width of the bark strip has been retained, its length was cut up into smaller pieces (of about four inches each). Nevertheless, the writing was made to run parallel to the narrow side of the *original* strip, though this narrow side became the longer side of the leaves. The general form of the *Bakhshālī MS.* is the pōthī, consisting of a large number of separate oblong leaves, though the oblong is not so decidedly elongated as in the palm leaf, and the string holes are wanting, probably being thought too risky for the material.

In still later times the strips of bark were cut into pieces of about twelve inches, which were folded in the middle, making up a kind of folio of two leaves or four pages. The writing was now made to run parallel to the narrow side of the page, so that if the "folios" were unfolded into the original strip, the writing would appear on each "folio" as being in two columns with lines running parallel to the longer side of the strip. In other words, the modern book form appears to have been introduced.

INDIAN PAPER MANUSCRIPTS

The earliest of all preserved Indian paper manuscripts seems to be one of the Calcutta Sanskrit College (*Library Catalogue*, No. 582): it is dated A.D. 1231. Another very early paper manuscript is dated A.D. 1343. "They are both written in a distinctly western type of Nāgārī, and must have been written somewhere in the North-West Provinces." They "point to their having been made in imitation of such a birch-bark prototype as the *Bakhshālī MS.* The oldest . . . has exactly the same squarish shape; it measures 6 × 4 inches. The next oldest . . . is rather more oblong, measuring $13\frac{1}{2}$ × 5 inches, but it has no string hole. . . . It seems permissible to conclude that when paper came into use, its leaves were cut and treated in imitation of birch-bark book leaves in those parts of India where birch-bark was the common writing material, and that it was cut and treated in imitation of palm-leaf, wherever the latter material was used for book-writing" (Hoernle).

Fig. VIII-8

Marathī and Gurumukhī manuscripts. *a*, Marathī manuscript in Modi script: *Notes on Nagpur*, *c*. 1800 (India Office Library, *Mar. B.15*); *b*, Gurumukhī manuscript: *Janam sāhkī*, 1750 (ibidem, *Panj. B.40*).

Very early manuscripts from the Central Asian Collections called after Weber and Macartney, which were edited by Dr Hoernle in the closing years of the last century, are written in Indian Gupta characters (see *The Alphabet*, pp. 345 ff.), and in Hoernle's opinion, they must have been written by native Indians migrated to Kuchar. These manuscripts consist of separate, elongated oblong leaves, from $2\frac{1}{4}$ to $2\frac{3}{4}$ inches wide, with a string hole, and with the writing running parallel to the longer side of the leaf. "Everything points to the inscribed Corypha leaf as model, not even to a Borassus leaf." Hoernle has suggested that the reason of the adoption by the people of Northern India and of Central Asia of the shape of palm leaves for their paper books lies in the sanction of immemorial usage of the palm leaf among the literary classes of India, the learned and the "religious", those who occupied themselves with the composing and copying of books; and with the speed of Indian culture, through Buddhist propaganda, its fashions of writing went with it beyond the borders of India.

In Western India paper superseded the palm leaf as writing material for books faster and more thoroughly than in Eastern India. About the middle of the fifteenth century (A.D.) in Western India palm leaf has ceased to be used as the main writing material for books; apparently, the latest palm-leaf manuscripts are dated A.D. 1400 and 1449. In Eastern India for some centuries both forms of books were employed: although there was a steady and marked rise in the number of paper manuscripts, the use of palm leaves as writing material for books lingered on in Bengal and Bihār until the early nineteenth century, and in Orissa until our own day. The earliest Eastern Indian paper manuscript is a Maithilī (Bihār) manuscript dated A.D. 1354; the earliest Bengāl paper manuscript is dated 1404.

It is generally agreed that the introduction of paper into India occurred in the eleventh century A.D., and was due to the Moslems. "It only very slowly and gradually displaced the Corypha palm-leaf, the use of which had the sanction of age and religion among the conservative Indian literates: they looked with distrust upon the product of the Mlecchas." Indeed, until quite recent times the Indian paper-mills were in the hands of the Moslems. There is no indigenous term for "paper"; the Hindū word *kāgaj* or *kāgad* is a corruption of the Persian *kāghaz*, itself a derivation from the Chinese word *kog-dz*, the term for "paper made of the bark of the paper-mulberry tree".

Fig. VIII-9

Limbū, Hindi, and Gujarāti manuscripts. *a*, Limbū manuscript: alphabet, *c.* 1800 (India Office Library, *Hodgson Collection, 87*); *b*, Hindi manuscript in Kaithi script: *Santasagara*, A.D. 1794 (ibidem, *MS. Hin. B.55*); *c*, Gujarāti: *Pavagadhazo garabo*, A.D. 1750 (ibidem, *MSS. Guj. 17*).

LITERARY SOURCES

Hoernle has proved that the common assumption that the early Indian words *lala* and *tali* indicate the Palmyra and the Talipat palms, respectively, is not exact, *tāla* being simply the generic name of any palm.

The Chinese traveller Hiuen Tsiang (seventh century A.D.) stated that "in all the countries of India the leaves of the Talipat palm are everywhere used for writing on". He also mentions the existence of a forest of Talipat trees near Konkanapura (the place has not yet been identified), in South India. In the forest there was a Buddhist *stūpa*. It is known that writing was mainly carried on in Buddhist and other monasteries; some of them must have possessed large plantations of Talipat palms.

Al-Bīrunī, the famous Moslem geographer (A.D. 973-1043), writes: "The Hindus have in the south of their country a slender tree like the date and coconut palms, bearing edible fruits, and leaves of the length of one yard, and as broad as three fingers, one put beside the other. They call these leaves *tārī*, and write on them. They bind a book of these leaves together by a cord on which they are arranged, the cord going through all the leaves by a hole in the middle of each." Further on, he says: "In Central and Northern India people use the bark of the *tūz* tree. It is called *bhūrja*. They take a piece one yard long and as broad as the outstretched fingers of the hand, or somewhat less [about eight inches] and prepare it in various ways. They oil and polish it so as to make it hard and smooth, and then they write on it. Their letters, and whatever else they have to write, they write on the bark of the *tūz* tree." Although al-Bīrunī's account is not completely clear and—at least in Dr. Hoernle's opinion—contain some misunderstandings and inaccuracies, it is nevertheless very important, particularly if we consider the scanty survival of birch-bark manuscripts. We may suppose that the vast majority of such manuscripts, as indeed also of palm-leaf manuscripts, have been destroyed by action of time and climate or through the agency of men—especially during the political or religious troubles, which so frequently convulsed the Indian continent: during the Moslem conquest, for instance, large destructions of Hindu manuscripts are reported to have taken place.

VERNACULAR BOOK PRODUCTIONS (Figs. VIII-7-12)

In India, two important linguistic events characterized the eleventh and twelfth centuries A.D.: (1) the Moslem conquest

Fig. VIII-10

Bengāli and Kannada manuscripts. (*Above*) Bengāli: *Svarodaya, c.* 1780 (India Office Library, *MSS. Ben. F.3*); (*below*) Kannada: *Viveka Chintamanya, c.* 1790 (ibidem *MSS. Kan. C.1*).

brought the Arabic-Persian script and language into use, and thus brought into being a serious competitor to Sanskrit and its script, Devanagari, as the main literary language and the *lingua franca*. (2) The decadence of Sanskrit as the only literary vehicle; this was probably one of the main reasons for the development of a few Indian vernaculars into literary languages.

NORTH-EASTERN INDIA (Figs. I–13, *below*; VIII–10, *above*)

The earliest proto-Bengālī manuscripts belong to the eleventh or twelfth centuries A.D. The early Nepālī or Newārī character was closely connected with the proto-Bengālī script, and it may be noticed that the earliest Newārī written documents belong to the twelfth century. Newārī has a considerable literature consisting of commentaries on, or translations of, Sanskrit Buddhist works, dictionaries, grammars, and dramatic works. The oldest work of an historical nature was written in the fourteenth century. Modern Bengālī literature goes back at least to the fifteenth century A.D.

Oriya, Bihārī, and Assamese—all sister languages of Bengālī, belonging to the eastern group of the Indo-Aryan linguistic family— have rich literatures. Various scripts are employed, and some of them, for instance Oriya, are peculiar. The peculiar shape of Oriya letters seems to be due to the fact already mentioned, that the long and narrow, and excessively fragile Talipat palm leaves were the only writing material in ancient Odra as in other parts of the sea-coast provinces of southern India. The local scribes employing an iron stilus to scratch the letters—the scratches being later filled in with ink rubbed on the surface of the leaf—were compelled to avoid long straight lines, because any scratch in the direction of the longitudinal fibre would split the palm leaf. Thus apparently arose the rounded shapes of the Oriya letters. One variety of the Oriya writing, called Brāhmānī (owing this name to the Brāhmāns of Orissa, who are generally the writers of the Oriya *sastras* or religious works), is still mainly employed for writing on palm leaves.

The ancient non-Indo-Aryan Manipuris, using Manipuri or Meithei, a Kuki-chin speech of the Tibeto-Burman linguistic branch, also have a considerable literature, *Takhelgnamba* and *Samsokgnamba* being their most important ancient books.

NORTH-WESTERN INDIA (Figs. VIII–6, *c*, 9)

Hindī and Gujarātī are the most important Indian vernacular literatures of the north-western and central groups of the Indo-

Fig. VIII-11

Lepcha and Telugu manuscripts. (*Left*) Lepcha manuscript, *c.* 1800 (India Office Library, *Hodgson Collection, 81*); (*right*) Telugu, *Urzees*, A.D. 1820 (ibidem, *Tel: D.6*).

Aryan languages. There is also a vast Urdu literature, but this is mainly modern. Of particular interest is the Sikh religious literature, composed—as already mentioned—in various dialects belonging to Punjābī and other important Indo-Aryan languages, and written in the Gurumukhī character, the invention of which is traditionally ascribed to Aṅgad (the second Sikh Guru (1538–52)). It is said that Aṅgad found that Sikh hymns, written hitherto in Landa character (see *The Alphabet*, p. 376), were liable to be misread, and therefore he improved the script and enabled it to record accurately the holy literature of the Sikhs.

DRAVIDIAN BOOKS (Figs. VIII–10, *below*; 11, *right*; 13, *lowest leaf*)

Of the four main Dravidian languages (see *The Alphabet*, pp. 378–87), Tamil, spoken by a population of about 18,000,000, possesses by far the most important literature. "Possessing a civilization as early as, if not earlier than, the Āryan, the Tamils, the chief of the Dravidian people, were the last to be Āryanized. Hence their literature shows least trace of Sanskrit influence. Even in pre-Christian days we hear of three Sangams (academies of scholars) at Madurā, the capital of the [ancient] Pandya [kingdom], and how they adjudicated on new literary works. . . . The earliest extant Tamil work is the *Tol kāp-piyam*, a versified grammar of about the first century A.D. But the literature really begins with the *Kural* of Tiru-Vulluvar" (J. C. Ghosh).

The *Kural*, a didactic poem, is assigned to the period between the first and the fifth centuries A.D.; it is the most important classical work of the Dravidians and it is even considered as a kind of Tamil Veda.

Tamil possesses a copious body of literary texts, excellently preserved, though in relatively late copies. These texts antedate the earliest Tamil inscriptions by several centuries—excluding, however, the so-called Dravidi inscriptions. The position regarding Kanarese or Kannaḍa is quite different: while the earliest Kanarese literary text preserved, the *Kavirajamarga*, dates from the latter part of the ninth century (A.D. *c*. 877), the earliest Kanarese inscription yet found, at Halmidi, is dated A.D. *c*. 450.

There are not many Dravidian literary remains extant, but the continued employment of various very ancient literary hands may be regarded as evidence that even in ancient times the main Dravidian peoples wrote and read books.

Grantha (see, *e.g.*, p. 355) is one of the most ancient and most

Fig. VIII-12

Indian and Malayan manuscripts written in Persian-Arabic script. *a*, Urdu: *Amwaj-i-khidi*, A.D. 1667 (India Office Library, *Hindust. B.2*); *b*, Malay: *Shair jeran Tamas*, *c*. 1800 (ibidem, *Malay, D.6*); *c*, Sirdni: *Shab-i-Mi'rāj*, A.D. 1807 (ibidem, *Sindhi 14*).

important scripts of South India. The term Grantha, which already appears in the fourteenth century A.D., indicates that this character was used for writing books. The oldest modern Grantha manuscript extant belongs to the end of the sixteenth century B.C. There are at present two Grantha varieties: the Brāhmānic or "square" hand, used chiefly at Tanjore, and the "round" or Jain hand, used by the Jains still remaining near Arcot and Madras: the latter has pre-served the original characteristics of the early Grantha far better.

The Tulu-Malayāḷam character seems to have been formed in the eighth or ninth century A.D. out of the Grantha, and like it, was originally used only for writing Sanskrit.

The Vaṭṭeluttu, or "round hand", perhaps an ancient cursive or literary hand of the Tamil character, was once widely used in all South India south of Tanjore, and also in South Malabar and Travancore where it still exists though in exceedingly limited use, and in a more modern form. The Mappiḷḷas of the neighbourhood of Tellicherry and in the islands used Vaṭṭeluttu until modern times, when it was superseded by a modified Arabic alphabet.

See *The Alphabet*, pp. 307-8.

TIBETAN BOOKS (Fig. VIII-11, *left*, and 14, *a*)

The connection of Tibet with India is old and intimate. Directly or indirectly, it borrowed from India the Buddhist religion, together with its sacred scriptures and its writing. Moreover, intimate acquaintance with Buddhism may also have been acquired by the Tibetans through their invasion and conquest of Eastern Turkestan (where they found numerous Buddhist monasteries and libraries in existence), as well as through relations with China.

With the establishment of the Tibetan state and of its capital at Lha-sa (in the first half of the seventh century A.D.), the Tibetans took kindly to writing and acquired an aptitude for literature. The earliest extant Tibetan books belong to the latter part of the seventh century A.D. and are mainly translations of Sanskrit books, but some of these translations are extremely important, as they preserve works which have been lost in their original language.

The cultural influence of the Tibetans on the surrounding peoples may be seen from the fact that some of these peoples, such as the Lepchas, of the State of Sikkim, adapted the Tibetan script to their own speech. Tibetan writing was adapted also to the Nam language —whose existence was unknown until the recent discovery of Central Asian manuscripts, to Mongolian (the Tibetan-Mongolian script

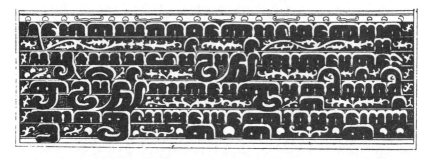

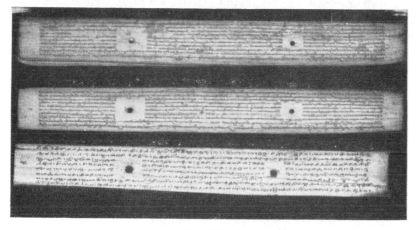

Fig. VIII-13

(*Above*) Pāli manuscript: a page, in square Burmese script, from the sacred
Buddhist book *Kammuwa*; (*below*) Pāli and Malayālam manuscripts on palm-leaf;
upper two leaves: Burmese Pāli (*Mahāvamsa, c.* 1800) (India Office Library, *Pali 91*);
lowest leaf: Malayālam (*Bhāsāśilparatanam, c.* 1800) (ibidem, *Mal. 3*).

being known as H̲phags-pa) and even to Chinese: three Chinese
Buddhist manuscripts written in Tibetan scripts were published in
the years 1926–9.

PĀLI LITERATURE (Figs. I–13, *above*; and VIII–13)

The term "Pāli" means actually the "text", the text *par excel-
lence*, the text of the Hīnayāna Buddhist scriptures, but it indicates
also the language in which the sacred scriptures of Buddhism are
recorded, and the script in which they are written. The Pāli earlier
scriptures (if the voluminous commentaries are disregarded) contain
a literature about double the size of the Bible, but if its repetitions

were discounted it would be somewhat smaller than the Bible. It consists of three *Pitakas* or "baskets" or collections (hence *Tripitaka*, "Three Baskets"). They are supposed to be the teachings of Buddha, which for many generations were handed down orally. Probably at the end of the first century B.C. (traditionally 80 B.C.) they were committed to writing.

The first Pitaka, known as "Profound Purity", mainly for the laity, is the *Vinaya*, dealing with discipline, but including also the *Mahāvagga*, a history of the founding of the order of Buddhism, and the exposition of monastic rules. The second, "Profound Mystery", for devotees such as the monks, is the *Sūtra* or *Sutta Pitaka*, or collection of teachings, consisting mainly of dialogues between the Buddha and various interlocutors, of books of meditation and devotion, sayings by the Master, poems, fairy-tales and fables, stories about saints, and so on. The third Pitaka, "Profound Spirituality", is a metaphysical section known as *Abhidhamma*, and is the dogmatic statement of the psychological and philosophical "discriminations", containing speculations and discussions on various subjects.

Other ancient books written in the Pāli language are the *Mahāvansa*, an historical work, the *Dhammapada* and the *Suttanipâta*, lofty and artistic ethical and religious verse; the highly literary *Jātaka* book of 547 stories of Buddha's prior incarnations in various animal and human forms; the beautiful poetic compositions of the *Therā-gātha* and *Therī-gātha*, or "Songs of the Monks" and "Songs of the Nuns"; the *Milinda-Pañha*, which contain supposed dialogues of the Buddhist monk Nāgasena with the Greek king Menander.

BUDDHISM'S PART IN ASIA'S CULTURAL HISTORY

It is well known that the cultural expansion of India into Ceylon, Tibet, Burma, Cambodia, Cochin China, Siam, Malaya, Indonesia, was due to a large extent to Buddhism. This religion penetrated deep into China, Korea and Japan.

The scripts of the Buddhist monks became the vehicle of their culture, and widespread organization. The Austro-Asiatic peoples of south-eastern and far-eastern Asia fell into line with the spiritual thought emanating from India, when they adopted and gradually assimilated Buddhism in one form or another. A unique empire was built up: an empire, based not on political and military unity, but on the common cultural and spiritual life of politically more or less independent peoples.

The culture of Buddhist India has been one of the great civilizing and humanizing agencies evolved by man. Buddhism, indeed, played a part in Asia similar to that of Roman Christianity in Europe in the Middle Ages (see pp. 205 f., 264 ff.). It must be stressed, moreover, that Pāli-Buddhism, that is the particular form of Buddhism which is based on the sacred Pāli books brought to Indo-China from Ceylon, was only a reinforcing of earlier forms of Indian Buddhism. Already before A.D. 500, various kingdoms arose in Indo-China and Indonesia, ruled by Hindu dynasties. In certain regions, indeed, the influence of Buddhism had become so deeply rooted, that whereas in India, its place of origin, where it suffered the effects of Moslem destruction, it ultimately gave way to Hinduism, in Tibet, Ceylon, Siam and Indo-China, Korea, and partly China and Japan, the Buddhist religion has been preserved up to the present day. Buddhism, Buddhist literature and culture advanced hand in hand. The scripts and the scriptures were the vehicles by which the religion and the culture were spread.

NUMEROUS INTERESTING PROBLEMS:

CEYLON, INDO-CHINA, SIAM, BURMA, INDONESIA
(Figs. VIII-14--16)

Interesting though it may be, we shall not be able to deal with the history of the Sinhalese books; of the books of the Indo-Chinese ancient peoples—the Chams and the Khmers; of the ancient and modern Burmese peoples—the Mons, the Pyu, the Karens, the Taungthu, the Yao, and other peoples; of the numerous Shan or Thai peoples, including the modern Siamese. (With regard to the Pyu, for instance, nothing was known of this people and its language until, through the discovery in recent times of numerous inscriptions—one even in four languages—of a manuscript of twenty gold leaves containing extracts of the Pāli canon, of Sanskrit-Pyu bilinguals, and of other material, scholarship was enabled to reconstruct the story of an eminent people.) Neither shall we discuss the numerous problems connected with the history of "the book" in relation to the Indonesian peoples or to the native peoples of the Philippine Islands: some of these problems have already, however, been mentioned in Chapter I, others have been examined in *The Alphabet*, pp. 401–41.

In Siam, until quite recent times, the Buddhist monasteries were the main seats of learning, and almost the only Siamese institutions

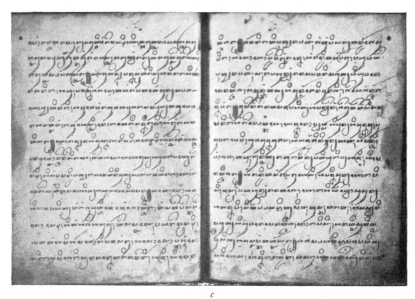

Fig. VIII–14

a, Tibetan manuscript (India Office Library, Sir Aurel Stein's Central Asian Collection); *b*, portion of the Siamese *Patimokkha* manuscript; *c*, Javanese manuscript: *Damar wulan*, A.D. 1790 (India Office Library, *Jav. C1*).

which preserved written documents. Sacred works were written on Corypha palm leaves, their edges being gilded or painted with vermilion, and the leaves threaded on strings and folded like a fan. More important copies of the religious books were engraved on ivory tablets.

FORMS OF BOOKS INFLUENCED BY SOCIAL CONDITIONS
(Figs. I–13, 14, *b*; VIII–13–16)

The material used for such work was an indication of the social standing of the person for whom the book or the written document was intended; the king's letters, for instance, were engraved on sheets of gold when they were sent to princes, and written on paper, either black or white, when addressed to lesser people. Corypha palm leaves, however, were the material chiefly used for writing books, and, strangely enough, the peculiar shapes of the modern Burmese characters are due mainly to this fact.

In the past the Burmese, in their more elegant books, wrote on sheets of ivory, or on very fine Palmyra leaves. The ivory was stained black, and the margins were ornamented with gilding, while the characters were enamelled or gilt. On the Palmyra leaves, the characters were in general of black enamel, and the leaves and margins were painted with flowers in various bright colours.

BALI AND JAVA

Although only two miles separate the island of Bali (ninety miles by fifty-five miles; 1,300,000 inhabitants) from Java, there is a curious cultural break between them. Bali was never submerged by Islam, and certain aspects of the ancient Hindu culture still survive here in full vigour.

On the island of Bali, some natives still use an iron stilus and cut the symbols on a prepared palm leaf, in the same manner as was done in ancient Odra (see p. 360 f.). This practice still obtains to a certain extent in some parts of the more eastern portion of Java, and was no doubt at a former period general throughout the island. Nowadays, however, the Javanese usually write with Indian ink upon paper manufactured by themselves, and sometimes on European or Chinese paper.

SUMATRA AND CELEBES (Figs. I–10 and 11)

The natives of these islands write by beginning at the bottom of

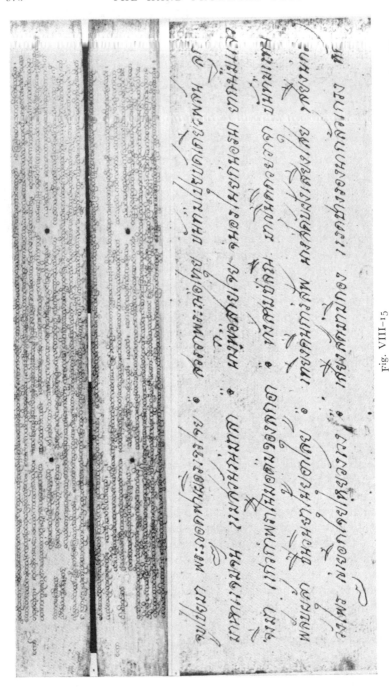

Fig. VIII-15

(*Above*) Burmese manuscript on palm-leaf: *The evil Nats*, 1805 (India Office Library, *Burm. 3449*); (*below*) Siamese manuscript: *The Savatthi racha* (ibidem, *Siam. 14*).

the page at the left-hand side, and placing letter above letter in a vertical column till they reach the top, when they return to the bottom; the columns follow each other from left to right. This curious method has been explained by the fact that the material that had been—and is still to some extent—used to write upon, consists of long strips of bamboo welded by "beating" them together, then folded together, accordion-like, between wooden covers, and bound together with a string of woven rushes.

Originally, the writing was from left to right in horizontal lines, one line following the other, as in modern European writing, from top to bottom. The completed book, however, when bound up was held upright for purposes of reading at an angle of ninety degrees, so that the original successive horizontal lines from left to right and from top to bottom appeared as vertical columns consisting of letters written one above the other from the bottom to the top; the columns consequently follow each other from left to right.

Instead of bamboo strips, long strips of thin bark of trees are sometimes used. As already mentioned, in Chapter I, the ancient books of Sumatran peoples are written in brilliant ink on a kind of paper made of tree bark. Dr. P. V. Voorhoeve, the leading authority in this field, has remarked that while the use of books consisting of a long strip of writing material, folded up like a concertina and written in lines parallel to the folds, is not uncommon in Eastern Asia (see, for instance, p. 404 f. and *passim*), the use of prepared tree bark for this purpose appears to be restricted to Sumatra. This kind of book—known in North Sumatra, in Java, and in other countries, with its Sanskrit term *pustaka*, and in South Sumatra as *pustaha*— is still employed among the Bataks, inhabiting North Sumatra, for magic and divination texts. Dr. Winkler, a German missionary doctor living amongst the Bataks, defined the *pustaka* as a notebook of a Batak medicine-man (*datu*), dictated to his pupils or copied by them as a supplement to oral instruction. An interesting *pustaka* has been reproduced in Chapter I (Fig. I–11; another Batak divination book on bark is reproduced on Fig. I–10). The Batak *pustaka* may deal with magic medicine, domestic remedies, "the art" of destroying life, and so on. A specimen of aggressive magic (*pangulubalang*) is thus explained by Voorhoeve: "The magician takes a toad and a lizard, feeds them on his magic medicine, makes them wear sashes of earth-worms and yokes them to a small plough. Out of the rib of a palm-leaf he makes a whip with a hibiscus flower bound at its top by means of three-coloured thread. Stark naked he goes to the battlefield and makes them plough seven furrows. Then

he throws away his whip and goes home. This practice will cause
storm and darkness that drive the approaching enemy back."

In South Sumatra, apart from divination texts, *pustahas* were also
used for codes of law and for legends, but apparently they are no

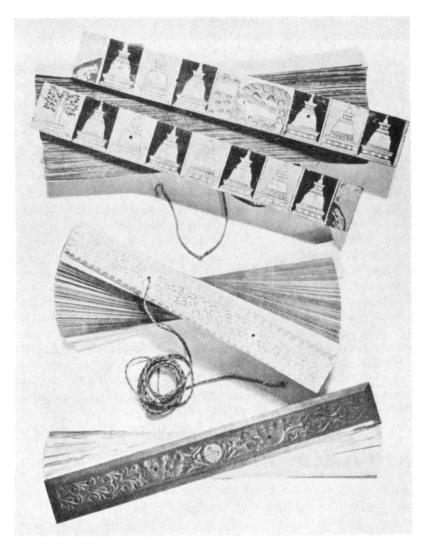

longer made nowadays. Voorhoeve considers the collection of Van der Tuuk (now partly in Amsterdam, at the Indian Institute, and partly in the University Library, at Leyden) as the most complete collection of *pustakas*. The best collection in England is that of The John Rylands Library, at Manchester, containing fourteen Batak books written on tree bark, nine on bamboo, and three on paper. (See P. Voorhoeve, *Batak Bark Books*, "BULL. OF THE JOHN RYL. LIBR.," Manchester, vol. 33, No. 2, March, 1951.)

BOOKBINDINGS (Fig. VIII–16)

The bookbindings of central and southern Asiatic peoples in the past differed totally from those which will be described in the book on *Illumination and Binding*; in fact, strictly speaking, particularly from the modern standpoint, they are not "bookbindings".

In the "binding", the palm leaves were laid one over the other. They were not sewn, as our books are, but were kept together by two cords or twines. These were laced through two holes made in each of the leaves, as well as in the lower covering, and were fastened to the upper covering of the book by two knobs, often formed of precious metal, or crystal, or other expensive material. Both boards were made of hard wood, generally obtained from the jack tree.

Moreover, in the finer "bindings", the boards were beautifully ornamented, painted and lacquered. Sometimes the edges of the leaves were cut smooth and gilt and the title written on the upper board. More elegant books were wrapped up in silk cloth, and bound round by a garter, on which, sometimes, the title of the book was woven in.

Some "bindings" were rather strange. The old East India Company's library possessed a very elegant Burmese Pāli book, presented by Col. Clifford, which was covered with coloured oriental paper painted with grotesque figures; a Batak book made and presented by a cannibal chief Munto Panei, which was bound with plain covers; and a book covered with leather, dressed with the hair on. See also Fig. I–11, *above*.

BIBLIOGRAPHY

See *The Alphabet*, pp. 402, 412, 418, 431–2, 439–40.

OUTLYING REGIONS (ii):
THE FAR EAST AND PRE-COLUMBIAN AMERICA

China (Figs. IX-1-5, and 9)

THE first country to which we might naturally look for an independent development of the book, a country whose civilization approaches in antiquity those of Mesopotamia and Egypt, is China. Chinese civilization is in one respect the oldest in the world, namely, it has come down to us from a remote antiquity with relatively few changes, at least in comparision with those of other countries. In other words, China is the land of arrested development. To take only one instance, the evolution of Chinese writing (see *The Alphabet*, pp. 98-119) is in certain respects all but imperceptible, except for its external evolution, notwithstanding its employment for almost four thousand years by a literary nation comprising one-fifth of the population of the world, in a country larger than the European continent. Centuries before the Christian Era the inhabitants of China had their settled civilization and religion. Although they were sometimes invaded by more restless tribes, sometimes even conquered, their culture and learning, their customs and traditions tamed their conquerors. An old saying declares, "China is a sea that salts all rivers flowing into it."

ANCIENT CHINESE LITERATURE

In far distant ages the Chinese were respectfully mentioned by other peoples as gifted scholars and most skilful artists and workers. The Chinese themselves reverence literature above all things, but we must be content to take the facts as we find them, and admit that China gives us no aid in carrying back the authentic history of her literature for anything like the time for which we have satisfactory evidence from Egypt or Mesopotamia.

Although the oracle bone inscriptions (Fig. I-14, *c*) cannot be

regarded as books, the pictographic form of certain characters which appear on these inscriptions, confirms, according to Hummel, the view based on literary references that books existed at that time, *i.e.* in the fourteenth and the thirteenth centuries B.C. For instance, the word *ts' ê*, which nowadays may mean "volume", appears both on the divination bones and on early bronzes. "The pictograph represents several narrow slips of wood laid side by side and held together by two cords, one near the top, another near the bottom. This is the interpretation of the character given in the dictionary *Shuo-wên.*" Hummel mentions that the character *shu*, meaning "to write" (later a noun meaning "book"), is represented on at least two bronzes of the ninth century B.C. as a hand holding some kind of pen to make marks on a tablet.

Thus it may be assumed that in very early times the Chinese had already quantities of books and a written language adequate to express any and all human ideas, but at first, and for many centuries, "the book" was a rarity; most of the school work done by children consisted in learning by heart. Whole books of moral teachings, pious maxims, and historical myths were thus committed to memory. Even in modern times, owing to the complexity of Chinese writing, the old system of teaching was employed in village schools; the teacher stood behind the class, and the children recited in chorus the appointed lesson. They thus learned from his spoken word instead of from books, the reading from a book being of the nature of a treat for advanced students.

BOOK OF ODES

The *Book of Odes* (*Shih Ching*)—containing some 300 poems, lyrical and historical, many of which treat of warfare and marital fidelity, others of agriculture, hunting or feasting—"gives us, virtually untouched by later hands, the finest picture we have of social conditions of the eighth and seventh centuries B.C. Men sung of their courtship and marriage, women of their errant lovers, soldiers of their misery and the general devastation, princes of their unworthiness; all this and more, together with popular myths and legends, were gathered together, as were the Hebrew Psalms and the Song of Solomon, to form this book" (Goodrich).

Other early books are omen and divination texts, histories of the royal house and of a few states, and the rituals practised at court. In Goodrich's opinion, these various books constitute a kind of Bible, which was transmitted orally from one person to another

and then from manuscript to manuscript, often corrupted, that became the textbook for every statesman, seer, and schoolboy for two thousand years.

CONFUCIUS

It would be impossible to deal with the early Chinese literature and book production without emphasizing the extraordinary importance of the three main religions of China—Confucianism, Taoism, and Buddhism—in the everyday life of the Chinese, and in their active intellectual development during many centuries.

The great Chinese sage Confucius, or K'ung Fu-tzŭ (c. 551–479 B.C.) is sometimes—but wrongly, as we have seen—considered the founder of Chinese literature. The *Ch'un Ch'iu*, or *Annals of Spring and Autumn*—being a chronology of events of the state of Lu (which was the state of Confucius)—is considered by Eberhard as "the only book in which he personally had a hand", being based on "the older documents available to him".

Confucius is credited traditionally with the authorship of the Classics which form the "canonical" books of the Chinese. The *Shu Ching* or *Canon of Documents*, which contains some portions in verse, two homilies against luxury, an allocution to an assembly of nobles, etc., is considered by some scholars as the beginning of Chinese literature. Of the other Classics the following are particularly important: *I Ching*, or *Canon of Changes*, *Li Chi*, or the *Book of Rites*, dealing with ceremonial, the *Lun Yü*, or *Analects* of Confucius.

Confucianism

Mencius (c. 372–289 B.C.)—"who played 'St. Paul' to Confucius" (Goodrich)—and Hsün Tzŭ (c. 298–238 B.C.) were both followers of Confucianism, and both elaborated the ideas of Confucius. "Hsün Tzŭ's chief importance lies in the fact that he compressed and simplified the ideas of Confucius. In the strongest contrast to his conservative tendency was the school of Mo Ti (at some time between 479 and 381 B.C.)" (Eberhard). This school, which championed the underdog, denounced war, and preached mutual love and asceticism, altered the fundamental principles of society.

From the second century B.C. onwards, Confucianism was steadily growing. Goodrich mentions that a Confucian college of doctors had only fifty students when it was established in 125 B.C.; three centuries later there were thirty thousand. Thus education grew among the privileged, this growth being due to the fact that

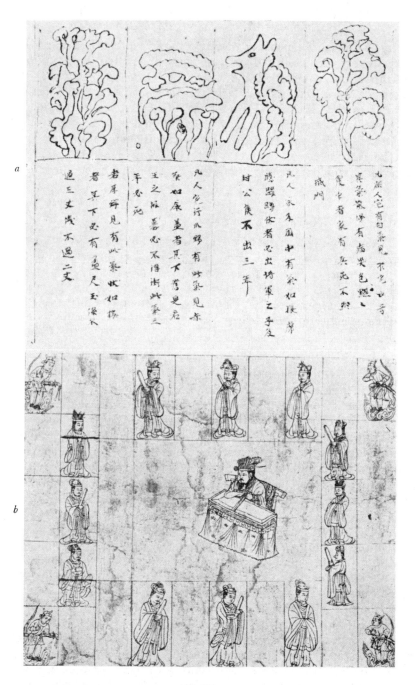

Fig. IX-1

a, Chinese Taoist text on divination from vapours; *b*, illustration to Chinese Taoist Calendar for the year A.D. 978. Found in Ch'ien-fo-tung ("Caves of the Thousand Buddhas") and now preserved in the British Museum.

"after 165 B.C. and especially after 125, most members of the growing bureaucracy were selected on the basis of written examinations, which generally included the *Odes*, the *Document of History*, the *Canon of Changes*, one of the *Rituals*, the *Spring and Autumn Annals*, and sometimes the *Analects* of Confucius". Chinese history is rich in examples of politicians, who may be considered both as scholars and as *literati*. Thus, in Chinese culture, learning and literature cannot be considered as separate branches, but must be regarded as a unity, which moreover is strictly connected with Confucianism.

Taoism (Fig. IX–1)

Taoism mainly flourished under the Han Dynasty and under the Six Minor Dynasties, *i.e.* from the third century B.C. to the seventh century A.D., and Buddhism flourished in the period between Kumārajīva and the end of the T'ang Dynasty, *i.e.* the fourth to the tenth centuries A.D., but Confucianism always formed the spine of Chinese literature and learning.

Lao–Tzŭ

A famous Chinese sage, the philosopher Lao-Tzŭ, according to Ssŭ-ma Ch'ien (*c.* 100 B.C.)—the author of *Shih chi*, or "Historical Memoirs" (the first history " in which truth was sifted from fancy")— was born in 604 B.C., but in the opinion of other scholars he lived in the late fourth century B.C., or even later. His "teaching is contained in a small book, the *Tao Tê Ching*, the 'Book of the World Law and its Power' " (Eberhard). In the opinion of many modern scholars, much is merely legendary in the story of Lao-Tzŭ's life.

The "Taoist" Chuang-Tzŭ (late fourth century B.C.) "was probably the most gifted poet among the Chinese philosophers" (Eberhard), but "Tradition assigns the actual establishment of Taoism to a member of the Chang family who lived during the second century A.D. in the region of Szechuan, and who is said to have 'manufactured writings on the Tao to deceive the people' " (Goodrich). In Eberhard's opinion, Chuang-Tzŭ left us the finest work of ancient times as regards form. He and his school occupied themselves mainly with mysticism and mystical puerilities.

In the first half of the second century A.D., Wei Po-Yang wrote a book describing " the process of preparing the pill of immortality "

(Goodrich). J. R. Ware has noticed striking similarities between this process and the preparation of the philosopher's stone in *Speculum Alchemiae* (attributed to Roger Bacon), and has suggested that European alchemy may have originated in China. According to Goodrich, the first *Materia Medica* that has come down to us was prepared by a Taoist of the early third century A.D. In addition to listing the medicines in use at that time, it gives instruction for making pills, powders, and poultices from drugs.

An official chronicle of the sixth century A.D. mentions—with the usual Oriental exaggeration—the "efficacious recipes and marvellous formulae which existed by thousands and tens of thousands", but even modern scholars, such as Goodrich, have emphasized that the Taoist scientists "discovered many valuable herbs and experimented with sulphur, arsenic, mercurial substances, compounds of zinc, of lead, and of copper, and iron".

BUDDHISM (see also p. 374 ff.)

It is known that in the first century B.C. Buddhism penetrated into China, but until A.D. 220 had little real effect on China. With the spread of Buddhism, especially amongst the lower and middle classes, Indian influence expanded into various fields. Chinese language, medicine, music, and folklore became greatly enriched; Indian mathematical and astronomical ideas influenced Chinese literature; Indian influence on architecture became apparent. But it would be wrong to assume that the newcomers were exclusively from India.

The Indian, Sogdian, and Turkestan monks were readily allowed to settle by the alien rulers of China, who had no national prejudice against other aliens. The monks were educated men, and brought much useful knowledge from abroad. Such educated men were needed at the courts of the alien rulers, and Buddhists were therefore engaged. "These foreign Buddhists had all the important Buddhist writings translated into Chinese, and so made use of their influence at court for religious propaganda. Big translation bureaux were set up for the preparation of these translations, in which many copyists simultaneously took down from dictation a translation made by a 'master' with the aid of a few native helpers" (Eberhard).

Two famous translators of Buddhist texts from Sanskrit into Chinese were Kumārajīva and Fa-hsien. Kumārajīva (second half of the fourth century A.D.), the son of an Indian and a Kucha princess, as a prisoner was taken to Ch'ang-an, where "working

with a large corps of assistants, he translated ninety-eight works (in 421 or 425 rolls), of which fifty-two (in 302 facsimiles) have survived in the current Tripitaka, or Buddhist canon". Fa-hsien, a Chinese from the province of Shan-si, of the late fourth and early fifth century, went to Pataliputra, where he collected and copied the sacred texts of the various schools. On his return to China in 414 he reached Ch'ang-an with his books, and there and in Nanking he worked on the translations and on his memoirs, in which he described the various places he visited.

TAOISM *versus* BUDDHISM

It was inevitable that these two movements, which in their antagonism to Confucianism had much in common, should enrich each other, but Buddhism, "which was the richer, was the greater giver" (Goodrich). The slavishness with which the devotees of Taoism aped not only the ideas but also the phraseology of their Buddhist rivals may be seen, for instance, in the fact that "the Taoist canon falls into three main divisions called 'Grottos' or 'Profundities', corresponding to the three Buddhist Pitakas, but the familiar Eight Immortals have been replaced by Nine" (Giles).

The controversies between Taoism and Buddhism started in the third century A.D. The popular belief that Lao-Tzŭ after having left China went to the West and became the Buddha, induced a third-century Buddhist to write *The Record of Central Asia*, maintaining that Lao-Tzŭ went to Kashmir and paid homage to a statue of Buddha. About 300 this book was re-written by a Taoist, under the title *The Conversion of the Barbarians*, and it was asserted that Lao-Tzŭ went to India where he became the teacher of the Buddha; to which the Buddhists replied that the latter preceded Lao-Tzŭ by more than two centuries. "And so this quarrel continued and widened, finally becoming so fierce that *The Conversion* was repeatedly proscribed, even as late as 1281" (Goodrich).

The imperial decree of 843, prohibiting alien religions, was applied to Buddhism, though by that time it was a Chinese religion, but it was not applied to Taoism, because the ruling aristocracy was then Confucianist and at the same time Taoist. A census of all the Buddhist clergy and their property showed that there were approximately 4,600 temples, 40,000 shrines, and 260,500 monks and nuns. All the properties were confiscated and all the books were burned; the monks and nuns were secularized. But Buddhism was not destroyed. The imperial decree contained a clause "that one Buddhist temple

should be left intact in every prefectural city", and some temples were rebuilt almost immediately after 845.

However, generally speaking, thinking Chinese culled from Buddhism and from Taoism what they wished to accept and what Confucianism had never provided—the doctrine of the universality of all existence and other alien ideas—and discarded everything else. Thus the so-called Neo-Confucianism arose, which took its form in the eleventh and twelfth centuries. By then, China's civilization probably outdistanced that of the rest of the world.

Fig. IX–2

(*Left*) Earliest example of a Chinese dated colophon (Vinaya text, *Prātimoksa* by Sarvāstivādin, dated 10.1.406); (*right*) printed and hand-coloured Chinese prayer-sheet dated 947; it gives the name (Lei Yen-mei) of the first known printer (or rather blockmaker). Both documents were found at the "Caves of the Thousand Buddhas" and are preserved in the British Museum.

BOOK PRODUCTION IN EARLY CHINA

(Fig. IX–1–4, and 5, *a–b*, also Fig. IX–9)

The literary output of the ancient Chinese has always been on a big scale, whether it was on wood or bamboo, thin fibres of wood and grass, silk or other textiles, in early times, or, in later periods, on paper. The literature of the Han dynasty, for instance, covers practically every branch, including poetry, history, lexicography, religious literature. Indeed, the first national bibliography was prepared at the end of the first century B.C. "by a corps of specialists in medicine, military science, philosophy, poetry, divination, and astronomy"; "it lists some 677 works written both on wooden tablets and on silk" (Goodrich). Thus the wholesale destruction of books by the emperor Shih Huang-ti of the Ch'in Dynasty, and the execution of some 460 *literati* in order to eliminate all who dared to criticize his politics, may have produced a reaction (which became one of the main causes of the revival of learning under the Han Dynasty) in order to restore the great loss. On the other hand, many modern scholars hold that this wholesale destruction and the execution are more or less legendary; at any rate, the preparation of the national bibliography may show "that fewer books had been lost in the strife at the end of the Ch'in Dynasty than was generally believed" (Goodrich).

Apparently the collection in the imperial library was completely destroyed by fire in A.D. 23 and later; but fortunately other collections were preserved, as may be shown by the fact that several thousand fragments of manuscripts on wood, and a complete volume of seventy-five tablets bound with the original thongs, have recently been recovered from the refuse heaps near the ancient watch towers of central Asia. See also p. 398 ff.

An "important event occurred in 281 (A.D.) when the tomb of a prince or some other person of rank who died nearly six centuries earlier was opened. Over 100,000 bamboo tablets covered with writing were discovered. Fifteen different works and fragments of other writings were said to have been found in the tomb, among them a copy of the *Canon of Changes*, the *Romance of Mu, Son of Heaven*, and the official chronicle of the state of Liang or Wei that ended in 299 B.C., the state of Chin, and the royal houses from legendary times on." "An entirely unexpected result was the fact that the sorting and cataloguing of these bamboo tablets led to a classification system that has been used by Chinese librarians ever since" (Goodrich).

The slips buried in this tomb in 296 B.C. were described as being bound together with silk cords, each slip holding forty characters written with ink. The shorter slips of the Han period are known to have held from seventeen to twenty-five characters. According to modern research the Classics appear to have been written on slips measuring two feet four inches in length, "probably equivalent to three feet by the Chou foot-measure". Similarly were the laws, which were often called *san-ch'ih fa*, or "laws on slips three feet long".

MAIN BRANCHES

Chinese literature is traditionally divided either into seven or into four branches. The latter division is better known, and it has been adopted for the *Ssŭ-k'u ch'üan-shu*, which is the most important Chinese collection. The four divisions are: *ching*, which includes the Confucian Classics and their commentaries, as well as works on philology, etymology, and phonology (also including works on rhymes); *shih*, comprising works on history, geography, politics and law, as well as catalogues and lists of contents of books; *tzu*, to which branch belong the philosophical works (excluding the Classics and commentaries belonging to *ching*) and books on astronomy, calendars, mathematics, medicine, divination, calligraphy, painting, religion, essays, and miscellanea; also foreign books on science, learning, and art; *chi*, poetry and prose, including critical works, important collections of more famous *literati* and scholars. Until the end of the Ch'ing Dynasty, dramas, novels and short stories were not considered as "books"; afterwards, dramas were sometimes included in the *chih* group, and novels (together with essays) in the *tzu* group; nowadays, dramas, novels and short stories are dealt with in a kind of appendix to the *chi* group. Natural sciences are hardly represented; indeed, it must be emphasized that by far the greatest part of Chinese literature has always been of humanistic nature.

According to Prof. W. Simon, three aspects deserve to be specially mentioned in Chinese book production, namely, encyclopaedias, dictionaries, and the reprint series, the last of which is beyond the scope of this book.

Encyclopaedias

In A.D. 220, when Ts'ao Ts'ao's son was about to inaugurate his rule over North China, he ordered his ministers to compile an imperial survey which would aid him in carving out an empire as

great as the Han. Although earlier rulers, such as the First Emperor, had endeavoured to encompass all the existing knowledge them selves, the son of Ts'ao Ts'ao realized the impossibility of doing this himself. Thus the first general compendium, or summary of each subject, came into existence; it had many successors for both imperial and private use. The survey made for the Wei prince has long since been lost, but was said to run to over 8,000,000 words.

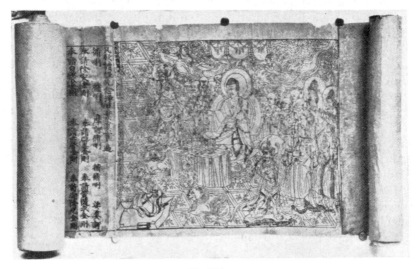

Fig. IX-3

(*Above*) The earliest preserved printing: Japanese Buddhist charms belonging to *c*. A.D. 770, in the Sanskrit language and in Chinese characters; (*below*) the earliest preserved printed book: the *Diamond Sutra* in Chinese, of A.D. 868 (British Museum).

Under the T'angs two Encylopaedias were compiled, "largely
to aid students in the civil examinations; these works must have had
great influence on the knowledge and writing of the educated youth
of the day". Their "subject matter ranged from government policy
to crafts and medicine". Another encyclopaedia, the *T'ung Tien*,
completed in 801 by Tu Yu, "is a similar work of even greater
magnitude" (Goodrich). Extremely important work in this field was
done in the tenth to thirteenth centuries. Li Fang (925–96) and his
editorial board produced two encyclopaedias, the *T'ai-p'ing yü lan*,
containing 1,000 chapters, and the *T'ai-p'ing kuang chi*, containing
500 chapters, both dealing with matters of general knowledge and
literature.

Yüeh Shih (930–1007) edited a geography of the Eastern
world in 200 chapters, under the title *T'ai-p'ing huan yü chi*. Chêng
Ch'iao (1104–62) wrote a kind of encyclopaedia, *T'ung chih*, contain-
ing monographs on archaeology, philology, phonetics and libraries,
politics, family and clan, flowers and insects. This work was brought
up to 1254 by Ma Tuan-lin (c. 1275), in *Wên hsien t'ung k'ao*, con-
taining 348 chapters. But by far the most important encyclopaedia,
according to P. van der Loon, is the *Yü Hai*, which was compiled in
200 *chüan*, or "scrolls", by Wang Ying-lin (1223–96), who was the
most learned scholar of the Sung period. Like most of the other
encyclopaedias, the *Yü Hai* contains quotations from the Classics,
histories, philosophers, *belles-lettres*, biographies, and other useful
material. The main purpose of this encyclopaedia was to supply
material, which would assist candidates for the high degree of
po hsüeh hung t'zǔ (a kind of doctorate).

Another encyclopaedia of the thirteenth century was *Fo tsu
t'ung chi*, published in 1269–71. In the same century, Ch'ên Ching-i
compiled a botanical encyclopaedia.

The most famous encyclopaedia is undoubtedly the *Yung-lo
ta-tien* (1403–7), consisting of 11,095 volumes containing 22,877
chapters (exclusive of the table of contents), which was compiled
by 2,180 scholars. It was "a universal compendium of all existing
Chinese history, ethics, science . . . in a word, of all human know-
ledge among the Chinese up to A.D. 1400" (Swingle). Finally, among
the illustrated encyclopaedias there are at least three which are
considered as outstanding. These are the *San ts'ai t'u hui*, published
c. 1609 by Wang Ch'i and Wang Ssǔ-i, and containing 106 chapters;
the *Wu pei chih* by Mao Yüan-i, 1628, containing 240 chapters; and
T'ien kung k'ai wu, by Sung Ying-hsing, 1637, of eighteen
chapters. All three contain woodcuts.

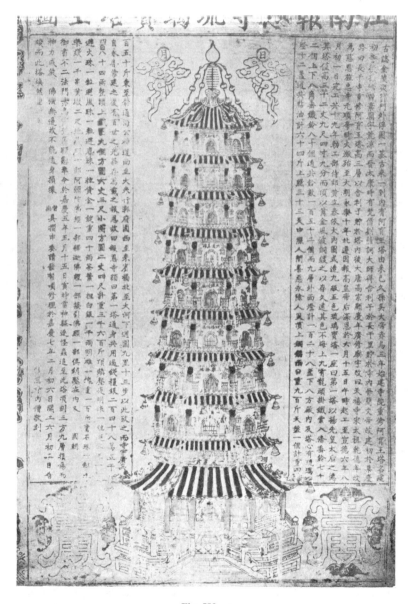

Fig. IX—4

Page from a Chinese book (The John Rylands Library, Manchester, *Chin. No. 465*).

Dictionaries and Lexicography

Goodrich mentions a tentative beginning of lexicography in the *Literary Expositor* by an unknown author of about 200 B.C., but the first true lexicon was Hsü Shên's *Shuo wên* (or *Shuo wên chieh tzŭ*, "An explanation of Ancient Figures and an Analysis of Compound Characters"), of A.D. *c.* 100. It was mainly concerned with the written forms of characters—giving an explanation of 9,353 symbols, and of 1,163 which have a double use—but its author who travelled to many parts of China, indicated also the sounds given to the words in the different regions. Various lexicographical works were published in the second, the third, the sixth, and the eleventh centuries, for instance, the important work *Shih-ming*, published in the third century.

One of the first Chinese philologists who dealt with "spelling" of Chinese characters was Shên Yüeh (A.D. 441–513), but no works of his have come down to us. Fragments of two dictionaries, published in 543 and 609, have survived, and both of them contain also "spelling". Three famous Buddhist scholars must be mentioned: Hsün-tsang, who translated Buddhist texts from Sanskrit into Chinese, devised a new method for transcribing Sanskrit (A.D. *c.* 650). I-ching compiled or edited a Sanskrit-Chinese lexicon of about 1,000 words (late seventh century). Li-yen, from Kucha (eighth century), compiled a Chinese-Sanskrit lexicon of about 1,200 words. He also translated a Sanskrit work on medicine and medicinal plants.

In the thirteenth century two important dictionaries were compiled, one of them containing an analysis of 53,525 characters, "or more than are included in the last standard dictionary compiled in 1716" (Goodrich). In a lexicon of the fourteenth century the Chinese main characters were reduced to 360.

Ch'ên Ti (*c.* 1541–1617) is considered as the founder of the science of philology in China. His work represents "a systematic application of the inductive method and a use of the very terminology we associate with that method in the west" (Hummel).

Mei Ying-tso published in 1615 a dictionary, *Tzŭ-hui*, containing 33,179 characters, and for the first time reducing all Chinese characters to 214 categories. This number has been used since both by Chinese and foreign (Japanese and Korean) lexicographers. Mei's re-arrangement of the radicals and characters on the basis of the number of strokes of each one has been generally accepted.

Finally, the vocabularies compiled in the years 1382, 1549,

c. 1620, and 1630, are still preserved. "They indicate that a few scholars at court had some knowledge, albeit scanty, of the languages of Korea, Japan, Persia, Turkey, Champa, Siam, Malaysia, Annam, the Lew Chew Islands, Mongolia, and Tibet, and of Uigur and Jurchen" (Goodrich).

BOOK PRODUCTION OF THE TENTH CENTURY

The first half of the tenth century A.D. was a period of political instability in China; it was the period of the five minor Dynasties between the two great Dynasties of the T'angs and the Sungs, but it was notwithstanding a period of great literary activity. Book production, including printing, and the formation of libraries were actively carried out through the country, and gave great impetus to writing of all kinds of books. Two facts of this period must be mentioned as having great importance for the history of books in China: the beginning of official printing under the direction of the government, a kind of His Majesty's Stationery Office, attributed to Wu Chao-li, and the printing of the monumental work of the Confucian Canon, in 130 volumes, commentaries included; this was done during the years 932–53, and was due mainly to the initiative of Fêng Ying-wang or Fêng Tao, traditionally considered (however wrongly) as the inventor of printing.

COLLECTING, COLLATING AND COPYING BOOKS

Analogously to the Alexandrian scholars of the third and second century B.C. (see p. 155)—roughly at the same time or slightly later, there were in China scholars who were fruitful in separating authentic from spurious writings, in the revision of texts of, and commentaries upon, the earlier Chinese works, and in useful collation of the best texts from the enormous mass of literature, which had come down to them. The present writer has it on the authority of his friend and colleague P. van der Loon—who has prepared for publication an important article on the transmission and collation of the works of Kuan-tzŭ—that apparently the first organization for collecting and copying books had been set up by Wu-ti in or shortly after 124 B.C. Van der Loon quotes *Ch'i lüeh*, by Liu Hsin (who died A.D. 23): "Emperor Wu instructed the Chancellor Kung-sun Hung to provide ample facilities for presenting books to the Throne. During the following century books piled up like mountains. Outside the Palace there were the storehouses of the Minister for Public Worship, the Grand Clerks, and the Gentlemen of Wide

Learning, and inside were depositories in the long galleries, the spacious rooms, and the private apartments."

Kung-sun was Chancellor from 11.12.125 to 7.4.124 B.C., and—following the imperial edict of July, 124—he presented a memorial with detailed proposals for the appointment of Disciples to the Gentlemen of Wide Learning. In that edict the Emperor had also expressed his concern for books, so we may assume that the two matters were closely connected. "In 26 B.C.—writes van der Loon—it was decided to send out an emissary to collect books from all over the Empire. At the same time, Liu Hsiang was engaged in a thorough survey of all the material. He collated the bundles of bamboo slips and scrolls of silk, which had come from many different places, and therefore contained a large number of duplicates. In this task, he was assisted by several scholars", such as the experts in military science (Jên Hung), in cosmology and divination (Yin Hsien), and in medical arts (Li Chuo-kuo), and other scholars (Fu Ts'an, Pan Yu, and others), as well as by his son, Liu Hsin.

Liu Hsiang did not confine himself to the Palace library, but also made use of other official and private collections. "Consequently he could in many cases avail himself of several versions of the same texts." "Often he found separate bundles of written slips which had a common origin or alleged authorship, but which had been handed down independently. . . . Each time he had finished collating a work, Liu Hsiang sent a memorial of official presentation to the Emperor. In these memorials a table of contents was followed by a description of the material from which the collators had compiled their text. Then came a short biography of the author, and an outline of the historical background, and finally a discussion of the authenticity, transmission and value of the work."

Following is an extract from the memorial on Kuan-tzŭ as quoted by van der Loon: "The Commissioner of the Eastern [Metropolitan Area] Conservancy and Imperial Counsellor First Class, Your servant [Liu] Hsiang speaking. 'The books by Master Kuan, which Your servant has collated, consisted of 389 bundles in the Palace, 27 bundles belonging to the Imperial Counsellor Second Class, Pu Kuei, 41 bundles belonging to Your servant Fu Ts'an, 11 bundles belonging to the Colonel of the Bowmen Guards, Li, and 96 bundles in the office of the Grand Clerks, making a total of 564 bundles of books inside and outside the Palace. In collating them, he has eliminated 484 duplicate bundles, and made 86 bundles the standard text. This he has written on bamboo slips to form a basis for exact copies.' . . ."

See, now, P. van der Loon, *On the Transmission of Kuan-tzŭ*, "T'OUNG PAO", XLI (1952), 4–5, pp. 357–393.

EARLY CHINESE WRITING MATERIALS

The date of the invention or creation of Chinese writing and its early history are unknown. See p. 66 ff. We may assume that it was already in existence in the early second millennium B.C., though the earliest inscriptions (Fig. I–14), on bones discovered in 1899 near An-yang in northern Honan, belong to the fourteenth and the thirteenth centuries B.C. These are, at any rate, much more recent than the earliest available Sumerian documents (middle fourth millennium B.C.) or the Egyptian ones (*c.* 3000 B.C.)—see pp. 54 and 58 ff.

On the other hand, "most of the things used by these people [*i.e.* Chinese], which might have come down to us as evidence of their culture, were very perishable. . . . Their books were written on tablets of wood or bamboo. In the wet climate of China such materials decay quickly" (Creel). According to the American scholar, A. W. Hummel, the philosopher Wang Ch'ung (A.D. *c.* 82) wrote: "Bamboo is cut into cylinders which are split into tablets. When brush and ink mark are added we have writing—the Classics being inscribed on long tablets, the historical records on shorter ones."

WOOD AND SILK AS WRITING MATERIALS

The earliest preserved manuscripts of Chinese books are written on thinly cut slips of wood. Together with hundreds of official or quasi-official communications and records (such as administrative orders, reports and account statements), all written on wood, various manuscripts were found in 1907 by Sir Aurel Stein, at the ruined stations—chiefly among their refuse heaps—of the western-most portion of the Chinese frontier wall which had been constructed by the great Emperor Wu-ti (second century B.C.): Fig. IX–5, *a*.

Stein's discoveries have thrown much light upon the employment of writing materials in China before the invention of paper (A.D. *c.* 105). It has long been known that silk was used in early times in China as writing material. Amongst Stein's discoveries are two letters on silk, one long and well preserved, "which were found sewn up into a small bag for holding some medicine or condiment— luckily with the surface turned inside". The well-preserved letter is 58 mm. wide, after folding, which would be of the right size for insertion into an envelope, such as the small silk envelope, also found

by Stein, which was used for a private letter (as its address shows), and is 65 mm. wide inside.

Silk, as a material for books, is mentioned by a number of writers of the fourth or the fifth century B.C., frequently with the implication that it was used much earlier. For instance, "Mo Ti states that the ancients handed down their counsels not only on metal and stone but also on 'bamboo and silk'. Similar references to silk may be found in the writing known as *Kuan-tzŭ* and *Han Fei-tzŭ*." Silk was of course much more costly than wood, and its use was much less general. But it had many advantages, and continued to be used for painting, "even though as a book it went out of existence soon after the manufacture of paper". Indeed, at first paper was looked upon as an inexpensive substitute for silk, and was given the name *chih*, which had long been used to denote a silk scroll. It is not surprising, therefore—writes Hummel—to hear of a scholar named Ts'ui Yüan, who died thirty-seven years after paper was first made, writing to a friend: "I send you the works of the Philosopher Hsü in ten scrolls—unable to afford a copy on silk, I am obliged to send you one on paper."

However, the communications and records written on wooden tablets form the vast majority of the documents recovered, and in their material and shape they agree very closely with the Chinese records on wood discovered by Stein in 1901 at Niya ("an ancient settlement of the Tarim Basin abandoned to the desert sands in the 3rd century A.D.").

These office records consist of inscribed narrow slips of wood—Fig. IX-5, *a*—from 9 to 9½ inches in length ("roughly corresponding to the Chinese foot of the Han period"), and from a ¼ to ½ inch in width. They may be inscribed on both sides, but ordinarily contain only one column of writing on either. Owing to the traditional tenacity of Chinese convention, the "slip" form of the ancient wooden writing material appears to be reflected in the arrangement of the pink coloured letter paper which ordinarily served for private correspondence in pre-Revolution China, *i.e.* until 1919. "The height of the vertical ruled lines on it and the distance between them correspond exactly to the average length and width of those ancient slips, each being meant to hold a single column of *tzŭ*" (Stein).

Moreover, the words *ch'ih-tu*, which the Chinese still use to denote letter-writing or correspondence, mean literally a "one-foot tablet"; and the phrase *i-ch'ih chih shu*, "a one-foot writing", means "brief note" (Hummel).

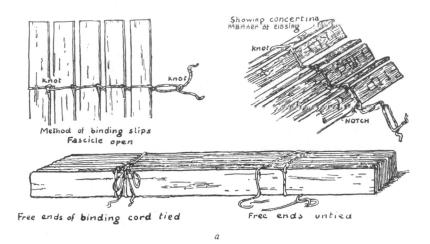

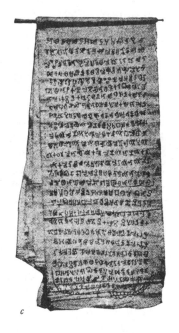

Fig. IX–5

a, Reconstruction of a Chinese book written on slips of wood; *b*, *Mahāaprajñā-paramitasūtra*, Ch. 110. Printed at Fêng-hua, A.D. 1162 (University Library, Cambridge); *c*, Lo-lo book written in horizontal script.

The narrow form of the "slips" is due to the fact that originally the slips were mainly made of bamboo sticks, but the great majority of the inscribed wooden slips discovered by Stein are not of bamboo —"a fact easily accounted for by the great distance separating that westernmost border of China Proper from the bamboo-growing regions of the Empire"; they are made from local varieties of trees, such as the cultivated poplar or the wild poplar, or the tamarisk. There are also tablets made of some conifer, including specimens containing more than one vertical line of characters on either or both faces, though otherwise these tablets conform in length and in character of contents to the narrow slips.

An interesting category of wooden slips, measuring up to fourteen inches in length, are numerous fragments of calendars. The French sinologist É. Chavannes has succeeded in restoring complete calendars for the years 63, 59 and 39 B.C. and A.D. 94 and 153.

Apart from the narrow slip called *ts' ê*, or *chien*, there were many other forms of wooden stationery for which the names are known, but which cannot be described with certainty. Two forms, however, are better known; there was the rectangular tablet, called *fang*, which could hold up to a hundred characters, and was mainly used for imperial edicts or government reports; and there was the triangular, prismatic form, known as *ku*, which in Hummel's opinion seems to have served as a kind of horn book for elementary instruction.

Wooden slips were used by both the Mongols and the Manchus, before their conquest of China, to record events and to convey orders. They had the size and shape of Chinese slips of Han times, but had "perforations at the ends to string them together, as was customary in Central Asia. Though the general use of such slips was abolished by decree in 1645 they served for transmitting official orders within the Palaces till the close of the dynasty" (Hummel).

Books on Wooden Slips (Fig. IX–5, *a*)

The oldest known manuscripts extant of a Chinese book are relatively numerous fragments of a famous lexicographical text, the *Chi chiu chang*, which was composed in 48–33 B.C., and played an important part in the primary education of China during the Later Han period (A.D. 25–220). Some of the discovered specimens seem to be "copy slips", *i.e.* the text appears to have been copied out as a writing exercise.

Amongst Stein's finds are also a few extracts from treatises on

divination and astrology; a fragment containing a passage from a treatise composed in 229 B.C. (it was apparently known as *Li-mu*) and dealing with military affairs; a fragmentary slip quoting the title of *Lieh nü chuan* (the "Biographies of Eminent Women"), a book composed in 32-7 B.C.; a brief extract and a few fragments from medical treatises; a curious multiplication table; and three slips containing fragments of vocabularies as yet unidentified.

The importance of Stein's discoveries lies also in the fact that they explain in a visible manner the reason why Chinese characters are arranged in vertical columns to be read from top to bottom. Indeed, the writing columns of any Chinese book present themselves like a series of narrow wooden slips.

It is known, however, that at first the direction of the lines of writing was not fixed, though generally the lines seem to have run vertically. Subsequently the vertical direction became exclusive, and this still continues. It "has affected the writing of the Uigur, Mongol and Manchu peoples, who in other respects have adopted the alphabetical script of the Mediterranean peoples" (Goodrich). See also *The Alphabet, passim.* Hummel asks: Did the narrow slip of bamboo or wood suggest a vertical rather than a horizontal column, and did the predominantly downward strokes of the brush suggest a movement from right to left? He states, "We may never really know why the Chinese preferred, from ancient times, to write in vertical columns from right to left. . . ."

While some scholars hold the opinion that the vertical direction was adopted in imitation of the funeral slabs set up at the graves of dead ancestors, it is more probable that it was due to the influence of the bamboo slips, on which most of the writing was done in ancient China and in the other Far Eastern countries. Indeed, it was long believed that a very early Chinese book consisted of a number of bamboo slips, the ordinary method of writing being to scratch with a sharp instrument, or stilus, the bamboo being held in the left hand, pointing directly away from the body. At a later stage, scratching with a stilus was supposed to have been replaced by writing in ink with a brush (see below).

Chavannes, Hummel and others have rejected this theory. According to Hummel, the old belief that in early times characters were engraved by means of a metal stilus is probably an error due to a misinterpretation of the term *shuo-tao*, or "book-knife", which frequently occurs in references to wooden documents. "More careful reading makes it clear that the knife was used not to en-

grave characters but to make erasures." Ink, whether derived from some colouring matter or from resin, as it is today, may well have been employed from the time that wooden slips were first used. On the other hand, early Chinese sources refer to the use of lead in writing, and the *ch'ien-pi*, or "lead pencil", was used "for making notes as early as the 2nd century, and probably earlier" (Hummel).

Stein's discoveries have enabled scholars to solve the problem of how proper cohesion and sequence could be assured for the numerous slips over which texts of any size written on bamboo or wood must necessarily have extended. Chavannes observed that a number of slips bore one or more notches on one of the edges, and he suggested that these notches were intended to serve the purpose of uniting the slips in groups. For instance, in one set, each slip has two notches on the right edge, one above and one below, and a third notch placed in the middle of the left edge: they all belong to a medical notebook; another set of slips of wood, forming part of a calendar for 59 B.C., shows two notches uniformly placed on the right edge of each slip; in a set of slips, belonging to a calendar of A.D. 63, we find the left edge of each provided with three notches at exactly uniform distances. *See* Fig. IX–5, *a*.

Moreover, Stein has remarked that no text is to be found on the reverse of any of the notched slips belonging to sets (notwithstanding the inconvenience which the bulk and weight of such books must have caused); he has, therefore, suggested that the fastening, for which the notches were undoubtedly intended, must have been arranged in a way that brought the blank reverses of consecutive slips back to back and thus made it inconvenient—indeed, if they were rigidly attached, it would be impossible—to use the reverse surface for inscribing or reading any portions of the text.

CHINESE PAPER BOOKS (for their forms see Fig. IX–9)

Similar methods were employed in the Chinese and Tibetan paper manuscripts, discovered in the "Caves of the Thousand Buddhas" of Tun-huang (see pp. 413–15). These manuscripts consist of long sheets of paper made up of several joint pieces and folded up concertina-wise into narrow pages; the reverse surface is always left blank: see below. Moreover, even in Chinese printed books—which actually were an adaptation to block printing of the concertina method, we find regularly the reverse surface left blank.

THE FOLDED BOOK

An important book discovered in the Caves, and now in the British Museum, is a Buddhist sutra, or collection of aphorisms, dated A.D. 949. It is a book folded concertina-wise, sometimes called *orihon* (which is still common in China and Japan). This kind of book is printed (or written) on one side of a roll—indeed, because of the fineness of the texture of the paper only one side can be written or printed on—and it is then folded up concertina-wise across the margin, into separate "pages". The blank backs of the "pages" are pasted together or are so hidden that their existence is frequently not realized, the final result resembling to a surprising degree the form of the modern book. But if some of the leaves are cut, the real structure of the book becomes evident, and it is then seen to consist of printed pages and blank pages alternately.

In some instances two pages are written, or printed, upon one leaf, which is then folded, and the leaves are sewn up in the open part, while the closed side composes the outer margin; the blank half of the leaf being thus joined, the written—or printed—part only is visible, which from the thinness of the paper appears as if on opposite sides of a single leaf. These leaves are then slightly stitched together in fascicles, of the size of modern magazines, which are then bound together so that a book may consist of four, six, or more fascicles.

The accordion method was introduced sometime in the T'ang period (A.D. 618–907); the change (from the scrolls) merely involved folding the scroll at measured intervals into accordion pleats like some railroad time-tables. "Such a book, when unfolded, was still in fact a scroll, but when folded it formed a rectangle which could be protected on two sides with covers, and had the appearance of the book we know." The advantages of the folded book, in comparison with the scroll, were in a certain way similar to those of the Western codex (see pp. 161 ff. and 193 f.). Indeed, most important of all, "the folded book eliminated the task of unrolling and made possible a book which could be consulted at any point with facility" (Hummel).

It is, however, doubtful whether Hummel is right in his dating of the introduction of the folded book. Is it not possible that—analogously to the roll form and the codex in the Western world—the two forms of the scroll and the folded book were used side by side for many centuries? It has already been mentioned, and Hummel has also pointed out "that this folded book was called *ts'ê* . . . is

worth noting, for that was the name of the ancient wooden-slip book which presumably could also be folded into pleated, rectangular sections". Priests in the monasteries found "the pleated book convenient in chanting the sutras, and it came to be the form required in the official examinations and for state documents where an uninterrupted text was wanted" (cf. the Western codex). Finally, as Hummel mentions, "it is also a form still favoured for albums of calligraphy and painting".

The change of the Chinese book, from the concertina method to the paged book with folded leaves, will be dealt with in the volume on *The Printed Book*. Here it may be mentioned that the Chinese paged book, "such as has been common in the last five centuries", "is still essentially an accordion-pleated book, but with the leaves fastened down at the right-hand side" (Hummel).

CHINESE SCROLLS (Fig. IX–9, *top, right-hand side*)

The concertina method was not the only and not the main system of the early Chinese books. It has long been known that both the Chinese and the Japanese (as well as other Asiatic peoples) anciently used the roll form of book, especially for all allegorical pictures, the ends of the rolls being fastened in much the same manner as were the Gracco-Roman books (see Chapter VI). The discovery of the numerous scrolls in the Caves of the Thousand Buddhas (see further on, pp. 413–15), has shown that the scroll was the main form of the book from the fifth century A.D. to 1035—to which period the scrolls of the Caves belong. These scrolls are up to 30 or 40 feet long, and 9 to 14 inches wide. The scrolls are made up of sheets 18 or 19 inches long, *i.e.* 2 feet by the Han foot-measure. This seems to have been for centuries the standard length of the sheet that was used to make the scroll, and is already referred to by Hsün Hsü (third century A.D.). Hummel has pointed out that these sheets were ruled off into *pien-chun*, or "side-lines", *i.e.* columns about the width of the olden wooden slip, and probably in imitation of it. "In Buddhist sutras it was common to write seventeen characters in each column."

The Chinese scroll may have looked externally like a papyrus book roll (see p. 129 ff.); similarly its inner end was wrapped round a wooden roller, metaphorically called *chou* (after the axle of a cart). "In imperial collections these rollers had knobs of sandalwood, lacquer, tortoise-shell, glass or ivory—variously coloured to differentiate the class of literature to which a work belonged, and to

obviate useless unrolling" (Hummel). Such a procedure was unknown in the Western world.

In the course of time the scroll form was discontinued for books, but it still continues to be employed for specimens of calligraphy, as well as for maps and especially for painting.

"Binding" of Chinese Wooden Books

The method of "binding" of ancient Chinese wooden books is suggested by F. H. Andrews: "Each 'slip', *i.e.* small lath of wood (belonging to a series which contained one text or connected record), being a folio, it is clear that some means of binding must have been employed to maintain the folios in correct collation. The small notches observed on the edges of the 'slips', and the fact that these exactly range when a number of 'slips' are collated, indicate that the connecting binding must have been of the nature of a string, an inference strengthened by the references in Chinese texts to silk or leather cords uniting the fascicles of wooden or bamboo slips." Having experimented with a fine raw silk thread, Andrews has suggested that the Chinese "binding" of wooden books may have been done with the method shown in Fig. IX–5, *a*.

This suggestion has been verified by an extremely important find made by F. Bergmann of Sven Hedin's Central Asian expedition. A wooden-slip book was recovered, consisting of some seventy-eight wooden slips, all in the original order, and tied together by hemp threads near the top and the bottom, as the ancient pictograph *ts'ê* shows. "Each slip is 9 inches long and about ½ inch wide—the total length of the book being about 4 feet. The text, written between the years A.D. 94 and 96, is an inventory of the weapons stored at the military outpost where it was found" (Hummel).

Butterfly-method Books (Fig. IX–9, *top, left-hand side*)

Hu-tieh chuang, or "butterfly format" owes its term to the fact that "when such a book is opened the corresponding ends of a (written or) printed sheet extend out from the spine like the wings of a butterfly". This form of book was used until about the fourteenth century A.D.

"Binding" of Folded and "Butterfly" Books (Fig. IX–9)

The cover is not glued to the leaves: it is a case wrapped round them, in some parts double, and secured by a fastening of silk and

bone. This case or cover is sometimes formed of a brown stiff pasteboard, made of a species of smooth and strong paper. For common books, in addition to the case, a cover of fancy paper is used, while for more important books silk is employed, or a species of taffeta with flowers, which is only used for this purpose. More expensive books are covered with red brocade, ornamented with flowers of gold and silver. The title, written or printed on a slip of paper, is generally pasted upon a corner of the cover.

The book "was placed vertically on the shelf, and in every respect resembled a Western book—except that every other page was blank. To overcome this handicap tabs were often placed at the fore-edge, precisely as in some Western books, or as in a card-index" (Hummel).

WRAPPERS FOR SCROLLS (Fig. IX–9, *top, right-hand side*)

In a similar, but not identical, manner to the Graeco-Roman roll, the more valuable Chinese scrolls had their opening ends protected, as Chinese paintings still are, by the *piao*, which was an extension of silk gauze or brocade, and a ribbon with an ivory clasp. "The scrolls comprising one work were arranged in pyramids of five or ten, and were encased in a wrapper, *chih*, made of brocade or bamboo screening. To make a pyramid complete, ten scrolls were needed, and this was usually the number of the scrolls contained in a wrapper. Such a wrapper, dated A.D. 742, is preserved in Japan, others were found in the Caves of the Thousand Buddhas" (Hummel). The ancient Chinese cataloguers, in describing books, recorded not only the number of scrolls, but also the number of wrappers.

THE WRITING-BRUSH AND THE DEVELOPMENT OF WRITING

The invention of the *pi*, the writing-brush or pencil, made of hair, was undoubtedly due to the increased popularity of the Chinese literary hand as well as to the use of silk as a writing material. According to Fan Yeh's history of the Later Han Dynasty (fifth century of the Christian Era), "In ancient times writing was generally on bamboo or on pieces of silk, which were then called *chih*, but silk being expensive and bamboo heavy, these two materials were not convenient." The invention of the writing-brush is tradition-ally attributed to Mêng T'ien, a reputed builder of the Great Wall who died about 210 B.C., but it is likely to have preceded him. It may be assumed, however, that the *pi* was invented or already

existed under the Ch'in Dynasty (221–207 B.C.). "Writing imple-
ments were improved by superior brushes and better ink and the
wider use of silk in rolls." Indeed, "silk, both plain and embroidered
with grotesque animals and symbolic Chinese characters, was made
not only for domestic consumption but also for foreign trade"
(Goodrich).

About twenty years ago, F. Bergmann (see p. 406) discovered
a complete and well-preserved writing-brush, 9 inches long; it
probably belongs to the period about the beginning of the Christian
Era.

In addition to the *ta chuan*, or "Great Seal" characters, already
in existence, about 220 B.C. the *hsiao chuan*, or "Small Seal" char-
acters are said to have been introduced by Li Ssŭ and two other
ministers of the first Ch'in emperor, whereas its more cursive form,
called *li shu* "was adopted to facilitate the drafting of documents
relating to the multitude of prisoners at that time" (W. P. Yetts).
This *li shu*, or "Official Script", which is the prototype of the
various Chinese scripts employed for nearly two thousand years
till the present day, is the earliest Chinese literary or book hand.
While tradition attributes its invention to Ch'êng Miao, its origin
"is more likely the result of the development of the script employed
for administrative purposes of the centralized government" (Yetts)
of that time.

The writing-brush naturally influenced the formal evolution of
the script; thus, in the *li shu* curves became straight or nearly so, and
the likeness of the signs to the original pictorial ideographs in most
cases disappeared. The fluid used for writing was generally a dark
varnish. A further development of the external forms of the signs
came with the invention of paper in A.D. 105.

BOOK DECORATION AND PAINTING

Not much can be said about early Chinese book illustration,
because of the scanty remains. Also the remains of actual paintings
are not too plentiful. It may, however, be argued that at least in the
third century (A.D.) there existed Chinese books containing paintings.
It should be borne in mind that the Chinese art of calligraphy—
which, also being done with brush, was an associated art of painting
—lent itself very much to painting and drawing.

In the second to fourth centuries there were famous Chinese
calligraphers, such as So Ching (239–303), the lady Wei Shuo
(272–349), and especially Wang Hsi-chih (321–79), who was "light

as floating cloud, vigorous as a startled dragon" (L. Giles), his style being compared by Sun Kuo (who lived under the Han Dynasty) with "flocks of queen-swans floating on their stately wings, or a frantic stampede rushing off at terrific speed" (quoted from L. C. Goodrich). "Wang broke with the past and he and his son, Wang Hsien-chih (344–88), set the fashion that has lasted a millennium and a half" (Goodrich).

More directly connected with our subject is the work of a great master in painting, Ku K'ai-chih (c.344 – c.406). He was a civil servant, and had therefore the opportunity to depict scenes of court life. The British Museum possesses a copy (attributed to the T'ang period) of a roll by him called *Admonitions of the Instructress of the Palace*, containing nine scenes of court life. While the landscape is depicted in a rather primitive manner, "the figure drawing seems to belong to the close of a tradition rather than its beginning; and we may conjecture behind it the ruder, masculine style of Han gradually subtilized and transformed in the direction of elegance and charm" (L. Binyon).

Already in the fifth century A.D. there appeared a book (by Sun Ch'ang-chih) dealing with painters and painting, and the canons of painting were enunciated for the first time by Hsieh Ho (A.D. c. 500). Under the T'ang Dynasty painting was specially practised by Taoists and Buddhists. "Taoism, with its mystic other-worldly character and its love of nature"—writes Goodrich—"gave special inspiration to painters and poets"; but the greatest artist of this period was a Buddhist, Wu Tao-hsüan (second half of the eighth century), "whose over three hundred Buddhist frescoes and many drawings on silk (none of which survives) had a profound influence on the world of his time. One of the minor arts, printing textiles from wood blocks, also came into existence. The earliest example extant is a blue print dating from the ninth century and is in the British Museum" (Goodrich). However, the best Chinese paintings that are now extant come from the period of the Sung Dynasty (960–1279). The illustrated encyclopaedias have already been mentioned.

The main centres of production were the religious houses, where numerous books on silk rolls, and albums "modest in size but of transcendant beauty" were produced. "Both Buddhism, particularly the Ch'an meditative sect, and Taoism, with its love of nature and freedom, contributed to awakening in the artistic mind a love for solitude clothed in magnificent scenery." The pictures included land-scapes (which are unique in their kind), figures of people, saints and

"arhats", animals—real and imaginary—palaces and cottages, birds,
fishes, and insects, bamboos and flowers.

BLOCK PRINTING

The invention of paper naturally increased the output of books.
At a later period the Chinese discovered a way to repeat designs
from a block of wood, i.e. block printing. The practice was very
simple; the artist carved the designs and the characters in relief on
wood, so that these designs and characters appeared raised; then they
inked them and pressed a sheet of paper on the face of the block. This
procedure could be repeated as many times as copies were required.
Thus the essential feature of printing was produced.

How and when this printing was invented is not clear. The
practice of stamping pottery with seals appears in the ancient Near
East in the first millennium B.C., and the stamping of patterns on
silk as a trade mark may have been a very old Chinese practice. It
has been pointed out that the Chinese word for "printing" is *yin*,
which indicates also a "seal". The step from the "seal" as a trade
mark to the wood-block "printing" of charms on silk or paper is not
very far.

Wood-blocks, known as *xylographica*, containing descriptive texts
in addition to, or in substitution of, pictures, are commonly
considered to occupy a position between the single picture and
the book printed from movable types.

Wood-block "Books"

It is commonly believed that the art of taking impressions on
paper from wooden blocks was practised, at least, in the sixth
century A.D., but then it would seem to have been employed mainly
for religious pictures, tracts and charms. Later, however (in or before
the tenth century), the art of printing books from wood-blocks was
quite common; the Confucian Canon (see p. 396) was so printed in
the tenth century.

The earliest Chinese wood-block "book" extant belongs to
A.D. 868—Fig. IX-3, *below*, but there is no doubt that wood-block
printing was practised much earlier. This is shown, for instance,
by the Japanese records—Japan, in certain cultural respects is a
colony of China—attesting that the Empress Shōtoku (748–69)
ordered a "million" Buddhist charms to be printed and placed in
miniature pagodas: many of them have survived (Fig. IX-3, *above*).
The oldest print extant is a "poster" of 594 from Toyung near Tūrfān.

In the seventh and eighth centuries (under the T'ang Dynasty, which, as already indicated, was one of the greatest periods of Chinese civilization), literature and art approached their highest level; Li Po, one of the greatest poets of China, Han Yü, a Buddhist scholar and statesman, Po Chu-I, a poet and governor, and many others are venerated names in Chinese literature. Until A.D. 845, with few interruptions, Buddhism flourished in China (see p. 387 ff.), and no doubt numerous wood-block impressions were produced of little images of the Buddha and of passages from Buddhist writings, paper being the material chiefly used, but no specimens have survived. However, thousands of copies of analogous images have been recovered in Eastern Turkestan; one roll, now in the British Museum, contains nearly five hundred impressions from the same stamp.

"It can be imagined what a boon the invention of printing must have been to the Buddhist, seeing that it enabled him to accumulate merit on a vast scale with comparatively little trouble or expense" (Giles).

EARLIEST PRINTS AND PRINTERS

The wood-block printed book of A.D. 868—referred to on p. 410—is a Chinese version of the Buddhist *Vajracchedika*, or *Diamond Sūtra*, now in the British Museum (see Fig. IX-3). It is a roll $17\frac{1}{2}$ feet long and about 1 foot wide, made up of seven sheets of paper pasted end to end, six of them containing the text, the seventh shorter than the others, containing a fine woodcut as a frontispiece, representing Śākyamuni enthroned, surrounded by shaven monks and divinities, and addressing himself to an aged disciple, Subhūti.

The exact date of the print is given in the colophon. "Reverently made for universal free distribution by Wang Chieh on behalf of his parents on the 15th of the fourth moon of the ninth year of Hsien-t'ung" (corresponding to 11.5.868).

Be it emphasized, however, that "The first known printer, or rather block-cutter, is really one Lei Yen-mei, whose name appears as the "artificer" on a printed and hand-coloured prayer-sheet dated 947, showing Kuan Yin with lotus and vase" (Fig. IX-2). "Two years later . . . Lei Yen-mei is definitely accorded the title of Superintendent of Block-engraving" (Giles).

MOVABLE TYPES

Movable types of baked clay are said to have been invented

during the period of Ch'ing-li (A.D. 1041–9) by Pi Shêng; others invented movable types of tin, and some centuries later movable types were fashioned of wood (Wang Chêng, 1314), copper, and lead, though they never ousted block printing from favour, and most of China's great literary works have been produced by block printing.

Experiments with movable types almost certainly go back to the period of the beginning of printing in China. Indeed, according to Hummel, "the thought of printing with movable type must have entered the minds of craftsmen some two centuries" before Pi Shêng, "for on certain Buddhist scrolls taken from the Tun-huang caves, . . . there are rows of miniature figures of the Buddha which were not struck off from one large block, but from separate woodcuts wedged together, it would seem, in a frame, like characters in a chase".

Hummel mentions a few early Chinese works printed with movable characters: a literary collection, printed in 1057 from baked clay types, a work (*Ti-hsüeh*), printed in 1221, and another work (*Mao-shih*) printed about the same time; the history of the district of Ching-tê (in the province of Anhwei), printed in 1298 with a fount of 60,000 types. The Library of Congress (Washington) possesses the following works printed with movable type: the encyclopaedia *Chin-hsiu Wan-hua-ku ch'ien-hou hsü-chi*, printed in 1494, and the work *Jung-chai hsü-pi*, printed in 1495, two encyclopaedias of the sixteenth century (*I-wu hui-yüan*, 1536; and *T'ai-p'ing yü-lan*, 100 volumes, 1572), and others.

The main reason why printing with movable types could not succeed in China, whereas it could have in Korea or Japan (see pp. 419 ff., 425), lies in the Chinese script (see *The Alphabet, passim*); the main reason for the complexity of Chinese writing lies in the Chinese language. Indeed, thousands and thousands of separate characters would have been necessary; thus, printing from woodblocks was much less expensive and much more practical. As illustrating the dimensions of the problem, it will suffice to mention that the famous Chinese encyclopaedia, *T'u shu chi chêng*, consisting of 6,000 volumes, completed in 1726, involved the casting of 250,000 copper movable types for printing. How much simpler is the casting of modern types for alphabetic scripts!

The influence of Chinese art on Persian-Arabic book illumination will be dealt with in the book on *Illumination and Binding*.

NON-CHINESE PEOPLES OF CHINA

The scripts and books of non-Chinese peoples of China have been dealt with in *The Alphabet*, pp. 141–8, and pp. 184–5. See here Fig. IX–5, *c*, 7 and 8, reproducing specimens of books of some of these peoples.

CAVES OF THE THOUSAND BUDDHAS

Before leaving China, it may be worth describing briefly one of the most important, though less known, discoveries in the history of "the book". In Eastern Turkestan, not far from the border of the province of Kansu, on the ancient route of the silk trade between China and the West, there lies the Tun-huang oasis. The famous Ch'ien-fo-tung, or "Caves of the Thousand Buddhas"—repeatedly referred to in this chapter—are situated in a barren valley some nine miles to the south of the centre of Tun-huang.

Hundreds of cave-temples are here cut into the face of a cliff. Here was the home of a colony of religious cave dwellers, founded apparently by Buddhists in A.D. *c.* 366; the Buddhist priest Lo-tsun is said to have begun the construction of these caves—Mo-kao grottos, as they were then called; but the earliest examples preserved belong to the fifth century A.D.; there are, in fact, votive inscriptions from A.D. 450 to 1100; nothing, however, is known of the earliest caves.

Since about 1900 rumours were current of a chamber piled high with books in the form of rolls, hidden behind a brick wall in the rear of an early fresco which was being restored. These rumours induced Stein to visit the place. The circumstances of its discovery read like a fairy tale.

NUMEROUS PRECIOUS MANUSCRIPTS RECOVERED (Figs. IX–2–3)

"Heaped up in layers, but without any order, there appeared in the dim light of the priest's little lamp a solid mass of manuscript bundles rising to a height of nearly 10 feet, and filling, as subsequent measurements showed, close on 500 cubic feet." "The total hoard must have comprised something like 13,500 paper rolls, each about a foot in width and averaging 15 to 20 feet in length (many are much longer, and one in the British Museum actually measures over 90 feet), besides a very large number of fragments and some hundreds of booklets; also large bundles of paintings on silk and cotton. Most of the texts were in Chinese . . . though there were numerous

manuscripts in other languages, such as Sanskrit, Sogdian, Brahmi and Tibetan. . . . These manuscripts, covering a period of six hundred years, would appear to have been brought together for safety from various monasteries in the neighbourhood, and to have lain, hidden and forgotten, for just about nine hundred years more" (Giles).

A great part of this treasure was acquired by Stein for the British Museum, a part was bought by P. Pelliot for the National Library, at Paris, and nearly all the rest were removed to Peking. Indeed, some 8,000 scrolls are now preserved in the National Library of the Chinese capital. Some of the manuscripts are in Japan, and a few in private hands or in minor collections. Dr. Hu Shih has recently presented to the Library of Congress a Chinese manuscript, discovered in the Caves in 1900. This manuscript, a scroll 29 feet long and $10\frac{3}{4}$ inches wide, is still mounted on the original wooden lacquered roller. It is attributed to the sixth century A.D., and it comprises the first and second books of *Ta Pan Nieh P'an Ching*, which is the Chinese version of the Indian *Mahāparinirvāṇa sūtra*, translated by the Indian priest Dharmaraksa, in the years A.D. 414–21.

Dr. L. Giles, who has prepared a catalogue of the material preserved in the British Museum, points out that the manuscripts number 8,080, of which 6,794 are Buddhist, 258 Taoist, and 1,028 secular or non-religious, including Confucian classics, bilingual manuscripts (Brāhmi, Uighur, Tibetan, Sanskrit, Khotanese, Sogdian, Kök Turki), historical and topographical works, epics and poetry, didactic poems and fiction. In addition, there are two Manichaean rolls and twenty printed documents.

Some of the rolls are lavishly illustrated with coloured drawings. At the end of some of the texts there is a "tailpiece" or "colophon", which contains the name of the person who caused the copy to be made, "his pious intention in so doing, and in many cases an exact date" (Giles). The earliest date given is 10.1.406: Fig. IX–2, *left*. Dr. Giles points out that as many as 380 separate pieces are carefully dated: six belong to the fifth century A.D., forty-four to the sixth century, and 160 to the tenth. The different kinds of paper employed and the styles of handwriting help to assign nearly all the manuscripts to particular periods. Most precious is the book (*Ch.* stands for Ch'ien-fo-tung) *Ch. ciii, 0014*, discussed on p.411. It is the earliest preserved book in print: Fig. IX–3. It is now in the British Museum.

Extremely important material is also to be found in the *Collection Pelliot* of the National Library, at Paris. About half of the

manuscripts are in Chinese, and the rest in Tibetan, Sogdian, Uighur, Kuchean, and Khotanese languages. A great part of the Chinese manuscripts are Buddhist text, including some of special historical interest. There are also many Taoist rolls and other non-Buddhist religious texts such as Nestorian and Manichaean.

PAPER

"The paper of even the earliest rolls is of wonderfully good quality. The oldest of all was made from the inner bark of a species of mulberry (*Broussonetia papyrifera*), and is of a brownish buff colour, tough and rather thick. The surface and sizing are both good. Other varieties of paper in the fifth century were made from China-grass (ramie), or from that and mulberry bark mixed. One of them has a smooth, glossy surface of a very pale cream colour, and is also tough, though somewhat less thick. Characteristic of the sixth century is a thin crisp paper sometimes stained a rich golden-yellow. After the disastrous rebellion of An Lu-shan in the eighth century a rapid deterioration sets in, and thenceforward most of the papers are very coarse and flabby, drab in colour, and difficult to write on" (Giles.)

According to Hummel, the generally yellowish colour of these scrolls is due not to their age, but to the fact that they were impregnated with an insecticidal substance, called *huang-nieh* (taken from the Amoor Cork Tree or *Phellodendron amurense*), which had a toxic effect; by an edict of A.D. 674 its use was made compulsory, at least for certain types of documents.

See also pp. 345 f. and 362 ff.

BIBLIOGRAPHY

In addition to bibliography quoted in *The Alphabet*, pp. 118–19, see:

L. Giles, *An Alphabetical Index to the Chinese Encyclopaedia*, London, 1911.

S. Couling, *The Encyclopaedia Sinica*, London, 1917.

A. W. Hummel, *The Development of the Book in China*, in "JOURN. OF THE AMER. OR. SOC.", 1941; *Movable Type Printing in China*, in "THE LIBR. OF CONGR. QUART. JOURN., etc.", 1944, and other articles.

L. C. Goodrich, *A Short History of the Chinese People*, New York, 1943.

Nagasawa Kikuya, *Shina gakujutsu bungeishi*, transl. into German, *Geschichte d. chines. Liter.*, Peking, 1945.

W. Simon, *A Beginners' Chinese-English Dictionary*, London, 1947.

W. Eberhard, *A History of China*, London, 1950.

H. Maspero, *Les Religions chinoises*, Paris, 1950.

Têng Ssŭ-yü and K. Biggerstaff, *An Annotated Bibliography*, etc., Rev. ed., Cambridge (Mass.), 1950.

C. H. Philips, *Handbook of Oriental History*, London, 1951.

Korean Books

(For the form of Korean books see Fig. IX–9)

Korean speech is quite different from Chinese, but the Koreans were under Chinese cultural and political influence for many centuries (probably from the first century B.C. onwards), and therefore it is natural that they should have adopted the Chinese script and Chinese methods of writing books. Local tradition attributes the introduction of the Chinese characters into Korea to Wan-shin (third century A.D.). For many centuries the Koreans employed only Chinese characters, although their pronunciation was entirely different from that in China. Moreover, as one might expect, the present-day Korean language contains many words borrowed from Chinese, especially those employed in literary essays by the higher social classes.

Chinese influence, which was dimmed during the thirteenth and fourteenth centuries A.D., rose again with the overthrowing of the Mongolian Dynasty in China and the advent of a new dynastic system in Korea in 1392.

TRIUMPH OF CONFUCIANISM

Various reforms introduced in the late fourteenth century were based mainly on Chinese culture. Confucianism, replacing Buddhism (which had been introduced, it would seem, as early as A.D. 372), was established as the state religion. Bitter strife developed between the Confucianists and the Buddhists; in the end, after a violent reaction against the latter, especially in the early sixteenth century, Confucianism triumphed, at least amongst the upper classes, although Buddhism continued to keep some hold amongst the lower classes.

GOVERNMENT BOOK DEPARTMENT

Amongst the various reforms of 1392, we find record of the establishment of a central department of books, among whose responsibilities were "the casting of type and the printing of books". According to McMurtrie, "there are records that printing with movable types had been known in Korea as far back as the first half of the thirteenth century, and the activities at the close of the fourteenth century should perhaps be regarded as a revival of a method of printing which had fallen into disuse. In this revival, however, the types to be used were made of metal". Printing must have been introduced into Korea by the Buddhists, and the reform referred to must have been a sort of change-over from "private enterprise" to "nationalization".

MOVABLE COPPER TYPES

The Korean king Ta-jong (1401–19) was a great reformer and was the first to conceive and carry out the idea of movable copper types. In 1403, within a few months, several hundred thousand types were cast of bronze; this, be it noted, occurred forty-seven years before the first printing from movable types was known in Europe.

The interest shown by the Korean Government in the art of printing is best evidenced by the fact that, between 1403 and 1544, as many as eleven royal decrees were issued concerning the casting of new founts of type.

The following earliest Korean movable type prints are possessed by the Library of Congress: *Chin-ssŭ lü*, four volumes, printed in 1519; *Hsin-ching*, two volumes, printed from cast metal type in 1566, with a commentary (*Hsin-ching fa-hui*) printed in 1603. "Thereafter movable type prints were produced in Korea in great numbers, too many, in fact, to be listed here" (Hummel).

GOLDEN AGE OF KOREAN LITERATURE

That, indeed, was the Golden Age of Korea's literary production. Buddhist monks imported numerous Sanskrit and Tibetan Buddhist books, while Confucian *literati* imported large numbers of Chinese Confucian books. A great number of Korean books were written and printed, and some fifteenth-century *incunabula* have been preserved in Korean and Japanese monasteries. McMurtrie quotes an enthusiastic chronicler of 1422 as having written: "There will be

no book left unprinted, and no man who does not learn. Literature and religion will make daily progress, and the cause of morality must gain enormously. The T'ang and Han rulers, who considered the first duty of the sovereign to be finance and war, are not to be mentioned in the same day with the sovereign to whom this work is due."

There is poignancy in the situation reported 528 years later by a representative of Western civilization; he wrote: "One of the blessings of this war is the Korean education system. Not because it educates Koreans, but because its schools provide us with such excellent warm billets. I have never been so school conscious in my life as here.

"When you arrive, dusty, frozen, tired and hungry in some town at nightfall you do not look for the hotel, but the nearest school where you are sure to find someone, like my friend Corporal Eric Jackson, with a fire made of blackboards and school desks.

"Jackson used to drive a truck in Doncaster, but now he is an Army cook, and what he does not know about the combustible qualities of school furniture is nobody's business.

"Natural history must figure high in the Korean curriculum because every school is richly endowed with stuffed birds and mounted skeletons. These now provide us with much innocent light relief . . ." (B. Wickstead, *Daily Express*, 4.12.1950).

The Korean Alphabet

The invention of the Korean movable copper types increased still more the difficulties of using the cumbersome ideographic characters of Chinese origin. It is thus not surprising that under the new king Set-jong (1419-51) a new, simplified, Korean script, called *Ŏn-mun*, was devised, which became the only native alphabet of the Far East.

There was, indeed, an earlier attempt at an indigenous Korean script: a Korean scholar, Syŏl Chong (A.D. *c.* 680–90), invented a syllabary, called Nitok (*li-tu*, *ni-do*), of thirty-six signs, based on Chinese characters, perhaps owing something to Indian scripts; little, however, is known of this earlier development.

The Ŏn-mun, whose origin is still a matter of dispute (see *The Alphabet*, pp. 442-6), was for many centuries regarded with contempt by the higher social classes. May we thus assume that the new script was of Buddhist origin—hence, the contempt of the Confucian *literati*?

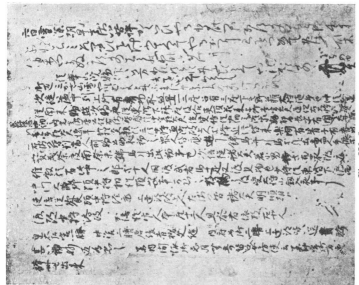

Fig. IX-6

(*Left*): The earliest extant work written by a Japanese: *Commentary* on a Buddhist *sūtra* written, in Chinese, by Shotoku Taishi (or Prince Shotoku), A.D. 573–622. The manuscript, now preserved in the library of the Imperial family of Japan, is regarded as the first draft of Prince Shotoku's *Commentary*; (*right*) earliest extant Japanese manuscript, of which both the date and the name of the writer are known: *Diary* by Fujiwara Michinaga (961–1095), written partly in pure Japanese, in *kana* script (in the illustration, on the right), and partly in Chinese characters, in pseudo Sino-Japanese style. The portion here reproduced gives the date 6.2.1004 A.D. according to the lunar calendar.

However, all official writing and books of instruction continued to be printed in Chinese characters; purely Korean literature was reserved for women and the "illiterate". Indeed, although types were actually cast for the Ön-mun alphabet, only one book printed from this type, in 1434, has been recorded.

Since the beginning of the twentieth century, the desire for a pure Chinese education has practically vanished, and Ön-mun has received much attention, especially after education had been completely re-organized. Nowadays (*i.e.* at least, before the 1950 war) it is generally used in schools, newspapers, popular literature and daily requirements.

PROBLEM OF INVENTION OF ALPHABETIC PRINTING

It is remarkable how close the Koreans came to the invention of printing with single-letter movable types, cast from matrices. They employed paper, they perfected printing from movable types, and they invented an alphabet: all these three things being the prime necessities of alphabetic printing.

The Korean wood-cuts, like the Chinese and the Japanese, were far better in drawing and execution than early European wood-cuts. Most of the blocks were made of soft wood (not box), and were cut with a short knife. The process was probably the same as that employed in Europe: the drawings were made on thin paper and stuck downwards on the blocks, then the knife was carefully run along the edges of the various lines, cutting outwards, the interlinear spaces being "grooved out" by a chisel and hammer. The wood-cuts were always in outline, thickened here and there.

Not only had the Koreans printing with copper movable types, but they developed a primitive type mould or method of casting types. "Their types were cast in sand, with wooden types used as dies in forming the sand matrix, as is recorded by Song Hyon, writing at the end of the fifteenth century" (McMurtrie).

What obstacles hindered the Koreans from developing the practice of printing with single-letter types? It may be surmised that the main obstacle arose from the difficulty inherent in Korean writing. If the Ön-mun alphabet were the only Korean script it is highly probable that the Koreans, of all the peoples in the world, would have been the true inventors of the modern art of printing. But, whether because of the opposition of the higher classes to Ön-mun, or because the Koreans were unable to get rid of the cumbersome Chinese characters, the fact is that the Koreans not

only stopped half-way, but—because printing from wood-blocks was cheaper and more practical for their Chinese script—they went back on their attempt to print with movable types.

According to the late Prof. Haloun, the importance of the Koreans should not be over-estimated, as they have never been original in any field of culture.

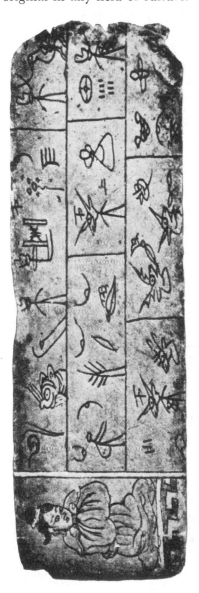

Fig. IX-7

Books of non-Chinese peoples of China, I. (*Above*) The first page of a Moso manuscript; (*below*) Lo-lo printed book, edited by Prince Len.

Japanese Books (Figs. IX 3, *above*, 6 and 9)

The beginnings of Chinese influence upon Japan lie in the same obscurity as the rest of early Japanese history. The earliest trade and cultural relations between China and the Japanese islands may be

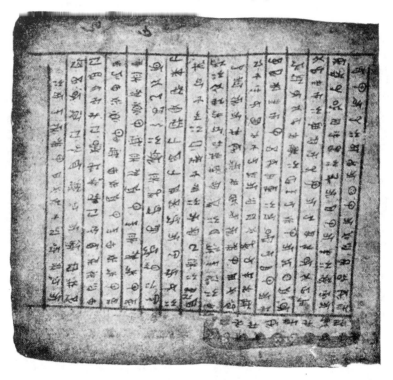

Fig. IX-8

Books of non-Chinese peoples of China, II. (*Above*) Lo-lo book in vertical script; (*below*) portion of a Chinese-Hsi-hsia glossary.

dated in the last centuries B.C., but the introduction of Chinese writing into Japan would seem to have taken place somewhere in the third or fourth century A.D. It was hardly employed actively before the fifth century, and it remained for some centuries a monopoly of circles of *literati*, many of whom were of Chinese or rather Korean origin.

CHINESE-KOREAN INFLUENCES

Indeed, most Chinese influences, according to the accepted tradition, reached Japan by way of Korea. According to tradition, too, in the third century A.D. Japan sent envoys to Korea in search of men of learning. They brought back one Onin or Wang Jên, who taught the Japanese Chinese writing, introduced them in the culture of his nation, and was later deified. Another tradition attributes the introduction of Chinese writing into Japan to two Korean scholars, Ajiki and Wani, the tutors of a Japanese crown prince of the fifth century A.D.

BUDDHIST INFLUENCES

The introduction of Buddhism, about the middle of the sixth century (A.D. 552, according to tradition), the direct and rather frequent contacts with China of the T'ang dynasty during the seventh to ninth centuries, and the steadily growing number of immigrant Chinese scholars and Buddhist monks, resulted both in the enormous increase of study of the Chinese language and script, and in the cultural development which characterizes the periods of Nara (710–83) and Hei.an, now Kyōto (794–1185). Art and literature flourished, and the necessity arose for the translation of Chinese works into Japanese, and for the adaptation of Chinese writing to the Japanese language. Buddhism took deep root, and one of the ways by which the devout Buddhist acquired merit was by the ceaseless repetition, orally or in writing, of passages from the Buddhist scriptures.

EARLIEST BOOKS OF JAPAN (Fig. IX–6)

The two earliest Japanese books are in the nature of ancient histories, the *Ko-ji-ki* ("Record of Ancient Matters"), of A.D. 712, and *Ni-hon-sho.ki* or *Ni-hon-gi* ("Chronicles of Japan"), A.D. 720. They show how difficult it is to write books in a non-literary lan-

guage, which has no script of its own. While the *Nihongi* is written entirely in Chinese—if we except a few passages (especially poems) transliterated phonetically by means of Chinese characters—in the *Kojiki* we find Chinese symbols (conventionally chosen) written with Chinese syntax, though the symbols are to be read with Japanese sounds.

The earliest Japanese purely literary work is the *Manyōshū*, or "Collection of the Myriad Leaves", an anthology of the ancient poems, published A.D. *c.* 760. For some centuries, most of the literature was published in Chinese, but certain diacritic signs were added (especially in Buddhist religious works), of which some

Fig. IX-9

Various forms of books in the Far East.

enabled the readers to change the syntax according to the requirements of the Japanese language, and others suggested the addition of grammatical terminations and other complements.

It is possible that the beginning of Japanese printing and of the employment of paper in Japan was contemporary with the earliest Japanese literary activity. It is known that in Europe the art of printing with movable metal types was preceded by the printing of single pictures from wood-blocks. There—as has been indicated on

p. 410—we have already the essential feature of printing: the wood-block is inked and thus allows of the taking of a great number of impressions.

PRINTING FROM WOOD-BLOCKS

The "million" Buddhist charms ordered by the Japanese Empress Shōtoku to be printed from wood-blocks on paper (see p. 410) are not only the oldest extant specimens made in Japan, but are also the earliest known specimens of printing.

On the whole, however, neither the literary activity nor the book production of Japan were original; bearing in mind the strong Chinese influence already noted, they may be considered as a simple reflection of the cultural achievement of China under the T'ang dynasty. It is, indeed, not unlikely that the practice of printing from wood-cuts on paper, of which we have Japanese evidence for A.D. 769, goes back to a practice established much earlier in China.

Interestingly enough, printing with movable types was not very fashionable in Japan. According to McMurtrie, "The first book printed in Japan with movable types was dated 1596, but this method of printing came to an abrupt end in 1629."

In point of fact, printing from wood-blocks was, on the whole, much more practical and less expensive, for, as may be imagined, separate types for the tens of thousands of Japanese, i.e. Chinese, ideograms meant far greater expenditure of time and labour in the work of composition. Printing from movable types, indeed, is in certain respect even more complicated in the case of Japanese than of Chinese: see *The Alphabet*, pp. 169–74, where also the various Japanese scripts are dealt with.

Pre-Columbian Central America and Mexico

The book production of the pre-Columbian American peoples will not be discussed at length, as it is not connected with the history of our modern book. On the other hand, a history of the Hand-produced Book must mention these independent achievements of civilization.

MAYA BOOKS (Figs. II–8, *a–c*, and IX–10–12)

The dates of the preserved Maya manuscripts are still uncertain; they seem to belong to the later Maya period, preceding by a few

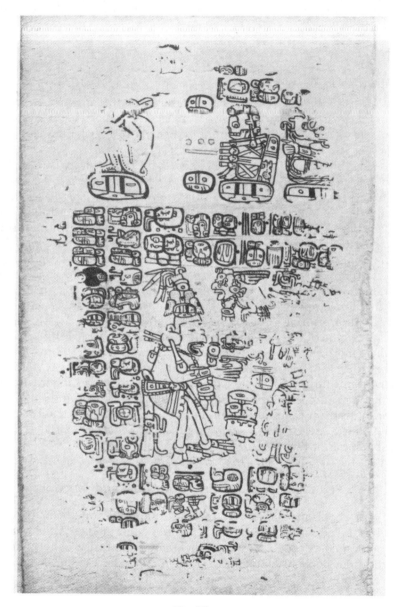

Fig. IX–10

Codex Paris (infra red photo of p. 4, the best preserved page of the manuscript).
Represents events connected with the Maya *katun* (twenty-year period) 11 *Ahau*.
(Explanation by J. Eric S. Thompson.)

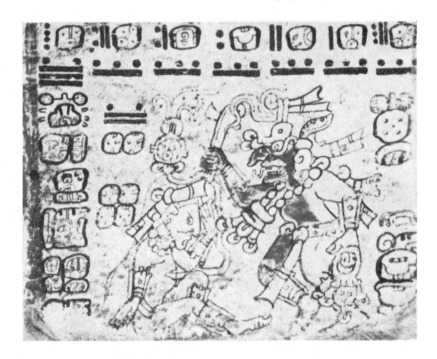

Fig. IX–11

Codex Dresden. (*Above*) Portion of divinatory almanac (4 *Ahau*, 12 *Lamat*, 7 *Cib*, 2 *Kan*, 10 *Eb*, 5 *Ahau*, 13 *Lamat*, South, God B, fire god, maize god, drought); (*below*) complete divinatory almanac with the four world directional colours: red, white, black, and yellow, and glyphs of various offerings to be made to the gods. (Explanation by J. Eric S. Thompson.)

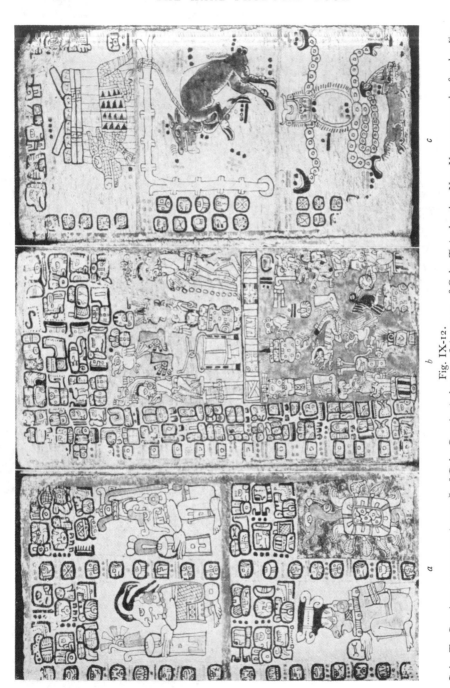

Fig. IX-12.

Codex Tro-Cortesiano. a, page 72 (page 38 of *Codex Cortesiano*). *b*, page 36 (page 21 of *Codex Tro*), showing New Year ceremonies for the *Ken* years, and including the unusual feature of a man walking on stilts and also a man sowing; *c*, page 48 (page 9 of *Codex Tro*), showing an *armadillo* in a dead-fall trap and a deer caught in a noose trap, and also the scorpion god. Each picture illustrates a divinatory almanac, pre-

centuries the European conquest, whereas the *stelae* (see Chapter II) seem to belong to an earlier period (perhaps, the first half of the first millennium A.D.).

According to Diego de Landa—to whom we owe not only the destruction of Maya manuscripts, but also what we know of Maya civilization, including part of our limited knowledge of Maya writing—the Mayas of Yucatan had a High Priest whom they called Ahkin May, or Ahaucan May, meaning the Priest May, or High Priest May. He provided books for the priests of the towns; they in turn not only attended to the service of the temples, but also taught sciences and writing books on these sciences, which were the reckoning of the years, months and days; the festivals and ceremonies; the administration of their sacraments; the omens of the days; their methods of divination and prophecies; historical events and antiquities; remedies for sicknesses; as well as the art of reading and writing by characters and by pictures illustrating these writings. "Some of the principal lords," wrote Landa, "were learned in these sciences, from interest, and for the greater esteem they enjoyed thereby; yet, they did not make use of them in public."

It must be assumed, therefore, that the priesthood had stores of books, or libraries, containing the history and the accumulated learning of the race. J. E. S. Thompson has pointed out that according to Spanish (and hispanicized Maya) writers, the Maya manuscripts dealt with historical records, lives of outstanding people, prophecies or divination, information on the planets, songs in metre, ceremonies, the order of sacrifices to their gods, and their calendars. "We can be reasonably sure that, like the peoples of central Mexico, the Maya had also hieroglyphic documents covering distribution and ownership of land, tribute lists, dynasties and mythology" (Thompson). However, the three surviving manuscripts seem to deal mainly with calendar and astronomical matters, as well as with ritual, ceremonies, and divination.

The books were painted in various colours: blue, dark blue, bluish green, violet, red, light and dark yellow, brown, pink, black, and intermediate shades. The manuscripts were written on sheets of deerskin, or, more often, on a single long strip of "paper", made from the fibre, or the roots, or the inner bark of the wild fig tree, which in ancient Mexico was called *amatl*, the same term also being applied to the "paper" and the books. Similar paper is still produced by some natives of Mexico: see Fig. IX–13.

Amatl gave the Spanish word *amate*, and some Spanish writers called also the Maya books (and glyphs) *analte*(*h*), or *amales* or

Fig. IX-13

Indigenous "paper" in modern Mexico. (*Above*) Its manufacture in San Pablito (Sierra Norte de Puebla, Mexico); (*right*) a sheet of *xalámatl* "paper," and a bundle of twelve sheets as sold on the market of San Pablito.

anares. "The Yucatec word for 'paper' or a book is *huun,* and 'to read', or rather 'to count a book' is *xochun*" (Thompson).

While the height of the sheet varied between $8\frac{3}{4}$ inches and nearly 1 foot, its length—as we have already seen—measured as much as nearly 20 feet, in the case of the *Codex Madrid,* and $12\frac{1}{2}$ feet in the case of the *Dresden Codex.* According to Landa, the Mayas wrote their books on a long sheet which was folded and then enclosed between two boards finely ornamented. Indeed, the preserved codices show that the book was folded concertina-wise to produce "pages" or "leaves", about $3\frac{3}{4}$ to $5\frac{1}{4}$ inches wide. The paper, according to Landa, was made from the roots of a tree, it was given a white finish and was excellent for writing upon. The Maya codices extant show that Landa's description is correct. Indeed, the smooth white surface was covered with a fine lime sizing.

The writing, with some exception, was on both sides of the sheet. The text runs from left to right through the whole length of the *recto* (the pagination being a modern procedure for convenience of reference), and is followed by the *verso,* with its text to be read from left to right, also through the whole length, thus, the *verso* of the first "page" or fold, is the last "page" or fold of the codex.

According to a leading Americanist, W. Gates, when the Maya writer set out to produce a manuscript, he measured off the desired width of the folds or pages, and made the actual folds. Next he outlined each separate page with red lines. The contents of "the book" were divided into chapters. By far the greater part of these chapters were arranged in a succession of *tzolkins* (the *tzolkin* being the count of 260 days), used as a ritual divinatory book of days. The *tzolkins* were divided into four, five or ten equal parts, of sixty-five, fifty-two, twenty-six days; the fifty-two-day division being commonest. Each of the *tzolkin* subdivisions (*e.g.* of fifty-two days) was again irregularly subdivided into minor sections, each headed by a black and a red numeral, the former being the counter of the passing days, the red the numeral of the day reached.

The "pages" of the chapters were subdivided into two, three or four horizontal bands, marked by red lines. The widths of these bands were adjusted to the requirement of the subject dealt with. The writer, then, did not think in terms of "pages", as we do, but wrote straight across these horizontal divisions, to the end of the section or chapter, and then back to the next lower horizontal band; at times, even a glyph, or figure, is half on one "page", half on the next. The ruling, breaking of text, consecutive march of pictures, and the glyph successions, enable us to reconstruct the text as a

continuous strip and as a consecutive whole. In the *Codex Paris* (see p. 436 f.), however, there are no *tzolkins*.

AZTEC BOOKS (Figs. II-8, *d*, and IX-14-17)

The "Aztec" books, like the Maya ones, were written on coarse cloth made from the fibre of the *agave americana* or on a long sheet of *amatl* paper of an average width of 6 or 7 inches, but of different lengths. As in the Maya manuscripts, the sheet was folded up concertina fashion to form leaves. The surface of the sheet was covered with a very thin coating of white varnish to receive the text, which was generally painted on both sides in a wide range of colours (red, yellow, blue, green, purple, brown, orange, black and white; some of them in more than one shade). The colours were outlined in black, but they were crude, and the pictures were without artistic merit. They were obviously merely utilitarian.

The sheet was fastened to what may be called the binding of the codex, which was of fine, thin wood, covered with brilliant varnish. Each cover measured nearly the same as the "leaves"; the binding had no back. One pre-conquest manuscript is bound with covers of wood with jade inlay.

Destruction of pre-Columbian Books

As a result of Christian intolerance, very few documents written by American pre-Columbian natives have survived. Diego de Landa (1524–79), the second bishop of Yucatan, who seems to have been responsible for the wholesale destruction of Maya manuscripts, and other worthy ecclesiastical authorities who were much concerned with "the salvation of souls", which could not have been achieved with the existence of the "devilish" picture-books, did their job thoroughly. The bishop himself wrote, "we found a great number of books . . . and since they contained nothing but superstitions and falsehoods of the devil, we burned them all, which they took most grievously, and which gave them great pain".

Maya manuscripts were, indeed, considered and "quite rightly, to be an integral part of the old Maya paganism. . . . From sixteenth-century Spanish writers we learn that sometimes codices were buried with Maya priests. . . . Some were probably destroyed by the Maya themselves because their existence endangered the souls of their owners if these were Christians; their bodies, if at heart they remained heathens. Others must have fallen victims to neglect and to the ravages of time" (Thompson).

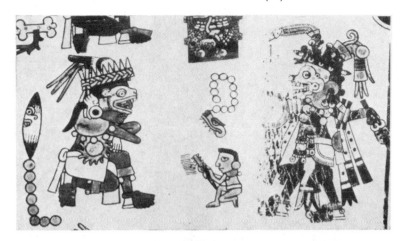

a

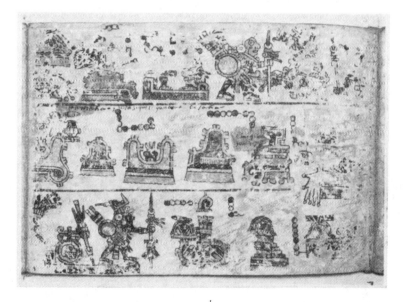

b

Fig. IX–14

a, Portion of *Codex Zouche* (*Nuttall*) (British Museum); *b*, page of the pre-Columbian
Codex Colombino (National Anthropological Museum, Mexico).

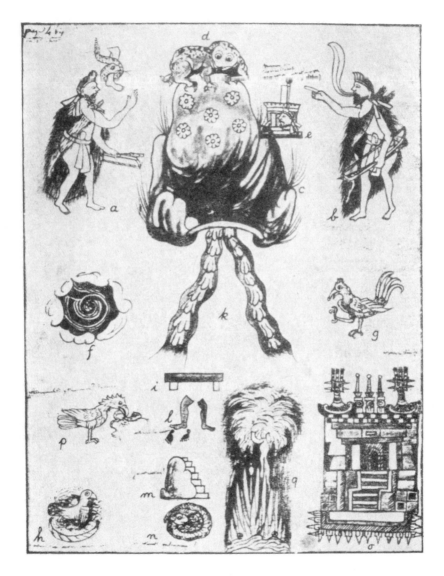

Fig. IX–15

Page from the Mexican manuscript *Historia Tolteca-Chichimeca*, showing the arrival of the Toltecs at Tlachiualtepec: Icxicouatl, *a*, and Quetzalteueyeac, *b*, at Tlachiualtepec, *c*, the seat of Aquiach-Amapane, *e*.

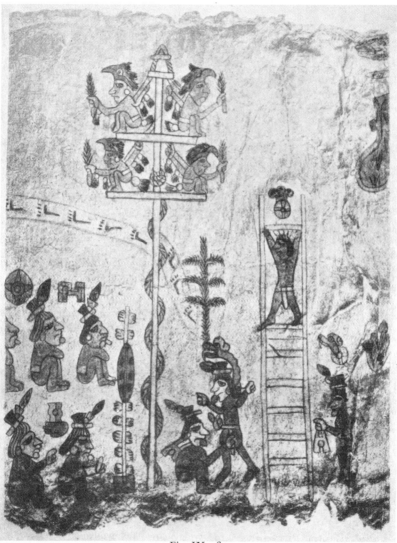

Fig. IX-16

Post-Conquest *Codex Fernandez Leal* (National Anthropological Museum, Mexico), shows a *volador;* the frame on which the fliers sit—owing to ignorance of perspective—is shown vertical instead of horizontal. (Explanation by Dr. Bodil Christensen).

PRESERVED CODICES

MAYA CODICES (Figs. IX-10-12)

As a result of this work, although a large number of Maya manuscripts were in existence at the time of the Conquest, only three have survived—by accident—their preservation being due to fortunate circumstances. Thus, we have now the beautiful *Codex Dresden*, the *Codex Madrid* and the *Codex Paris*: they are so called from the collections in which they are preserved.

The first of them, which is the finest, is assigned to the twelfth century A.D., and is preserved in the State Library, at Dresden,

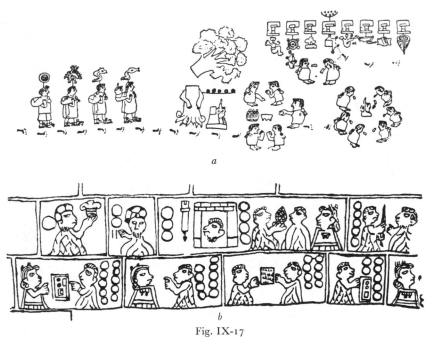

a

b

Fig. IX-17

a, Portion of *Codex Boturini*, showing the migrations of the Aztecs.
b, The Ten Commandments in an Aztec Catechism.

having been acquired in 1739 at Vienna, where it may have been sent by Emperor Charles V. It measures $12\frac{1}{2}$ feet by $3\frac{3}{4}$ inches, and is folded into thirty-nine "leaves", four of which are written and painted on the *recto* only. It contains divinatory, astronomical, mythological, and other matters. See also Fig. IX-11.

The *Codex Paris*, also known as *Codex Perez* or *Codex Peresianus* (Fig. IX-10), was "discovered" in 1859 in the now National Library,

at Paris. It is probably only a fragment, measuring about 4 feet 9 inches by 8¾ inches, and is folded into eleven "leaves", all written on both sides. It apparently contains divinatory, ceremonial, and ritual matter, and perhaps also historical records. In Thompson's opinion, it is of a slightly later date than the *Codex Dresden*.

The *Codex Madrid* (Fig. IX–12) is also known as *Codex Tro-Cortes* (in Spanish, *Códice Tro-Cortesiano*), because it was formerly divided into two parts; one of them, known as *Codex Tro*, in 1866 was found by the Abbé Brasseur de Bourbourg in the possession of the palaeographer Juan de Tro y Ortolano—by coincidence, a descendant of Hernando Cortés; the second part, known as *Codex Cortes*, was recovered in Spain in 1875, and was acquired by the Spanish Government. The Americanist Léon de Rosny recognized that the two parts belong together. The whole manuscript, now preserved in the American Museum, at Madrid, is nearly 20 feet long and about 8⁶⁄₇ inches wide. It is folded into fifty-six "leaves", and inscribed and painted on both sides. It appears to have served purely as a book of divination, and belongs to a much later period than the other two codices.

MEXICAN CODICES (Figs. IX–14–17)

With regard to the Mexican manuscripts, the situation is slightly better. Although masses of pre-Columbian manuscripts are known to have been burned by Spanish priests, about fifteen of the pre-conquest Mexican codices have survived; five are in England, four in Italy, two in France, one each in the U.S.A., Mexico and Austria. There are also a great number of Mexican Christian manuscripts written by Spanish priests or by natives under Spanish domination.

The "Aztec" manuscripts extant have been divided by some scholars into four groups: (1) Aztec proper; (2) Xicalanca (northern Oaxaca); (3) Mixtec (central Oaxaca); and (4) Zapotec, Cuicateco, Mazateco, Mixe and Chinanteco (Oaxaca and Chiapas). A clear distinction, however, cannot be made as yet.

The greater part of the codices extant is devoted to divinations, rituals and astrology; a few are concerned primarily with genealogies and the sequences of political events, being in fact a kind of history. The few pre-conquest codices extant were written mainly by the native priests, amongst whose duties was that of keeping records of ceremonies appropriate to the various religious festivals, of tributes

due to the king and to the temples, of legal trials, of historical events, and so on. The post-Conquest manuscripts deal with historical and religious matters, such as the Catholic catechism (Fig. IX–17, *b*).

BIBLIOGRAPHY

In addition to works quoted in *The Alphabet*, pp. 134–5, see J. E. S. Thompson, *Maya Hieroglyphic Writing*, Washington, D.C., 1950.

CHAPTER X

ANGLO-CELTIC CONTRIBUTIONS TO THE DEVELOPMENT OF THE MEDIEVAL BOOK

EARLIER chapters of the present book have been concerned with the Middle Ages and in this last chapter we may summarize the conditions prevailing in Europe during this period. It has already been emphasized that it is extremely difficult or impossible to determine the exact origin of certain important events. Historians have adopted conventional terms and dates on the assumption that the cultured laymen who employ them know that all ages overlap, and so do important events and their causes. For instance, the traditional division of history into Antiquity and Middle Ages (preceding the Modern Age) is of no significance for the history of medicine or science; "in mathematical astronomy ancient methods prevailed until Newton" (Neugebauer).

THE MIDDLE AGES

With this proviso we may generalize about certain conditions and events. In the Middle Ages, and especially in the "Dark Ages"— a term also applied on occasion to this period, but more particularly to its first half—the once civilized Graeco-Roman Europe was battered, first from the north and the north-east by barbarian Teutonic tribes, then from the south and the east by Arabs and other Moslems, then from the west and the north-west by Northmen. Thousands upon thousands of poor, tired human beings, who shared their food and lodgings with the animals of the fields, sometimes themselves occupying the stables, worked for the benefit of a few privileged ones, and lived and died without hope. No wonder superstition universally prevailed, and intolerance and fanaticism, under the fair names of religion and chivalry, produced more and more massacres or expulsions of Moslems and Jews. All too often the hope was plunder, a hope usually realized by the subsequent grabbing of the property of the "infidels" and "heretics".

439

At the same time the few cultured people, scattered here and there, were much more internationally minded—so to say—than are people today. They belonged to an international republic of culture which knew no national, linguistic, or political boundaries. Latin was the international language of culture and science. The Universities of Salerno, Bologna, Paris, Oxford, Salamanca, Padua, Prague, Cracow, and a few others were truly cosmopolitan. Great men, such as St. Augustine, St. Jerome, St. Patrick, St. Benedict, St. Columba, the Venerable Bede, Alcuin of York, Thomas Aquinas, Dante, Chaucer, Giotto, Petrarca, Boccaccio, Froissart, Thomas à Kempis, St. Dominic, St. Francis of Assisi, St. Isidore of Seville, St. Beatus de Liebana, made contributions of enduring value in the international fields of religion and theology, philosophy, literature and art, rather than in any particular national branch of culture.

BIBLE VERSIONS INTO "VULGAR" LANGUAGES

However, although the monks and clergy learned Latin, and although a knowledge of Latin was the most essential ingredient in an educated man's culture, it was never the language of the common people.

The Church was ever quick to realize that if the Bible came at all to the common man, it must come to him in the "vulgar" tongue, not in the learned language of the few cultured individuals. Some concern was even felt for the great mass of illiterates (this concern being one of the main causes of development of illumination— see the forthcoming book on *Illumination and Binding*). When Benedict Biscop—the Northumbrian monk who founded the monasteries of St. Peter at Wearmouth or Monkwearmouth (674) and of St. Paul at Jarrow (682), which soon became the most important seats of learning and book production in England—came back from his repeated visits to Rome, he brought with him a number of carefully selected paintings of educational value, "setting forth the Christian story in an understandable form, whether the beholder could read or no". Thus, for instance, "at Jarrow there was a set of types and antitypes in which scenes from the Old and the New Testament were juxtaposed, such as Isaac bearing the wood for his sacrifice and Christ carrying the cross" (Kendrick).

According to Bede (*Hist. Eccles.*, i, 30), Pope Gregory the Great outlined to Mellitus the following policy: "Keep the old temples, and turn them into churches after having destroyed the idols they contain. Keep the old festivals and allow the people to kill oxen as

usual, but dedicate the feast to the Holy Martyrs whose relics are in the church." Thanks to this happy compromise between the pagan customs and the new faith, there were few violent disturbances, few martyrs and persecutions. And because of this policy of compromise, almost from earliest times, there were churchmen and missionaries whose care it was to see that the common people—whether by reading it for themselves if they were able (which was seldom the case) or by hearing it read to them—should have at least the more important parts of the Bible accessible to them in their own language. At a later stage, the Church provided for the translation of the whole Bible into this "vulgar" language.

ENGLAND AND IRELAND

This fact concerns particularly the islands of Great Britain and Ireland. Indeed, these two great islands were the first western European countries in which books were written in the "native" language. The Germans followed suit (in the ninth and tenth centuries A.D.), whereas peoples speaking Romance languages (*i.e.* languages derived from Latin) — Italians, French, Provençals, Catalans, Castilians, and others—did not yet realize that Latin was to them a foreign language (this being considered as the literary language of their own speech): thus, their literature in "vulgar" language began a few centuries later.

The Irish "Book"

The most interesting European medieval books are the "early Irish Manuscripts, which stand at the head of a long and glorious line stretching chronologically from the seventh century of our era to the fifteenth" (G. Burford Rawlings). And the British expert on the medieval manuscripts, F. Madan, has pointed out, "that in the seventh century, when our earliest existing Irish manuscripts were written, we find not only a style of writing (or indeed two: see *The Alphabet*, p. 546) distinctive, national and of a high type of excellence, but also a school of illumination which, in the combined lines of mechanical acuracy and intricacy, in fertile invention of form and figure and of striking arrangements of colour, has never been surpassed. And this is in the seventh century—the nadir of the rest of Europe". See also the forthcoming book on *Illumination and Binding*.

How did it come about that in Ireland—a country so remote from the capital of Christianity and from all active cultural influences of the time—the first really great development in medieval book production took place, in the seventh and eighth centuries A.D.?

IRELAND BEFORE ST. PATRICK

Ireland occupies a unique place in the history of culture: it had never been invaded by the Romans, and its relations with the Latin world consisted in peaceful and friendly trade connections with the provinces of Gaul and Britain; and, what is even more important, it was the only land in western Europe that escaped the invasions and destructions of the Germanic tribes. Some scholars even maintained that in the fifth century A.D., during the Gothic and Frankish invasions of Gaul, many learned people fled from that country and found a place of refuge in Ireland. They brought with them not only Christianity, but also a certain devotion to the ancient literatures of Greece and Rome, and thus founded a new centre of learning.

While not many scholars accept this theory, Prof. MacNeill mentions evidence of the high degree of Christian learning that was displayed in Ireland possibly as early as St. Patrick's time. It is provided in a letter on the Paschal controversy written by the Irishman St. Columbanus or Columban within the years 595 to 600. Writing about the noted Aquitanian scholar Victorius, who flourished in the middle fifth century A.D., Columban adds: "Victorius was regarded with indulgence, not to say contempt, by our masters and by the ancient Irish philosophers."

However, the best authorities on Irish history maintain that already, before St. Patrick's mission to Ireland, there were in the island not only individual Christians, but also small Christian communities. This is also implied in St. Patrick's *Confessio* and in St. Prosper's *Chronicle*, under the year 431.

It has already been pointed out that while the vigour of Christianity in Italy, Gaul, and Spain was exhausted in a bare struggle for life against the northern barbarians, Ireland, which remained unscourged by invaders, drew from its conversion an energy such as it has never known since. The spread of Christianity was accompanied by a rapid progress in letters and arts. The scientific and Biblical knowledge which fled from the Continent took refuge in famous schools and made Durrow (in the province of Leinster) and Armagh, in some sense, universities of the West.

The vigour of the new Christian life was soon too strong to

brook confinement within the bounds of Ireland itself. Irish Christianity flung itself with a fiery zeal into the battle with the mass of Germanic heathenism which was rolling in upon the west European Christian world. Nearer home, Irish missionaries laboured among the Picts of the Highlands, and the Germanic Frisians of the northern seas.

St. Columba, after founding monastic houses in Ireland—at Derry on Lough Foyle, and at Durrow—founded soon after the middle of the sixth century the monastery of Iona (one of the islands of the Inner Hebrides off the coast of Mull, in Argyllshire, Scotland), from which he journeyed to Scotland and converted the Picts. It was Columba who brought the arts of writing and decorating manuscripts, from his native Ireland to Iona. Another Irish missionary, with a similar name, Columban (already referred to) founded monasteries in Burgundy, Italy and Switzerland. The monastery, town and canton of St. Gall still commemorate in their name another Irish missionary. For a time it seemed as if Celtic Christianity was to mould the destinies of the Roman Church.

BLENDING OF THE OLD CULTURE WITH CHRISTIAN CIVILIZATION

Although Ireland's conversion did not begin with the Apostle of Ireland, St. Patrick (389?–461), and although he did not live to complete it, the foundations which he established proved solid and lasting. Not only did he lead the mission which spread Christianity in Ireland, but in so doing he opened up that country to the wider cultural influences of the Christian world. And yet, professed paganism continued to exist in Ireland for at least a century after St. Patrick's death.

By that time (second half of the sixth century A.D.), a blending of the old native culture and the newly introduced Christian learning had taken place. Indeed, the Druidic tradition, not as yet completely dead, had surrounded learning with a certain supernatural halo. "The Druid, according to the most probable etymology of the word, was the 'very knowing one'; he was the adept, the knowledgeable man in all matters in which the life of this world came into contact with that of the other" (R. A. S. Macalister). The newly introduced religion therefore faced this dilemma: should it continue to cultivate a literature, the atmosphere of which was altogether pagan, or should it discountenance it, thereby putting itself into a position of educational and cultural inferiority to the pagan Druids?

Apparently Irish Church leaders found a temporary refuge in the "half way house", as we can see, for instance, from the fact that in privileges as well as in character the Irish saints enter into the druidic heritage. "With the acceptance of Christianity," write Gould and Fisher, "the saints simply occupied the shells left vacant by the druids who had disappeared." Even St. Columba, the founder of the great monasteries of Durrow and Iona, and of many smaller ones, the virtual founder of the Church of Scotland, the man who perhaps created the Irish script (see p. 470), "had not advanced very far out of the darkness which surrounded him, and . . . his own mind was shadowed by a very real belief in many of the superstitions of his age" (Duke). Thus, " 'conversion' was a mere transference of allegiance from one magic power (or group of powers) to another, believed to be more powerful" (Crawford). This blending of two traditions brought forth an almost new nation, with a character and an individuality that gave it distinction in that and subsequent ages.

Alexander Bertrand sought to trace a connection between the Irish monastic establishments and the preceding druidic colleges; the late Prof. R. A. S. Macalister, although affirming that there is nothing druidic in the institution of Christian monasticism *per se*, suggested that most, if not all, of the various monastic establishments scattered over Celtic Ireland, were situated in places which had already possessed sanctity of some sort in pre-Christian times.

It has already been mentioned that among the Irish and British Christians, scholars lived and worked in circumstances different from those of their Continental brethren. The latter employed Latin as their universal language, while in Ireland and Britain the vernaculars were the current speech: Latin was practically unknown in Ireland, and even in Romanized Britain was a sorry and ungrammatical veneer.

Ireland was a notable exception in early Christian Europe; "Irish kings already maintained literati (*filed*) amongst their followers, and thus were not dependent on the missionary priest for advice or knowledge in affairs other than spiritual" (Kenny). This opinion contrasts with the recent theory, propounded by eminent scholars, such as Clapham, Nordenfalk, and especially Masai, which considers the flourishing Irish culture of the eighth and ninth centuries as a derivation from Northumbria. According to Clapham, for instance, "We must . . . conclude that Hiberno-Saxon art was in origin in no sense Irish but that the Irish perhaps welded its component parts into one style; that this welding probably took

place in Northumbria in the second half of the 7th century, and that it was transmitted thence to Ireland and from Ireland over half Europe."

Masai, who has published an excellent work on this subject, is about to publish the *Introduction* to the archaeological edition of the *Regula Magistri* (manuscripts preserved in Paris, by some scholars assigned to A.D. *c.* 600, and containing the most important monastic legislation) which will appear as Vol. 2 of the "Publications of Scriptorium", and will be edited by Dom H. Vanderhoven. In Masai's opinion, the research on the Italian manuscripts of the late sixth century confirms the chronology already suggested by him. Miniature, or rather ornamented lettering (as well, indeed, as learning and culture), was transmitted by Italy to Gaul about the middle of the seventh century, and reached Great Britain (directly, not through Gaul) slightly later. While this theory would explain the *origin* of Northumbrian and Irish illumination (the latter being considered by Masai as derivative from the former), the perfection of this art—argues Masai—was mainly due to the transposition of the design from the art of jewellery to the art of decorating books. On the other hand, some leading authorities in this field, such as Geneviève Micheli and Françoise Henry, still hold the traditional view that the Irish of the sixth and the seventh centuries were masters of book hands and book illumination, and brought their arts to their missionary colonies in Northumbria and on the Continent. In Mlle Henry's opinion, the origins of Irish illumination go back to the early seventh century or even to the sixth century A.D. This book decoration is based on Irish art of the pagan period, though, as early as from the fifth century A.D. onwards, it was influenced by Christian Continental and, especially, Coptic art. The problem of origin of Insular book illumination will be dealt with in greater detail in the book on *Illumination and Binding*.

The poor view of Irish learning, culture and art in the sixth to eighth centuries—which is held by eminent scholars such as Esposito, Cappuyns, and Masai—is opposed by authorities such as MacNeill, who maintains that "the laws, the local histories and genealogies, the heroic legends, of the Irish Nation, were copiously recorded in writing within a period covering portions of the sixth, seventh and eighth centuries" (see also p. 448 f.). Even as recently as 1950, G. E. Powell has suggested that the range of the Irish native learning "reveals in its very existence and organization, an oral scholastic tradition which can only have sprung from ancient sources in the Celtic homelands". Furthermore, Powell accepts D. A. Binchy's

analysis—in "Proceedings of the British Academy", 1943—of the nature of the early Irish laws, their pre-Christian embodiment, and old Celtic origins.

Another authority, Bieler, remarks that "Bede himself admits (iii, 27) that in his time many Englishmen went to Ireland for 'sacred reading', thus implying that his Irish contemporaries had at least some reputation as theologians". Bieler also points out that Continental writers of the seventh and eighth centuries are quite positive about Irish learning, and that "it is unthinkable that the Irish script could have spread over so large areas had it not been for the intellectual superiority of those who brought it".

The leading palaeographer, E. A. Lowe, after having discussed the differences between Ireland and the Continent "in nearly everything that pertained to the art of producing a book"—manufacture of parchment, making of quires, ruling, punctuation, abbreviations, spelling, and so on—writes as follows. "If there are all these differences it is because, during the dark centuries which followed the break-up of the Roman empire, Ireland, undisturbed by war, was able to work out traditions of her own unaffected by the main currents of Latin civilization."

Incidentally, it may be noted that traditions—such as the tradition regarding the position of Irish culture and art in the sixth- and seventh-century Christian Europe—which go against the main stream (which would be, for instance, Rome - western Europe - England - Ireland) are more likely to be genuine than traditions which follow the general pattern.

Irish Civilization of the Seventh and Eighth Centuries

While according to some scholars the Irish civilization of the seventh and eighth centuries—as already pointed out—stands out clearly from what are called the Dark Ages, nevertheless, because of uncertainty with regard to dates, no scholar has been able to determine the actual scope of Irish learning. MacNeill indicated the importance of the preservation of Latin literature in manuscripts copied by Irish scribes, and of Latin authors quoted in ancient Irish books, as well as the singular knowledge of Greek possessed by Irish scholars and their disciples of other nationalities in the period of Charlemagne.

The Irish missionaries brought their writing not only to the Anglo-Saxons, but also to such main centres of European monastic culture, as Luxeuil, Echternach, St. Gall, Bobbio, where this script

was known as *littera scottica, litterae tunsae* or *scriptura saxonica*. The Irish system of abbreviations influenced the development of all the medieval abbreviations.

Luxeuil, in Burgundy, was the first great monastery founded by St. Columban in Gaul (*c.* 590). The monastery of Bobbio (now in the province of Pavia, Lombardy, Italy) was founded by St. Columban in 614; St. Gall was also founded by him in the early seventh century; Peronne, or Perrona Scottorum (founded over the tomb of St. Fursa), Corbie, St. Riquier, and some other French monasteries, were either Irish foundations, or had close relations with Ireland; some had Irish abbots; the later Benedictine monasteries of Fulda (in Hesse) and Reichenau (on an island on Lake Constance), which together with St. Gall were the main centres of Christian culture in Germany in the early Middle Ages, were also strongly influenced by the cultural activity of the Irish monks.

The influence of Irish book production on the culture of Britain and of the Continent was thus paramount, though, according to the theory of F. Masai and others, it was England—that is, Northumbria —which influenced Irish book production, and not *vice versa*.

CELTIC LANGUAGES

The Celtic branch of the Indo-European linguistic family is commonly divided into two sub-branches, the Q group (also known as Gadhelic or Gaelic) and the P group (or Cymric or Brittonic). Indeed, the main difference between the two sub-branches is the fact that in Q-Celtic the original Indo-European guttural combined with a *w*-sound (like *kw* or *qu*) remained for a certain period (in Oghamic inscriptions) *kw* or *qu*, and came gradually to be *c* with the sound *k*, whereas in P-Celtic it changed into *p* or *pw*. Q-Celtic includes Irish, Manx, and Gaelic of the Highlands of Scotland, while P-Celtic embraces Welsh, the extinct Cornish, and the Breton or Armorican in Brittany.

EARLY IRISH LITERATURE

The earliest extant documents written in Old Irish date from the eighth century A.D., and are mostly glosses and explanations of books used in Irish church schools. According to MacNeill, the oldest known piece (running to one page of print) is, or was until recently, in a copy of *Homilies* preserved in Cambrai, and is ascribed by him to the seventh century. In his opinion, however, a chronicle of the world, written in continuation of the chronicle of Eusebius,

Jerome, and Prosper, and embodying a skeleton of Irish history, was written in Ireland in the last years of the sixth century and in the first decade of the seventh. "What survives of it with relation to Ireland is the oldest known history of Ireland." However, the Cambrai fragment appears to have been composed between the years 763 and 790.

Some scholars consider the *Wuerzburg Codex* the earliest surviving manuscript containing Irish glosses. The codex is not earlier than A.D. 700, and may even belong to the ninth century.

Two Gaelic poems are in a codex at Milan; four quatrains are written on the margin of a copy of Priscian at St. Gall; there are a few lines in the *Codex Boernerianus* of Dresden; five short Gaelic poems or fragments are in a codex at St. Paul in Carinthia; and a few poems are in a manuscript at Klosterneuburg. Other manuscripts, containing Irish material, are preserved in Berne, Carlsruhe, Laon, Leyden, Nancy, Paris, the Vatican Library, St. Gall, Turin, and Vienna. They belong to the period between the ninth and the eleventh centuries.

In the three important books, the *Antiphonary of Bangor*, written before 691, the *Liber hymnorum*, transcribed in the second half of the eleventh century, and the *Lebor Brecc*, transcribed before 1411, there are preserved early litanies, invocations, and poems of adoration, "which bear more directly upon the work of the Christian preacher, and indicate much literary merit as well as deep religious feeling". There is also a rich hagiographical and purely devotional literature, as well as imaginative religious literature in prose and verse—though such works belong to a relatively late date.

Early poems, or parts of poems, are attributed to Lugaid Lánfili (whom the German scholar Meyer dates in the sixth century), or to Colmán mac Lénéni, edited by the leading scholar Thurneysen. The most remarkable of these early poems is the famous *Amra Choluim Chille*, preserved in the *Liber hymnorum*, which is said to have been composed by Dallán Forgaill in honour of St. Columcille, or St. Columba (late sixth century). It has been suggested that the rhythmical texts in the great legal composition known as *Senchas Már* may also go back to such an early date.

Before that time, however, apparently a certain body of Irish heroic literature existed in writing, and consequently this literature seems to have already begun in the sixth century A.D. During the sixth century a blending of the old Irish heathen lore and learned

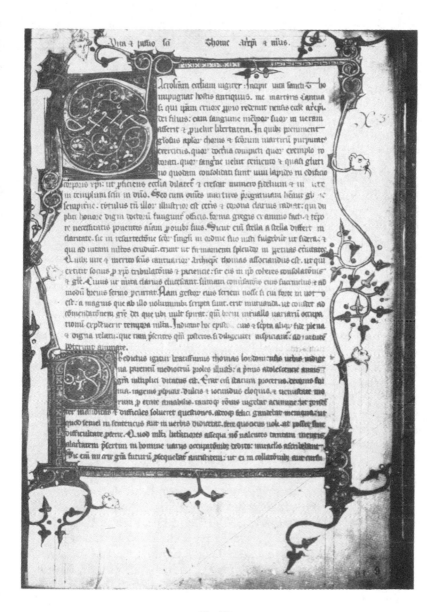

Fig. X–1

Vitae Sanctorum Hiberniae (Trinity College Library, Dublin, *B. 2*, 7, fol. 9).

tradition with the new Christian learning was probably taking place, the native school of poets, originally druids, becoming Christian and adopting the apparatus of Christian learning. In the *Vitae Sanctorum Hiberniae* (Fig. X–1), or *Lives of the Saints of Ireland*, we find references to the Christian colleges, but little is known of the preceding bardic schools which—we may assume—were formed round a chosen bardic poet followed from place to place by his disciples.

Nevertheless, a good deal of specifically heathen practice and teaching was preserved, more or less covertly, among the secular poets of Ireland, for centuries after St. Columba's activity. The *Lives of the Saints of Ireland*, which indeed are centuries later than the saints referred to, and therefore historically nearly worthless, preserve "large lumps of pagan material": a saint such as Find-Chua, son of Find-Lug, can with unalloyed relief be restored by Christianity to the paganism where he belongs. The *Lebor na Huidre* or *Book of the Dun Cow* (see Fig. X–2, *b*, and p. 453), written in Clonmacnoise about the year 1100, is the earliest preserved version of the ancient epic tale *Táin Bó Cúalnge*, and the earliest secular work extant.

At any rate, writing in the Irish language appears to have become very common in the seventh century, but while the secular school of *literati* considered this language a "choice language" (as we know from an early grammar of Irish, partly attributed to the seventh century), the Irish religious scholars belittled its value (so, for instance, did Adamnán, early eighth century). "Why is God said to regard a man who reads Gaelic as uncivilized?" asks a glosser of *The Scholar's Primer*. This depreciation of Irish by Christian scholars is probably one of the reasons for the monastic failure in vernacular *creative* literature.

The monks were the successors of the druids on the religious side; they revolutionized learning not only from the religious, but also from the linguistic standpoint. The Bible became the basis of their schools; the Psalms, in Latin, became a standard textbook; but, in addition, Latin became their scholarly language, taking the place of the druidic "secret tongue". What the monks did write in Irish, was destined for the common people, and consisted of compilation, copying and translation.

However, Irish literature did not die. The hereditary bards, attached to the courts and to the noble houses, and especially the *ollamhs* or chief bards, were in a sense literary inheritors of the

druidic bards. "They likewise instructed pupils in their art, and classified their attainments by an elaborate system of graduation, not unlike the degrees of a university." In the seventh century new metrical forms in Irish poetry, based mainly on Latin hymns, made their appearance, and afterwards developed into a varied and elaborate system of metrics, but the Christian bards were not bookmen, at least not primarily: they depended on memory rather than on books. Some of their poems and sagas (such as stories of courtships, battles, cattle raids), or romances (the *Cycle of Tuatha De Danann*), the Cycles of Finn Nac Cumhail, Ossian, and Oscar, the *Red Branch Cycle*, and others) have come down to us in later compilations or revisions.

Whereas the traditional classification of the earliest Irish prose literature—epic and romance—was according to types (such as love stories, courtships, banquets, cave stories, cattle raids, invasions, battles, destructions, travel stories, adventures), nowadays it is based on cycles or great leading periods. Three main cycles can be distinguished: the Mythological—the mass of sagas carried over from pre-historical pagan times, the Heroic cycles (of the period immediately before, and the early centuries of, the Christian era)—also known as the Ulster and the Fenian cycles, and the Historical.

The best known, and most perfectly preserved, is the already discussed *Elegy* on St. Columba, apparently written by Dallán Forgaill soon after the saint's death (597). "It is a typical example of its kind; in form a sort of anticipation of the *vers libres* of modern affectation, with no regular metre, unrhymed . . ." (Macalister). It is full of peculiar words, often artificially modified. The form is rendered even more obscure by enormously long annotations interspersed through the text. See also p. 448.

BEST PERIODS OF IRISH LITERATURE

The seventh and eighth centuries, the eleventh and twelfth, and the fourteenth to eighteenth centuries are the best periods of Irish literature. Generally speaking, however, it can be said that the Christian bards left parchment and ink to the monks, and it is, indeed, to the products of monastic scriptoria that we are indebted for most of what we know of early Irish literature. The late nineteenth and early twentieth centuries saw a revival of Irish literature.

IRISH MANUSCRIPTS

There are probably as many as two thousand Irish manuscripts

now in existence, but the majority were written in the eighteenth and the nineteenth centuries, and many are mere transcripts of earlier manuscripts and have no independent value. Of the total number, more than thirteen hundred manuscripts are in the Royal Irish Academy, of which some sixty (out of a hundred which have survived) are important. A smaller number (about 150), but of relatively greater importance, is the superb collection of Trinity College Library, at Dublin, and that of the British Museum, containing over 200. Other important collections are in the Vatican Library, at St. Gall, in Oxford, Cambridge, Paris, Brussels, and in a

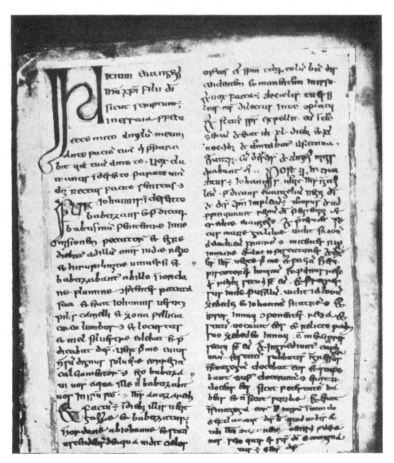

Fig. X–2a

The *Book of Dimma* (Trinity College Library, Dublin, MS. No. 59; *A. 4. 23*).

few other great libraries. It may be noticed that a few Celtic Latin codices belonging to the ninth or the tenth century—such as the *Book of Armagh* (see p. 466), *the Book of Dimma* (p. 468), the *Stowe Missal* (p. 468), the *Gospel of Maeielbrid* (p. 469), the *Psalter of Southampton* (now at Cambridge), the *Irish Canons* (at Cambridge), the Ambrosian *Cod. C. 301 inf.* (p. 469), also contain Irish material, though in some instances this consists of no more than a few lines.

Fig. X-2*b*

Lebor na Huidre or the *Book of the Dun Cow* (Royal Irish Academy, Dublin).

Three codices are of special interest on account of their relatively early date and the importance of their contents:

(1) The *Book of the Dun Cow* (*Lebor na Huidre*, known by the symbol *LU*), now preserved in the Royal Irish Academy in Dublin; this was written at Clonmacnois before 1106, and is thus the oldest book written wholly in the Irish language which has come down to us. Tradition assigns it to St. Ciarán, the founder of Clonmacnois, who was supposed to have written it on the hide of his favourite dun-coloured cow, which (while alive) had supplied him and others with an abundance of milk while he remained at the school of St. Finnian. *LU* is fragmentary and contains many interpolations, but it is our earliest written source for many of the Irish heroic sagas, particularly for the great saga of the *Táin bó Cúalnge*, or the Cattle-Raid of Cooley, which is the central saga of the Ulster cycle. Fig. X-2 *b*.

(2) Next in importance comes the *Book of Leinster* (*Lebor Laigen*,

or *LL*), written some fifty years later (before 1160), and now pre-
served in Trinity College, Dublin. It contains history, genealogy,
poetry, and is rich in saga; indeed, it contains the fullest account of
the *Táin bó Cúalnge*. Fig. X–3 (*below*).

(3) *Cod. Rawlinson B 502* (or *Rawl.*) of the Bodleian Library, at
Oxford, contains twelve leaves written in the eleventh century in

Fig. X–3

(*Above*) The *Book of Ballymote* (Royal Irish Academy, *MS. 23, P. 12*); (*below*) the
Book of Leinster (Trinity College Library, Dublin, *H. 2. 18*).

which the *Annals of Tigernach* are recorded, and seventy leaves written in the twelfth century which are devoted to historical matter, law tracts, *dinnshenchas* or "history of places" (collection of legends in prose and verse, purporting to be a history of the place), a copy of *Saltair na Rann*, and the famous glossary of Cormac mac Cuilennáin (who died in 908).

Four other codices belong to the "seven great books of Ireland"; they are compilations similar in content to the *Book of Leinster*, a compendium of medieval lore, legend, history, genealogy, topography. All the four are great vellums, closely associated in place and time, all written in the late fourteenth or early fifteenth century, and all in the west of Ireland:

(1) *The Book of Ballymote* (or *BB*), now preserved in the Royal Irish Academy (*23.P.12*), was written at Ballymote in Co. Sligo, in the house of Tomaltach Og Mac Donnchadha Lord of Corann when Tairdelbach Og Mac Aedha O Conchubhair was King, *c.* 1400. Fig. X–3 (*above*).

(2) The *Great Book of Lecan* (or *Lec.*) received its name from the place Lecan (Irish, Leacán) or Lecan Mic Firbhisigh, where it was compiled. This Lecan is situated in the parish of Kilglass in the north-west portion of Co. Sligo. The book was written, or at least begun, before 1417.

(3) The *Yellow Book of Lecan* (or *YBL*), preserved in Trinity College, Dublin, written in the early fourteenth century, preserves an almost complete version of the *Táin bó Cúalnge*.

(4) The *Book of Hy Many*, written in the fourteenth century, and now in the Royal Irish Academy, largely contains historical material and has many texts in common with the other manuscripts of this series.

Three other folios should be mentioned: (1) the *Speckled Book of Mac Egan* (the *Lebor Brecc* or *LB*), written in the late fourteenth century, and now in the Royal Irish Academy; it contains important sacred texts; (2) the *Book of Fermoy* (or *F*), written in the fifteenth century, and preserved in the same collection; and (3) the *Book of Lismore*, written in the fifteenth century, and preserved in the collection of the Duke of Devonshire.

Geoffrey Keating—whose *History of Ireland*, written *c.* 1640, was the last important work in western Europe to circulate in manuscript —was the Irish Herodotus or Thucydides, Livy or Caesar. The precious historical composition known as the *Chronicon Scotorum* is preserved in a copy written *c.* 1650 by Duald Mac Firbis; its original belonged to the twelfth century, and dealt with events up to 1135.

The *Annals of the Kingdom of Ireland by the Four Masters*, known as *The Four Masters*, written by Michael O'Cleary and three other scholars, was begun in 1632 and completed in 1636.

LATIN CODICES IN "IRISH" SCRIPT

There were two main Irish scripts—see *The Alphabet*, p. 546—one being the semi-uncial, known as the Irish majuscule, employed from the seventh to the thirteenth centuries. The best representatives of this script are the *Book of Durrow* and the *Book of Kells*.

MAJUSCULE MANUSCRIPTS

The Book of Durrow (Fig. X-4) is named after the Columban monastery of Durrow (near Tullamore, Co. Offaly), where it is known to have been kept. It is also called *Codex Durmachensis* or *Durmach*. About the middle of the seventeenth century it was presented by Bishop Henry Jones, Vice-Chancellor, to Trinity College, Dublin, where it is now preserved (No. 57; *A.4.5*). It contains the Gospels, in Latin, in the Vulgate version, partly contaminated by the Irish text (see p. 458). There are 248 leaves measuring $9\frac{1}{2} \times 6\frac{1}{2}$ inches. The manuscript contains beautiful illuminations; these will be dealt with in the book on *Illumination and Binding*. The place of its origin is uncertain; some authorities—such as Mlle Henry—consider it as Irish, others (Burkitt, Zimmermann, Lowe, Mynors, Bieler) as Northumbrian. A note in the book states that it was formerly kept in a silver case (the inscription on which recorded that it was made for the book by Flann, son of Malachy, King of Ireland, who died in A.D. 916). The date of the codex implied in its colophon has been rejected by the palaeographers (the colophon assigns the manuscript to St. Columba), and various other dates have been suggested: *c.* 650 (Kendrick), the second half of the seventh century (Henry), a date between 664 and 675 (Oakeshott), late seventh or early eighth century (Lowe, Zimmermann, Bieler); *c.* 675 being its most likely date.

The Book of Kells (Fig. X-5), also known as *Codex Cenannensis* and quoted as (codex) *Q*, is called in Irish *Soiscela mor Choluim Chille*, "The Great Gospel of Columcille (=Columba)". It is one of the finest books that has ever been produced. Tradition has it that the unerring lines of its ornamentation—in one space of about $\frac{1}{4}$ inch square may be counted, with a magnifying glass, 158 interlacements —should have been traced by angels. The illumination of this

Fig. X-4

The *Book of Durrow* (Trinity College Library, Dublin, MS. No. 57, *A. 4. 5.* fol. 78 *verso*).

stupendous work will be discussed in the volume on *Illumination and Binding*. Here it will suffice to quote from A. A. Luce a few of its distinctive features, "the noble script, the generous margins, the ample spacing, the huge initial letters at the opening of each gospel, the single-column text, the mere magnitude of the ornament, the ocean of colour and the forest of ornate capitals (more than two thousand one hundred of them), the large number of pages devoted to ornament, the sustained beauty and dignity of the six hundred 'ordinary pages'." The book contains 339 leaves, measuring 13 × 10 inches, and there are seventeen lines to the page (eighteen in the last portion).

The codex contains the Four Gospels in Latin, with the usual subsidiary matter; the text is the Irish recension of the Vulgate version, "that is to say a Vulgate text, much contaminated by inferior readings of uncertain origin", though "it does often side with the best manuscripts" (Burkitt). Although the contents "are, roughly, the same" as in the *Lindisfarne Gospels* (see p. 501 ff.), "they are arranged on different plans . . . *Kells* assembled all the standard preliminaries . . . and prefixed them *en bloc* to the sacred text, without troubling much about their internal order; . . . the architect of *Kells* . . . puts the stress on the unity of the Gospel" (Luce). On pages left blank by the original scribe are written sundry deeds in Irish (they date to the eleventh and the twelfth centuries).

The book is probably of A.D. *c.* 800. It was kept throughout the Middle Ages in the monastery of Cenannus or Kells (on the River Blackwater, in Co. Meath, thirty-eight miles north-west from Dublin), founded in the sixth century by St. Columba. According to some scholars, however, the codex was brought to Kells from Iona (see p. 443) when its monks deserted the island and retired to Kells. However, Mlle Henry remarks that at that period the monastery of Iona was as Irish as that of Kells. The codex belonged to Archbishop James Ussher, better known as Usher, and with its library passed (in 1661) to Trinity College, Dublin.

EARLIER MAJUSCULE CODICES

The earliest extant manuscript written in a round Insular majuscule is the *Cathach of St. Columcille* (or *Columba*)—Fig. X-6, *left*—now preserved in the library of the Royal Irish Academy. It is traditionally attributed to St. Columba (521–97), and although traditional attributions of books to famous saints are very common, according to Lowe the early date implied in this instance (latter

half of the sixth century) is palaeographically possible. Adamnán, St. Columba's biographer and abbot of the Iona monastery, stated that Columba was frequently occupied in copying sacred texts. The *Cathach of St. Columba* contains fifty-eight folios, and is a fragmentary

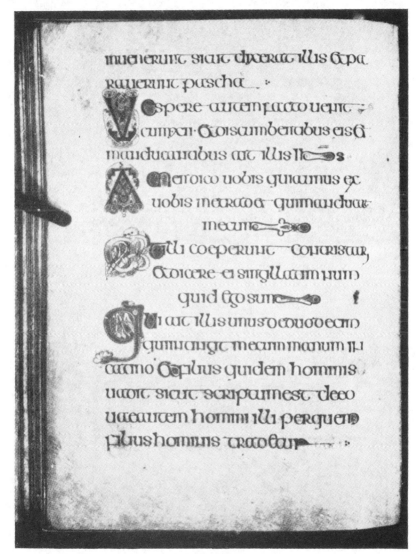

Fig. X–5

The *Book of Kells*, folio 176 *verso* (Trinity College Library, Dublin).

Fig. X-6

(*Left*) The Cathach of St. Columba; (*right*) Codex Usserianus Primus; fol. 150 recto.

"Gallican Psalter". Its ornamentation "consists in initials, drawn in outline with the pen, and surrounded by red dots" (Bieler). The *Cathach* was preserved in a cumhdach or shrine (see *Illumination and Binding*), which was made between 1062 and 1098. It was carried into battle (hence the name *Cathach*, "battler") to ensure victory. If carried three times right-wise round an army by a pure cleric, a safe and victorious return was ensured. Adamnán, already referred to, says that Columba's power to ensure victory for one side and defeat for the other continued after his death. Irish refugees took the *Cathach*, enshrined in its cumhdach, to France where it was until 1802. In 1813 it was opened and the *Cathach* was discovered. It belonged to the family O'Donnell, and in 1842 Sir Richard O'Donnell deposited it in the Royal Irish Academy. The cumhdach is preserved in the National Museum, at Dublin.

Codex Usserianus Primus, quoted as r^1—Fig. X–6, *right*—is preserved in Trinity College, Dublin (No. 55; *A.4.15*). Only the remains of about 180 folios are extant; they measure $7 \times 5\frac{1}{2}$ inches, and contain an Old Latin (pre-Jerome) version of the Gospels, the order being St. Matthew, St. John, St. Luke, and St. Mark. Both r^1 and r^2 (see below) belonged to Archbishop Usher, and with his library passed in 1661 to Trinity College of Dublin: hence, the names *Codex Usserianus Primus* and *Alter*. The writing of *Codex Usserianus Primus* "shows a very early type of Irish script combined with some Italian elements" (Henry).

According to Lowe *Codex* r^1 was probably written in Bobbio in the early seventh century. Two manuscripts written in Bobbio, and now preserved in the Ambrosian Library, at Milan—*Cod. C.26. sup.* and *Cod. D.23. sup.* (Fig. X–7, *below*)—are in a closely allied script. Another Bobbio manuscript, preserved in the Ambrosiana (*Cod. S.45. sup.*: Fig. X–7, *above*), containing St. Jerome's *Commentaries on Isaia*, is an interesting palimpsest (see pp. 215–23). The earlier text is a copy of the Gothic Bible of Wulfilas (see p. 290), while the *Commentaries* are in semi-uncial showing "here and there, some traces of Irish influence; p. 44 is written in Irish characters" (Henry). An inscription on p. 2 of the manuscript (see Fig. X–7)— L B DE ARCA DOMNO ATALANI—refers to Atalanus, St. Colomban's successor as abbot of Bobbio (615–22). In Bieler's opinion, *Codex Usserianus Primus*, and Ambrosian *C.26. sup.* and *D.23. sup.* are "written in a seventh-century insular majuscule, verging on minuscule. . . . Although the half-uncial of the Bobbio triad has apparently not descended from that of Cathach, both scripts have

Fig. X-7

(*Above*) *Codex Ambrosianus S.45. sup.* (Ambrosian Library, Milan); palimpsest—lower script: Wulfilas, translation of the Bible into Gothic; upper script: St. Jerome, *Commentary on Isaiah,* written in half-uncials showing Irish influence; (*below*) *Codex Ambrosianus D.23. sup.* (Ambrosian Library, Milan): Orosius, *Christian Universal History,* written in Irish majuscules.

more in common than has either of them with the Durrow-type. . . .
Different again, but more in the style of the Cathach, is the leaf from
an Isidore codex saec. VII med. of which fragments have been found
in the covers of Sangallensis 267 and 150 by P. A. Dold and Dr.
B. Bischoff. . . . The script of this fragment is an Irish majuscule with
some semi-cursive elements. . . . The provenance . . . is unknown,
but the archaic character of the script seems to exclude St. Gall.
The manuscript might have come from Ireland."

Fig. X–8
The *Book of Armagh* (Trinity College Library, Dublin, No. 52; fol. 49 *verso*).

LATER MAJUSCULE MANUSCRIPTS

The manuscript of the *Domhnach Airgid* (see *Illumination and Binding*)—Fig. X–9 *a*—preserved in the Royal Irish Academy since 1847 (No. 24. *Q.23*), consists of fragments of thirty-nine sheets written in Irish majuscule of the eighth or ninth century. The celebrated shrine known as *Domhnach Airgid*, in which this manuscript was preserved, was opened about 1830.

Examples of the majuscule are *Codex Ceaddae* (L) or *St. Chad Gospels* (see also p. 471 and Fig. X–12), of the eighth century and,

Fig. X-9*a*

Manuscript of the *Domhnach Airgid* (Royal Irish Academy, Dublin, *Q.23*), showing *Luke*, i, 6–9, ii, 30–32.

now preserved in the Cathedral Library, at Lichfield, and *Codex Usserianus Alter*, quoted as (codex) *r²*, also known as *Garland of Howth* (having been found on the island Ireland's Eye, near Howth): it is preserved in Trinity College, Dublin (No. 56; *A.4.6*); it consists of eighty-six folios measuring $9\frac{3}{4} \times 7$ inches, and contains the Four Gospels in Latin, partly of pre-Jerome version; it is attributed to the eighth or ninth century. Another important codex is St. Gall manuscript *No. 1395*. Finally, mention must be made of the *Mac Regol Gospels*, also known as the *Rushworth Gospels* or *Codex Rushworthianus* (*R*) (preserved in the Bodleian Library, at Oxford, *Auct.D.2.19*, No. 3946), which can be dated with certainty as they were written and illuminated by Bishop Mac Regol, abbot of Birr (Co. Offaly) who died in 822.

On the whole, the Irish semi-uncial or majuscule seems to have predominated in the codices *de luxe* until the early ninth century, but it was not adopted for the more ordinary purposes of literature or the requirements of daily intercourse.

MINUSCULE MANUSCRIPTS

The second Irish script was the minuscule, a pointed hand, which flourished in the eleventh and twelfth centuries, when the shape of its letters became rigid and fixed: it remained unchanged

Fig. X–9*b*

The *Stowe Missal* (Royal Irish Academy, Dublin, Ashburnham Collection, *Stowe MS., D. 2. 3*; fol. 34 *recto*).

in subsequent centuries and is still employed in printing. This hand appears in some of the pages of the *Book of Kells*; it is, however, best represented by the *Book of Armagh* (Fig. X–8), which is also known as *Liber Armachanus* or the *Armagh Gospels* or the *Gwynn Manuscript*, or else *Codex Dublinensis*, and is preserved in Trinity College, Dublin (No. 52; 221 leaves, measuring $7\frac{3}{4} \times 5\frac{3}{4}$ inches); formerly it was assigned to St. Patrick, but it is now known that it was written by Ferdomnach, of Armagh, from the dictation of Torbach, abbot of Armagh in 807–8. The book contains the New Testament in Latin, with (amongst other matter) the *Lives* of St. Patrick and St. Martin of Tours, and the *Confession* of St. Patrick, also in Latin; it also has four pages of glosses, which "comprise the most copious specimens

Fig. X-10a

The *Bangor Antiphonary* (Ambrosian Library, Milan, C. 5. inf.; fol. 13 *verso*).

of Old-Irish prose yet discovered" (E. J. Gwynn). It has been suggested that the *Life* of St. Martin (by Sulpicius Severus) was copied from a book which reached Ireland before 460.

The earliest extant manuscript written in Irish minuscule is the *Bangor Antiphonary* (Fig. X–10 a). It is a collection of religious hymns and poems, two of which connect this codex with the monastery of Bangor (N. Ireland) and date it *ante* 680–91. The codex was brought to Bobbio by Irish missionaries, and with other Bobbio manuscripts it was transferred to the Ambrosian Library, at Milan, where it is now

preserved (*Cod. C. 5. inf.*). Slightly later is the *Book of Mulling* or *Moling*, also known as *St. Mulling's Gospels* (Fig. X–10 b). It was preserved in a cumhdach (see *Illumination and Binding*); it contains the Four Gospels in Latin, partly from pre-Jerome version. It is preserved in Trinity College, Dublin (No. 60; *A.1.15*; there are eighty-four folios measuring 6 × 5 inches). It also contains an Office of Communion of the Sick, a liturgical fragment and other

Fig. X–10b

The *Book of Mulling* (Trinity College Library, Dublin, MS. No. 60; *A. 1. 15*; fol. 30).

matter. At the end of *St. John* it bears a subscription ([*N*]*omen scriptoris Mulling dicitur*), which suggests that it was written in the late seventh century (St. Moling, the founder of Tech-Moling, died in 697). It was written probably at Tech-Moling (now St. Mullins), Co. Carlow. On the last page there is a curious circular device with Irish words. The *Dorbbéne Codex*, now preserved in Schaffhausen, Switzerland (*Codex Gen. 1*)—Fig. X–15 *a*—can be dated to the early eighth century: it contains a copy of Adamnán, *Life of St. Columba*. Another manuscript of which we know the name of the scribe (Cadmug)—and therefore it can be dated to the eighth century— is preserved in Fulda (near Cassel, Germany), *Cod. Bonif. 3*; it is a Gospel-book. For the *Dorbbéne Codex* see p. 482 f.

More famous is the *Book of Dimma* (Fig. X–2 *a*), now preserved with its cumhdach (see *Illumination and Binding*) in Trinity College, Dublin (No. 59; *A.4.23*); of the original seventy-six leaves, two have disappeared; the leaves measure $7 \times 5\frac{1}{2}$ inches. The codex contains the Four Gospels in Latin, of which the first three, with few exceptions, are the work of the same scribe written partly in a carefully formed round hand, and partly in a rapid cursive hand, while the *Gospel of St. John* is written by another scribe mainly employing a neat uniform minuscule book hand. At the end of each Gospel there is a colophon, in which the scribe who calls himself Dimma Macc Nathi beseeches the reader's prayers on its completion. Dr. R. I. Best has proved that these colophons are a pious fraud perpetrated at some time in the tenth to eleventh century, in order to identify this copy of the Gospels with the one said to have been miraculously written by one Dimma, in forty days, for St. Cronan, the founder of Roscrea, who died about 619. (Hence, the name *Book of Dimma* and the alleged date, early seventh century.) "The volume, which can safely be assigned to the end of the eighth century, has accordingly no claim to be called the *Book of Dimma*, but rather the Book of Roscrea", from the name of the abbey of Roscrea (Co. Tipperary), where it has apparently been written.

Two codices belong to the late eighth or early ninth century. They are the *Stowe Missal* (Fig. X–9 *b*) and *Cod. C. 301. inf.* of the Ambrosian Library, at Milan. The former, now preserved in the Royal Irish Academy (Ashburnham Collection; Stowe MS., *D.2.3*), consisting of sixty-seven folios which contain a Vulgate text with Old Latin mixture, has been attributed to St. Tigernach, the founder of Clones, who died in 550; it is now dated to 792–812, and is assigned to the monastery of Tallaght; the anchorite Mael-

dithruib seems to have removed the codex to Terryglass; in the twelfth century it was transferred to the important monastery of Lorrha (in Ormond, Co. Tipperary), where it remained until the Dissolution.

In 1883 it was purchased by the British Government from the Earl of Ashburnham, and was deposited in the Royal Irish Academy.

The Ambrosian *Cod. C.* 301. *inf.*, containing a *Commentary on the Psalms* (with glosses in Old Irish), was written by a scribe Diarmait in the late eighth or ninth century, either in Bangor or in Leinster (this theory has been suggested by Lowe). Later examples of the Irish minuscule are the *Mac Durnan Gospels*, preserved in Lambeth Palace, London, assigned to the ninth century and attributed to Armagh (it belonged to Mac Durnan, who died in 927, but "there is no indication that he was the scribe who wrote it": Bieler), and the *Maelbrighte Gospels* or *Gospels of Maielbrid*, written in 1138 and preserved in the British Museum.

Later Development of the Irish Minuscule

Dr. Bieler distinguishes the history of the later Irish script into three main periods: a period of formation (eleventh and twelfth centuries), a period of standardization (thirteenth to sixteenth centuries), and a period of fossilization (from the seventeenth century onwards); "during the nineteenth century a revival of the classical Irish script of the 14th and 15th century was attempted by certain Gaelic scholars".

Origin of Irish Writing

The origin of the Irish scripts is still an open problem. In F. Masai's opinion, there was only one Irish script, the pointed minuscule. The majuscule or semi-uncial, the script of the great Gospel-books of the eighth century, beginning with the *Book of Durrow*, is to be attributed to England; its prototype may have been (1) either an Italian semi-uncial of the sixth or seventh century (*i.e.* of the period of St. Augustine of Canterbury), in which some letters have changed under the influence of the Irish script of the "Scottish" missionaries of the seventh century; or else (2) an Irish script of the seventh century changed under the influence of Italian models which arrived in Northumbria at that period. The *Bangor Antiphonary* (see p. 466 f. and Fig. X–10 *a*), in Masai's opinion, may represent the common ancestor of the two Insular scripts, but it was not before the

ninth century—when the *Mac Regol Book* was written—that the "English" semi-uncial under the influence of Northumbria was adopted for Irish manuscripts.

Masai's theory is a revolutionary one. The theory hitherto commonly held, as expressed by a leading authority in this field, was as follows: We do not know exactly when the Irish scripts came into being or what were their precise progenitors; the Irish majuscule was mainly based on a Roman semi-uncial untouched by Roman cursive but with considerable uncial admixture; of the two distinct Irish types, the majuscule must be older than the minuscule: the latter may be derived from the former, but not *vice versa*. More recently, Lowe authoritatively suggested that the Italian fifth-century quarter-uncial, as shown in manuscripts of Naples, *Lat.* 2 (*Vind.* 16), Turin, *G.v.*4, and ex-Royal Library (of the Italian King), *Varia* 186 *bis*, must have had considerable influence on the formation of the Irish minuscule. Bieler accepting this theory suggests that an early uncial, as shown in three manuscripts, which come from Bobbio, but "almost certainly were in Ireland at some time", and apparently are of African origin—may have influenced the creation of the Irish majuscule. Of the three manuscripts—all of the fourth or fifth century A.D.—two contain works of Cyprian: one is preserved in the Vatican. (*Vat. Lat. 10959*), Turin (National Library, *F.iv.*27), and Milan (Ambrosian Library, *D.* 519. *inf.*); the other in Turin, (National Library, *G.v.37*); and the third is *Codex Bobiensis*, quoted *k*, which "is said to have been the pocket gospel book of St. Columbanus"; moreover, Cyprian "is the sole ecclesiastical writer whose works echo in those of Patrick".

Bieler is probably right in suggesting that for the origin of the Irish script we have to look in the great monastic foundations of the sixth century, and that this script is not a direct continuation, even in a modified form, of any one of the ancient book hands, but an original creation. Its "inventors" naturally worked on existing material, but they selected freely elements from various scripts and created with these a new system. If this theory is right, as it probably is, then the main fault of other theories is that they do not take sufficient account of the part consciously played by the inventive power of individuals in the formation of new alphabets (see, for instance, *The Alphabet*, pp. 322, 487, and *passim*). Who was the inventor of the Irish script? One can only guess, and "a tempting guess would be St. Columba" (Bieler). However, "Irish majuscule and minuscule are both eclectic types purposely devised for the literary needs and ambitions of Irish monasticism. With it, they

spread over Europe, but only in few continental centres were they maintained beyond the first generation."

"Willibrord, Aldhelm, Bede, sit at the feet of Celtic masters," writes our leading palaeographer. "These facts are in our histories. But they are also writ large on the face of our manuscripts. . . . The oldest manuscripts of England are so like the Irish as to seem identical. This fact speaks volumes. To realize the fundamental character of England's indebtedness to Ireland in educational matters in the early period, we need only consider these simple facts: the manuscripts read and copied during the four centuries of Roman occupation . . . must have been in 'capitalis rustica', or in uncials. . . . For all that, Rome's example was not strong enough to counteract the nearer influence of the Celtic teachers. For the predominant script of England, that which became her national script, is the script she learned from Ireland and not from Rome" (E. A. Lowe).

Welsh Book Production

The earliest period of Welsh literature is that of *Cynfeirdd*, or early poets, the great age of bardic literature, associated with the celebrated names of Aneirin (the reputed author of the great poem *Gododdin*: his name has been identified by some scholars with the Roman name Honorinus), Taliesin, Myrddin, and Llywarch Hên, and with other names—not so well known—such as Kian, Talhaearn, Meugant, and Kywryd. This first literary awakening began in the sixth century A.D., and continued (though with considerably less creative and imaginative production) for two or three centuries, until the results of the Norse invasions put an end to it.

Only poetry attributed to Aneirin and Taliesin has survived. The other names are more or less legendary.

Although many of the preserved Welsh literary productions—both in verse and in prose—contain elements partly attributed even to the sixth century A.D., the earliest Welsh glosses and written literature appear only in manuscripts of the ninth to the eleventh centuries. The oldest of these glosses are in the *Liber Commonei* and in the *Gospels of St. Chad* (see p. 464). Figs. X–11 and 12.

The *Liber Commonei*, written by a son of Commoneus in a Welsh

variety of the Hiberno-Saxon minuscules, is assigned to A.D. *c.* 820 and was considered by Henry Bradshaw as "the patriarch of all Welsh books known". It is "a medley of useful knowledge", containing a portion from the Old Testament in Latin and Greek written in Roman character, a Runic alphabet, a calendrical piece, etc.; there are Latin glosses, a few Welsh glosses, and several notes in

Fig. X–11

Liber Commonei (Bodleian Library, Oxford, *MS. Auct. F. IV 32*, fol. 32).

mixed Latin and Welsh. The portion shown in Fig. X–11 contains notes on several kinds of measures of quantity and weight. The book is part *C* of a manuscript containing four parts, of which *A* comes from Brittany and contains Latin and Breton glosses of the ninth and

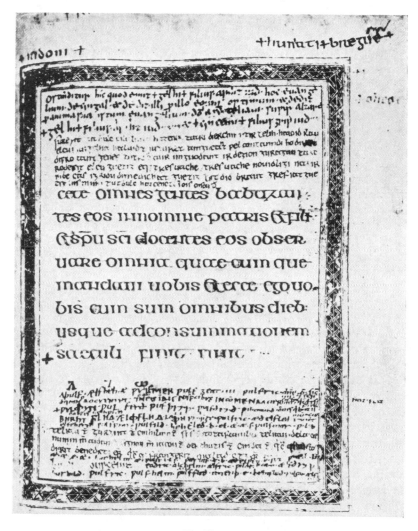

Fig. X–12

Codex Ceaddae or *St. Chad Gospels,* quoted as *L* (Cathedral Library, Lichfield); comes probably from a Welsh centre; was at Llandaff already in the eighth century. Contains eighth-ninth century entries in Welsh minuscules, as well as entries in Anglo-Saxon and Caroline minuscules of the tenth century.

tenth centuries, and *D* was written in Wales in the second half of the ninth century. *A*, *C*, and *D* seem to have been transmitted from Wales to Glastonbury in the time of St. Dunstan, and were owned by him. *B* was written in Glastonbury and added to the volume in the eleventh century.

On the whole, as in the case of many other peoples, sagas in verse and prose had been floating among the Welsh for centuries, but it was only during the twelfth century that there became evident a desire to have these collected and written down, with relevant modifications and accretions from every succeeding age.

The advent of new rulers ushered in a new remarkable intellectual awakening: it was the period of the *Gogynfeirdd*, or the medieval poets, the court poets of the Norman period, chief among whom were Gwalchmai, the son of Meilyr, Prince Owain Kyveiliog, and Prince Howel ab Owain Gwynedd. According to Thomas Stephens no less than seventy-nine bards flourished between 1080 and 1400. Tradition assigns to this period the institution of bardic meetings, the precursors of the modern *Eisteddfod*, *i.e.* "assembly, sitting". "The first assembly of this kind of which we have some knowledge was held in Cardigan Castle in 1176 under the patronage of the Lord Rhys" (I. C. Peate).

The Mabinogion

In the twelfth century written form was first given to the great eleven tales in prose, or the romances, known as the *Mabinogion*. This cycle of romance may be distinguished in three groups: The original *Mabinogion* consisted of four tales (Pwyll, Prince of Dyfed; Branwen, Daughter of Llyr; Manawyddan, Son of Llyr; and Math, Son of Mathonwy); later the other two groups were added, one consisting of three stories (Llud and Llevelys; Culhwch and Olwen; and the Dream of Rhonabwy), and the other containing four romances (the *Lady of the Fountain;* Peredur, Son of Evrawc; Geraint, Son of Erbin; and Maxen Wledig). The importance of the *Mabinogion* may be realized from J. C. Morrice's statement that "without the Mabinogion, not only Welsh literature, but the literature of Europe would be decidedly the poorer".

Some of the stories seem to refer to the period of Roman settlements in Britain; some appear to be Irish in origin, or "mixed romances", containing elements of Irish mythology and of the Arthurian legend; and some deal with the "deeds" of King Arthur.

Fig. X-13

The *Black Book of Carmarthen* (Wynne Collection, Peniarth), fol. 18 *verso* and 19 *recto*.

The Four Ancient Books of Wales

To a slightly later period belong the earliest preserved manuscripts of Welsh book production, *The Four Ancient Books of Wales*. These are: (1) The *Black Book of Carmarthen*—it is so called because it belonged originally to the "black Canons" of the priory of Carmarthen. The manuscript, consisting of fifty-four leaves of vellum, in small quarto, with illuminated capitals, is in four different handwritings (discounting the later glosses), all attributed to the twelfth century A.D. This manuscript is in a private collection, at Peniarth. See Fig. X–13.

(2) The *Book of Aneirin*: this contains, amongst other poems, the oldest preserved copy of Aneirin's *Gododdin*. This thirteenth-century manuscript, consisting of nineteen leaves in small quarto, is in two different handwritings, and is characterized by the fact that the initial letters of the stanzas are coloured alternately red and green. This codex is in a private collection at Middle Hill.

(3) The *Book of Taliesin*, an early fourteenth-century manuscript consisting of thirty-eight folios, formerly belonging to the same private collection. It contains the poems of various bards of the thirteenth and fourteenth centuries, who loved the protecting shelter of a great name of the early period. Indeed, of the seventy-seven poems attributed to Taliesin, only twelve seem to belong to the sixth century, and eight are doubtful. See Fig. X–14.

(4) The *Red Book of Hergest*, preserved in Jesus College, Oxford. This is supposed to have been written at Hergest Court, a seat of the Vaughans, near Knighton, Radnorshire; it has a magnificent binding (of much later date than the manuscript) in red morocco with steel clasps: hence its name. It is a folio volume of 360 leaves written in double columns in three different handwritings, and is a collection of poems and stories in prose, some of them relating to King Arthur and the early British kings. It was begun in or before 1318 and was finished in 1454. Many poems of this book refer to the cycle of Llywarch Hên. The stories in prose belong to the *Mabinogion*.

The Ancient Laws

Of the other books produced in Wales, *The Ancient Laws and Institutions* deserve special mention. The oldest, the *Laws of Howel Dda* —king of South Wales in the first half of the tenth century—is of the greatest historical interest. These books throw great light on the life and customs of the people and their rulers.

Fig. X-14

The *Book of Taliesin* (National Library of Wales, *Peniarth MS. 2*).

The Arthurian Romance

Even more important is the part played by Welsh writers in the creation of the Arthurian romance, which had a paramount influence on European medieval literature. It illustrates, in a striking manner, how small beginnings gradually evolve into great semi-legendary tales. The early English historian Gildas writing in the year A.D. 560 a Latin treatise on the early history of the country, mentions the military achievements of a Cornish chief with a following in Wales. Another historian, Nennius, who was a pupil of Elbod, bishop of Bangor, and is the traditional author of the *Historia Britonum*, written in the early ninth century, first mentions Arthur by name, and gives the names of twelve great battles which Arthur fought, finishing up with the battle at Mons Badon, where—he states—960 men fell to Arthur's sword.

Nennius's story is vastly amplified by Geoffrey of Monmouth or Gruffud Arthur, archdeacon of Monmouth, who *c.* 1150 wrote (or copied) *Historia Regum Britanniae*. This became the main foundation of all Arthurian legend. Robert Wace's *Brut d'Angleterre* (*c.* 1165) is a translation of Geoffrey's *Historia*, but an interesting detail was added, the celebrated Round Table. Layamon in his great poem *Brut* (containing 32,250 lines)—which is the earliest great poem written in the English language after the Norman Conquest—is considerably indebted to Geoffrey. (Of the two preserved copies of Layamon's *Brut*, both being in the British Museum, the earlier is attributed to a not later date than 1205.)

It is interesting to note that up to this point the Arthurian romance is purely pagan and is rich in magic, in stories of giants and dwarfs, and similar material. Apparently, *c.* 1210 Walter Map introduced Christian elements, and from that time onwards, on the Continent and in England, Arthur became the ideal of the true Christian knight. The importance of the Arthurian romance in the history of European literature has been emphasized by many historians. Here it will suffice to quote Prof. Magnus Maclean. "The influence of these tales upon the literature, the taste, the social life of the whole of Western Europe has been immense, and they are still as fresh and enchanting to the intelligent reader as any Arabian Night's Entertainment." Furthermore, with regard to its influence on English literature, Maclean writes: "Though the different branches of the Celtic people had been producing a literature from the sixth century, that literature does not seem to have affected English authorship, until in the Middle Ages it created the captivat-

ing Arthurian romances. Then, like the other Continental literatures, the English for the first time fell under the sway of the Celtic imagination."

Scottish Gaelic Book Production

Amid the darkness which enshrouds the early civilization of the Scottish Gael, the great St. Columba (521-97) stands out with relative clearness. Tradition is probably correct in ascribing to him the largest share in the great work of civilization accomplished by the missionaries who brought Christian teaching to the heathen tribes of Alba. When Columba first took possession for Christ of the little island of Hy—which under the name of Iona (see p. 443) achieved fame in the Christian world—he founded upon it a monastery which furnished the atmosphere most suitable for raising a literature; this soon took root and began to grow.

Hy or Iona became more than a religious retreat and a centre of learning. Every main settlement which the saint and his disciples founded, as from Iona they pushed their Christian conquests— whether in the bigger islands of the Hebrides or in the Pictish main- land country—consisted of a monastery for a body of clerics, from which they might disperse themselves in circuits among the sur- rounding tribes, returning to their home for shelter and mutual support. One of these monastic settlements was that of Deer, in Buchan, a district of Aberdeenshire, which projecting into the North Sea, forms the most easterly point of Scotland; and the legend in the *Book of Deer* preserves in traditional detail the circum- stances which marked the origin of this important establishment.

Thus, as for Ireland and Wales, it is possible to place the begin- nings of the literature of the Scottish Gael in the sixth century A.D., but very little is known of these beginnings. The paucity of early Scottish Gaelic manuscripts has been partly explained by Magnus Maclean, a leading authority in this field.

(1) Prior to the Norse invasions, Ireland and Scotland had a common language and literature; there was constant coming and going between the two countries, and no clean-cut distinction can be made between them. The Norse invasions made a profound change; for two centuries the kindred realms were kept apart, and never again was the original unity restored. During the period of disjunc- tion, both language and literature began to develop on different lines, and when the general conditions became settled, the language

and literature of the two countries were sufficiently distinct to be considered separate entities. The *Book of Deer* is the first monument of this departure in Scotland, whereas the *Book of the Dun Cow* (see p. 453) and *Liber hymnorum* (p. 448) are the earliest of the new period in Ireland.

DESTRUCTION OF EARLY SCOTTISH BOOKS

(2) Maclean suggests that not only in the Irish, but also in the Scottish monasteries "many men were arising within their sacred walls who had a genuine love and taste for writing—a love so great that they were not merely content with copying books, composing poems, or writing history, but they embellished them in a way which has excited the admiration of modern times". This statement is

Fig. X-15*a*

Copy of Adamnán, *Vita Columbae*, known as the *Dorbbéne Codex* (Schaffhausen, on the Rhine, Switzerland; *MS. Gen. 1*, fol. 43).

probably exaggerated at least in relation to Scotland, but there can be no doubt that also in the Scottish monasteries books were produced in early times. The marauding Norsemen saw to it that these books should not come down to us. The description of the havoc brought by the Vikings reminds us of the Gothic destructions in the Roman Empire, of the Mongol plunderings in Asia and eastern Europe, of the "Vandalism" in Spain and North Africa. In 794 "the marauding Norsemen emerged in the Western Isles, which from this time till the middle of the thirteenth century were destined to be favourite haunts and special theatres of their operations. They quickly found

and sacked defenceless Iona, and for years took spoils of the sea between that Island and Erin . . . in 802 they revisited Iona and burned its sacred buildings to the ground. Returning four years later, they put the whole community to the sword . . . the freebooters made another swift and dire descent upon the island in 825."

"Once more, on Christmas eve in 986, the famous monastery of Hy, ever rising on its own ashes, was attacked and destroyed by

Fig. X–15*b*

The *Book of Deer* (University Library, Cambridge, *I.i.b.32*; fol. 85).

the successors of these old Danes, and this time the abbot and fifteen monks were put to a violent death. From Orkney and Shetland, and the coasts of Caithness and the Hebrides the hardy Norsemen swooped down upon Eastern Scotland as well as upon the English and Irish seaboards, until at length they made themselves masters of a great part of the country" (Maclean). The havoc was so great that the pleading "From the fury of the Northmen, good Lord, deliver us!" was introduced into the Litany. The author of the *Wars of the Gael with the Gaill* (*i.e.* the Norsemen), a copy of which is preserved in the *Book of Leinster* (written *c.* 1150; see p. 453 f.), writes "In a word, even if there existed a hundred sharp, ready, cool, never-resting brazen tongues in each head, and a hundred garrullous, loud, unceasing voices for each tongue, they could not recount nor narrate nor enumerate nor tell what all the Gael suffered in common, both men and women, laity and clergy, old and young, noble and ignoble, of hardship and of injury, and of oppression in every house from these valiant, wrathful, foreign, purely pagan people."

Monasteries and other centres of culture were favourite objects of attacks. "It was not allowed," wrote the historian Keating, "to give instruction in letters. . . . No scholars, no clerics, no books, no holy relics were left in church or monastery through dread of them. Neither bard nor philosopher nor musician pursued his wonted profession in the land." And the *Wars of the Gael with the Gaill*, after having described the endurance of the few remaining scholars, mentions that "their writings and their books in every church and in every sanctuary where they were, were burnt and thrown into water by the plunderers from beginning to end (of the Viking invasion)". Maclean therefore concludes—perhaps with some exaggeration— "Countless numbers of the illuminated books of the men of Erin and Alba thus perished."

(3) Two other results of the Norse invasions may be mentioned. First, when the condition of life became such that men could no longer cultivate the arts, the production of books became more and more rare or even non-existent. Second, numerous monks and missionaries fled to the Continent with such books and manuscripts as they could save from the violence and destruction of the invaders. In consequence, there followed a long period of sterility in Scottish Gaelic literature and book production.

The "Life of St. Columba"

In Magnus Maclean's opinion, the Schaffhausen copy of

Adamnán's *Vita Columbae*—Fig. X–15 *a*—is the oldest Scottish book in existence. It is an interesting manuscript of sixty-eight leaves (measuring about 11 × 9 inches), in a very early binding, which is perhaps the original one. The sides of the binding are of beechwood (greatly worm-eaten) covered with calfskin; the front would seem to have been formerly secured by clasps; the sewing of the back is very rude and rather curious. The text is in Latin in double columns. There are numerous capital letters; some of them are of great size and adorned with red and yellow paint. There are three handwritings, of which two seem to be the work of the same scribe, the third being that of later corrections in spelling.

This codex is one of the few Celtic manuscripts, which give us the name of the scribe and may be dated with relative precision. The colophon, at the end of the manuscript, says: "I beseech those who wish to transcribe these books, yea, rather, I adjure them by Christ, the judge of the world, after they have them diligently transcribed, carefully to compare and correct their copies with that from which they have copied them, and also to subjoin here this adjuration: 'Whoever readeth these books on the virtues of St. Columba, let him pray to the Lord for me Dorbene that after death I may possess eternal life'." This Dorbbéne was probably the man bearing this name who was abbot-elect of Iona in 713, but died that same year before assuming office. Adamnán, the author of this work, was the ninth abbot of Iona, who died in 704. The *Dorbbéne Codex* is reproduced in Fig. X–15 *a*; see also p. 468.

As a matter of fact, this codex can hardly be considered a Scottish Gaelic production. Iona was, indeed, an Irish Gaelic colony. Early in the fifth century, a small kingdom had been founded in Argyll by settlers from Ireland; their "descendants had always kept in touch with their Irish kinsmen, and throughout the sixth century their kings seem to have regarded the king of Ulster as their lord. Under Aedan mac Gabrain, who became their king in 574, they suddenly appear as a formidable people" (F. M. Stenton), but in the seventh century their influence declines, and "their importance in the history of the time rests on their possession of the sanctuary of Iona".

The Book of Deer

It is generally assumed that the earliest manuscript containing Scottish Gaelic glosses is the *Book of Deer* (University Library, Cambridge, *I.i.b.32*). Fig. X–15 *b*. The codex is of small but rather

wide octavo form of eighty-six leaves. It contains, in Latin, *St. John* and portions of the other three Gospels in the "Irish" text which —as already said—mainly corresponds with the Vulgate, but preserves also occasional readings from earlier versions; this codex appears to be a careless transcript of a corrupt text. Included also in Latin is a fragment of an Office for the Visitation of the sick, a copy of the Apostles' Creed, and of a charter of King David I to the clerics of Deer. The glosses in Gaelic are the interesting legend recording the foundation of the monastery, the colophon, and copies of grants made to the monastery of Deer: they are written on blank pages or in the margins. The ornamented capital letters and the illuminations will be dealt with in the forthcoming book on *Illumination and Binding*. The *Book of Deer* is generally assigned to the ninth century, while the six Gaelic glosses may be dated from the late tenth or early eleventh century to the middle of the twelfth century. In the opinion of leading authorities the *Book of Deer*, whose early connections with the monastery of Deer seem to be unquestionable, may have been written by a native scribe of Alba.

Other Books

The earliest manuscript written entirely in Scottish Gaelic is the codex known as *The Book of the Dean of Lismore*: it is so called because it is generally held that Sir James Macgregor, at that time Dean of Lismore in Argyllshire, and his brother Duncan were its compilers. The manuscript, preserved in the National Library, Edinburgh, consists of 311 folios in quarto, and is a collection of Gaelic poetry taken down from oral recitation in the years 1512 to 1526. The poems, composed by about sixty-six poets, vary from less than ten lines to a hundred lines; on the whole there are about 11,000 lines, 800 of them in the early style, known as Ossianic. The manuscript is written in the current Roman hand of the period, and the spelling is phonetic. The *Book of Clanranald* (of which two manuscripts are extant, known as the *Black* and the *Red*), and the *Book of Fernaig*— both of the seventeenth century—are the only ones of the Scottish Gaelic literature prior to the eighteenth century which deserve mention.

Anglo-Saxon Book Production

Lord Macaulay remarked that Britain received only a faint tincture of Roman arts and letters. Of the western provinces which obeyed the Caesars she was the last that was conquered, and the

first that was flung away. . . . No writer of British birth is reckoned among the masters of Latian poetry and eloquence. It is not probable that the islanders were at any time generally familiar with the tongue of their Italian rulers. From the Atlantic to the vicinity of the Rhine the Latin has, during many centuries, been predominant. It drove out the Celtic; it was not driven out by the Teutonic. . . . In our island the Latin appears never to have superseded the old Gaelic speech, and could not stand its ground against the German. . . . The scanty and superficial civilization which the Britons had derived from their southern masters was effaced by the calamities of the fifth century.

Roman Britain

Another great historian of the last century, J. R. Green, wrote: "In Britain alone Rome died into a vague tradition of the past. The whole organization of government and society disappeared with the people who used it. . . . Its law, its literature, its manners, its faith, went with it. The new England was a heathen country."

Even more important, from the point of view of the subject here dealt with, is the following statement by Prof. E. A. Lowe: "Whereas Roman walls, Roman inscriptions, camps, villas, mosaics, coins, pottery, are to be seen in plenty, there is not a single manuscript or scrap of manuscript which may with any semblance of justice be ascribed to the pre-Saxon period."

Cultural History of Early England

Modern research and historical criticism have done much for early English culture and learning. Not long ago, the subject might have been regarded as a tangled web of fact and fiction. Inquirers found it hard to thread their way through the unsifted mass of materials, to distinguish the true from the fabulous, authentic history from myth and legend. English civilization has a fascinating history, going back for over fourteen hundred years. The records available here and there, from which the development can be traced, carry us back to the first half of the sixth century A.D., to St. Aidan, in the north, and St. Augustine, in the south. From the time Christianity was introduced by these men, English civilization has a history, which—although with some exceptions—is continuous and verifiable.

The cultural history of pagan England, however, is still enshrouded in mystery. We know from later records that there existed sagas and poems, but they were probably based on oral tradition.

We may assume, therefore, that there was no native book production before the seventh century of the Christian era.

In that century, England suddenly became one of the main centres of Christian culture. At its zenith, it "influenced the whole development of letters and learning in western Europe. . . . There is nothing in European history closely parallel to this sudden development of a civilization by one of the most primitive peoples established within the ancient Roman Empire. . . . The comparative security . . . permitted the cultivation of learning at many different centres, the creation of libraries, the multiplication of books, and a certain amount of intercourse between scholars" (F. M. Stenton).

This awakening was due mainly to two streams of influence, one coming from Irish missionaries, the other from Roman emissaries. The two movements, at first independent of each other, and later going on side by side, were at times mutually helpful and conjoined, but also at times—though on the whole only for a short period— they seemed mutually hostile. Although both the Irish and the Roman learning were based on classical scholarship, they present quite distinct features. In Sir F. M. Stenton's opinion, the main Irish influences are: (1) the curiously involved and artificial Latin style, which in its extreme form approximates to a secret language of the learned; (2) the Irish scripts—although English scribes of the seventh and eighth centuries produced masterpieces, such as the *Codex Amiatinus* (see p. 501 f.), written in superb continental writing, for all except the most solemn purposes they normally used one or other of the Irish scripts: the result is that it is sometimes impossible to distinguish the products of English and Irish *scriptoria* on palaeographical evidence alone; (3) in the penitential system of the early English Church, there was a strong Irish element. On the other hand, Stenton remarks that it is very difficult to distinguish between the Irish and continental strains in the substance of English learning. There is, indeed, evidence that certain old Latin texts of the Bible, "undoubtedly of Celtic origin", were used by English scholars of this period, and apparently "Old English religious poets were familiar with a large body of apocryphal literature, discountenanced by the Roman church, but popular in Ireland". Notwithstanding this, Stenton believes that the debt owed by early English scholarship to the Irish has often been exaggerated.

CONVERSION OF ENGLAND

Pope Gregory the Great (590–604), considered it his task to

christianize Britain and is said to have formed a plan for buying English youths to be given to God in the monasteries. In the year 597 St. Augustine, made Abbot by the Pope, landed with forty monks in the Isle of Thanet, in Kent, and through the influence of Queen Bertha, a devoted Christian, was received sympathetically by King Aethelbert, who gave him a home at Canterbury, and who himself shortly afterwards was converted to Christianity. In 601, Augustine received from the Pope the pallium as Archbishop of Canterbury and Primate of Britain. His mission extended the monastic system and encouraged the resort hither of foreign monks. In 634, the Franco-Roman priest Birinus converted the West Saxons. In 634-5, St. Aidan, a monk in the monastery of Iona, founded by St. Columba, preached the Gospel in Northumbria, having his centre at Lindisfarne, of which he became bishop.

Indeed, when Oswiu became king of Northumbria, he sent to the monastery of Iona—where he had lived in exile as a youth—for a bishop, and in 634 a company of enthusiastic Irish monks, headed by St. Aidan, settled in Lindisfarne.

Lindisfarne, also known as the Holy Island, is an island 3 miles long and $1\frac{3}{4}$ miles broad, off the coast of Northumberland, not far from royal Bebbanburgh or Bamburgh or Bamborough. For a whole generation it remained the only bishopric in Northumbria, and the main cultural centre. Under Aidan's successors, Finan (651–60) and Colman, both monks from Iona, a bitter controversy developed in the Northumbrian Church between the adherents of Roman and of Irish customs (see also p. 493). The Roman party won at the Synod of Whitby (in 664); tradition has it that the king declared that, as between St. Peter and St. Columba, he would obey St. Peter who is in charge of the keys of heaven. But Irish influence was not eliminated. Eata, a pupil of Aidan, was abbot of the important monastery of Melrose, and later became bishop of Lindisfarne. He was a teacher and friend of the greatest saint of seventh-century Northumbria, Cuthbert, who "belongs to the world of ancient Irish saints". Cuthbert was bishop of Lindisfarne from 684 till he died in 687.

By then, the centre of Northumbrian Christian culture passed to the twin monasteries of Wearmouth and Jarrow (see p. 505). Lindisfarne priory was destroyed in 893, and in 1093 its remaining materials were used to build a Benedictine priory. Lindisfarne was ravaged several times by the Danes, and the increasing importance of the see of Durham caused it to be ultimately abandoned. "The Cathedral Church of Durham in the Middle Ages"—writes the

leading expert in this subject—"can have had few more remarkable features than its wealth of books, or fragments of books, surviving from the golden age of the early English Church—an inheritance from the original foundations of Lindisfarne and the twin monasteries of Jarrow and Monkwearmouth" (R. A. B. Mynors).

In the second half of the seventh century, missionaries of Rome and of Ireland proclaimed the Gospel of Christ all over England, the former mainly in the south, the latter mainly in the north. "The effective conversion of Northumbria was the work . . . of a missionary enterprise which had come to Lindisfarne from Iona, and to Iona from the Church in Ireland. Upon this Celtic foundation built men like Wilfred and Benedict Biscop, who were inspired by the traditions of the Continent . . ." (Mynors). Generally speaking, Christianity among the Anglo-Saxons was a missionary undertaking, and it encouraged the foundation of organizing centres. Later on, the abbeys partook rather of the nature of large training colleges, where learning and book production were carried on.

At first, the missionaries did not need a Bible written in the native language—the common people could neither read nor write, anyway; but before long a version of the Bible or a portion of it became part and parcel of English literature. Besides, wherever Christianity was accepted, a system of worship was begun, which needed service-books in the native language and other books without which the new faith would not have prospered.

BEGINNINGS OF EARLY ENGLISH LITERATURE

Space does not allow us to examine the roots of English literature in the pre-Christian heroic poems of the early Teuton settlers, and even less, the poems which may have been brought by them from their previous home across the North Sea, and the tales of adventure and of mighty deeds of mythical Germanic heroes in a period before the Anglo-Saxon forefathers left their own country for Britain.

These pre-Christian poems—they contain, indeed, so few traces of the Christian faith that it seems quite unlikely that they were written by authors who knew anything of Christianity—have been preserved in relatively late copies; we may mention *Widsith*, an early English poem on the scop, or "The Traveller", *Deor's Complaint*, recorded in the *Exeter Book*, of A.D. *c.* 980, *The Fight at Finn's Borough*, but particularly *Beowulf* (Fig. X–16), which contains over 3,000 lines; the spells form a literary group of their own, one of them (*Wyrta*) containing as many as sixty-three lines of verse; another one, the Christian spell *Bethlem*, may go back to a heathen original. The

Fig. X–16

Beowulf (British Museum, *Cott. Vit. A.xv*; fol. 176 *verso*, ll.2105–27).

unique copy of *Beowulf* (Fig. X–16), preserved at the British Museum, was written A.D. *c*. 1000, but it has been suggested that this manuscript was transcribed from a copy written at least 300 years earlier. Another precious Cotton manuscript in the British Museum is the tenth-century copy of *Heliand*, "almost the only waif of the Old Saxon literature that has survived" (Esdaile).

These poems have been preserved in West Saxon manuscripts of the tenth century, just referred to, but they "contain many ancient forms of words, which show that an Anglian original lies behind the existing texts . . . it seems clear that the poems took substantially their present shape in a period which may be arbitrarily defined by the birth of Bede in 672 and the final departure of Alcuin from England in 782" (Stenton).

However, there can hardly be any doubt that "the Christian learning of the seventh-century schools was confronted by a heathen culture which had already given rise to a literature. . . . Most of the great stories which had arrested the imagination of the Germanic world had received a definite, though by no means stereotyped, form at their hands. Reflection on life and its vicissitudes was already being expressed from the heathen standpoint in verse to which there is no close parallel elsewhere in Europe. To a strict churchman of the period this pagan literature was intensely distasteful. . . . The clergy became more tolerant of this tradition as the danger of a heathen reaction died away, and, indeed, played an essential part in its transmission. The English poetry of the heathen age was first written down by Christian clerks, and most of it only survives in texts which are affected by Christian ideas and imagery" (Stenton).

It must be remembered that, as in the case of early Irish literature, whereas the earliest preserved was chiefly occupied in Christian devotional and sacred poetry, the heathen or half-heathen war songs of the minstrels, attached to the courts and great houses, were destined to die out unwritten (unless they chanced to be collected and edited, more than probably with great changes, in later times), because the monks did not transcribe them.

Caedmon and Cynewulf

The first piece of true English literature which we can actually date is a fragment of a religious epic, a Bible paraphrase, of Caedmon, a poor brother in the abbey of Lady Hilda (the grand-niece to King Edwin; she was abbess of a "double monastery" for both

monks and nuns, from 657 to 680) at Streoneshalch (Whitby), North Riding, Yorkshire. Caedmon is generally considered as the "father of English song". The only trustworthy information about him is in Bede's *Ecclesiastical History*, iv. The hymn which Caedmon is said to have composed in his dream is preserved in manuscripts of Bede's *History*, now in Cambridge and elsewhere. A manuscript, containing a paraphrase of parts of the Bible, is preserved in the Bodleian Library, Oxford (*Junius, xi*); previously it was attributed to Caedmon: it is now assigned to the "school of Caedmon".

Indeed, as most of the early English religious poetry which has survived relates to subjects which according to Bede have been dealt with in verse by Caedmon, a considerable portion of it has at one time or another been attributed to him. It is agreed, however, by the leading authorities in this field that the only verses which can be definitely assigned to him, are the nine lines copied into the oldest manuscripts—already referred to—of Bede's *Ecclesiastical History*.

However, Caedmon's verses are definite evidence that already in the seventh century the technique of the heroic epic was being applied to Christian subjects. Judging from the archaic language in the preserved West Saxon manuscripts of the late tenth century, and from other evidence (such as the celebrated Northumbrian cross, of the late seventh century, at Ruthwell, near Dumfries, in Scotland, containing part of the poem on the Crucifixion from the *Dream of the Rood*), it may be assumed that the earliest English religious poetry flourished in Northumbria from the late seventh century till the middle of the ninth century. Some religious poetry has been assigned to Mercia, where apparently in the early ninth century Cynewulf composed his poems; they are partly preserved in the *Vercelli Codex*, of the late tenth century, which also contains a complete text of *Dream of the Rood*.

Sir F. M. Stenton—a leading authority on Anglo-Saxon England —considers as the oldest piece of English historical writing now extant, an anonymous life of St. Cuthbert. It was written at Lindisfarne; it refers to Aldfrith, son of Oswiu, king of Northumbria (who reigned from 685 till 704), as "Aldfrith, who now reigns peacefully".

The late seventh-century Northumbria may thus be referred to as the starting point of English poetry and prose. Therefore, Sir F. M. Stenton is probably right in his suggestion that King Aldfrith's influence on the development of Northumbrian learning (and, we may add, of English learning in general) was much greater than appears on the surface of history, and that he stands with Alfred of

Wessex among the few Old English kings who combined skill in warfare with a desire for knowledge. It can hardly be doubted that the king himself took an active part in the cultivation of letters and learning, that he wrote Irish verse, and that he was one of the most learned men in his kingdom.

The Danish raids (since 835) and the invasion of the Danish armies (since 865) destroyed the northern English civilization and interrupted the current of Northumbrian Old English poetry.

Fig. X-17a

Maccabees, i; fragment of about half a leaf in a sixth-century uncial hand (Durham Cathedral Library, *B.iv.6*; Mynors's list, No. 1).

EARLY ENGLISH BOOK PRODUCTION

It is known that, for about its first four centuries, English literary production was not very original, although it was outstanding in comparison with other "national" literatures. There were, however, two fields in which England was hardly surpassed by any Christian country of that period: writing and "illuminating" of books.

At the same time as St. Columba founded the monastery of Iona —and, apparently, brought there, from Ireland, the art of writing manuscripts—Christianity and books reached this country also from another source, Rome. Roman Christianity spread mainly south of

the Wash, Irish Christianity mainly from the Wash to the Firth of Forth. The Roman influence may also be seen in the fact that in the south, the Runic inscriptions are very rare (see, for instance, *The Alphabet*, p. 509); indeed, the Runes (regarded as heathenish relics) were superseded by the Roman alphabet.

Rome or Ireland? St. Peter or St. John? was now the practical question. Rome won: the vexed question was settled in 664 at the Synod of Whitby (see p. 487). The followers of the Irish Church acquiesced, or else returned to Scotland; the English Church remained in close communion with the Roman Church. But, as with most things in this great Island, there was no clear-cut course

Fig. X–17*b*

Canterbury (or *St. Augustine*) *Gospels* from St. Augustine's, Canterbury, now in Corpus Christi College, Cambridge, *MS. 286*).

of the settlement of this religious controversy. Considerable mixture of the two streams of influence continued to take place even when the Roman letters, arts, and organization became predominant.

"At the Council of Whitby—writes Prof. Lowe—the conflict between the Roman and the Celtic liturgy ended in a victory for Rome. The less dramatic conflict, however, between the two scripts, ended in a victory for the Celts."

The typically English amalgamation may be seen particularly in the development of book production. Indeed, it is still held by many scholars, despite the recent theory of Masai and others, that the great Anglo-Irish school of writing and illuminating manuscripts of the seventh and eighth centuries originated in Ireland and was carried by Irish missionaries through Scotland into Northumbria.

On the whole, Lowe's conclusion stated in 1935 seems to be still valid: "It is nothing strange if, when Insular manuscripts of the late seventh or early eighth century are in question, the palaeographer finds himself unable to say whether they were written by an English or by an Irish scribe, since at that period the English were still imitators, following closely the methods of their Irish masters. We have good examples of this in Cambridge, Corpus Christi College 197 (No. 125), and in the main portion of Durham A.II.17 (No. 149), to mention but two." This statement may be amplified by the following opinion expressed by another leading palaeographer:

"In the books before us we see the two streams of influence, Insular and Continental, flowing on side by side. The Irish—then, as ever, a law unto themselves—had developed, along with a typical Celtic style of illumination, a kind of script completely unlike anything else . . . we call it 'insular' majuscule or minuscule. The books brought back from the Continent by Benedict Biscop would be for the most part in the clear rounded hand . . . which we call 'uncial'. Both these styles of writing were available as models to the Northumbrian scribes, and both they carried on simultaneously without distinction" (Mynors).

There is a fly-leaf at the end of the twelfth-century codex *B.iv.6* of Durham Cathedral (No. 75 of the list given by Mynors), containing part of *Maccabees*, i, written in a sixth-century uncial hand. In Lowe's opinion "the probability is that the manuscript was written in Italy and constitutes one of the excellent sixth-century Italian models which were available in Northumbria". See Fig. X-17 *a*.

In the opinion of another leading authority, "whatever may have been the class or classes of manuscripts, which St. Augustine

Fig. X-18

(Left) Moore Bede (University Library, Cambridge, Kk. v. 16); most important copy of Bede's *Historia Ecclesiastica Gentis Anglorum*, written A.D. c. 737, "presumably in the North of England or possibly in a Continental centre with Northumbrian connections" (Lowe); (right) Aldhelm, *De Laudibus Virginum*, "written probably on the Continent, in a Germanic centre with South English connections" (Lowe); assigned to the eighth or ninth century.

Fig. X-19

(*Above*) *Martyrology of St. Willibrord* (National Library, Paris, *Lat. 10837*; portion of fol. 3); (*below*) St. Gregory the Great, *Liber Pastoralis*, translated by King Alfred (?) from Latin into Old English (Bodleian Library, Oxford, *MS. Hatton 20*, portion of fol. 2), *c.* 890.

and the Roman missionaries brought with them or imported into England, no national form of handwriting was evolved from them. That these manuscripts were written in uncials and half-uncials, or mixed characters, the ordinary literary hand of Italy, may be assumed. But uncial writing was never received with favour in these islands" (Thompson).

ANGLO-SAXON MANUSCRIPTS

The relatively few Anglo-Saxon manuscripts of the eighth to the tenth centuries which have been preserved are generally divided into three groups: (1) Northumbrian, which is by far the most important; (2) Mercian: and (3) South English, chiefly West Saxon. The Northumbrian hands were nearer to the Irish than those of the other two groups, while the Mercian and West Saxon hands were very similar.

As in Ireland, there were in England two main styles of writing: (1) the round hand or majuscule, the Insular Anglo-Saxon half-uncial, which was used during the eighth and ninth centuries, mainly for books and rarely for charters; (2) the pointed hand or minuscule, which was used for both books and documents, but is chiefly seen in the latter. In the course of the tenth century a marked change took place in the English minuscule, chiefly under the influence of the French minuscule, and in the eleventh century the minuscule hand became so changed—the letters became larger and the strokes above and below the lines became longer than before— that it cannot any longer be called a pointed hand.

The relationship between the two hands has aptly been described by Prof. E. A. Lowe. "It is clear that the two types of Insular script were early in use, majuscule and minuscule. . . . Majuscule came before minuscule, not only in rank but also in time. The second may be derived from the first, but not vice versa. . . . The priority which they (the Insular scribes) give to majuscule in the hierarchy of scripts is conclusive. Whenever a fine liturgical book was required it was written in majuscule, even though minuscule was known at the time. In writing a minuscule text the headings and colophons, for which it was customary to use an older and more dignified script, are in majuscule; in short, Insular scribes invariably give majuscule the place of honour, and that can only be because it is the older type."

According to Sir E. M. Thompson, England borrowed the Irish pointed minuscule hand, the resemblance between these two

hands being very close. Moreover, the Irish minuscule existed in the seventh century, "it probably had been formed much earlier", and in Ireland "it must have been the common form of handwriting in use among the educated. Once introduced into Northern England, it rapidly spread through the country. By the eighth century, it had been cast into a set form to serve as a literary hand, of a fine ample type, such as seen in the copy of Bede's *Ecclesiastical* History" (Thompson), reproduced on Fig. X–18. An excellent specimen of the South-English minuscule hand is given in Fig. X–18. The

Fig. X–20

Northumbrian uncial manuscript of the seventh or eighth century (Durham Cathedral Library, *A.ii.17*; fol. 106).

Fig. X–21

The *Durham Rituale,* early tenth century (Durham Cathedral Library, *A.iv.19*; p. 100; Mynors's list, No. 12).

Anglo-Saxon minuscule spread very early to the Continent, and particularly to the monastery of Echternach (see p. 510 f.), founded in 698. Fig. X–19, *above*, reproduces a portion from the earliest dated Anglo-Saxon codex, written in minuscule hand: it was written in the monastery of Echternach between A.D. 703 and 721.

NORTHUMBRIAN CODICES WRITTEN IN MAJUSCULE

Two important Northumbrian manuscripts clearly show the influence of the Italian uncial hand. (1) The *Gospel of St. John*, preserved in Stonyhurst College, in Lancashire (at one time it belonged to Durham Cathedral; later it was preserved in Liège). It was "written in Northumbria in the late VIIth century in a very good, small uncial hand" (Mynors). This codex contains ninety leaves, measuring about 13.5 by 8.8 cm. It is neither illuminated nor otherwise decorated, but it is covered with an exceptional binding; if the latter is of the same date as the text (see the book on *Illumination and Binding*), it would be the oldest European book to have survived in its original binding. (2) Part of codex *A.ii.17* (leaves 103–11) of Durham Cathedral—No. 3 in Mynors's list—is written "in large Northumbrian uncial of the late VIIth or early VIIIth century". Its text "is exceedingly close to that of the Lindisfarne Gospels" (Mynors). Fig. X–20.

Other Northumbrian manuscripts, however, seem to show Irish influence. Part of the Durham codex *A.ii.17* (leaves 2–102), containing the *Four Gospels*, each preceded by a summary and prologue, is in late seventh- or early eighth-century writing, and was produced in a Northumbrian "great centre of calligraphy in the direct line of Irish tradition, or else in Ireland itself" (Lowe). Mynors assigns the text to the Irish family, sharing as it does some peculiar readings with the *Mac Regol Gospels* (see p. 464) and the *Book of Kells* (see p. 456 ff.); the ornament is related to that of the *Lindisfarne Gospels*. The manuscript is now incomplete; three lines from leaf 70 were presented (in 1700) by the Dean and Chapter of Durham Cathedral to Samuel Pepys, and are now in Pepys Library, Magdalen College, Cambridge (*MS. 2981*, No. 19). The ornament of this codex will be discussed in *Illumination and Binding*.

A fragmentary manuscript of Durham Cathedral (No. 6 in Mynors's list, corresponding to *C.iii.20* with fly-leaves of *A.ii.10* and *C.iii,13*), consisting of twelve leaves from a *Gospel*, is written in a large seventh- or eighth-century insular majuscule hand with

ornamental initials. "The text is of the Irish family [of manuscripts], and it is possible that the volume when complete contained not the Gospels only, but the whole New Testament" (Mynors). *Codex A.ii.16* of Durham Cathedral (No. 7 in Mynors's list), containing the *Four Gospels*, is a copy written in "the VIIIth century and doubtless in Northumbria . . . in a text of Irish type". Three hands can be distinguished. Two fly-leaves of Durham codex *C.iv.7* (Mynors's No. 10) are "very well and accurately written in an insular majuscule hand of the VIIIth century, and a fragmentary leaf of the *Durham Rituale (A.iv.19*; Mynors's No. 12) is in "an VIII/IXth-century Anglo-Saxon hand". For the beautiful *Durham Rituale*, containing Anglo-Saxon glosses, see Fig. X–21.

Codex B.ii.30 of Durham Cathedral (No. 9 in Mynors's list), containing an abbreviated version of Cassiodorus, *Commentary on the Psalms*, is one of the most important manuscripts produced in Northumbria. "An impressive book: the text is the work of at least six expert scribes, and each of its three main divisions had a full-page frontispiece, of which two survive." The writing, in excellent "insular" style, dates this codex to the middle of the eighth century.

THE LINDISFARNE GOSPELS (Fig. X–22 and XI–4, *right*)

The basis of the Masai theory, mentioned on p. 445 and *passim*, is the great and rightly celebrated *Lindisfarne Gospels*, already referred to. The tenth-century author of the Saxon paraphrase of the Latin text, tells us in his "post-scriptum" at the end of the volume that the book was written by Eadfrith (bishop of Lindisfarne from 698 to 721), in honour of St. Cuthbert; that it was covered and "made firm on the outside" by Ethilwald (who was bishop from 724 to 740; he, thus, bound the book), and that Billfrith the anchorite wrought in smith's work the ornaments on its cover (*i.e.* the book was probably encased in a binding of precious metal set with jewels, which have long since disappeared). However, there can be hardly any doubt that the book—a fine specimen of Saxon calligraphy—was written shortly after St. Cuthbert's death (A.D. 687), *i.e.* not later than, say, A.D. 700.

This precious book has had an interesting history: written in honour of St. Cuthbert, it was preserved at Lindisfarne with the latter's body, but in 875, in the flight before the Danish invasion, body and book were carried away. For over a century, the book "rested" at Chester-le-Street; then it was brought to the hill of Dunholm, where a new church (the present Durham Cathedral)

was built over Cuthbert's body, and the book became the possession of the Dean and Chapter of Durham, but was later returned to the monastery of Lindisfarne. At the dissolution of the monasteries it was taken abroad and stripped of its jewelled covers, but fortunately it was acquired by Sir Robert Cotton for the famous Cotton Collection, and with this it passed into the British Museum, where it is now preserved (*Cotton, Nero D.iv*). It is also known as *Codex Lindisfarnensis* or *Durham Book*, and quoted as *Codex Y*. (Sometimes it was called *St. Cuthbert Gospel*.)

Fig. X–22

The *Lindisfarne Gospels* (British Museum, *Cott. Nero D.iv*).

ENGLISH *Versus* IRISH

In the opinion of the present writer, the problem of the artistic relationships of the Irish and English manuscripts is still open. The fact that the earliest illuminated North English manuscripts extant may be older than the Irish—if we agree that the *Book of Durrow* is Northumbrian—is of no great significance, as preserved illuminated manuscripts of this period are very scarce indeed; there is no doubt that there were illuminated Irish manuscripts in the seventh century, but they have not come down to us.

We can follow up the development of the Irish majuscule or semi-uncial book hand, and it appears that the North English semi-uncial book hand was at first nothing more than the Irish hand transplanted into new soil, so that the former is scarcely to be distinguished from the latter. There is the further fact that the ornamental designs of the Irish manuscripts could have been copied from, or modelled on, the designs of local works of art, otherwise the origin of these designs and of those of the magnificent *Lindisfarne Gospels* (except for the representations of the human figures, which are undoubtedly of continental origin), would be inexplicable if we took for granted a Roman or continental origin, unless we assume at least indirect Oriental influences.

On the other hand, while Bieler credits the Irish—see p. 470 f.—with the creation of the Irish majuscule, which he tentatively dates to the middle of the sixth century A.D., and of the minuscule, placing its beginnings in the early seventh century—he thinks that the majuscule reached its perfection in Northumbria round about 700; and considering the *Book of Durrow* (see p. 456) as Northumbrian, he holds this codex and the *Lindisfarne Gospels* as the earliest specimens written in the type which is now known as the "Insular majuscule". Furthermore, "throughout the eighth century most of its pure representatives appear to be products of Northumbria or of Continental centres with Northumbrian connections. It was imitated, sometimes with a high degree of perfection, in other parts of England as well as in Ireland; yet its most finished specimen, the *Book of Kells*, may, after all, have been produced at Iona, about A.D. 800, thus testifying to a more direct Northumbrian influence". See, however, p. 458. The problem is, at any rate, very complicated.

May we tentatively suggest a compromise solution and assume that the style of the *Lindisfarne Gospels* represents a syncretism based on Irish and Roman-continental influences? Such a suggestion would

be in conformity with the internal evidence, as indeed is shown by
Sir Frederic Kenyon. The text of the *Lindisfarne Gospels* depends on
Italian and not Irish texts. According to Kenyon, the Irish text of the
Scriptures "is a considerably contaminated Vulgate, while the
English texts are the best Vulgate texts extant. This they owe to
their direct descent from Italian manuscripts of the best quality."
See also pp. 471, 486, 494 and *passim.*

CODEX AMIATINUS (Fig. VII-5)

Kenyon's statement is mainly based on this celebrated manu-
script, also known as *Codex Am.* or *A*, which is now preserved in the
Laurentian Library, Florence. It contains 1,030 leaves, measuring
20 inches × 13½ inches, written in Northumbrian uncial, in two
columns, of forty-four lines to the page. Experts consider this manu-
script as the best copy of the Vulgate that has come down to us
(see p. 284). It has been suggested that it represents Cassiodorus's
recension, which became the official text for his monastery at Vivarium
and for the whole of South Italy, and that it was derived from a
manuscript possessed by Eugippius, abbot of Lucullanum (now
the Castel dell'Uovo, at Naples), which MS. was believed in 558
to have belonged to St. Jerome himself. Scholars agree that it was one
of the three Vulgate copies of the Bible which, according to Bede,
Ceolfrid, Benedict Biscop's successor as abbot, caused to be made,
probably at his twin monasteries of Jarrow and Monkwearmouth in
the late seventh or early eighth century, and to be copied from
manuscripts brought from Italy by Ceolfrid himself. In 716, the
Amiatinus was chosen by the same Ceolfrid, who intended to present
it as a gift to Pope Gregory II, but died on his way to Rome. In
1585–90, the *Amiatinus* was used in the revision of the Vulgate by
Pope Sixtus V (see p. 284). It was preserved in the abbey of
Monte Amiata (hence its name "Amiatinus"), in Tuscany, whence
it passed to the Laurentian Library of Florence.

"The two sister manuscripts which he (*i.e.* Ceolfrid) left behind
him were supposed to have perished long since, until the late Canon
Greenwell of Durham found a single leaf of one of them, serving as
the cover of an old book, in a shop in Newcastle-on-Tyne; he gave
it in 1909 to the British Museum, where it is now Additional MS.
39999. Ten more leaves, from the same volume, with fragments of
an eleventh, which had likewise been used to make wrappers for
documents, came to light about the same time among the muniments
belonging to Lord Middleton; these were acquired by the British

Museum in 1937 for the sum of £1,000, and are now MS. 45025" (Mynors).

The *Codex Amiatinus* is thus an Anglo-Saxon production, having been written by a native artist, though it is "almost entirely Italian in style and shows no weakening whatsoever in the direction of a barbaric Celtic or English ornamental apparatus . . ." (Kendrick). On the other hand, its most important miniature, representing the Christ in Majesty (folio 796 b) is "crude and unsophisticated" as compared with those in the *St. Augustine Gospels* (Fig. X–17 *b*), "though the original the artist had before him must have been very close in style to the pictures in the Corpus book" (Oakeshott): see *Illumination and Binding*.

In Sir E. M. Thompson's opinion, however, the *Codex Amiatinus* and similar books "were the work of Italian scribes who had been brought thither."

The text of the *Lindisfarne Gospels* is practically the same as that of the *Amiatinus*. Even more important is the fact that "before each Gospel is placed a list of festivals on which lessons were read from that book; and, strange as it may seem at first sight, it has been shown that these festivals are unquestionably festivals of the Church of Naples" (Kenyon). It has been therefore suggested that these tables of lessons (and perhaps also the whole book) were copied from a manuscript brought from Italy by Hadrian, abbot of a monastery near Naples, who accompanied Theodore of Tarsus sent in 669 by Pope Vitalian to England to be Archbishop of Canterbury.

That the text possessed by Eugippius "should have been taken to Northumbria and survived there is a strange historical accident, but carries with it the rider that all books with real affinity to the Gospel-text of *A* have a Northumbrian origin" (Burkitt). It should be realized that the twin houses of Wearmouth and Jarrow, only about six miles apart, were in the late seventh and early eighth centuries the Christian intellectual centre of northern England (see p. 506) and the most flourishing home of Christian scholarship in western Europe; in this connection, it will suffice, once more, to mention the names of Benedict Biscop and Ceolfrid.

EARLY ENGLISH SCHOLARS

Theodore and Hadrian, Aldhelm, Bede, and Alcuin are considered the great names of early English learning. "The ascendant phase of English scholarship may end with Alcuin," but for another

half century after his death English religious houses showed a living interest in learning and produced works remarkable in their accomplishment in the style of writing.

When in 668 Pope Vitalian, on the advice of Hadrian—the learned monk of African origin, who has been referred to on p. 505—consecrated the monk Theodore of Tarsus as archbishop of Canterbury, he hardly realized that his nominee—though already a great scholar, philosopher and theologian—would prove himself a great ecclesiastical statesman, and was destined to give unity and organization to a church which at the time was passing through a most critical period. Theodore, "the last known pupil of the schools of Athens" (F. M. Stenton), was also an outstanding scholar in classical lore.

Hadrian, who accompanied Theodore, remained with him in England, became abbot of the monastery of St. Peter and St. Paul outside Canterbury, and worked beside him as scholar and teacher—he taught at Canterbury for nearly forty years. The school at Canterbury had a great reputation, and included among other studies, Roman law, Greek and Latin. According to Bede, in his time there were former pupils of Theodore and Hadrian to whom Latin and Greek were as familiar as their own language, and one of these pupils, the bishop of Rochester Tobias, was an excellent Greek scholar. Thus, for the school of Canterbury a proficiency in classical learning was claimed, "rivalled so far as is known, by no other learned community north of the Alps" (F. M. Stenton).

For Aldhelm see p. 508, for Bede p. 509 f., and for Alcuin p.512. ff.

ABBOT BENEDICT BISCOP

The twin monasteries of Wearmouth and Jarrow (see also p. 505), founded by St. Benedict Biscop may be considered, in a certain sense, as one of the earliest Universities, or the earliest, of England.

The historian F. M. Stenton, has rightly emphasized the fact that Benedict's importance in the history of English learning is due to the libraries which his knowledge of southern cities enabled him to bring together at his monasteries. "When he died, in 689, he had brought into being two neighbouring monasteries, governed as a single community, which possessed an endowment in relics, religious ornaments, and books unparalleled in England. Without this great library, it is doubtful whether Bede—who was a member of the Jarrow community from the age of seven till he died, at the age of

sixty-three—would have acquired his remarkable scholarship".
Benedict had brought some beautiful books from Rome: these
books perhaps included the manuscript of the *Acts of the Apostles* in
parallel columns of Greek and Latin, which is known as the *Codex
Laudianus*—having been presented by Archbishop Laud (who
apparently acquired it in Germany)—and is preserved in the
Bodleian Library, at Oxford (MS. *Laud. Gr. 35*): see Fig. V–13, *right*.

Fig. X–23
The *Paris Psalter* (National Library, Paris, *Fonds Latin 8824*).

ALDHELM (Fig. X–18, *right*)

Athelmus, known as Ealdhelm or Aldhelm (*c.* 640–709), one of the first English scholars, wrote treatises and verse in Latin and English. Aldhelm (who later became the first bishop of Sherborne) was the most illustrious pupil of the school of Canterbury. He was the virtual founder and abbot of Malmesbury, and the most learned of West Saxon abbots. His influence was very powerful in southern England; the monasteries at Frome and Bradford on Avon were his foundations, and he kept control of all his "houses" in his own hands. Even after he became bishop of Sherborne, he was persuaded by his monks to continue the direct supervision of these houses.

"All the influences which contributed to the origins of English learning, meet in the work of Aldhelm. His first teacher was the Irish scholar Maildubh. . . . The fame of Theodore's teaching drew him to Canterbury. . . . By birth he belonged to the West Saxon royal family, and he was therefore familiar with a mass of floating tradition which later writers were to shape into history" (F. M. Stenton). As a man of learning and of culture he is the most representative personality of his age, and his writings influenced English and continental scholarship for more than a century. He was affected, however, by the influence of the curiously involved and artificial Latin style, which early Irish scholars had developed in their isolation.

His longest works are a poem, *De Laudibus Virginum*, dedicated to "Ad maximam abbatissimam", and a prose discourse, *De Laudibus Virginitatis*, dedicated to Hildelith, abbess of Barking, and nine of her nuns. He also wrote learned epistles and poems. "Aldhelm was beyond comparison the most learned and ingenious western scholar of the late seventh century."

Some scholars attributed to Aldhelm a version of the Psalms and considered him as the first translator of a part of the Bible into English. It is uncertain whether any portion of his original English works has come down to us. An Anglo-Saxon translation of the Psalms, partly in prose (fifty Psalms) and partly in verse, which is preserved in a manuscript at the National Library, Paris (*Fonds Latin 8824*), commonly known as the *Paris Psalter*—Fig. X–23—is still held in some encyclopaedias and textbooks to be Aldhelm's version. This theory has been proved baseless, both by H. Bartlett, in 1896, and, especially, by A. S. Cook (*Biblical Quotations in Old English Prose Writers*, London and New York, 1898 and 1903). See also p. 515.

BEDE (Fig. X–18, *left*)

The Venerable Bede (or Beda or Baeda), *c.* 673–735, the great historian of the early English Church, and "the teacher of all the Middle Ages" (Wattenbach), wrote many important works in Latin, the most important and best known being *Historia Ecclesiastica Gentis Anglorum* ("Church History of the English People"); his other works include the *History of the Abbots* of his own monasteries, *De Ratione Temporum, De Metrica Arte,* and *De Natura Rerum.* The manuscripts extant—one of which, copied only two years after Bede's death, is now in the University Library of Cambridge—preserve for us the text of the priceless *Ecclesiastical History* (Fig. X–18, *left*).

This work, which was completed in 731, and which King Ceolwulf of Northumbria read and critized in draft, "is the response of a great scholar to a great opportunity . . . the quality which makes his work great is not his scholarship, nor the faculty of narrative which he shared with many contemporaries, but his astonishing power of co ordinating the fragments of information which came to him through tradition, the relation of friends, or documentary evidence. In an age when little was attempted beyond the registration of fact, he had reached the conception of history. It is in virtue of this conception that the *Historia Ecclesiastica* still lives after twelve hundred years" (Stenton).

Bede lived in the famous Benedictine monastery of Jarrow, which was in close touch with Rome, and was a pupil of Abbot Benedict Biscop. He gave himself to a life of study and writing, and had thoroughly imbibed the spirit of the southern culture. M. L. W. Laistner has proved that what is now known as *Codex Laudianus*—already referred to on p. 507; see also Fig. V–13, *right*—was used by Bede in writing his commentary on the *Acts.* As to the problem of distinguishing the books attributed to Bede from those which belonged to him, Prof. R. A. B. Mynors reached the conclusion, that three of the Durham manuscripts (Nos. 7–9 of his list), which were thought in the fourteenth century to have been written in Bede's hand, differ so much among themselves that the traditional belief cannot be accepted; "and we must suppose that when the monks of Durham in the later Middle Ages saw what we call an 'insular' script with its air of venerable antiquity, it seemed to them that it must be the work of the master".

However, these three codices are not in a continental but in an "insular" hand. They are (see p. 501), Durham *Codex A. ii 16* Cassiodorus, *Commentary on the Psalms (Codex B. ii 30),* and the *Pauline*

Epistles, preserved in Trinity College, at Cambridge (*MS. B. 10.5*) and apparently in the British Museum (*Cotton. Vitellius, C.viii,* leaves 85–90). The *Pauline Epistles*, also known as *Codex S* of the Vulgate New Testament, have interlinear glosses in Anglo-Saxon hand. The manuscript is "in an irregular hand of the first half of the VIIIth century" (Mynors); it was "written in England, probably by an Irish scribe" (Lowe).

In medieval Durham there were, however, other survivals of Bede's period besides those that have come down to us; for instance, "a second copy of the Pauline Epistles 'in the hand of Bede' . . . and 'the book of St. Boisil, master of St. Cuthbert', kept among the relics in the Cathedral, was probably another; but these are lost beyond recall" (Mynors).

Scholars agree that Bede may be considered the "father" of English learning and English history. While all his main works, which obviously were intended primarily for scholars, were written in Latin, it is not always remembered that this great man was one of the first who wrote in English.

We know, indeed, that Bede tried his hand at regular English prose. Following the general rules of the Church, he took care that parts of the Holy Scriptures might be faithfully delivered to the common people in their native speech. He translated the first essentials of the Christian faith, the Creed and the Lord's Prayer, and in the last days of his life he was engaged on the translation of *St. John's Gospel*: the story of its completion has been beautifully described by one of his disciples. Unfortunately, no remains or trace have come down to us of this and the other translations, but a five-line vernacular poem, known as the "Death Song", has survived. It is preserved in the *Epistola Cuthberti de Obitu Bedae*, which is extant in a ninth-century manuscript of St. Gall (*MS. No. 254*).

Such are the meagre beginnings of English prose.

SPREAD OF ANGLO-CHRISTIAN CULTURE

Already in the seventh century, but particularly in the eighth, English Christian culture and learning spread to the Continent. It will suffice to mention a few names. In 677, the Northumbrian monk, St. Wilfrid, laid the foundation of the Christian Church in Frisia, and St. Willibrord, who in 695 was invested with the metropolitan pallium, was the real founder of the Frisian Church; he died in 739 in the monastery of Echternach—one of the

many monasteries and churches he had founded—which was one of the greatest centres of Anglo-Saxon culture and book production (Fig. X-19, *above*).

Even more important was the activity of the monk Wynfrith, a West Saxon, who is known as St. Boniface. In 722 he was consecrated bishop to the Germans, and in 732 he was invested with an archbishop's pallium by Pope Gregory III. He organized the German Church, adopted the church of Mainz as his cathedral, established various bishoprics (appointing Englishmen as bishops or assistant bishops), founded many churches, including the great abbey of Fulda, which became the greatest centre of German Christian learning, and thus "made possible the Carolingian renaissance of the next generation".

Under Carloman and Pippin, Charlemagne's father, Boniface became the leading authority in the Frankish Church. "As a direct result of his policy, English learning rapidly came to extend beyond the monasteries newly founded by English missionaries to older houses like St. Gall and Reichenau . . ." (F. M. Stenton). His letters and the letters of his correspondents which have been preserved, show that the level of English eighth-century learning and culture was very high.

Not only Augustine and Jerome, but also pagan poets like Virgil were read. "Most of the writers belonged to southern England, and their literacy proves the high quality of the education which could be obtained in Kentish or West Saxon monasteries in the age of Bede." Lull, Boniface's successor as archbishop of Mainz, St. Willibald, his brother St. Wynbald, their sister St. Waldburg, and St. Willehad, who became the bishop of Bremen, are a few of the other "great evangelists who made the eighth century the heroic age of the Anglo-Saxon church" (Stenton).

From Bede to Alcuin

In the third quarter of the eighth century, the city of York suddenly became the main seat of English scholarship and book production. Egbert, archbishop of York and brother of the strong Northumbrian king Eadberht, had been one of Bede's disciples. He founded a school in his cathedral which soon became famous not only in England, but also on the Continent. As head of this school was appointed a great teacher, Aethelberht, who was Egbert's kinsman. When Aethelberht became archbishop (in 767), he put Alcuin in charge of the school, which by then eclipsed Wearmouth-

Jarrow as the principal centre of English learning. Thus, through Egbort tho oubotanco of Bede'ʀ teaching was transmitted to a genera-tion of scholars who became a main factor in the general development of European culture and learning.

ALCUIN OF YORK (735–804)

Alcuin of York—a great English name—more than any other single Englishman before him or for some centuries after him, contributed on the European continent to the spread of scholarship, of the copying of books, and of the knowledge of the Sacred Scriptures. Alcuin was born at York, in the year of the death of another great Englishman, Bede. He was educated at the cathedral school of York, probably under the able headship of Aethelberht, and succeeded him as head of the school. He founded a library at York, which became one of the finest in Europe; according to Alcuin himself, this library contained "all Latin literature, all that Greece had handed on to the Romans, all that the Hebrew people had received from on High, all that Africa with clear-flowing light had given" (as quoted by Can. F. Harrison).

As a friend of Charlemagne (742–814) he played an important part in the revival of learning in Europe. "Thanks to this revival—writes Malone—the culture of classical antiquity did not die out in western Europe but was transmitted to later generations and became the foundation upon which modern civilization was built."

Alcuin became the "master of the Schools of the Palace", and confidant and adviser of the Emperor in education and in Church affairs. Although it is still uncertain what exact part Charlemagne and Alcuin played in the creation of the Caroline hand (which became the literary hand of the Frankish Empire, and during the following two centuries the main book hand of western Europe), there is no doubt that the Imperial decree of the year 789 calling for the revision of church books, was mainly due to Alcuin: the work of revision naturally brought with it great activity in the writing schools of the chief monastic centres of the Empire.

Alcuin is intimately associated with the most important stage of the history of the Vulgate in the Middle Ages. While Ireland and England were taking the lead in promoting the study and circulation of the Bible, the Sacred Scriptures in the Frankish Empire were sinking into confusion and corruption.

Having already in 796 been appointed abbot of the great and wealthy abbey of St. Martin at Tours, which he transformed into a great centre of learning, Alcuin received the Imperial commission to prepare a revised edition of the Latin Bible. He settled at Tours where he died in 804.

Finding that the great majority of Bible manuscripts were seriously defective, and knowing the value of the texts of northern England, he sent to York in 796 for copies. In the light of these texts the work proceeded. In 801 the revision was complete, and on Christmas Day in that year a copy of the restored Vulgate was presented by him to Charlemagne. Of the many copies of this revised text, written under Alcuin's own direction, none has come down to us, but there are several manuscripts which preserve Alcuin's text. The best is the *Codex Vallicellianus*, in Rome, which contains the whole Bible; so does also another good copy, now in the British Museum (*Add. MS. 10546*): the text is written in double columns on pages measuring 20 inches × 14½ inches.

The revision of the Latin Bible was only one of Alcuin's great cultural activities. He was also "the principal agent in carrying the English influence into the Continent". Indeed, the artistic inspiration of a series of splendid manuscripts of the Gospels—written in gold letters upon white or purple vellum, and adorned with magnificent decorations—is clearly derived from the Anglo-Irish manuscripts. The original centre of the production of these "Golden Gospels" appears to have been "in the neighbourhood of the Rhine, where Alcuin was settled . . . before his retirement to Tours; and the earliest examples of this style appear to have been written during the time of his residence in that region. In any case they are a splendid evidence of the value in which the sacred volume was held, and they show how the tradition of the English illumination was carried abroad into France" (Kenyon).

Alcuin wrote Latin poetry as well as treatises on theology, grammar, rhetoric, history, spelling, argumentation, and other subjects, but, curiously enough, his works are not famous for their depth. On the other hand his letters (written mainly to Charlemagne and to Arno of Salzburg) are very important for their reflection of the life and customs of that period.

To sum up, "Alcuin's career is of peculiar interest as a link between the phase of English scholarship which culminated in the work of Bede and the revival of western learning under Charle-

magne" (F. M. Stenton). Indeed, "Alcuin and his pupils brought about a continental reception of English learning which profoundly influenced the whole literature of the Carolingian age".

KING ALFRED

(Fig. X–19, *below*)

English prose is still poor when we reach the period of the greatest of the early English sovereigns, King Alfred the Great (*c.* 849–99), who is commonly (though, as we have indicated, wrongly) associated with the beginnings of English prose. Careful for the moral and intellectual welfare of his people, he invited to his court learned men (such as Asser, Werferth, and Plegmund) from all parts of Europe, in order to put into execution his great scheme for the education of his people. He did much to revive the know-ledge of writing (neglected during the Danish invasion), and, by his own toil and the work of his school, not a little was added to the work which Aldhelm and Bede had begun. His capital, Win-chester, became the centre of English thought, and the West Saxon dialect—the dialect of his dwarfed dominions—became the English literary language, and maintained its supremacy until the close of the Old English period.

Under Alfred and his immediate successors, monasticism flourished in Wessex, but in the north it had been so thoroughly uprooted during the Danish invasions—the Danes, indeed, burnt the religious houses and put their inmates to the sword—"that it did not come back into its own until the twelfth century" (Malone). English learning was, therefore, chiefly concentrated in the south and west: at Glastonbury, Winchester, Canterbury, Worcester, and other centres.

Though apparently no copy of King Alfred's work has come down to us, it is well known that he prefixed a translation of the Ten Commandments and other extracts from the Mosaic Law to his own codes of laws, and translated (or caused to be translated) several other parts of the Bible. He is said to have been engaged on a version of the Psalter in the last days of his life. Many other Winchester works are attributed to his pen, but some are undoubtedly the production of the scholars who were associated with him. These works include translations into English of Boëthius, *de Consolatione*, the *Universal History* of Orosius; Bede's *Ecclesiastical History*, Pope Gregory's *Regulae* or *Cura Pastoralis* ("Pastoral Care")—Fig. X-19, *below*, and a few other works.

Fig. X–19, *below*, reproduces a portion of the manuscript, which "is undoubtedly the copy sent (by King Alfred) to Werferth, bishop of Worcester" (Lowe). There are interlinear Latin glosses.

According to some scholars, the Anglo-Saxon version of the *Paris Psalter* (see p. 508) may have been King Alfred's work. Recently (1950) J. I' A. Bromwich has suggested that "the boldest and simplest explanation is that Alfred has just as good a claim to the translation of the *Paris Psalter* as he has to the *Cura Pastoralis* and the Boëthius. The unfinished state of the version lends weight to William of Malmesbury's assertion that the king's death interrupted his work." Bromwich throws additional doubt on Alfred's authorship of the Old English translation of Bede's *Ecclesiastical History*.

In Stenton's opinion, however, the authenticity of the translation of Orosius (to which King Alfred added a section, including a piece of systematic geography) is beyond question, while the translation of Bede although certainly produced under Alfred's influence, may not be his work. However, Alfred not only "was the most effective ruler who had appeared in western Europe since the death of Charlemagne. . . . His unique importance in the history of English letters comes from his conviction that a life without knowledge or reflection was unworthy of respect, and from his determination to bring the thought of the past within the range of his subjects' understanding. . . . His books remained an isolated achievement . . . (but they) were still being copied in Norman England. . . . Through the strength and reputation of King Alfred and his son Christianity was saved from obliteration even in the regions of the densest Danish settlement" (Stenton).

THE GOLDEN AGE OF MONASTICISM

Anglo-Saxon civilization, just as it began to rise, was met by a new blow, and sunk down once more. During many decades, what is now Denmark and Scandinavia continued to pour forth innumerable pirates, distinguished by strength and valour, by ignorance and cruelty. No country suffered so much from these invaders as England. Her coast lay near to the ports whence they sailed; nor was any part of the Island so far distant from the sea as to be secure from attack. The same atrocities which had attended the victory of the Saxon over the Celt were now, after the lapse of ages, suffered by the Saxon at the hands of the Dane. The Danish raids and invasions shattered the organization of the English Church, religious houses were destroyed and their inmates put to the sword; the whole monastic

life, especially in the north and the east, was disrupted; the libraries were plundered, and the pursuit of learning became a matter of the greatest difficulty. See also p. 480 ff.

Christian Revival following the Danish Raids

The early tenth century brought a remarkable Christian revival together with the re-establishment of English monasticism, mainly, however, in the south. In the north, the invasion of Norsemen from Ireland, who founded a kingdom at York, produced a strange hybrid Norse and Irish culture combined with the preceding Anglo-Celtic elements.

Monastic England

In the five centuries which followed the arrival in Kent of St. Augustine, changes of all kinds took place in monastic England. At first the monasteries were poor; they were given land, but not always of the best, and often in wild regions. In the course of time, by skill and industry the monks brought the land into a fertile state, they became leaders in agriculture and craftsmanship, learning was kept alive in their schools, and numerous books were produced in their cloisters.

Soon enough they became rich: they lived on the produce of the land and the abundant gifts of their patrons. The need for toil being over, they sank into indolent affluence. The old Benedictine Order relaxed its severity. Large abbeys sunk into poverty, though others arose in their places. In the age of feudalism and disorder, the monks exhibited the same disorder as did society.

St. Dunstan

The great reform of English monasticism was mainly associated with St. Dunstan (*c.* 925–88), abbot of the wealthy and ancient abbey of Glastonbury and, later, archbishop of Canterbury. A nephew of Athelm, archbishop of Canterbury, he was son of a thane, and kinsman of a chaplain to King Athelstan, Aelfheah, who was bishop of Winchester (934–51) and a forerunner of the English monastic revival: it was Aelfheah to whom Dunstan made a monk's profession and who ordained him priest. Dunstan studied at the then celebrated school of Glastonbury.

Collaborating with St. Aethelwold and St. Oswald, St. Dunstan restored many of the old monasteries, especially those plundered by the Danes. Some of the double monasteries were restored for one

sex only. The system of the double monasteries seems to have died out in other countries, too, at the same time.

Moreover, always with the king's authority, he reformed some monasteries by replacing the canons by monks and by enforcing the rule of celibacy.

St. Aethelwold, since 963 bishop of Winchester, was Dunstan's greatest pupil; he restored the famous monastery of Abingdon. St. Oswald, a pupil of the monks of Fleury, himself the founder of the great abbey of Ramsey, succeeded Dunstan as bishop of Worcester, and later became archbishop of York.

Other Monastic Reforms

In the early tenth century, the Benedictines were overshadowed by the rise of a new Order, of reformed Benedictines, known as the Congregation of Cluny (now in the Dept. of Saône-et-Loire, Central France). The contribution of Cluniac monasticism (especially through the monastery of Fleury on the Loire) and of the reformed monastic movements of Burgundy and Lorraine (especially through Einsiedeln) to the English reform was very great, though Stenton believes that foreign example came to English reformers not as an incentive to a new task, but as a means of perfecting work which had already been well begun. The years 955 to 980—with relative peace in England—were the best in this movement. In the synodal council at Winchester, which took place between 963 and 975, the *Regularis Concordia* was composed, *i.e.* the Agreement concerning the Rule of the monks and nuns of the English nation. All the English monasteries were to follow the same usages. The strength of the movement may be seen from the institution of the monastic cathedral, which was a unique feature of the medieval English Church. Indeed, as Stenton has remarked, between 975 and 1066 every English diocese came for a time under the rule of a bishop who was a professed monk.

BOOK PRODUCTION OF MONASTIC ENGLAND

It is agreed that the Benedictine reformation brought fresh vitality to the whole English Church. It brought into being a new religious literature in the English language. It also produced the golden age of monastic book production. The monastic revival lasted too short to be able to produce an important Latin literary school, but it certainly created an atmosphere favourable to the multiplication of Latin books. Stenton has emphasized that for the monastic revival it was necessary that every monastery should

possess the liturgical texts essential to its services, calendars recording the feast-days of the saints whom it honoured, Psalters, Gospel-books, and writings by the Fathers of the Church. "The need for such volumes, and for more specialized texts, such as the benedictionals or pontificals which contained the offices proper to a bishop, stimulated the development of English penmanship, and resulted in the production of books which in quality of script and excellence of decoration could not be rivalled in contemporary Europe. The famous manuscripts of this period, such as the Winchester 'Benedictional of St. Aethelwold' and the 'Bosworth Psalter', which was probably written at Canterbury for Dunstan, stand for a large amount of work which, if less ornate, is equally accomplished. By the early part of the eleventh century England was supplying books to foreign churches. . . . No foreign bishop or abbot of this age could have conceived it possible that a time would come when the isolation and illiteracy of the late Old English church would be accepted as a commonplace by most historians" (Stenton).

The book production of this period, with its superb illumination, will be dealt with in the volume on *Illumination and Binding*. Here a few general remarks can be made. Already in the ninth century foreign elements came into England through the Carolingian school of Rheims; the Anglo-Celtic elements gradually disappeared. It is true that the old "Insular" script continued to be the basic English hand (as may be shown by the superb codex of English verse known as the *Exeter Book*), but the Carolingian minuscule introduced about this time began to influence the development of the "Insular" script. The main centre of artistic book production was the Winchester school—the greatest English school of illumination; it flourished particularly in the last decades of the tenth century and in the eleventh century. But many other monasteries—such as Bury St. Edmunds, Peterborough (the new name of the old Medeshamstede, given after the reform of Aethelwold), and even the far distant monasteries of York and Durham—produced richly illuminated Gospel-books, benedictionals, pontificals, sacramentaries, and service books. A new type of book was developed, giving rise to a truly national style.

The monastic *scriptoria* (see p. 207 f.) did not yet exist. Very often the monastic scribes did their work in the cloisters. In later times, especially in the thirteenth to the fifteenth centuries *scriptoria* came into being. At first, they were small rooms, quite often on the first floor. Apparently no *scriptorium* can be identified among the remains of the English monasteries. Curiously enough, when

scriptoria came to be regularly employed, *i.e.* in the thirteenth century, the golden age of monastic book production was already gone. By then, books were mainly produced commercially by non-monastic scribes, and even monasteries often bought their books from lay copyists.

AETHELRED II UNREAD (979–1016)

The epithet *Unread* (meaning "No Counsel" or, better perhaps, "Without Deliberation") given to the king who bore the name Aethelred (meaning "Noble Counsel") clearly indicates the opinion held of him by his contemporaries. He marks the end of the Old English Monarchy. Athelstan (*c.* 895–940), the grandson of Alfred the Great, having annexed Northumbria and made tributary to himself the rulers of Wales, Cumberland, and Scotland, was the first king to unite England, and to be intimately associated with the leading Western rulers of his time. This situation did not last long. The political union of this Island was as yet too artificial. The completion of the West-Saxon realm was reserved for the hands, not of a king or warrior, but of a priest: St. Dunstan, the great ecclesiastical statesman of the tenth century (see p. 516 f.). There "are few parallels in any country to the enthusiasm with which Edgar brought the whole power of the English state to the furtherance of Dunstan's religious policy" (Stenton). Never before had England seemed so strong or so peaceful.

But with the King's death, in 975, the whole fabric fell asunder, and the disorder became acute when in 978, after the treacherous assassination of Edward, his brother Aethelred became king. Soon afterwards (in 980) new Danish raids molested the Island, and ruin hung over the West Saxon realm. In time, Aethelred's kingdom shrank into the realms of Wessex and Kent, and no efforts of force or policy seemed able to restore even the political unity of Wessex, Mercia, and Northumbria. The want of political stability rendered entirely ineffective the struggle against the Danes, and with the death of Aethelred (on 23.4.1016) and of his son and successor Edmund (on 30.11.1016), the West Saxons accepted the Dane Cnut as their king. With the conversion of the Danes to Christianity, one cause of deadly animosity was removed, while the Danish and Saxon forms of speech, both dialects of one linguistic group, began to be blended together. But the distinction between the two nations had by no means disappeared, when an event took place which prostrated both, in common slavery and degradation, at the feet of

Fig. X–24

Latin Hymnal with interlinear Anglo-Saxon Gloss; eleventh century (Durham
Cathedral Library, *B.iii. 32*; Mynors's list, No. 22).

another people; the new conquerors were a most remarkable nation, the Normans.

Last Luminaries of Old English Learning

The cultural level of England at this time is in striking contrast to the political humiliation. ". . . a number of manuscripts written in England during this period have a distinctive place in the history of European book production. Few of them can be dated with precision. Some of the most famous may have been written before the Danish peril became acute. But the unbroken development of English hand-writing between the reign of Edgar and the Norman Conquest shows that the activities of English *scriptoria* were never seriously interrupted during the years of trouble. The Danish ravages must have impoverished many religious communities, and may have brought permanent destruction to some, but they had no discernible effect on the intellectual quality of English monasticism" (Stenton).

It will suffice to mention two luminaries of the Old English scholarship and two lesser lights, who flourished in Aethelred's reign; they wrote at a time when civilization was again threatened by foreign invaders. Aelfric, a pupil of St. Aethelwold (see p. 517), was undoubtedly the leader of the religious literary movement of the time. He has been confused with Aelfric, archbishop of Canterbury (995–1005), or even with Aelfric, archbishop of York. In point of fact, c. 987, Aelfheah, Aethelwold's successor as bishop of Winchester, appointed him as abbot of the new monastery of Cerne Abbas (in Dorset), and in 1005 Aelfric became abbot of the new monastery at Eynsham (in Oxfordshire), both these monasteries having been founded by Aethelmaer, son of the chronicler Aethelweard. Abbot Aelfric wrote books both in English for the "needs of men with little knowledge or inadequate scholarship", and in Latin: "it was obviously essential that the knowledge of Latin should be kept alive for use in the services of the church" (Stenton). His Latin books included the biography of Aethelwold, an abridgment of the *Regularis Concordia* (see p. 517) for his monks at Eynsham, and *A Latin and English Grammar and Glossary* (for which he was called *Grammaticus*), containing a set of imaginary dialogues in Latin and English.

Byrhtfert of Ramsey was "the most eminent man of science produced by the English church since the death of Bede" (Stenton).

He was a pupil of Abbo—a learned monk from Fleury, who for two years taught at the monastic school of Ramsey, which for a certain period "was in closer touch with continental learning than any other house of the English revival". Byrhtfert's most important work was a scientific treatise known as *Byrhtfert's Manual*, dealing with reckoning time, with the purpose to help parish priests in their regular duties. Wulfstan, archbishop of York, in 1014 wrote a treatise on the principles of government in Church and State, and a great homily, known as *Sermo Lupi ad Anglos*, in which he denounced the misdeeds of his people. Aelfric's friend Aethelweard, ealdorman of the southwestern shires, translated the *Anglo-Saxon Chronicle* into (a rather barbaric) Latin, for the benefit of Matilda, abbess of Essen (both, Matilda and Aethelweard, were scions of the royal house of Wessex).

An interesting feature of the new religious literature was that, although it was an "outcome of the monastic revival, it was not written for monastic readers" (Stenton).

Last Old English Writers

Abbot Aelfric wrote in 991 and 992 the *Catholic Homilies*, a collection of the lives and passions of English saints, which has been described as "the classic example of Anglo-Saxon prose". Soon afterwards, at the request of Aethelweard (see *above*) and his son, he wrote the *Lives of the Saints*, dealing with the saints honoured by the Anglo-Saxon monks in their services. At the same time, also at the request of Aethelweard, he translated portions from the Bible, starting from *Genesis*. He also wrote *Pastoral Letters*, both for Wulfsige, bishop of Sherborne, and especially for Wulfstan, bishop of Worcester and archbishop of York. "The pastoral letters which Aelfric had written for Wulfstan of York . . . were still being copied in the reign of Henry II" (Stenton). Archbishop Wulfstan and Byrhtferth of Ramsey both wrote in the Old English language.

Fig. X–24 reproduces an interesting book from this period—a *Latin Hymnal* with Anglo-Saxon glosses.

ANGLO-SAXON CHRONICLE (Fig. X–25)

The chief literary monument, actually the only great work written in English (then Anglo-Saxon) before the Norman Conquest, is the so-called *Anglo-Saxon Chronicle*, a collection of chronicles

mid him to baldeƿine eorle · ⁊ he his ealle under fenᵹ · ⁊ hi
ƿæron eontie þone ƿinter þær · cetigede cometa xviii· kł· maii · ⁊
An·dccc·lxvi· On þiſſū ᵹeaꞃe man halᵹode þet
mynſteꞃ æt peſtminſtre on ealda mæſſe dæᵹ · ⁊ ſe cyninᵹ
eadƿaꞃd foꞃðfeꞃde on tƿelfta mæſſe æfen · ⁊ hine mann
bebyꞃᵹede on tƿelftan mæſſe dæᵹ · innan þære nƿa·
halᵹodne ciꞃican on peſtmynſtre · ⁊ haꞃold eoꞃl fenᵹ
to engla lander cyneꞃice · ſƿa ſƿa ſe cyninᵹ hit him ᵹe uðe ·
⁊ eac men hine þær to ᵹecuꞃon · ⁊ ƿæſ ᵹebletſod to cyn
ᵹe on tƿelftan mæſſe dæᵹ · ⁊ þy ilcan ᵹeaꞃe þe he cyninᵹ
ƿæſ · he foꞃ ut mid ſcipheꞃe to ᵹeaneſ Ƿillme · ⁊ þa hƿi
le com toſtiᵹ eoꞃl into humbꞃan mid· lx· ſcipū · Ead
ƿine eoꞃl com land fyꞃde · ⁊ dꞃaf hine ut · ⁊ þa butſecaꞃlaꞃ
hine foꞃſocan · ⁊ he foꞃ to ſcotlande mid· xii· ſnaccū · ⁊ hi
ne ᵹemette haꞃold ſe noꞃꞃena cyninᵹ mid· ccc· ſcipū · ⁊
toſtiᵹ hi to beah · ⁊ hi bæᵹen foꞃan into humbꞃan oð þet
hi coman to eofeꞃƿic · ⁊ heo ƿið fealht moꞃkeꞃe eoꞃl · ⁊
eadƿine eoꞃl · ⁊ ſe noꞃꞃena cyninᵹ ahte ſiᵹeſ ᵹe peald · ⁊ man
cydde haꞃolde cyninᵹ hu hit þær þær ᵹedon ⁊ ᵹeƿoꞃden ·
⁊ he com mid mycclū heꞃe engliſcꞃa manna · ⁊ ᵹemette hine
æt ſtænᵹ foꞃdeſ bꞃyꞃcᵹe · ⁊ hine ofſloh · ⁊ þone eoꞃl toſtiᵹ ·
⁊ ealne þone heꞃe ahtlice ofeꞃ com · ⁊ þa hƿile com ƿittin eoꞃl
upp æt heſtinᵹan on ſcē michaeleſ mæſſe dæᵹ · ⁊ haꞃold
com noꞃðan ⁊ hī ƿið fealht eaꞃ þan þe hiſ heꞃe come eall · ⁊
þæꞃ he feoll · ⁊ hiſ tƿæᵹen ᵹe bꞃoðꞃa Gyꞃð ⁊ leoꞃfƿine · and
Ƿillelm þiſ land ᵹe eode · ⁊ com to peſtmynſtre · ⁊ ealdꞃed
apceb hine to cyninᵹe ᵹe halᵹode · ⁊ menn ᵹuldon him ᵹyld ·
⁊ ᵹiſlaꞃ ſealdon · ⁊ ſyðða n heoꞃa land bohꞃan · ⁊ Ða þæꞃ leo
fꞃic abbot of buꞃh æt filca feoꞃð · ⁊ ſeclode þæꞃ ⁊ ƿham ·
⁊ yꞃæꞃ dæd ſone þæꞃ æfteꞃ on ælꞃe halᵹan mæſſe niht ᵹod

Fig. X–25

The *Peterborough Anglo-Saxon Chronicle*, quoted as *MS.E* (Bodleian Library, Oxford, *Laud. MS. 636*).

of English history, begun and completed by English writers in the English tongue. That invaluable document, the oldest history of any Germanic people written in a Germanic language, was composed in the tenth and eleventh centuries in the monasteries of Winchester, Canterbury, Worcester, and Abingdon; after the Norman Conquest it was continued in Peterborough until the year 1154.

Six complete manuscripts of the *Anglo-Saxon Chronicle* are extant (a seventh was burnt in the British Museum fire of 1731, *Cotton. Otho, B.xi;* only three leaves are preserved; of an eighth, only one leaf is preserved, *Cotton. Domitian, A.ix);* the earliest, written in 891, and continued to 1070, is now in Corpus Christi College, Cambridge; the Peterborough manuscript is in Oxford; the other four are in the British Museum.

All the preserved manuscripts begin with a kind of introduction purporting to be an outline of history from the invasion of Britain by Julius Caesar to the middle of the fifth century A.D. This introduction and the annals which follow down to the year 891, are generally speaking common to all the *Chronicles*; they are ultimately derived from an original written in English in King Alfred's time. As regards the following years, the manuscripts contain rather different accounts, though down to the year 915, a large amount of material is common to most of them. The preserved manuscripts are generally distinguished by the symbols *A–F*, the manuscript *A*, preserved in Corpus Christi College, Cambridge (*MS. 173*) being the most important: it is also known as *Parker's Chronicle*, because it belonged to Archbishop Parker. The *Peterborough Chronicle* or *MS.E*, preserved in the Bodleian Library (*Laud. MS. 636*), covers the longest period (down to 1154), and is particularly important for the reign of the Conqueror and of the Norman kings. See Fig. X–25. The manuscripts preserved in the British Museum are *MS.B* (*Cott. Tiberius, A.vi*), *MS.C* (*Cott. Tiberius, B.i*)—these being closely related—*MS.D* (*Cott. Tiberius, B.iv*), for which it has been suggested that its final form may have been destined for the Scottish court, *MS.F* (*Cott. Domitian, A.viii*), which is a bilingual text, in English and Latin. There are also three important Latin versions. *Cott. Otho, B.xi* is known as *MS.W.*

BIBLE VERSIONS

It must be emphasized that the English productions were mainly translations of Latin originals, which shows that the prose literature was as yet mainly imitative. There were many other translations

from this period, some of which have come down to us. Of all books of the Bible none has been Englished so often as the *Psalter*. Numerous versions in prose as well as in verse, some of which still survive, were written before those of John Wycliffe's followers. A manuscript in the British Museum, containing the Psalms in Latin—formerly supposed to have been once in St. Augustine's possession, but now assigned to A.D. *c.* 700—has glosses or "word-for-word translation" in an Old English dialect of the late ninth century; according to Prof. B. Dickins, it is not Kentish (as some scholars thought), but a dialect of the Midlands. The Oldest English Psalter is the Anglo-Saxon *Paris Psalter* (see pp. 508 and 515). Only the first fifty Psalms are in prose, and these are variously ascribed to Aldhelm, to King Alfred, or to others.

The earliest complete English prose Psalter, which at the same time is also the earliest version in English prose of any entire book of Scripture, belongs to a later period; it is preserved in two manuscripts, one at the British Museum (*Add. MS. 17376*), and the other at Trinity College, Dublin. The former—a small thick octavo volume, containing 220 leaves of vellum—is assigned by F. Madden to the first half of the fourteenth century. It also contains William Shoreham's *Religious Poems*.

The Trinity College manuscript (*A.4.4*)—Fig. X 26—is a quarto volume, written in the fourteenth century. A note at the end of the *Psalter*, in the hand of the original scribe, gives the name of John Hyde as the owner of the book. The *Psalter* now fills the first fifty-five leaves of the manuscript, and is followed by Wycliffe's *Commentary on the Apocalypse*, a *Tale of Charity*, an *Exposition of the Decalogue*, a *Description of Jerusalem*, in Latin prose. It also contains Richard Rolle's poem *The Prykke of Conscience*, but this is written by a different scribe. The language of the *Psalter* is almost pure West Midland; the *Psalter* is very carefully and distinctly written. Fig. X-6, *above*.

Both manuscripts—the British Museum one and the Trinity College one—contain the Latin text as well as the English translation, which follow each other verse by verse. To the *Psalter* are added eleven *Canticles* used for Divine Offices, and the *Athanasian Creed*. The Latin text is that of the Vulgate, with some deviations from the modern editions. Another difference exists in the division of some of the Psalms.

Rolle's poem—previously referred to—may here be briefly dealt with: Richard Rolle (*c.* 1300–49) was an Oxford theologian who gave up scholarship to become a hermit; he was a poet and mystic; he wrote beautifully, especially in English (he also wrote in Latin),

and was widely read. The numerous preserved manuscripts of the *Prykke of Conscience* have been divided into four families of recensions, designated respectively by the symbols *P*, *Xii*, *C*, and *Z*, of which the fourth (*Z*) represents the Northern recension; the second (*Xii*) is an East Midland recension, differing notably from the others in

Fig. X–26

(*Above*) Earliest complete English Psalter written in prose (Trinity College, Dublin, MS. No. 69; *A.4.4*; portion of fol. 29 *recto*); (*below*) *Prykke of Conscience* (the same manuscript; portion of fol. 83 *verso*).

content and arrangement as well as in dialect colour. The Trinity College manuscript belongs to this second group and forms a special sub-group with numerous other manuscripts of the British Museum (*Harl. 1731, 2281,* and *2377; Royal 18. A. v; Landsd. 348; Arund. 140; Add. 11305*), the University Library in Cambridge (*Ee.4.35*). the Bodleian Library (*Bodl. 1491* and *2322*), the Princeton University

Fig. X–27

"Early Version" of the *Wycliffe Bible*; original copy of the translator(?), Nicholas de Hereford (Bodleian Library, *MS. Bodl. 959,* fol. 288).

Library (*Yates MS.*), the Cathedral Library, at Lichfield (Nos. 6 and 18), and of other collections. Fig. X 26, *below.*

The earliest preserved version of the Gospels is the paraphrase, in the Northumbrian dialect—written by Aldred the Priest *c.* 950—between the lines of the Latin text of the magnificent *Lindisfarne Codex* (see p. 501 ff.), which is dated to *c.* 700.

The first independent translation of the Gospels also belongs to *c.* 950, and was written in the West Saxon dialect, but the earliest manuscripts extant (two and a fragment of a third, at Oxford, two at Cambridge, and two in the British Museum) are of a later period, the oldest being a manuscript written by Aelfric at Bath about the year 1000, and now in Corpus Christi College, Cambridge.

The earliest English version of a great portion of the Old Testament (the *Pentateuch, Joshua, Judges, Kings, Esther, Job, Judith* and *Maccabees*), of which two copies are extant—one at Oxford and the other in the British Museum—is attributed to Aelfric, Archbishop of Canterbury, *c.* the year 990.

The first English translation of the whole Bible is known as the *Wycliffe Bible,* but John Wycliffe (*c.* 1324–84)—the great English reformer of Oxford, who became notable for his freedom of faith, fearlessness of character and the persecution which tried to hamper him in his work—had very little to do with this version. It was, indeed, produced by his followers in the late fourteenth century. As a matter of fact, there are two versions of the *Wycliffe Bible*: both were made from the Latin Vulgate, and neither had any influence on our present English Bible. The *Early Version,* the work of Nicholas Hereford and other followers of Wycliffe, was finished in 1382; the original (?) copy, of which all the preserved manuscripts are transcripts, is preserved in Oxford (Bodleian Library, *Bodl. MS. 959;* see Fig. X–27). The codex, of 323 leaves, measuring 13 × 9¼ inches, contains *Genesis* to *Baruch,* iii, 20; the text is in double columns, usually of fifty-three lines to the page. In 1388, a much more accurate rendering of the Bible—the *Revised Version*—was issued by a group headed by John Purvey. A prologue, commentary, and notes were added. This recension—of which 150 copies survive—superseded the earlier one. Both versions were suppressed during the fifteenth-century persecution of Wycliffe's followers, the Lollards. Under the statute *De Heretico Comburendo,* in 1400, many Lollards and their books were burned. An act of Parliament at Hampton Court, in 1414, declared that "all who read the Scriptures in the mother-tongue shall forfeit land and money". The English Bible was regarded by Church and State of England as being of such a dangerous

Fig. X–28

Chaucer, fifteenth-century copy, English (Pierpont Morgan Library, New York, *M. 817*).

and incendiary character that long after the invention of printing no translation into English was permitted.

DECADENCE OF OLD ENGLISH LITERATURE

The Norman Conquest almost at once struck a death blow at Anglo-Saxon literature. The English upper class was overthrown and kept in subjection; the lower classes were too ignorant to carry on the work for themselves; the new upper classes spoke and wrote in Norman French. The English native literature died out wholly, and a new literature, founded on Romance models, took its place. English poetry struggled on, but in the end it, too, succumbed to Romance models. Latin was taught in the schools, not English.

Nevertheless, the English language itself was not stamped out; it continued to be spoken by the common people. In the late twelfth and early thirteenth centuries the intermixture of Norman and English was progressing fast, and, in the combination, English was beginning to take pride of place. Early in the fourteenth century the amalgamation was all but complete. The new form of the English language ("Middle English"), with its splendid literary productions, such as Chaucer's *Canterbury Tales*, cannot be dealt with in detail in the present book. See Fig. X–28; also p. 533. f.

THE DOMESDAY OR DOOMSDAY BOOK (Fig. X–29)

The origin of this name is uncertain; according to tradition, it was so called because of the tyranny of the Norman nobles: in the eyes of the people it was like the great reckoning of doomsday.

[According to *The Oxford English Dictionary*, the name—already applied in the twelfth century—"appears to have been derived directly from *Domesday* the Day of the Last Judgement, and *Domesday Book* the Book by which all men would be judged. It originated as a popular appellation . . ., given to the Book as being a final and conclusive authority on all matters on which it had to be referred to].

It was also known as *Liber de Wintonia* or *Rotulus Wintoniae*, *Liber de Regis* or *Scriptura Thesauri Regis*, *Angliæ Notitiæ et Lustratio*, *Censualis Angliæ*, or *Liber Judicarius*. The original manuscript, in two volumes, is written in Latin, and is preserved in the Public Record Office, London. It is the record of an official survey of England made in 1085–7 during the reign of William the Conqueror.

Fig. X 29

Domesday Book (Public Record Office, London). The page here reproduced deals with Cambridgeshire.

Other books carry us on through the succeeding centuries, which make it more valuable still as a source of information.

The decision to compile the *Domesday* survey was taken at the Christmas council of 1085, and before the end of 1086 the returns, written on separate rolls, had been brought to the king. The exact date of the writing of the two volumes of the *Domesday Book* is uncertain. "It is uncertain how many hands were employed on them,

and therefore hard to estimate the speed at which they could have
been produced. The handwriting as a whole points definitely to a
late 11th-century date for the manuscript. On general grounds, there
is an overwhelming probability that the volumes were written before
the information which they contain was seriously out of date; that is,
before, at least, the confiscations after the revolt of 1088" (F. M.
Stenton).

Domesday Book is divided into two volumes; one, known as the
second volume (though according to some scholars it seems to have
been compiled first), deals with the counties of Essex, Norfolk, and
Suffolk; the other deals with the rest of England. Curiously enough,
not only Cumberland, not yet conquered, is not dealt with, but
neither are Northumberland or Durham. London, Winchester, and
other towns are not considered either.

The term given to this survey in the colophon of Volume II is
descriptio. "As the ordered description of a national economy it is
unique among the records of the medieval world" (Stenton).

It is a systematic record of the ownership and occupancy of the
land, of the nature of its cultivation, the number of its inhabitants and
their respective classes (freemen, villeins, serfs), of estate valuations,
and so on. It was so thorough that the author of the *Anglo-Saxon
Chronicle* wrote: "So very straitly did he [William] cause the survey
to be made, that there was not a single hyde, nor a yardland of
ground, nor—it is shameful to say what he thought no shame to do—
was there an ox or a cow or a pig passed by, and that was not down
in the accounts, and then all these writings were brought to
him."

The *Doomsday Book* became the official register of land ownership;
it covers the greater part of England. It is, therefore, the starting-
point of every manorial history of England. Indeed, many land
titles start with it.

Its compilation was thus a marvellous enterprise, admirably
planned. King William sent into each county the commissioners, who
ascertained and recorded the dues to the crown, the special "customs"
of the single manors, and so on. A jury empanelled in each Hundred
declared on oath the extent and nature of each estate, the names,
numbers, condition of its inhabitants, its value before and after the
Conquest, the sums due from it to the Crown, and so forth. This
survey thus made possible taxation on a sound basis, and became an
essential census roll, though it was not a complete survey, because it
omitted to mention any land which was not taxable.

Post-conquest Monastic Reform

The second great reform of monasticism took place after the Norman Conquest. This restoration is connected with the activity of the Cluniac Benedictines and the Cistercian Benedictines. The first English establishment of the Cistercians was Waverley Abbey (1128), near Farnham, in Surrey, but much more important was Rievaulx Abbey (1132), some thirty miles north of York. When the monasteries were suppressed (see p. 534) the Cistercians had seventy-five abbeys and twenty-six nunneries in England, and eleven abbeys and seven nunneries in Scotland. Beside the Orders of monks (including the Carthusians), there were also the Orders of canons (Augustinian or Austin, and Premonstratensian) and the Orders of friars (Dominican, Franciscan, Carmelite, and Austin). By the time of the Dissolution, there were some 300 flourishing Benedictine houses in England, including Ely, Durham, Winchester, St. Albans, Westminster Abbey, Peterborough, Norwich, Shrewsbury, Bath, Whitby, St. Mary's of York, Glastonbury, Bury St. Edmunds, Abingdon, Rochester, Reading, Gloucester, Evesham, Worcester.

Middle English

With the Norman Conquest Anglo-Saxon literature and book production suffered an eclipse; at the same time, it was the beginning of the final process in the welding of the English nation into one compact body. New influences, new words and new thoughts necessarily affected the literary output. Latin became the medium of government and scholarship; Norman French was the exclusive language of the higher classes. Thus the survival of an English literary language was extremely difficult if not impossible during the period of Norman French dominance. But English did not die out; as mentioned, the *Anglo-Saxon Chronicle* was continued until 1154 (see p. 523 f).

However, although there was a certain renaissance in the thirteenth century, it was only in the fourteenth century that literature became once more a force in England. Three names stand out in this period: William Langland (*c.* 1332–*c.* 1400), the reputed author of the allegorical poem *The Vision of Piers the Plowman* (about forty manuscripts are extant); John Gower (*c.* 1325–1408), author of three long poems; and especially, Geoffrey Chaucer (*c.* 1340–1400), the author of the *Canterbury Tales* and other poems, which established his claim to be called "the father of English poetry" (Fig. X–28). The British Museum possesses a copy of the so-called C Text of *Piers*

Plowman (a Cotton manuscript), an illuminated copy of Gower's *Confessio Amantis* (*Harl. MS. 7184*), one of the best copies of the *Canterbury Tales* (*Harl. MS. 1758*). Also a copy each of *The Governail of Princes* by Hoccleve or Occleve (*c.* 1368–*c.* 1450), of *Storie of Thebes* and of *The Falls of Princis*, by the very prolific poet John Lydgate, a monk of Bury (*c.* 1370–*c.* 1446), are preserved in the British Museum (respectively, *Harl. MSS. 4866* and *1766*), the former containing the famous portrait of Chaucer in the margin opposite stanza 714; the latter is the author's dedication copy to Humphrey, Duke of Gloucester.

A recent interesting discovery may here be mentioned. Dr. Derek Price, of Cambridge, having examined *The Equatorie of the Planetis*, a manuscript written in 1392 and preserved in the Perne Library, Peterhouse, Cambridge, has proved that its author could not have been—as hitherto thought—Simon Bredon, who died in 1372. It would appear, instead, that the codex is a hitherto unknown work of Chaucer, and would provide for the first time an example of his handwriting as well as an uncorrupted specimen of his language and spelling. Apparently, we have in this manuscript a free adaptation from an Arabic or Persian source, presumably through a Latin translation.

END OF THE MIDDLE AGES IN ENGLAND

The ending of the Middle Ages, signalized so resoundingly on the Continent, was marked by quite distinctive events in England, events which had profound consequences not only on the political and constitutional history of the country, but also in the sphere of its art and culture. These are the Wars of the Roses (1455-85), and the establishment, with the House of Tudor, in 1485, of a system of absolute monarchy; the new nationalism, fostered by Henry VII (1485-1509), and developed by Henry VIII (1509-47), separated the country from the Roman Church and the Continent.

The dissolution of the monasteries was followed by the book massacres, when the university and college libraries and the parish service books were plundered and stripped by the commissioners of Edward VI. At the same time, however, noble book collectors, like Archbishop Parker (1504-74) and Sir Robert Cotton (1571-1631), set to work to gather what they could of the scattered records of English book production. So also did Sir Thomas Bodley (1545-1613) in Oxford, Sir Thomas Smith (1513-77) and Archbishop Williams (1582-1650) in Cambridge, Archbishop Usher (1581-1656) in

Dublin, Sir Hans Sloane (1660–1753), Kings George II (1683–1760) and George III (1738–1820), Robert Harley, Earl of Oxford (1661–1724), and many others, to whom Great Britain and Western Civilization owe the foundation of the British Museum Library, and the University libraries of Oxford, Cambridge and Dublin. There were no such bibliophiles in Durham; hence this city, which could boast the only English monastic library to survive in bulk after the

Fig. X–30

Luttrell Psalter (British Museum, *Add. MS. 42130*); neighbourhood of East Anglia; *c.* 1340; Gothic "liturgical" hand.

Reformation, in later times lost such precious treasures as the *Lindisfarne Gospels*.

As a result of the Reformation, the continuity of English religious art was broken and the book illumination, for which England was famous in the fourteenth century, died out. Unlike, for instance, the Italian illumination, which could boast an uninterrupted development and a steadily maintained religious patronage, the English religious art of the Middle Ages left no inheritance. There were, however, later painters in East Anglia; they are connected by certain scholars with the purely local artistic strain left by the East Anglian school of illumination: Fig. X-30.

BIBLIOGRAPHY

W. H. Hennessy (transl. and ed.): Dubhaltach Machrbisich, *Chronicum Scotorum, a Chronicle of Irish Affairs, from the Earliest Times to A.D. 1135*, London, 1866.

J. O. Westwood, *Fac-similes of the Miniatures and Ornaments of Anglo-Saxon and Irish Manuscripts*, London, 1868.

M. MacNair Stokes, *Early Christian Art in Ireland*, London, 1887; Dublin, 1911 and 1928.

Annals of Ulster, etc., vol. I, ed. by W. M. Hennessy; vol. II, ed. by B. MacCarthy, Dublin, 1887 and 1893.

C. Plummer, *Two of the Saxon Chronicles*, Oxford, 1892; *Vitae Sanctorum Hiberniae*, Oxford, 1910.

H. J. Lawlor, *Chapters on the Book of Mulling*, Edinburgh, 1897.

S. A. Brooke, *English Literature from the Beginning*, etc., London, 1898.

T. K. Abbott, *Catalogue of the Manuscripts in the Library of Trinity College*, Dublin, 1900.

W. F. Wakeman, *A Handbook of Irish Antiquities*, 3rd ed., Dublin, 1903.

G. B. Brown, *The Arts in Early England*, London, 1903-21.

J. R. Allen, *The Early Christian Monuments of Scotland*, etc., Edinburgh, 1903; *Celtic Art in Pagan and Christian Times*, 2nd ed., London, 1912.

J. B. Bury, *St. Patrick and his Place in History*, London, 1905.

Cambridge History of English Literature, Cambridge, 1907 onwards.

H. M. Chadwick, *The Origin of the English Nation*, Cambridge, 1907 (repr., 1924); *The Heroic Age*, Cambridge, 1912 (repr., 1926); *The Study of Anglo-Saxon*, Cambridge, 1941; ——and N. K. Chadwick, *The Growth of Literature*, 3 vols., Cambridge, 1932-40.

J. M. Doran, *The . . . Origin of the Ornament in the Book of Durrow*, "The Burlington Magazine", 1908.

A. Brandl, *Englische Literatur* (=*Geschichte der altenglischen Literatur*), Strasbourg, 1908.

J. Déchelette, *Manuel d'archéologie préhistorique, celtique et gallo-rom.*, Paris, 1908-14.

F. Cabrol, *L'Angleterre chrétienne avant les Normands*, Paris, 1909.

C. W. C. Oman, *England before the Norman Conquest*, London, 1910.

W. M. Lindsay, *Early Irish Minuscule Script*, Oxford, 1910; *Early Welsh Script*, Oxford, 1912.

L. Gougaud, *Les Chrétientés celtiques*, Paris, 1911; *Christianity in Celtic Lands*, London, 1932.

G. H. Orpen, *Ireland under the Normans*, 4 vols., Oxford, 1911–20.

J. Gwynn, *Liber Ardmachanus, The Book of Armagh*, Dublin, 1913.

British Museum, *Schools of Illumination.* Reproductions from manuscripts, 6th Part (Hiberno-Saxon, English and French), London, 1914–30; *Guide to an Exhibition of English Art*, London, 1934.

E. Sullivan, *The Book of Kells*, London, Paris, and New York, 1914.

E. G. Millar, *Les Manuscr. à peintures des biblioth. de Londres*, Paris, 1914–20; *The Lindisfarne Gospels*, London, 1923; *English Illuminated Manuscripts*, Paris and Brussels, 1926–8; *The Library of A. C. Beatty*, etc., Oxford, 1927 —; *The Luttrell Psalter*, London, 1932; *The St. Trond Lectionary*, etc., Oxford, 1949.

B. Dickins, *Runic and Heroic Poems*, etc., Cambridge, 1915.

G. P. Krapp, *The Rise of English Literary Prose*, New York, 1915; *The Paris Psalter and the Meters of Boethius*, New York, 1932; —— and E. van Kirk Dobbie (ed.), *The Anglo-Saxon Poetic Records* (*The Junius Manuscript, The Vercelli Book, The Exeter Book*, etc.), New York, 1931 42.

E. MacNeill, *Phases of Irish History*, Dublin, 1920 (3rd impress., 1937); *Celtic Ireland*, Dublin and London, 1921.

W. A. Neilson and A. H. Thorndike, *A History of English Literature*, New York, 1921.

R. Dunlop, *Ireland from the Earliest Times to the Present Days*, Oxford, 1922.

J. Brøndsted, *Early English Ornament*, etc., London and Copenhagen, 1924.

C. G. Crump and E. F. Jacob (ed.), *The Legacy of the Middle Ages*, Oxford, 1926.

N. Åberg, *The Anglo-Saxons in England*, etc., Uppsala, 1926.

E. Hull, *A History of Ireland*, etc., 2 vols., London, 1926–30.

G. Neckel, *Germanen und Kelten*, etc., Heidelberg, 1929.

J. F. Kenney, *The Sources for the Early History of Ireland*, etc., I, New York, 1929.

J. E. King (transl. and ed.), Bede, *Opera Historica*, 2 vols., London and New York, 1930.

T. D. Kendrick, *A History of the Vikings*, London, 1930; *Anglo-Saxon Art to A.D. 900*, London, 1938.

A. W. Clapham, *English Romanesque Architecture before the Conquest*, Oxford, 1930.

A. H. Hensinkveld and E. J. Bashe, *A Bibliographical Guide to Old English*, Iowa City, 1931.

J. Ryan, *Irish Monasticism*, etc., Dublin and Cork, 1931.

A. Kingsley Porter, *The Crosses and Culture of Ireland*, New Haven, 1931.

M. Maclean, *The Literature of the Celts*, new ed., London, 1926.

A. Mahr, *Christian Art in Ancient Ireland*, etc., Dublin, 1932.

R. E. W. Flower, *The Two Eyes of Ireland, Religion and Literature*, etc., "Rep. of the Church of Ireland Conf.", Dublin, 1932; *The Irish Tradition*, Oxford, 1947.

E. T. Leeds, *Celtic Ornament in the Brit. Isles down to A.D. 700*, Oxford, 1933—.

W. A. Phillips, *History of the Church of Ireland from the Earliest Times*, etc., London, 1933—.

A. W. Clapham, *Notes on the Origins of Hiberno-Saxon Art*, "Antiquity", 1934.

R. A. S. Macalister, *Ancient Ireland*, etc., London, 1935.

F. C. Burkitt, *Kells, Durrow, and Lindisfarne*, "Antiquity", 1935.

W. J. Sedgefield (ed.), *Beowulf*, Manchester, 1935.

E. E. Wardale, *Chapters on Old English Literature*, London, 1935.

B. Salin, *Die altgermanische Tierornamentik*, etc., 2nd ed., Stockholm, 1935.

E. Curtiss, *A History of Ireland*, London, 1936 (6th ed., 1950); *A History of Medieval Ireland*, etc., 2nd ed., London, 1938.

R. V. Collingwood and J. N. L. Myres, *Roman Britain and the Engl. Settlem.*, 2nd ed., Oxford, 1937.

R. H. Hodgkin, *A History of the Anglo-Saxons*, etc., 2 vols., 2nd ed., Oxford, 1939.

C. H. Verbist, *Saint Willibrord*, etc., Louvain, 1939.

R. B. A. Mynors, *The Durham Cathedral Manuscripts*, Oxford, 1939.

G. L. Micheli, *La Miniature du Haut M.-A. et les influenç. irlandaises*, Brussels, 1939.

D. Knowles, *The Monastic Order in England*, etc., Cambridge, 1940 (repr., 1949).

F. Henry, *Irish Art*, etc., London, 1940.

F. Klaeber (ed.), *Beowulf*, new ed., Boston, Mass., 1941.

J. L. Weisberger, *Die keltischen Voelker im Umkreis von England*, Marburg, 1941.

C. W. Kennedy, *The Earliest English Poetry*, New York and London, 1943; (ed.) *Beowulf*, 4th print., New York, 1950.

M. L. W. Laistner, *A Hand-List of Bede Manuscripts*, Ithaca, New York, 1943.

G. Sampson, *The Concise Cambridge History of English Literature*, Cambridge, 1945.

T. F. O'Rahilly, *Early Irish History and Mythology*, Dublin, 1946.

P. Harvey (ed.), *The Oxford Companion to English Literature*, 3rd ed., Oxford, 1946.

É. Legouis and L. Cazamian, *A History of English Literature*, rev. ed., London, 1947.

F. Masai, *Essai sur les origines de la miniature dite irlandaise*, Brussels and Antwerp, 1947.

M. Dillon, *Early Irish Literature*, Chicago, 1948.

W. J. Entwistle and E. Gillett, *The Literature of England*, A.D. *500–1946*, 2nd ed., London, 1948.

A. C. Baugh and others, *A Literary History of England*, New York, 1948, London, 1950.

F. Mossé, *Manuel de l' anglais du Moyen Age des origines* etc., Paris, 1949.

W. F. Schirmer, *Kurze Geschichte der englischen Literatur*, 2nd. ed., Halle, 1949.

G. K. Anderson, *Literature of the Anglo-Saxons*, Princeton, 1949.

M. D. Legge, *Anglo-Norman in the Cloister*, Edinburgh, 1950.

F. M. Stenton, *Anglo-Saxon England*, 2nd ed., repr., Oxford, 1950.

C. Fox and B. Dickins (ed.), *The Early Cultures of N.-W. Europe* ("II. M. CHADWICK MEMORIAL STUDIES"), Cambridge, 1950.

C. L. Wrenn and J. R. C. Hall (ed. and transl.), *Beowulf*, London, 1950.

F. S. Delmer, *English Literature from 'Beowulf' to T. S. Eliot*, 22nd ed., London, 1951.

CONCLUSION—FATE OF BOOKS

What has happened to the many thousands of books produced in the British Isles which have not come down to us? We have already mentioned the numerous causes of destruction of books. "The trials and tribulations of books," writes H. Jackson, "are equalled only by the trials and tribulations of mankind; their sufferings are identical with those of their creators, and if they live longer they are not immune from decay and death. They have been beaten and burnt, drowned, tortured, imprisoned, suppressed, executed, censored, exiled, reviled, condemned, buried; they are overworked and under-worked, misused and maltreated in every manner known to fate and chance and the most ingenious of miscreants and misguided zealots."

What has here been said about books in general, can be said about English books in particular. Time, damp, the book worm, and religious zealotry have worked the destruction of numerous early manuscripts. The mistaken zeal, enthusiasm, and bigotry of the early leaders of the Reformation, and of those whom they employed, swept away without distinction the secular books with those of devotion, preserved in the religious houses, and thus deprived culture of many treasures. Even where the books may have been preserved, the cupidity of official visitants of the religious establishments would lead to the destruction of many valuable ornaments with which the bindings were enriched and embellished.

Not only were the libraries completely sacked, but the huge volumes which contained the ancient services, and abounded in all the churches and monasteries, were destroyed without mercy, ardently and enthusiastically. To show the extent of the devastation and frightful havoc then committed, W. S. Brassington quotes the following account of a writer of the time (Bale's *Preface* to *Leland's Journey*, 1549): "Never had we been offended for the loss of our libraries, being so many in number, and in so desolate places for the more part, if the chief monuments and most notable works of our most excellent writers had been preserved. If there had been in every shire of England but one *solempne* library, to the preservation of those noble works, and preferment of good learning in our posterity, it had been yet somewhat. But to destroy all without consideration is, and will be, unto England for ever a most horrible infamy among the grave seniors of other nations. A great number of them which purchased those superstitious mansions, reserved of those library books, some to scour their candlesticks, and to rub their boots; some they sold to the grocers and soap-sellers; some they sent over sea to the bookbinders, not in small numbers, but at times whole ships full, to the wondering of the foreign nations. Yea, the universities of this realm are not all clear of this detestable fact. But cursed is that belly which seeketh to be fed with such ungodly gains, and shameth his natural country. I know a merchant man, which shall at this time be nameless, that bought the contents of *two noble libraries* for *forty shillings* price; a shame it is to be spoken. This stuff hath he occupied in the stead of grey paper, by the space of more than ten years, and yet he hath store enough for as many years to come!"

This is not the place to tell the whole story of this wholesale destruction of books. It will suffice to relate that when the Commissioners of Edward VI came to Oxford in 1550, and found the

magnificent public library, founded in 1426 by Humfrey Duke of Gloucester, they decided that all the books were "popish", and even without due examination of the contents of the volumes—the ornaments upon the binding being sufficient in many instances to seal the fate of a book—they ordered the burning of some books, and the sale of the others to bookbinders to be cut up for covers and end-papers, or to tailors for measures. When the antiquary John Leland (chaplain and librarian to Henry VIII, from 1533, and also commissioner of king's antiquary, with power to search for manuscripts and records in all the suppressed religious houses of England) visited Oxford after the suppression of the monasteries, he found few books, only moths and beetles swarming over the empty shelves. The University even sold the benches at which the readers had sat. When Sir Thomas Bodley returned to Oxford in the early seventeenth century, he found Duke Humfrey's library a roofless and grass-grown ruin.

The mistaken zeal of the early leaders of the Reformation in England was only one cause, though the main one, of the wholesale destruction of early English books. Other causes—both in time of war and peace—have already been mentioned (see, for instance, Chapter VI). Here a few more details may be given of the peacetime enemies of the books. Jackson rightly says that "every library, especially those that are old and large, or small and neglected, breeds its own inimical flora and fauna, mould, bookworms, moths, *anthrene, vorilette,* bugs, mice, rats, the story of whose devastations would fill many volumes". Other scholars have added to this list: gas, bookbinders, houseflies, black-beetles, and servants; but especially dust, and the act of irreverent and unskilled dusting. Neglect is one of the most dangerous enemies of "the book". Jackson mentions Henry Bradshaw (1831–86; he was University librarian at Cambridge) as saying, "Nothing could be more disgraceful than the way in which the manuscripts of Bishop Moore's library, presented to the University by George I, were literally shovelled into their places; and for the thirty-five years that followed the presentation the pillage was so unlimited that the only wonder is that we have any valuable books left."

Then, again, there are those ferocious enemies, fire and water. Damage by water is a common misfortune, and many good books have been lost or damaged at sea, on inland waterways, through floods, and especially through damp. As to fire, it will suffice to mention again the fire which, on October 23, 1731, burned many precious manuscripts of the valuable library of Sir John Cotton at

Ashburnham House, Little Dean's Yard, in the City of Westminster: 114 of the total 958 volumes were destroyed, and ninety-eight partially destroyed. The Cotton Library, founded by Sir Robert Bruce Cotton (1571–1631), was by his grandson bequeathed to the nation in 1700, and after the foundation of the British Museum (in 1753), it was incorporated with the latter.

The Roman writer Terentianus Maurus (late second century A.D.), author of a popular manual on metre, used to say: *habent sua fata libelli*, "books have their fates". Indeed, the fate of a book is often stranger than that of a human being. Many great books only by miracle escaped from total loss. The strange stories of the recovery of some books have already been mentioned. Jackson tells the following story. Upon Midsummer's Eve, 1626, a cod-fish was brought to Cambridge Market and cut up for sale. In the maw of the fish a hard thing was found, which was drawn out with the entrails; it was congealed with a jelly, and the mass gave off "an ancient and fish-like smell", but, after a washing, it was seen to be a book bound in parchment. Those standing about looked upon it with wonder and admiration, and Benjamin Prime, the Bachelor's Beadle, who was present, carried the book to Dr. Samuel Ward, Master of Sidney Sussex College, who took special notice of it, afterwards describing the discovery of this literary Jonah in a letter to Archbishop Usher. The book contained three treatises, (1) *A Preparation for Death*; (2) *The Treasure of Knowledge*; and (3) *A Mirror, or Looking Glass to know thyself by, a brief Instruction to teach one willing to die not to fear Death*. Dr. Ward thought that it was probably *a special admonition to us at Cambridge*, but apparently its author was a Protestant, Richard Tracy, who published this book in 1540, and dedicated it to Lord Thomas Cromwell. However, this "fish book" induced a Cambridge man, Thomas Randolph, to write an amusing poem, which included the following two lines:

> *If fishes thus do bring to us books, then we*
> *May hope to equal Bodley's Library.*

Many precious books were discovered on the shelves of libraries. The aforementioned Bradshaw discovered in 1857, in the University Library of Cambridge, the *Book of Deer*, one of the most ancient Celtic manuscripts, which threw light on ancient Celtic language and literature. Another discovery was that of manuscripts containing the earliest remains of the Waldensian literature. Bradshaw's successor, Francis Jenkinson, "was constantly discovering fresh

treasures on the shelves" (Jackson). Jackson also mentions, among many other similar discoveries, how Dr. Williamson found the only copy of the famous *Service Book*, of 1612, in a monastery, among a lot of printer's rubbish in a room which had not been opened for twenty years.

The history of books teems with such accounts as those of the story of the *Lindisfarne Gospels*, or of the *Book of Kells*, or of the beautifully illuminated *Latin Psalter*, clearly English workmanship of the fourteenth century, of Exeter College, Oxford, but it will suffice to end this list with the *Gospel-book of St. Margaret*, Queen of Scotland, who died in 1093. She was the sister of Edgar the Atheling, wife of Malcolm III "Canmore", of Scotland, and mother-in-law of Henry I. Madan tells us that the book in question, a little octavo volume in worn brown binding, in 1887 stood on the shelves of a small parish library in Suffolk; but was turned out and offered at the end of a sale at Sotheby's, the parishioners probably preferring to have, instead, a few works of fiction. At Sotheby's it was catalogued as "Latin Gospels of the Fourteenth Century, with Illuminations". It was bought, for £6, by the Bodleian Library, and described in its catalogue as an ordinary accession. Later it was found that the writing was of the eleventh century, and the illumination was English, although influenced by the Byzantine style. It contained on a fly-leaf a poem in Latin hexameters, describing how this very volume was dropped into a stream, given up for lost, and then recovered by a soldier "sent back", who plunged head first into the water and brought it up. By a sheer miracle, the beautiful volume suffered very little from the effect of the water.

INKS, PENS AND OTHER WRITING TOOLS

FOLLOWING A. Lucas, the Honorary Consulting Chemist of the Egyptian Department of Antiquities and formerly Director of the Chemical Department of Egypt, we may distinguish writing materials into two main classes, the essential and the accessory. The essential, or primary materials comprise the pigment (or ink), the ground (parchment, paper and so on) on which ink is placed in the process of writing, and the implements (such as pens) used to transfer the ink to the ground destined to receive it. The secondary materials include the receptacles in, or on which the inks and pens are kept (inkhorn, writing box), the grinders used by ancient scribes to prepare the ink.

Various ancient "writing grounds"—such as clay tablets, papyrus rolls, waxen tablets, leather, parchment, palm leaves, bamboo sticks, silk—have been dealt with in previous chapters. Paper, of which the invention was almost as important as that of printing itself, did not become commonly available until the 15th century A.D. and so is beyond our present scope but inks, pens and other accessories concern us now.

Ink

Writing ink is a liquid containing a colouring matter—mainly black, when not specified otherwise—used for writing on paper, parchment, and similar substances; the term may also be applied to viscous paste, known as "printing ink" used in printing. Other sorts of ink—such as marking or indelible inks, sympathetic or cobalt inks, or copying inks—are outside the subject here dealt with, and will not be discussed. However, ink in all its forms has not only been useful in all ages, but still continues to be indispensable both for our spiritual necessities and for conducting the ordinary business of life.

The word "ink"—as may be seen from the old forms *enke, enk, henk,* and *inke*—derives from Old French *enque* (modern French being *encre*), itself a derivation from late Greek *énkauston* and late Latin *incaustum,* from which the Italian term for "ink", *inchiostro,* has derived; *incaustum* was the name of the (Tyrian) purple ink used by the Byzantine emperors for their signatures. It was also called *kinnábaris,* in Greek, and *sacrum incaustum,* in Latin, but in later times *kinnábaris* became synonymous with the Latin term *minium.* The term *énkauston,* derived from the Greek verb, *énkaíein* (Latin, *inurere,* "to burn in"), may suggest some process of fixing the ink by a caustic, *i.e.* "burning", corrosive substance; or else, it may be connected with "encaustic" painting, as described by Pliny, xxxv, 122,149, but neither suggestion is satisfactory, or else, the term "ink" is etymologically not exact.

The Greek word *mélan,* "black", and its Latin equivalent *atramentum*—hence, for instance, the Polish term for "ink", *atrament*— were used in Graeco-Roman times and in late Latin for the common carbon ink (see p. 548 ff).

The German term for "ink", *Tinte,* and the Spanish *tinta,* have derived from Italian *tinta* (=*colore,* "colour") and the Latin and Italian *lingere,* "to colour".

ANCIENT CHINA AND INDIAN INK

In China, ink—now known as "Chinese ink" or "Mandarin black"—is usually moulded into sticks or small cakes of solid material, and is sometimes perfumed; it is lamp-black, prepared with glue or sometimes gum. It is attributed to T'ien Chu, supposed to have lived under the legendary emperor Huang Ti (reputed to have lived in the early second millennium B.C.). It is, at any rate, a very ancient invention. See also p. 403.

An ancient Chinese palette for fluid ink is reproduced in Fig. XI-1, *below.*

Ink similar to "Chinese ink", but in fluid condition, is nowadays known as "India ink", and is employed by artists, architects, civil engineers, and others, who need a superior ink, for instance, for drawing plans and maps. India ink, too, is occasionally manufactured in little cakes or sticks. It is a "high-class" carbon ink (see p. 550). In Japan it is prepared from pine soot and sesame-oil lamp-black, mixed with a liquid glue obtained from the hides of cattle.

Some manufacturers use cuttle-fish for the same purpose; and it is interesting that the Romans also used liquid obtained from

cuttle-fish, as we are informed by Cicero, 106–43 B.C. (*De Natura Deorum*, ii.50.127), and from a satire by A. Persius Flaccus, A.D. 34–62 (iii.12).

EGYPTIAN CARBON INK (Fig. XI–1, *above*)

In Egypt, ink was already employed in pre-Dynastic times, *i.e.*

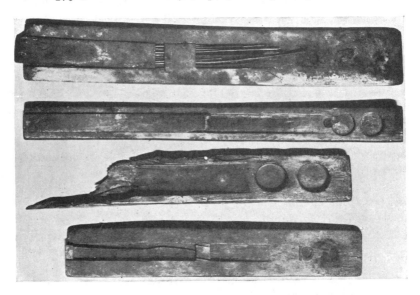

Fig. XI–1

(*Above*) Egyptian writing palettes (Cairo Museum); (*below*) Chinese inkstand (Collection of Sir Herbert Ingram, Bt.), attributed by Sir Herbert Ingram to the late Chou period, *c.* 250 B.C.

before the third millennium B.C. as we can see from pottery bearing inscriptions in ink, which was found by Sir W. M. Flinders Petrie in pre-Dynastic tombs. If thus, as would seem, the need for writing ink in Egypt arose in pre-Dynastic times, its employment became more general with the introduction of papyrus, on which characters were formed by the application of coloured fluids by means of a brush. Early Egyptian ink was carbon ink, which is thus the oldest ink material known.

We can see from the palettes (Fig. XI–1, *above*), which have come down to us, that in Egypt the ink was in the form of small cakes resembling, except in shape, modern water colours. Black ink was prepared by mixing soot with water and a gummy substance. In Lucas's opinion, the soot employed was in most cases scraped from cooking vessels, but occasionally the carbon was specially prepared, and in exceptional instances it was prepared from charcoal. However, the chemical analysis of the writing ink of the Egyptian papyrus documents or of the ostraca and pottery inscriptions, as well as of the remains of the black-ink "cakes" on the palettes, shows that Egyptian black ink was what we know as carbon ink; it was composed of very finely divided carbon in a solution of some adhesive substance, which held the carbon in suspension and fixed it to the writing ground (such as papyrus).

Coloured Inks

The Egyptians also used inks of various colours, but generally only for illustrated scenes and not in writing. Red, however, was in common use for writing, and it is seen on early Egyptian papyri. Ordinary papyrus documents or books were written in black ink, but titles and certain passages, such as the first lines of columns or chapters, were often written in red, in a manner similar to the "rubrics" as they appear in medieval manuscripts, and even in some modern editions of the Prayer Book.

The Greek term for red ink was *mĕlánion kókkinon*, the Latin term *minium* or *rubrica*. In the Middle Ages, red ink was made—apart from purple ink, which was very expensive—from vermilion (sometimes from vermilion and gum) or cinnabar. A volume written entirely in red ink, of the ninth or tenth century, is in the British Museum (*Harl. MS. 2795*), but such manuscripts are extremely rare.

Lucas has suggested that the Egyptian cakes of colour were probably made by mixing finely ground pigment with gum and water and drying, and were used in the same manner as modern

water-colours, namely, by dipping the painting brush in water and rubbing it on ink. Having examined various specimens of pigments from Egyptian palettes, Lucas has found that the materials employed were red ochre (for red), calcium carbonate or calcium sulphate (for white), orpiment or sulphide of arsenic (for bright yellow). Other analyses have shown that magnesium carbonate or gypsum were also used for white; red lead (*minium*) for red; yellow ochre, containing in some instances calcium sulphate, for yellow; limonite (one form of oxide of iron) for brown; artificial green frit (a powdered glass) or malachite, for green; and blue frit, for blue.

The employment of gold and silver as writing fluids will be discussed in the book on *Illumination and Binding*; see also, in the present book, pp. 278 ff., 290 f. and *passim*. In a third- or fourth-century (A.D.) papyrus preserved at Leiden there is an old recipe for manufacture of golden ink.

WRITING INK IN GRAECO-ROMAN AND LATER TIMES

Ink (*deyô*) is mentioned once in the Hebrew Bible (*Jer.* xxxvi, 18), where Baruch says that he wrote Jeremiah's prophecies "in the book with ink". We have no means of knowing what kind of ink it was. While W. R. Smith, referring to *Ex.* xxxii, 33, and *Num.* v, 23, has suggested that *deyô* was made from lamp-black, and could be washed off, in the opinion of other scholars, it was not carbon ink, but iron-gall ink. If, however, we consider talmudic information and the early Jewish tradition, we must assume that *deyô* was a carbon ink. On the other hand, in the second century A.D., apparently a new ingredient was added, *khálkanthon*, which in this instance seems to indicate sulphate of copper. Later, the *Mishnah* also mentions copperas, gall-nuts and gum.

Carbon Ink (Fig. XI-2)

A. Lewis, who analysed the ink of the Early Hebrew ostraca discovered at Lachish (South Palestine) in 1935 and assigned to *c.* 587 B.C. (see *The Alphabet*, p. 240), has found that they were written with an iron-carbon mixture quite unlike a carbon ink. He therefore has suggested that while the Hebrews commonly used a mixed iron-carbon ink, they reserved carbon inks for religious writings to avoid confusing erasures with worn-down texts.

It is generally agreed that, before the introduction of vellum (see Chapter V), the Greeks and the Romans used carbon ink. They

had various kinds of ink, but we are mainly concerned with the following; (1) *Mélan graphikón*, in Greek (in the Byzantine period, also called *melánion* or *atéramnon*) or *atramentum librarium*, in Latin, *i.e.* "book ink" or "writing ink"; this was usually prepared of soot

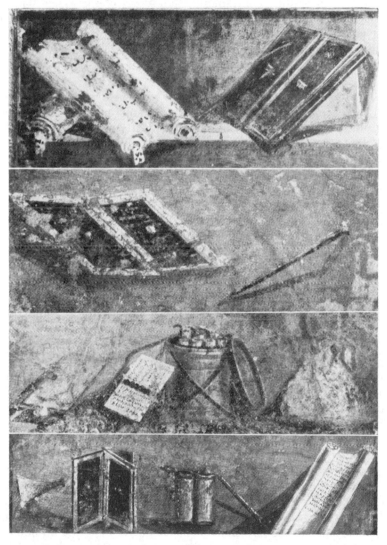

Fig. XI–2

Roman writing materials and implements as represented in wall-paintings of Pompei (now preserved in the National Museum, Naples).

from pitch-pine, mixed with gum, or vinegar; it was more unctuous than ours, and resembled printer's ink; (2) *atramentum tectorium* or *pictorium*, which was mainly used by painters; and (3) *atramentum sutorium* (in Greek, *khálkanthon*), which was mainly used to dye leather; it probably contained sulphate of copper (see Cicero, *Ep. ad familiares*, ix, 21). We have sufficient literary evidence to show that *atramentum librarium* was carbon ink: see Vitruvius, vii, 10: *ex fulgine factum atramentum*; Pliny (*Nat. Hist.* xxxv, 6) mentions soot and gum as the main ingredients of writing ink.

In later Graeco-Roman times iron-gall writing ink (see below) was used, and in course of time, its use became universal in Europe; but in the East, carbon ink continued to be employed. Lucas mentions the following two recipes for Oriental inks. (1) For carbon ink still prepared for Coptic religious books, "put a quantity of incense on the ground and round it place three stones or bricks, and, resting on these, an earthenware dish bottom upwards, covered with a damp cloth; ignite the incense. The carbon formed is deposited on the dish, from which it is removed and made into ink by mixing with gum and water". (2) For "Persian Ink", as described in an old Arabic book of the Cairo Royal Library: "An earthenware vessel containing date stones and stoppered with clay, is put over a fire until the next day; then it is removed and allowed to cool; its contents, then, are ground and sifted, and made into ink with gum arabic and water." Such ink—containing very little free carbon—would be of poor quality.

If we accept the principle that the perfect record ink should be harmless to the manuscript and permanently readable however aged, then carbon ink should be considered as superior to ordinary iron-gall inks; these contain sulphuric acid which damages paper, especially good paper, sometimes irreparably. Carbon ink has no harmful effect upon the material written on, and it appears to be the most permanent of all inks, because it is not bleached nor changed by atmospheric agencies, such as sunlight.

On the other hand, such ink requires frequent stirring to prevent the carbon from sinking in the liquid; in other words, it easily becomes thick, and clogs the pen. Moreover, while the perfect ink, when applied to paper, should penetrate so as to be difficult of erasure, carbon ink can be easily wiped out soon after writing. Hence, in Roman times, the sponge (from Greek *spóngos*) was one of the regular implements of the *scriba librarius* (Suetonius, *Augustus*, 85).

IRON-GALL WRITING INK

Modern common ink is essentially a solution of an iron salt, ferrous sulphate, such as copperas or green vitriol, clear yellow tannin nut-galls or other tannin-yielding substance, a preservative, and soft water. The use of this decoction depends upon the formation of a bluish substance, which is produced by exposure to the air. Such ink is known as iron-gall ink.

The origin of iron-gall writing ink is generally dated to the Middle Ages; the American authors of the standard work on *Inks*, give the date 1126. According to Lucas, it appeared first on parchment assigned to the seventh or eighth century A.D.; and Mitchell, who accepts this date, has argued that iron-gall ink was first described in the eleventh century.

Wiesser's analysis of the ink on Fayyûm papyri has shown two kinds of ink: carbon ink and iron ink; the latter would also seem to have been employed on a papyrus of the fourth century A.D., analysed by Schubart. But various specimens of ink on Coptic ostraca examined by W. E. Crum, and numerous specimens on ostraca and papyri from Roman times and up to the ninth century A.D., examined by Lucas, were all carbon ink. On the other hand, in various instances of parchment documents examined by Lucas and dated between the seventh and the twelfth centuries, the ink was an iron compound.

In late Roman times such ink was already employed for writing on vellum; of the Roman vellum manuscripts examined at the British Museum in 1935, nine out of twelve were written with iron ink free of carbon; amongst those so written were one of the earliest known vellum documents, a second-century A.D. copy of Demosthenes, *De falsa legatione*, and the famous fourth-century *Codex Sinaiticus* (see Chapter V). Fig. V–10, A, and 11.

Therefore, in considering the results of his analysis of the ink of the Lachish ostraca, A. Lewis concludes that iron inks pre-dated classical times, and that they developed with the use of skins as writing material, from which carbon inks wear or wash off cleanly. It may be assumed that both the origin and the development of the iron inks were slow processes, lasting many centuries. "Permanent and imperishable record or safety inks have been the subject of an unending quest" (Lewis).

Philo of Byzantium (third century B.C.) in his treatise on *Ancient Mathematicians*, described a kind of sympathetic ink, which may be considered as a non-coloured type of iron ink; it was made of nut-

galls; when the writing was completed and the document was dipped in an extract of iron salt, this writing became nearly black.

Theophilus, in his work *De diversis artibus* (i, 40), written probably in the twelfth century, gives a recipe for the manufacture of ink from thorn wood boiled down.

In the Middle Ages ink was mainly produced in the monasteries. A fifteenth-century Italian recipe informs us that iron-gall ink was then universally known (at least, in the Christian world). In the sixteenth century, we get information about its production from the Italians, Gerolamo Cardano (1535), Alessio Piemontese (1557), and Giovan Battista della Porta (1567). In the seventeenth century, Pietro Maria Canepario, Professor of Medicine at Venice, wrote a curious book concerning inks, in six parts (*De atramentis cujuscunque generis opus*, etc., 1619; an edition was printed in London in 1660).

Robert Boyle (1663), Otto Taccherini (1666), and especially the French chemists Nicholas and Louis Lémery published works or articles on ink. From the eighteenth century onwards, much scientific research was done in this field. It will suffice to mention that the English chemist and physician, William Lewis, found that the colouring of iron-gall ink depends not only upon metallic iron, but also upon a reaction produced by a vegetable extract. Thus, by using logwood he obtained an improvement of colour without loss of permanence. R. W. Scheele (1786), N. Denyeux (1793), A. Seguin (1795), Reids (1820), J. J. Berzelius (1832), F. J. Runge (1847), A. Leonhardi (1856), and in more recent times, O. Shuttig and G. S. Neumann may be mentioned amongst those who developed ink production and the ink industry.

The importance of the study of ink for the dating of manuscripts and for their attribution to a certain country is very great, and it has been emphasized by eminent scholars, such as Prof. E. A. Lowe. "If librarians"—he writes—"could be induced to grant permission, one would like to submit the ink of our manuscripts to chemical analysis; the experiment might yield instructive results. For instance, it could establish whether the blue ink found in the ninth-century additions to the Codex Bezae . . . is identical with the blue ink in the manuscripts of the Excerpts from St. Augustine made by Florus . . .; if it is then it too was made at Lyons. It might also tell us whether Northumbrian ink differed from Kentish, Irish from English and Insular from Continental. The only observation which a layman can safely make is that the ink in Continental manuscripts has now a brownish hue, whereas the ink in Insular manu-

scripts is mostly black and very fresh: some Insular manuscripts might have been written yesterday, the Lindisfarne Gospels, for example. There is another difference between Insular and Continental manuscripts. In the latter it can often be noticed that the ink has flaked off on the flesh-side of the leaf. Insular manuscripts are remarkably free from this, both flesh-side and hair-side holding the ink equally well. The Insular method of preparing the membrane probably account for this."

Writing Tools

GRAECO-ROMAN TIMES (Fig. XI–2 and 3)

For ancient Mesopotamia, see Chapter III, particularly p. 83 and Fig. III–1 and 2, *f*; for ancient Egypt see Chapter IV (p. 158) and pp. 547 f., 557 and Fig. IV–1, XI–1, *above*.

STILUS

The main writing tools of the Greeks and the Romans were the *stilus* and the reed-pen or *calamus*. The "stilus" (not stylus) was called in Greek *graphís*, *grapheîon* or *graphídion*; in late writers, *stylos*, and in Latin *stilus*—see Horace, *Sat.* I, x, 72—or simply *ferrum* ("iron") —see for instance, Ovid, *Metam.*, ix, 521—or else, from Greek, *graphium*—see Ovid, *Amores*, I, xi, 23. It was an instrument of iron, bronze, silver or other material, such as ivory (Ovid, *Metam.*, ix, 521; Martial, xiv, 21) and was used for writing on boards or waxen tablets (Plautus, *Bacch.*, iv, 4, 63; Pliny, xxxiv, 139), the letters being scratched with a sharp point. The other end of the stilus was rounded into a knob or flattened, and was used, in the event of an error, to deface what had been written, by smoothening the wax. Hence, the expression *vertere stilum* ("to turn the stilus"), for "blot out, correct".

The case, in which the stilus was kept, was called in Greek *graphiothékē*, and in Latin *graphiarium* (Martial, xiv, 21) or *graphiaria theca* (Suetonius, *Claudius*, 35).

The iron stilus was a dangerous weapon, and in later times it was prohibited by the Romans. Suetonius tells us that Caesar seized the arm of Cassius in full Senate, and pierced it with his stilus. He also says that Caligula excited the people to massacre a Roman senator with their stili. Seneca mentions that a Roman knight, Erixo, having scourged his son to death was attacked in the forum by the mob who stabbed him with their iron stili, so that he narrowly escaped being killed, though the emperor interposed his authority (*De Clementia*, i, §14).

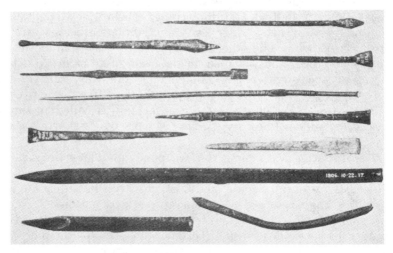

Fig. XI–3

(*Above*) Graeco-Roman "poetess" with codex and stilus as represented in a Pompeian wall-painting; (*below*) Roman stili and pens.

Fig. XI-⁵⁄₇

(*Left*) A scribe as represented in a Bible written and illuminated in Italy in A.D. 1169 (preserved in Certosa di Pisa; photo by Gabinetto Fotografico Nazionale, Rome); (*right*) St. John, reading from a roll, as represented in the *Lindisfarne Gospels* (British Museum, *Cott. Nero. D. iv*).

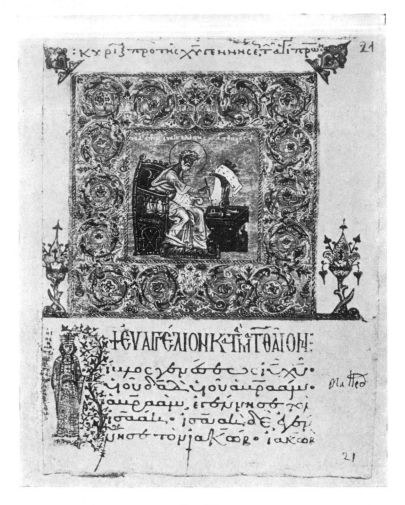

Fig. XI-5

Byzantine scribe (*Byzantine Gospels*, Vatican Library, *Urb. Gr. MS. 2*, fol. 21 *recto*).

CALAMUS

For writing on papyrus the reed-pen (a stick of common reed, *Paragamites communis*) was used, at least from the third century B.C. onwards; it was called in Greek *kálamos* (also *dónax grapheîos*), and in Latin *calamus* (also *canna*). Reeds were used also for thatching and wall building, for making mats, crates, and so on; hence, the exact term for a reed-pen was *calamus scriptorius* or *chartarius*.

At first, it was used with the end frayed or pulped; later, like the quill-pen, it was cut to a point and split; it was sharpened with a knife; in Greek *kalamoglyphein*, and in Latin *calamum acuere* or *temperare* (the last term appears also in modern Italian) meant "to sharpen"; the penknife used was called in Greek *glýphanon* or *smílē*, and in Latin *scalprum librarium*—see for instance Tacitus, *Annal.*, v, 8. Suitable calami came chiefly from Egypt (Pliny, xvi, 36; Martial, xiv, 38) or Cnidus, on the southern coast of Asia Minor (Ausonius, *Epistles*, vii). Some specimens of ancient reeds cut like a pen are preserved in the British Museum.

The calamus was introduced into Egypt in Graeco-Roman times, and Sir W. M. Flinders Petrie discovered in that country a number of such pens belonging to the Roman period. According to Winlock, the complete adoption of the split pen by the Egyptians "may be safely related to the adoption of the Greek alphabet for writing the Egyptian language during the fourth century A.D.", *i.e.* to the creation of the Coptic alphabet. (In fact, the Coptic alphabet originated much earlier: see p. 307 and *The Alphabet*, p. 467 ff.)

In the sixth or seventh century, the monks of the Christian monastery of Thebes (see Winlock and Crum, *The Monastery of Epiphanius at Thebes*) were using reed split pens. "The pens were made of reeds, which averaged about 1 inch in diameter. An unused new pen . . . was 26.5 cm. long. The old pens had been resharpened so often that finally they were mere stumps less than 6 cm. long . . . and one of them had been lengthened by sticking a bit of wood into the end."

Reeds continued in use to some extent through the Middle Ages; in Italy they appear to have survived into the fifteenth century. Ranwolff, who travelled in 1583, wrote that the "Turks, Moors, and eastern nations, use canes for pens, which are small and hollow within, smooth without, and of a brownish red colour". Later travellers, such as Halhed, Tavernier, and others, related that the Indians, the Tartars, and the Persians "write with small reeds bearing the hand exceedingly lightly". In some countries—such as Egypt, India and Persia—the use of reed-pens lingered on down to our own times, though nowadays it has gradually died out. In eastern and south-eastern Asia, as already mentioned, bamboo canes, cut to about the length and thickness of our pen, are still used for writing.

Corresponding to our steel pen were the Roman metal reeds of bronze or silver, of which a few have been found in Italy, one in England (which is preserved in the British Museum), and one near

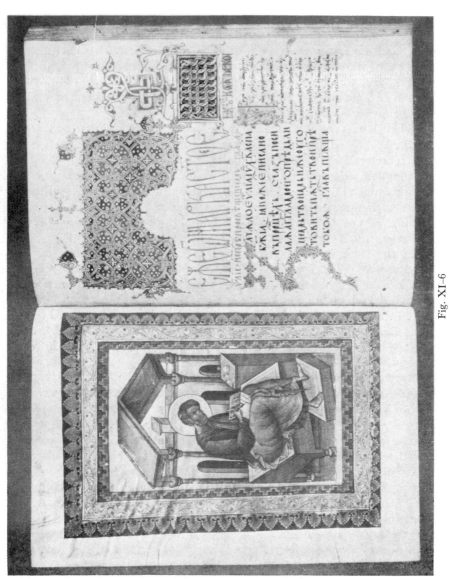

Fig. XI-6

Late Byzantine scribe (Bodleian Library, Oxford, *MS. Can. Gr. 122*).

Cologne; such pens, however, were not greatly used. A metal pen, about 2 inches long, shaped and slit after the fashion of a quill pen, was found by Prof. Waldstein in the so-called tomb of Aristotle at Eretria (modern Aletria), the ancient seaport of the Greek island of Euboea.

ACCESSORY WRITING MATERIALS

The case in which the reed-pens were kept was called in Greek *kalamothékē* or *kalamís*, and in Latin *calamarium* (hence *calamaio*, the Italian word for "inkstand") or *theca calamaria*, also *theca libraria*, or *theca cannarum*, or else *graphiarium*. In the same case the inkstand,

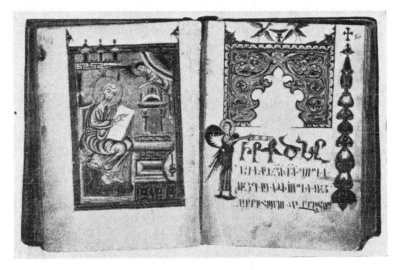

Fig. XI 7

Armenian scribe (illuminated Armenian *Gospel-book*, National Library, Paris, *Armén., 18*).

atramentarium (in Greek, *melandókon* or *melandokheíon*) was usually kept. In the famous Diocletian's edict *De Pretiis rerum venalium* (*Corp. Inscr. Lat.*, iii, 801), the *calamarium* is referred to as made of leather. Sometimes, however, separate receptacles were provided for the ink and the reed-pens.

In Egypt, the pens were kept in recesses on the palettes which also contained depressions (usually circular, but sometimes rectangular) for the cakes of ink. See Fig. XI-1, *above*. These palettes

were made of various materials such as wood, stone, often alabaster or serpentine, even wood covered with gold (such a specimen was found in the tomb of Tutankhamen, as also was a beautifully decorated pen-holder; both are preserved in the Cairo Museum).

In Chapter V, in the section dealing with *The Scriptorium* other accessory writing implements have been mentioned. There can be hardly any doubt that similar tools were used in Graeco-Roman

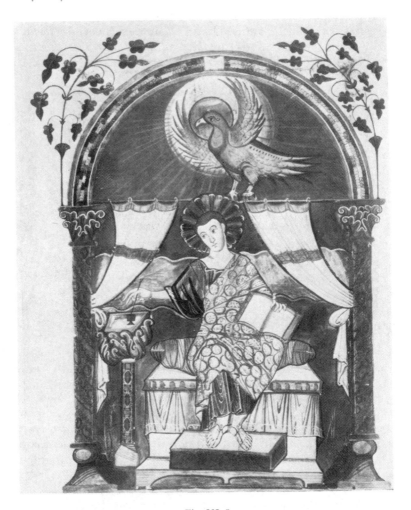

Fig. XI–8

Carolingian scribe (the *Lorsch Gospels*, eleventh century; written and illuminated in the Carolingian school of Trèves (Vatican Library, *Pal. Lat. 50*; fol. 67, *verso*).

times. The late M. R. James has pointed out that a number of epigrams in the *Palatine Anthology*, vi, 62–8, 295, "mostly late, but all variations on an ancient theme", give lists of various Greek writing implements, including—apart from those which have already been referred to—the *mólibdos* (a disc of lead with which lines were ruled), the *kanón* (the ruler which served to keep the lines and columns straight), and the *kíséris* (the pumice stone, with which the nib of the pen was smoothed, and the roughness of the papyrus or parchment was rubbed away).

THE QUILL (Fig. XI-4, *left*)

The quill-feather (in Latin *penna*), made from the wing feather of geese, swans (swan-quills were much valued), peacocks, crows (crow-quills were used for fine lines), or turkeys, was used in the West in early medieval times, but it is not easy to ascertain when it was introduced. It is possible that, as soon as vellum came into general use, so obviously convenient an implement, always ready to hand, came to be used, particularly in places where reeds of a kind suitable for writing could not be had. Indeed, the flexible pressure of the quill-feather, which in heavy strokes might have proved too much for the fragile papyrus, was much more suitable for the hard but smooth surface of the parchment than the non-flexible reed-pen. Because of its suitability for writing on vellum, the quill-feather was the main pen of the Middle Ages, as well as of modern times down to the nineteenth century.

However, the word "pen" (Lat. *penna*) is first mentioned by an anonymous historian who tells us that, to enable the unlettered founder of the Ostrogothic kingdom in Italy, Theodoric the Great (A.D. 455–526), to write his name, he was provided with a stencil plate, through which he drew with a *penna* the strokes which formed the first four letters of his name. In time, the terms "pen" and "calamus" became synonymous and interchangeable. It is, therefore, impossible to say when the quill-feather superseded the reed-pen. There is no doubt, however, that for quite a long period both the calamus and the quill-feather were in use. St. Isidore of Seville or Isidorus Hispalensis (*c.* 560 636), mentions both as being used in his time (*Instrumenta scribae calamus et penna. Ex his enim verba paginis infiguntur, sed calamus arboris est, penna avis, cuius acumen in duo dividitur, in toto corpore unitate servata* [*Ethymologiae*, vi, 14; ed. Migne, *Patrologia Latina*, 82.241]).

Figs. XI–4–8 reproduce medieval scribes as represented in Byzantine, Northumbrian, early Italian, Balcan, Armenian, and Carolingian codices.

THE STEEL-PEN

The quill-feather could not last long, and each user, as in the case of the reed-pen, had to cut or sharpen his quill-pen with a penknife. Therefore, owing to the loss of time involved in sharpening the points of quill-nibs, various attempts were made either to employ other materials, or to give durability to the quill-feather by gilding the nib (Watt, in 1818), or by attaching to it horn or tortoiseshell tips (such nibs, invented in 1823 by J. I. Hawkins and S. Morden, were beautifully decorated). All these attempts were unsuccessful.

Around 1780, a split-ring manufacturer, S. Harrison of Birmingham, produced a metallic pen for the chemist Dr. J. Priestly; in 1803, Wise introduced in London the complete steel nib, or rather the split cylinder steel-pen. In 1805, Breithaupt of Kassel marketed silver and steel pens: they were too heavy, too hard, and non-flexible. The nib was patented by Donkin in 1808.

In 1809, the English engineer J. Bramah (1748–1814) patented a machine for cutting goose-feathers into three or four nibs to be used with a pen-holder. In 1810, the first patent was granted in America to P. Williamson (of Baltimore) for the manufacture of metallic pens. In 1822, J. Mitchell invented the machine-made pen. In 1830, J. Perry of Birmingham, assisted by Mason, patented his system to produce pens which were so flexible that they could compete with quill-pens. It was the birth of the modern pen, and Birmingham became the first centre of the steel-pen industry, of which it is still one of the main centres. In 1845, Sonnecken and Renleaux invented special pens for Gothic writing. Mass production of steel-pens was started in 1860 at Camden (New Jersey, U.S.A.). Steel-pens, however, did not displace the quill-feather until late in the nineteenth century, and soon afterwards the gold-nibbed fountain-pen conquered the market.

HAIR BRUSHES

Fine hair brushes—a very early Chinese invention, see p. 407 f.— are still used by the Chinese for their writing: they first liquefy their ink, then dip their brushes into it. In the West also, fine hair brushes were used, but mainly for the large capital letters. They were so

employed until the sixteenth century; even after the invention of printing, they were used mainly by illuminators for the drawing of large capital letters. A still finer brush was used in applying gold to illumination; this was called in Greek *kondilion*, and in Latin *penicillus*; hence, the word "pencil", which literally means "little tail". This finer type is still used by artists in painting, and is made of hog's bristles or finer camel hair, fitch, or sable. The larger pencil brushes are sometimes set in tin tubes; the smaller ones in feather quills.

GENERAL BIBLIOGRAPHY

J. Janin, *Le Livre*, Paris, 1870.

É. Egger, *Histoire du Livre*, etc., Paris, 1880.

H. Bouchot, *Le Livre*, Paris, 1886; *The Book*, etc. (Engl. transl.), London, 1890.

O. Noël, *Histoire du commerce*, Paris, 1891.

G. H. Putnam, *Books and their Makers during the Middle Ages*, London and New York, 1896.

W. Wattenbach, *Das Schriftwesen im Mittelalter*, 3rd ed., Leipsic, 1896.

L. Blau, *Studien zum althebraeischen Buchwesen*, Strasbourg, 1902.

J. E. Sandys, *A History of Classical Scholarship*, etc., Cambridge, 1903–8; 3rd ed., 1921.

E. M. Thompson, *Handb. of Greek and Latin Palaeography*, 3rd ed. London, 1906; *An Introduction to Greek and Lat. Palaeography*, Oxford, 1912.

C. J. Davenport, *The Book*, etc., London, 1907; *The Book*, etc., New York, 1908; *Byways among English Books*, London, 1927.

F. Poppenberg, *Buchkunst*, "Die Kunst", vols. 57–8, 1908.

A. Cim, *Le Livre*, 5 vols., Paris, 1908.

W. Morris, *The Ideal Book*, London, 1908.

G. Burford Rawlings, *The Story of Books*, London, 1910.

B. Haendke, in "REPERTORIUM FUER KUNSTWISSENSCHAFT", 1911.

V. Gardthausen, *Griechische Palaeographie*, I, *Das Buchwesen*, 2nd ed., Leipsic, 1911.

A. W. Pollard, *Fine Books*, London, 1912.

E. A. Lowe, *The Beneventan Script*, etc., Oxford, 1914; *Scriptura Beneventana*, Oxford, 1929; *Codices Latini antiquiores*, etc., 5 vols., Oxford, 1934-1950.

The Art of the Book, "Studio", Special number, London, 1914.

M. Gerlach, *Das alte Buch und seine Ausstattung vom 15 bis zum 19 Jahrh.*, Vienna, Gerlach and Wiedling, 1918.

F. Madan, *Books in Manuscript*, London, 1920 (latest ed.).

M. Audin, *Le Livre*, etc., Lyon, 1921; *Le Livre*, etc., Paris, 1927.

F. Harrison, *Book about Books*, London, 1943.

A. Esdaile, *The British Museum Library*, London, 1946.

H. Foerster, *Mittelalt. Buch– und Urkundeninschriften*, Bern, 1946.

W. Levison, *England and the Continent in the Eighth Century*, Oxford, 1946.

J. Vorstius, *Grundzuege der Bibliotheksgeschichte*, 4th ed., Leipsic, 1948.

G. Leyh, *Handbuch der Bibliothekswissenshaft*, 2nd ed., vol. 1: *Schrift und Buch*, Leipsic, 1949.

D. Diringer, *The Alphabet*, 2nd ed., London and New York, 1949.

H. Lehmann-Haupt, ed., *One Hundred Books about Bookmaking*, New York and Oxford, 1949.

K. Jacob, *Quellenkunde d. deutschen Geschichte im Mittelatter*, 2nd vol., 4th ed., Berlin, 1949.

G. A. Catton, *ABC of Bookcraft*, London, 1950.

R. Latouche, *Textes d'histoire médiévale*, etc., Paris, 1951.

E. R. Sawyer, *Books are People*, Portland, Ore., 1951.

P. A. Bennett, ed., *Books and Printing*, Cleveland, 1951.

H. C. Gardiner, ed., *Great Books*, New York, 1951.

S. Jennett, *Making of Books*, London, 1951.

E. Mehl, *Deutsche Bibliotheksgeschichte*, and B. Bischoff, *Palaeographie*, in "DEUTSCHE PHILOLOGIE IM AUFRISS" (1951–2), col. 315–78, and 379–451.

A. Allen, *Story of the Book*, London, 1952.

P. A. Schneider and F. Wormald, in "BULL. OF THE JOHN RYLANDS LIBRARY," Manchester, 1952.

T. Birt, *Aus dem Leben der Antike*, Leipsic, 4th ed., 1922.

A. Bauckner, *Einfuehrung in das mittolalt. Schrifttum*, Munich, 1923.

A. Meillet and M. Cohen, *Les Langues du monde*, Paris, 1924.

B. Adarjukukoff and A. Sidaroff, *The Book in Russia*, 2 vols. (in Russian), Moscow, 1924.

P. G. Angoulvent, *The Development of the Book*, "Fleuron", London, 1924.

S. De Ricci, ed., *Catalogue de l'Exposition du livre italien*, etc., Paris, 1926.

F. H. Hitchcock, *The Building of a Book*, New York, 1927; 2nd ed., 1929.

F. G. Kenyon, *Ancient Books and Modern Discoveries*, Chicago, 1927.

C. J. Sawyer and F. J. Harvey Darton, *English Books, 1575–1900*, 2 vols., Westminster, 1927.

R. B. McKerrow, *Introduction to Bibliography for Literary Students*, Oxford, 1927.

W. Dana Orcutt, *In Quest of the Perfect Book*, etc., London, 1927; *The Book in Italy during the XVth and XVIth centuries*, London, 1928.

E. Stemplinger, *Buchhandel im Altertum*, Munich, 1927.

A. von Le Coq, *Buried Treasures of Chinese Turkestan*, London, 1928.

H. Bohatta, *Einfuehrung in die Buchkunde*, Vienna, 1928.

H. Guppy, *Stepping-stones to the Art of Typography*, Manchester, 1928; *Human Records*, etc., "BULL. OF THE JOHN RYLANDS LIBRARY", Manchester, 1942.

S. Dahl, *Geschichte des Buches*, Leipsic, 1928; *Histoire du Livre*, etc., Paris, 1933; Germ. 2nd ed., 1941.

A. M. Kimball, *Story of Books*, Dallas (Texas), 1929.

W. H. Boulton, *The Romance of the British Museum*, London, 1931.

C. Dawson, *The Making of Europe*, London, 1932.

R. N. D. Wilson, *Books and their History*, New York, 1933.

B. Boyce, *Progressive Bookcraft*, Oxford, 1934.

J. B. Poynton, *Books and Authors*, "GREECE AND ROME", 1934.

M. Lipman, *How Men kept their Records*, New York, 1934.

M. Ilin, *Black on White*, etc., London, 1937.

B. H. Newdigate, *The Art of the Book*, London, 1938.

K. Loeffler and J. Kirchner, ed., *Lexicon des gesamten Buchwesens*, 3 vols., Leipsic, 1934–7.

D. C. McMurtrie, *Book: the Story of Printing and Bookmaking*, New York, 1937; London, 1938; 3rd ed., New York, 1943, Oxford, 1944.

E. Lesne, *Les livres, 'Scriptoria' et bibliothèques*, Lille, 1938.

E. Curtius, *Schrift und Buchmetaphorik*, etc., Halle, 1942.

INDEX

Proper names include Territories, Peoples, Languages and Scripts; modern authorities (quoted in the bibliography or cited in the text) have been omitted.

N. B.—I express my gratitude to a few friends—particularly Mrs. R. Singer and Mr. W. C. Ivory—who helped me in the preparation of this index.—D. D.

A CATALOG OF SELECTED
DOVER BOOKS
IN ALL FIELDS OF INTEREST

A CATALOG OF SELECTED DOVER
BOOKS IN ALL FIELDS OF INTEREST

CONCERNING THE SPIRITUAL IN ART, Wassily Kandinsky. Pioneering work by father of abstract art. Thoughts on color theory, nature of art. Analysis of earlier masters. 12 illustrations. 80pp. of text. 5⅜ x 8½. 23411-8

ANIMALS: 1,419 Copyright-Free Illustrations of Mammals, Birds, Fish, Insects, etc., Jim Harter (ed.). Clear wood engravings present, in extremely lifelike poses, over 1,000 species of animals. One of the most extensive pictorial sourcebooks of its kind. Captions. Index. 284pp. 9 x 12. 23766-4

CELTIC ART: The Methods of Construction, George Bain. Simple geometric techniques for making Celtic interlacements, spirals, Kells-type initials, animals, humans, etc. Over 500 illustrations. 160pp. 9 x 12. (Available in U.S. only.) 22923-8

AN ATLAS OF ANATOMY FOR ARTISTS, Fritz Schider. Most thorough reference work on art anatomy in the world. Hundreds of illustrations, including selections from works by Vesalius, Leonardo, Goya, Ingres, Michelangelo, others. 593 illustrations. 192pp. 7⅛ x 10¼. 20241-0

CELTIC HAND STROKE-BY-STROKE (Irish Half-Uncial from "The Book of Kells"): An Arthur Baker Calligraphy Manual, Arthur Baker. Complete guide to creating each letter of the alphabet in distinctive Celtic manner. Covers hand position, strokes, pens, inks, paper, more. Illustrated. 48pp. 8¼ x 11. 24336-2

EASY ORIGAMI, John Montroll. Charming collection of 32 projects (hat, cup, pelican, piano, swan, many more) specially designed for the novice origami hobbyist. Clearly illustrated easy-to-follow instructions insure that even beginning papercrafters will achieve successful results. 48pp. 8¼ x 11. 27298-2

THE COMPLETE BOOK OF BIRDHOUSE CONSTRUCTION FOR WOODWORKERS, Scott D. Campbell. Detailed instructions, illustrations, tables. Also data on bird habitat and instinct patterns. Bibliography. 3 tables. 63 illustrations in 15 figures. 48pp. 5¼ x 8½. 24407-5

BLOOMINGDALE'S ILLUSTRATED 1886 CATALOG: Fashions, Dry Goods and Housewares, Bloomingdale Brothers. Famed merchants' extremely rare catalog depicting about 1,700 products: clothing, housewares, firearms, dry goods, jewelry, more. Invaluable for dating, identifying vintage items. Also, copyright-free graphics for artists, designers. Co-published with Henry Ford Museum & Greenfield Village. 160pp. 8¼ x 11. 25780-0

HISTORIC COSTUME IN PICTURES, Braun & Schneider. Over 1,450 costumed figures in clearly detailed engravings–from dawn of civilization to end of 19th century. Captions. Many folk costumes. 256pp. 8⅜ x 11¾. 23150-X

STICKLEY CRAFTSMAN FURNITURE CATALOGS, Gustav Stickley and L. & J. G. Stickley. Beautiful, functional furniture in two authentic catalogs from 1910. 594 illustrations, including 277 photos, show settles, rockers, armchairs, reclining chairs, bookcases, desks, tables. 183pp. 6½ x 9¼. 23838-5

AMERICAN LOCOMOTIVES IN HISTORIC PHOTOGRAPHS: 1858 to 1949, Ron Ziel (ed.). A rare collection of 126 meticulously detailed official photographs, called "builder portraits," of American locomotives that majestically chronicle the rise of steam locomotive power in America. Introduction. Detailed captions. xi+ 129pp. 9 x 12. 27393-8

AMERICA'S LIGHTHOUSES: An Illustrated History, Francis Ross Holland, Jr. Delightfully written, profusely illustrated fact-filled survey of over 200 American lighthouses since 1716. History, anecdotes, technological advances, more. 240pp. 8 x 10¾. 25576-X

TOWARDS A NEW ARCHITECTURE, Le Corbusier. Pioneering manifesto by founder of "International School." Technical and aesthetic theories, views of industry, economics, relation of form to function, "mass-production split" and much more. Profusely illustrated. 320pp. 6⅛ x 9¼. (Available in U.S. only.) 25023-7

HOW THE OTHER HALF LIVES, Jacob Riis. Famous journalistic record, exposing poverty and degradation of New York slums around 1900, by major social reformer. 100 striking and influential photographs. 233pp. 10 x 7⅝. 22012-5

FRUIT KEY AND TWIG KEY TO TREES AND SHRUBS, William M. Harlow. One of the handiest and most widely used identification aids. Fruit key covers 120 deciduous and evergreen species; twig key 160 deciduous species. Easily used. Over 300 photographs. 126pp. 5⅜ x 8½. 20511-8

COMMON BIRD SONGS, Dr. Donald J. Borror. Songs of 60 most common U.S. birds: robins, sparrows, cardinals, bluejays, finches, more—arranged in order of increasing complexity. Up to 9 variations of songs of each species.
Cassette and manual 99911-4

ORCHIDS AS HOUSE PLANTS, Rebecca Tyson Northen. Grow cattleyas and many other kinds of orchids—in a window, in a case, or under artificial light. 63 illustrations. 148pp. 5⅜ x 8½. 23261-1

MONSTER MAZES, Dave Phillips. Masterful mazes at four levels of difficulty. Avoid deadly perils and evil creatures to find magical treasures. Solutions for all 32 exciting illustrated puzzles. 48pp. 8¼ x 11. 26005-4

MOZART'S DON GIOVANNI (DOVER OPERA LIBRETTO SERIES), Wolfgang Amadeus Mozart. Introduced and translated by Ellen H. Bleiler. Standard Italian libretto, with complete English translation. Convenient and thoroughly portable—an ideal companion for reading along with a recording or the performance itself. Introduction. List of characters. Plot summary. 121pp. 5¼ x 8½. 24944-1

TECHNICAL MANUAL AND DICTIONARY OF CLASSICAL BALLET, Gail Grant. Defines, explains, comments on steps, movements, poses and concepts. 15-page pictorial section. Basic book for student, viewer. 127pp. 5⅜ x 8½. 21843-0

THE CLARINET AND CLARINET PLAYING, David Pino. Lively, comprehensive work features suggestions about technique, musicianship, and musical interpretation, as well as guidelines for teaching, making your own reeds, and preparing for public performance. Includes an intriguing look at clarinet history. "A godsend," *The Clarinet,* Journal of the International Clarinet Society. Appendixes. 7 illus. 320pp. 5⅜ x 8½. 40270-3

HOLLYWOOD GLAMOR PORTRAITS, John Kobal (ed.). 145 photos from 1926-49. Harlow, Gable, Bogart, Bacall, 94 stars in all. Full background on photographers, technical aspects. 160pp. 8⅞ x 11¼. 23352-9

THE ANNOTATED CASEY AT THE BAT: A Collection of Ballads about the Mighty Casey/Third, Revised Edition, Martin Gardner (ed.). Amusing sequels and parodies of one of America's best-loved poems: Casey's Revenge, Why Casey Whiffed, Casey's Sister at the Bat, others. 256pp. 5⅜ x 8½. 28598-7

THE RAVEN AND OTHER FAVORITE POEMS, Edgar Allan Poe. Over 40 of the author's most memorable poems: "The Bells," "Ulalume," "Israfel," "To Helen," "The Conqueror Worm," "Eldorado," "Annabel Lee," many more. Alphabetic lists of titles and first lines. 64pp. 5 9/16 x 8¼. 26685-0

PERSONAL MEMOIRS OF U. S. GRANT, Ulysses Simpson Grant. Intelligent, deeply moving firsthand account of Civil War campaigns, considered by many the finest military memoirs ever written. Includes letters, historic photographs, maps and more. 528pp. 6⅛ x 9¼. 28587-1

ANCIENT EGYPTIAN MATERIALS AND INDUSTRIES, A. Lucas and J. Harris. Fascinating, comprehensive, thoroughly documented text describes this ancient civilization's vast resources and the processes that incorporated them in daily life, including the use of animal products, building materials, cosmetics, perfumes and incense, fibers, glazed ware, glass and its manufacture, materials used in the mummification process, and much more. 544pp. 6⅛ x 9¼. (Available in U.S. only.) 40446-3

RUSSIAN STORIES/RUSSKIE RASSKAZY: A Dual-Language Book, edited by Gleb Struve. Twelve tales by such masters as Chekhov, Tolstoy, Dostoevsky, Pushkin, others. Excellent word-for-word English translations on facing pages, plus teaching and study aids, Russian/English vocabulary, biographical/critical introductions, more. 416pp. 5⅜ x 8½. 26244-8

PHILADELPHIA THEN AND NOW: 60 Sites Photographed in the Past and Present, Kenneth Finkel and Susan Oyama. Rare photographs of City Hall, Logan Square, Independence Hall, Betsy Ross House, other landmarks juxtaposed with contemporary views. Captures changing face of historic city. Introduction. Captions. 128pp. 8¼ x 11. 25790-8

AIA ARCHITECTURAL GUIDE TO NASSAU AND SUFFOLK COUNTIES, LONG ISLAND, The American Institute of Architects, Long Island Chapter, and the Society for the Preservation of Long Island Antiquities. Comprehensive, well-researched and generously illustrated volume brings to life over three centuries of Long Island's great architectural heritage. More than 240 photographs with authoritative, extensively detailed captions. 176pp. 8¼ x 11. 26946-9

NORTH AMERICAN INDIAN LIFE: Customs and Traditions of 23 Tribes, Elsie Clews Parsons (ed.). 27 fictionalized essays by noted anthropologists examine religion, customs, government, additional facets of life among the Winnebago, Crow, Zuni, Eskimo, other tribes. 480pp. 6⅛ x 9¼. 27377-6

FRANK LLOYD WRIGHT'S DANA HOUSE, Donald Hoffmann. Pictorial essay of residential masterpiece with over 160 interior and exterior photos, plans, elevations, sketches and studies. 128pp. 9¼ x 10¾. 29120-0

THE MALE AND FEMALE FIGURE IN MOTION: 60 Classic Photographic Sequences, Eadweard Muybridge. 60 true-action photographs of men and women walking, running, climbing, bending, turning, etc., reproduced from rare 19th-century masterpiece. vi + 121pp. 9 x 12. 24745-7

1001 QUESTIONS ANSWERED ABOUT THE SEASHORE, N. J. Berrill and Jacquelyn Berrill. Queries answered about dolphins, sea snails, sponges, starfish, fishes, shore birds, many others. Covers appearance, breeding, growth, feeding, much more. 305pp. 5¼ x 8¼. 23366-9

ATTRACTING BIRDS TO YOUR YARD, William J. Weber. Easy-to-follow guide offers advice on how to attract the greatest diversity of birds: birdhouses, feeders, water and waterers, much more. 96pp. 5³⁄₁₆ x 8¼. 28927-3

MEDICINAL AND OTHER USES OF NORTH AMERICAN PLANTS: A Historical Survey with Special Reference to the Eastern Indian Tribes, Charlotte Erichsen-Brown. Chronological historical citations document 500 years of usage of plants, trees, shrubs native to eastern Canada, northeastern U.S. Also complete identifying information. 343 illustrations. 544pp. 6½ x 9¼. 25951-X

STORYBOOK MAZES, Dave Phillips. 23 stories and mazes on two-page spreads: Wizard of Oz, Treasure Island, Robin Hood, etc. Solutions. 64pp. 8¼ x 11. 23628-5

AMERICAN NEGRO SONGS: 230 Folk Songs and Spirituals, Religious and Secular, John W. Work. This authoritative study traces the African influences of songs sung and played by black Americans at work, in church, and as entertainment. The author discusses the lyric significance of such songs as "Swing Low, Sweet Chariot," "John Henry," and others and offers the words and music for 230 songs. Bibliography. Index of Song Titles. 272pp. 6½ x 9¼. 40271-1

MOVIE-STAR PORTRAITS OF THE FORTIES, John Kobal (ed.). 163 glamor, studio photos of 106 stars of the 1940s: Rita Hayworth, Ava Gardner, Marlon Brando, Clark Gable, many more. 176pp. 8⅜ x 11¼. 23546-7

BENCHLEY LOST AND FOUND, Robert Benchley. Finest humor from early 30s, about pet peeves, child psychologists, post office and others. Mostly unavailable elsewhere. 73 illustrations by Peter Arno and others. 183pp. 5⅜ x 8½. 22410-4

YEKL and THE IMPORTED BRIDEGROOM AND OTHER STORIES OF YIDDISH NEW YORK, Abraham Cahan. Film Hester Street based on *Yekl* (1896). Novel, other stories among first about Jewish immigrants on N.Y.'s East Side. 240pp. 5⅜ x 8½. 22427-9

SELECTED POEMS, Walt Whitman. Generous sampling from *Leaves of Grass.* Twenty-four poems include "I Hear America Singing," "Song of the Open Road," "I Sing the Body Electric," "When Lilacs Last in the Dooryard Bloom'd," "O Captain! My Captain!"–all reprinted from an authoritative edition. Lists of titles and first lines. 128pp. 5³⁄₁₆ x 8¼. 26878-0

THE BEST TALES OF HOFFMANN, E. T. A. Hoffmann. 10 of Hoffmann's most important stories: "Nutcracker and the King of Mice," "The Golden Flowerpot," etc. 458pp. 5⅜ x 8½. 21793-0

FROM FETISH TO GOD IN ANCIENT EGYPT, E. A. Wallis Budge. Rich detailed survey of Egyptian conception of "God" and gods, magic, cult of animals, Osiris, more. Also, superb English translations of hymns and legends. 240 illustrations. 545pp. 5⅜ x 8½. 25803-3

FRENCH STORIES/CONTES FRANÇAIS: A Dual-Language Book, Wallace Fowlie. Ten stories by French masters, Voltaire to Camus: "Micromegas" by Voltaire; "The Atheist's Mass" by Balzac; "Minuet" by de Maupassant; "The Guest" by Camus, six more. Excellent English translations on facing pages. Also French-English vocabulary list, exercises, more. 352pp. 5⅜ x 8½. 26443-2

CHICAGO AT THE TURN OF THE CENTURY IN PHOTOGRAPHS: 122 Historic Views from the Collections of the Chicago Historical Society, Larry A. Viskochil. Rare large-format prints offer detailed views of City Hall, State Street, the Loop, Hull House, Union Station, many other landmarks, circa 1904-1913. Introduction. Captions. Maps. 144pp. 9⅜ x 12¼. 24656-6

OLD BROOKLYN IN EARLY PHOTOGRAPHS, 1865-1929, William Lee Younger. Luna Park, Gravesend race track, construction of Grand Army Plaza, moving of Hotel Brighton, etc. 157 previously unpublished photographs. 165pp. 8⅞ x 11¾. 23587-4

THE MYTHS OF THE NORTH AMERICAN INDIANS, Lewis Spence. Rich anthology of the myths and legends of the Algonquins, Iroquois, Pawnees and Sioux, prefaced by an extensive historical and ethnological commentary. 36 illustrations. 480pp. 5⅜ x 8½. 25967-6

AN ENCYCLOPEDIA OF BATTLES: Accounts of Over 1,560 Battles from 1479 B.C. to the Present, David Eggenberger. Essential details of every major battle in recorded history from the first battle of Megiddo in 1479 B.C. to Grenada in 1984. List of Battle Maps. New Appendix covering the years 1967-1984. Index. 99 illustrations. 544pp. 6½ x 9¼. 24913-1

SAILING ALONE AROUND THE WORLD, Captain Joshua Slocum. First man to sail around the world, alone, in small boat. One of great feats of seamanship told in delightful manner. 67 illustrations. 294pp. 5⅜ x 8½. 20326-3

ANARCHISM AND OTHER ESSAYS, Emma Goldman. Powerful, penetrating, prophetic essays on direct action, role of minorities, prison reform, puritan hypocrisy, violence, etc. 271pp. 5⅜ x 8½. 22484-8

MYTHS OF THE HINDUS AND BUDDHISTS, Ananda K. Coomaraswamy and Sister Nivedita. Great stories of the epics; deeds of Krishna, Shiva, taken from puranas, Vedas, folk tales; etc. 32 illustrations. 400pp. 5⅜ x 8½. 21759-0

THE TRAUMA OF BIRTH, Otto Rank. Rank's controversial thesis that anxiety neurosis is caused by profound psychological trauma which occurs at birth. 256pp. 5⅜ x 8½. 27974-X

A THEOLOGICO-POLITICAL TREATISE, Benedict Spinoza. Also contains unfinished Political Treatise. Great classic on religious liberty, theory of government on common consent. R. Elwes translation. Total of 421pp. 5⅜ x 8½. 20249-6

MY BONDAGE AND MY FREEDOM, Frederick Douglass. Born a slave, Douglass became outspoken force in antislavery movement. The best of Douglass' autobiographies. Graphic description of slave life. 464pp. 5⅜ x 8½. 22457-0

FOLLOWING THE EQUATOR: A Journey Around the World, Mark Twain. Fascinating humorous account of 1897 voyage to Hawaii, Australia, India, New Zealand, etc. Ironic, bemused reports on peoples, customs, climate, flora and fauna, politics, much more. 197 illustrations. 720pp. 5⅜ x 8½. 26113-1

THE PEOPLE CALLED SHAKERS, Edward D. Andrews. Definitive study of Shakers: origins, beliefs, practices, dances, social organization, furniture and crafts, etc. 33 illustrations. 351pp. 5⅜ x 8½. 21081-2

THE MYTHS OF GREECE AND ROME, H. A. Guerber. A classic of mythology, generously illustrated, long prized for its simple, graphic, accurate retelling of the principal myths of Greece and Rome, and for its commentary on their origins and significance. With 64 illustrations by Michelangelo, Raphael, Titian, Rubens, Canova, Bernini and others. 480pp. 5⅜ x 8½. 27584-1

PSYCHOLOGY OF MUSIC, Carl E. Seashore. Classic work discusses music as a medium from psychological viewpoint. Clear treatment of physical acoustics, auditory apparatus, sound perception, development of musical skills, nature of musical feeling, host of other topics. 88 figures. 408pp. 5⅜ x 8½. 21851-1

THE PHILOSOPHY OF HISTORY, Georg W. Hegel. Great classic of Western thought develops concept that history is not chance but rational process, the evolution of freedom. 457pp. 5⅜ x 8½. 20112-0

THE BOOK OF TEA, Kakuzo Okakura. Minor classic of the Orient: entertaining, charming explanation, interpretation of traditional Japanese culture in terms of tea ceremony. 94pp. 5⅜ x 8½. 20070-1

LIFE IN ANCIENT EGYPT, Adolf Erman. Fullest, most thorough, detailed older account with much not in more recent books, domestic life, religion, magic, medicine, commerce, much more. Many illustrations reproduce tomb paintings, carvings, hieroglyphs, etc. 597pp. 5⅜ x 8½. 22632-8

SUNDIALS, Their Theory and Construction, Albert Waugh. Far and away the best, most thorough coverage of ideas, mathematics concerned, types, construction, adjusting anywhere. Simple, nontechnical treatment allows even children to build several of these dials. Over 100 illustrations. 230pp. 5⅜ x 8½. 22947-5

THEORETICAL HYDRODYNAMICS, L. M. Milne-Thomson. Classic exposition of the mathematical theory of fluid motion, applicable to both hydrodynamics and aerodynamics. Over 600 exercises. 768pp. 6⅛ x 9¼. 68970-0

SONGS OF EXPERIENCE: Facsimile Reproduction with 26 Plates in Full Color, William Blake. 26 full color plates from a rare 1826 edition. Includes "The Tyger," "London," "Holy Thursday," and other poems. Printed text of poems. 48pp. 5¼ x 7. 24636-1

OLD-TIME VIGNETTES IN FULL COLOR, Carol Belanger Grafton (ed.). Over 390 charming, often sentimental illustrations, selected from archives of Victorian graphics—pretty women posing, children playing, food, flowers, kittens and puppies, smiling cherubs, birds and butterflies, much more. All copyright-free. 48pp. 9¼ x 12¼. 27269-9

PERSPECTIVE FOR ARTISTS, Rex Vicat Cole. Depth, perspective of sky and sea, shadows, much more, not usually covered. 391 diagrams, 81 reproductions of drawings and paintings. 279pp. 5⅜ x 8½. 22487-2

DRAWING THE LIVING FIGURE, Joseph Sheppard. Innovative approach to artistic anatomy focuses on specifics of surface anatomy, rather than muscles and bones. Over 170 drawings of live models in front, back and side views, and in widely varying poses. Accompanying diagrams. 177 illustrations. Introduction. Index. 144pp. 8⅜ x11¼. 26723-7

GOTHIC AND OLD ENGLISH ALPHABETS: 100 Complete Fonts, Dan X. Solo. Add power, elegance to posters, signs, other graphics with 100 stunning copyright-free alphabets: Blackstone, Dolbey, Germania, 97 more—including many lower-case, numerals, punctuation marks. 104pp. 8⅛ x 11. 24695-7

HOW TO DO BEADWORK, Mary White. Fundamental book on craft from simple projects to five-bead chains and woven works. 106 illustrations. 142pp. 5⅜ x 8. 20697-1

THE BOOK OF WOOD CARVING, Charles Marshall Sayers. Finest book for beginners discusses fundamentals and offers 34 designs. "Absolutely first rate . . . well thought out and well executed."–E. J. Tangerman. 118pp. 7¾ x 10⅜. 23654-4

ILLUSTRATED CATALOG OF CIVIL WAR MILITARY GOODS: Union Army Weapons, Insignia, Uniform Accessories, and Other Equipment, Schuyler, Hartley, and Graham. Rare, profusely illustrated 1846 catalog includes Union Army uniform and dress regulations, arms and ammunition, coats, insignia, flags, swords, rifles, etc. 226 illustrations. 160pp. 9 x 12. 24939-5

WOMEN'S FASHIONS OF THE EARLY 1900s: An Unabridged Republication of "New York Fashions, 1909," National Cloak & Suit Co. Rare catalog of mail-order fashions documents women's and children's clothing styles shortly after the turn of the century. Captions offer full descriptions, prices. Invaluable resource for fashion, costume historians. Approximately 725 illustrations. 128pp. 8⅜ x 11¼. 27276-1

THE 1912 AND 1915 GUSTAV STICKLEY FURNITURE CATALOGS, Gustav Stickley. With over 200 detailed illustrations and descriptions, these two catalogs are essential reading and reference materials and identification guides for Stickley furniture. Captions cite materials, dimensions and prices. 112pp. 6½ x 9¼. 26676-1

EARLY AMERICAN LOCOMOTIVES, John H. White, Jr. Finest locomotive engravings from early 19th century: historical (1804–74), main-line (after 1870), special, foreign, etc. 147 plates. 142pp. 11⅜ x 8¼. 22772-3

THE TALL SHIPS OF TODAY IN PHOTOGRAPHS, Frank O. Braynard. Lavishly illustrated tribute to nearly 100 majestic contemporary sailing vessels: Amerigo Vespucci, Clearwater, Constitution, Eagle, Mayflower, Sea Cloud, Victory, many more. Authoritative captions provide statistics, background on each ship. 190 black-and-white photographs and illustrations. Introduction. 128pp. 8⅞ x 11¾. 27163-3

LITTLE BOOK OF EARLY AMERICAN CRAFTS AND TRADES, Peter Stockham (ed.). 1807 children's book explains crafts and trades: baker, hatter, cooper, potter, and many others. 23 copperplate illustrations. 140pp. 4⅝ x 6. 23336-7

VICTORIAN FASHIONS AND COSTUMES FROM HARPER'S BAZAR, 1867–1898, Stella Blum (ed.). Day costumes, evening wear, sports clothes, shoes, hats, other accessories in over 1,000 detailed engravings. 320pp. 9⅜ x 12¼. 22990-4

GUSTAV STICKLEY, THE CRAFTSMAN, Mary Ann Smith. Superb study surveys broad scope of Stickley's achievement, especially in architecture. Design philosophy, rise and fall of the Craftsman empire, descriptions and floor plans for many Craftsman houses, more. 86 black-and-white halftones. 31 line illustrations. Introduction 208pp. 6½ x 9¼. 27210-9

THE LONG ISLAND RAIL ROAD IN EARLY PHOTOGRAPHS, Ron Ziel. Over 220 rare photos, informative text document origin (1844) and development of rail service on Long Island. Vintage views of early trains, locomotives, stations, passengers, crews, much more. Captions. 8⅞ x 11¾. 26301-0

VOYAGE OF THE LIBERDADE, Joshua Slocum. Great 19th-century mariner's thrilling, first hand account of the wreck of his ship off South America, the 35-foot boat he built from the wreckage, and its remarkable voyage home. 128pp. 5⅜ x 8½. 40022-0

TEN BOOKS ON ARCHITECTURE, Vitruvius. The most important book ever written on architecture. Early Roman aesthetics, technology, classical orders, site selection, all other aspects. Morgan translation. 331pp. 5⅜ x 8½. 20645-9

THE HUMAN FIGURE IN MOTION, Eadweard Muybridge. More than 4,500 stopped-action photos, in action series, showing undraped men, women, children jumping, lying down, throwing, sitting, wrestling, carrying, etc. 390pp. 7⅞ x 10⅝. 20204-6 Clothbd.

TREES OF THE EASTERN AND CENTRAL UNITED STATES AND CANADA, William M. Harlow. Best one-volume guide to 140 trees. Full descriptions, woodlore, range, etc. Over 600 illustrations. Handy size. 288pp. 4½ x 6⅜. 20395-6

SONGS OF WESTERN BIRDS, Dr. Donald J. Borror. Complete song and call repertoire of 60 western species, including flycatchers, juncoes, cactus wrens, many more—includes fully illustrated booklet. Cassette and manual 99913-0

GROWING AND USING HERBS AND SPICES, Milo Miloradovich. Versatile handbook provides all the information needed for cultivation and use of all the herbs and spices available in North America. 4 illustrations. Index. Glossary. 236pp. 5⅜ x 8½. 25058-X

BIG BOOK OF MAZES AND LABYRINTHS, Walter Shepherd. 50 mazes and labyrinths in all—classical, solid, ripple, and more—in one great volume. Perfect inexpensive puzzler for clever youngsters. Full solutions. 112pp. 8⅛ x 11. 22951-3

PIANO TUNING, J. Cree Fischer. Clearest, best book for beginner, amateur. Simple opening, raising dropped notes, tuning by own method of flattened fifths. No previous skills needed. 4 illustrations. 201pp. 5⅜ x 8½. 23267-0

HINTS TO SINGERS, Lillian Nordica. Selecting the right teacher, developing confidence, overcoming stage fright, and many other important skills receive thoughtful discussion in this indispensible guide, written by a world-famous diva of four decades' experience. 96pp. 5⅜ x 8½. 40094-8

THE COMPLETE NONSENSE OF EDWARD LEAR, Edward Lear. All nonsense limericks, zany alphabets, Owl and Pussycat, songs, nonsense botany, etc., illustrated by Lear. Total of 320pp. 5⅜ x 8½. (Available in U.S. only.) 20167-8

VICTORIAN PARLOUR POETRY: An Annotated Anthology, Michael R. Turner. 117 gems by Longfellow, Tennyson, Browning, many lesser-known poets. "The Village Blacksmith," "Curfew Must Not Ring Tonight," "Only a Baby Small," dozens more, often difficult to find elsewhere. Index of poets, titles, first lines. xxiii + 325pp. 5⅜ x 8¼. 27044-0

DUBLINERS, James Joyce. Fifteen stories offer vivid, tightly focused observations of the lives of Dublin's poorer classes. At least one, "The Dead," is considered a masterpiece. Reprinted complete and unabridged from standard edition. 160pp. 5³⁄₁₆ x 8¼. 26870-5

GREAT WEIRD TALES: 14 Stories by Lovecraft, Blackwood, Machen and Others, S. T. Joshi (ed.). 14 spellbinding tales, including "The Sin Eater," by Fiona McLeod, "The Eye Above the Mantel," by Frank Belknap Long, as well as renowned works by R. H. Barlow, Lord Dunsany, Arthur Machen, W. C. Morrow and eight other masters of the genre. 256pp. 5⅜ x 8½. (Available in U.S. only.) 40436-6

THE BOOK OF THE SACRED MAGIC OF ABRAMELIN THE MAGE, translated by S. MacGregor Mathers. Medieval manuscript of ceremonial magic. Basic document in Aleister Crowley, Golden Dawn groups. 268pp. 5⅜ x 8½. 23211-5

NEW RUSSIAN-ENGLISH AND ENGLISH-RUSSIAN DICTIONARY, M. A. O'Brien. This is a remarkably handy Russian dictionary, containing a surprising amount of information, including over 70,000 entries. 366pp. 4½ x 6¼. 20208-9

HISTORIC HOMES OF THE AMERICAN PRESIDENTS, Second, Revised Edition, Irvin Haas. A traveler's guide to American Presidential homes, most open to the public, depicting and describing homes occupied by every American President from George Washington to George Bush. With visiting hours, admission charges, travel routes. 175 photographs. Index. 160pp. 8¼ x 11. 26751-2

NEW YORK IN THE FORTIES, Andreas Feininger. 162 brilliant photographs by the well-known photographer, formerly with *Life* magazine. Commuters, shoppers, Times Square at night, much else from city at its peak. Captions by John von Hartz. 181pp. 9¼ x 10¾. 23585-8

INDIAN SIGN LANGUAGE, William Tomkins. Over 525 signs developed by Sioux and other tribes. Written instructions and diagrams. Also 290 pictographs. 111pp. 6⅛ x 9¼. 22029-X

ANATOMY: A Complete Guide for Artists, Joseph Sheppard. A master of figure drawing shows artists how to render human anatomy convincingly. Over 460 illustrations. 224pp. 8⅜ x 11¼. 27279-6

MEDIEVAL CALLIGRAPHY: Its History and Technique, Marc Drogin. Spirited history, comprehensive instruction manual covers 13 styles (ca. 4th century through 15th). Excellent photographs; directions for duplicating medieval techniques with modern tools. 224pp. 8⅜ x 11¼. 26142-5

DRIED FLOWERS: How to Prepare Them, Sarah Whitlock and Martha Rankin. Complete instructions on how to use silica gel, meal and borax, perlite aggregate, sand and borax, glycerine and water to create attractive permanent flower arrangements. 12 illustrations. 32pp. 5⅜ x 8½. 21802-3

EASY-TO-MAKE BIRD FEEDERS FOR WOODWORKERS, Scott D. Campbell. Detailed, simple-to-use guide for designing, constructing, caring for and using feeders. Text, illustrations for 12 classic and contemporary designs. 96pp. 5⅜ x 8½.

25847-5

SCOTTISH WONDER TALES FROM MYTH AND LEGEND, Donald A. Mackenzie. 16 lively tales tell of giants rumbling down mountainsides, of a magic wand that turns stone pillars into warriors, of gods and goddesses, evil hags, powerful forces and more. 240pp. 5⅜ x 8½. 29677-6

THE HISTORY OF UNDERCLOTHES, C. Willett Cunnington and Phyllis Cunnington. Fascinating, well-documented survey covering six centuries of English undergarments, enhanced with over 100 illustrations: 12th-century laced-up bodice, footed long drawers (1795), 19th-century bustles, 19th-century corsets for men, Victorian "bust improvers," much more. 272pp. 5⅜ x 8¼. 27124-2

ARTS AND CRAFTS FURNITURE: The Complete Brooks Catalog of 1912, Brooks Manufacturing Co. Photos and detailed descriptions of more than 150 now very collectible furniture designs from the Arts and Crafts movement depict davenports, settees, buffets, desks, tables, chairs, bedsteads, dressers and more, all built of solid, quarter-sawed oak. Invaluable for students and enthusiasts of antiques, Americana and the decorative arts. 80pp. 6½ x 9¼. 27471-3

WILBUR AND ORVILLE: A Biography of the Wright Brothers, Fred Howard. Definitive, crisply written study tells the full story of the brothers' lives and work. A vividly written biography, unparalleled in scope and color, that also captures the spirit of an extraordinary era. 560pp. 6⅛ x 9¼. 40297-5

THE ARTS OF THE SAILOR: Knotting, Splicing and Ropework, Hervey Garrett Smith. Indispensable shipboard reference covers tools, basic knots and useful hitches; handsewing and canvas work, more. Over 100 illustrations. Delightful reading for sea lovers. 256pp. 5⅜ x 8½. 26440-8

FRANK LLOYD WRIGHT'S FALLINGWATER: The House and Its History, Second, Revised Edition, Donald Hoffmann. A total revision—both in text and illustrations—of the standard document on Fallingwater, the boldest, most personal architectural statement of Wright's mature years, updated with valuable new material from the recently opened Frank Lloyd Wright Archives. "Fascinating"–*The New York Times*. 116 illustrations. 128pp. 9¼ x 10¾. 27430-6

PHOTOGRAPHIC SKETCHBOOK OF THE CIVIL WAR, Alexander Gardner. 100 photos taken on field during the Civil War. Famous shots of Manassas Harper's Ferry, Lincoln, Richmond, slave pens, etc. 244pp. 10⅝ x 8¼. 22731-6

FIVE ACRES AND INDEPENDENCE, Maurice G. Kains. Great back-to-the-land classic explains basics of self-sufficient farming. The one book to get. 95 illustrations. 397pp. 5⅜ x 8½. 20974-1

SONGS OF EASTERN BIRDS, Dr. Donald J. Borror. Songs and calls of 60 species most common to eastern U.S.: warblers, woodpeckers, flycatchers, thrushes, larks, many more in high-quality recording. Cassette and manual 99912-2

A MODERN HERBAL, Margaret Grieve. Much the fullest, most exact, most useful compilation of herbal material. Gigantic alphabetical encyclopedia, from aconite to zedoary, gives botanical information, medical properties, folklore, economic uses, much else. Indispensable to serious reader. 161 illustrations. 888pp. 6½ x 9¼. 2-vol. set. (Available in U.S. only.) Vol. I: 22798-7
Vol. II: 22799-5

HIDDEN TREASURE MAZE BOOK, Dave Phillips. Solve 34 challenging mazes accompanied by heroic tales of adventure. Evil dragons, people-eating plants, blood-thirsty giants, many more dangerous adversaries lurk at every twist and turn. 34 mazes, stories, solutions. 48pp. 8¼ x 11. 24566-7

LETTERS OF W. A. MOZART, Wolfgang A. Mozart. Remarkable letters show bawdy wit, humor, imagination, musical insights, contemporary musical world; includes some letters from Leopold Mozart. 276pp. 5⅜ x 8½. 22859-2

BASIC PRINCIPLES OF CLASSICAL BALLET, Agrippina Vaganova. Great Russian theoretician, teacher explains methods for teaching classical ballet. 118 illustrations. 175pp. 5⅜ x 8½. 22036-2

THE JUMPING FROG, Mark Twain. Revenge edition. The original story of The Celebrated Jumping Frog of Calaveras County, a hapless French translation, and Twain's hilarious "retranslation" from the French. 12 illustrations. 66pp. 5⅜ x 8½. 22686-7

BEST REMEMBERED POEMS, Martin Gardner (ed.). The 126 poems in this superb collection of 19th- and 20th-century British and American verse range from Shelley's "To a Skylark" to the impassioned "Renascence" of Edna St. Vincent Millay and to Edward Lear's whimsical "The Owl and the Pussycat." 224pp. 5⅜ x 8½. 27165-X

COMPLETE SONNETS, William Shakespeare. Over 150 exquisite poems deal with love, friendship, the tyranny of time, beauty's evanescence, death and other themes in language of remarkable power, precision and beauty. Glossary of archaic terms. 80pp. 5³⁄₁₆ x 8¼. 26686-9

THE BATTLES THAT CHANGED HISTORY, Fletcher Pratt. Eminent historian profiles 16 crucial conflicts, ancient to modern, that changed the course of civilization. 352pp. 5⅜ x 8½. 41129-X

THE WIT AND HUMOR OF OSCAR WILDE, Alvin Redman (ed.). More than 1,000 ripostes, paradoxes, wisecracks: Work is the curse of the drinking classes; I can resist everything except temptation; etc. 258pp. 5⅜ x 8½. 20602-5

SHAKESPEARE LEXICON AND QUOTATION DICTIONARY, Alexander Schmidt. Full definitions, locations, shades of meaning in every word in plays and poems. More than 50,000 exact quotations. 1,485pp. 6½ x 9¼. 2-vol. set.
Vol. 1: 22726-X
Vol. 2: 22727-8

SELECTED POEMS, Emily Dickinson. Over 100 best-known, best-loved poems by one of America's foremost poets, reprinted from authoritative early editions. No comparable edition at this price. Index of first lines. 64pp. 5³⁄₁₆ x 8¼. 26466-1

THE INSIDIOUS DR. FU-MANCHU, Sax Rohmer. The first of the popular mystery series introduces a pair of English detectives to their archnemesis, the diabolical Dr. Fu-Manchu. Flavorful atmosphere, fast-paced action, and colorful characters enliven this classic of the genre. 208pp. 5³⁄₁₆ x 8¼. 29898-1

THE MALLEUS MALEFICARUM OF KRAMER AND SPRENGER, translated by Montague Summers. Full text of most important witchhunter's "bible," used by both Catholics and Protestants. 278pp. 6⅜ x 10. 22802-9

SPANISH STORIES/CUENTOS ESPAÑOLES: A Dual-Language Book, Angel Flores (ed.). Unique format offers 13 great stories in Spanish by Cervantes, Borges, others. Faithful English translations on facing pages. 352pp. 5⅜ x 8½. 25399-6

GARDEN CITY, LONG ISLAND, IN EARLY PHOTOGRAPHS, 1869–1919, Mildred H. Smith. Handsome treasury of 118 vintage pictures, accompanied by carefully researched captions, document the Garden City Hotel fire (1899), the Vanderbilt Cup Race (1908), the first airmail flight departing from the Nassau Boulevard Aerodrome (1911), and much more. 96pp. 8⅞ x 11¾. 40669-5

OLD QUEENS, N.Y., IN EARLY PHOTOGRAPHS, Vincent F. Seyfried and William Asadorian. Over 160 rare photographs of Maspeth, Jamaica, Jackson Heights, and other areas. Vintage views of DeWitt Clinton mansion, 1939 World's Fair and more. Captions. 192pp. 8⅞ x 11. 26358-4

CAPTURED BY THE INDIANS: 15 Firsthand Accounts, 1750-1870, Frederick Drimmer. Astounding true historical accounts of grisly torture, bloody conflicts, relentless pursuits, miraculous escapes and more, by people who lived to tell the tale. 384pp. 5⅜ x 8½. 24901-8

THE WORLD'S GREAT SPEECHES (Fourth Enlarged Edition), Lewis Copeland, Lawrence W. Lamm, and Stephen J. McKenna. Nearly 300 speeches provide public speakers with a wealth of updated quotes and inspiration–from Pericles' funeral oration and William Jennings Bryan's "Cross of Gold Speech" to Malcolm X's powerful words on the Black Revolution and Earl of Spenser's tribute to his sister, Diana, Princess of Wales. 944pp. 5⅜ x 8⅜. 40903-1

THE BOOK OF THE SWORD, Sir Richard F. Burton. Great Victorian scholar/adventurer's eloquent, erudite history of the "queen of weapons"–from prehistory to early Roman Empire. Evolution and development of early swords, variations (sabre, broadsword, cutlass, scimitar, etc.), much more. 336pp. 6⅛ x 9¼. 25434-8

AUTOBIOGRAPHY: The Story of My Experiments with Truth, Mohandas K. Gandhi. Boyhood, legal studies, purification, the growth of the Satyagraha (nonviolent protest) movement. Critical, inspiring work of the man responsible for the freedom of India. 480pp. 5⅜ x 8½. (Available in U.S. only.) 24593-4

CELTIC MYTHS AND LEGENDS, T. W. Rolleston. Masterful retelling of Irish and Welsh stories and tales. Cuchulain, King Arthur, Deirdre, the Grail, many more. First paperback edition. 58 full-page illustrations. 512pp. 5⅜ x 8½. 26507-2

THE PRINCIPLES OF PSYCHOLOGY, William James. Famous long course complete, unabridged. Stream of thought, time perception, memory, experimental methods; great work decades ahead of its time. 94 figures. 1,391pp. 5⅜ x 8½. 2-vol. set.
Vol. I: 20381-6 Vol. II: 20382-4

THE WORLD AS WILL AND REPRESENTATION, Arthur Schopenhauer. Definitive English translation of Schopenhauer's life work, correcting more than 1,000 errors, omissions in earlier translations. Translated by E. F. J. Payne. Total of 1,269pp. 5⅜ x 8½. 2-vol. set. Vol. 1: 21761-2 Vol. 2: 21762-0

MAGIC AND MYSTERY IN TIBET, Madame Alexandra David-Neel. Experiences among lamas, magicians, sages, sorcerers, Bonpa wizards. A true psychic discovery. 32 illustrations. 321pp. 5⅜ x 8½. (Available in U.S. only.) 22682-4

THE EGYPTIAN BOOK OF THE DEAD, E. A. Wallis Budge. Complete reproduction of Ani's papyrus, finest ever found. Full hieroglyphic text, interlinear transliteration, word-for-word translation, smooth translation. 533pp. 6½ x 9¼. 21866-X

MATHEMATICS FOR THE NONMATHEMATICIAN, Morris Kline. Detailed, college-level treatment of mathematics in cultural and historical context, with numerous exercises. Recommended Reading Lists. Tables. Numerous figures. 641pp. 5⅜ x 8½.
24823-2

PROBABILISTIC METHODS IN THE THEORY OF STRUCTURES, Isaac Elishakoff. Well-written introduction covers the elements of the theory of probability from two or more random variables, the reliability of such multivariable structures, the theory of random function, Monte Carlo methods of treating problems incapable of exact solution, and more. Examples. 502pp. 5⅜ x 8½. 40691-1

THE RIME OF THE ANCIENT MARINER, Gustave Doré, S. T. Coleridge. Doré's finest work; 34 plates capture moods, subtleties of poem. Flawless full-size reproductions printed on facing pages with authoritative text of poem. "Beautiful. Simply beautiful."—*Publisher's Weekly.* 77pp. 9¼ x 12. 22305-1

NORTH AMERICAN INDIAN DESIGNS FOR ARTISTS AND CRAFTSPEOPLE, Eva Wilson. Over 360 authentic copyright-free designs adapted from Navajo blankets, Hopi pottery, Sioux buffalo hides, more. Geometrics, symbolic figures, plant and animal motifs, etc. 128pp. 8⅜ x 11. (Not for sale in the United Kingdom.) 25341-4

SCULPTURE: Principles and Practice, Louis Slobodkin. Step-by-step approach to clay, plaster, metals, stone; classical and modern. 253 drawings, photos. 255pp. 8⅛ x 11.
22960-2

THE INFLUENCE OF SEA POWER UPON HISTORY, 1660–1783, A. T. Mahan. Influential classic of naval history and tactics still used as text in war colleges. First paperback edition. 4 maps. 24 battle plans. 640pp. 5⅜ x 8½. 25509-3

CATALOG OF DOVER BOOKS

THE STORY OF THE TITANIC AS TOLD BY ITS SURVIVORS, Jack Winocour (ed.). What it was really like. Panic, despair, shocking inefficiency, and a little heroism. More thrilling than any fictional account. 26 illustrations. 320pp. 5⅜ x 8½.
20610-6

FAIRY AND FOLK TALES OF THE IRISH PEASANTRY, William Butler Yeats (ed.). Treasury of 64 tales from the twilight world of Celtic myth and legend: "The Soul Cages," "The Kildare Pooka," "King O'Toole and his Goose," many more. Introduction and Notes by W. B. Yeats. 352pp. 5⅜ x 8½.
26941-8

BUDDHIST MAHAYANA TEXTS, E. B. Cowell and others (eds.). Superb, accurate translations of basic documents in Mahayana Buddhism, highly important in history of religions. The Buddha-karita of Asvaghosha, Larger Sukhavativyuha, more. 448pp. 5⅜ x 8½.
25552-2

ONE TWO THREE . . . INFINITY: Facts and Speculations of Science, George Gamow. Great physicist's fascinating, readable overview of contemporary science: number theory, relativity, fourth dimension, entropy, genes, atomic structure, much more. 128 illustrations. Index. 352pp. 5⅜ x 8½.
25664-2

EXPERIMENTATION AND MEASUREMENT, W. J. Youden. Introductory manual explains laws of measurement in simple terms and offers tips for achieving accuracy and minimizing errors. Mathematics of measurement, use of instruments, experimenting with machines. 1994 edition. Foreword. Preface. Introduction. Epilogue. Selected Readings. Glossary. Index. Tables and figures. 128pp. 5⅜ x 8½. 40451-X

DALÍ ON MODERN ART: The Cuckolds of Antiquated Modern Art, Salvador Dalí. Influential painter skewers modern art and its practitioners. Outrageous evaluations of Picasso, Cézanne, Turner, more. 15 renderings of paintings discussed. 44 calligraphic decorations by Dalí. 96pp. 5⅜ x 8½. (Available in U.S. only.) 29220-7

ANTIQUE PLAYING CARDS: A Pictorial History, Henry René D'Allemagne. Over 900 elaborate, decorative images from rare playing cards (14th–20th centuries): Bacchus, death, dancing dogs, hunting scenes, royal coats of arms, players cheating, much more. 96pp. 9¼ x 12¼.
29265-7

MAKING FURNITURE MASTERPIECES: 30 Projects with Measured Drawings, Franklin H. Gottshall. Step-by-step instructions, illustrations for constructing handsome, useful pieces, among them a Sheraton desk, Chippendale chair, Spanish desk, Queen Anne table and a William and Mary dressing mirror. 224pp. 8⅛ x 11¼.
29338-6

THE FOSSIL BOOK: A Record of Prehistoric Life, Patricia V. Rich et al. Profusely illustrated definitive guide covers everything from single-celled organisms and dinosaurs to birds and mammals and the interplay between climate and man. Over 1,500 illustrations. 760pp. 7½ x 10⅛.
29371-8

Paperbound unless otherwise indicated. Available at your book dealer, online at **www.doverpublications.com**, or by writing to Dept. GI, Dover Publications, Inc., 31 East 2nd Street, Mineola, NY 11501. For current price information or for free catalogues (please indicate field of interest), write to Dover Publications or log on to **www.doverpublications.com** and see every Dover book in print. Dover publishes more than 500 books each year on science, elementary and advanced mathematics, biology, music, art, literary history, social sciences, and other areas.